The Art of
PETER SCOTT

IMAGES FROM A LIFETIME

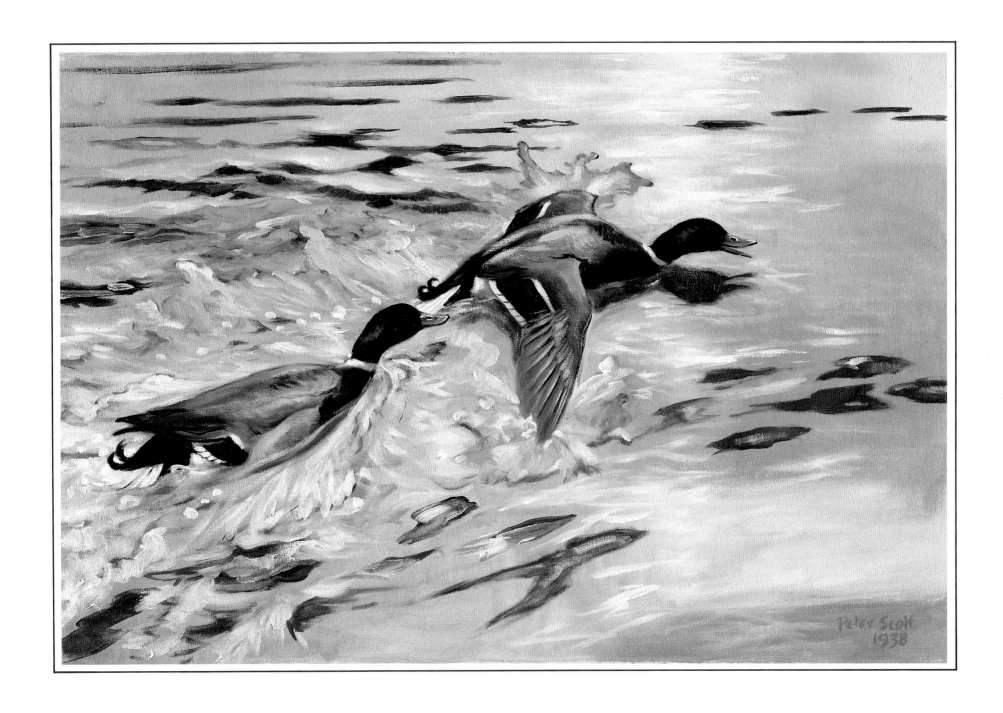

Spring rivals – two mallard drakes
Oil on canvas, 1938. 20″ × 30″ (50.8 × 76.2 cm).

The Art of
PETER SCOTT

IMAGES FROM A LIFETIME

Selected and with captions by
PHILIPPA SCOTT

Foreword by
HRH the Duke of Edinburgh

Introduction by
Keith Shackleton

SINCLAIR-STEVENSON

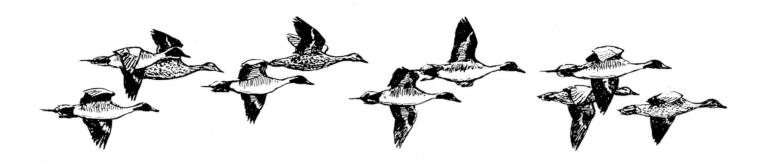

All royalties from this book
will go to The Wildfowl
& Wetlands Trust.

First published in Great Britain by
Sinclair-Stevenson Limited
7/8 Kendrick Mews
London sw7 3HG England

British Library Cataloguing in Publication Data
A CIP catalogue record for this book is available from the British Library.

ISBN: 1 85619 100 1

Typeset by Rowland Phototypesetting Limited, Bury St Edmunds, Suffolk.
Reproduction by Dot Gradations
Printed and bound in Italy by
Arnoldo Mondadori Company Limited, Milan.

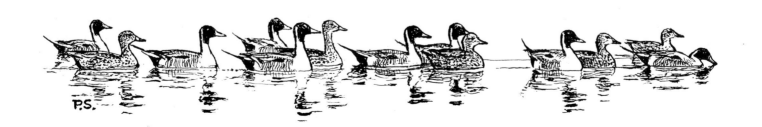

Contents

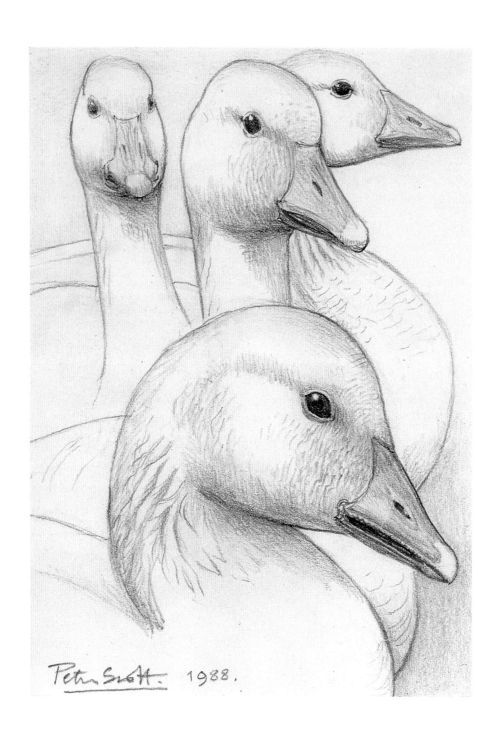

Four lesser snow geese heads
(*actual size*). Pencil and pastel, 1988.

Few people have a better claim to be described as 'a man of many parts' than Peter Scott. Sailor, glider pilot, naturalist, broadcaster, leader of the conservation movement and an outstanding artist. His paintings give immense pleasure to their owners and I am delighted that this book will bring his remarkable talents to a much wider audience.

Philippa Scott had the splendid idea of including examples of his early work from his sketch books and I am sure that this will be warmly welcomed, particularly by present and future artists, who will be able to follow the development of his talent over the years.

I have to say that I am very pleased to see the reproduction of "Ground Mist - Pinkfeet" on the cover of this book. I bought it at Peter Scott's last exhibition and I think it is one of the most evocative of his many images in a lifetime of observing, caring for and painting wildfowl.

1991

Preface

BEFORE he died in 1989, Peter Scott had been planning a book of his paintings and drawings. He was encouraged by the success of an exhibition at Arthur Ackermann & Son's gallery in London earlier that year, and it seemed a good time to follow up with a book of his art. A publisher was showing interest and the project was almost underway. Now, as a tribute to my husband, I have revived the idea, and have delved into the archives and found his early sketch books and drawings dating from his preparatory school days.

This is probably a rather different sort of book from that which Peter had in mind. The early works would not have been included. With the help of Keith Shackleton I have selected a number of drawings from old sketch books dating back to his childhood. Artists today may be encouraged by these early drawings and it is interesting to see how his work develops over the years. I have also included works inspired at the time he was a wildfowler since it was partly through wildfowling that he later became a conservationist.

Keith Shackleton, who has written the Introduction, first met Peter when they were punt-gunning on the Ribble estuary. They met again after the War, dinghy-racing, and together they learned to fly. Keith is a distinguished wildlife artist who has been President of the Royal Society of Marine Artists and succeeded Peter as President of the Society of Wildlife Artists. Importantly, too, he has been a family friend for as long as I have known Peter. Who better, then, to help with this book?

It was very important to Peter that he should share his enjoyment of a subject with other people. By putting on canvas things he had seen while out in the marshes at dawn or sunset, he was trying to bring something of the beauty and excitement he had experienced, for others to enjoy. His two early books *Morning Flight* and *Wild Chorus* became classics in their field. Creating The Wildfowl & Wetlands Trust at Slimbridge was part of the same need to share his love of wildfowl with other people.

He always said that he did not like a day to go by without him having drawn something. He was at his happiest when he was painting, drawing or being creative. Some of his earliest memories were of lying on his tummy on the floor, drawing. His mother, Kathleen Scott, the distinguished sculptor, mercifully kept many of those early drawings, thus providing me with a wealth of material from which to choose.

Those artists who most influenced his career were, Peter wrote: 'Frank Southgate – freedom of style at a time when many artists painted birds in very tight and precise detail; Bruno Liljefors – I recognised him as an oil painter of wildlife without equal in the period of his lifetime; Leonardo da Vinci – draughtsmanship; El Greco – use of minor distortions of the human shape to accentuate feeling.'

Some of the oil paintings in this book have been reproduced before but, as they are some of the best, or show some particular aspect of his work, it would have been a pity to leave them out.

Although happiest working with oil, Peter used watercolour extensively through his illustrated *Travel Diaries*, some of which have been published in three volumes.

He often said that he was not a very good painter but would have liked to be one. But when he was spending two-thirds of his life working for his two favourite charities (The Wildfowl & Wetlands Trust and World Wide Fund for Nature) how could he expect to be the ultimate in something to which he could only devote one-third of his time? He does not seem to have done too badly.

Discussing our three children once, when they were small, he said that more than anything he would like one to be an artist. He would be pleased to see his scientist daughter, Dafila, now following in his footsteps.

Philippa Scott.
Slimbridge, 1992.

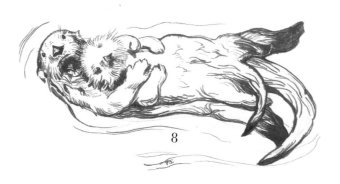

Introduction

Sir Peter Scott died on 29 August, 1989. Sixteen days later he would have been eighty years old.

To celebrate his fourscore years, the Cheltenham Art Gallery and Museums had prepared a retrospective exhibition of his pictures and drawings. It opened on 8 September. Lady Scott came alone and Sir Peter was sorely missed. The exhibition was packed; later it moved to Norwich and Dundee and finally to the Natural History Museum in London. To coincide with these showings, Alan Sutton, in association with Cheltenham Art Gallery and Museums, published *Sir Peter Scott at Eighty – a retrospective*. I had the honour of writing the Foreword, with a brief to cover, in a condensed form, the artistic side of his endeavours. Inevitably, some of what I wrote then will have to be said again here – but with a little more depth.

I had painted with Peter Scott over many years, watched his technique and even painted similar subjects from the same source of inspiration. As a boy, along with hundreds of other aspiring bird painters, I had been enormously influenced by his work.

Sir Peter Scott was a renaissance man. This book, however, is devoted to his art alone; other interests reveal themselves through the variety of his creative work and the zest they gave it. Painters tend to paint what moves them as a personal act of gratitude for the experience, and Peter was no exception. Evidence of a full, rich, happy and exciting life bursts out all over. Artists are, after all, what they paint and, with refreshingly simple logic, they paint what they are, what they know and what they love best.

The first original 'Scotts' I ever saw turned up while I was rummaging in a cupboard at school. I was about thirteen.

Generations of boys had kept their artistic bits and pieces in this cupboard and that is just how it looked. The cupboard, big as a garden shed, formed the main storage place in a de-consecrated tin chapel, reincarnated as an overflow Studio and now, long since demolished.

The originals were dry-point etchings on copper plates and must have lain there unnoticed for the fourteen years that separated Peter Scott's and my own attendance at Oundle, and the school's regular sessions of creative encouragement known as 'Voluntary Studio'.

The Studio differed from the Art Room proper. The Art Room was somewhat sanitised and institutional – a parquet floor, tidily stacked drawing boards, lay-figures on window ledges. Geometric forms for studies in perspective were arranged on glass-topped tables, while a big plaster Venus de Milo introduced us to the freer line. There was a stuffed Osprey, I remember, sun-bleached and threadbare, with its centre of gravity too far forward. A dip-in pen had been utilised as a prop to prevent the bird pitching forward on to its beak. There was a bust of Voltaire, whose sickly likeness we sought in vain to capture during portrait lessons. Everything was geared to formal instruction and whole classes attended at a time.

Drawing is a gift, we were told – but a measure of success lay within the grasp of all. Encouragement was the key-word and we saw Art teachers more as entertainers than pedagogues. They were permitted a certain raffish individuality in dress and demeanour within a framework based on discipline. Despite the strictured atmosphere of the Art Room itself, they made the weekly Art class a welcome break from Latin or Trigonometry. We assessed Art as level-pegging with the evil smells and minor explosions that delighted us so much in the Chemistry labs. But for all that it was still 'school'.

The much-loved 'Tin Tabernacle' – the Studio – was something else. Mysterious and exciting things happened. All the sets for the school play were designed, built and painted there. It was by a wood and a long walk from the centre of things. There was a badger sett beneath it and we could hear the animals snuffling about under the floor-boards.

Here, freedom of expression was propagated under skilled guidance. We were allowed to do our own thing – *encouraged* to do it. The 'Studio boys' had seen the light – or certainly we thought we had. *We* were volunteers; Art Rooms were strictly for conscripts. Moreover, nothing could have lain hidden for a week in the Art Room cupboards, let alone fourteen years.

So, not surprisingly, it was in the Studio at Oundle that Peter Scott had first taken off and here we were, years later, revelling in the treasure trove of evidence. An eager group surrounded the printing press where we were shown how etching plates were inked and impressions taken on special absorbent paper. The first subject to emerge was a lizard; another a hawk-moth. There was a kingfisher on a willow stem and a fat trout rising eagerly to a fly – but no geese.

By then *Morning Flight* had been published, if not *Wild Chorus* as well, so we were unprepared for such an omission. Peter Scott painted *geese*. We all knew it as a simple truth and several of us had picked up the challenge and tried to do the same. Were we not 'into' Art? We knew all about Corot and his willow trees, Munnings' horses, Montague Dawson's windjammers and Farquarson's sheep at sunset (but always in snow because he had problems drawing their feet – other animal painters were to use dust for the same purpose). Had those plates not been clearly signed 'P.S.', we would have doubted their authenticity.

But the drypoints carried a very special significance. 'Make the boy interested in Natural History,' Robert Falcon Scott, the infant Peter's father, had written in his last Antarctic message home. 'It is better than games. They encourage it at some schools.' Had Captain Scott lived another twelve years, he would surely have seen – in the moth, the kingfisher, the lizard and the rising trout – the fulfilment of his wish, testimony of a deep and burgeoning interest, broadly based.

A Life Fellowship of the Zoological Society of London, given as a christening present by his godfather, J. M. Barrie, was a flying start for Peter and a myth still persists that Peter was Barrie's inspiration for 'Peter Pan'.

For those entranced by living creatures while blessed with an ability to draw, subjects decide themselves and demonstrate at the same time the strength of the motivation behind each one. Small wonder, too, that increasing knowledge and feeling for a subject, combined with increasing skill as an artist, will lead to more convincing interpretations of the truth. The wider and more immediate the interest, the more varied the choice of subject. I am reminded of Motor Torpedo Boats racing through the night, lit by star-shells and laced with red and green tracer, in Peter's book *The Battle of the Narrow Seas*. But it was always animals, in one form or another, that took pride of place.

Peter's first published work was an illustration – a Privet hawk-moth caterpillar – for a book of insects. References for such drawings were easily come by. He was never without the companionship of caterpillars in jam-jars, mice in cages, fish in tanks and a lizard in the pocket. A story is told of Sunday Chapel at Oundle with the headmaster's sermon in progress, when a large gecko was seen making its way ceremoniously up the aisle towards the altar. The headmaster was Dr Kenneth (Bud) Fisher, sire of an ornithological dynasty. (James Fisher his son, Crispin his grandson.) 'Scott!' boomed the voice of Bud (from 500 pupils, Scott indeed could be the only suspect). 'Collect this reptile forthwith and keep it under better control.'

Formal art training followed Oundle and Cambridge; first at the State Academy in Munich and later at the Royal Academy Schools in London. It would be interesting to know at what stage the enviable ability to write and draw equally well with either hand crept into his growing catalogue of attainments. Peter, in common with a surprisingly large proportion of gifted artists, was left-handed. But an equally effective right was there in reserve against writer's cramp. His sculptor mother Kathleen (Lady Kennet) is often credited with having taken the pencil out of his right hand and put it in his left when he was young.

In the years after the War, he and I painted several times on the same picture. Occasionally it was a case of stark necessity with a deadline set for delivery and time running out. His left hand and my right proved a bonus, in that he could work on the right side of the canvas and I on the left, our brush handles occasionally clacking together in the middle-ground like the bills of courting gannets.

The overall plan was always his, as was the final brushwork, on my side as well. This part became known as 'Scotting-over', on the laudable grounds of artistic integrity – 'A Scott is a Scott and no nonsense.' But our collaborations led to years of subtle subterfuge and poker-faced denials. Occasionally I thought a picture of mine had improved and attributed it to a more tolerant appraisal – little knowing! By way of making the score even, I learned to undertake minor adjustments on his easel, too, of which several, I am happy to say, passed unnoticed. . . .

Peter would be the first to admit that there is little future in acquiring skills for their own sake; they must be used. To him an Art School training bestowed no more than a heightened capability to portray what he truly cared about – natural spectacle, living things,

moments of special joy or excitement. Nor would he flinch from admitting that much of this – mist and half-light, birds moving over reflecting mud, extravagant dawns and golden sunsets – was first witnessed over the coaming of a gun-punt. There is a deep-down primaeval urge, throughout all mankind, for the hunter, if he has the skill, to portray his quarry. I believe it to be no more than a gesture of gratitude to the animal itself and homage to the god that put it there.

Morning Flight was the first real revelation of Peter's painting imperative. Moreover, the book became a milestone in the unfolding trend of bird painting.

If one had to dredge up an influence on Peter's work, rather than attributing it to something totally original, the nearest could be the great Swedish painter, Bruno Liljefors. There are certain links – animals in their landscape seen as a cohesive entity, enriched by the union of both elements. Somehow he made the established animal portrait look dated, a record rather than a picture. There is another factor. The Wright brothers had made a significant contribution, without realising it, to the painting of birds, simply by introducing an awareness of aerodynamics. Lift and trim, drag and stall, are instinctive factors in birds, giving them a dimension above all other warm-blooded creatures but bats. Before aeroplanes demonstrated these principles for us, the early painters seemed to accept merely that birds had wings and somehow flew with them. They painted them with meticulous clarity when at rest, but seemed reluctant to be drawn on the specifics of what happened when the wings flapped and the birds passed through the air. As a pilot himself, wings to Peter were the essence of any bird. He broke the mould of the old-time masters to whom wings in use were a mild embarrassment, calling for the equivalent of a fig-leaf to cover the short-fall of understanding yet to come.

Peter's loyalty to his chosen subject is legendary – and for the simplest of reasons. With care and thought and renewed observation, there is *always* something more to be distilled from a subject, no matter how familiar it has become over the years. This is the key to understanding the reasons behind the Peter-Scott-paints-geese dictum. It began in the 1920s and survived to the end, even though he had laid aside the last vestige of hunting fervour forty years earlier. In its place there may have been an ingredient of making amends – a direction in which converts often show heightened commitment. But, more realistically, it seems that a long and self-punishing dedication to conservation is just another by-product of caring very deeply about wild animals in their own right, especially in the context of their present predicament, rather than just as lovely subjects for pictures.

So wildfowl kept happening on the canvas. They were always the mainstream, and painting them was like touching base. Here were subjects completely understood, drawing on a life-long memory bank, recalled, selected and pieced together in planned composition. There were always changes in light, in direction, in grouping, in background. And because the exercise became so familiar, there went with it all the pleasures and laid-back assurance of working close to home. A picture

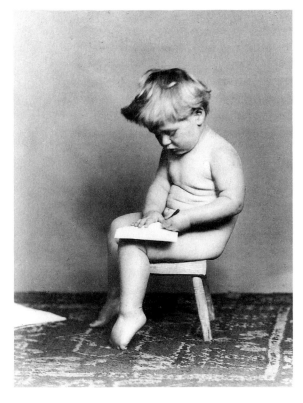

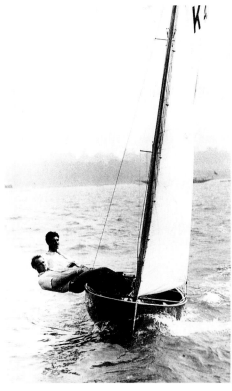

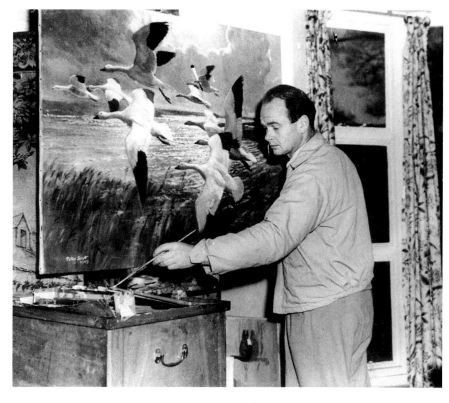

Not quite two, in London

Dinghy racing with John Winter

In the cottage at Slimbridge

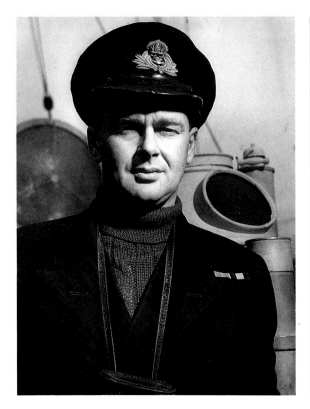

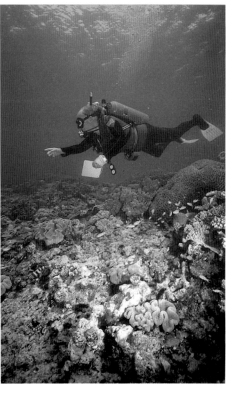

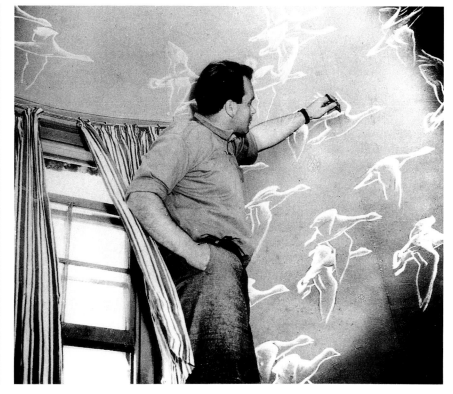

On the bridge of SGB *Grey Goose* c. 1942

Fishwatching on the
Great Barrier Reef

In the lighthouse, pre-war

painted for sheer enjoyment was always a picture of wildfowl.

Conformity to the mainstream, however, was something that could never appeal on any permanent basis. There had to be experiment. Adventures and escape were always built-in potentials whenever a new white canvas was set on the easel.

It was to feel closer to the lifestyle of birds that Peter felt obliged to fly aeroplanes and soar in gliders – with, incidentally, an indecent display of skill. To indulge a fascination for whales and coral-reef fishes, he had to become a diver and share their element at their own level. Artistically, each new realm of understanding showed in his pictures because each one sprang from the authentic. They displayed the conviction of a first-hand experience translated into paint.

For years Peter had kept diaries of his travels, later to be passed into the care of the Royal Geographical Society. They are fat little books, about the size of a Field Guide, and made fatter by the inclusion of Philippa Scott's photographs, clippings from newspapers, notes and letters and retained from bursting by stout elastic bands. Extracts have been published in the past few years; but the clinical selection of tit-bits – which is, I suppose, inevitable – gives no hint of the original character of the books, nor yet of the author himself. With handwriting clear and legible as a typewriter, a chance was missed to reproduce them in facsimile, with all the random annotations that display the detail that busies an alert mind in a wild place, when there is a pencil in hand to record it.

It was indeed the pencil as a drawing instrument that set Peter apart from other artists I have watched at work – no matter what the subject. With a brush in hand his approach was less remarkable.

He drew a great deal with pencils and this must include felt-tip, ball-point and even fountain pens. Nobody who was ever present at meetings with Peter would fail to remember what began to appear on his Agenda paper as discussion dragged on. It would happen discreetly and in a seemingly detached manner as if the hand enjoyed a life-force of its own – independent, while the mind, acutely attentive, contributed to the thrust of debate. Sometimes the drawings, which were slowly covering the Agenda, would bear some tenuous association with the subject matter of the meeting, but as often as not they were splendid pieces of irrelevance – the subconscious set free – a defence mechanism perhaps, against the onset of boredom.

These Agendas became collector's items, and this may have been responsible for introducing the first hints of subject conformity: a little sailplane would come to life on the Agenda of the British Gliding Association; for The Wildfowl Trust, wild geese. For the Royal Yachting Association or the International Yacht Racing Union, there would be dinghies close-hauled, their crews sitting-out at full stretch. But all these Agendas were liberally sprinkled with reef fish and lizards, a caricature of someone sitting across the table, a plan for a duck decoy or the patterns of a hawk-moth's wing. (Without some knowledge of this esoteric subject, this last one might well be taken for mere abstract doodling.)

Constant exercise of the point medium led to an amazing degree of dexterity in the handling of shape and proportion. When he began a pencil portrait, there was never the more usual roughing out of basic masses to achieve a framework for the head as a whole – he went straight in.

An eye would appear, meticulously delineated, shaded and finished. It was placed, first time, exactly where it needed to be on the sheet of paper. Somehow this precise positioning came to him without effort; there was none of this pencil-and-thumb-nail-at-arm's-length-with-one-eye-shut stuff. What was to surround the finished eye and the space it needed was all there in his mind. He would then move to the bridge of the nose.

The corner of the other eye would begin to resolve itself and was quickly finished liked the first. As if working on a tapestry, the profile of the nose, the curl of the lips, followed and were each finished in turn before moving across to an ear or down to the chin.

The last part of all was generally the part that would have been an early priority for most conventional draughtsmen – the outline. The astonishing thing was the accuracy of the result and the way it consolidated all its beautifully finished ingredients.

With so much field work to be covered in the *Travel Diaries*, his skill in delineation was his greatest single asset. Proportion had to be maintained. He worked like the great recording naturalists of the past before there were cameras to relieve the burden. There was a warts-and-all fidelity in every drawing. Truth was sacrosanct and its achievement a creative satisfaction in itself.

This was where his attitude to painting 'pictures' differed and an intriguing dichotomy emerged. By 'pictures' I mean paintings in oils, free from any strictures of conformity that might apply to text-book colour plates, frontispieces and jacket designs for scientific books and journals. In painting a 'picture' he felt somehow off the hook. Here was where Peter found the best part of his artistic fun.

Once he painted a startling *blue* goose, flying in a group of the more usual version. The picture was called, not surprisingly, *The Blue Goose*, and the blue was the brightest cobalt. To comments like: 'But there *isn't* such a thing,' he would reply: 'But don't you wish there were?'

A tendency to caricature crept into this category, too – a conscious over-emphasis of the length of a swan's neck or a duck's wing. Realism carries a quality of illusion and can sometimes be better served this way. Transporting a whole, three-dimensional, living scene onto a humble two-dimensional canvas calls for all the artifice that can be mustered. Peter's playfully exaggerated swans somehow looked more like swans than swans do themselves. By the same token, a photograph, which is supposed to tell the whole truth, is often simply grotesque and a pitiless snare set for those who seek to copy it.

Peter experimented like most artists and found in the occasional break-through a sustaining wave of pleasure. That the break-through might be nothing more exciting than a new way to wash his brushes never detracted from the joy of its discovery. He was keen on textures and surfaces and different ways of applying paint. A spate of pictures employing a speckled effect, comprising both a gravelly prepared

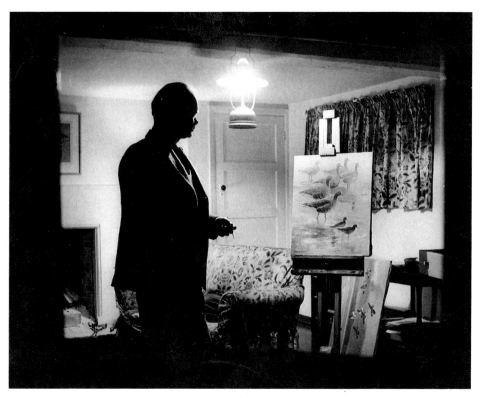

In the cottage at Slimbridge

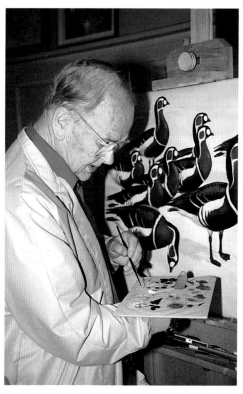

In the house at Slimbridge

On a fishwatching expedition

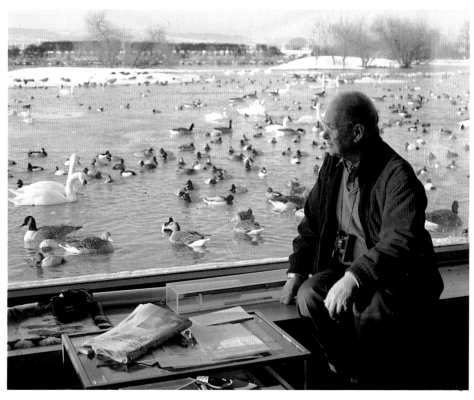

The studio window, Slimbridge

Philippa and Peter at The Wildfowl & Wetlands Trust,
Slimbridge

surface and stippled brushwork, was termed by his peers 'the lavatory window period'.

He tried painting on glass, then lifting prints off it in decreasing strength, on absorbent paper. The results were often startling. He remarked one day about the theory floated by Picasso (doubtless with tongue in cheek) that all 'happy accidents' should be eliminated from an artist's work. 'If I were to eliminate the odd "happy accident",' protested Peter, 'where would the fun be in painting? It's the multiplicity of *un*happy ones that I would like to do something about!'

There was a type of picture with which he became inseparably linked. He knew and accepted it and referred to such pictures as 'Standard Formula Scotts' (S.F.S.). The first of these began to appear in his early twenties and endured in varying forms throughout his life. The Standard Formula Scott was typically a dawn or sunset, water, mud, reeds and groups of wildfowl. The wildfowl content was the master ingredient in the compositions and they could be rising, settling or just passing across the scene. Peter appreciated that their actual positioning was vital to the picture but nonetheless relied on an instinctive sense of balance and movement to lay out a harmonious grouping. Much in the way he would treat a pencil portrait, his brush shifted from one image to the next, guided by no more than pure instinct. Later, another of his perfectionist experiments led to a different approach.

Mindful of the possibility that there were other unexplored permutations of grouping beyond the one he had instinctively chosen, he decided to put this to the test.

He drew a host of similar-sized bird silhouettes on black paper, all in different but complementary attitudes of flight, and cut them out with scissors. With the help of bluetack, he began positioning them on the canvas. This developed into a game which all the family could play, mischievously moving a couple of ducks before turning in, to see if Peter would notice any difference when he came into the Studio next morning.

The importance of this exercise was, I believe, largely in the mind. Its reward was the warm feeling that every avenue had been explored. I have doubts whether the game ever yielded a composition that materially differed from an arrangement straight off the cuff.

Painters, I suppose, vary much in their individual modus operandi and those who follow their work in the pursuit of enlightenment will always ask about the nuts and bolts of their trade. Peter was an explorer by nature but he ended up using Windsor & Newton's oil paints and a medium called 'Liquin'. Paints, brushes, solvents and canvases seemed to have been acquired in generous quantity as if he were in fear of running out of one particular item at a moment of high creative urge. Drawer upon drawer of tubes, brushes, bottles, were always beckoning, and a spirited rummage was needed to find the exact one for the job in hand. He used disposable parchment palettes which themselves emerged as attractive abstractions of ordered colour after serving their primary purpose. Often he would sign them for the 'works of art' status attributed to them. I remember how clinical and restrained these colour sheets used to be and wondered if he kept them deliberately so. My own resembled squares of grease-proof paper that had been left for twenty-four hours in a sea-bird colony.

Peter simply loved to paint. A day without a few minutes at the easel or with his diaries left him with a sense of deprivation. Moreover he was no recluse. The Studio was a meeting place, a crossroads. Sometimes it was a babble of conversation from a full-scale meeting. But because it was his Studio, he just painted through it all, occasionally injecting some food for thought into the conversation or firing a question over his shoulder. On festive occasions he might be wearing a paper hat, unconscious of its incongruity, but the brush was always busy, imparting its own special brand of escape.

All representational painters, who have a personal subject allegiance, have favourites within the general margins of their interest. Peter was no exception. Because of the varied richness of the animal kingdom however, his particular preferences tended to be wider based than most.

I return to the notion that drawing is a personal statement of gratitude; and it comes as no surprise to find Peter painting montage-type compositions embodying all his favourites in one. In these, size and respective scale are set aside, design is paramount. An insect's intricate wing pattern can be given greater prominence than a herd of migrating wildebeest. The abstract values in realism always exert a fascination, while the realism itself betrays tender evidence of love, respect and admiration.

Running through his work there is always hope. Art's more doom-laden messages are noteworthy only for their absence.

Peter was deferential towards abstract painting – and even toyed with it himself – but he expected to see some hint of skill in it before taking it too seriously. He would have found himself in complete accord with Picasso – a self-confessed puller-of-legs and a brilliant painter who 'exhausted as best I could the imbecility, the vanity, the cupidity of my contemporaries'. (And, I have no doubt, had a good laugh on the side.) Peter Scott played with colour and played with shape, for the fun of it. The *serious* business was all about truth – painted with sincerity.

'I'll never be a great painter,' he once said in his early years, 'not even a very good one.' But, because of the vagaries of self-denegration, these are issues best left to others to decide. 'Good' has no real meaning because it is dependent upon impossible comparisons and the volatility of fashion.

'Sincerity', on the other hand, is easier to define. It means to paint from the heart – and this is just what Peter Scott did through all his eighty years.

Keith Shackleton.
South Devon, 1992.

No date, but probably pre-preparatory school, age six or seven.

Grayling
(*reduced*).

Stickleback
(*reduced*).

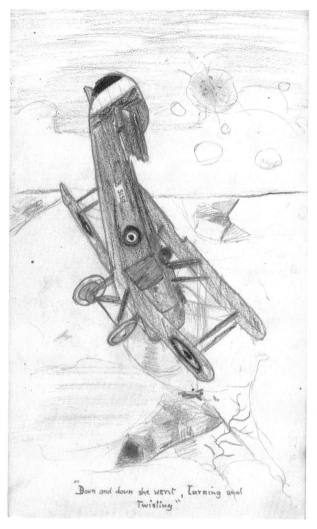

Aeroplane
(*reduced*).

'Down and down she went, Turning and Twisting.'

The aeroplane is a Sopwith Camel. Undated.

Spike of

20 spiked

Dragonet

spike of

Centispiked

Dragonet

20 Spiked

Dragonet

"Stalking"

+ winged

Dragon

"In flight"

Head of

Centispiked

Dragonet

Dragons (cont)

mother Single-spike Dragon

with brood of four, father will be seen in flight

Head of Crested Dragon

Spike of Single-spike Dragon

This spike is sharper than any other spike. It will prick holes smaller than the smallest needle

Dragons
(*reduced*). Age (?) nine.

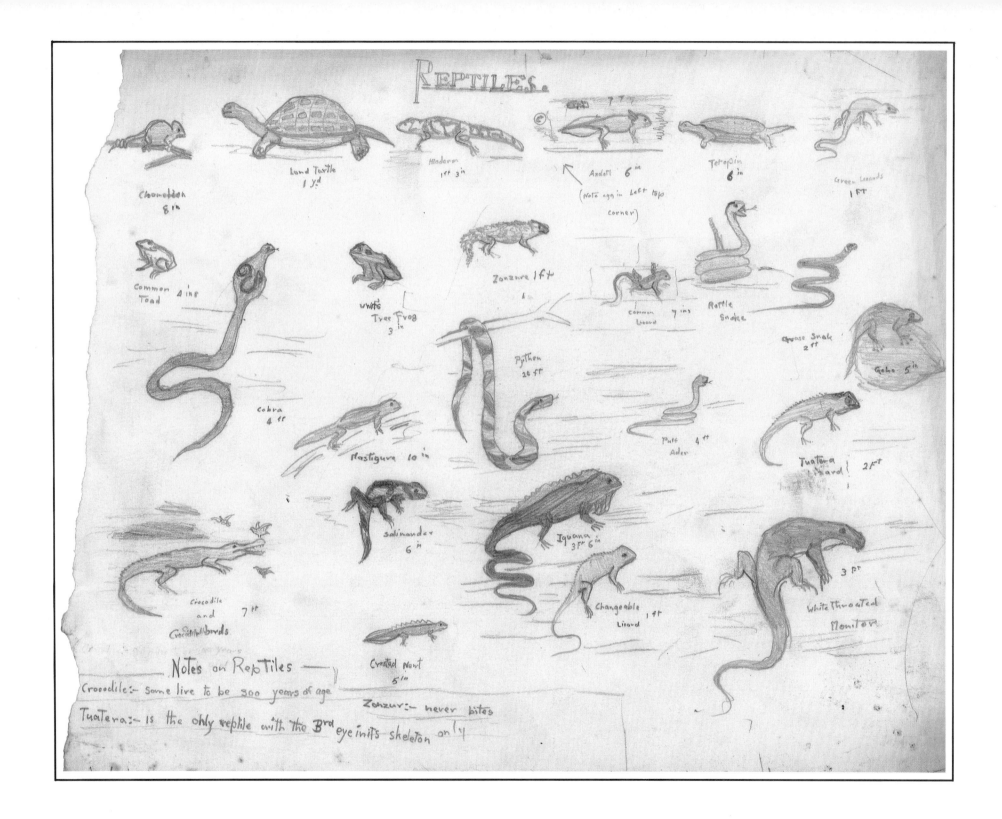

Reptiles

(*reduced*). Age (?) nine.

'I cannot remember a time when I was not interested in animals; nor
can I remember a time when I did not draw.' *Observations of Wildlife*

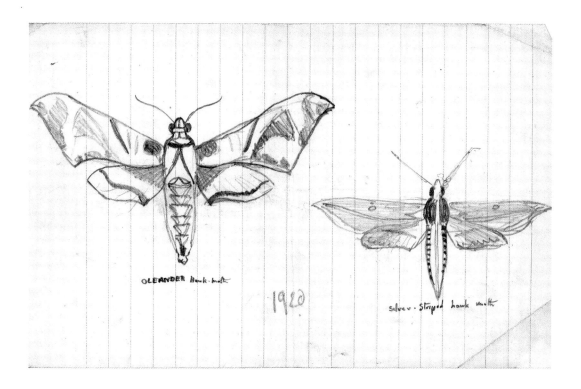

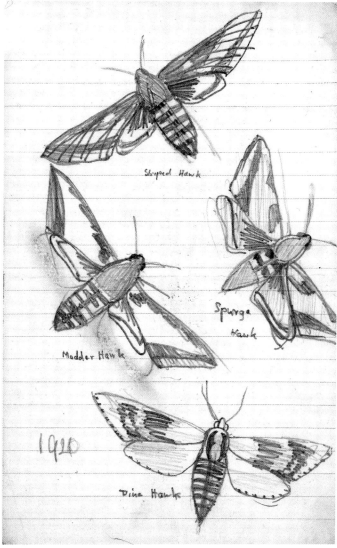

Hawk moths

(*reduced*). Age eleven.

Very early examples of an interest which lasted a lifetime. 'Hawk moths – which I always thought of as the crême de la crême.' *Observations of Wildlife*

1920 and 1922. These drawings were dated by Peter's mother.

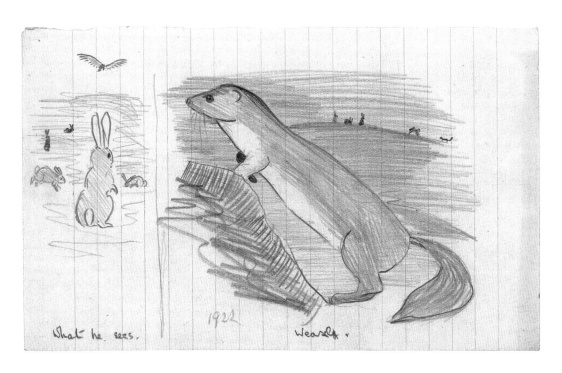

Weasel and what he sees

(*reduced*). Age thirteen.

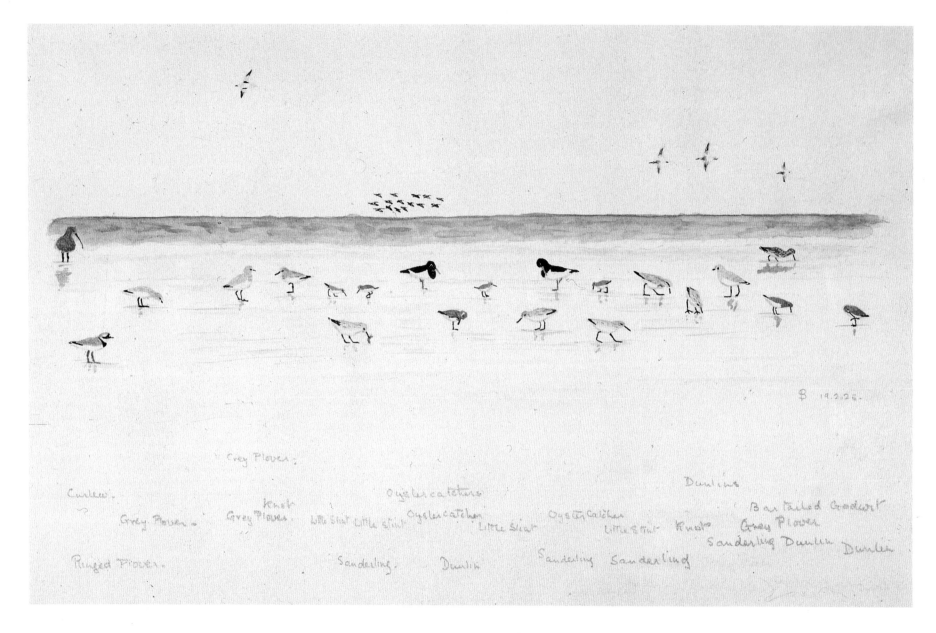

Waders on the seashore
(*actual size*). Watercolour. Signed PS and dated 19 February 1925.

Right: Dry-point etchings from Oundle schooldays, *c*.1923. These etchings are some of those mentioned by Keith Shackleton in his Introduction to this book.

Above and overleaf: from an early sketch book.
'Birds were a very early interest, from the age of four onward, especially the shorebirds to be seen from our cottage at Sandwich. I saw my first wild geese there, which led to a general interest in wildfowl and ultimately to Slimbridge and The Wildfowl Trust.' *Sports Afield*, 1987. Interview
'Sir Peter Scott' by Kit and George Harrison

Fish taking fly
(*reduced*).

Pike chasing dolphin
(*reduced*).

Motor car
(*reduced*).

Great crested grebe under water
(*reduced*).

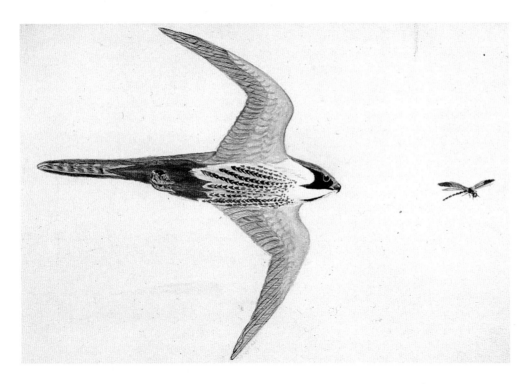

Hobby in pursuit of greenish demoiselle dragonfly
(*reduced*). Watercolour, 1925.

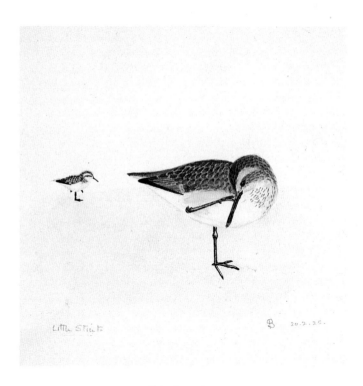

Little stint
(*reduced*). Watercolour. Signed PS and dated 20 February 1925.

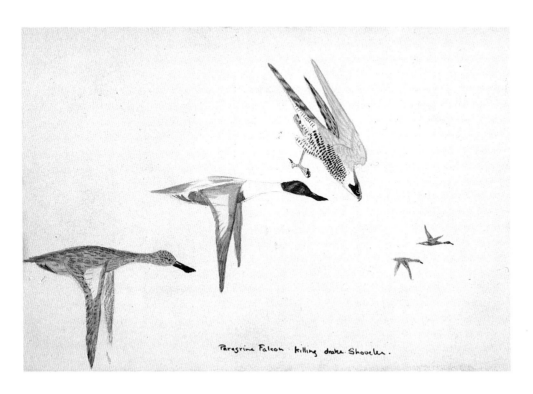

Peregrine falcon killing drake shoveler
(*reduced*). Watercolour, 1925.

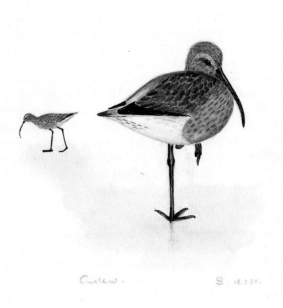

Curlew
(*reduced*). Watercolour, 18 February 1925.

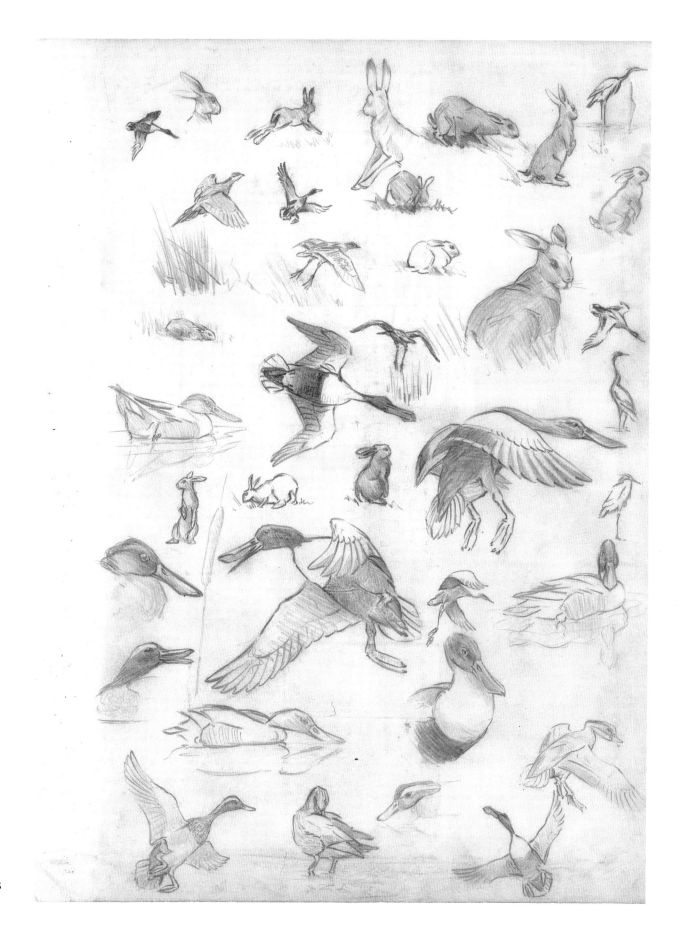

Ducks and rabbits
(*reduced*). Pencil, 1929.

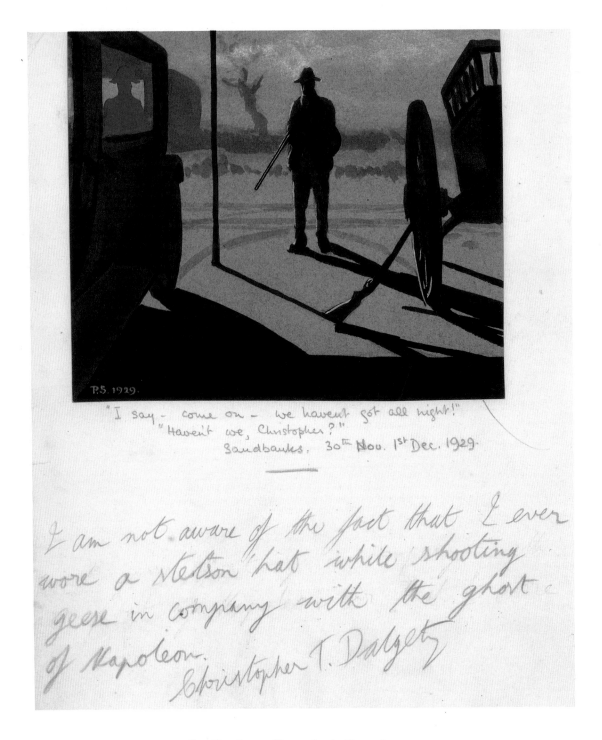

"I say – come on – we haven't got all night!"
"Haven't we, Christopher?"
Sandbanks. 30ᵗʰ Nov. 1ˢᵗ Dec. 1929.

I am not aware of the fact that I ever wore a stetson hat while shooting geese in company with the ghost of Napoleon.
Christopher T. Dalgety

Sandbanks. 30 November/1 December 1929
(*actual size*). Pen and ink and wash on coloured paper.

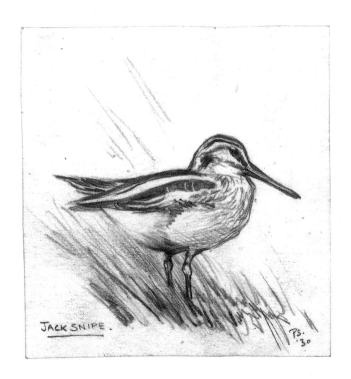

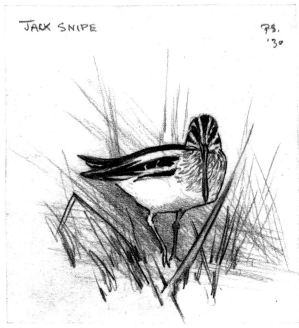

(*Actual size*). Two pencil drawings, 1930.

During the period when Peter was up at Cambridge he and his friends became enthusiastic wildfowlers. He kept an illustrated diary from the first day that he discovered this new and exciting interest. After the war he gave up shooting altogether.

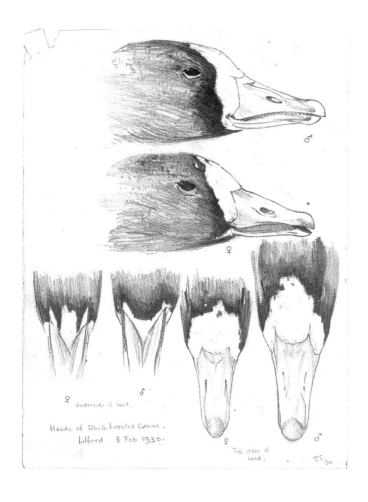

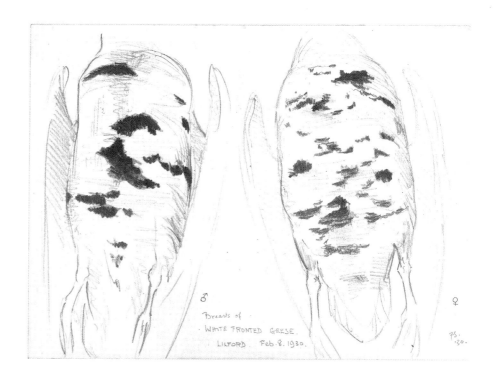

(Reduced). Two pencil drawings, 1930.

These are all taken from a wildfowling album dating from 1928 to 1930.

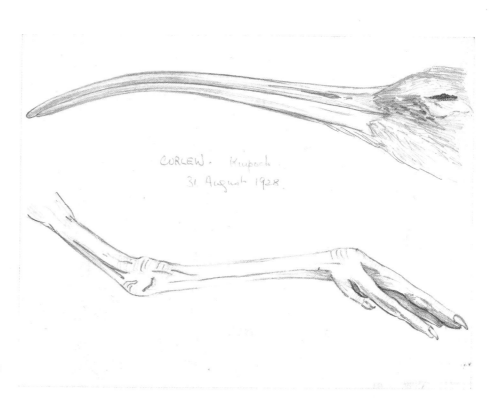

(Reduced). Pencil, 31 August 1928.

Like Tunnicliffe and Edward Wilson, Peter felt that it was important to make anatomical records of dead birds.

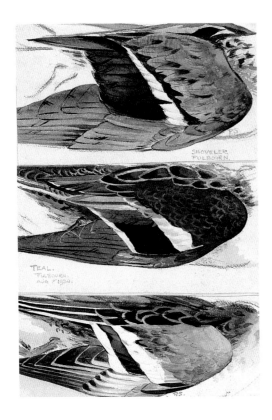

Wings showing speculum of shoveler, teal and garganey drake
Watercolour, 1930. 10½″ × 6¾ (26.7 × 17 cm).

Shoveler swerving
Title page of one of Peter's albums.
Watercolour, 1929. 4½″ × 2¾″ (26.7 × 7.1 cm).

Mallards in flight
(*slightly reduced*). Watercolour, 1930.

The sketches on this and the following three pages are all taken from beautifully and carefully illustrated wild-fowling albums which include photographs as well as paintings and drawings.

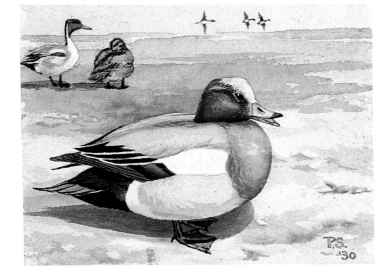

'A frosty morning. Cock wigeon keeping warm.'
(*slightly reduced*). Watercolour, 1930.

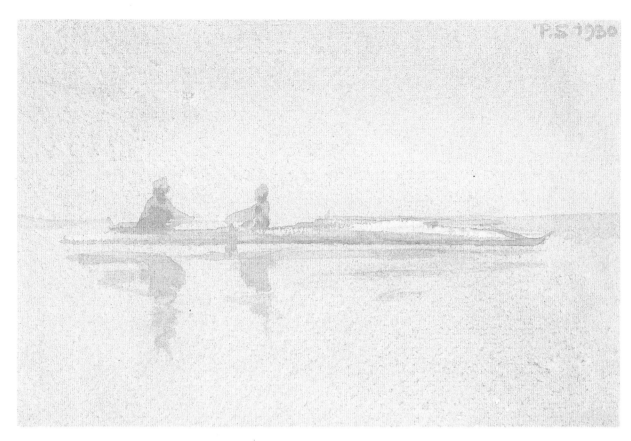

'Punting in the fog with P. Maclean. Skeldyke.'
(*actual size*). Watercolour, 1930.

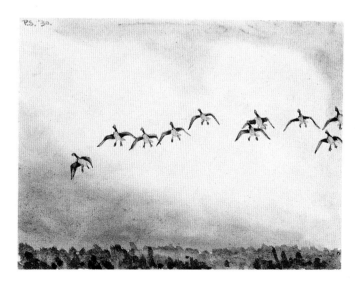

'The most ungainly impression of geese pitching
in the fields on Kirkham's Farm. 6 February
1930. A snowstorm had just passed over.'
(*actual size*). Watercolour, 1930.

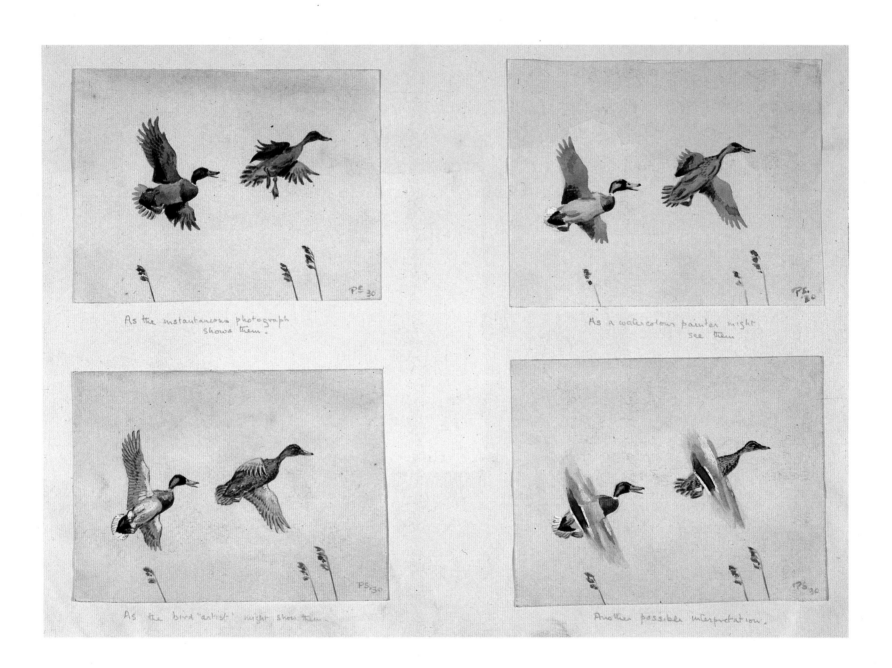

As the instantaneous photograph shows them.

As a watercolour painter might see them.

As the bird 'artist' might show them.

Another possible interpretation.

Mallards in flight showing four different ways in which
they might be painted
(*actual size*). Watercolours, 1930.

As the instantaneous photograph shows them.
As a watercolour painter might see them.
As the bird 'artist' might show them.
Another possible interpretation.

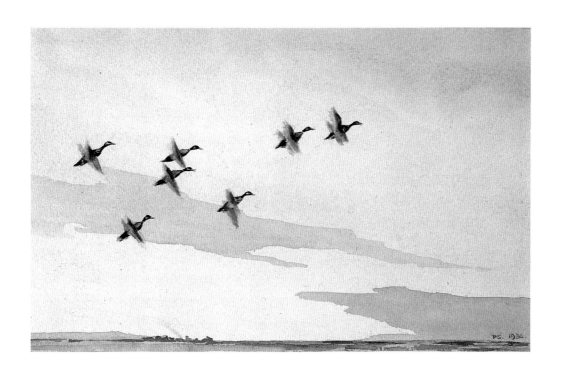

Mallards rising
(*much reduced*). Watercolour, 1930.

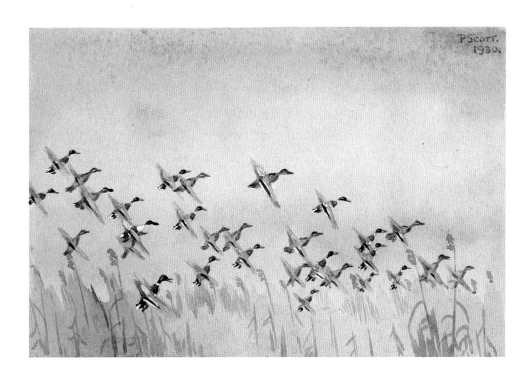

'The sanctuary disturbed'. Mallards and a pair of shovelers
(*actual size*). Watercolour, 1930.

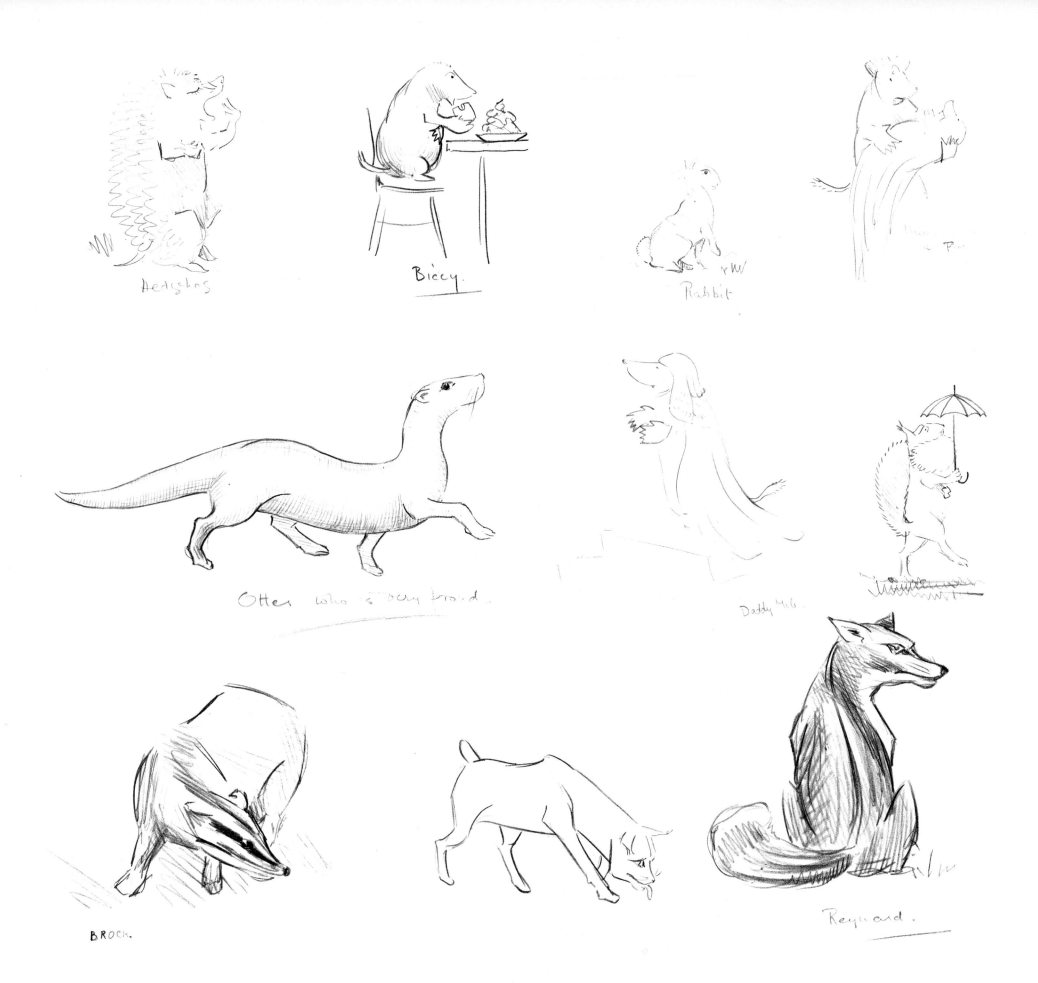

Hedgehog

Biccy.

Rabbit

Otter who is very proud.

Daddy Mole.

BROCK.

Reynard.

MUNICH.
MARCH 1931

MY DEAR WAYLAND.

HERE IS A PICTURE OF BRUIN IN A
MOTH AEROPLANE SCOUTING OVER A
TROPICAL FOREST ON A CORAL ISLAND.

PLEASE NOTE THE FOLLOWING FEATURES:

(1) PACIFIC SWELL BREAKING OVER CORAL REEF
WITH CALM LAGOON INSIDE. VAST FISH 6 FEET LONG
RISING IN CALM WATER.

(2) ON BEACH TWO LARGE LAND CRABS.

(3) STANDING ON A FALLEN TREE, A LARGE CAT,
POSSIBLY JAGUAR, POSSIBLY OCCELOT.
POSSIBLY LEOPARD.
[SPECIES TO BE DETERMINED BY GEOGRAPHICAL RANGE]

(4) ABOVE HIM A TOUCAN [ALWAYS REMEMBERING
THAT "ONE CANT"!]
BUT TWO CAN.

(5) LEVEL WITH THE TOUCAN BUT TO THE RIGHT,
IS A PYTHON.

(6) AND FURTHER TO THE RIGHT ARE TWO
MONKEYS.

(7) ABOVE THE MONKEYS ARE 4 MACAWS,
TWO FLYING + TWO ON THE TALL TREE.

TROPICAL FORESTS WERE NEVER MY
STRONG POINT, AND YOU WILL PROBABLY
FIND THAT, SCIENTIFICALLY, THEY COULD
NOT ALL BE IN THE SAME FOREST. ALL I CAN
SAY IS :- IN THIS CASE YOUR SPECIAL ILLUSTRATOR.
THEY WERE. PETE.

Above: **Bruin scouting over a coral island**
(*reduced*). Munich, 1931

Left: The Moley family and their friends

The little watercolour of 'Bruin scouting over a coral island' and the drawings of 'The Moley family and their friends' were made by Peter Scott for the amusement of his half brother, Wayland Young, who was then six.

Bruin, also known as the Rt Hon Sir Edward Bear PC, GBE, DSO, DSC, was a small teddy bear of darkish brown, a bit patchy by then. He had that grand title because Wayland's father, Sir Edward Hilton Young, did. The resemblance ended there: the human Sir Edward was not an aviator, and Bruin was not a paternal figure. A letter to Wayland from Bruin survives; it concerns Bruin's plans to go and live near Wayland when he was sent to boarding school, to keep the teachers in order.

The Moleys were a family of moles who lived in Lockeridge Dene in Wiltshire and whose lives formed an oral chronical told to Wayland by his father over several years. There were seven children including Biccy, the second, and Paws, the youngest. Among the others were Shiny and Velvety, who were twins, and Fumble, or sometimes Flumble. Peter took a leading hand in the Moley saga, as can be seen from these illustrations.

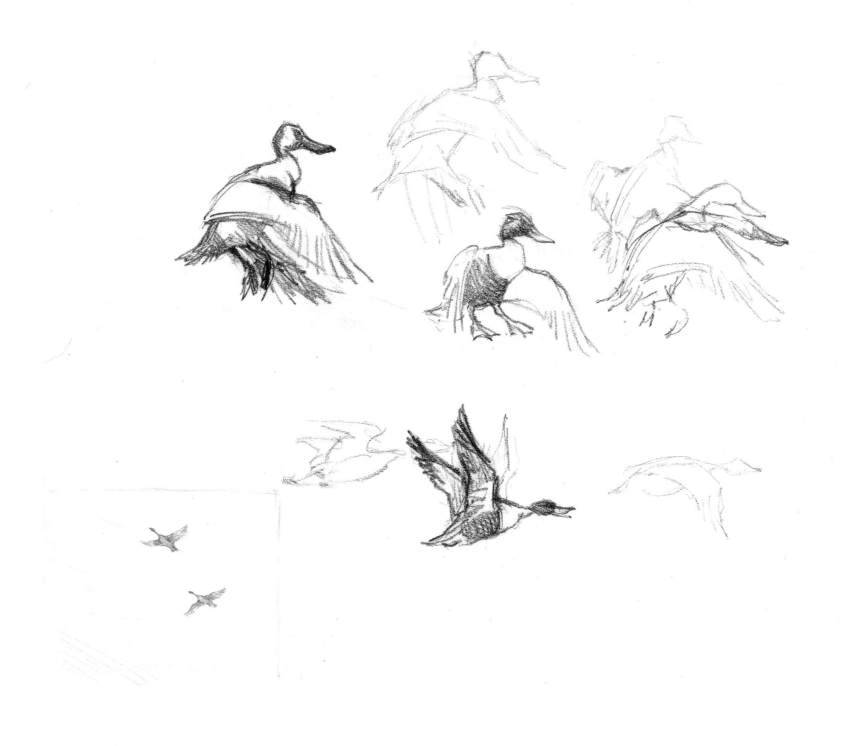

Ducks in flight
(*reduced*). Pencil, 1930. Munich.

Right: Mallards and a boat on the Round Pond
(*slightly reduced*). Watercolour and gouache, 1931.

With his half brother, Wayland, then aged eight, Peter often sailed
boats on the Round Pond in Kensington Gardens which was close to
his home.

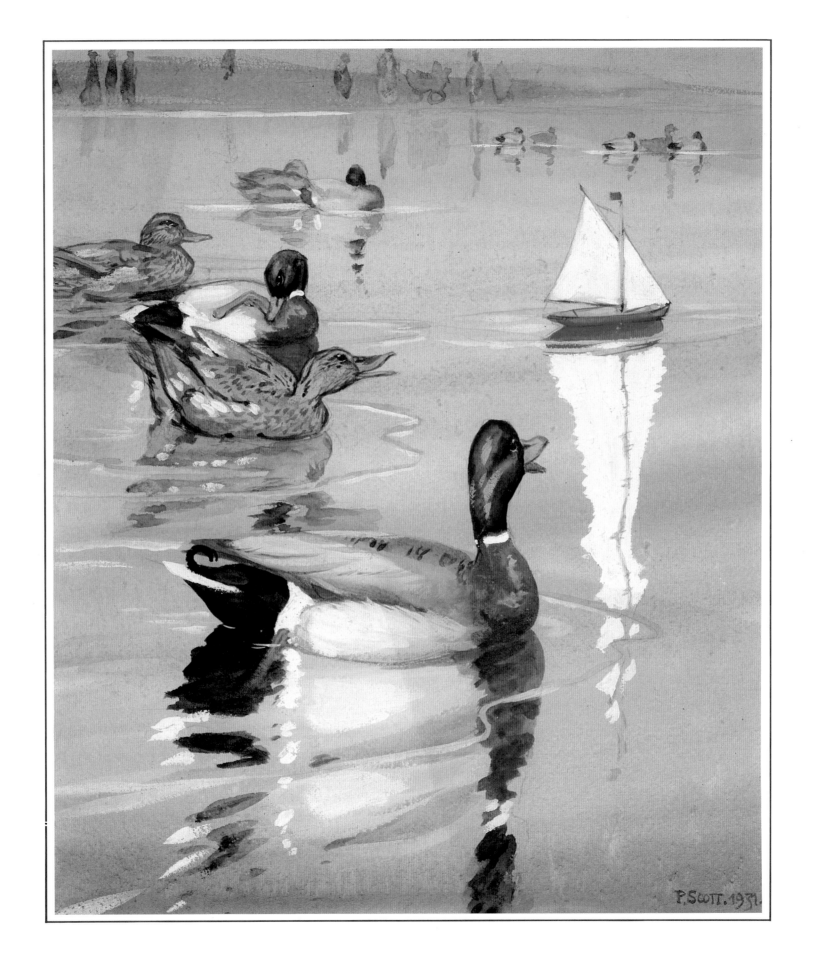

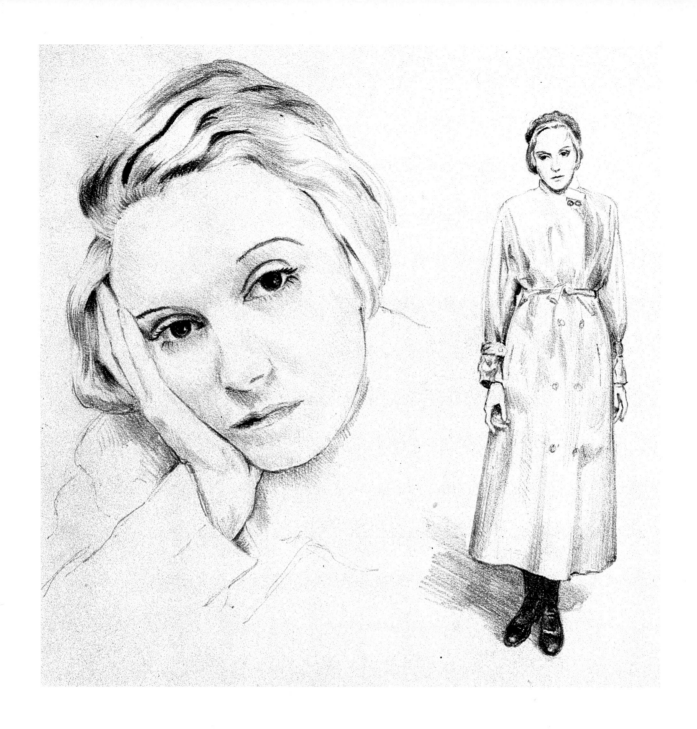

Above and right: Portrait studies of Elizabeth Bergner
Pencil drawings, c. 1934. Each 10″ × 7″ (25.4 × 17.8 cm).

Elizabeth Bergner was perhaps most famous for her performance as
Gemma Jones in *Escape Me Never*. Peter went to see it seventeen times
and was responsible for introducing her to his godfather, J. M. Barrie,
who was so impressed by her that he wrote *The Boy David* with her
in mind.

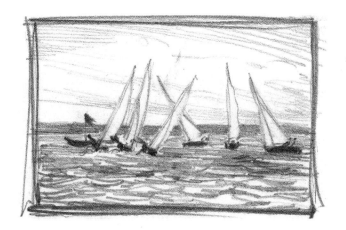

Fourteen-foot dinghies and (bottom right) an Olympic
Monotype
(*actual size*). Pencil Sketches.

From sketch books 1933/1936. With Peter's enthusiasm for dinghy racing came
the urge to commit the scene to paper.

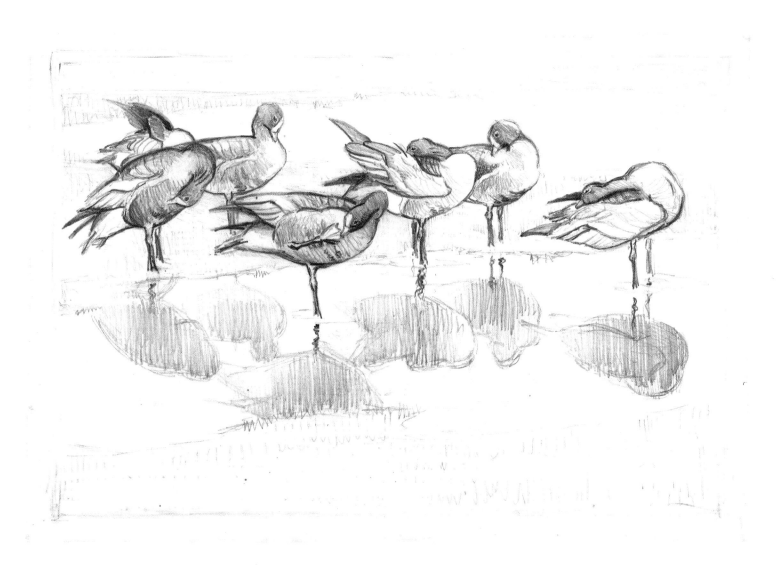

Lesser white-fronted geese
(*actual size*). Pencil sketch, 1933.

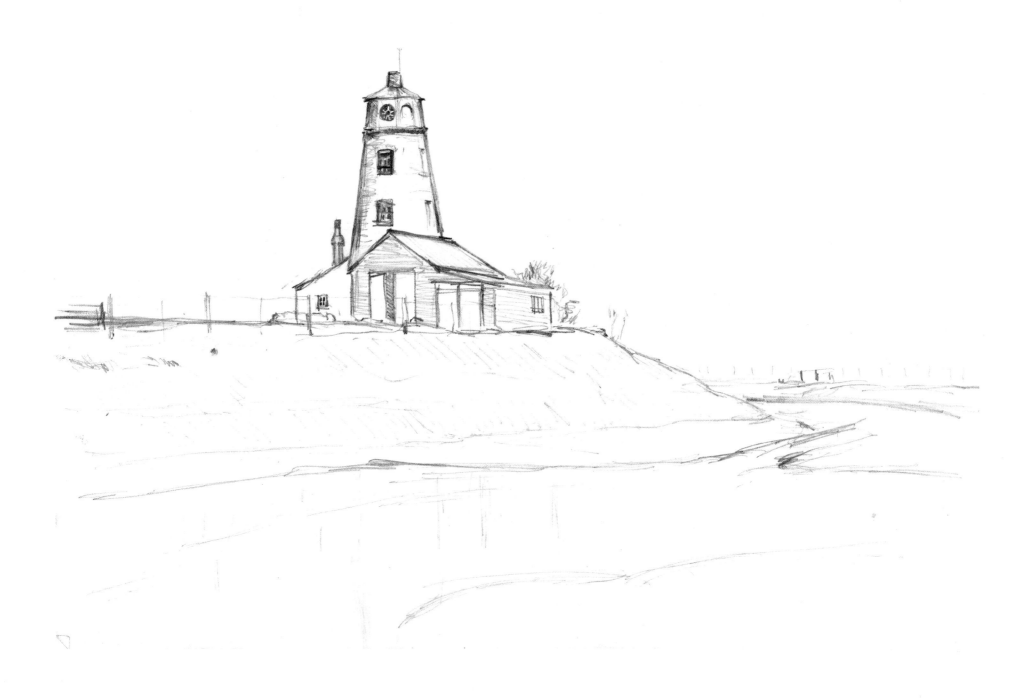

The East Lighthouse
(*actual size*). Pencil sketch, 1933.

At that time the East Lighthouse stood on the edge of the marsh. Behind the flood bank on the south side (in the foreground of this picture) Peter started his collection of tame waterfowl.

'The innocent had the manner of one who performs a duty.'
(*actual size*). Pen, brush and ink, c. 1936.

These three drawings were used as illustrations for *A Bird in the Bush* by Peter's stepfather, E. Hilton Young, which was published in 1936.

'It is the nightingale's frog-voice that distinguishes him.'
(*actual size*). Pen, brush and ink, c. 1936.

'The whitethroat gives himself no airs.'
(*actual size*). Pen, brush and ink, c. 1936.

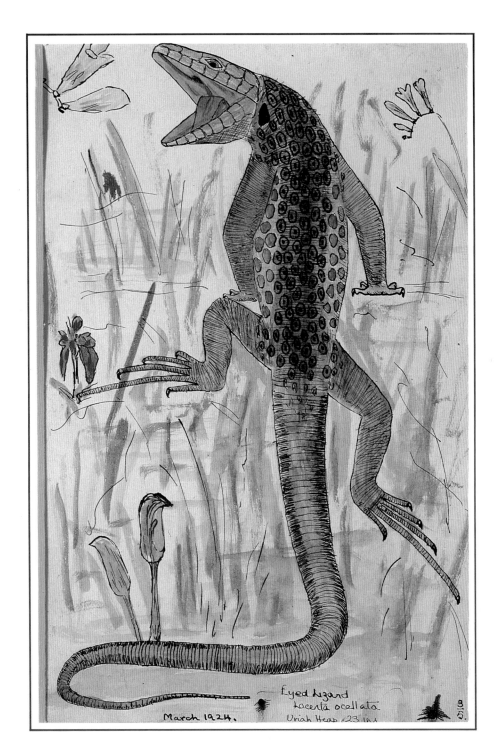

Eyed Lizard
Lacerta ocellata
March 1924.
Uriah Heap 23 ins

'Uriah Heap' Eyed lizard. *Lacerta ocellata*, 23 ins

(*actual size*). Pen and watercolour, March 1924.

It was while travelling in Italy with his mother that Peter's love for lizards developed. 'On this long tour of Italy we had punctures which happened very regularly in those days of motoring: we used to walk on ahead while the tyre was being mended and I caught wall lizards and geckos and kept them in a meat safe. How often I used to long for another puncture . . . and another.'

The Eye of the Wind

But this lizard came from Noirmoutier, in France.

Right: Self-portrait, skating

(*slightly reduced*). Pencil, watercolour and bodycolour, c. 1930.

It was suggested to Peter in 1931 that if he gave his uninterrupted time to skating he would make a world champion.

Right: Pencil sketches of dogs

I suspect these were doodles, drawn during the period Peter was at the Munich State Academy. Dogs were not a normal or natural subject for Peter, but to me these have great charm.

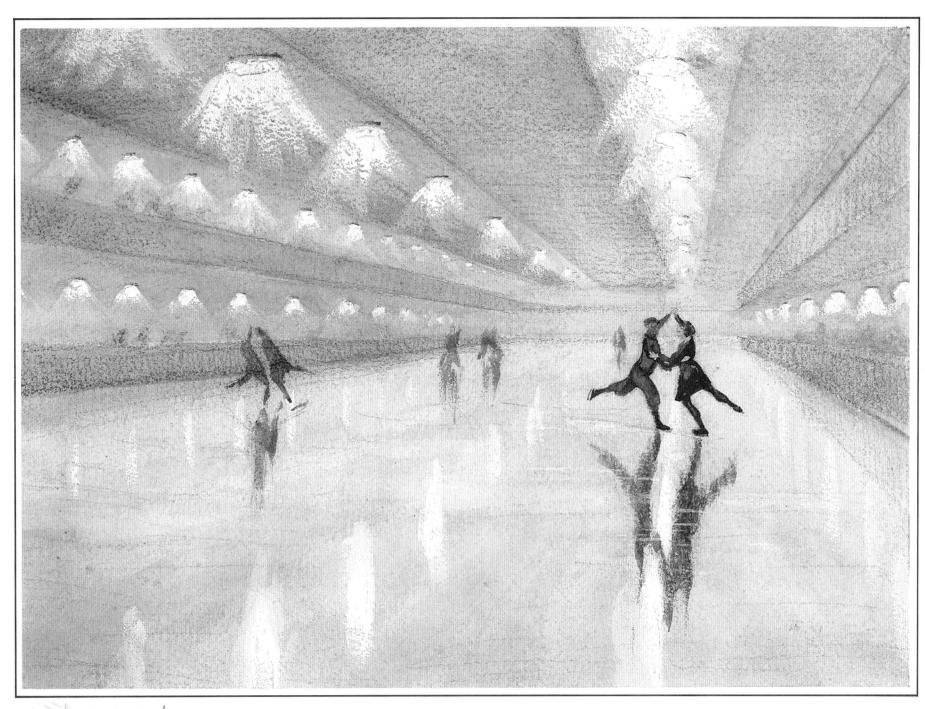

These two watercolours date from the time when Peter was studying
Art and Architecture at Cambridge.

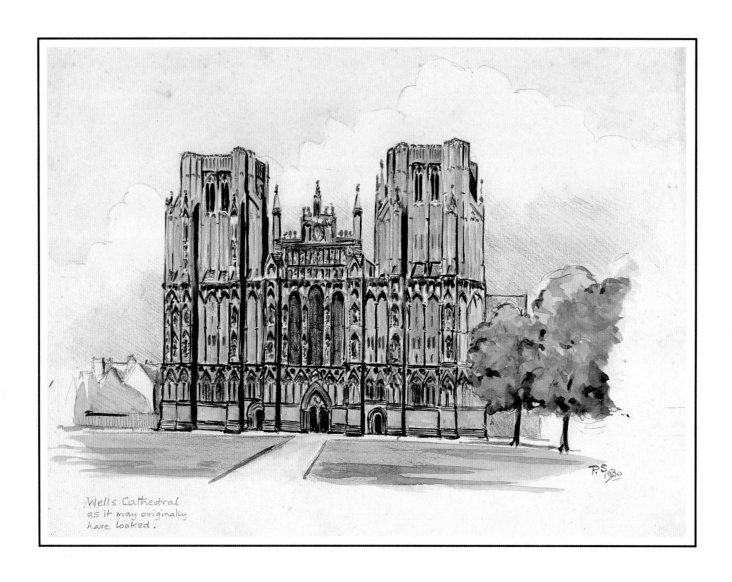

Wells Cathedral as it may originally have looked
Coloured drawing, 1930. 7″ × 9″ (17.8 × 22.9 cm).

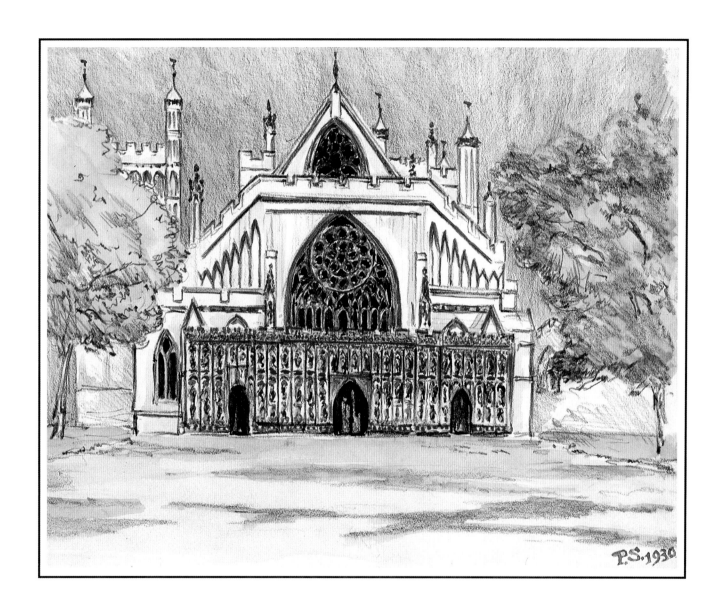

Exeter Cathedral
Coloured drawing, 1930. 7″ × 9″ (17.8 × 22.9 cm).

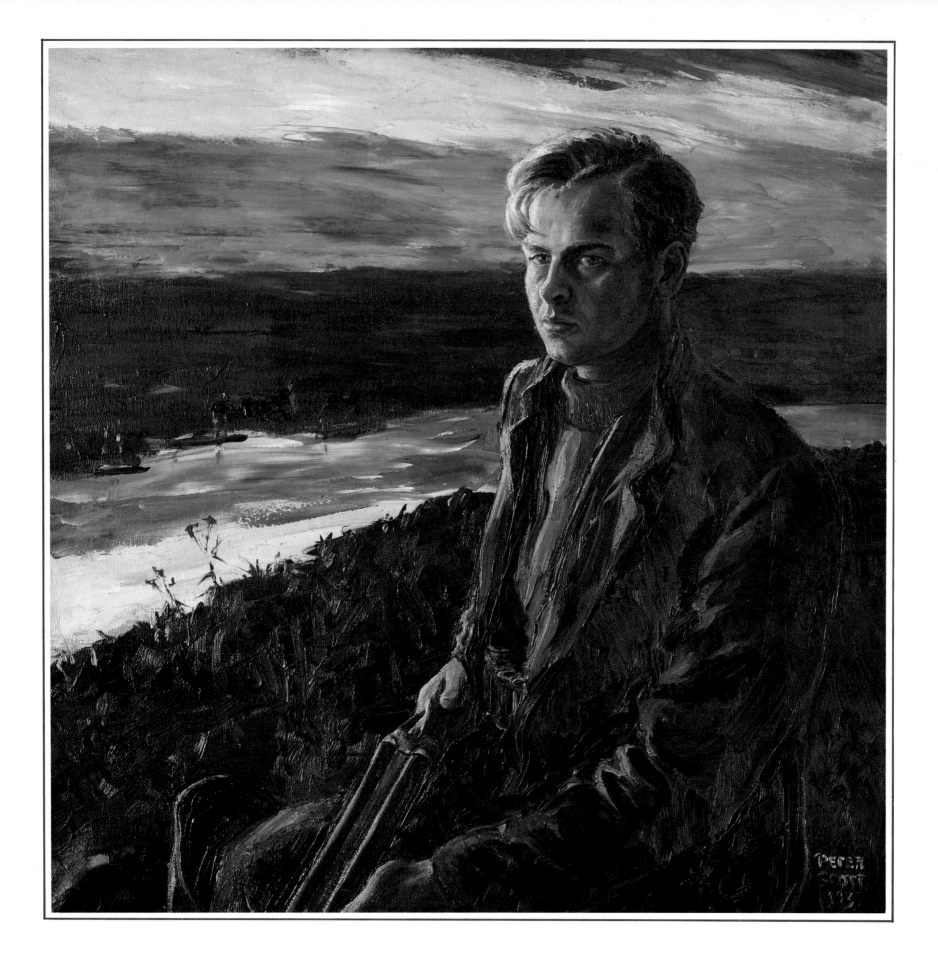

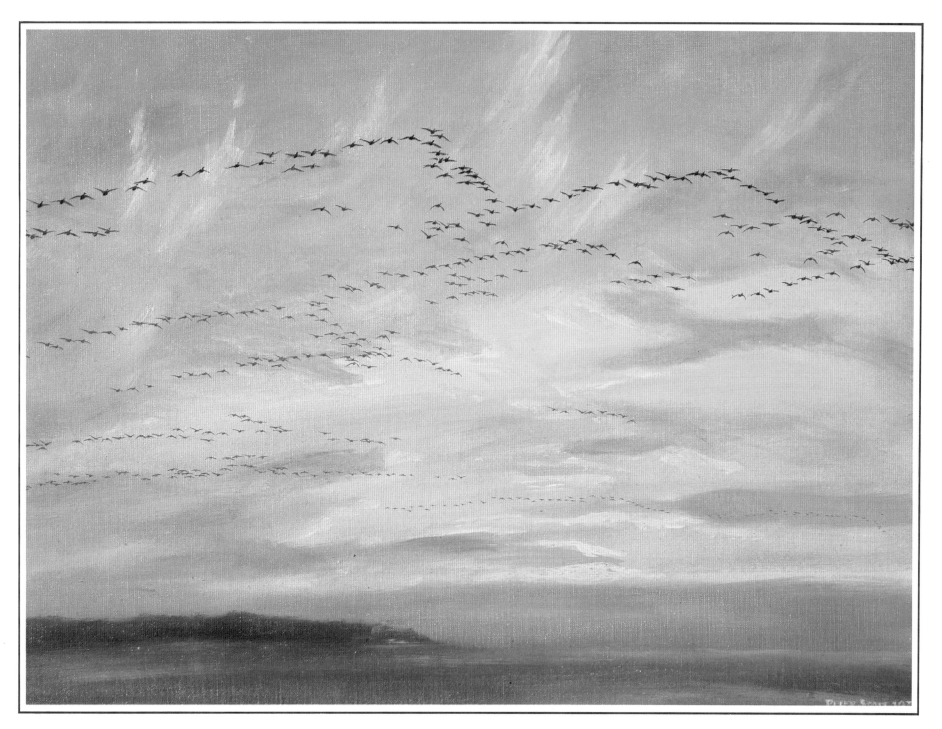

Pinkfeet in huge skeins fly from Holkham Fresh Marsh
at dusk
Oil painting 1933. 15″ × 20″ (38.1 × 50.8 cm).

It was with evocative paintings such as this that Peter made his name as an
artist with a ready market among the sporting fraternity.

Left: Self-portrait
Oil painting, 1933. 24″ × 24″ (61 × 61 cm).

In later years Peter did not like this portrait because it depicts him with a gun.

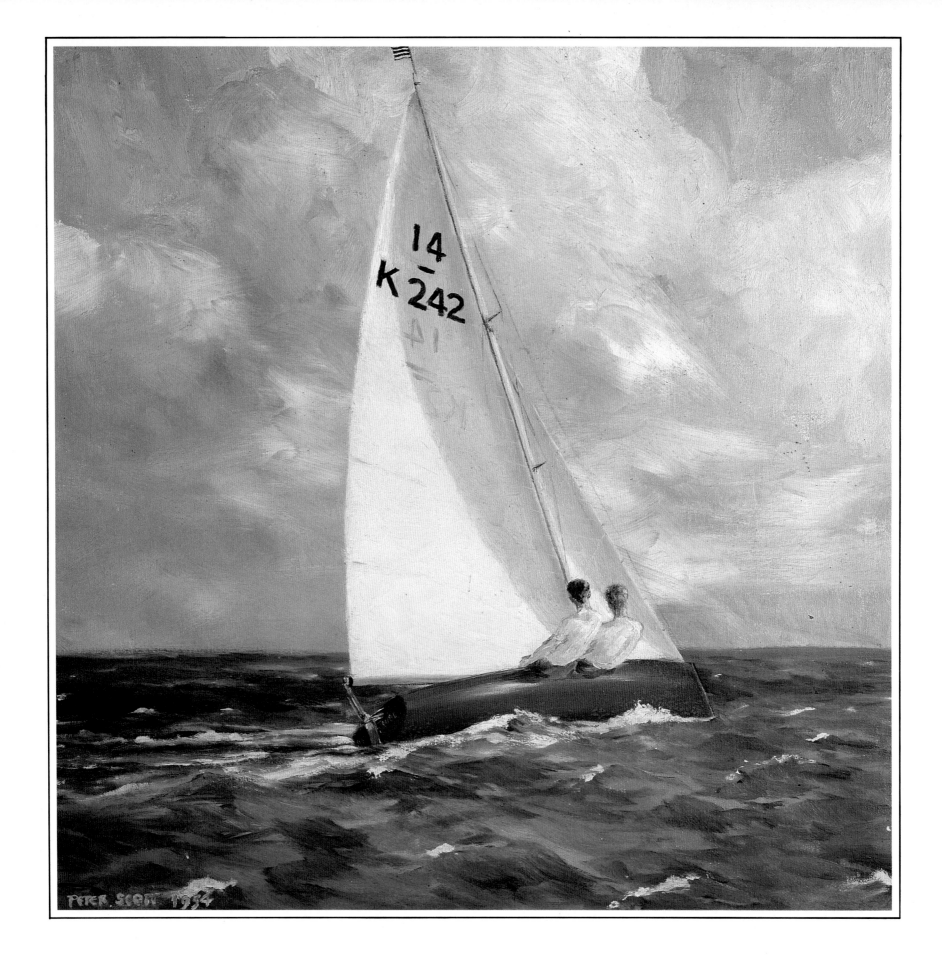

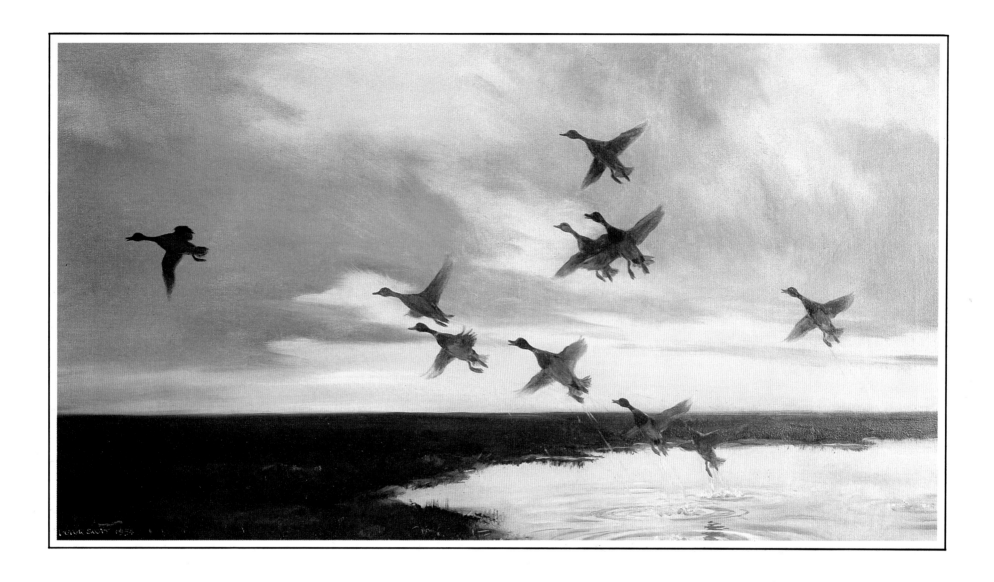

Mallards rising at dawn from a pool on the salting
Oil painting, 1934. 22″ × 40″ (55.9 × 101.6 cm).

A very famous early painting which was reproduced as an artist's proof by
Ackermann's Gallery in London. It illustrates particularly well Peter's flair
for showing movement.

Left: With John Winter, sailing *Lightning*
Oil painting, 1934. 24″ × 24″ (61 × 61 cm).

Although there are numerous sketches of dinghies and yacht races, there
evidently was not much time for painting and oil paintings of yachts are rare.

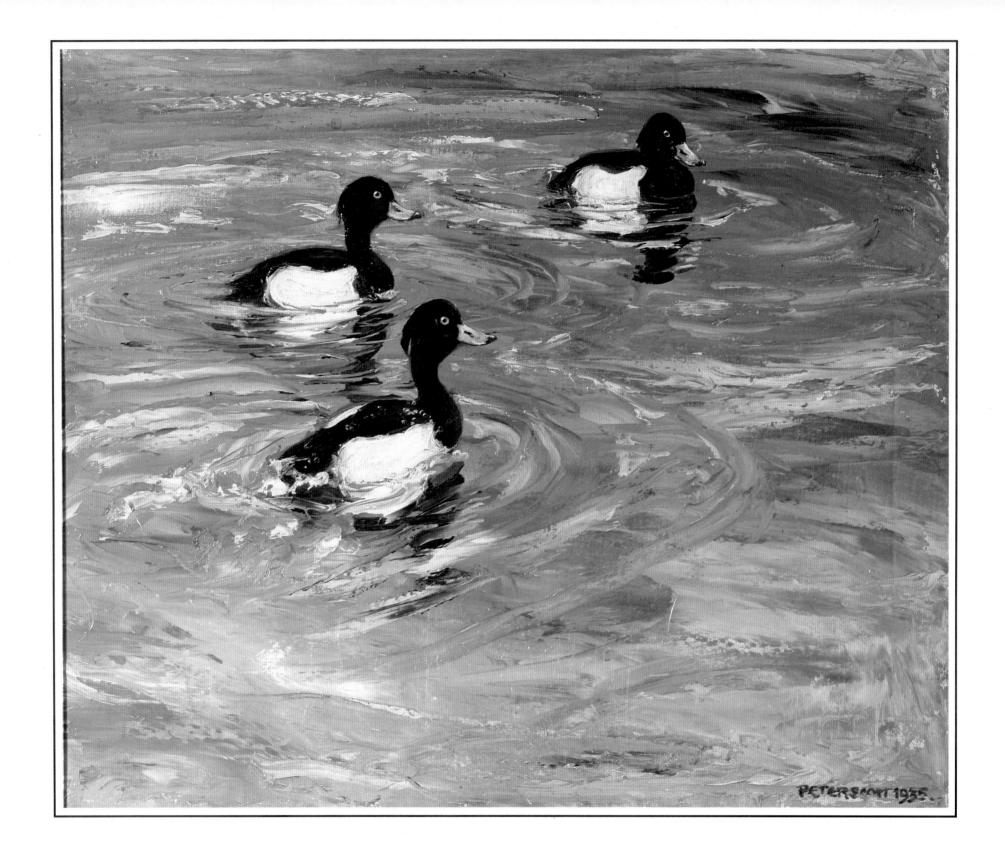

Tufted drakes diving

Oil painting, 1935. 15″ × 18″ (38.1 × 45.4 cm).

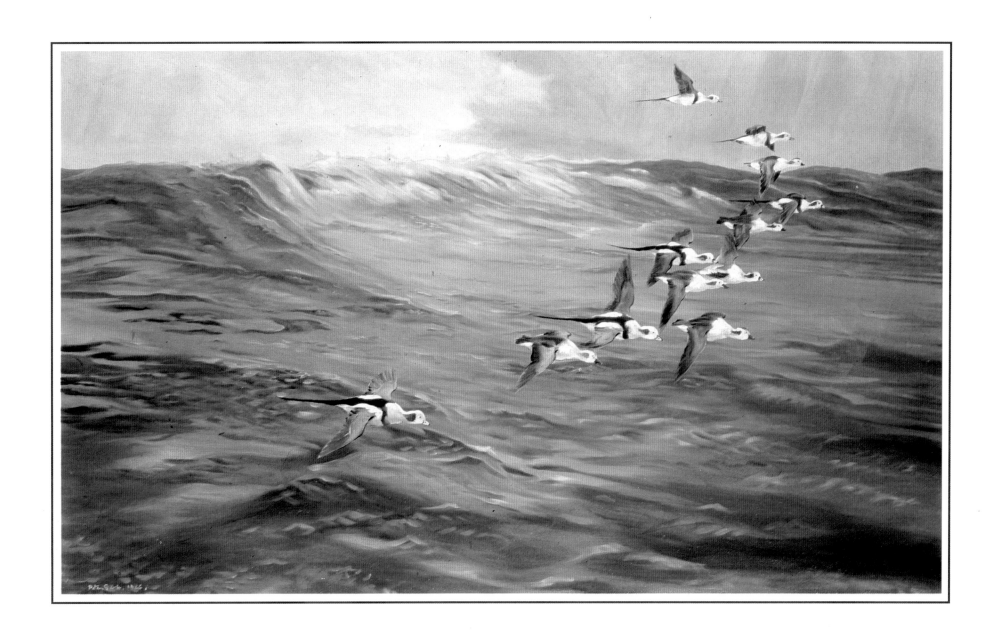

Old squaws at sea
(Long-tailed ducks)
Oil painting, 1936. 36″ × 60″ (91.4 × 152.4 cm).

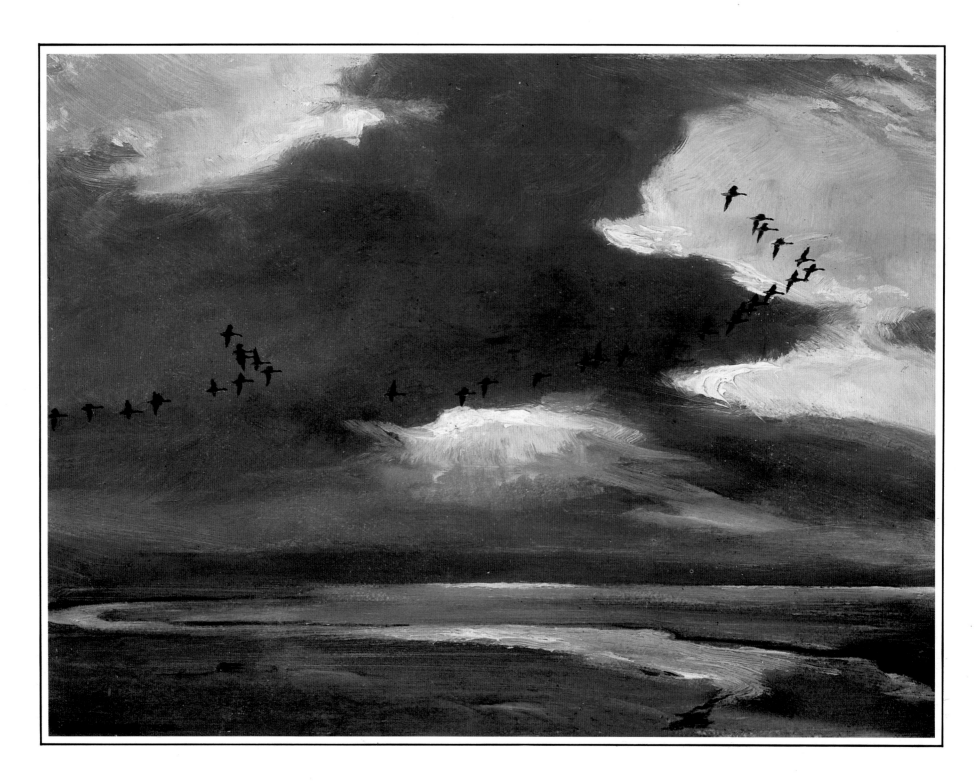

Greylags coming out early
Oil on millboard, 1936. 8″ × 10½″ (20.3 × 26.7 cm).

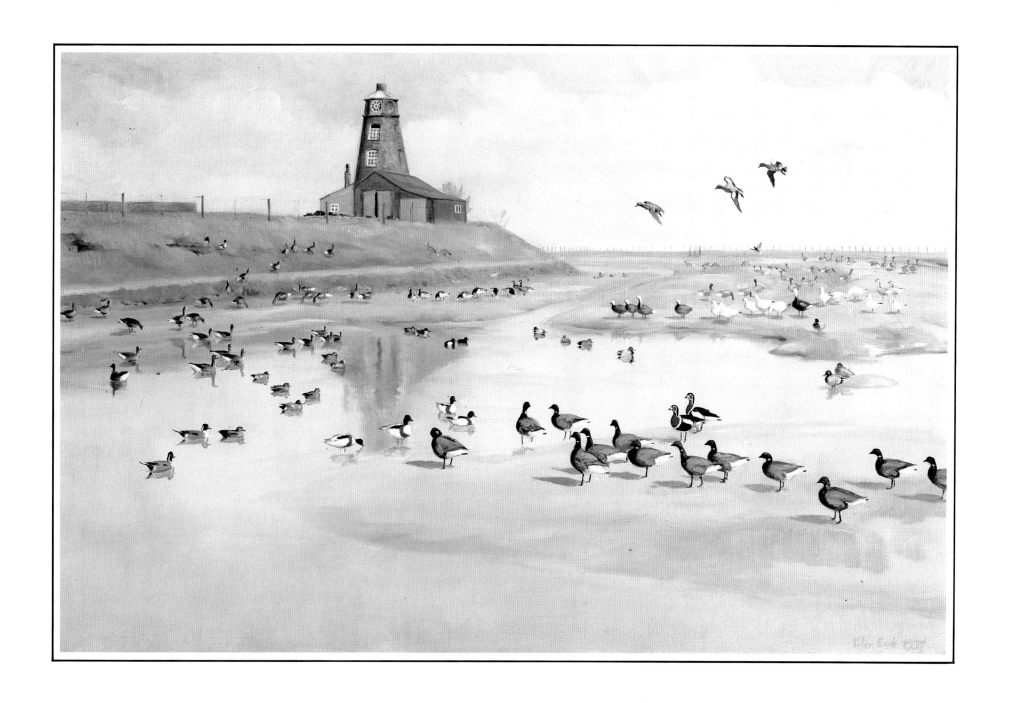

The East Lighthouse, Sutton Bridge
Oil painting, 1937. 20″ × 30″ (50.8 × 76.2 cm).

Peter's home from 1933 until the Second World War started. He rented it
from the Nene Catchment Board and built up a collection of tame water-
fowl there.

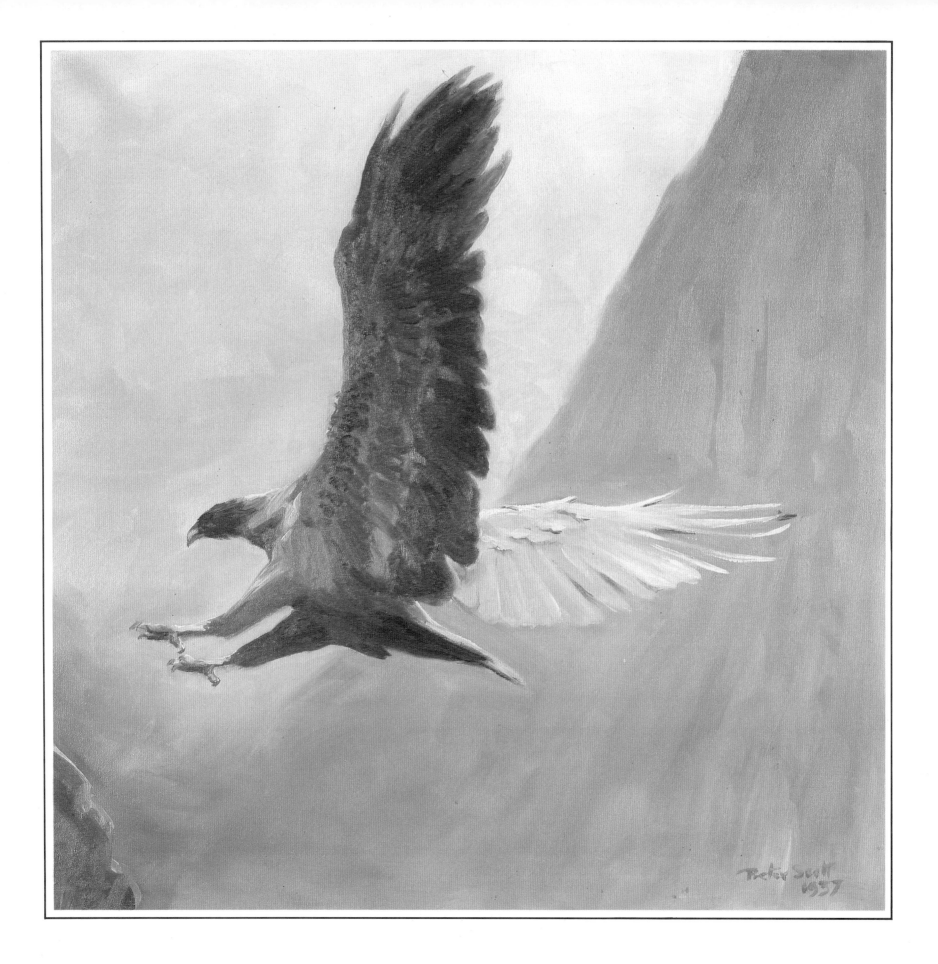

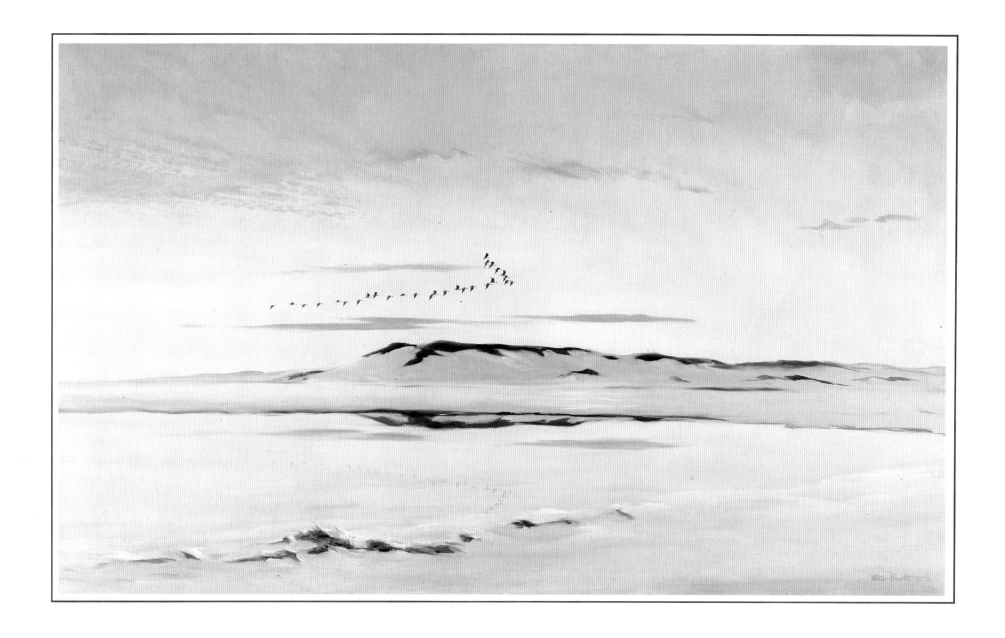

The coming of the winter on the Danube Delta
Oil painting, 1938. 40″ × 60″ (101.6 × 152.4 cm).

'I arrived [on the Danube Delta] at the same time as a blizzard and in three days the continental winter had descended on the land, driving all before it.'

The Eye of the Wind

Left: Golden Eagle
Oil painting, 1937. 24″ × 24″ (61 × 61 cm).

'I draw quite a lot from nature; I also do a great deal of drawing from what I hold in my memory.'

Sports Afield, 1987. Interview.
'Sir Peter Scott' by Kit and George Harrison

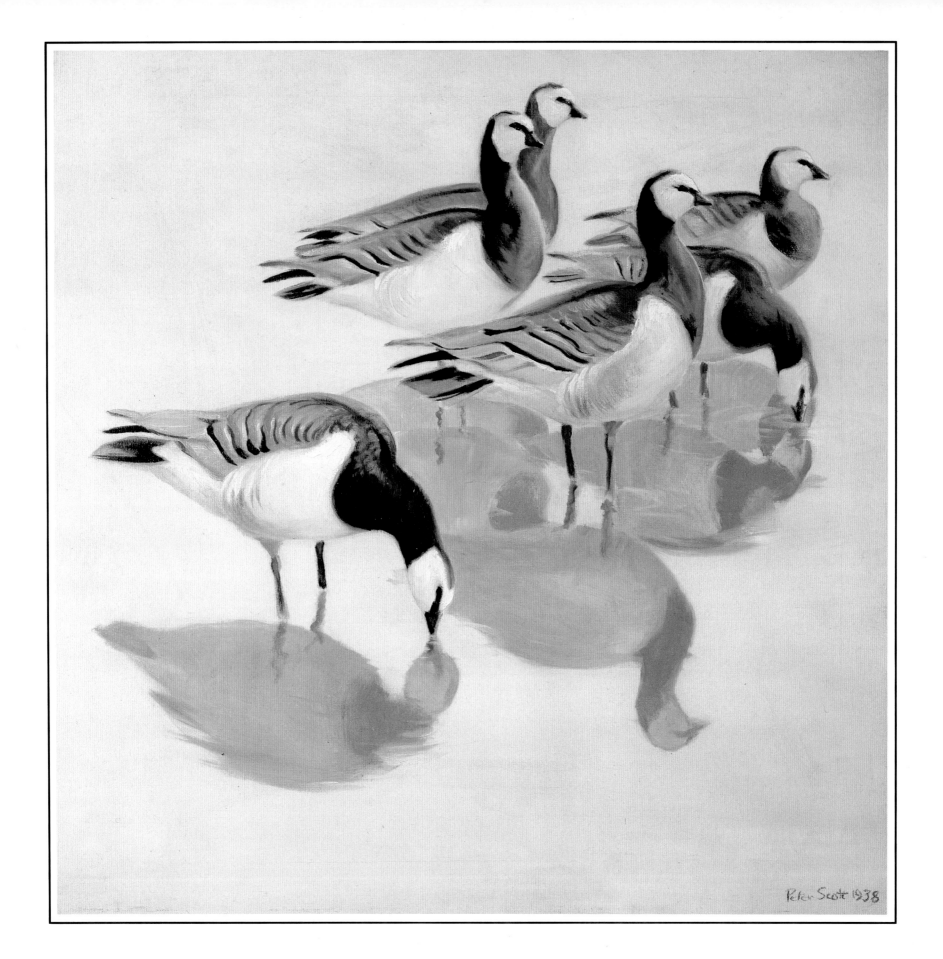

Peter Scott 1938

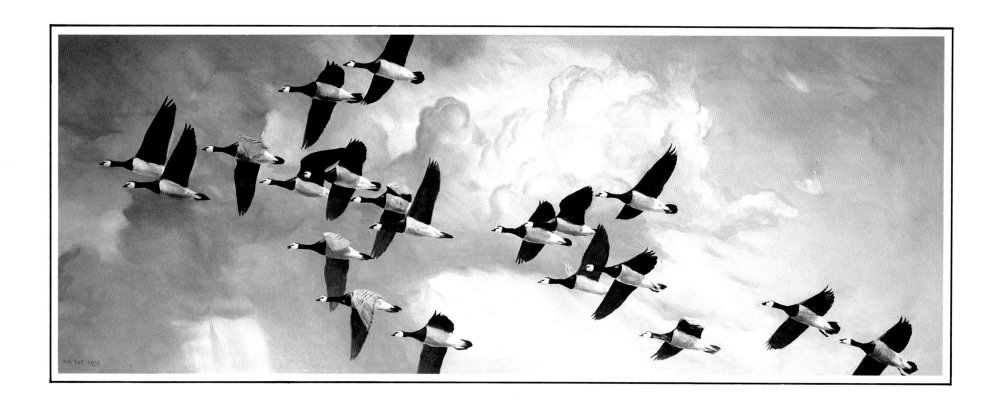

Barnacle geese against a stormy sky
Oil painting, 1939. 36″ × 96″ (91.4 × 243.8 cm).

From the time when Peter was wildfowling on the Solway and for the
rest of his life there was something very special about barnacle geese.

Left: **Barnacle geese**
Oil painting, 1938. 24″ × 24″ (61 × 61 cm).

Painting a group of birds of one species appealed to Peter.

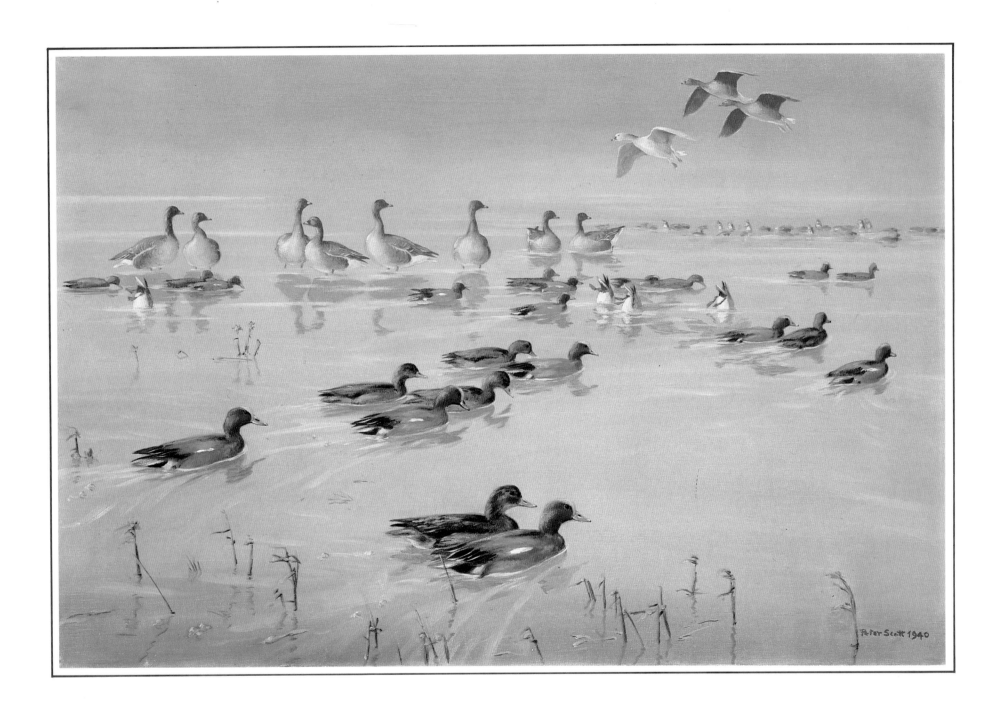

Pinkfeet, wigeon, albino goose. River Ribble
Oil painting, 1940. 20″ × 30″ (50.8 × 76.2 cm).

Albino geese were always an attraction. There were attempts to catch
them to add to his tame collection. They were not in fact albino, but
leucistic since they did not have red eyes but were only lacking in
pigmentation.

U-boat and destroyer
(*actual size*). Pencil, 1941.

Motor torpedo boat during action
(*actual size*). Pencil, 1941.

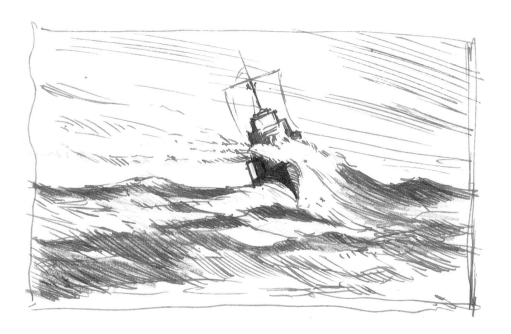

HMS *Broke* **advancing into head seas**
(*actual size*). Pencil, 1941.

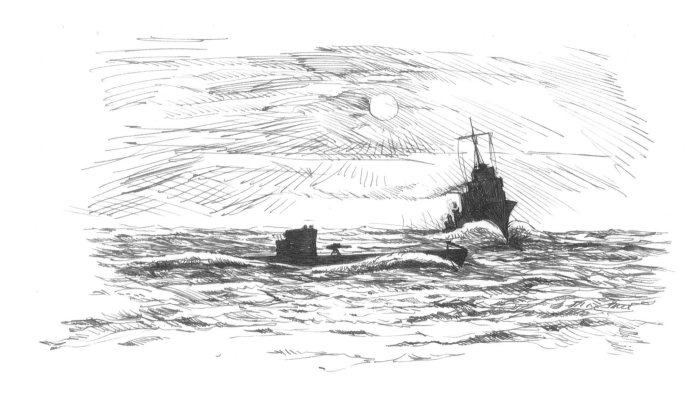

Atlantic encounter. U-boat and destroyer
(*reduced*). Pen and ink, 1941.

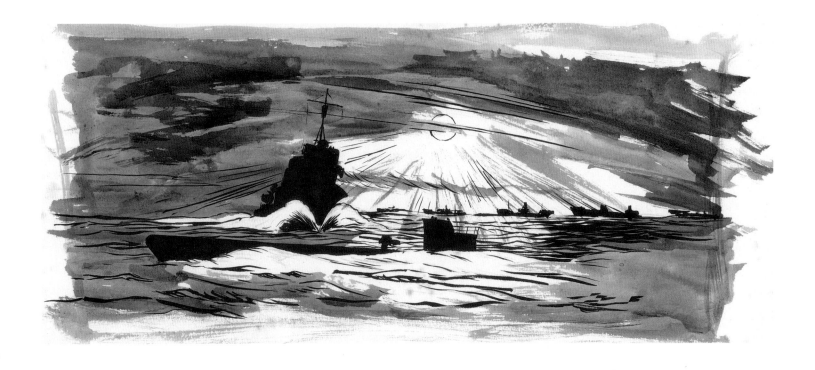

Destroyer, U-boat and convoy
(*reduced*). Pen and ink and wash, 1941.

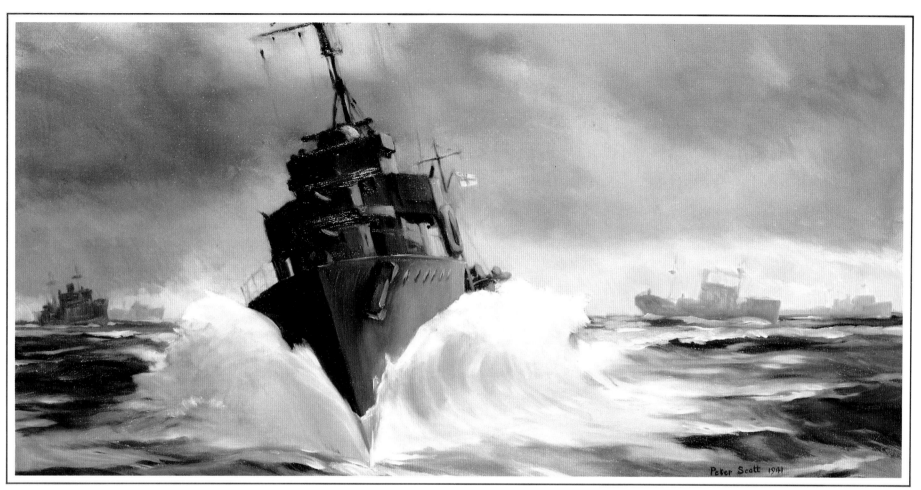

HMS *Broke* on Atlantic convoy duty in 1941,
investigating an asdic contact
Oil on canvas, 1941. 22″ × 40″ (55.9 × 101.6 cm).

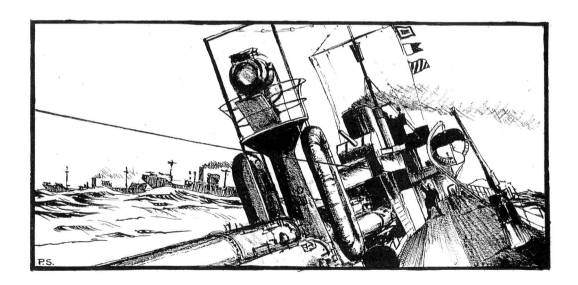

HMS *Broke*
(*reduced*). Pen and ink, 1941.

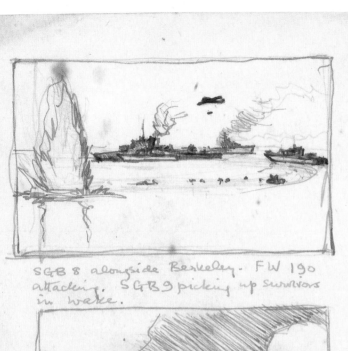

SGB 8 alongside Berkeley. FW 190
attacking. SGB 9 picking up survivors
in wake.

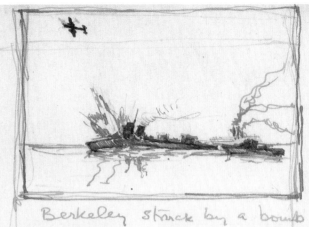

Berkeley struck by a bomb

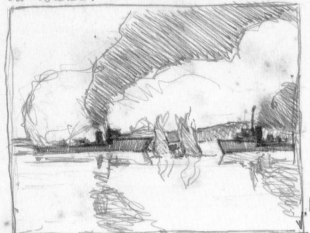

Calpe's duel with shore battery

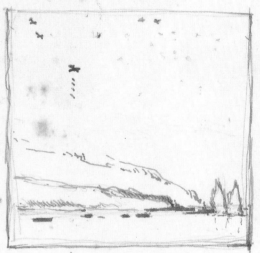

Dornier dive attack

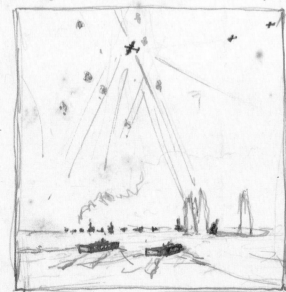

Dornier near miss on
destroyers during the
withdrawal

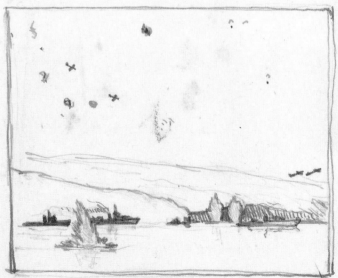

JU 88's attacking
Green beaches

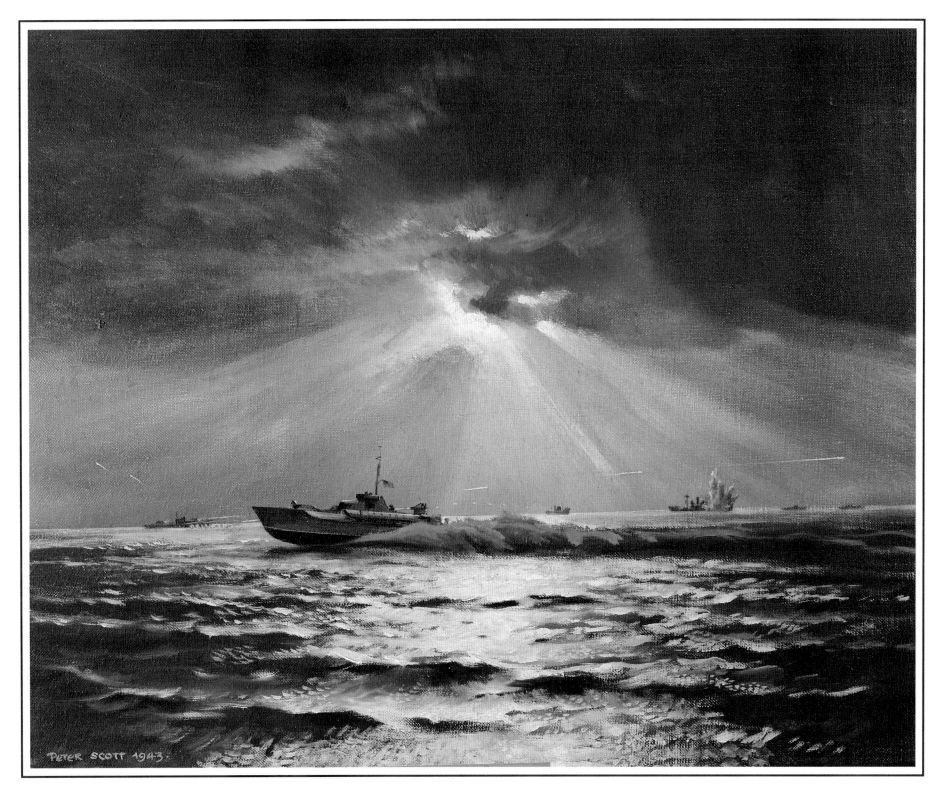

Moonlight attack
Oil painting, 1943. 18″ × 22″ (45.4 × 55.9 cm).

Whatever Peter was doing, he had to paint, and so when time permitted wartime scenes
were put on canvas.

Left: Six wartime sketches, Dieppe Raid
Orange and blue ink and wash, 1941.

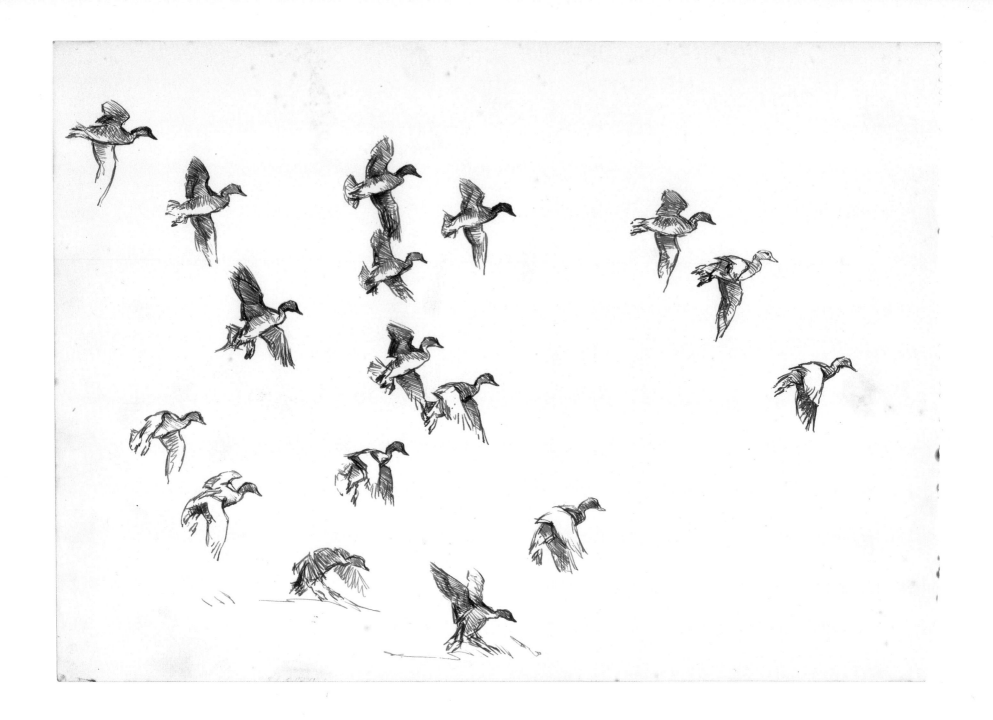

Ducks in flight
(*reduced*). From a wartime sketchbook, 1941.

'Drawing was an urgent and essential escape to a creative life.'
Peter Scott, writing about wartime, in *The Eye of the Wind*.

These three sketches are from the same 1941 sketch book.

Duck sketches
(*reduced*). Red and black ink, 1941.

Motor gunboats, 1941
(*reduced*). Red ink, 1941.

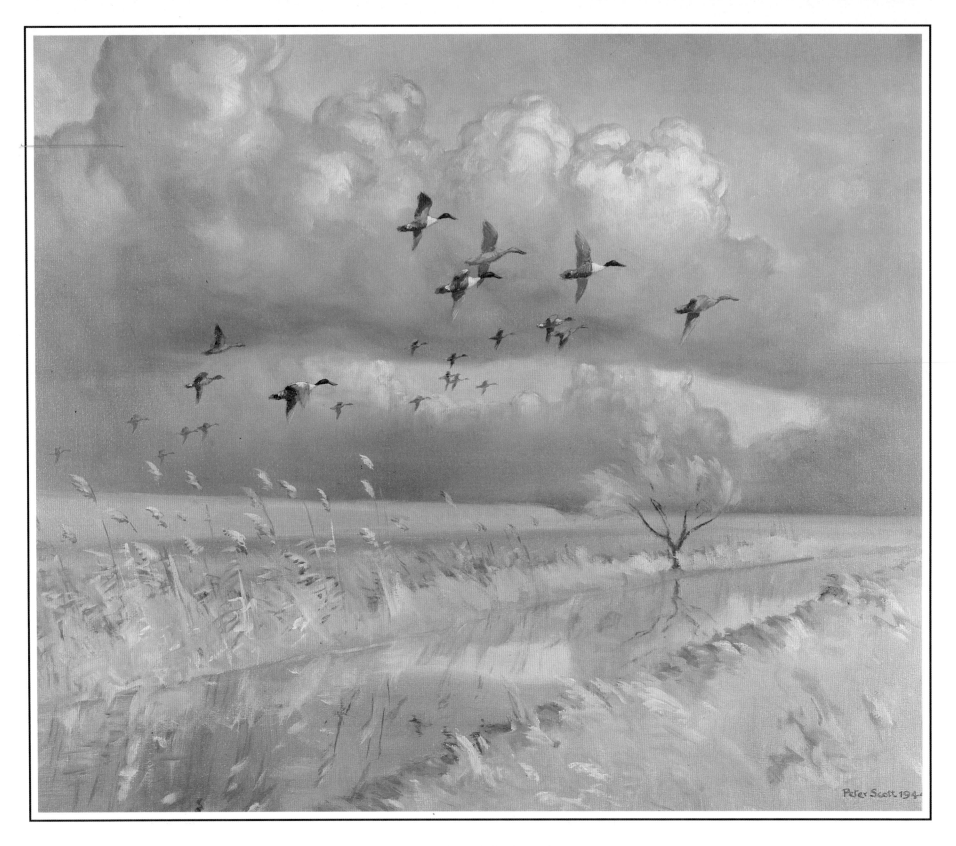

The boundary dyke in spring
Oil painting, 1944. 25″ × 30″ (66 × 76.2 cm).

Even with all the excitement of Peter's wartime activities, he still found time to get his
inspiration from watching and painting birds.

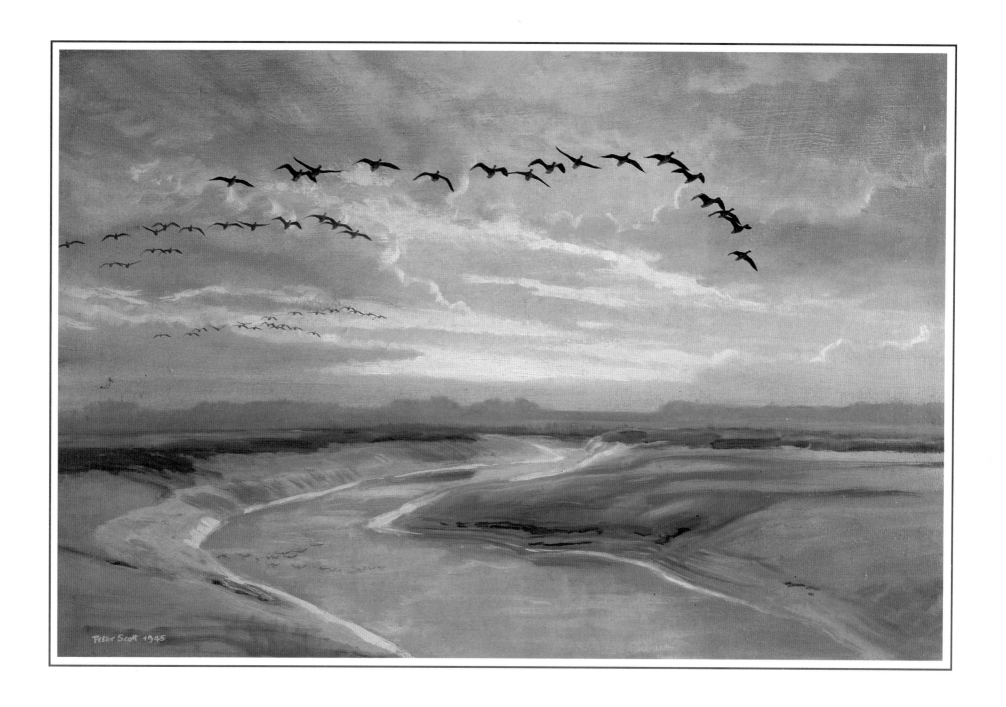

Pinkfeet
Oil painting, 1945. 20″ × 30″ (50.8 × 76.2 cm).

'I found a new delight in painting birds I spent so much time in pursuing. My pleasure was to re-create the tense excitement that I felt when I was out on a marsh, recapture some of it each time that I looked at the picture, and convey some of it to those who had shared the experience.'

The Eye of the Wind

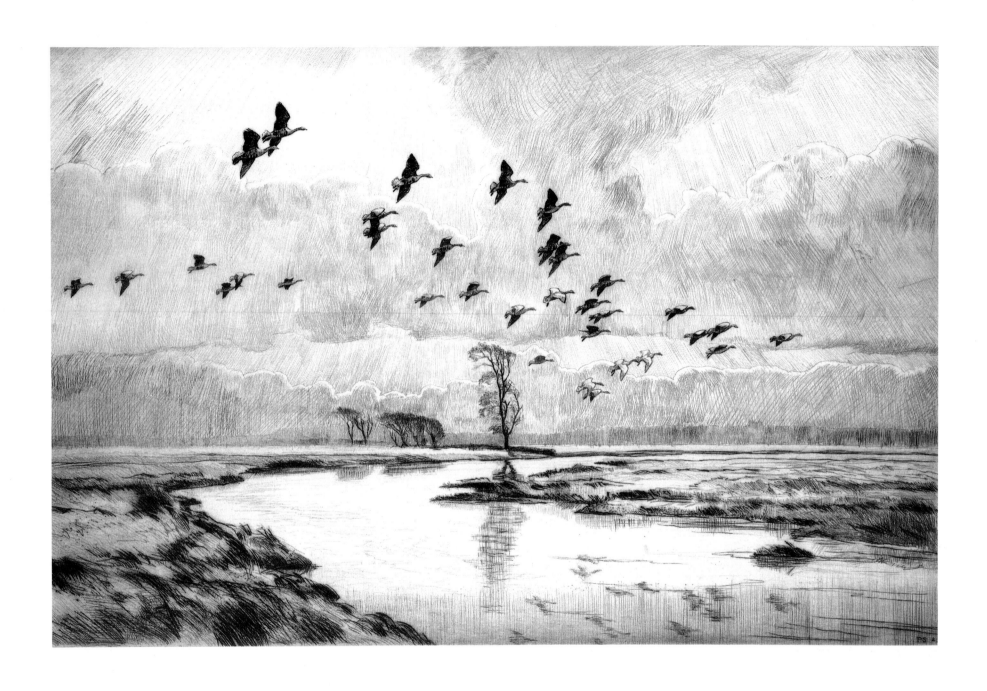

White-fronted geese
Drypoint etching, 1946. 9″ × 14″ (22.9 × 35.6 cm).

This drypoint etching, and that on the opposite page, are from a series
made by Peter when he was in New York.

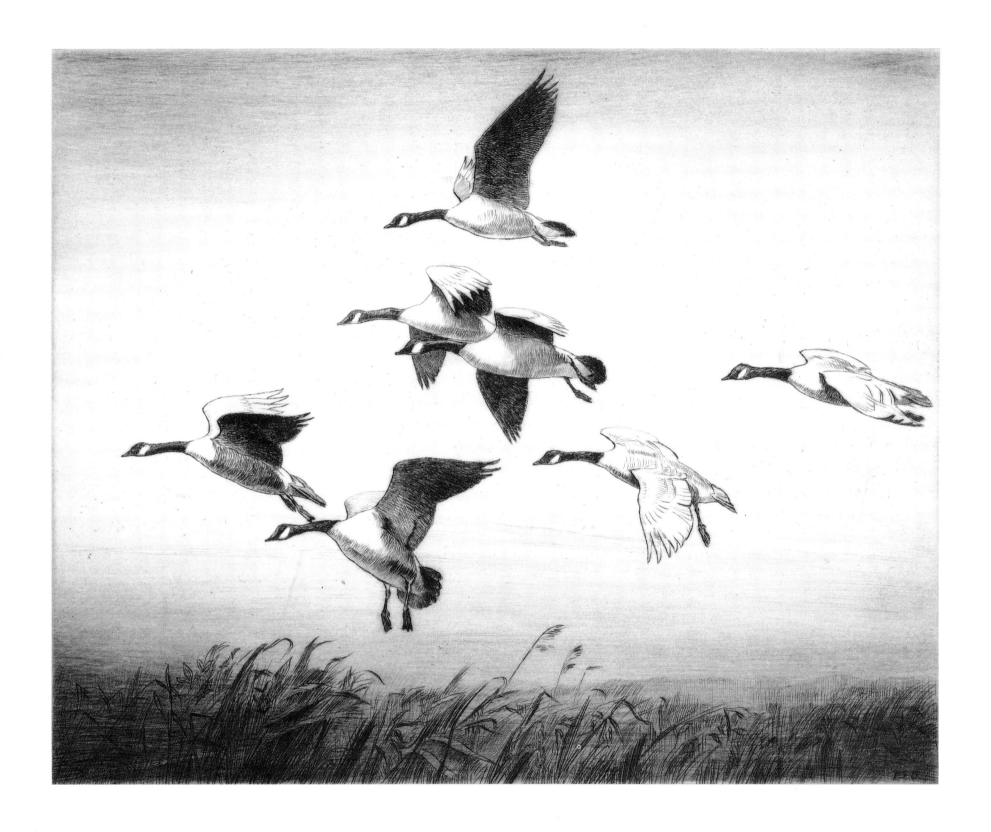

Canada geese
Drypoint etching, 1946. 8″ × 10″ (20.3 × 25.4 cm).

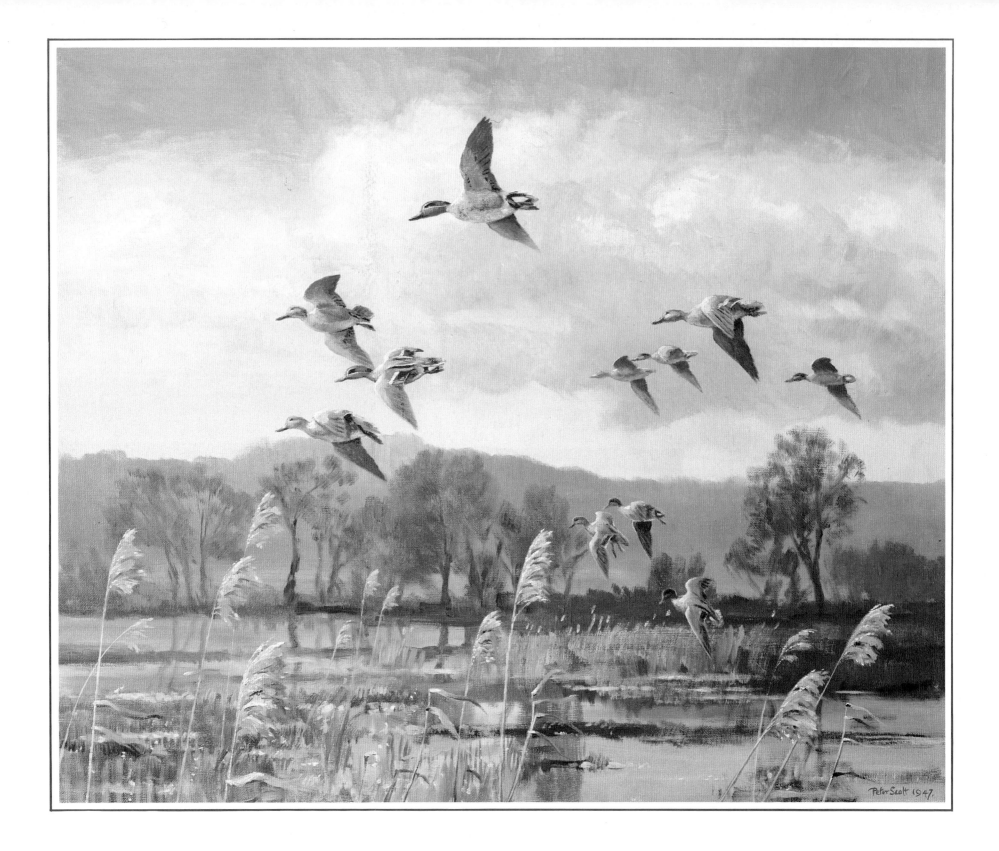

Teal on the River Severn
Oil painting, 1947. 26″ × 30″ (66 × 76.2 cm).

Near the river at flood time, higher up than Slimbridge, there are
hidden marshy places where teal love to come.

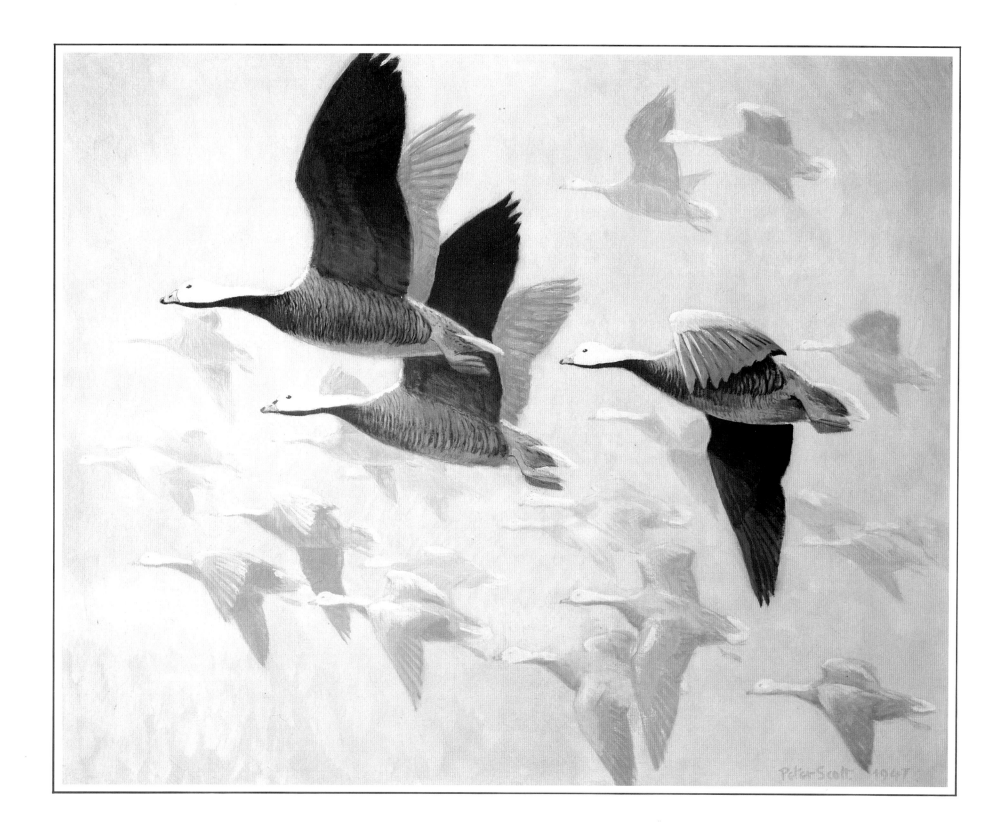

Emperor geese
Oil painting, 1947. 26″ × 30″ (66 × 76.2 cm).

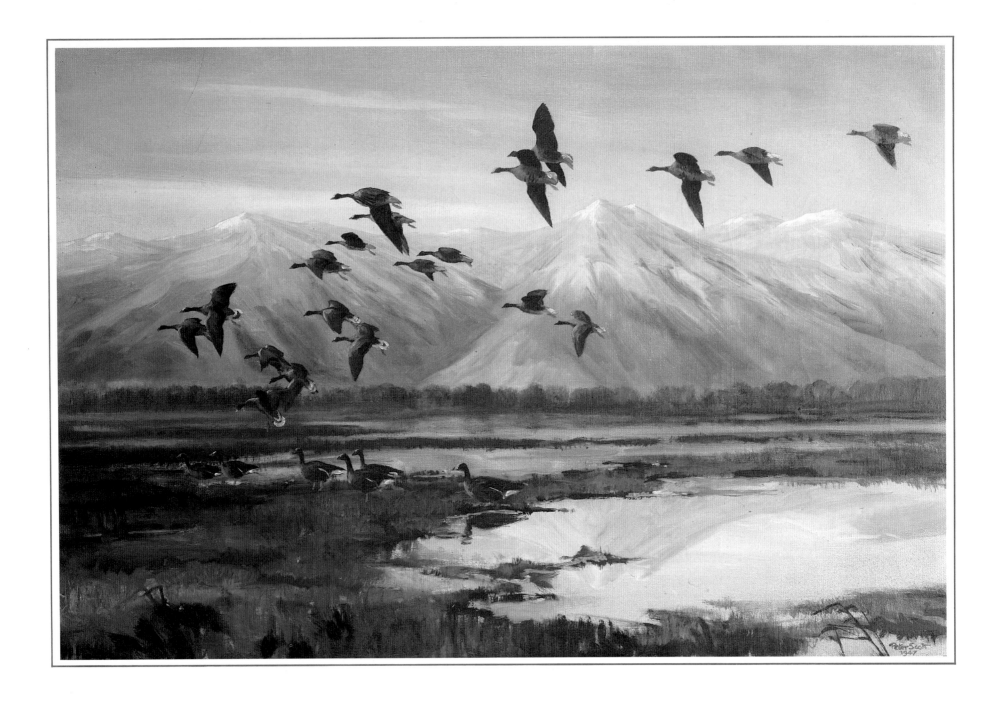

Lesser white-fronted geese flighting over the Caspian
marshes at dawn
Oil painting, 1947. 20″ × 30″ (50.8 × 76.2 cm).

Peter had gone to Hungary in 1936 looking for lesser whitefronts and red-breasted geese. In Hungary, lesser whitefronts have the delightful name kis lillik (pronounced kish, which means small). The following year he went to the Caspian where he saw an estimated 30,000 on a marsh but failed to find the redbreasts he so much longed to see in the wild.

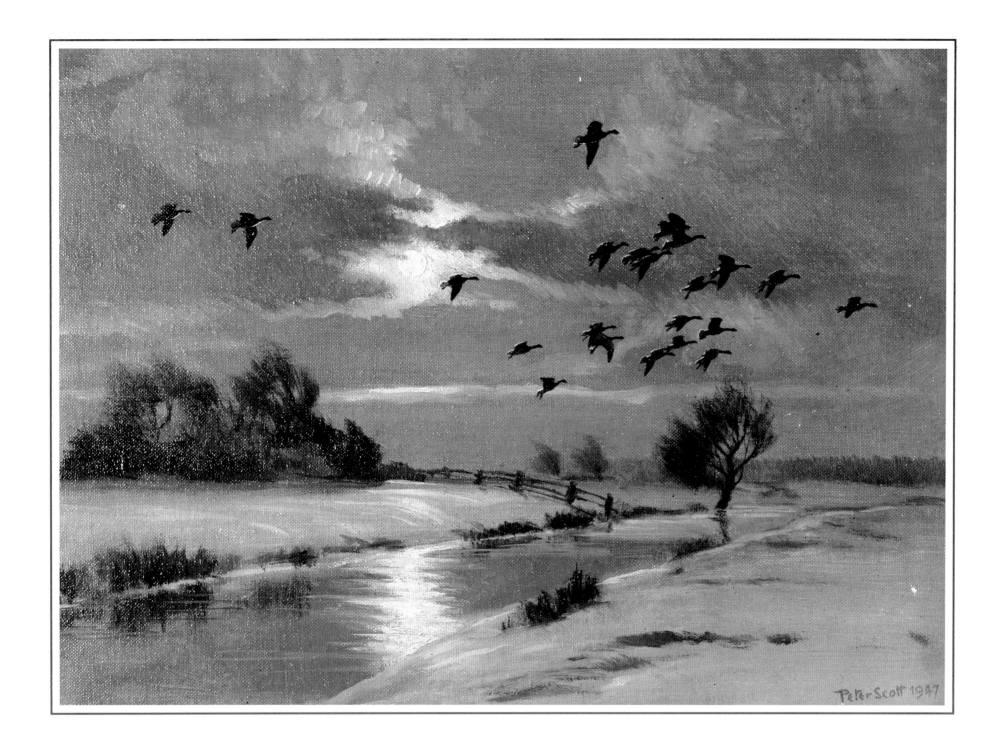

Snow geese flying by moonlight
Oil painting, 1947. 10″ × 14″ (25.4 × 35.6 cm).

'I had only to put onto the canvas, to the best of my oil painting capacity, the birds as I had seen them at dawn or dusk or moonlight, or in storm or frost or snow, and I could not fail to be doing something original.'

The Eye of the Wind.

Philippa
(*reduced*). Lithograph,
1948.

This portrait and
that on the opposite
page were both
published in *Portrait
Drawings* by Peter in
1949.

James Robertson
Justice
(*reduced*). Lithograph,
1948.

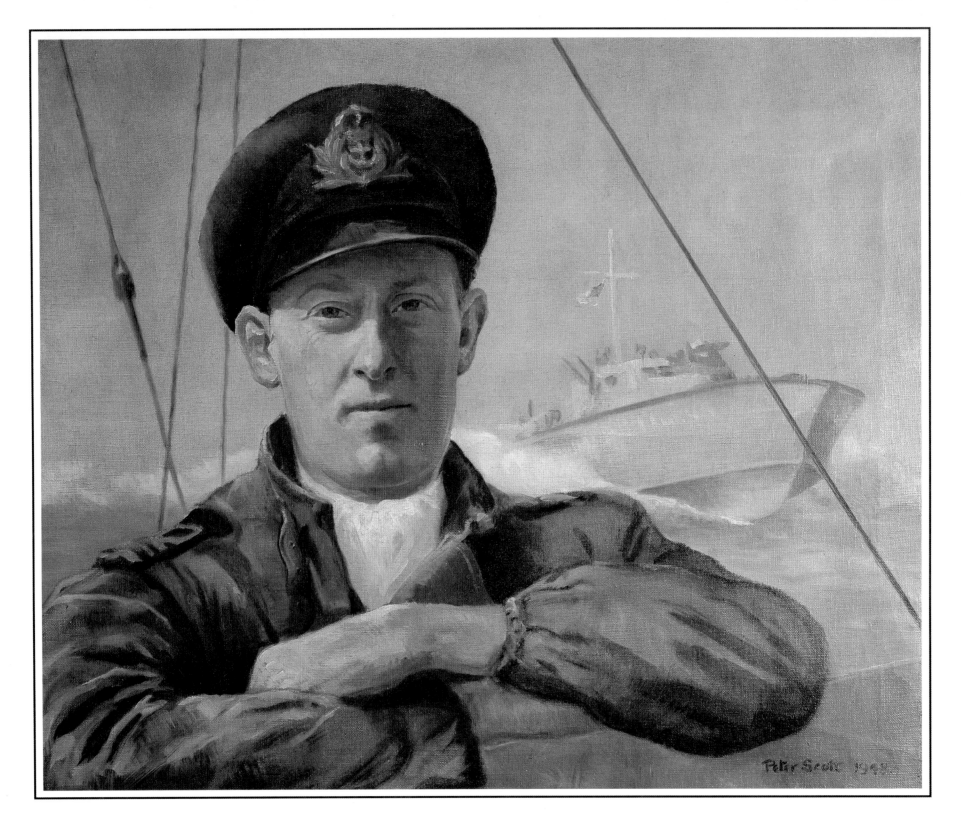

Lieutenant Commander R. P. Hichens
Oil painting, 1948. 24″ × 36″ (61 × 91.4 cm).

Robert Hichens was an old friend from fourteen-foot dinghy sailing days. He won more decorations than anyone else in Coastal Forces and was killed on active service in 1943. The painting was a commission for the RNVR Club after the war.

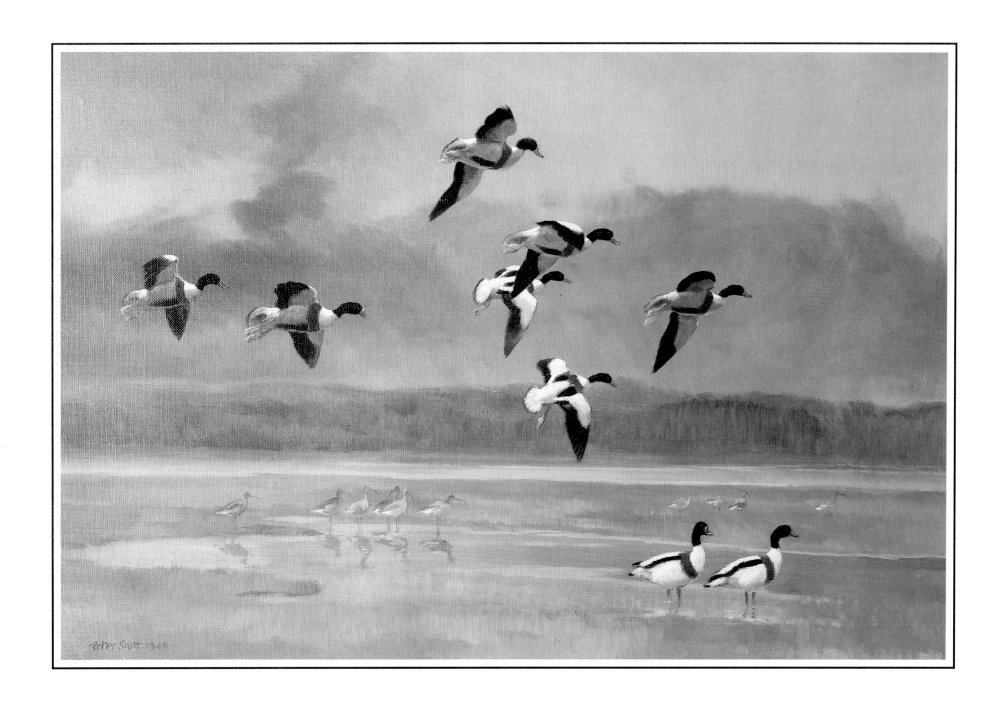

Shelduck alighting on The Dumbles
Oil painting, 1948. 20″ × 30″ (50.8 × 76.2 cm).

The salt marsh at Slimbridge, known as The Dumbles, is a great place for seeing shelduck. They breed in this area and are quite common in the winter when the wild geese are here.

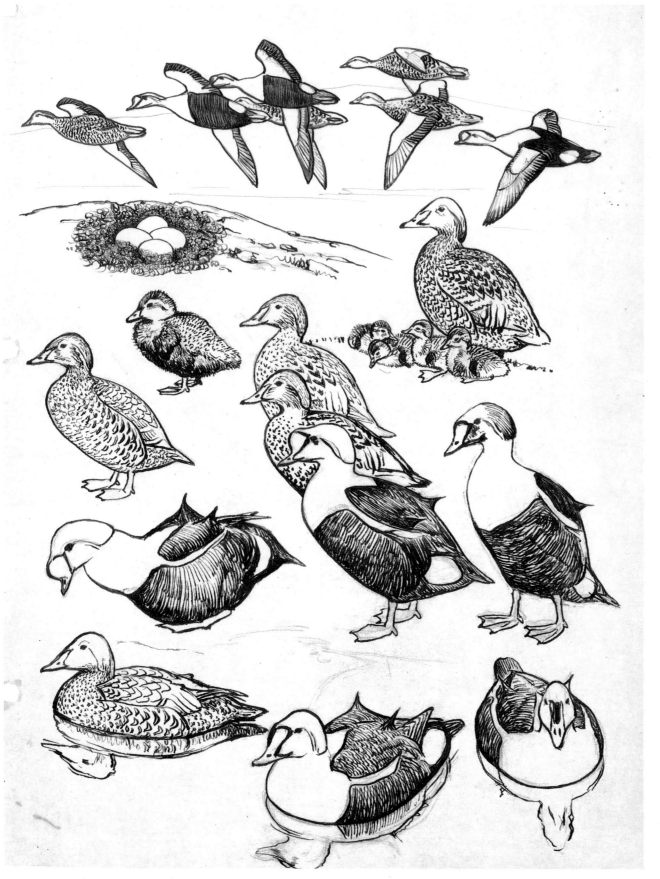

Sketches of king eiders.
Perry River, Canada
A page from a sketch
book, 1949.

Within the sketch (handwritten annotations):

Snow filled clouds. against sun.

Bright snow with grey shadows

Cranes nearly black

Top back light on geese

Thin grass yellow.

Brown river.

**Perry River sketch for a painting –
Ross's geese and cranes.**
Brown brush point pen. From a sketch book, 1949.

With Paul Queneau and Harold Hanson, Peter visited the Perry River area of the North West Territories in search of the breeding grounds of Ross's geese. An account of this was published in 1951 in *Wild Geese and Eskimos*.

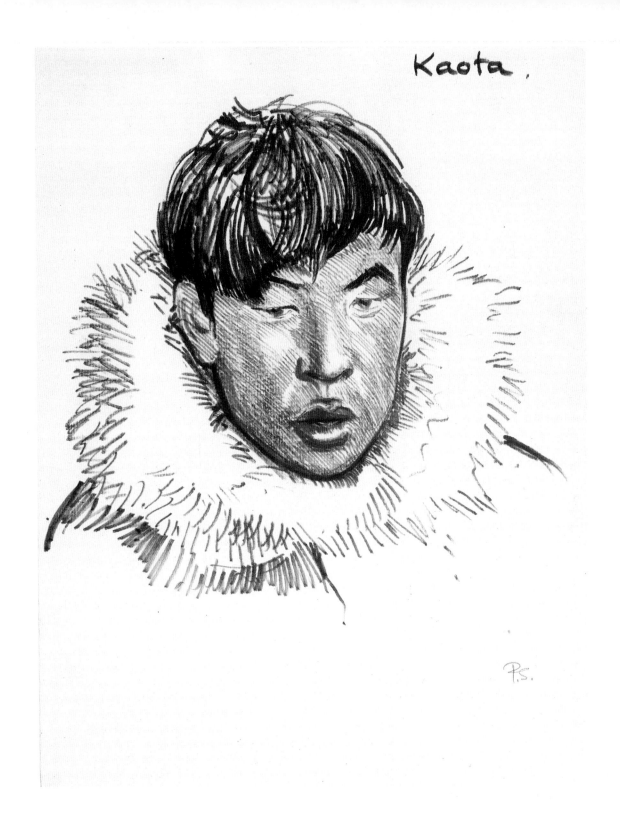

Kaota
Black and brown brush point pens, 1949. 11″ × 9″ (28 × 22.9 cm).

In 1949 Peter went on an expedition to the Perry River area of the Canadian Arctic. The Kogmuit tribe of Eskimos were local to that area and were friendly and helpful.

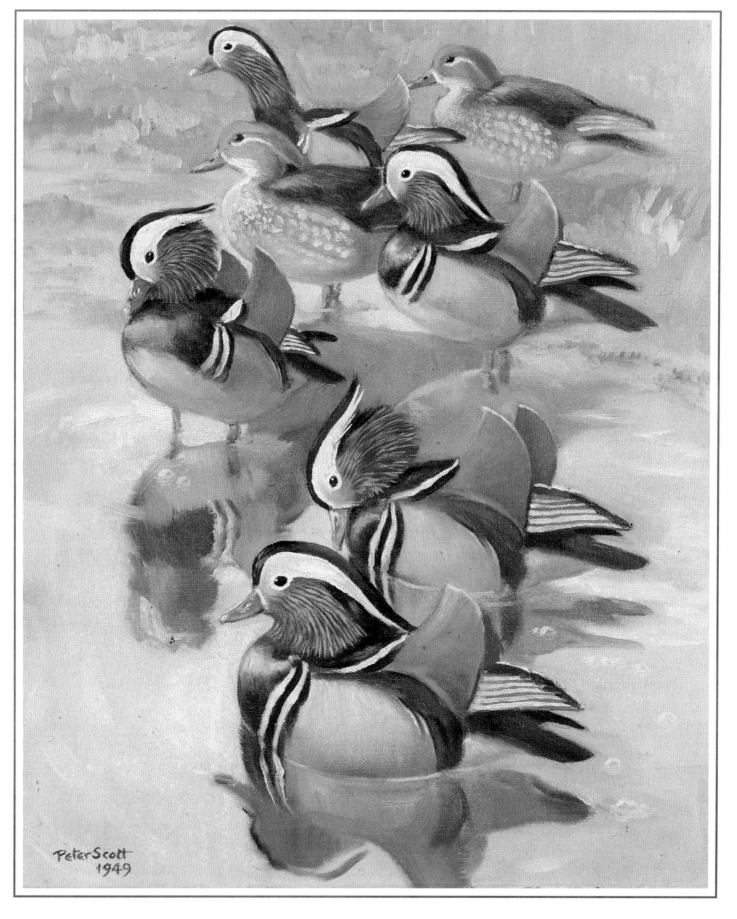

Mandarin ducks
Oil painting, 1949. 18″ × 15″
(45.4 × 38.1 cm).

This was painted for Nicola,
Peter's daughter. At that time
they were her favourite ducks.

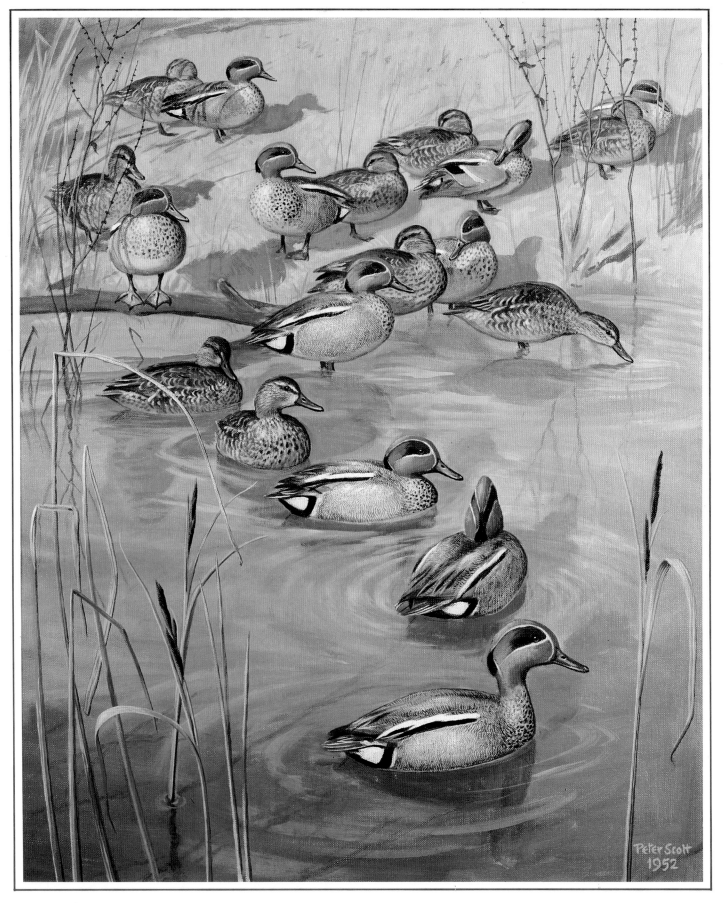

A quiet place for teal
Oil painting, 1952. 30″ × 25″
(76.2 × 63.5 cm).

Inspired perhaps by a marshy
pool near Slimbridge. 'My style
is governed by a zoological
training, so that I try to avoid
distorting what I know to be the
natural shapes of the animals
and plants I am drawing.'
The Repository of Arts.
September 1988.
Arthur Ackermann & Son

Right: The blue goose
Oil on canvas, 1953. 25″ × 30″
(63.5 × 76.2 cm).

The basic outlines of the birds
are those of pink-footed geese.
This is one of the few
paintings where Peter has
used artistic licence with his
beloved geese, but the result is
a colour harmony, and shapes
so pleasing that it was chosen
to hang as the centrepiece over
the fireplace in the studio. It is
one of my favourites.

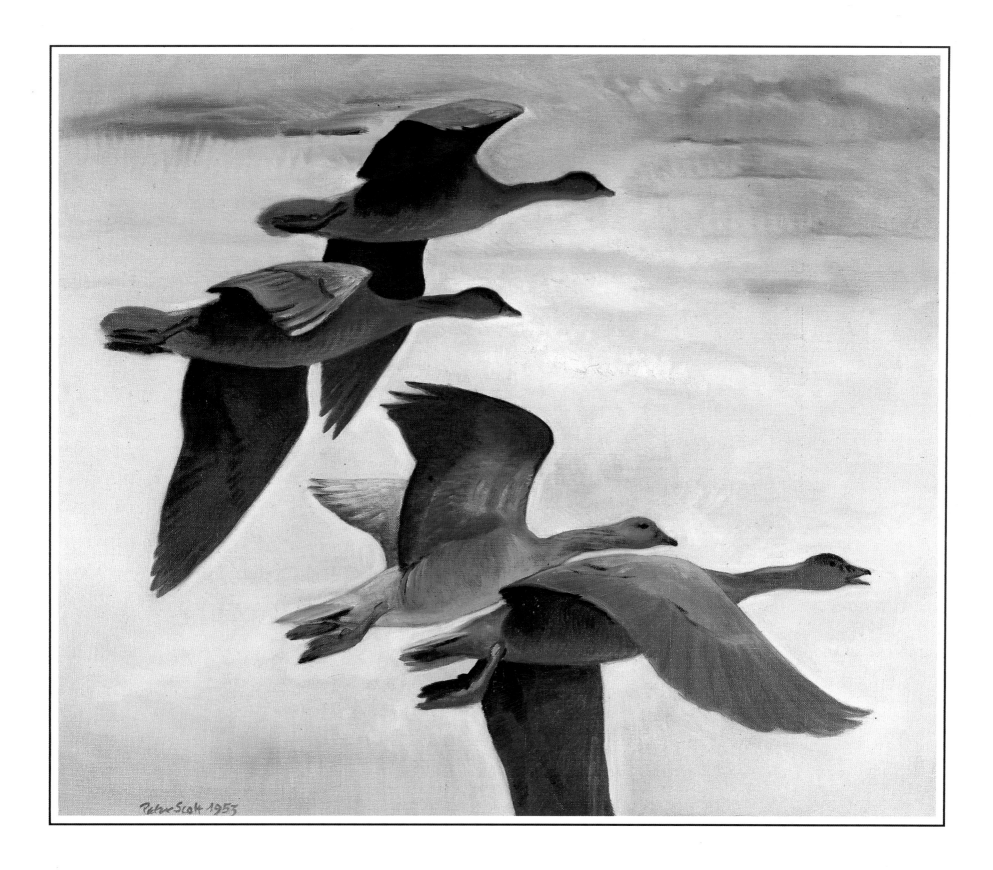

Pencil sketches, 1954.

Cackling Geese.

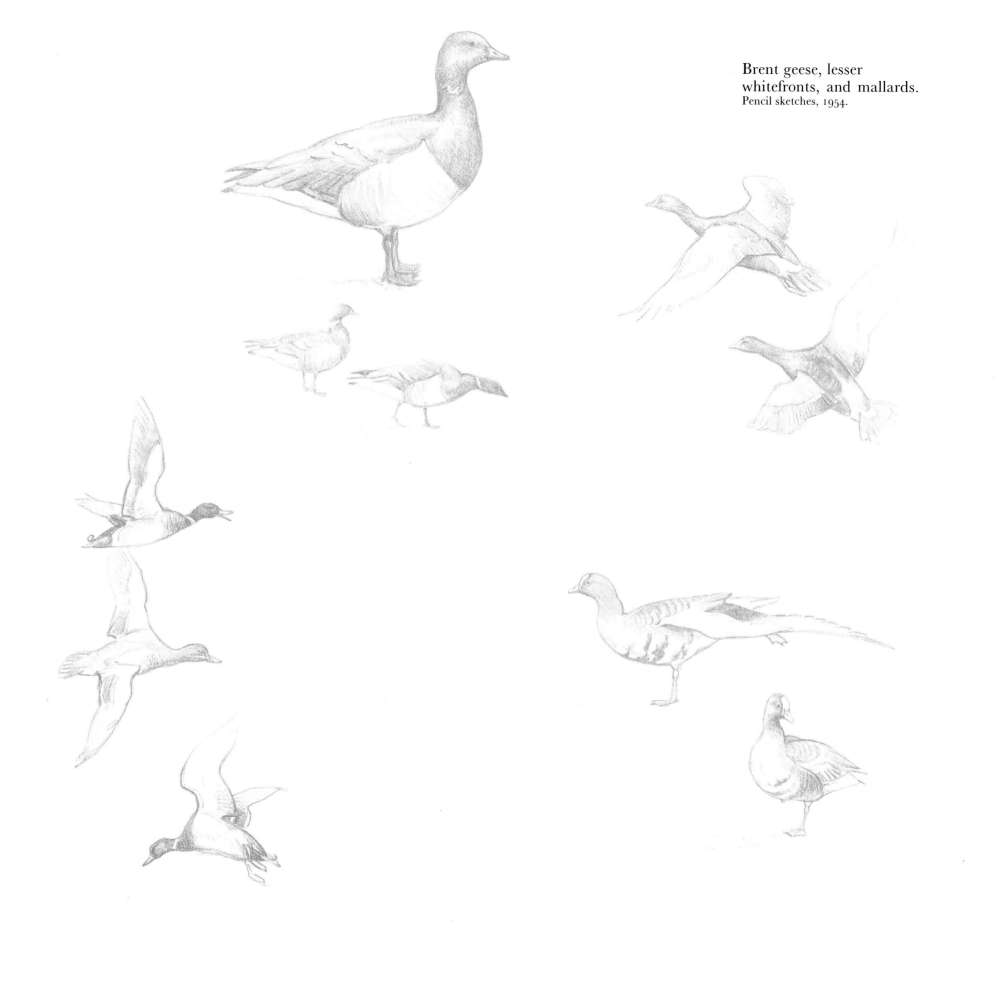

Brent geese, lesser whitefronts, and mallards.
Pencil sketches, 1954.

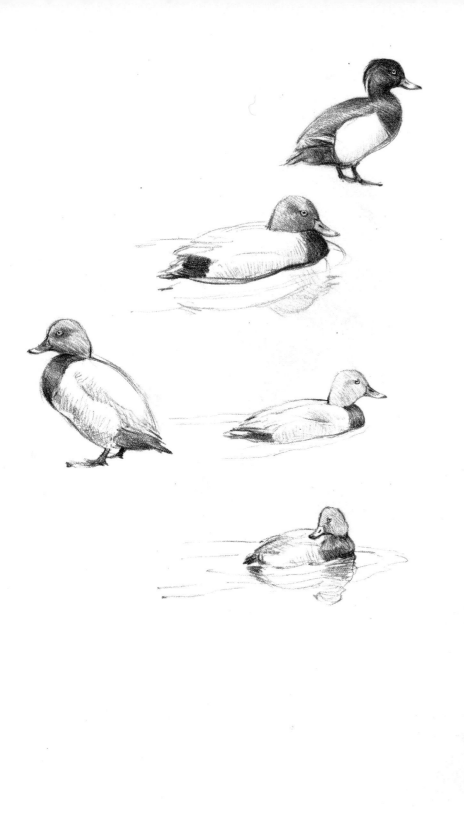

Tufted Duck. Pochard. Waders
Pencil sketches, 1954.

Ducklings of
Indian spotbill
and African
yellowbill

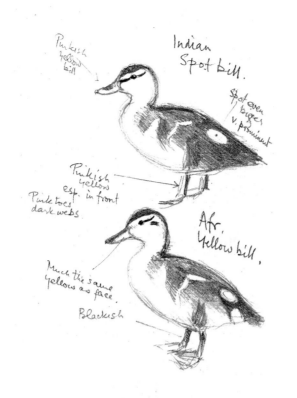

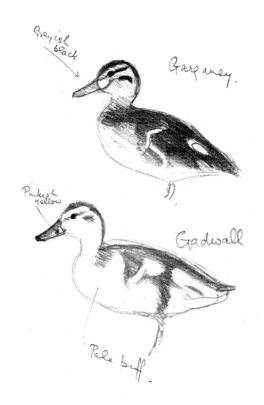

Ducklings of
garganey and
gadwall

Ducklings of blue-
winged teal,
pintail, chestnut
teal

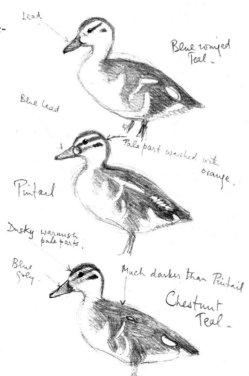

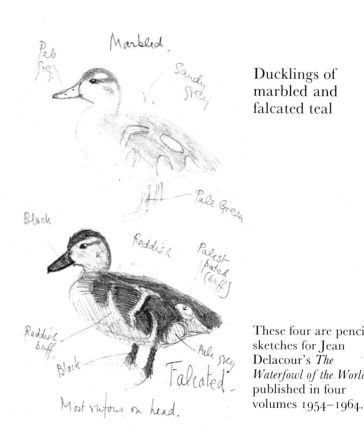

Ducklings of
marbled and
falcated teal

These four are pencil
sketches for Jean
Delacour's *The
Waterfowl of the World*,
published in four
volumes 1954–1964.

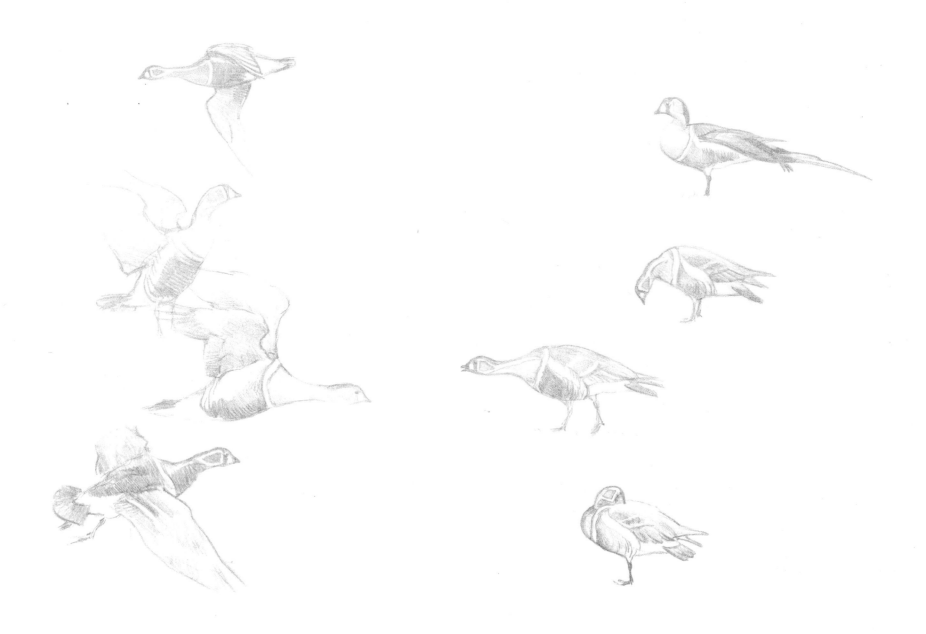

Red-breasted geese
(*reduced*). Pencil, 1954.

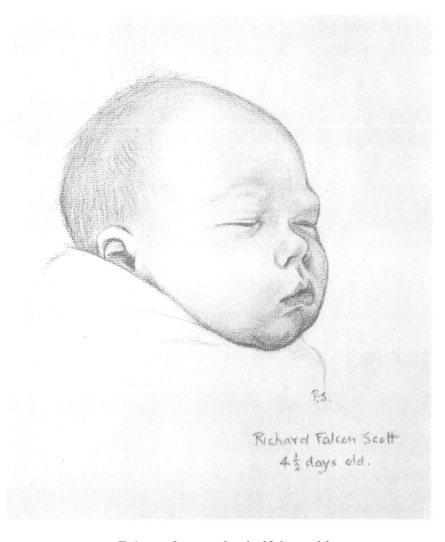

Falcon, four-and-a-half days old
Pencil, 1954.

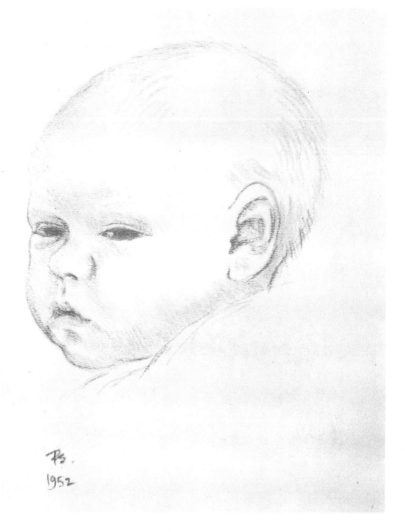

Dafila, nine days old
Pencil, 1952.

There are pencil drawings of children and grandchildren as very
small babies, but portraits of the family are rare. Perhaps Peter was
afraid to commit them to paper.

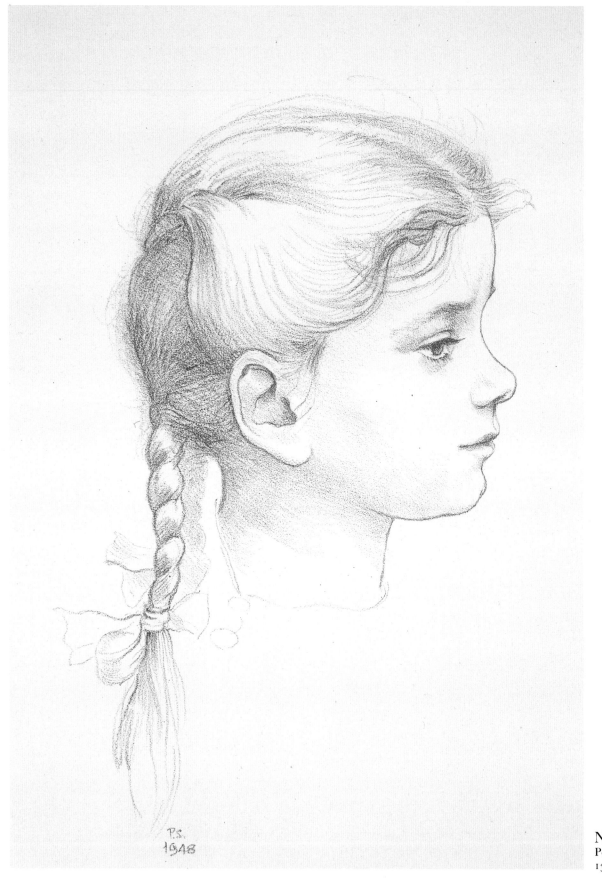

Nicola, five-and-a-half years old
Pencil, 1948.
13″ × 11″ (33 × 28 cm).

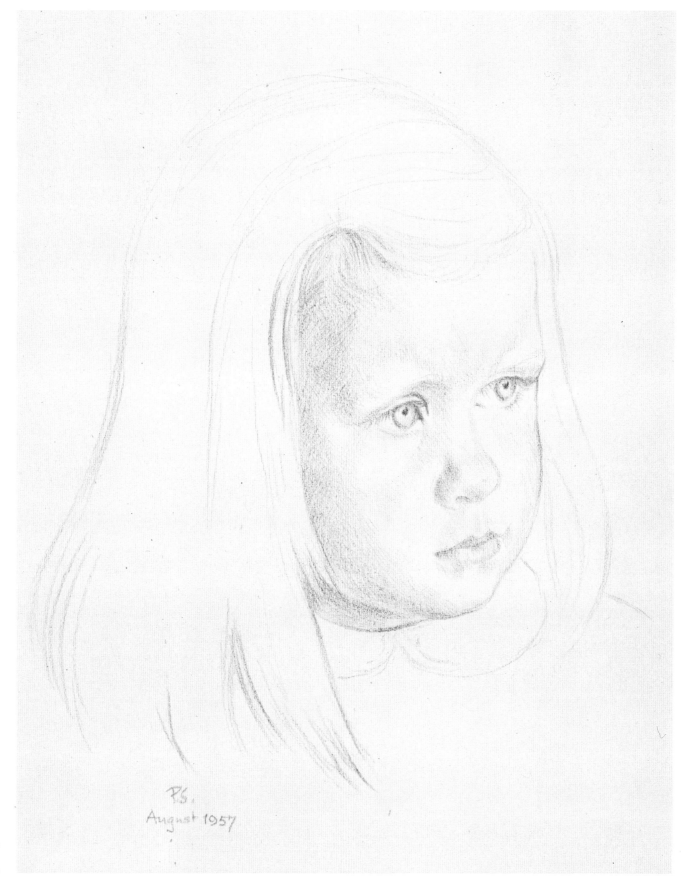

Dafila, five years old
Pencil, 1957.
9½″ × 8″ (24.1 × 20.3 cm).

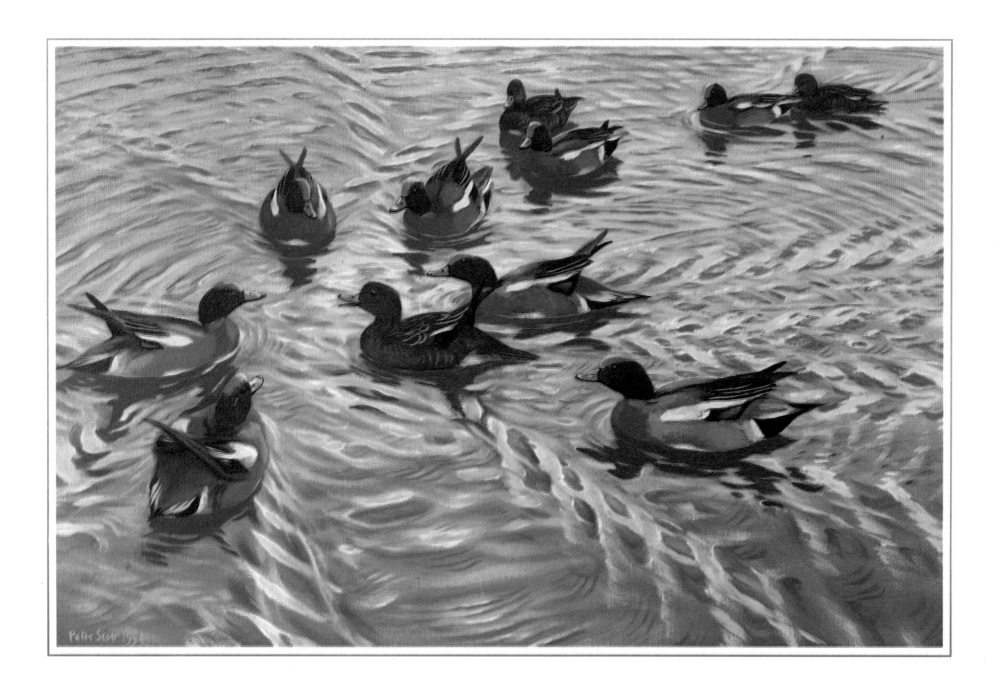

Wigeon courtship

Oil painting, 1954. 20″ × 30″ (50.8 × 76.2 cm).

Patterns of groups of birds and patterns on the water – both fascinated
Peter. 'Clouds and water surfaces I find particularly exciting to create
on canvas.'

The Repository of Arts. September 1988
Arthur Ackermann & Son

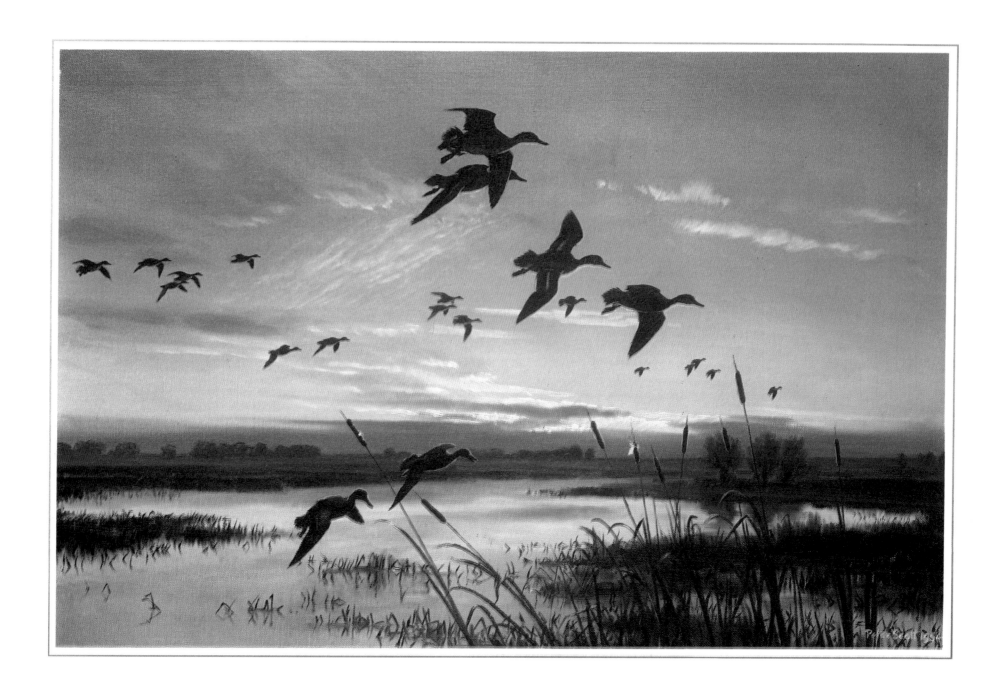

Teal flight before sunrise
Oil on canvas, 1954. 20″ × 30″ (50.8 × 76.2 cm).

'I hope the viewer derives as much pleasure out of seeing my art as I,
as an artist, have derived out of seeing my subjects.'
Birds in Art, 1986. Catalogue
Leigh Yawkey Woodson Art Museum, USA

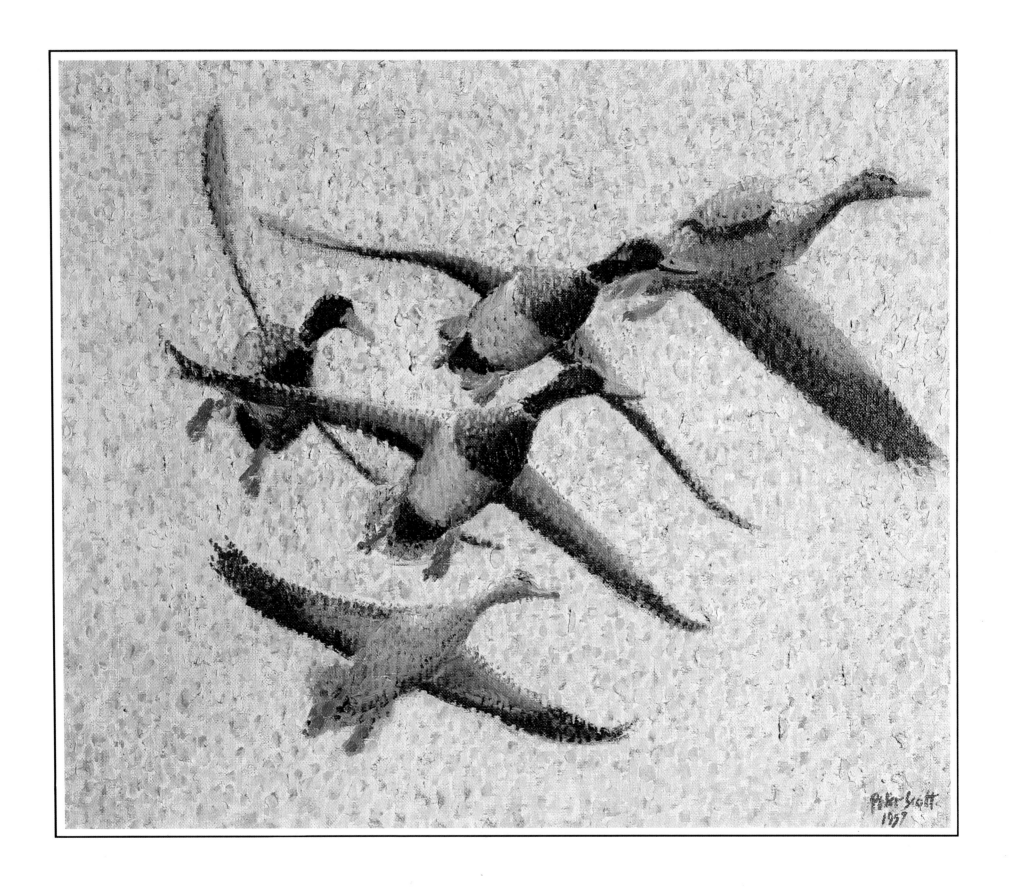

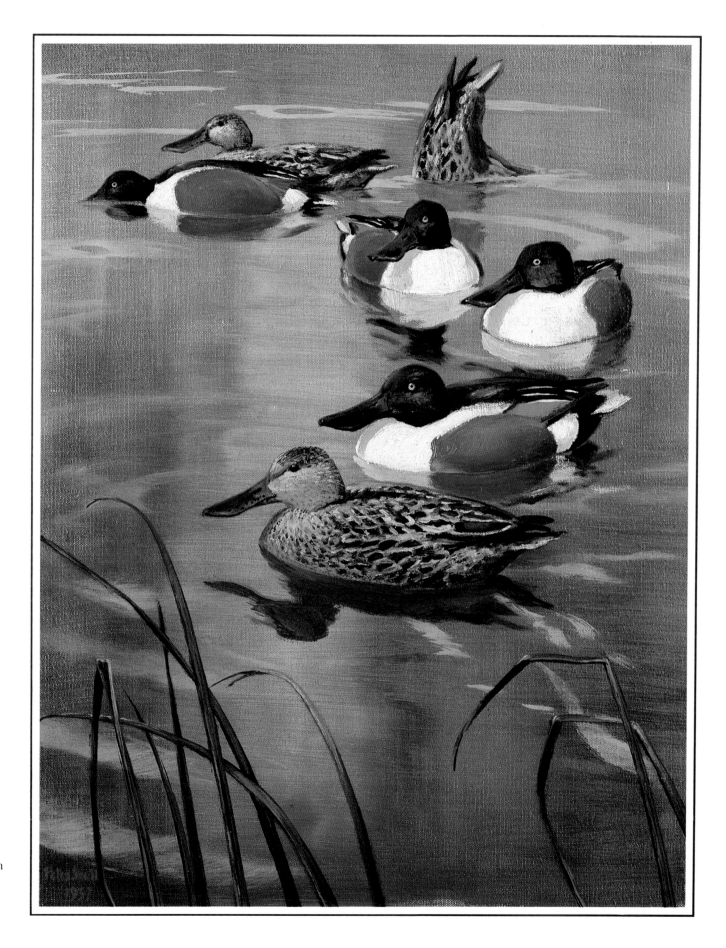

Shovelers
Oil on canvas, 1957.
18″ × 14″ (45.4 × 35.6 cm).

Left: Mallards in a pearly
sky
Oil painting, 1957. 20″ × 24″
(50.8 × 61 cm).
This is Peter's only painting in
this style. He loved to try
something new, something
different.

The natural world of man

Oil on canvas, 1963. 28″ × 36″ (71.1 × 91.4 cm).

'This picture represents man's dilemma in his relationship with nature. I saw the problem as triangular. At the pointed end are ethical responsibilities to save the animals facing extinction – the blue whale, the whooping crane, Hispaniolán solenodon, tuatara, Galapagos tortoise, rhinoceros. From there the scope broadens to encompass communities of animals – wild geese, fishes, antelopes – and their relationship to flowers and trees and to water and soil. All are a part of the biosphere in which man must live. The water is in the cumulus cloud (under which a white glider soars), and the river system with its tree-like formation, bearing leaves, and its foam-polluted tributary, is echoed by the pattern of soil erosion caused by the over-grazing of cattle being herded below with their accompanying dust. There are suggestions of urbanisation and industrialisation. A ship gives out oil pollution, a plane is spraying toxic chemicals, and there is a rocket missile. The peak of Everest ("because it is there") peeps from behind the mushroom cloud whose fall-out is destroying the people spreading from the population explosion. "The pill" is there too.

'The three-dimensional triangle itself is carried by arms in a sea of space dominated by the moon, with a nearby sputnik. In the right-hand corner a new galaxy is born.

'Man, with one white and one black hand, stands transfixed before this vast and terrifying pyramid of problems.'

P.S.

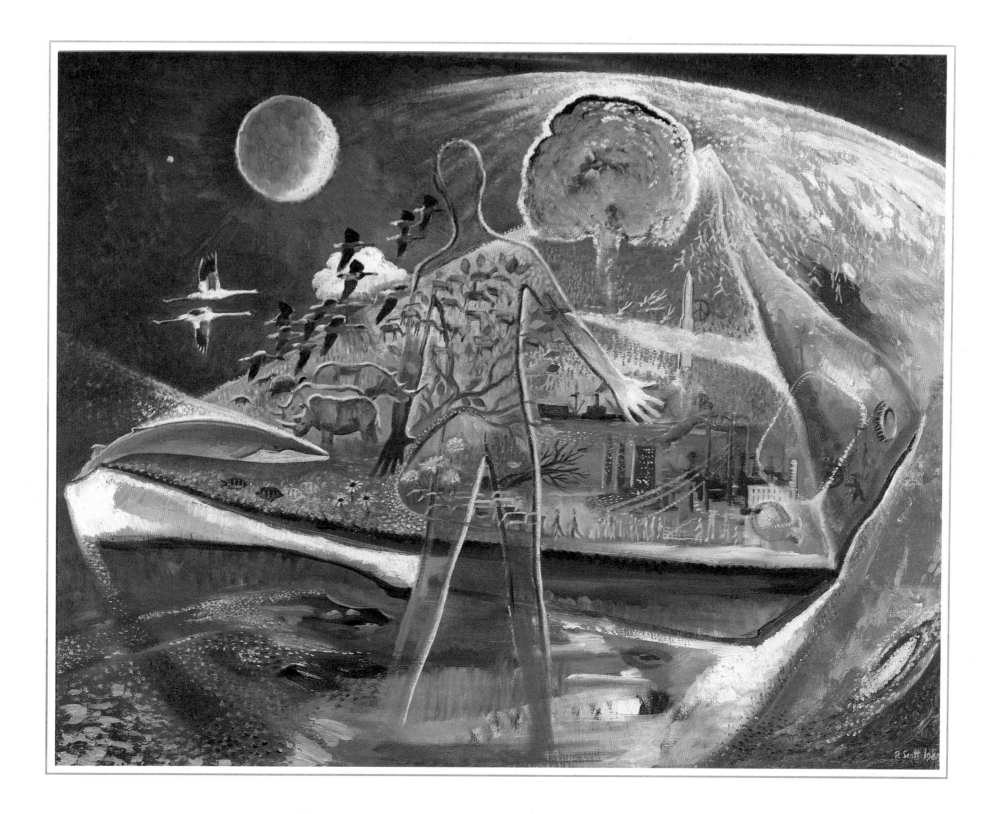

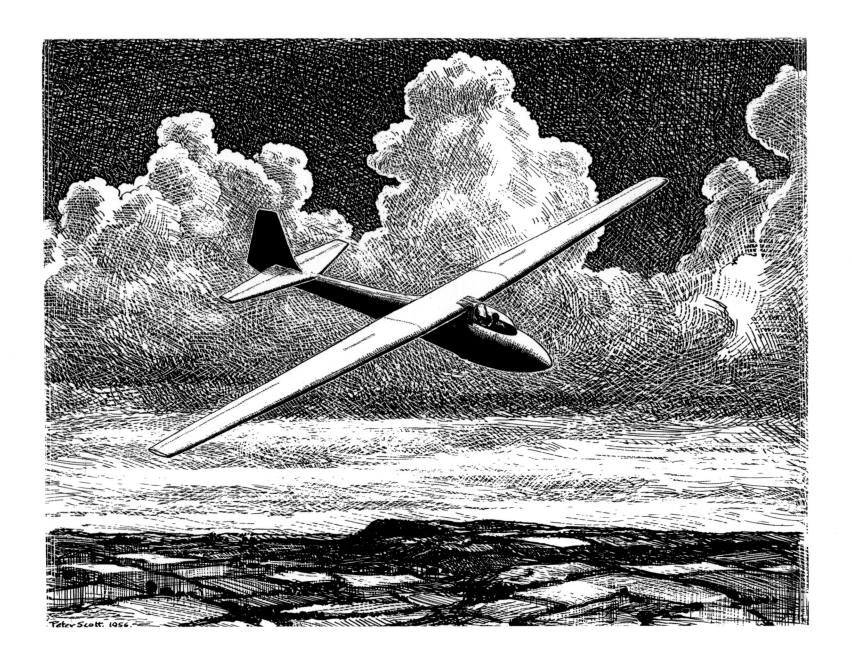

Sailplane
(*actual size*). Scraperboard, 1956.

Peter's enthusiasm for gliding equalled all his other enthusiasms through his life.
Although he only took up gliding in 1956, he won the British Gliding
Championship in 1963.

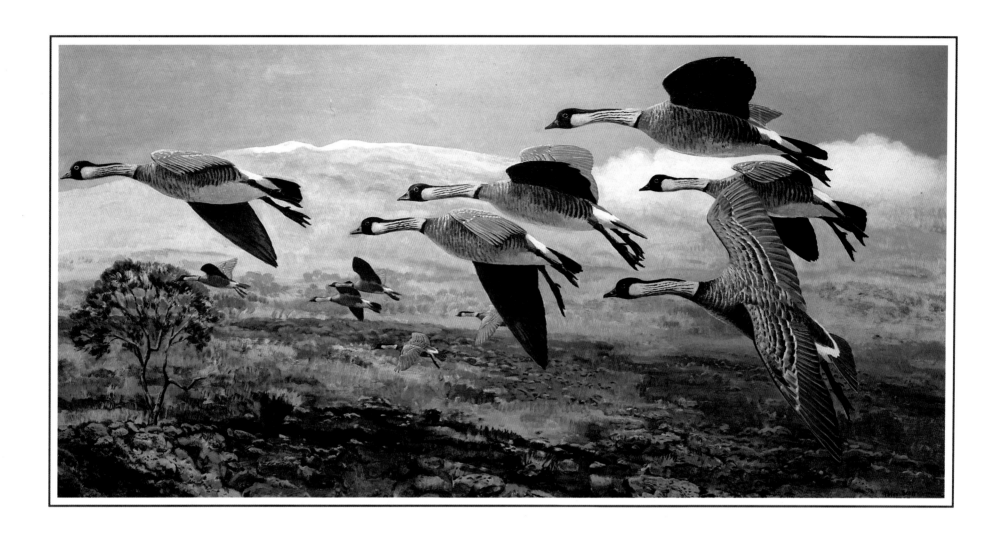

Ne-nes on Mauna Loa
Oil on board, 1965. 48″ × 96″ (121.9 × 243.8 cm).

Ne-nes or Hawaiian geese on the slopes of Mauna Loa on the Big Island of
Hawaii with the peak of Mauna Kea beyond. This oil painting was presented to
The Wildfowl & Wetlands Trust by Mrs Enid Haupt to commemorate the
appointment of her brother the Hon Walter Annenberg as U.S. Ambassador to
the Court of St James in 1969.

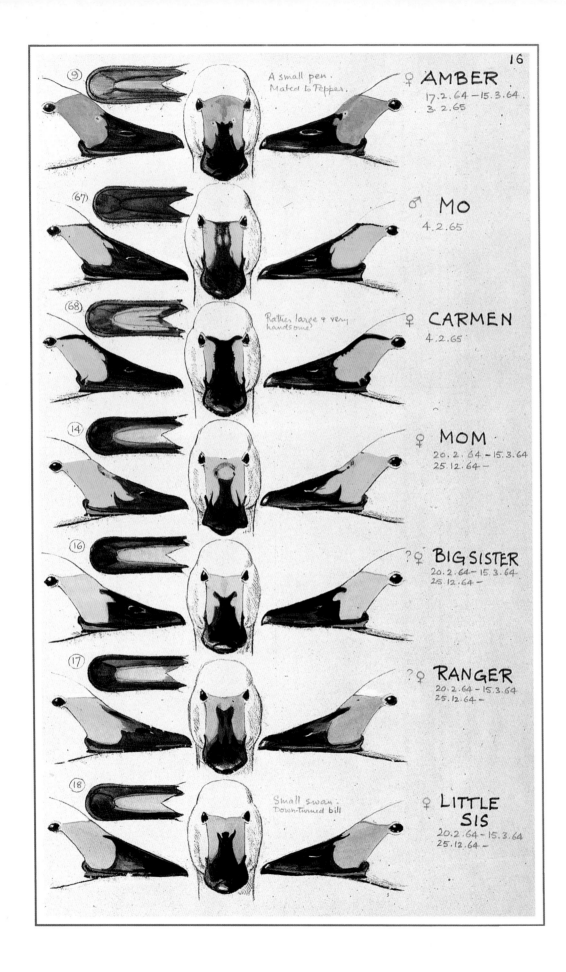

(9) ♀ AMBER
A small pen.
Mated to Pepper.
17.2.64 – 15.3.64.
3.2.65

(67) ♂ MO
4.2.65

(68) ♀ CARMEN
Rather large & very handsome
4.2.65

(14) ♀ MOM
20.2.64 – 15.3.64
25.12.64 –

(16) ?♀ BIG SISTER
20.2.64 – 15.3.64
25.12.64 –

(17) ?♀ RANGER
20.2.64 – 15.3.64
25.12.64 –

(18) ♀ LITTLE SIS
Small swan.
Down-turned bill
20.2.64 – 15.3.64
25.12.64 –

Lancelot
This Bewick's swan, named
by Keith Shackleton,
visited Slimbridge for
twenty-six consecutive
winters. His arrival was
always noted in *The Times*.

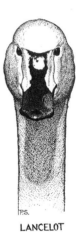

LANCELOT

Bewick's swans' bill patterns
From the Logbook at Slimbridge, 1965.

In 1963 the first wild Bewick's swans landed on Swan
Lake in front of the studio window. After we discovered
that their bill patterns were individual, each bird was
recorded and named for future recognition and study. By
1991 we had over 3,000 named swans on our books and
also on computer. Each year in October they arrive from
their breeding grounds in the far north of Siberia to winter
in Britain.

Bewick's swans against the setting November sun
Oil painting, 1968. 20″ × 30″ (50.8 × 76.2 cm).

'Ever since I started to paint in the 1920s, backlighting has been a special interest of mine, and I believe dawn and dusk are essentially romantic and sometimes dramatic times of day.'

The Repository of Arts. September 1988
Arthur Ackermann & Son

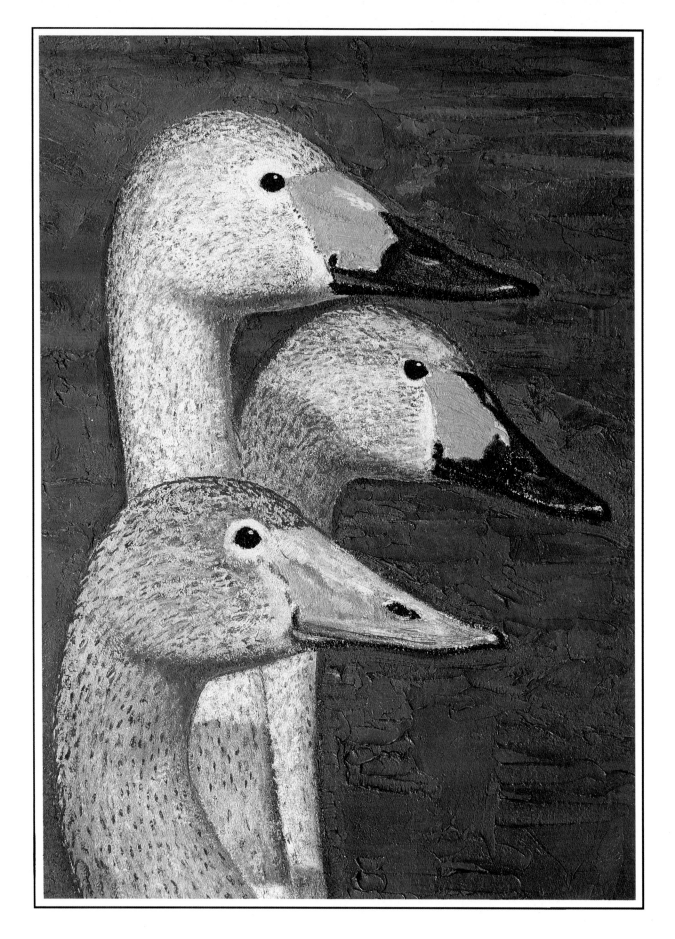

Peasant and Gypsy with their cygnet
Oil on canvas, 1968. 12″ × 10″ (30.5 × 24.4 cm).

Peasant and Gypsy were Scott family favourites among the wild Bewick's swans. Peter painted them for our daughter, Dafila. Dafila sighted them in Holland, recognising them by their distinctive bill patterns, in March 1970 on their way north to the Arctic tundra to breed. She saw them again in Holland on 18 March 1972 and again four days later in Germany. They came to Slimbridge for the last time for the 1977/78 winter season.

Right: Barnacle geese with Criffel beyond
Oil on canvas, 1974. 20″ × 24″ (50.8 × 61 cm).

There are several paintings with Criffel as a background. This is a view over a field next to the farmhouse at The Wildfowl & Wetlands Trust Centre at Caerlaverock on the Solway Firth. The flock of barnacles includes two white birds. Caerlaverock was always a magic place for Peter: 'To creep into one of the hides at Caerlaverock when the barnacles are close in front of it is unforgettably exciting.'

Observations of Wildlife

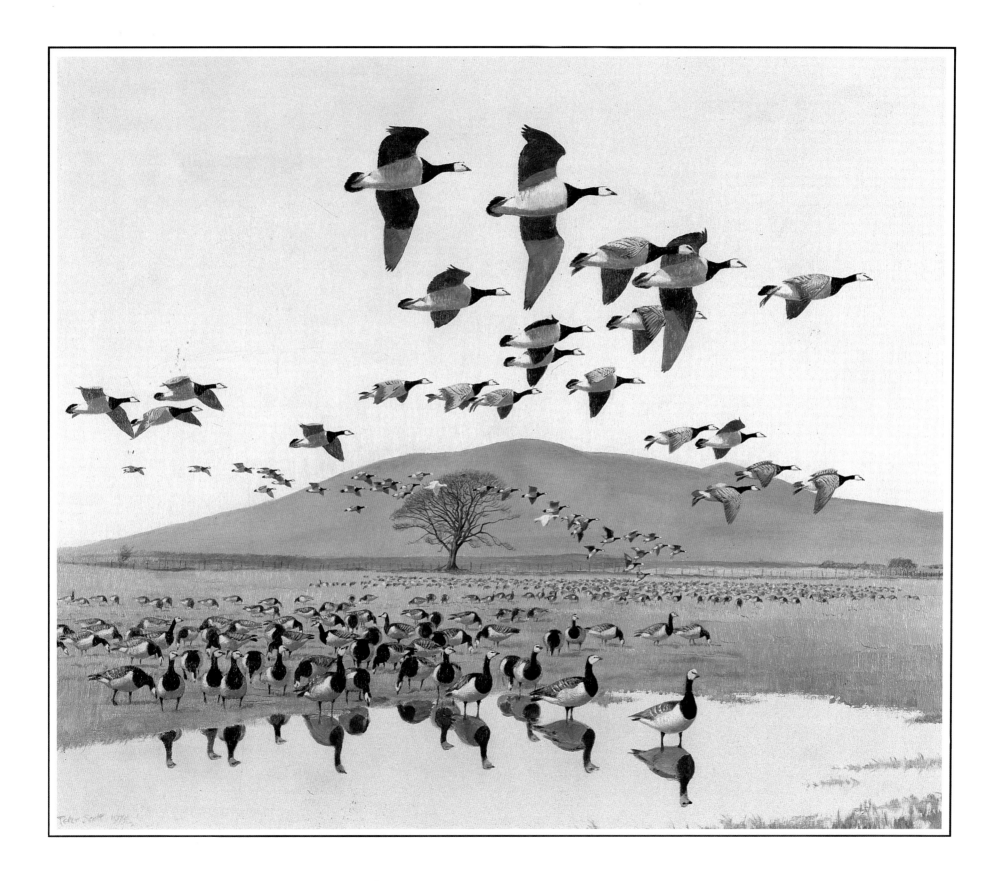

Tues 27 Feb. Puerto Varas – Puerto Montt.
 to airport.

Black Vulture
House Sparrow in P. Varas
Martin
Hummingbird
Barn Swallow
Andean Gull
Kelp Gull
Chimango
Teru-Tero.
Dark Cinclodes
Gt. Skua

Copihue
The national flower of Chile.

Lapageria rosea.

Copihue,
national flower of
Chile
(*actual size*). List and
watercolour from a
diary, 1968.

Flowers of <u>Sud Island</u>.

Cornus canadensis
Sedum rosea
Iris setosa
• Fritillaria
Trientalis europaea (or arctica)
Salix reticulata
Salix sp.
Pedicularis verticilata ?
Pedicularis sp. ? lanata
Silene acaulis
Potentilla uniflora
Geum sp
• Geranium erianthum
Viola ? langsdorfii
• Rhododendron camtschaticum ? ssp glandulosum.
Dodecatheon pulchellum.
Castilleja unalaschensis.
(Pinguicula vulgaris.)
• Campanula lasiocarpa
Aster sibiricus
Erigeron hyperboreus
Erigeron caespitosus
Draba ? hirta
Armeria maritima
Platanthera dilitata.

Shooting Star
<u>Dodecatheon
pulchellum</u>

Hoary Marmot. <u>Marmota caligata</u>

Flowers of Sud Island. Shooting star and hoary marmot (*actual size*). List and watercolours from a diary, 1976.

Sud Island is one of the Barren Islands off the south coast of Alaska, visited in 1976, as a lecturer, on a *Lindblad Explorer* cruise. The island was a carpet of flowers. As a naturalist, Peter made lists wherever he went of animals, birds, flowers and fishes.

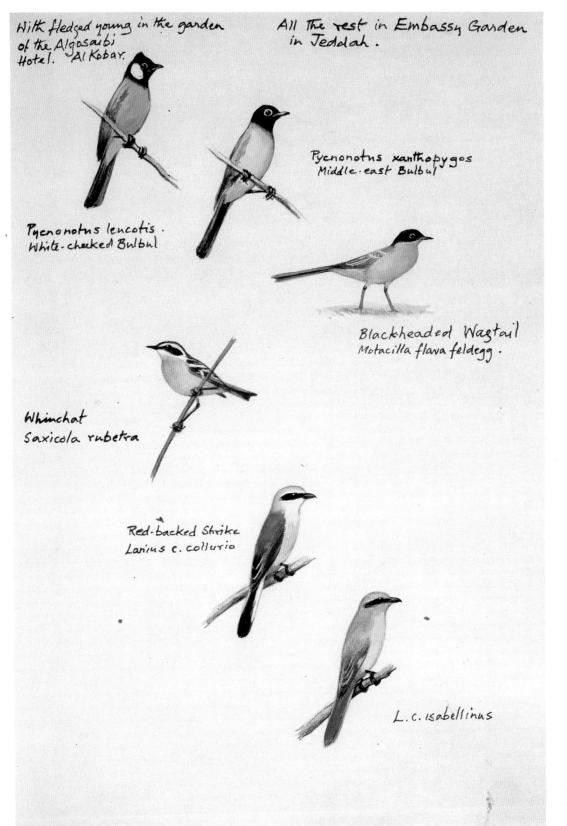

With fledged young in the garden of the Algosaibi Hotel. Al Kobar.

All the rest in Embassy Garden in Jeddah.

Pycnonotus xanthopygos
Middle-east Bulbul

Pycnonotus leucotis.
White-cheeked Bulbul

Blackheaded Wagtail
Motacilla flava feldegg.

Whinchat
Saxicola rubetra

Red-backed Shrike
Lanius c. collurio

L. c. isabellinus

Garden birds.
Jeddah
(*actual size*).
Watercolour from a
diary, 1974.

Bird List for Helsinki 12.6.85

Mute Swan
Mallard
Wigeon
Red breasted Merganser
Tufted Duck
Great crested Grebe
Gt Black-backed Gull
Lesser Black-back
Herring Gull
10 Common Gull
Black-headed Gull
Arctic Tern
Hooded Crow
Wheatear
Swallow
Skylark
Meadow Pipit
Greenfinch
Chaffinch
20 Siskin
Blackbird
House Sparrow
Fieldfare
Swift
House Martin
White Wagtail
Grey headed Wagtail
Reed Warbler
Willow Warbler
30 Shoveler
Pochard
Starling
Great Tit
Wood Pigeon
Garden Warbler
Redwing
Pied Flycatcher
Scarlet Grosbeak
Robin
40 Whinchat
Buzzard
Snipe
43 Pheasant.

Bird list for
Helsinki
(*actual size*). List and
watercolour from a
diary, 1985.

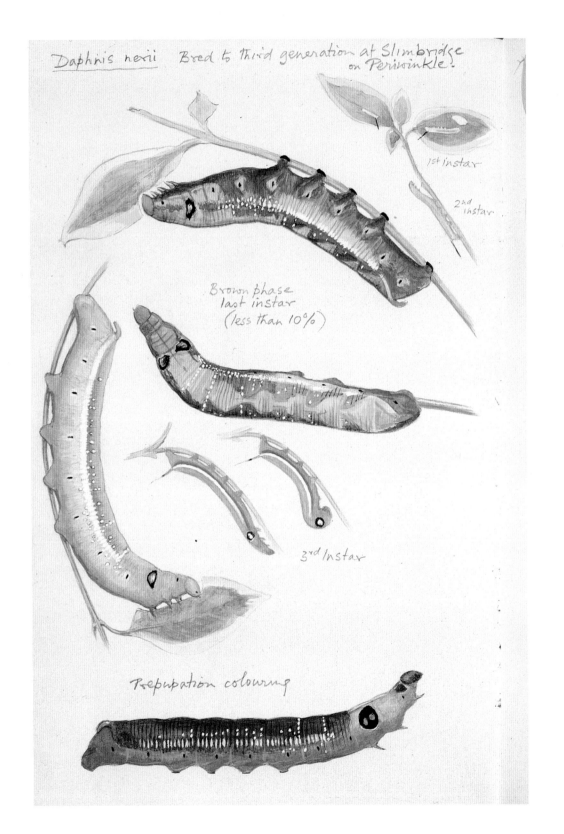

Daphnis nerii Bred to third generation at Slimbridge
on Periwinkle.

1st instar

2nd instar

Brown phase
last instar
(less than 10%)

3rd Instar

Prepupation colouring

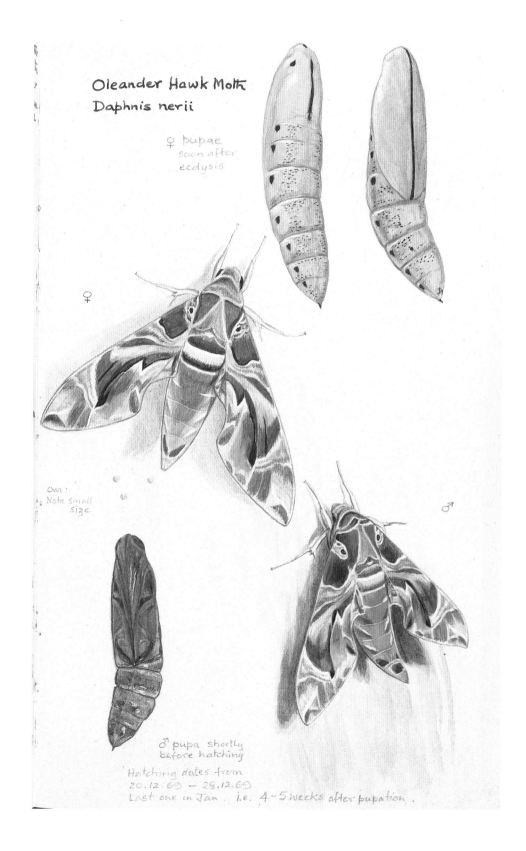

Left: Oleander hawk moth larvae
Right: Oleander hawk moth pupae and imagos
(*actual size*). Watercolour. Two pages from a diary, 1969.

Since his schooldays, hawk moths had been of great interest to Peter and particularly the oleander hawk moth which is rare in Britain. It was on a trip to Qatar that Peter had the excitement of finding twelve caterpillars which pupated, were brought home to England and bred in captivity here to the third generation. These diary drawings were made during a short spell in hospital where Peter had a cage with several larvae feeding on periwinkle on the table in front of him.

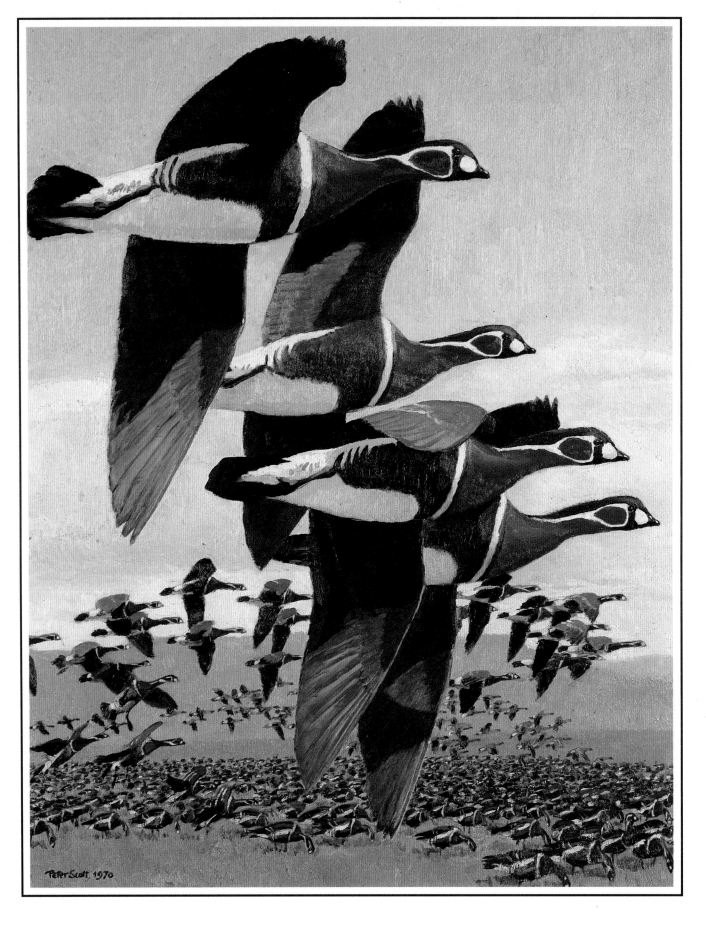

Red-breasted
geese in the big
field below the
quarry at Sinoie
Oil painting, 1970.
18″ × 14″ (45.4 ×
38.1 cm).

'For me, *Branta
ruficollis* is a very
special bird,
comparable with
Anser brachyrhynchus
(pink-footed
goose), *Cygnus
bewickii* (Bewick's
swan) and *Branta
leucopsis* (barnacle
goose), but the
least familiar and
therefore at the
moment the most
stirring.'

P.S.'s Diary.
November 1971.

THE SEVERN WILDFOWL TRUST

PATRON - HER MAJESTY THE QUEEN

President - Field-Marshal the Rt. Hon.
Viscount Alanbrooke, KG - GCB - GCVO - OM - DSO

Hon. Treasurers - J. H. Bevan Esq. CB - MC

Sir Archibald Jamieson, KBE

Hon. Director - Peter Scott Esq. CBE - DSC

SLIMBRIDGE

GLOUCESTERSHIRE

Cambridge (Glos) 268

Station - Coaley Junction

Hon. Secretary - Michael Bratby Esq.

Secretaries - Miss P. Talbot-Ponsonby
E. A. Scholes Esq.

Assistant Secretary - Miss B. Newton

Curator - S. T. Johnstone Esq.

THE WATERFOWL REGISTRY.

(UNDER THE AUSPICES OF THE AVICULTURAL SOCIETY)

THE WILDFOWL TRUST

SLIMBRIDGE GLOUCESTERSHIRE

Designs for three letter headings

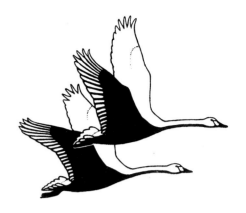

Logo for The Wildfowl
& Wetlands Trust,
formerly named The
Wildfowl Trust.

Logo for World
Wildlife Fund.
This has now been replaced
by a more stylised panda.

It was Peter's custom to doodle through meetings while still paying attention to the discussion.

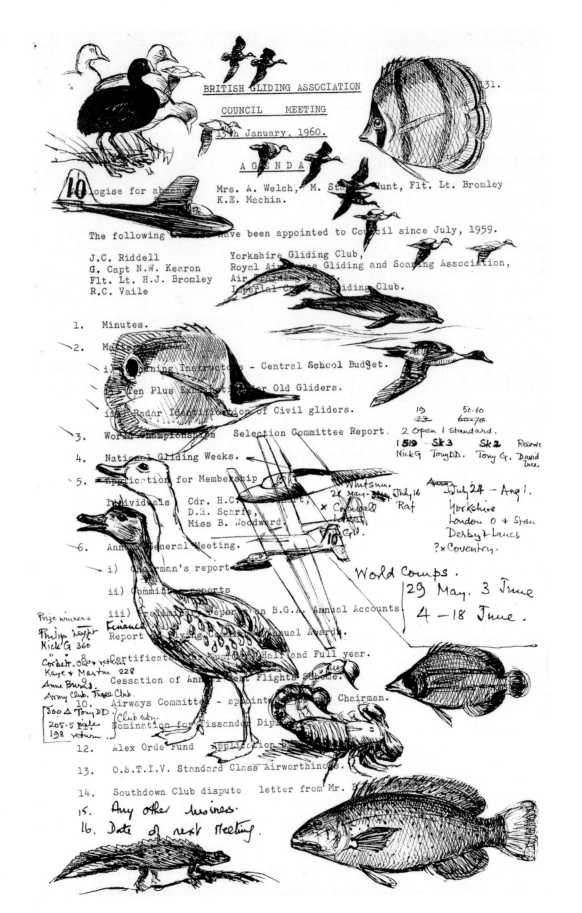

BRITISH GLIDING ASSOCIATION

COUNCIL MEETING

15th January, 1960.

A G E N D A

Mrs. A. Welch, M. Sta... Hunt, Flt. Lt. Bromley
K.E. Machin.

The following ... have been appointed to Council since July, 1959.

J.C. Riddell Yorkshire Gliding Club,
G. Capt N.W. Kearon Royal Air Force Gliding and Soaring Association,
Flt. Lt. H.J. Bromley Air,
R.C. Vaile Imperial Co... ...iding Club.

1. Minutes.

2. Ma...

 i) ...ning Instructors - Central School Budget.

 ... Ten Plus Exe... ...r Old Gliders.

 i... Radar Ide... ...ion of Civil gliders.

3. World Championships Selection Committee Report. 2 Open 1 Standard.

4. National Gliding Weeks.

5. ...lication for Membership

 Individuals Cdr. H.C. ...t;
 D.H. Scarfe,
 Miss B. Woodward.

6. Annual General Meeting.

 i) Chairman's report

 ii) Committee ...ports

 iii) Treasurer's Report on B.G.A. Annual Accounts

 Finance... ...ing ... Annual Awards.

 ...Certificate... ...ug ... Half and Full year.

 Cessation of Ann... ...est Flights Scheme.

10. Airways Committee - appoint... ... Chairman.

 Nomination for Tissandier Dip...

12. Alex Orde Fund Application...

13. O.S.T.I.V. Standard Class Airworthiness.

14. Southdown Club dispute letter from Mr. ...

15. Any other business.

16. Date of next Meeting.

Handwritten doodles/notes:
19 50-60
23 60-70

1519 - Sk3 Sk2 Reserve
NickG TonyDD. Tony G. David Ince.

Whitsun. 28 May-... July 16 July 24 - Aug 1.
Cornwall Raf Yorkshire
Ticket London O + Stan
GU. Derby + Lancs
 ? x Coventry.

World Comps.
29 May. 3 June
4 - 18 June.

Prize winners
Philip Leyth
Nick G 360
Corbett. Ok + ret...
Kaye + Martin 228
Anne Burns.
Army Club. Three Club.
300 △ Tony DD
205.5 ... (Club ent...
198 return

Doodles – on a British Gliding Association Council Agenda, 1960

The baby on this agenda is our son, Falcon, who was born a week before the meeting.

THE R.Y.A. COUNCIL WILL MEET AT 10.45 a.m. on WEDNESDAY, 9th JUNE, 1954
at the ROYAL THAMES YACHT CLUB, KNIGHTSBRIDGE, S.W.1. (by courtesy of
the flag officers and committee)
===

A G E N D A

1. Minutes of meeting 28th April, 1954 (circulated 7.5.54)

2. Correspondence –
 (a) R.Y.A. to S.Y.U. – 26.5.54
 (b) S.Y.U. to R.Y.A. – 25.5.54
 (both circulated 20.5.54 – R.Y.A. council minute 3, 28th April, 1954 refers)

3. Correspondence – Sunday Times letter of May 23rd (circulated 4.6.54)

4. Olympic committee –
 (1) Mr. W.J. Borthwick, D.S.C., will submit minutes of meeting
 28th April, 1954, (circulated 20.5.54)
 (2) Correspondence –
 (a) E.E.S.M. to R.Y.A. – 25.5.54
 (b) R.Y.A. to E.E.S.M. – 26.5.54
 (both circulated 4.6.54)

5. Dinghy committee – Mr. Stewart H. Morris, O.B.E., will submit minutes of
 meeting 29th April, 1954, (circulated 10.5.54)

6. Private and Confidential paper (circulated 20.5.54) – R.Y.A. council
 minute 9 of the 30th March, 1954, para 2, refers – Mr. N. Warington Smyth, O.B.E.

7. General purposes committee – Mr. N. Warington Smyth, O.B.E., will submit the
 minutes of meeting 17th May, 1954 (circulated 1.6.54)

8. Summary of R.Y.A. committee work in section 2 of the R.Y.A. year book –
 Mr. N. Warington Smyth, O.B.E.

9. The European One-man Championship at Berlin-Wannsee, 30th August, 1954 –
 Mr. W.J. Borthwick, D.S.C.

10. The European Two-man Championship at Rimini June 20th – Mr. Stewart H. Morris,
 O.B.E. (R.Y.A. council minute 7(2) of the 28th April, 1954, refers.)

11. Report on Blithfield Reservoir – Mr. John Winter (circulated 4.6.54.)

12. Correspondence –
 (a) K.A.C. to R.Y.A. – 23.4.54.
 (b) R.Y.A. to K.A.C. – 28.4.54
 (c) K.A.C. to R.Y.A. – 30.4.54.
 (circulated 20.5.54)
 and to confirm that no sail aft of the mast or main may be deemed
 a headsail.

13. Finance and cash book balance

14. (a) Recognition of clubs
 (b) Election of candidates

15. Any other business – next meeting 6th August, 1954, at the Royal London
 Yacht Club, Cowes, (by courtesy of the flag officers and committee).

Circulation:- R.Y.A. council
 4th June, 1954.

Doodles – on a Royal Yachting Association Council Agenda, 1954

Proj.Nº 286 Meru.LightA/c.

E.Africa.
Coordination of Fund·Raising.
Designated·Funds.

WORLD WILDLIFE FUND

To: The Conservation Committee

10th Meeting of the Conservation Committee

to be held at the Tenuta Olgiata (known as l'Olgiata), Via Cassia 1951,
La Storta, 00123 Rome, Italy

on Thursday, 19 June 1969, 15.00 - 19.00

The Madagascar Day Gecko
Phelsuma
madagascariensis

Proposed agenda

I. Administration and Way of information

1. Approval already circulated
 (19 December

2. Date and place verbally

3. Relationship with verbally

II. WWF Projects

4. Consideration of current projects verbally

5. Elaboration of new criteria for initiation tabled
 and consideration of WWF projects

III. Further conservation matters

6. Destruction of birds of prey in Austria verbally

AbuSimbel 7. Conservation in Indonesia verbally

World 8. Conservation in the Galapagos Islands verbally
Heritage
Trust! 9. Conservation of crocodilians verbally

10. Conservation of underwater world Cousteau. verbally

 11. Falkland Is. Grand & SteepleJason Islands.
IV. Other business 12. Aldabra.
 13. Tigers

11. Second International WWF Congress 1970 verbally

12. World Heritage Trust Galapagos. verbally

13. World Conservation Yearbook verbally

14. Any other business verbally

Canadian Cons. Conference

This draft agenda was ready to be typed, together with the agenda for the other
WWF Meetings in Rome, on 21 May 1969, but was then mislaid and not sent out.
Hence its late dispatch, for which I apologise.

Doodles – on a
World Wildlife
Fund Committee
Agenda, 1969

WORLD WILDLIFE FUND

Morges, 21 May 1974
V/mb - V/70

Conservation Projects Grant-aided in 1973

International Projects

In 1973 the WWF supported 134 conservation projects of international importance around the world with grants amounting to $ 1,984,355, as compared with $ 1,234,288 paid the previous year. This figure - by far the highest yearly total ever reached - brings the total of the grants allocated to international projects since 1961 to $ 10,255,787.

National Projects

In 1973 the WWF National Appeals allocated a total of $ 554,164 to 148 conservation projects of national importance within their countries as against $ 540,119 the year before. Thus, the grants to national projects since 1961 increased to $ 2,814,453.

Summary

Adding up grants to international and national conservation projects, the total grants allocated in 1973 amounted to $ 2,538,519 as compared with $ 1,774,407 the previous year. With this addition, the overall total of grants allocated since 1961 reached the sum of $ 13,070,240 as per 31 December 1973.

Year	International Projects	National Projects	Total
1972	$ 1,234,288	$ 540,119	$ 1,774,407
1973	$ 1,984,355	$ 554,164	$ 2,538,519
1961-1973	$ 10,255,787	$ 2,814,453	$ 13,070,240

Doodles – on a
World Wildlife
Fund Report,
1974

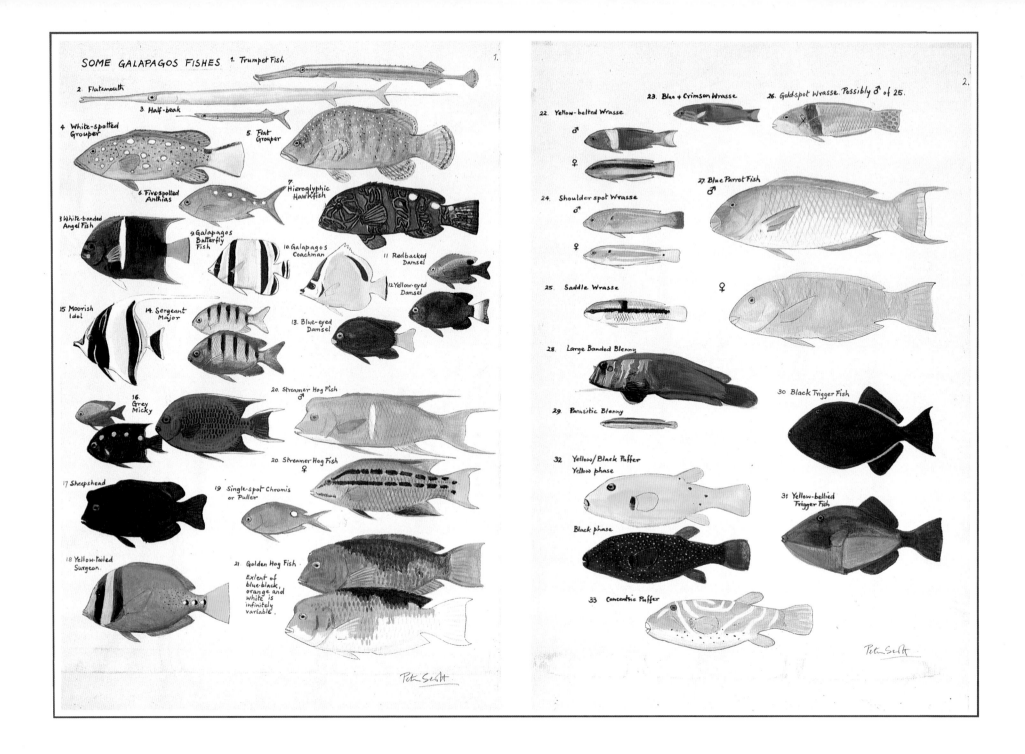

Key to Galapagos fishes
Watercolour, 1976. Two sheets, each 12½″ × 8½″ (31.8 × 21.7 cm).

To encourage the passengers in the *Lindblad Explorer* to observe and identify the fishes, Peter made this key, coloured it and had photocopies made so that enthusiasts could colour their own with crayons provided at the reception desk. *Lindblad Explorer* cruises were expeditions and Peter was a lecturer on board twenty-six times.

Courtship of Anthias squamipinnis
Itsandra 4 July. 60 ft.

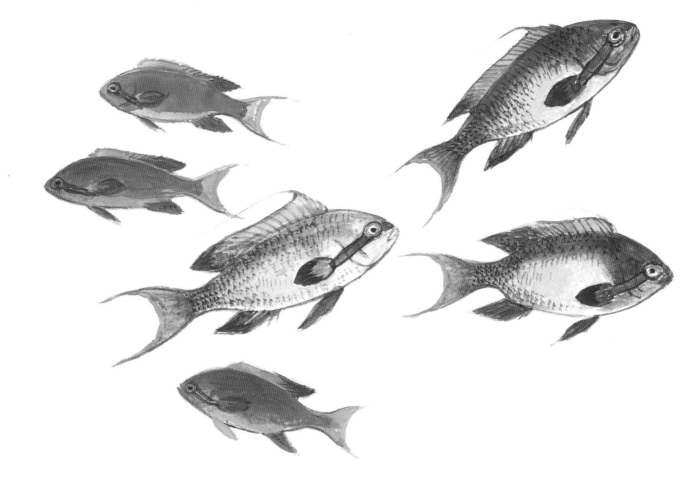

A ~~super~~.male making aggressive darts at other super.males
would take on a blue head for a period of 2 – 4 seconds
after which it would return to the orange shoal coloured
its normal purple. This was observed over a period of 5-10
minutes.

Courtship of *Anthias squamipinnis*
Seen off Itsandra, Seychelles, at a depth of sixty feet.
(*actual size*). Watercolour from a diary, 1971.

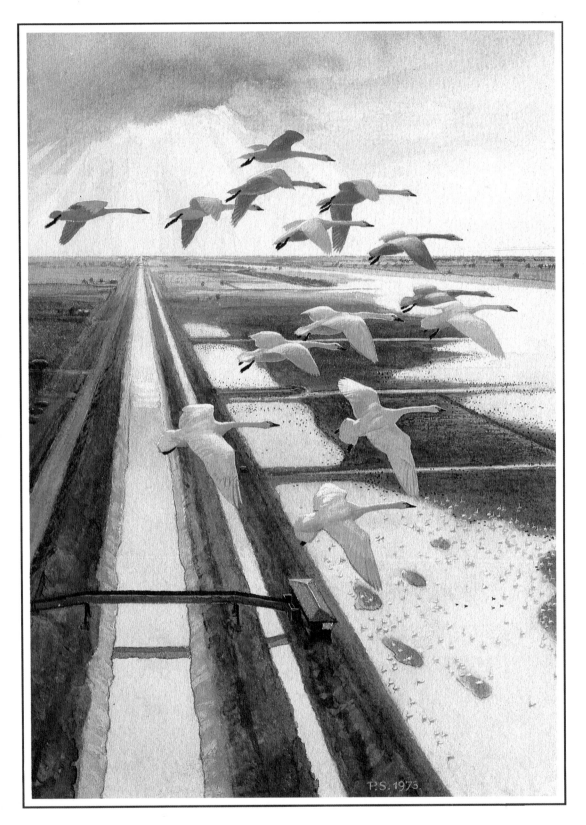

Bewick's swans over Welney
(*actual size*). Gouache, 1973.

This painting illustrates The Wildfowl & Wetlands Trust Centre on the Ouse Washes. Since then the observation hide has been extended.

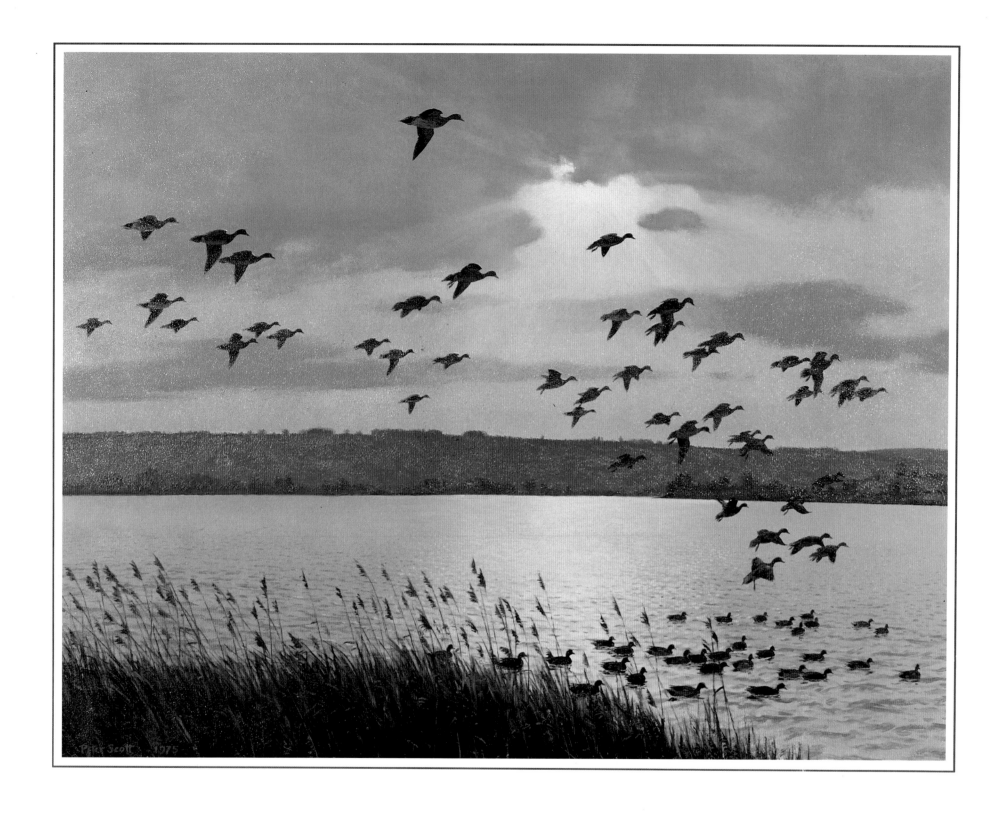

Wigeon in the afternoon. Chew Valley Lake

Oil painting, 1975. 28″ × 36″ (71.1 × 91.4 cm).

Salmon at risk in Loch Ness
Oil on artist's board, 1975. 15″ × 18″ (38.1 × 45.4 cm).

Peter's interest in the possibility of there being a Loch Ness Monster reached its highest point when the American, Doctor Robert Rines, produced some interesting underwater photographs of what appeared to be a diamond-shaped fin. To provide legal protection for any undescribed animal in the Loch a scientific name had to be published, and this was done in the journal *Nature* in December 1975. The name *Nessiteras rhombopteryx*, which they gave it, means 'the Ness monster with diamond-shaped fin'. Peter enjoyed speculating as to what it might look like, and so he painted various pictures of this mythical animal. He maintained an open mind about the existence of a monster in the Loch but became more doubtful as time went on.

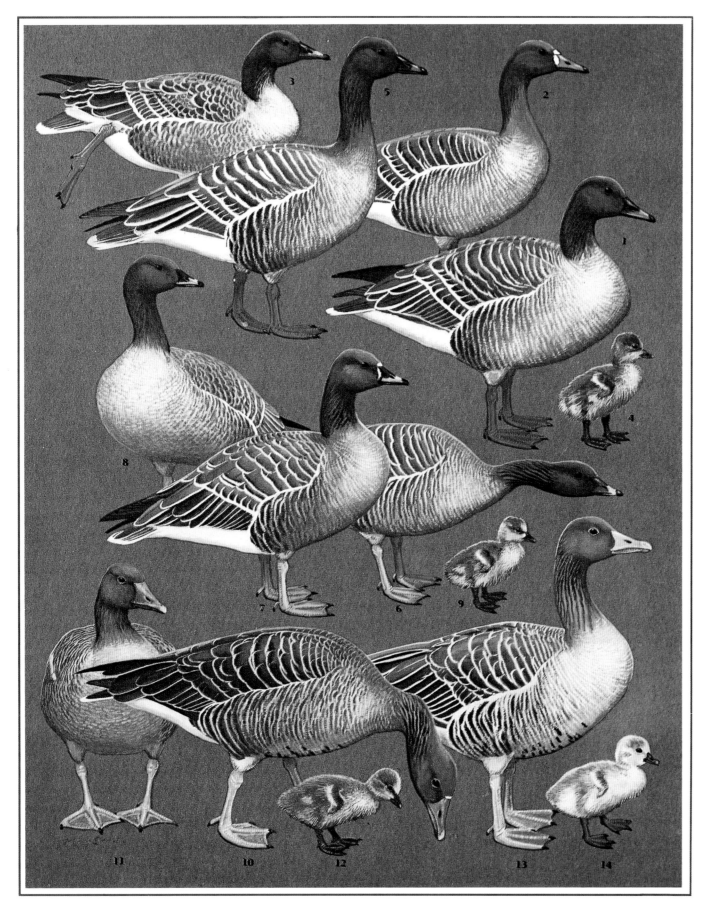

Grey geese of the Western Palearctic

Plate 52 from *Handbook of the Birds of Europe, the Middle East and North Africa. The Birds of the Western Palearctic Vol 1.* Gouache on tinted paper, 1976. 12″ × 8″ (30.5 × 20.3 cm).

The composition of illustrative plates was as important to Peter as the detail of the plumage of the birds – bean geese, pinkfeet and greylags.

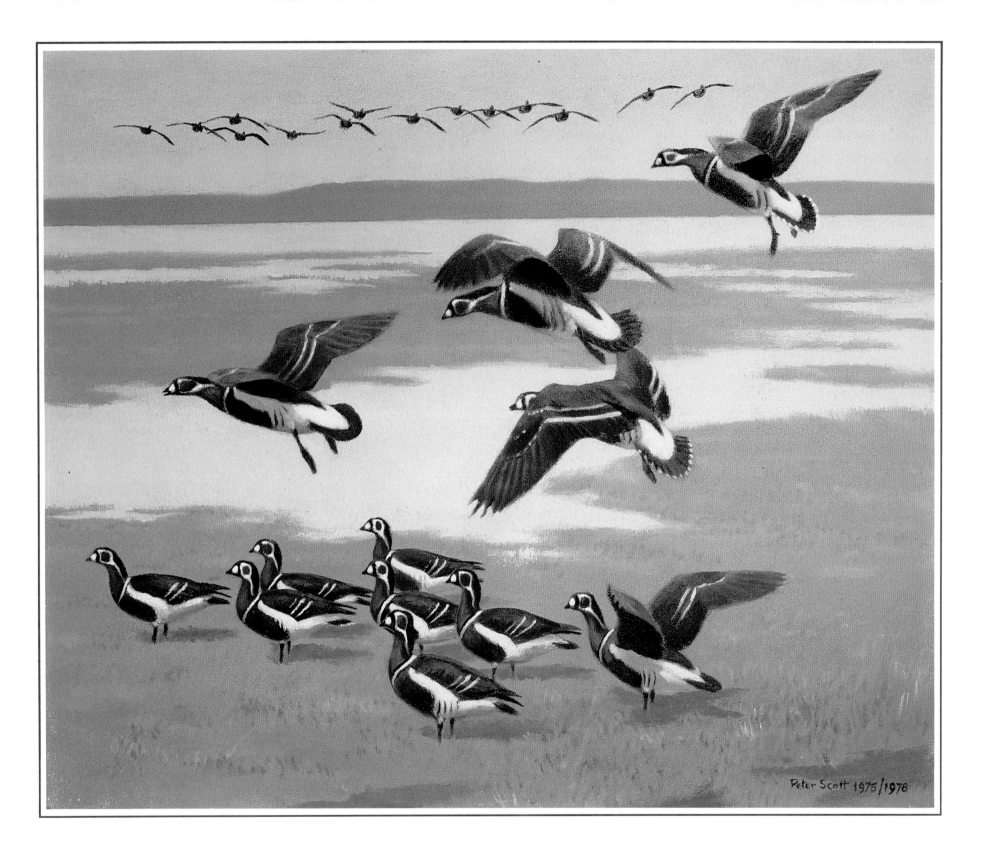

First landing – red-breasted geese
Oil on board, 1975/1978. 15″ × 18″ (38.1 × 45.4 cm).

Inspired by a visit to Romania, Peter started this painting in 1975 and decided in 1978
to add some more water to the scene.

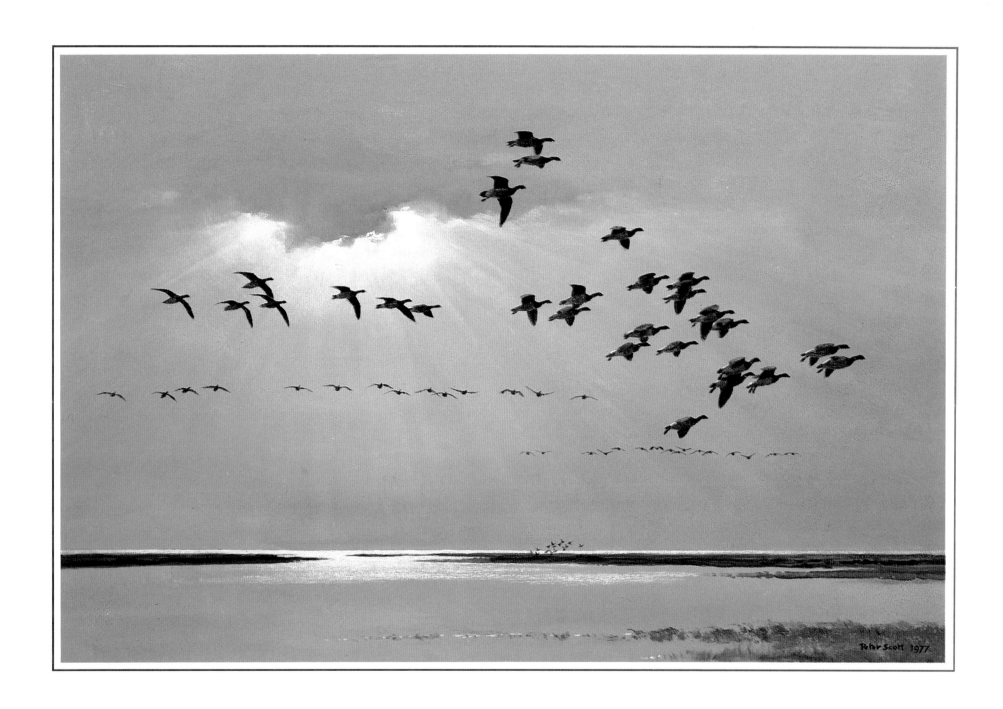

Brant in moonlight
Oil painting, 1977. 20″ × 30″ (50.8 × 76.2 cm).

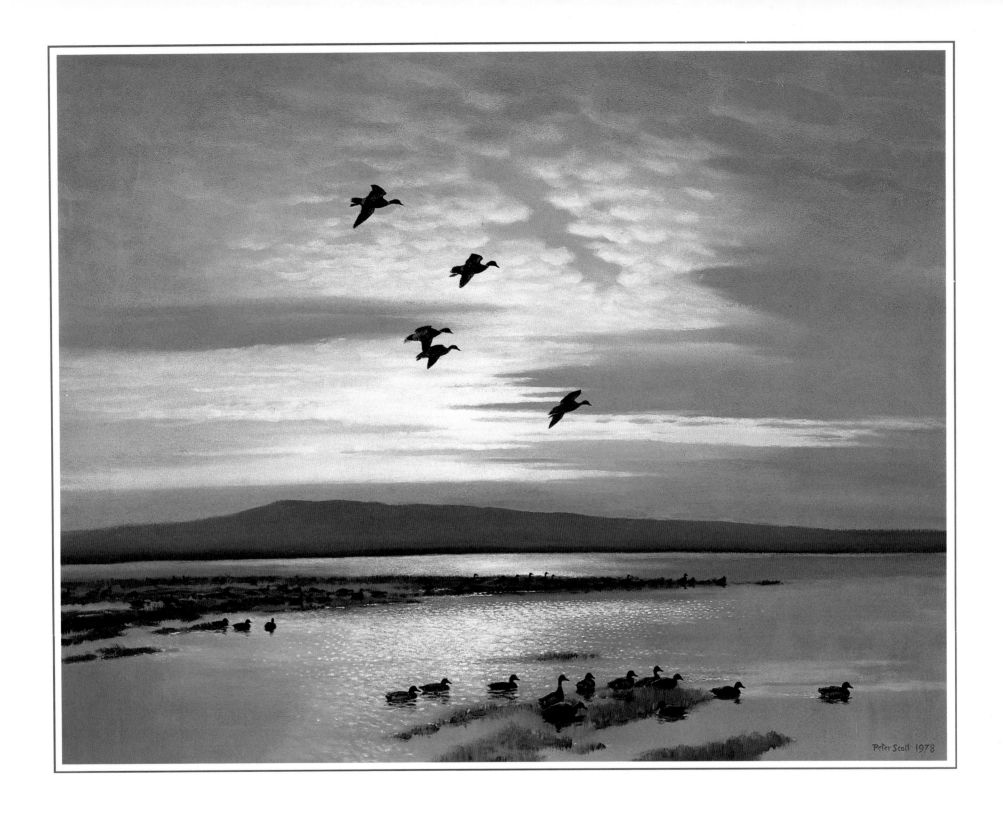

Mallards at dawn
Oil on canvas, 1978. 28″ × 36″ (71.1 × 91.4 cm).

Right: Giant panda
Oil on canvas, 1979. 12″ × 10″ (30.5 × 25.4 cm).

This was painted for WWF.

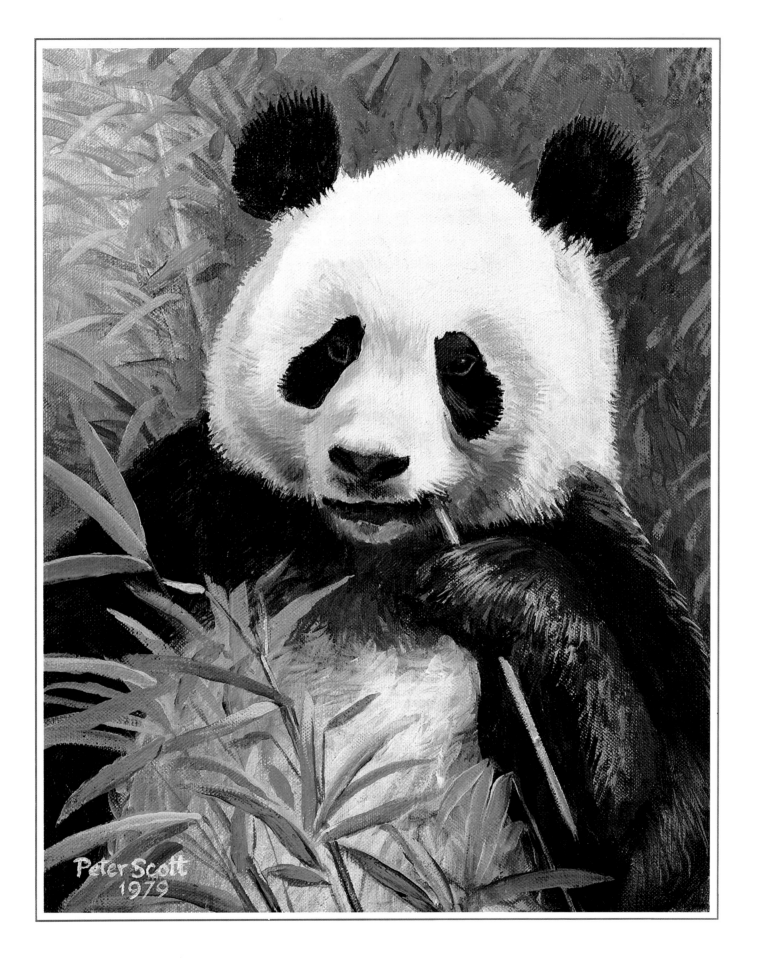

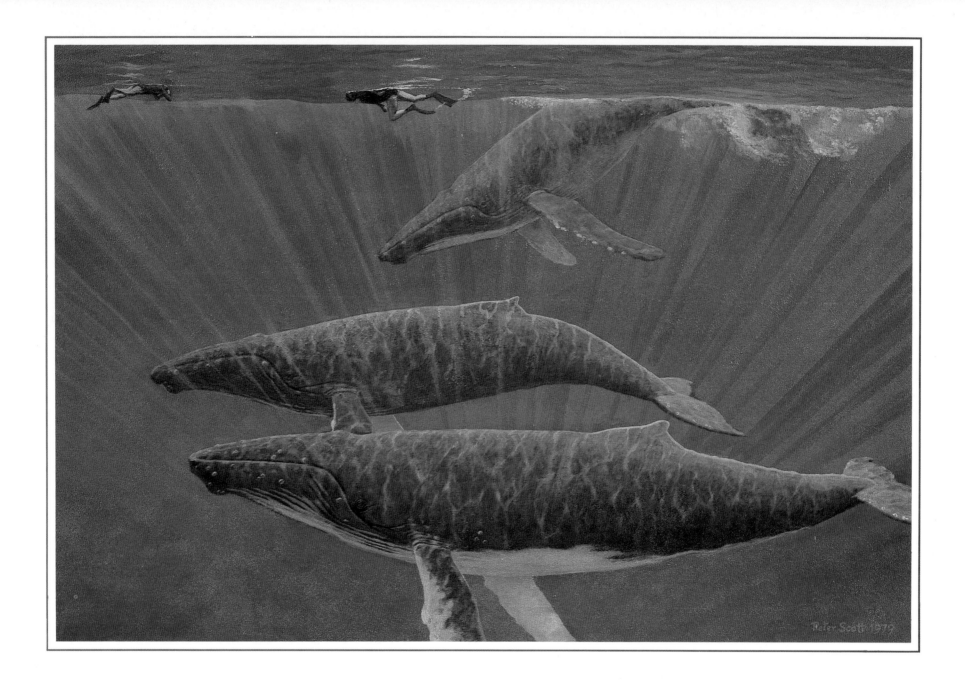

Self-portrait and wife with humpbacks
Oil on canvas, 1979. 24″ × 36″ (61 × 91.4 cm).

'No conservationist can fail to be aware of the danger of extinction which threatens some of the great whales. I have been interested in cetaceans since childhood and had a hand in promoting one of the more important resolutions of the 1972 United Nations Conference on the Human Environment in Stockholm which called for a ten-year moratorium on commercial whaling.

'It was not, however, until 1979 that I swam with great whales off the Hawaiian island of Maui. My first close underwater encounter with humpback whales was probably the most exciting natural history experience of my life; sharing it with my wife, who was swimming next to me, made it all the more delightful. About nine whales swam up to and around us, passing at times within ten feet and giving the impression that they were utterly friendly.'

From an illustrated talk about whales.

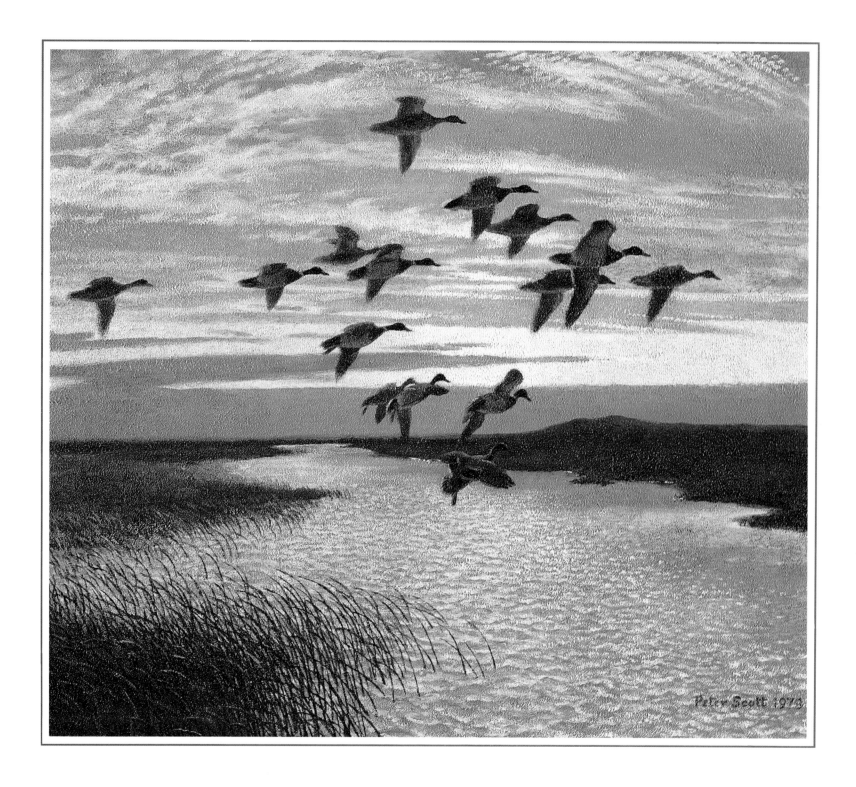

Mallards coming in from the south
Oil on canvas, 1979. 28″ × 36″ (71.1 × 91.4 cm).

'The stippled effect was produced by rolling a pair of discarded nylon tights into a ball and dabbing it onto paint initially added to the canvas with a palette knife.'
Observations of Wildlife

This painting recalls to mind a remark by Konrad Lorenz: 'I don't know a man who can paint wind like Peter does.'

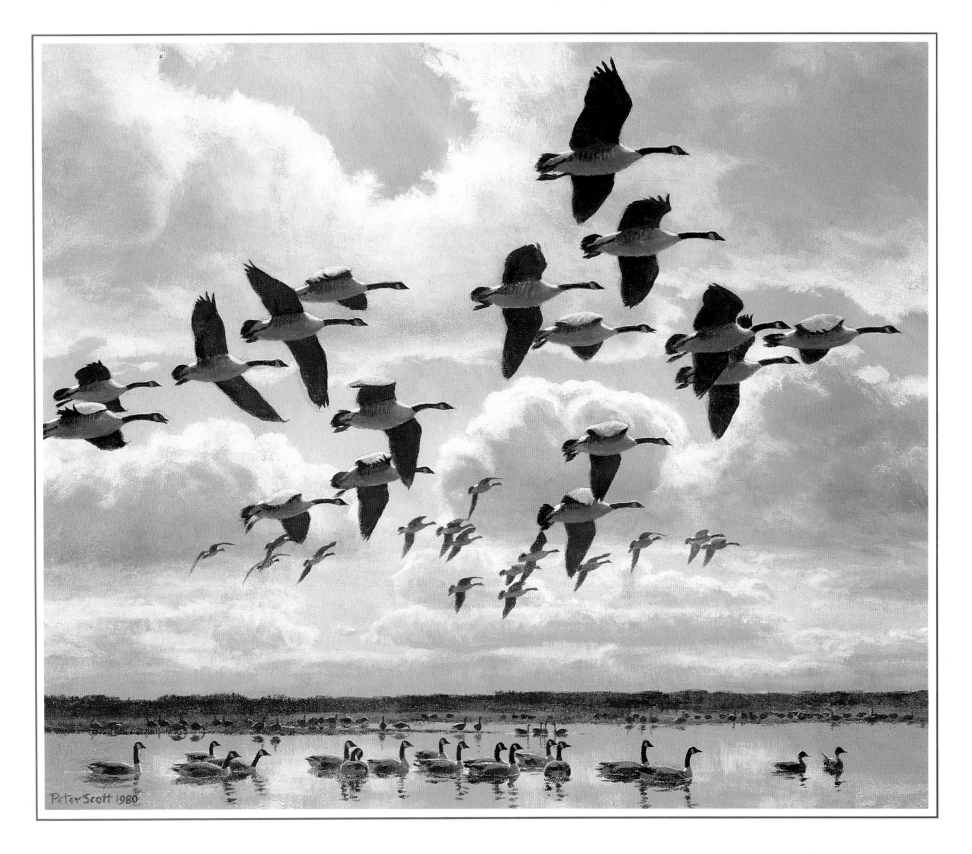

Honkers against a cumulus sky
Oil on board, 1980. 20″ × 24″ (50.8 × 61 cm).

This picture and the one on the page after next were painted specially for the
North American market.

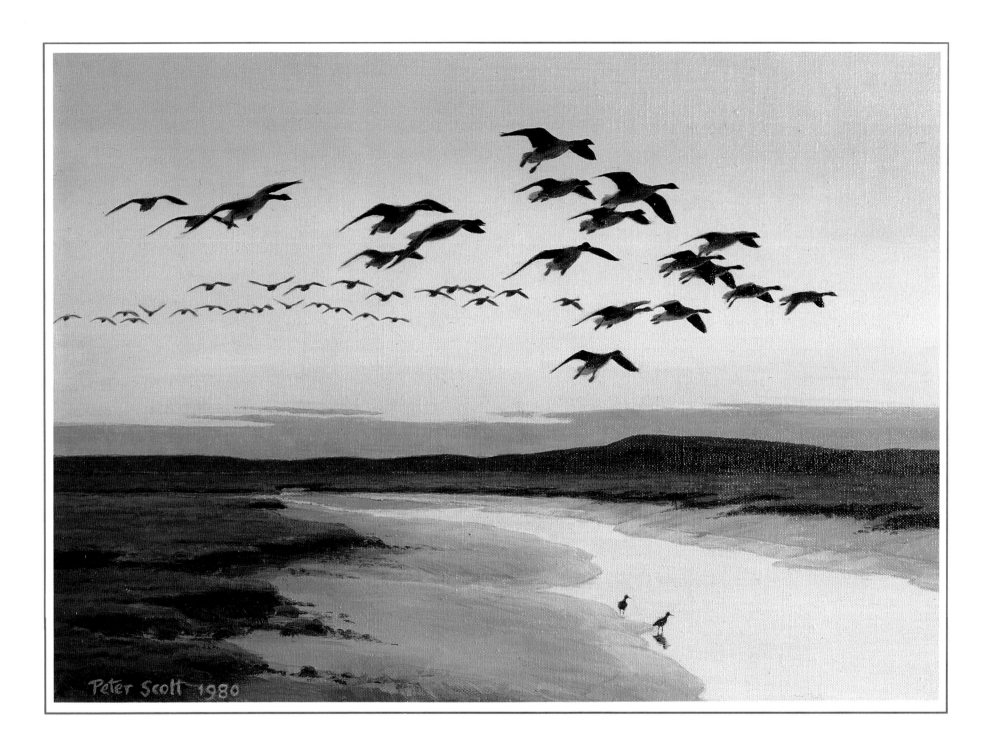

In the morning the pinkfeet flew down the creek to drink and
wash
Oil painting, 1980. 10″ × 14″ (25.4 × 35.6 cm).

'. . . the first of my objectives is to give pleasure to people – as many people as
possible, some possibly not yet born. I like to draw things that have excited me to
reflect my own enthusiasm for nature in general and especially for birds . . .'
Observations of Wildlife.

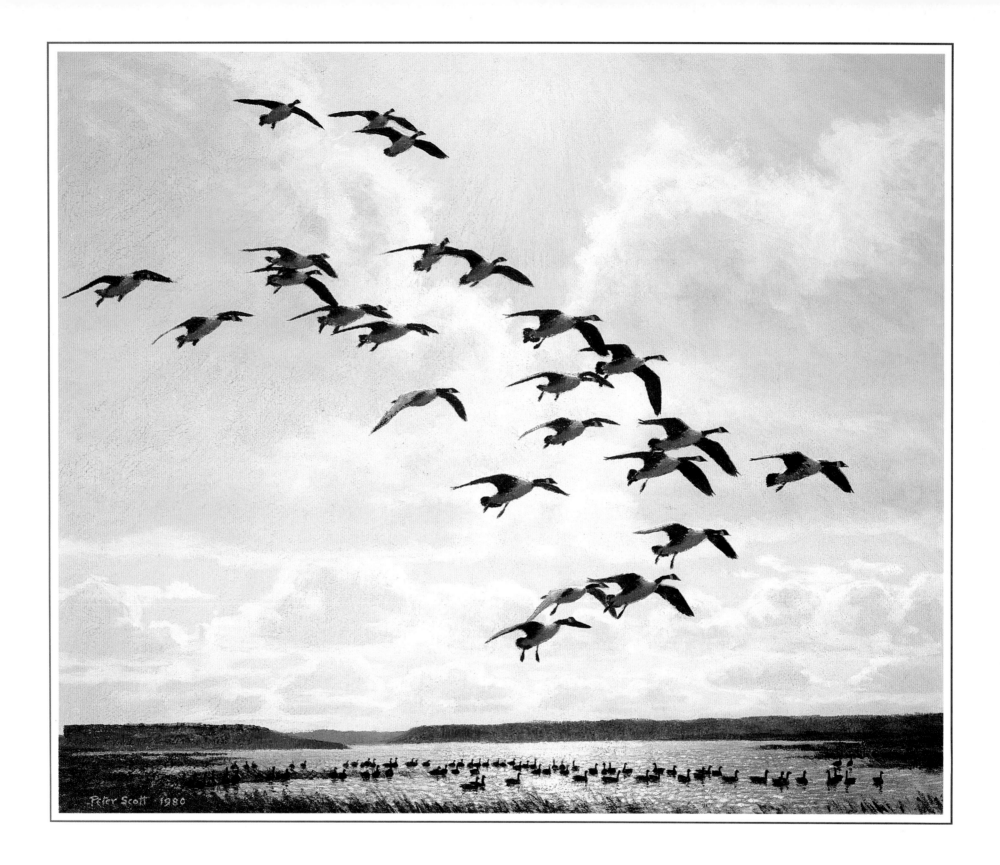

Canada geese coming to the marsh
Oil on board, 1980. 22″ × 26″ (55.9 × 66 cm).

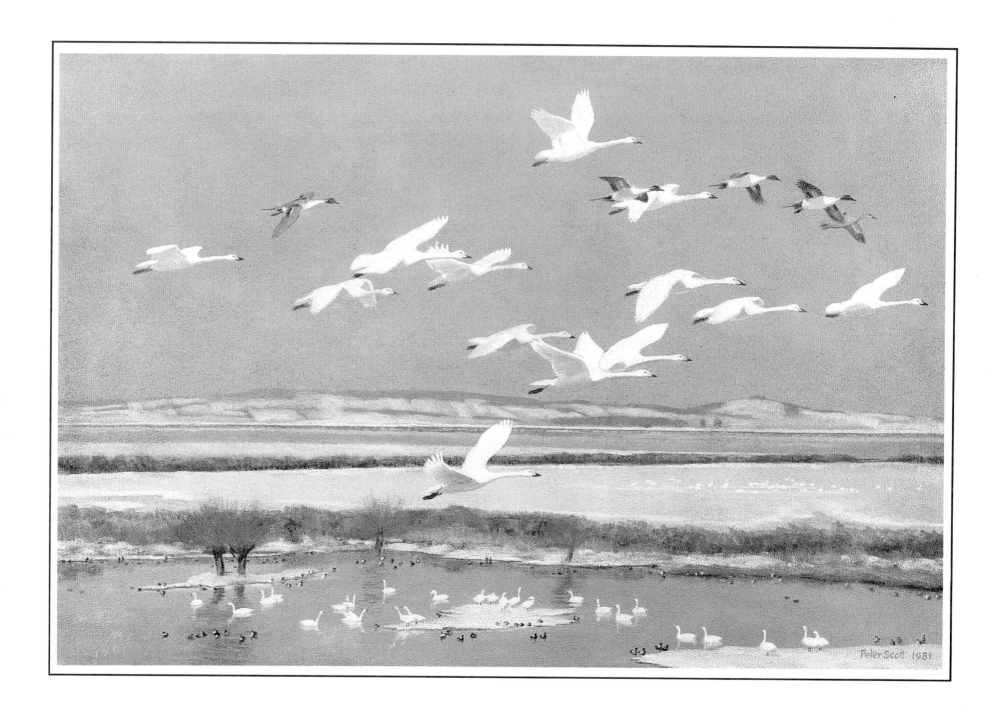

**Wild Bewick's swans and pintails at Slimbridge on the Severn
Estuary after a snowstorm**
Oil on canvas, 1981. 20″ × 30″ (50.8 × 76.2 cm).

The Wildfowl & Wetlands Trust has been making a study of Bewick's swans
since 1963, the first winter they came to 'Swan Lake' outside our house. They
were a continual source of inspiration to Peter and have undoubtedly enriched
our lives. The painting shows 'Swan Lake' in the foreground.

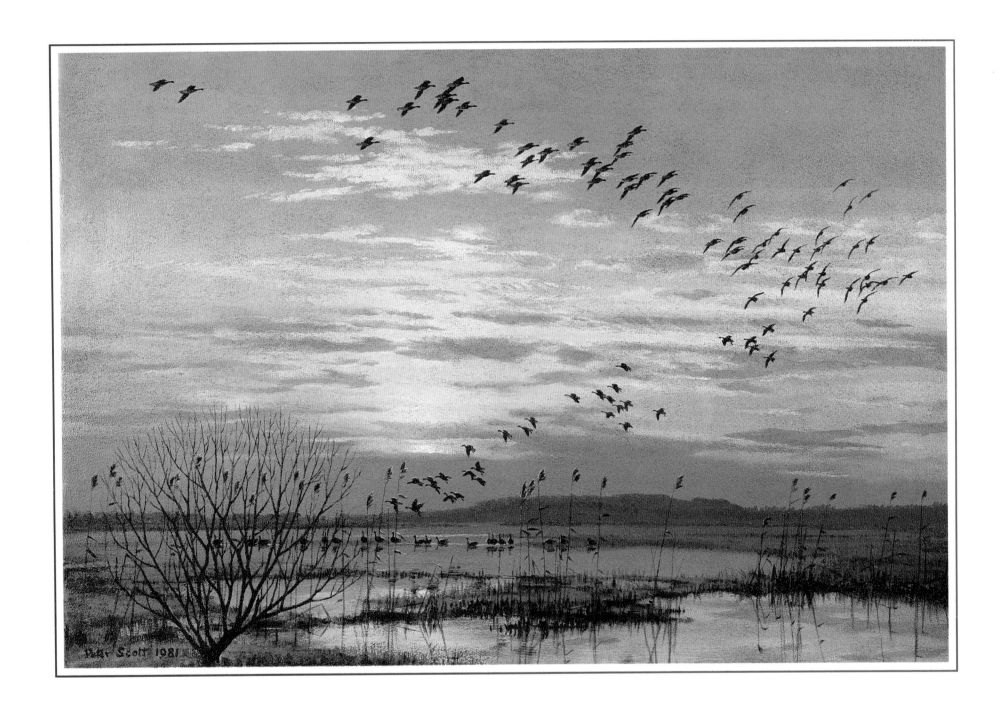

In the winter dusk more than a hundred white-fronted
geese swept down to roost in the marsh
Oil painting, 1981. 20″ × 30″ (50.8 × 76.2 cm).

This is what most people would think of as 'a typical Peter Scott'.

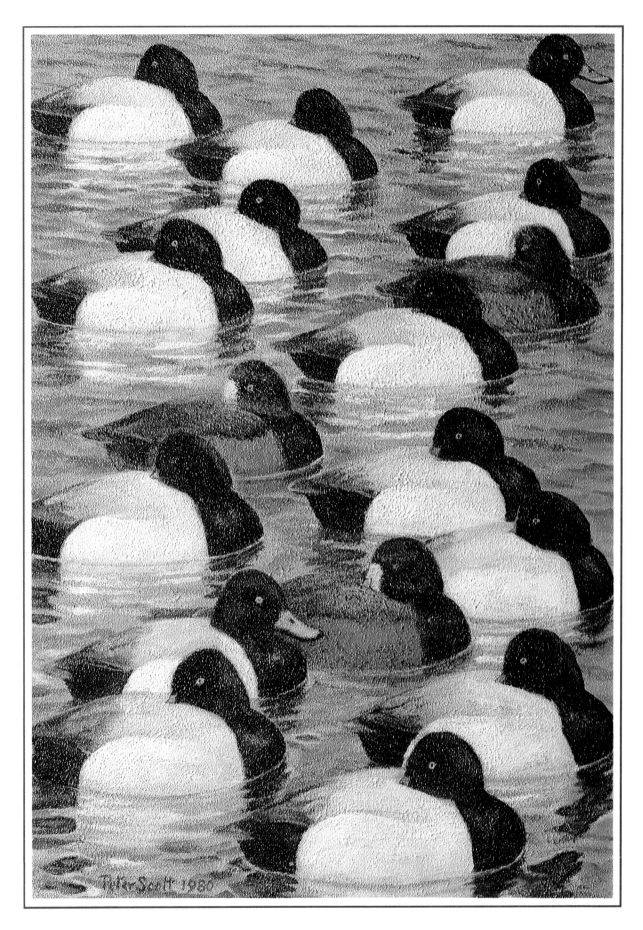

A raft of scaup
Oil painting, 1980.
14″ × 10″ (35.6 × 25.4 cm).

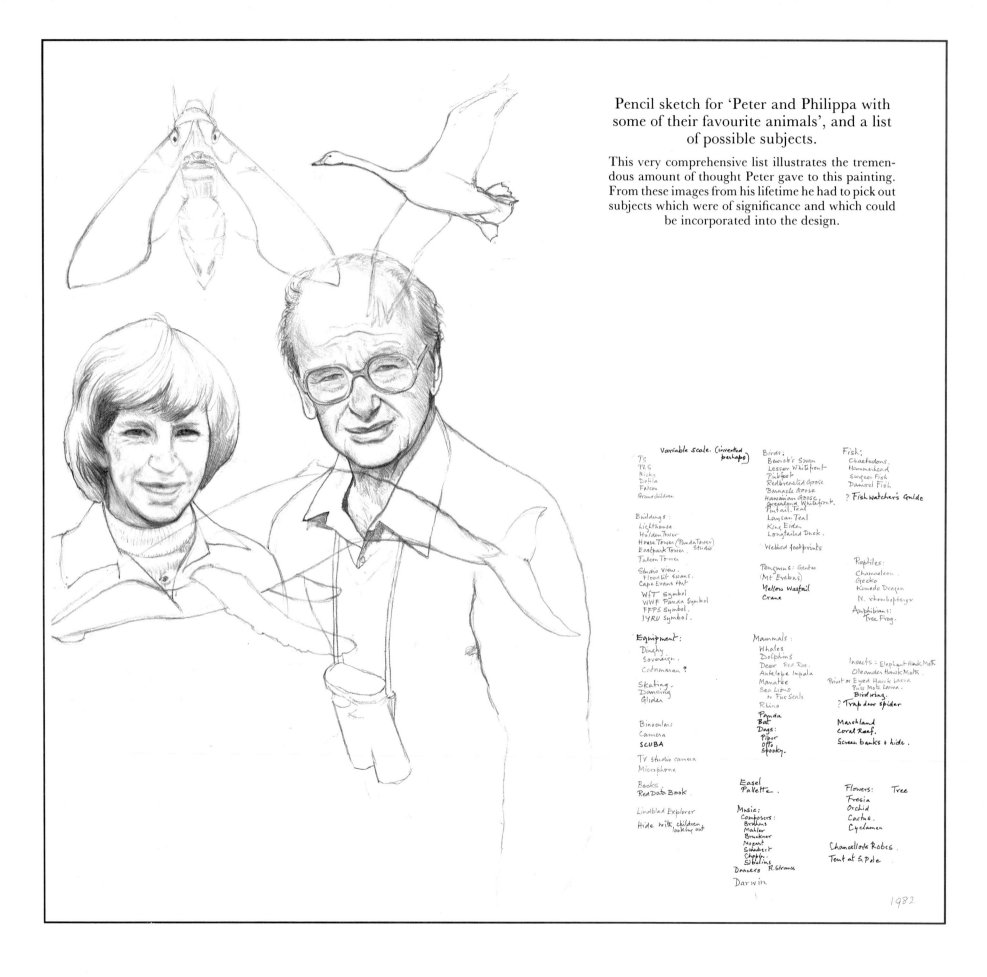

Pencil sketch for 'Peter and Philippa with some of their favourite animals', and a list of possible subjects.

This very comprehensive list illustrates the tremendous amount of thought Peter gave to this painting. From these images from his lifetime he had to pick out subjects which were of significance and which could be incorporated into the design.

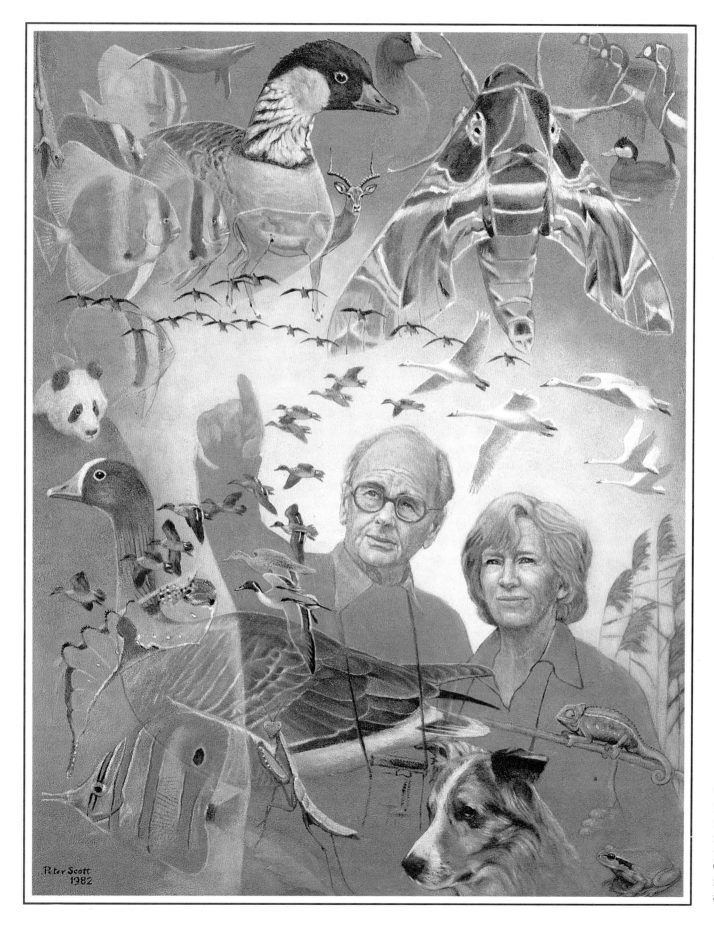

Peter and Philippa with some of their favourite animals
Oil on canvas, 1982.
36″ × 28″ (91.4 × 71.1 cm).

The scale here is inverted so that the blue whale, top left, is very small while the Oleander hawk moth and the coral fish, *Chelmon rostratus*, are large. Peter painted the picture while I was in Cambridge with our daughter when our first grandchild was born, so Peter was able to stay up half the night painting.

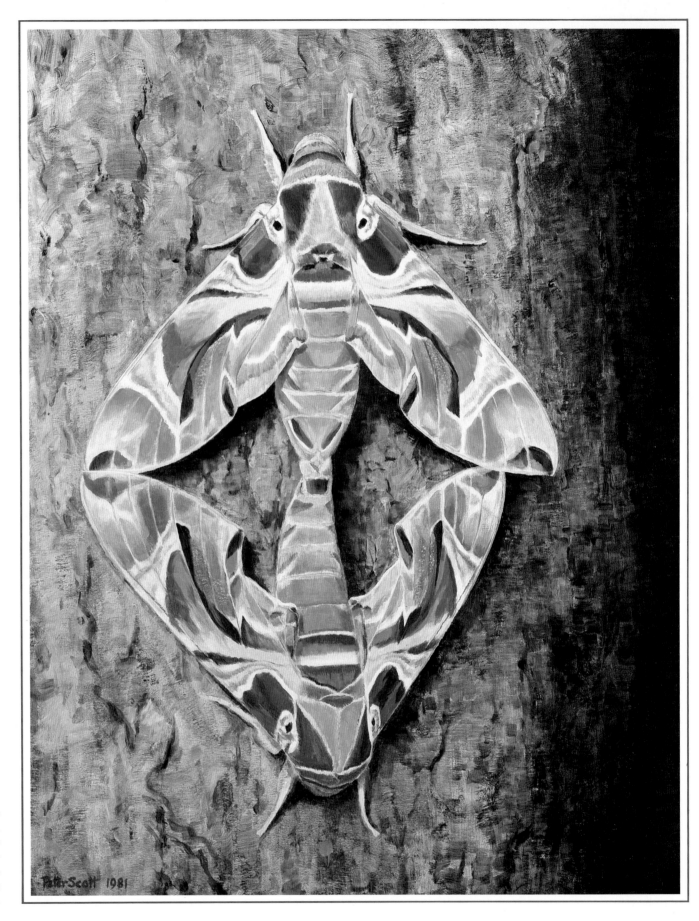

Procreation. Oleander hawk moths
Oil on canvas, 1981.
36″ × 28″ (91.4 × 71.1 cm).

This large painting, which now hangs at Nature in Art, the International Centre for Wildlife Art near Gloucester, owned and managed by the Society for Wildlife Art of the Nations (SWAN), was thought by Peter to be the best oil painting that he ever did.

Pegasus, a forty-ton humpback performing a spinning breach
Oil on canvas, 1983.
36″ × 28″ (91.4 × 71.1 cm).

In 1983 Peter attended the Whales Alive Conference in Boston, USA, where he made the Keynote Address. The Conference excursion took the delegates on a whale-watching trip at sea. The viewing was 'mind-blowing'. After some very close encounters with individually-recognisable humpbacks, they saw some whales breaching in the distance. He wrote in his diary: 'When we arrived only one whale was still at it and this turned out to be Pegasus, one of the three adult females we had seen when we first reached the Stellwagen Banks. She proceeded to breach at least eight more times – once within fifty-yards of us. Finally she began "flipper-slapping" . . .'

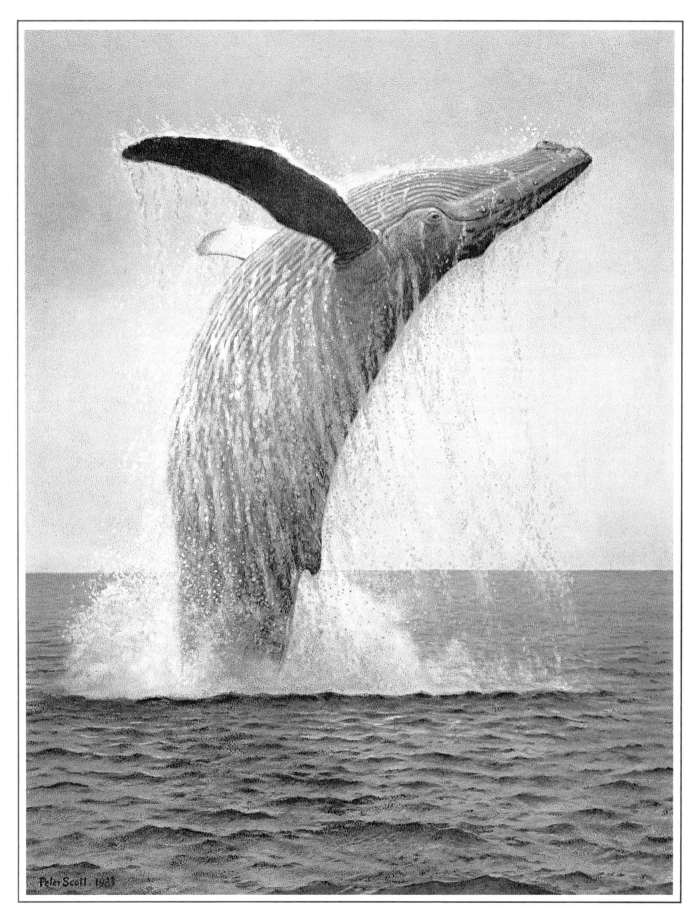

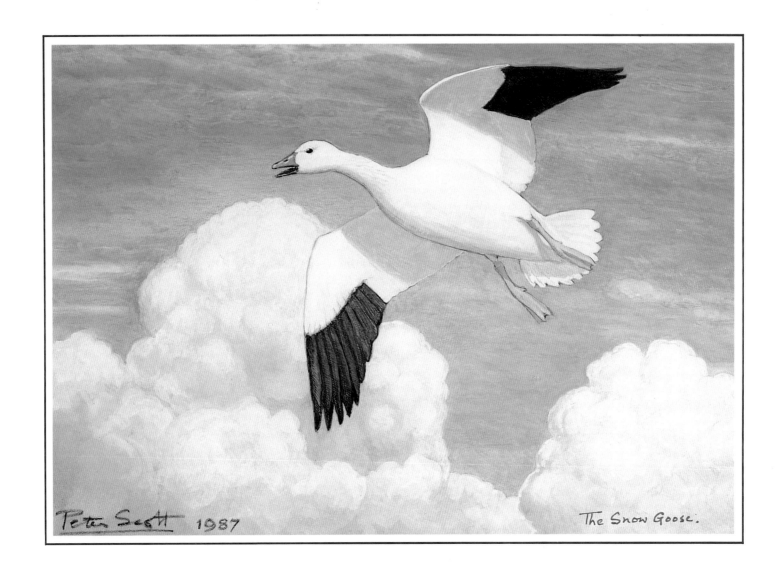

The Snow Goose

Gouache, 1987. 7½″ × 10½″ (19 × 25.7 cm).

The popularity of Paul Gallico's *The Snow Goose*, which Peter illustrated, made
people want to have a similar kind of painting to that which is in the book. Putting
a single bird on canvas is difficult from the composition point of view and Peter
never much liked commissions of this kind.

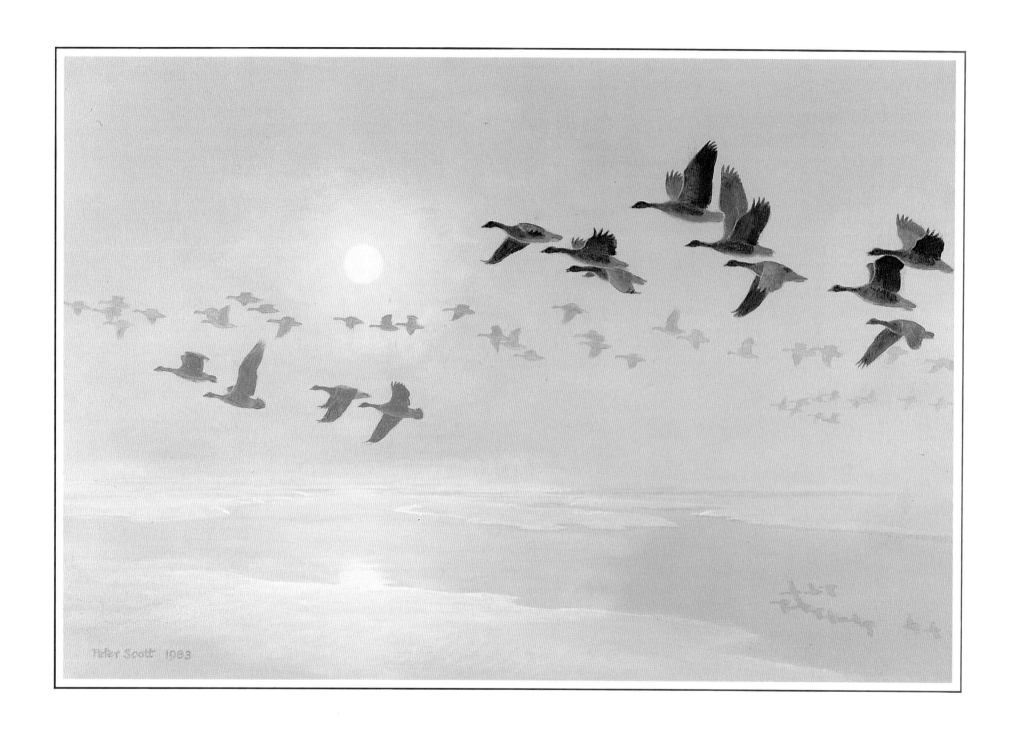

Pinkfeet coming in from the Solway across the Blackshaw Bank
Oil on canvas, 1983. 20″ × 30″ (50.8 × 76.2 cm).

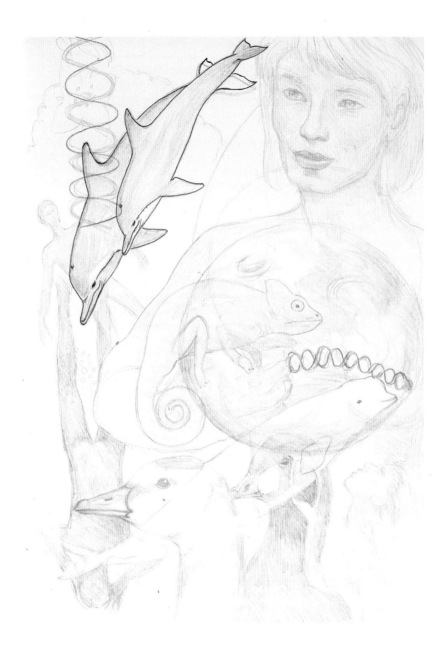

Sketch for 'The mermaid and the blue planet'. Taken from a diary
Pencil and crayon, 1985. 8¼″ × 5¾″ (21 × 14.7 cm).

Right: The mermaid and the blue planet
Oil on canvas, 1985. 24″ × 20″ (61 × 50.8 cm).

'This allegorical picture stresses the fragility of life on earth. A mermaid holds the planet protectively while hands try to grasp it from her, the snake-like pattern on the wing-tips of a moth whispering temptation in her ear. Arranged around the figure are some of the Scotts' favourite animals – cuttle fish, chamaeleon, dolphin, sea horse, barnacle goose and the white whale. Because this species of whale is believed to be the most intelligent marine mammal, the formula $E = MC^2$ may well be held in its brain. Why should it not carry Einstein's equation in its memory?'

Caption by Peter Scott for
Sir Peter Scott at 80 – A Retrospective

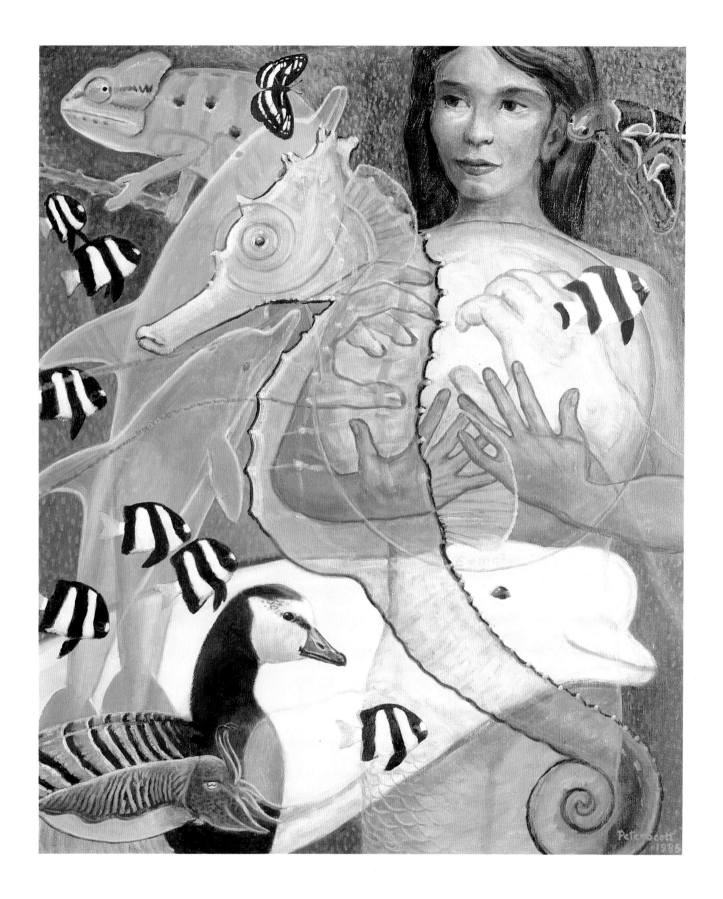

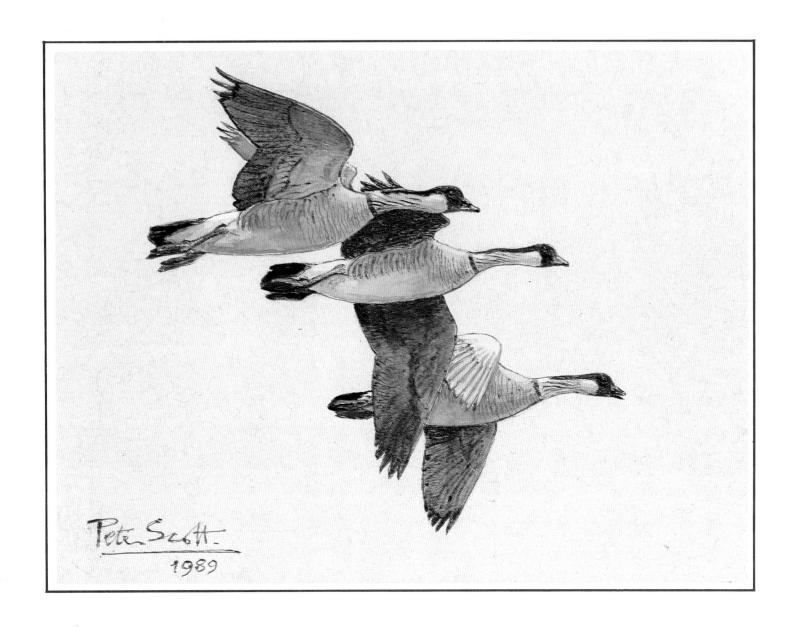

Three ne-nes in flight
(*actual size*). Coloured drawing, 1989.

Right: Pinkfeet leaving the marsh on a showery day
Oil on canvas, 1989. 16″ × 12″ (40.7 × 30.5 cm).

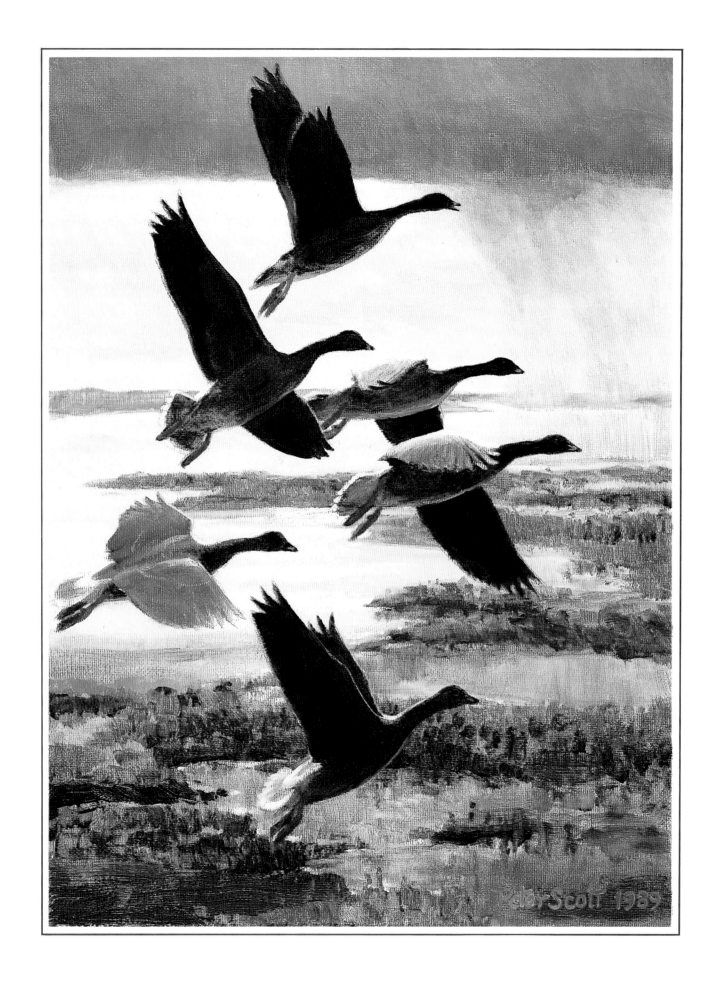

The paintings on the following pages were all in the Exhibition at Arthur Ackermann & Son's Gallery in Bond Street, London, in March 1989. At that time Peter wrote: 'I have been excited by wildfowl for most of my life and have been painting them and the wild areas they live in for more than sixty years. Wildness is the aspect that specially appeals to me. I believe Thoreau was right when he wrote "In wildness is the preservation of the world". He was ahead of his time.'

Lesser white-fronted geese
(reduced). Pencil sketches.

'Among the steep mountains of Lapland is the summer home of one of the world's most beautiful geese, a trim little bird for which British ornithologists can find no better name than the lesser white-fronted goose. To the people of Scandinavia it is the mountain goose, and to me also that will always be its most appropriate name, for although I have seen it on the vast expanses of the Hungarian Caspian Sea, surely its most romantic setting is among the fierce highlands of Torne Lappmark. There, hidden in the dwarf birch and arctic willow scrub beside the little lakes and tarns, the mountain geese make their nests, and the yearlings feed high in the corries above, on the lush green of the newly sprouted vegetation; and there, in due course, they moult their flight feathers and pass the dangerous ten day flightless period before the new pinions are grown.'

Mountain Geese. From a notebook/sketchbook, entitled: *Upsala June 1950. Peter Scott*

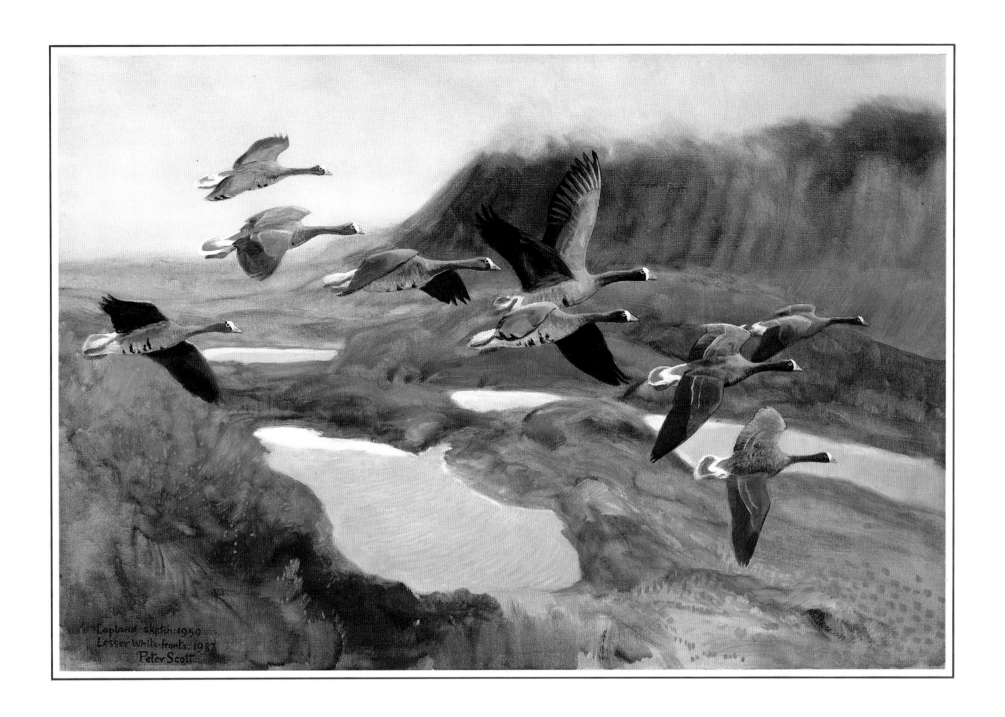

Lapland sketch, 1950. Lesser whitefronts, 1987
Oil on canvas, 1950 and 1987. 20″ × 30″ (50.8 × 76.2 cm).

Started in 1950, this painting was finished in 1987 and hung in the exhibition at
Ackermann's Gallery in 1989.

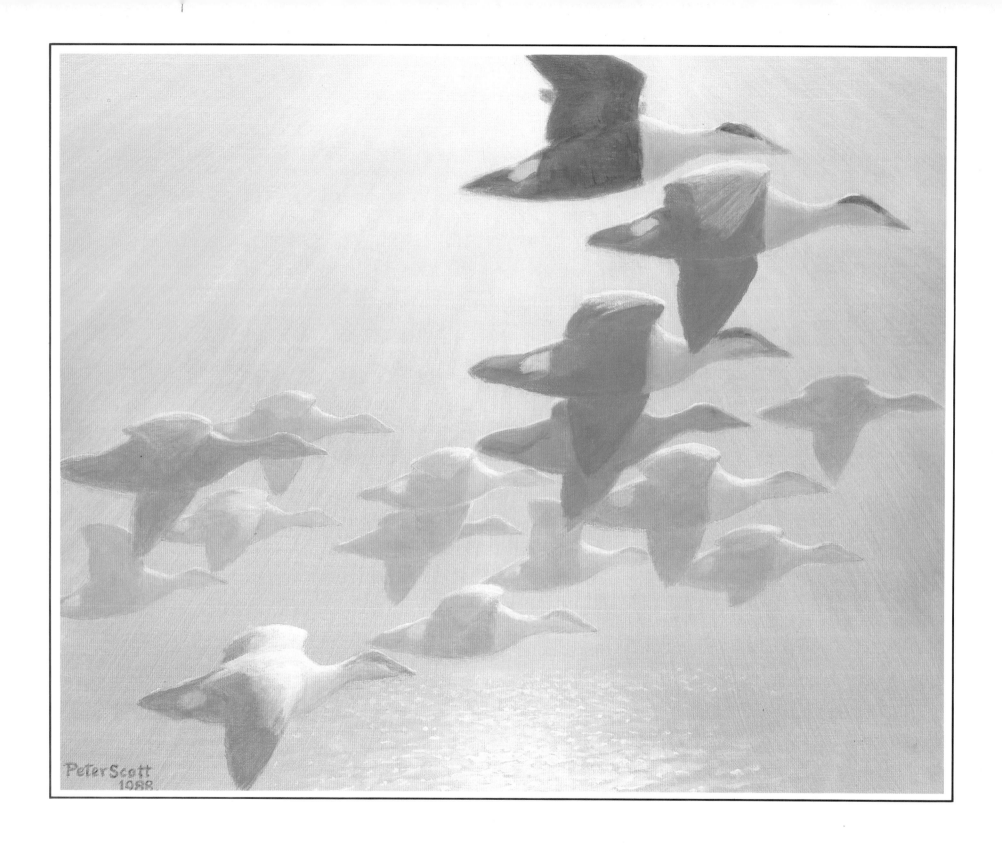

Eiders passing in a fog
Oil on canvas, 1988. 15″ × 18″ (38.1 × 45.4 cm).

Backlit and in a mist. This was the kind of painting Peter loved to
produce in the late 1980s.

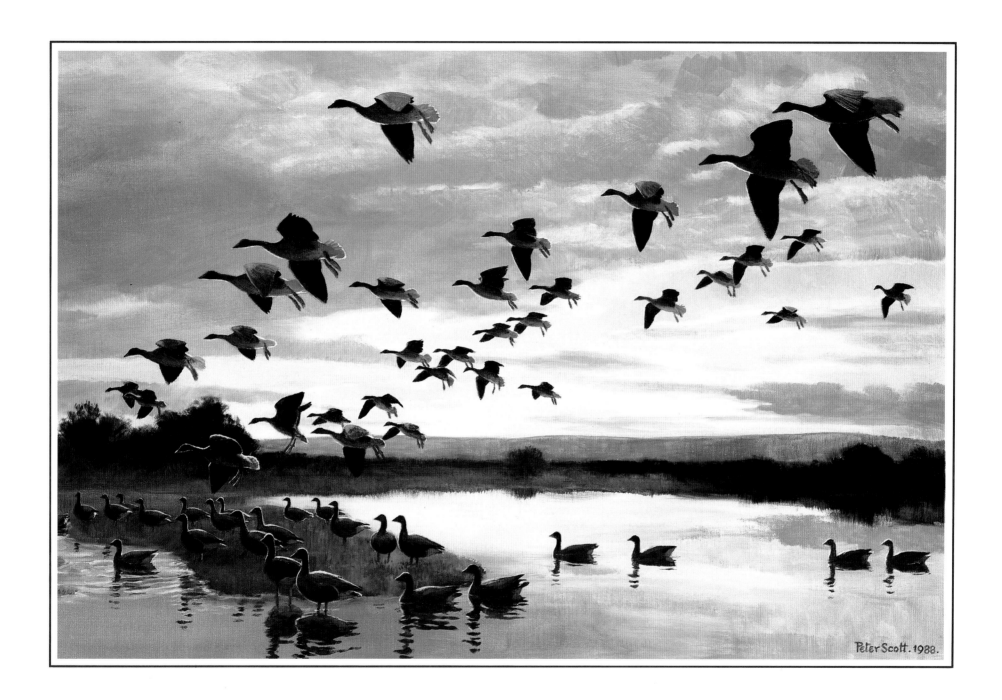

Greylags coming to roost outside the artist's studio
Oil on canvas, 1988. 20″ × 30″ (50.8 × 76.2 cm).

'Wildfowl species towards which I am forever drawn and which I particularly enjoy painting are red-breasted geese, pinkfeet, whitefronts, greylags, barnacles, Bewick's swans and pintails. All of these are here at The Wildfowl Trust [now The Wildfowl & Wetlands Trust] in winter. My studio is at the edge of "Swan Lake" so that the birds are often only a few feet from my easel.'

The Repository of Arts, September 1988
Arthur Ackermann & Son

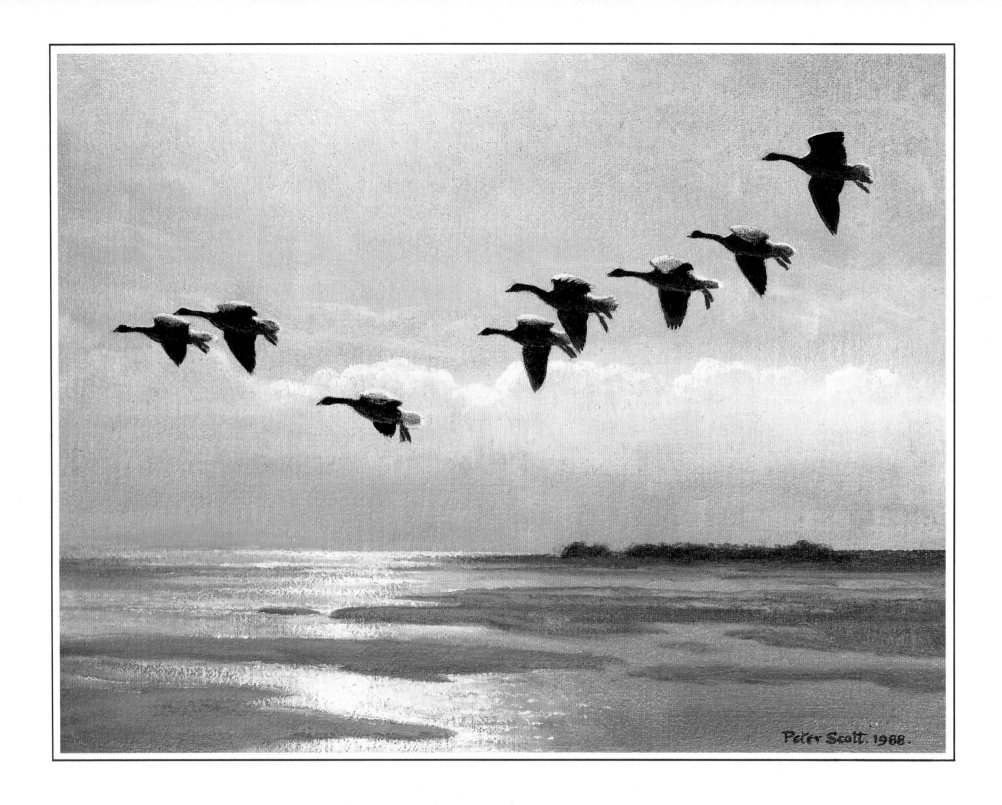

The first eight pinkfeet came out to the estuary
Oil on canvas, 1988. 14″ × 18″ (35.6 × 45.4 cm).

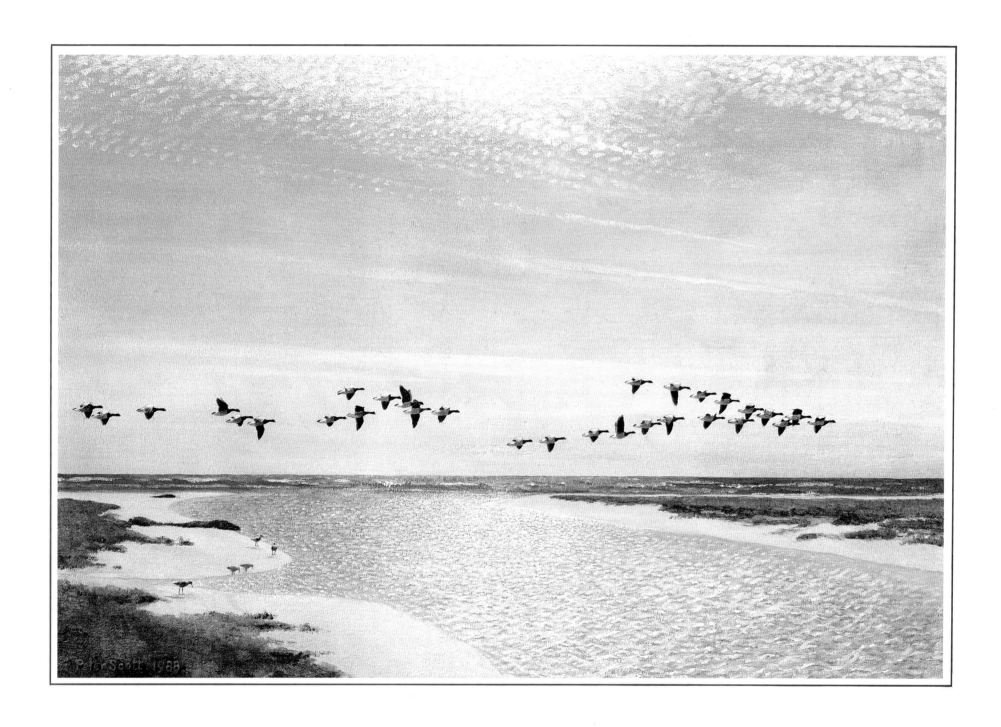

Brents crossing the mouth of the creek at flood tide
Oil on canvas, 1988. 25″ × 36″ (63.5 × 90.4 cm).

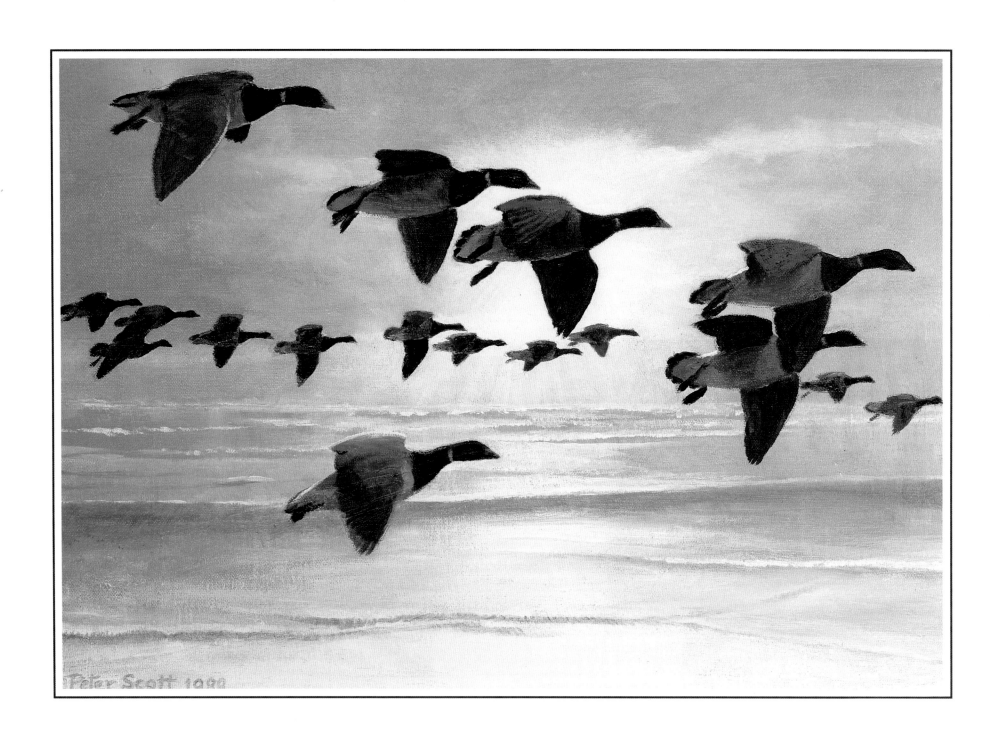

Brent geese on a falling tide
Oil on canvas, 1988. 10″ × 14″ (25.4 × 35.6 cm).

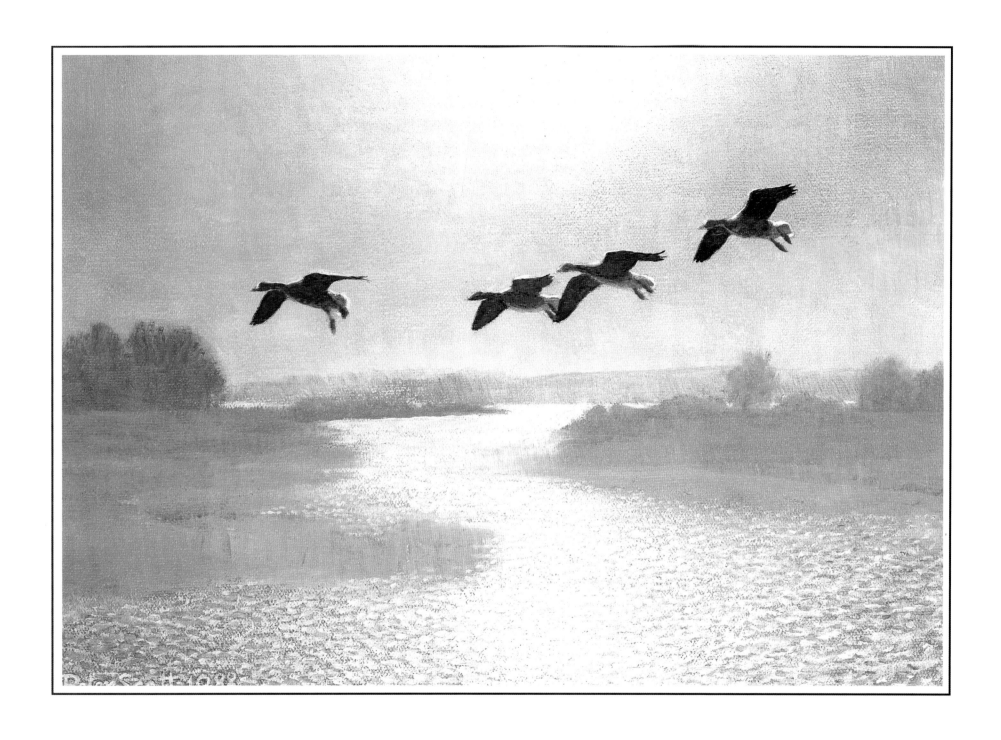

Four whitefronts over a misty marsh
Oil on canvas, 1988. 10″ × 14″ (25.4 × 35.6 cm).

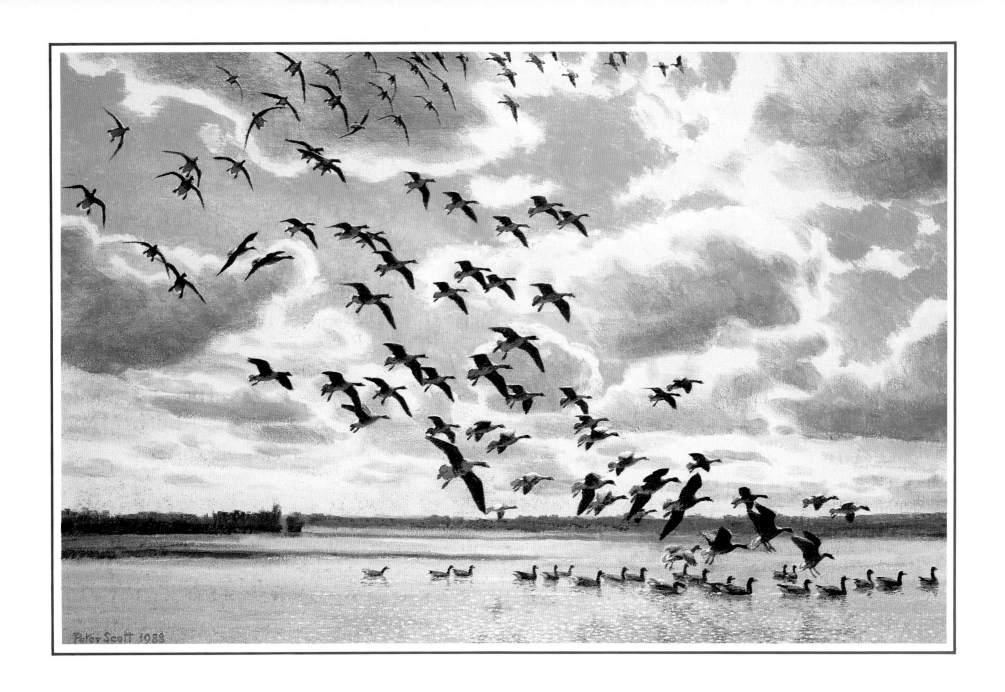

Whitefronts whiffling down onto flood water
Oil on canvas, 1988. 20″ × 30″ (50.8 × 76.2 cm).

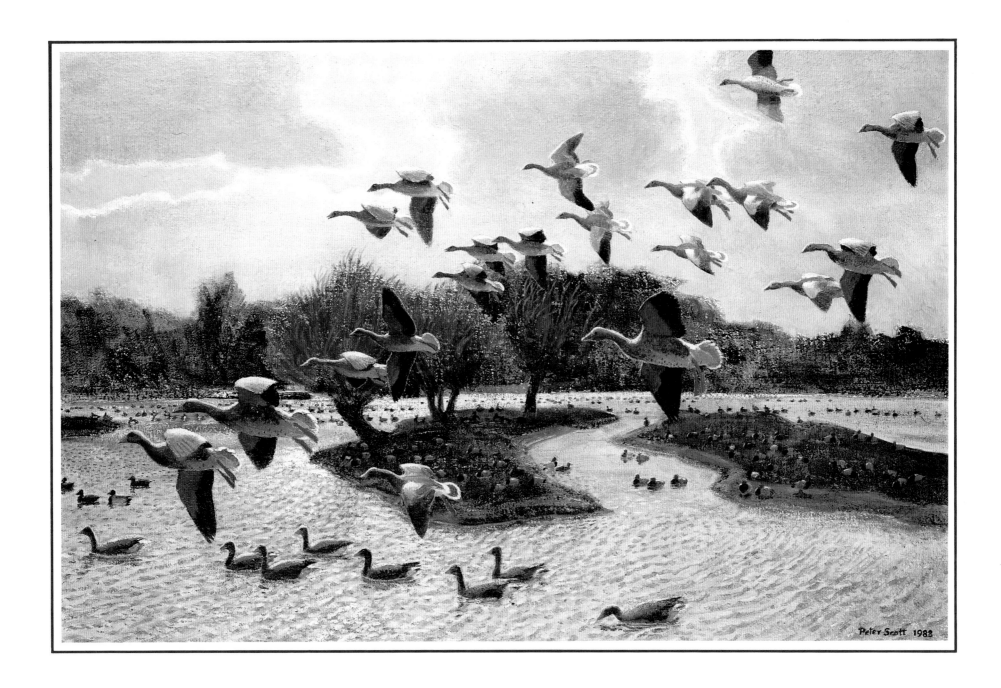

Greylags whiffling in to land in front of the studio
Oil on canvas, 1988. 20″ × 30″ (50.8 × 76.2 cm).

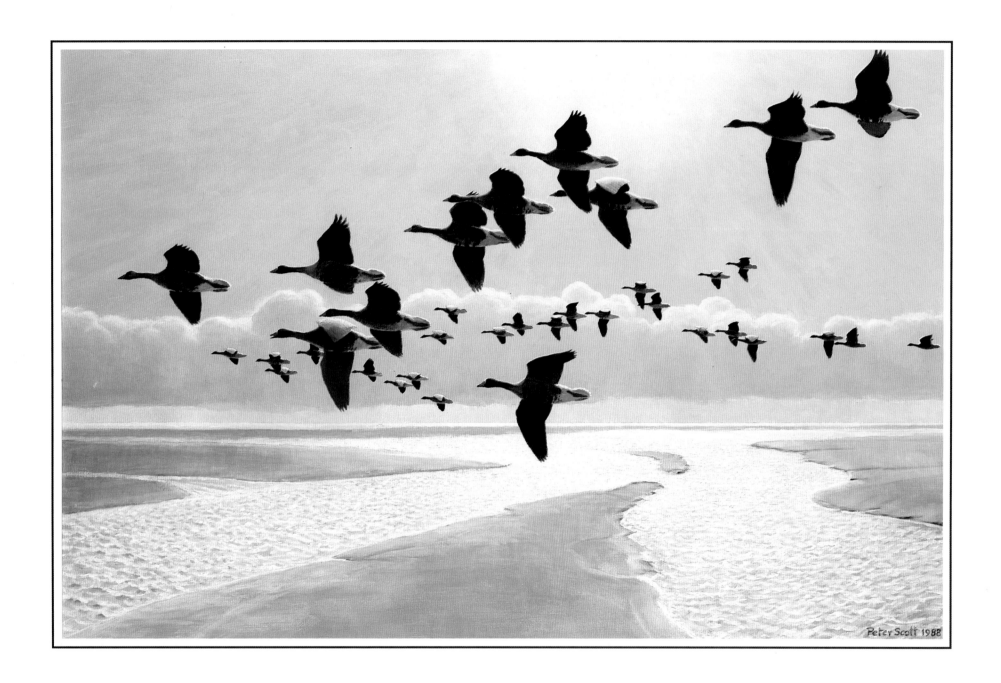

Where the creeks join – white-fronted geese
Oil on canvas, 1988. 24″ × 36″ (61 × 91.4 cm).

'The particular attraction of painting flock birds is that the pattern in which they are grouped can itself convey their movement. So the composition is an enormously important element in such pictures.'
Repository of Arts. September 1988. Arthur Ackermann & Son

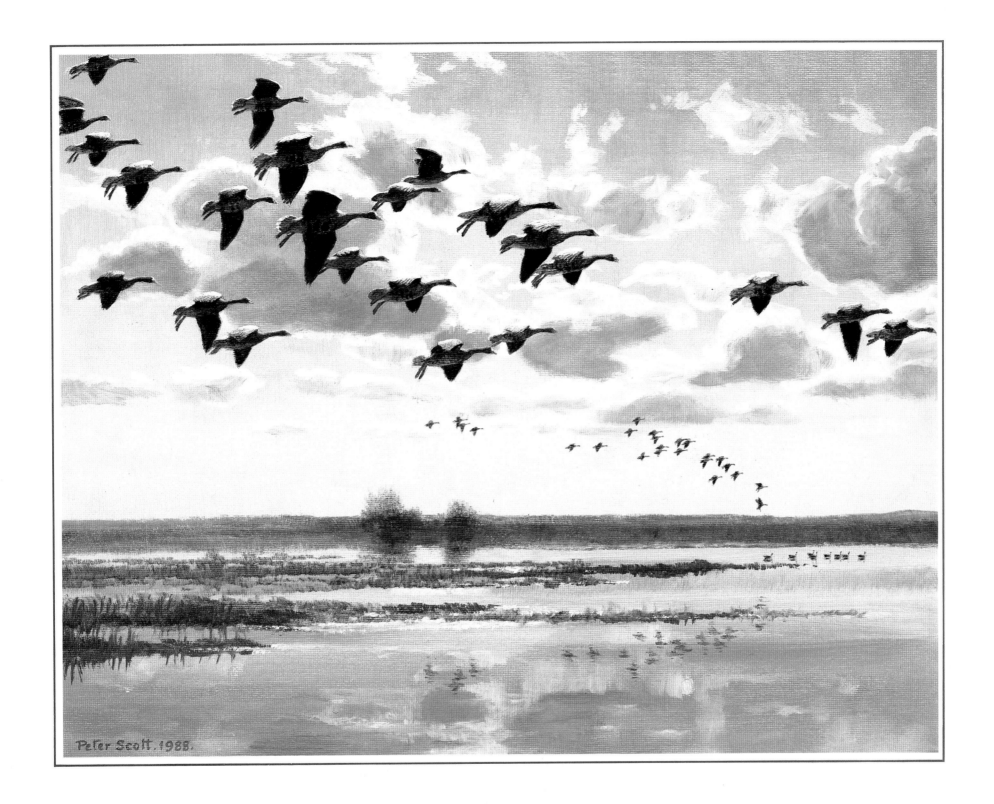

Whitefronts over a flooded marsh
Oil on board, 1988. 16″ × 20″ (40.7 × 50.8 cm).

'I was likely, I thought, to paint best those things which moved me most. That meant my wildfowl.'

The Eye of the Wind

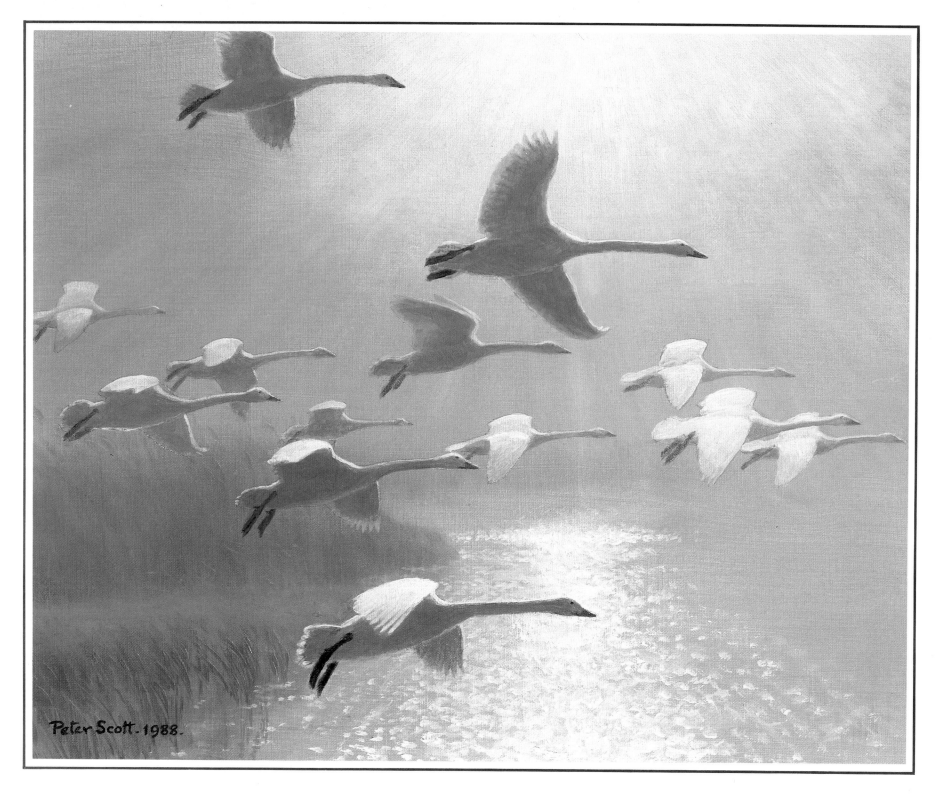

Peter Scott. 1988.

Thirteen Bewick's swans came in over the reed bed
Oil on canvas, 1988. 15″ × 18″ (38.1 × 45.4 cm).

'The idea of a white bird seen against the light in a thick mist has always appealed
to me and I have painted a number of pictures depicting swans flying over water,
backlit by a misty sun, with very little colour – a silvery symphony.'

Birds in Art, 1988. Catalogue
Leigh Yawkey Woodson Art Museum, USA

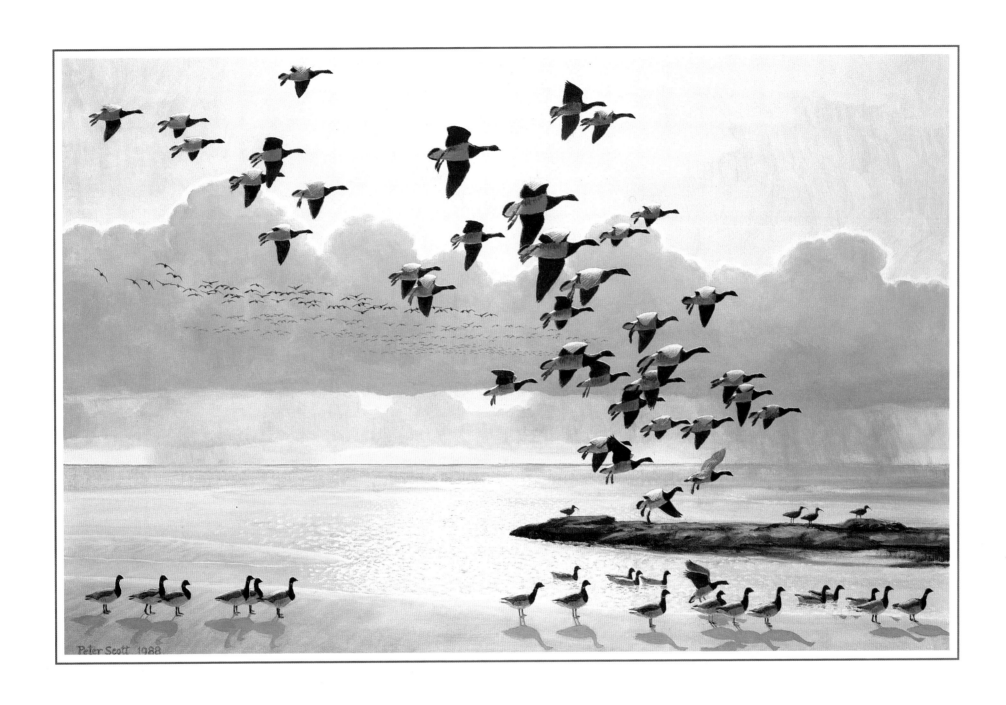

When the tide turned, the brent geese came in against a
background of showers
Oil on canvas, 1988. 24″ × 36″ (61 × 91.4 cm).

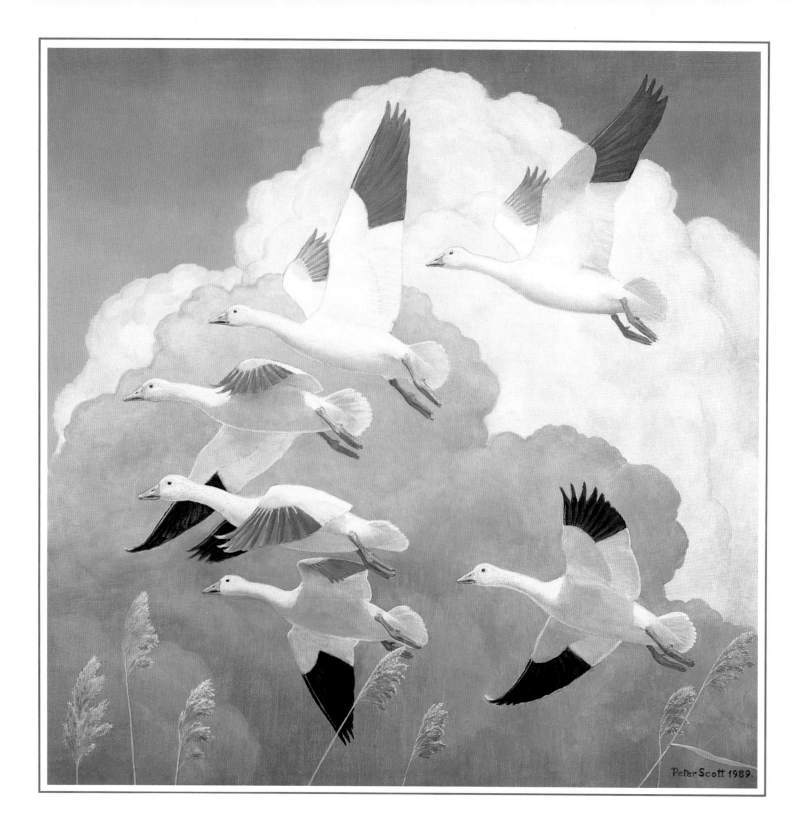

Snow geese climbing into a cumulus sky
Oil on canvas, 1989. 36″ × 36″ (91.4 × 91.4 cm).

Peter described his motivation for this painting as: 'The challenge of painting white birds with black wingtips against cumulus clouds in sunlight and in shadow and trying to get the greys integrated with the right values for the shadows on the birds and the clouds.'

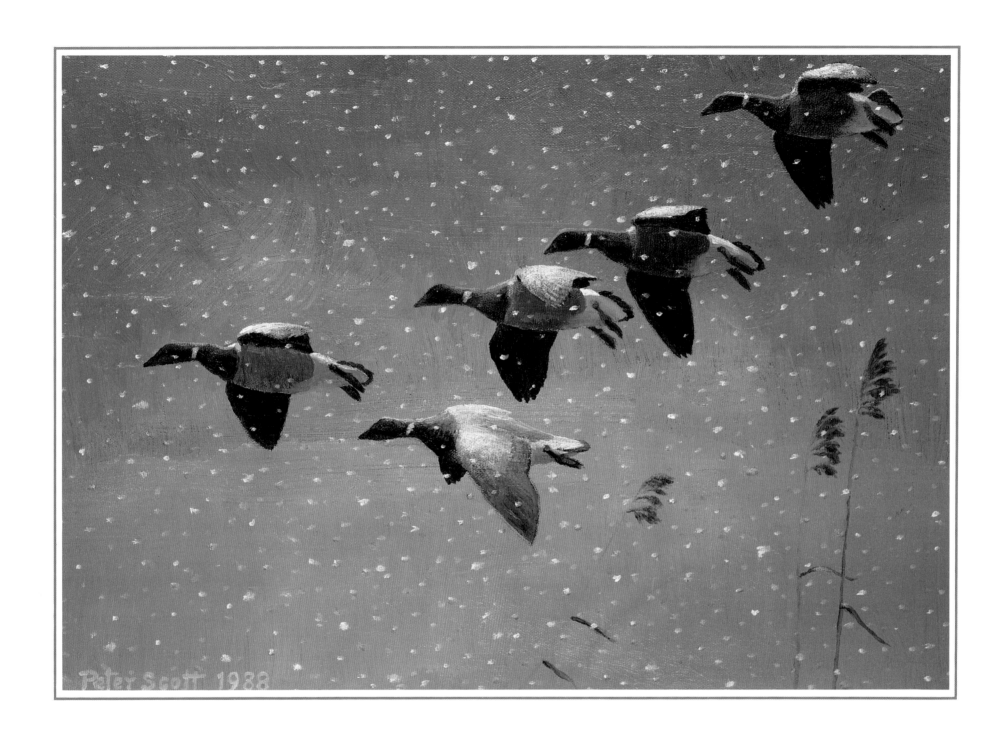

A flash of sun through the snowstorm
Oil on canvas, 1988. 10″ × 14″ (25.4 × 35.6 cm).

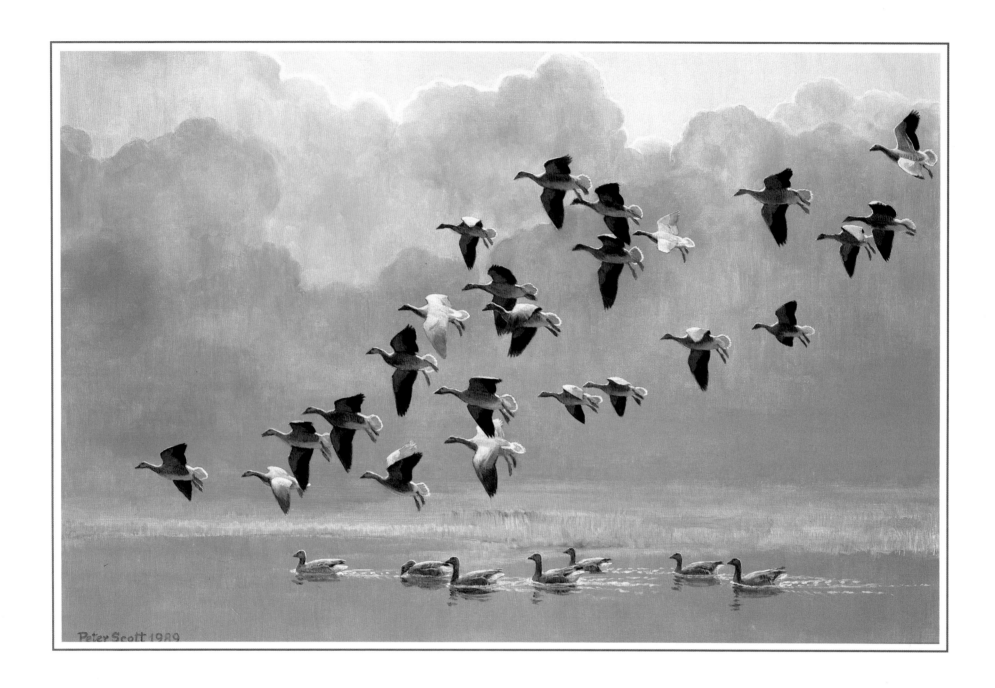

Greylags before the storm
Oil on canvas, 1989. 24″ × 36″ (61 × 91.4 cm).

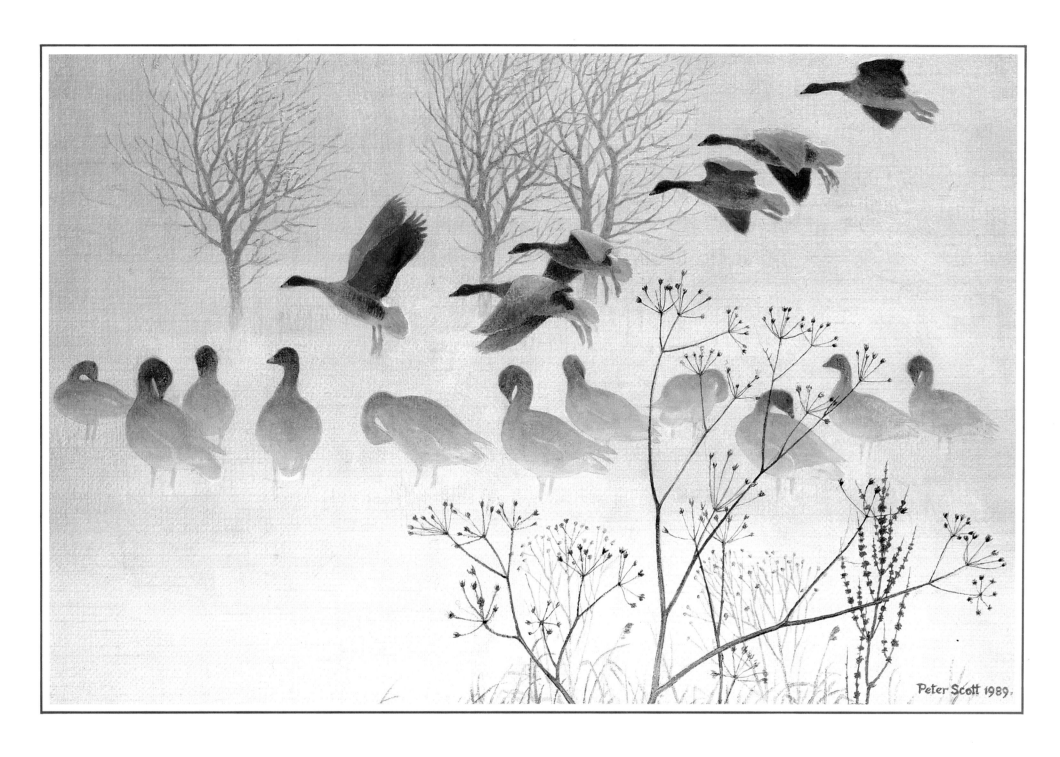

Ground mist – pinkfeet
Oil on canvas, 1989. 20″ × 30″ (50.8 × 76.2 cm).

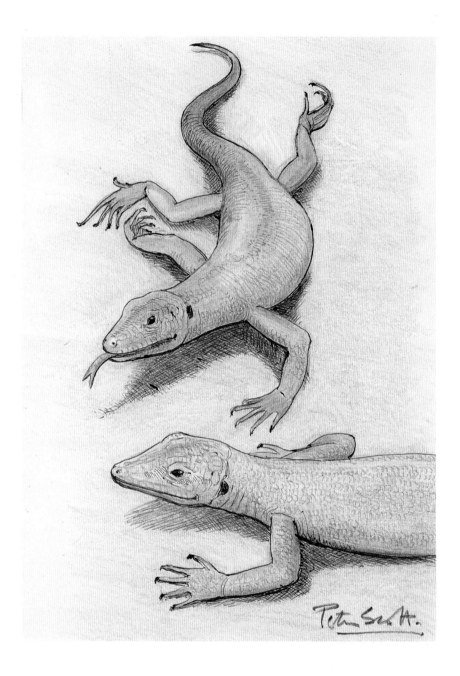

Green lizards
(*actual size*). Pen and ink and crayon, 1989.

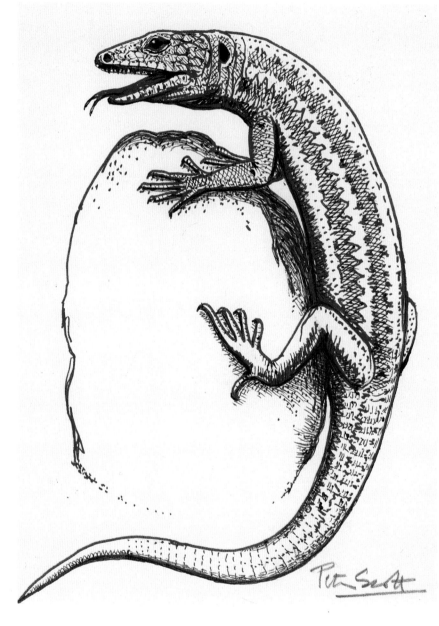

Unidentified lizard – largely fictitious
(*actual size*). Pen and ink, 1989.

Peter's interest in reptiles was still evident in the 1989 exhibition.

Red-breasted geese pair
Gouache, 1989. 8⅛″ × 8⅘″ (20.7 × 22 cm).

Three red-breasted geese
Pen and ink, watercolour and crayon, 1989. 5″ × 7″ (13.5 × 19.7 cm).

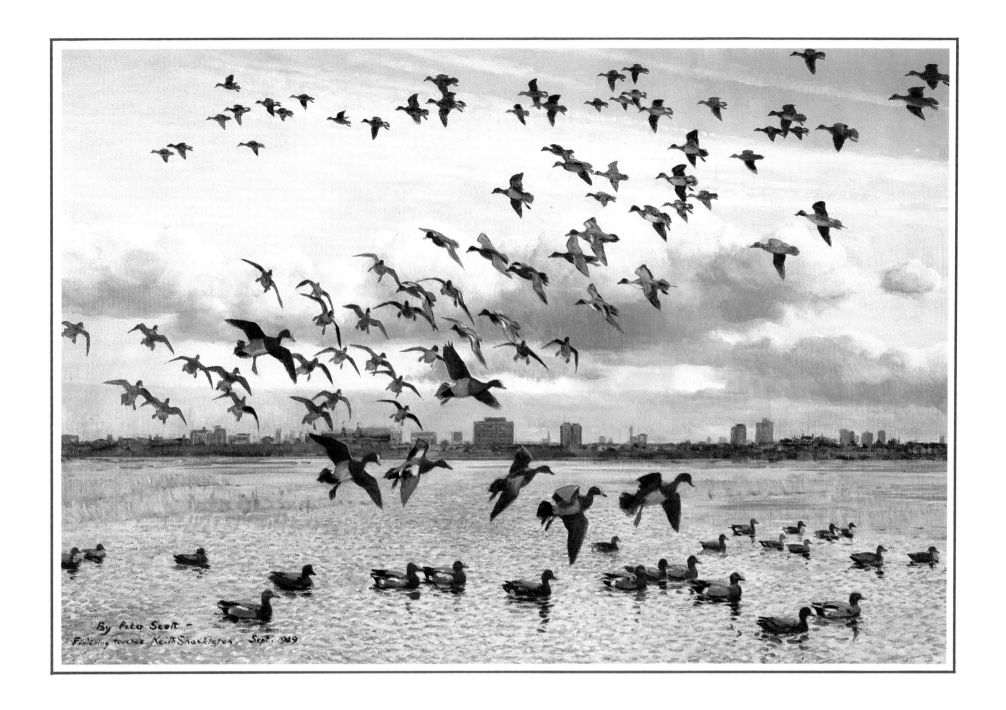

Barn Elms

Finishing touches by Keith Shackleton, September 1989. Not signed by Peter Scott. Oil
on canvas, 1989. 20″ × 30″ (50.8 × 76.2 cm).

This painting was commissioned by The Wildfowl & Wetlands Trust to illustrate
Peter's vision of what the Barn Elms reservoirs might look like in the event of the
area becoming the Trust's London Centre. It was the last picture that he painted.

Bibliography

Sir Peter Scott's output of illustration spanned some sixty-five years. The talent that he portrayed in oils and pen and ink made his work much sought after to enliven the text of books and journals.

His first illustrations were published in 1924 when he was only fifteen years old, in *Everyday Doings of Insects*, a book by Evelyn Cheesman, in which seven of his drawings were used.

Since then, illustrations have appeared in many books including twenty-five of his own. The long running *Wildfowl*, The Wildfowl & Wetlands Trust Annual Report, bears special mention. This publication first appeared in 1948 as *The Severn Wildfowl Trust Annual Report*; the 1990 copy was number forty-one and will be the last to feature a colour painting by Sir Peter. A colour reproduction of wildfowl in their habitat had been used on the cover of every report. In the early days this report related the happenings at Slimbridge. However, as the years passed, it became a collection of scientific papers. Over the years over a thousand illustrations of Sir Peter's have been included and these are some of his finest pen and ink drawings. The largest single volume collection of drawings is to be found in the *Seventh Annual Report 1953/54*, in which there are one hundred pen and ink drawings.

Until now the best book in which to find a complete cross-section of the artist's work, was *Observations of Wildlife*, published in 1980 by Phaidon, with a reprint in 1987. It contains a collection of works covering a period of forty years, and has thirty-nine colour plates with sixty-six other illustrations.

The final books published under Sir Peter's name were *Travel Diaries of a Naturalist* volumes one, two and three, published in 1983, 1985 and 1987 respectively. These were lavishly illustrated with watercolours painted on his many journeys around the world. They also contain photographs by his wife, Lady Scott, who accompanied him on trips. The text was selected from the diaries which make fascinating reading following his work with the World Wide Fund for Nature, advising on conservation issues, establishing areas for reserves, setting up

and launching the Fund in other countries, his travels aboard the Linblad Explorer as one of the ship's naturalists and lecturers, and his travels film making.

The following list has been put together over a period of twelve years and has been a labour of love. The books listed chronologically by publication date were published in London unless otherwise stated.

The bibliography would never have been completed but for the help and patience shown to me by Sir Peter and Lady Scott.

1. BOOKS WRITTEN AND ILLUSTRATED OR EDITED BY SIR PETER SCOTT

Morning Flight. Country Life. Signed limited edition of 750 copies 1935. Further editions: April 1936, Nov. 1936, Nov. 1937, Oct. 1939, May 1941, Aug. 1942, May 1944, Aug. 1946, Sep. 1947, Nov. 1949 and Nov. 1950.

Wild Chorus. Country Life. Signed limited edition of 1250 copies 1938. Further editions: Sep. 1939, Nov. 1939, April 1941, Sep. 1942, May 1944, April 1946, April 1947, Dec. 1948 and Nov. 1949.

Battle of the Narrow Seas. Country Life, 1945. Further edition 1946.

Portrait Drawings. Country life. 1949. All signed by author.

Key to the Wildfowl of the World. Severn Wildfowl Trust. First appeared in the 'Second Annual Report 1948–1949'. 1949. Reprinted as a separate booklet in 1950 with a revised edition in 1951.

Wild Geese and Eskimos. Country Life. 1951.

Nature Parliament, A Book of Broadcasts. With Newman, L. H. and Fisher, J. (editor). Dent. 1952.

A Thousand Geese. With Fisher, J. Collins. 1953. Further edition 1954.

The Geography, Birds and Mammals of the Perry River Region. With Hanson, H. C. and Queneau, P. The Arctic Institute of North America. 1956.

Wildfowl of the British Isles. With Boyd, H. Country Life. 1957.

A Coloured Key to the Wildfowl of the World. Wildfowl Trust. 1957. Further editions: 1961, 1965, 1968, 1972, 1977 and 1988.

Faraway Look One. With Scott, Ph. Cassell. 1960.

Faraway Look Two. With Scott, Ph. Cassell. 1960.

The Eye of the Wind. Hodder and Stoughton. 1961. Further editions: June 1961, July 1961, 1962, 1963, 1966, 1966, 1967, 1967, 1968 and 1977.

Animals in Africa. With Scott, Ph. Cassell. 1962.

Wildlife in Danger. Brooke Bond. 1963.

My Favourite Stories of Wildlife. (editor). Illustrated by Shackleton, K. Lutterworth. 1965.

The Launching of a New Ark. (editor). Collins. 1965.

Happy the Man. Sitwell, N. (editor). Sphere. 1967.

The Wild Swans at Slimbridge. With Scott, Ph. Wildfowl Trust. 1970.

The Living World of Animals. (editor). Readers Digest. 1970.

The Swans. With the Wildfowl Trust. Michael Joseph. 1972. 24 copies were leatherbound and signed.

Conservation in Mauritius. Privately printed. 1973.

Waterfowl. Berkshire Printing Company. 1973.

Mitchell Beazley World Atlas of Birds. (editor). Mitchell Beazley. 1974.

The Amazing World of Animals. (editor). Nelson. 1975.

Observations of Wildlife. Phaidon. Signed limited edition of 200 copies 1980. Further editions: 1981 and 1987.

The Swans Fly In. With Scott, Ph. Wildfowl Trust. 1983. Further edition edited by Rees, E. 1989.

Travel Diaries of a Naturalist 1. Collins/Harvill. 1983.

Travel Diaries of a Naturalist 2. Collins/Harvill. 1985.

Travel Diaries of a Naturalist 3. Collins/Harvill. 1987.

2. BOOKS AND BOOKLETS ILLUSTRATED IN WHOLE, OR IN PART BY SIR PETER SCOTT

Cheesman, E. *Everyday Doings of Insects*. 7 illustrations. Harrap. 1924. Further edition 1930.

Three Schoolboys. *Adventures Among Birds*. Privately printed (525 copies only). 1926.

Moody, A. F. *Waterfowl and Game Birds in Captivity*. 2 photographs. 1932.

Players, J. & Sons. *Wildfowl*. 25 Cigarette cards. 1936.

West London Shooting Ground. *Prospectus*. 13 pencil drawings. 1936.

Kennet, Lord. *A Bird in the Bush*. Signed limited edition (550 copies): 3 Colour plates and 24 b/w illustrations. Ordinary edition: 1 colour plate and 24 b/w illustrations. Country Life. Both editions 1936.

Perry, R. *At the Turn of the Tide*. Coloured frontispiece. Drummond. 1938.

Witherby, H. F. *The Handbook of British Birds*. 10 colour illustrations. Volume 3. Witherby. 5 volume set, 1938/41.

Bratby, M. *Grey Goose*. Colour frontispiece with 25 b/w illustrations. Geoffrey Bles. 1939.

Campen Heilner, V. *A Book on Duck Shooting*. 3 photographs. Alfred Knopf, New York, U.S.A. 1939.

Bratby, M. *Through the Air*. 25 b/w illustrations. Country Life. 1941.

Gallico, P. *The Snow Goose*. Special edition (750 copies), signed by author and illustrator. 4 colour plates and 24 pen and ink drawings. Michael Joseph. 1946.

Harman, R. *Countryside Character*. 2 colour plates. Blandford. 1946.

Vesey-Fitzgerald, B. *British Game*. 1 colour plate. Collins. 1946.

Pitman, I. *And Clouds Flying*. 2 colour plates, 51 line drawings and 8 mono photographs of paintings. Faber. 1947.

Gregorson, R. *Lemuel*. 250 copies, special edition, signed by author and illustrator. 31 drawings. Owl Press. 1947.

Pitt, F. *The Frontier of a Baronry*. Gloucester, Bellows. 1 b/w illustration. 1948.

British Ornithologist's Club. Bulletin, vol. 68 no. 6. with Dalgety, C. *A New Race of the Whitefronted Goose*. 7 b/w illustrations. 1948.

Severn Wildfowl Trust. *Book of Rules*. 5 b/w illustrations. 1948.

Ministry of Works. *Birds in London*. Report by Committee on Bird Sanctuaries in the Royal Parks. 1939–47. Cover illustration. 1948.

Severn Wildfowl Trust. *Prospectus*. Colour cover and 7 b/w illustrations. 1948.

Chapman, F. S. *The Jungle is Neutral*. b/w

frontispiece. Chatto and Windus. 1949.

Ministry of Works. *Birds in London*. Report by the Committee on Bird Sanctuaries in the Royal Parks 1948. Cover illustration. 1949.

Ministry of Works. *Birds in London*. Report by the Committee on Bird Sanctuaries in the Royal Parks 1949. Cover illustration. 1950.

Ministry of Works. *Birds in London*. Report by the Committee on Bird Sanctuaries in the Royal Parks 1950. Cover illustration. 1951.

Wildfowl Trust. *Prospectus*. Colour cover and back. 1951.

Savage, C. *The Mandarin Duck*. Colour frontispiece. A & C Black. 1952.

Fisher, J. *The Fulmar*. Colour frontispiece. Collins. 1952.

Hollom, P. A. D. *The Popular Handbook of British Birds*. 9 colour plates. Witherby. 1952.

Atkinson-Willes, G. *National Wildfowl Counts 1952–54*. 8 b/w illustrations. Wildfowl Trust. 1954.

Delacour, J. *Waterfowl of the World*. 4 volume set. 66 colour plates. Country Life. 1954/64.

Atkinson-Willes, G. *National Wildfowl Counts 1954–55*. 16 b/w illustrations. Dursley, Wildfowl Trust. 1955.

Sowls, L. K. *Prairie Ducks*. b/w frontispiece. University of Nebraska, U.S.A. 1955.

Knight, L. A. *The Morlo*. 2 colour plates and 30 b/w illustrations. Smith Gryphon. 1956.

Wildfowl Trust. *Wildfowl Trust at Slimbridge*. 2 colour illustrations. 1956.

Powell, B. *The Grey Geese Call*. 1 photograph. Jenkins. 1956.

Cadman, A. *Tales of a Wildfowler*. 42 b/w illustrations. Collins. 1957.

Atkinson-Willes, G. *National Wildfowl Counts, Fourth Report*. 14 b/w illustrations. Dursley. Wildfowl Trust. 1957.

Wildfowl Trust. *Book of Rules*. 4 b/w illustrations. Dursley. 1958.

Hollom, P. A. D. *The Popular Handbook of Rarer British Birds*. 2 colour plates. Witherby. 1960.

Sedgwick, N. and others. *The New Wildfowler*. 1 colour frontispiece. Barrie & Jenkins. 1961.

Christian, G. *Down the Long Wind*. Dust wrapper illustration in colour. Newnes. 1961.

Wildfowl Trust. *The Story of the Wildfowl Trust*. Colour cover illustration. Dursley. 1961.

Bond, Brooke. *Wildlife in Danger*. 50 colour teacards with 2 colour covers and 20 b/w illustrations. 1963.

Atkinson-Wills, G. *Wildfowl in Great Britain*. 15 colour plates and 70 b/w

illustrations. H.M.S.O. 1963.

Fisher, J. *The Shell Bird Book*. 1 colour plate. Ebury Press. 1966.

Wildfowl Trust. *An Introduction to the Collection and Work*. 17 b/w illustrations. Dursley. 1968.

Fisher, J. and others. *The Red Book, Wildlife in Danger*. 9 colour drawings and 7 b/w illustrations. Collins. 1969.

Sedgwick, N. and others. *The New Wildfowler in the 70's*. 2 colour plates. Barrie & Jenkins. 1970.

Wildfowl Trust. *The Wild Swans at Slimbridge*. 1 colour cover and 2 b/w illustrations. 1970.

Philip, H.R.H. Prince and Fisher, J. *Wildlife Crisis*. 7 b/w illustrations. Arcadia. 1971.

Chaplin, C. *Fishwatchers' Guide to West Atlantic Coral Reefs*. 23 colour plates. Livingston Publishing, Pennsylvania, U.S.A. 1972.

Wildfowl Trust. *Guide to Centres*. Colour cover and 9 b/w illustrations. 1973.

Driver, P. *In Search of the Eider*. 1 b/w plate. Saturn. 1974.

Kear, J. and Duplaix-Hall, N. *Flamingos*. 1 colour plate and 6 b/w illustrations. Berkhamsted, Poyser. 1975.

Witchell, N. *The Loch Ness Story*. Colour dust wrapper, 2nd edition. Dalton, Suffolk. 1976. 3rd edition. Cover illustration. Corgi. 1989.

Douglas-Home, H. *The Birdman, Memories of Birds*. 12 b/w illustrations. Collins 1977.

Cramp, S. and others. *Birds of the Western Palearctic*. Volume 1. 8 colour plates. Oxford University Press. 1977.

Fitter, R. S. R. *The Penitent Butchers*. 10 b/w illustrations and dust wrapper illustration. Collins. 1978.

Wildfowl Trust. *Special Appeal Brochure*. 2 colour and 2 b/w illustrations. 1979.

Smart, M. (editor). *First Technical Meeting on Western Palearctic Migratory Bird Management*. 2 b/w illustrations. International Waterfowl Research Bureau, Slimbridge. 1979.

Salmon, D. (editor). *Wildfowl and Wader Counts 1979–80*. Wildfowl Trust, Nympsfield, 1980.

Kear, J. and Berger, A. J. *The Hawaiian Goose*. 17 b/w illustrations. Calton, Poyser. 1980.

Matthews, G. V. T. and Smart, M. *Second International Swan Symposium* (proceedings). 3 b/w illustrations. International Waterfowl Research Bureau, Slimbridge. 1981.

Stonehouse, B. *Saving the Animals*. Endpaper illustration. Weidenfeld & Nicholson. 1981.

McCullagh, S. *Where Wild Geese Fly*. 1 colour and 14 b/w illustrations. St

Albans, Hart-Davis. 1981.

Salmon, D. (editor). *Wildfowl and Wader Counts 1981–82*. 5 b/w illustrations. Wildfowl Trust, Nympsfield. 1982.

Ogilvie, M. *The Wildfowl of Britain and Europe*. 7 colour plates. Oxford University Press. 1982.

Kalchreuter, H. (editor). *Second European Woodcock and Snipe Workshop* (proceedings). 1 b/w illustration. International Waterfowl Research Bureau, Slimbridge. 1983.

Hickling, R. *Enjoying Ornithology*. 9 b/w illustrations. Calton, Poyser. 1983.

Salmon, D. (editor). *Wildfowl and Wader Counts 1982–83*. Cover illustration. Wildfowl Trust, Slimbridge. 1983.

Baker, R. *Bird Navigation, The Solution to a Mystery*. Colour cover illustration. Hodder & Stoughton. 1984.

Wildfowl Trust. *Souvenir Booklet*. Colour cover with b/w illustration. 1985.

Salmon, D. and Moser, M. (editors). *Wildfowl and Wader Counts 1984–85*. Cover illustration. Wildfowl Trust, Slimbridge, 1985.

Ruger, A. and others. *Results of the I.W.R.B. International Waterfowl Census 1967–1983*. 2 b/w cover illustrations. International Waterfowl Research Bureau, Slimbridge. 1986.

Shackleton, K. and Snyder, J. *Ship in the Wilderness*. 3 colour illustrations. Dent. 1986.

Owen, M., Atkinson-Willes, G. L. and Salmon, D. *Wildfowl in Great Britain*. 70 b/w illustrations. 2 repeated on dust cover. Cambridge University Press. 1986.

Aickman, R. *The River Runs Uphill*. 1 b/w illustration. J. M. Pearson, Burton on Trent. 1986.

Hammond, N. *Twentieth Century Wildlife Artists*. 4 colour and 1 b/w illustration. Croom Helm. 1986.

Owen, M. *Barnacle Goose Project: 1986 Report*. Cover illustration. Wildfowl Trust, Nympsfield. 1987.

Salmon, D. and others. (editors). *Wildfowl and Wader Counts 1986–87*. Cover illustration. Wildfowl Trust, Nympsfield. 1987.

Wildfowl Trust. *Souvenir Booklet*. Colour cover with b/w illustration. 1987.

Cooke, F. and Buckley, P. A. *Avian Genetics*. Cover illustration. Academic Press. 1988.

Courtney, J. *Sir Peter Scott*. 9 colour and 2 b/w illustrations. Exley, Watford. 1989.

Benington, J. *Sir Peter Scott at 80, A Retrospective*. Colour cover, 10 colour plates and 45 paintings and drawings reproduced in b/w. Alan Sutton, Gloucester. 1989.

Salmon, D. and others. (editors). *Wildfowl and Wader Counts 1988–89*. Cover illustration. The Wildfowl & Wetlands Trust, Nympsfield. 1989.

Perring, F. and Paige, J. (compilers). *Tomorrow Is Too Late*. 1 colour illustration. Macmillan. 1990.

Brynildson, I. and Hagge, W. *Birds in Art, The Masters*. 6 colour plates. Leigh Yawkley Woodson Art Museum, Wisconsin, U.S.A. 1990.

Kear, J. *Man and Wildfowl*. 7 b/w illustrations. Poyser. 1990.

Scott, Ph. *Lucky Me*. 1 b/w illustration, repeated. Kenilworth. 1990.

Trapnell, D. *Nature in Art*. 1 colour illustration, David and Charles 1991.

3. BOOKS CONTAINING CONTRIBUTIONS BY SIR PETER SCOTT.

Fisher, J. *The New Naturalist*. 'The Migration of Wild Geese'. 3 b/w illustrations. Collins. 1948.

Koch, L. (editor). *The Encyclopedia of British Birds*. Contributor. Waverley. 1955.

Hawkins, D. (editor). *The B.B.C. Naturalist*. 'Painting Wild Birds'. 2 b/w illustrations. Rathbone. 1957.

Hawkins, D. (editor). *The Second B.B.C. Naturalist*. 'Fishwatching'. 3 b/w illustrations. Adprint. 1960.

Landsborough Thomson, A. *A New Dictionary of Birds*. Contributor. 2 plates, 1 in colour. Nelson. 1964.

Vollmar, Dr. E. (editor) *World Wildlife Fund Yearbook 1968*. 'Otters in Danger'. 1969.

Boddey, M. (editor). *The Twelfth Man*. 'The Pond'. 3 b/w illustrations. Cassell. 1971.

Jackson, P. (editor). *World Wildlife Yearbook 1970–71*. 'Tenth Anniversary Year 1971'. Morges, Switzerland. World Wildlife Fund. 1972.

Duplaix-Hall, N. (editor). *1973 International Zoo Yearbook*. 'Reconciling the Irreconcilable – Wildfowl and People'. 7 b/w illustrations. Zoological Society of London. 1973.

Jackson, P. (editor). *World Wildlife Yearbook 1971–72*. 'World Wildlife Tenth Birthday Address'. Morges, Switzerland. 1973.

Campbell, B. and Lack, E. (editors). *A Dictionary of Birds*. Contributor. 1 b/w plate. Calton, Poyser. 1985.

4. A SELECTION OF ARTICLES BY SIR PETER SCOTT FROM JOURNALS AND MAGAZINES

'Wild Geese'. *Country Life*. 5 mono photographs of paintings. 24 Aug. 1929.

'Wild Geese and Ducks'. *Country Life*. 6 mono photographs of paintings. 30 Nov. 1929.

'Mr Spriggs and the Crane.' *Cornhill Magazine*. Oct. 1934.

'Barnacle Bill.' *Country Life Annual, 'Country Fair'*. 1 colour illustration. 1938.

'Snow Geese.' *Country Life*. 1940.

'The Magic of Wild Geese.' *Animal Pictorial*. 1 colour plate. Autumn 1945.

'Wild Geese in Winter.' *Times Newspaper*. 6 Dec. 1947.

'The Severn Wildfowl Trust.' *Gloucestershire Countryside*. 3 photographs. Jan/Mar. 1948.

'Catching Wild Geese.' *Country Life*. 2 April 1948.

'Duck Decoys and Wild Geese.' *Illustrated London News*. 26 June 1948.

'Happy Ending to an Arctic Expedition.' *News Chronicle*. 14 Nov. 1949.

'The Mysterious Sense of Direction.' *London Mystery Magazine*. 5 b/w illustrations. 1950.

'Over Manitoba Marshes.' *The Beaver*. 5 mono photographs of paintings. Sep. 1951.

'To Save the Hawaiian Goose.' *Times Newspapers*. Illustrated with photographs. 2 June 1952.

'Wild Geese in Icelandic Fells.' *Times Newspapers*. 26 Aug. 1953.

'Catching Wild Geese With Rocket Nets.' *Country Life*. 29 Sep. 1955.

'For Gold C Completed.' *Sailplane and Gliding Magazine*. Aug. 1958.

'Straight and Level Please.' *Sailplane and Gliding Magazine*. Oct. 1958.

Womans Journal. Cover illustration repeated inside. Feb. 1959.

'Slimbridge, Winter Home of the Wild Geese.' *Meccano Magazine*. 5 photographs. July 1959.

'I Live in Gloucestershire.' *Homes and Gardens*. Illustrated. 1960.

'Nature of Fear.' *Argosy*. March 1960.

'Search for Salvadoris Duck.' *Animals Magazine*. vol. 5 no. 4.

'Skin Diving: A New World.' *Animals Magazine*. vol. 5. no. 5.

'Sightseeing in East Africa's Game Parks.' *Animals Magazine*. vol. 5. no. 6.

'Peter Scott in Kenya.' *Animals Magazine*. vol. 5. no. 7.

Birds Magazine. Colour cover illustration. March/April 1967.

Birds Magazine. Colour cover illustration. Spring 1978.

'The Call of the Wild Geese.' *Birds Magazine*. 4 illustrations. Autumn 1980.

Compiled by Paul Walkden

Key to Illustrations

Acknowledgements

To start at the very beginning, I would like to thank Barbara Cooper for introducing me to Penelope Hoare of Sinclair-Stevenson Ltd, the publishers. Barbara has continued to give me advice and support during the birth of the book, for which I am extremely grateful. Penny has been wonderfully kind and patient, allowing me, with Keith Shackleton, a free hand in the selection of drawings and paintings.

Without June White this book would have been much more difficult. Sketch books deep in dust had to be dug out from cupboards, trunks, boxes and shelves; material for quotation had to be photocopied and presented in a massive file; and the correlating of the illustrations was a very complicated job – as original drawings were mixed up with photographic copies. June was also responsible for the typing and has helped me with the proof reading. I am greatly indebted to her. Last but not least, I would like to acknowledge the secretarial support I have received from The Wildfowl & Wetlands Trust.

I am indebted to Paul Walkden for allowing me to include his bibliography, to Lord Kennet for permission to use the watercolour *Bruin and the aeroplane*, to Phaidon for allowing me to include some of the paintings which appeared in *Observations of Wildlife* and to Alan Sutton for the use of paintings reproduced in *Sir Peter Scott at 80*. I would like to thank those owners of paintings by Peter Scott who lent their pictures to Retrospective Exhibition arranged by the Cheltenham Gallery & Museums, thus enabling me to have them photographed for this book.

Philippa Scott

Cormorants P.S. 1989

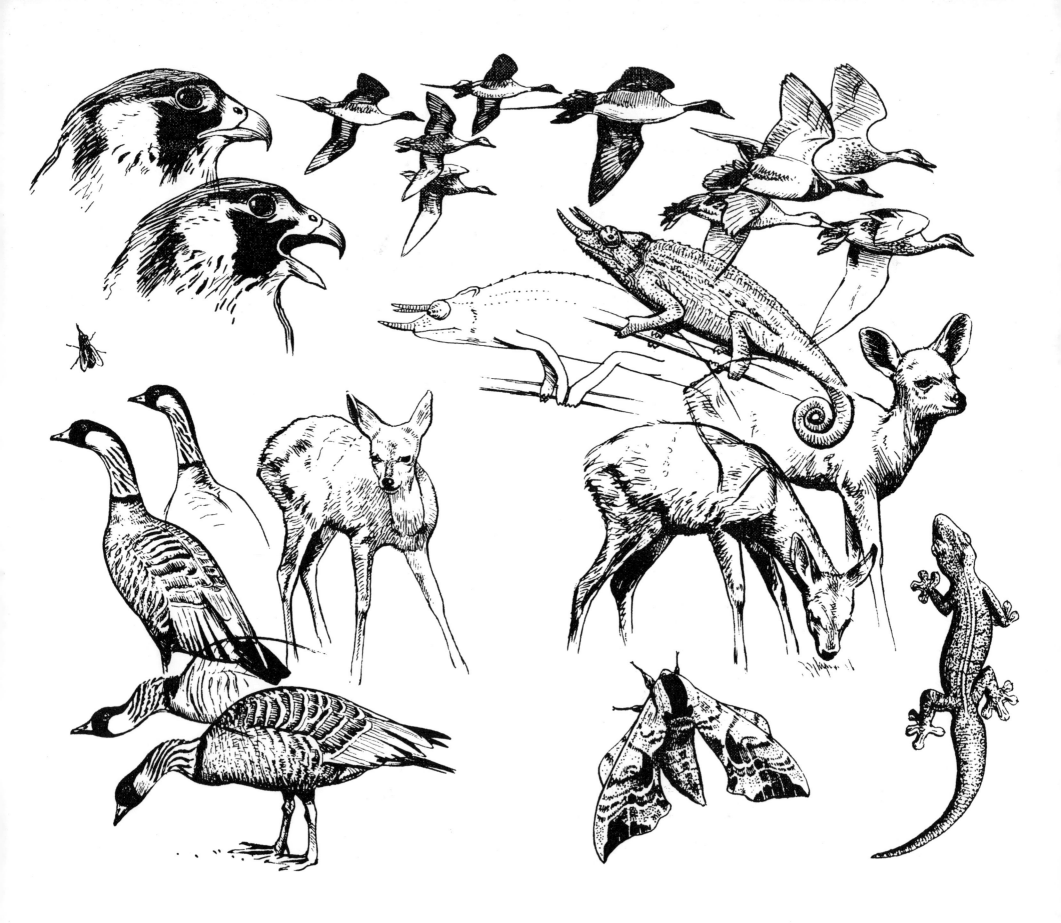

THE FOLLIES AND GARDEN BUILDINGS OF IRELAND

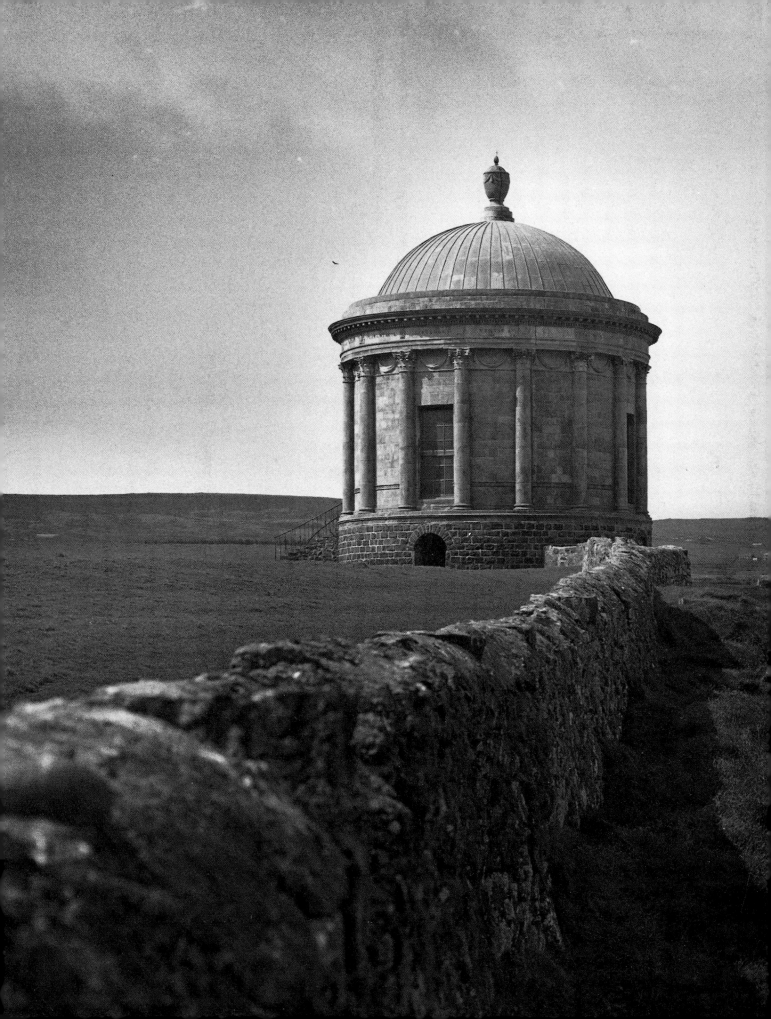

THE FOLLIES AND GARDEN BUILDINGS OF IRELAND

James Howley

Photographs by

James Howley and Roberto D'Ussy

Drawings by

James Howley and Duncan Moss

YALE UNIVERSITY PRESS NEW HAVEN AND LONDON

TO PETER PEARSON

Set in Linotron Ehrhardt by Best-set Typesetter Ltd., Hong Kong,
and printed in Singapore by C.S. Graphics

Designed by James Howley

Library of Congress Cataloging-in-Publication Data
Howley, James, 1956–
The follies and garden buildings of Ireland / James Howley;
photographs by Roberto d'Ussy and James Howley; drawings by
Duncan Moss and James Howley.
p. cm.
Includes bibliographical references and index.
ISBN 0-300-05577-3
1. Follies (Architecture)—Ireland. 2. Garden structures—
Ireland. I. Title.
NA8460.H68 1993
728'.9—dc20
93-1460
CIP

Title page: Mussenden Temple, Co. Derry. (Photograph
by Roberto d'Ussy.)

CONTENTS

PREFACE

This study started out as a history dissertation presented during the final year of an architectural course at the Cambridge School of Architecture. Since then the scope and size of the work have expanded considerably although the basic format of grouping the buildings as types, and not by geographical location, remains the same. This approach follows that of the late Barbara Jones, whose excellent *Follies and Grottoes* was the only published book on the subject at the time of writing my dissertation. The first edition of *Follies and Grottoes* dealt only with buildings in Britain, although the revised and enlarged second edition does include some Irish examples.

One problem encountered repeatedly throughout my researches was the ruinous state in which I found so many of the buildings. Neglect of Ireland's eighteenth-century architectural heritage is a problem even for the major large-scale buildings, not to mention obscure, small-scale garden structures. This resulted in the decision to prepare measured surveys of many of those buildings under threat, to preserve, at least, a drawn record of what had been. In time the scope of the surveys grew to include many others whose future was not in danger, for the benefit of comparison.

During one visit to Dublin I was fortunate to obtain a copy of Thomas Wright's *Louthiana* and I was interested to see that he had carried out a similar exercise in the mid-eighteenth century, by recording many of the antiquities which he could see were disappearing in Ireland at that time. While the drawings in this book cannot be compared to Wright's excellent illustrations, there is nonetheless an interesting parallel. The ruins which Wright surveyed in Co. Louth greatly influenced his ideas on landscaping and his many designs for garden buildings, some of which survive in Ireland. It is a cruel twist of fate that the innovative follies and garden buildings of Wright's day are now being recorded, in *Louthiana* fashion, as disappearing ruins. The object of this book is to preserve the memory of these buildings, and in doing so to applaud their art, while trying to unravel a little of their mystery and meaning along the way.

A great many people helped and encouraged me in the production of this book and it is only fair to thank all concerned in a full and detailed way. The Architects' Registration Council of the United Kingdom, the Irish Georgian Society, and the Georgian Group all kindly supported my work with research grants. David Griffin of the Irish Architectural Archive read most of the text and generously shared his remarkable knowledge of Irish architecture. Professor Alistair Rowan was equally generous and helpful in pointing out many of my omissions. Dr Malcolm Higgs, the head of Canterbury School of Architecture, and Dr Roy Hayes commented on parts of the text, and Fred London read it through in its entirety, making many thoughtful observations. May Hayes deserves my very special thanks for tackling the first rough draft and making the task of the above mentioned readers much less onerous. The Hon. Desmond Guinness and the Knight of Glin both encouraged and assisted my researches, as did Daniel Gillman, William Stuart, Ian Lumley, Roger White, Una Sugrue, Neil Kenmuir, and Rita and Pieter van den Boogaart. I am also indebted to John O'Regan, who encouraged me to turn a college dissertation into a book and suggested the addition of the measured surveys. At the start of my researches, when still a student, I enjoyed the enthusiastic support of the late Mariga Guinness, along with the pleasure of her company on several visits. Donald Moss kindly provided translations for the Latin inscriptions and Sandra Raphael deserves much credit for her thorough copy-editing of the final text. I would also like to express gratitude to all of the landowners and guardians of the estates on which many of the buildings in this study stand. In all but a few isolated instances I was warmly welcomed onto their land, and without such hospitality this book would have been greatly depleted. Although I have never met them, I must also acknowledge a debt to both Maurice Craig and Mark Bence-Jones, whose books are essential sources of reference to any student of eighteenth- and nineteenth-century Irish architecture. Many friends have helped throughout all stages of the work by holding the end of a tape measure or providing me with good company and often transport on a multitude of trips. My father Bert has accompanied me on most of the visits within the north of Ireland, and my wife Fionnuala has been a continual source of advice and support throughout. I am also grateful to John Nicoll who gave me the opportunity to design this book and then guided me through the process. Finally, there is one other person who has readily shared with me his own very special knowledge of Ireland's countryside and architectural history. He has also provided a constant supply of help, enthusiasm and friendship, and it is to him that this book is dedicated—with thanks.

Visiting Follies and Garden Buildings

While many of the buildings described in this book fall either on the edge of or within the public demesne, the majority stand on privately owned land. For anyone wishing to visit these buildings it is always important to respect privacy and adopt the common courtesy of seeking the owners' permission. In my own experience this has seldom been withheld, but it is no doubt dependent on the sense of visitors and their observance of the Countryside Code. Many follies and garden buildings in Ireland survive in a ruinous and dangerous state. To visit them one should wear sensible clothing and footwear, bring a torch, a companion, and a good supply of common sense. Accidents through lack of care may result in personal injury, causing the building concerned and others like it to be classified as dangerous structures, a sequence which often leads to their needless demolition. Being ruinous, they are often fragile and subject to further deterioration by clumsy or insensitive treatment. If in any doubt—keep out!

The Illustrations

With a few exceptions, all of the measured drawings were surveyed on site and drawn especially for this book. The surveys were carried out by the author, mostly with the help of Duncan Moss and Peter Wermund, and the drawing was shared equally between Duncan Moss and the author. All of the buildings were drawn at a scale of 1:100 and are reproduced to half this size at a scale of 1:200. This leads to a great disparity in the size of drawings, which range from under 10 feet to almost 150 feet in height. A single drawing scale is used the better to facilitate comparisons and demonstrate the great size of this range. The reader can measure the drawings with a simple metric ruler on which one centimetre will equal two metres. While the surveys were carried out to a fair degree of detail, some errors will no doubt have slipped in. Sophisticated height-measuring devices were not employed and on a few occasions the omission of a vital dimension was discovered only during the drawing up. The drawings of the Marino Casino as built were redrawn from the excellent survey drawings of 1917–18 by Alfred E. Jones. Similarly, Chambers's original design sketch has been redrawn, as I have been unable to discover its source. The basement plan and section of the Mussenden Temple were redrawn from a survey by Michael McCafferty and the ground-floor plan of the Temple of the Winds at Mount Stewart from the *Archaeological Survey of Co. Down*.

The fashion and travel photographer Roberto D'Ussy has enriched the photographic content of this book through his excellent cover photographs and many of the finest images within the text. Archive material has come from a variety of sources and thanks are due to the staff of the Courtauld Institute, the Sir John Soane Museum, the RIBA Drawings collection, and especially to the ever friendly staff of the Irish Architectural Archive.

All photographs and historic prints are by the author, or from the author's private collection, unless credited otherwise.

INTRODUCTION

Follies and Garden Buildings

Follies and garden buildings fall into a rather ill-defined class of architecture, which may partly explain why they have been so neglected by architectural historians throughout the years. Sir Banister Fletcher's authoritative *History of Architecture on the Comparative Method* (1896) makes no mention of the term 'folly' and gives only a brief reference to Sir William Chambers's masterpiece of garden architecture, designed for Lord Charlemont at Marino on the outskirts of Dublin. Written almost a hundred years later, the revised and enlarged nineteenth edition[1] provides us with less than half a dozen lines on the subject and cites a single example. Architectural historians have always placed great importance on the interpretation of buildings through categorization in terms of period and style. Follies and garden buildings fail totally to comply with any neat recognizable group because they are so inconsistent, a feature that contributes greatly to their charm. In one sense their designers are architecture's greatest plagiarists, happy to quote unashamedly from anything good that is going, with a rather cavalier attitude to time and geography. Egypt and China may provide inspiration just as readily as Greece or medieval Europe, and the time-scale of influence stretches back from Palladianism

1. Powerscourt gardens, looking towards the Wicklow mountains.

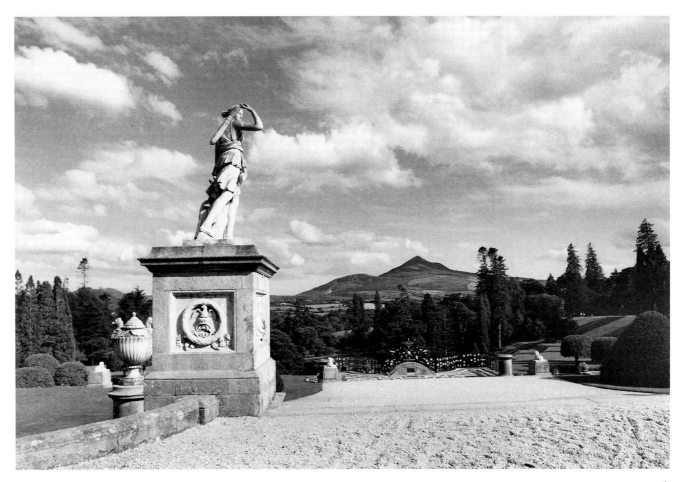

1

or the Gothic Revival to Antiquity and beyond to prehistoric primitivism.

Despite the frequency of historical quotation, the buildings only rarely result in an exercise of bland imitation, and even then they can often be more than acceptable by virtue of their setting and scale. In contrast, some other examples retain a remarkable originality, which seems to defy all precedent in a display of uninhibited imagination. Inconsistency and ambiguity are the only reliable points of reference for any serious attempt to define this odd collection of buildings, and it is these unlikely attributes which makes it so intriguing.

Starting from such a vague definition of the subject, the first problem is to try to limit the scope. A great many different building types fall happily under the all-encompassing, but not very specific title of follies and garden buildings. These may be large or small, frivolous or scholarly, and their beauty may be pastoral or sublime. The list of adjectives commonly used to describe them is as varied as the many different categories into which they can be roughly grouped: grottoes and hermitages, obelisks and columns, sham castles and eye-catchers, gazebos, towers and temples, to which in some cases can readily be added gates, lodges, bridges, and even some monuments and mausoleums.

Although the term folly is commonly used in describing buildings of this nature, no clear definition of it exists. The few authors who have directly addressed the subject generally tend towards definitions which are poetic in their imagery but vague in content. 'Follies are built for pleasure and pleasure is personal—difficult to define,'[2] or 'foolish monuments to greatness and great monuments to foolishness'[3] are two such examples. Others regret the tendency to refer to all Georgian landscape architecture as follies,[4] as this detracts from the intrinsic quality of the buildings and undermines their contribution to a unique art form, 'the Georgian landscape garden, which is after all generally reckoned to be one of this country's most original contributions to European civilisation'.[5] The author goes on to define a folly as being 'a building eccentric for the sake of it . . . with no obvious practical function except what may be suggested by some folkloric myth'.[6] This interpretation is consistent with the *Oxford English Dictionary* which gives us 'a building erected for no definite purpose; a costly structure apparently built for fantastic reasons, or a useless and generally foolish building erected in the grounds of a wealthy eccentric'.[7] These explanations may all contain some degree of truth, but they are by no means definitive. Many of the most eccentric and outrageous examples that we shall consider will include some element of function. This may range from the simplest of activities, such as sitting down to enjoy a view or drink a cup of tea, to quite sophisticated venues for banqueting, writing, or contemplation. Sometimes they serve the more serious functions of providing landmarks and navigation aids, or they may simply evoke memories of past events or loved ones. In this sense,

the late Lord Clark's definition, of follies as being 'monuments to a mood', is perhaps the most evocative.[8]

High cost is another factor often associated with the genre. While examples of uncontrolled extravagance do often occur, a great many will be found to be extremely modest in both their appearance and the cost of their construction. Through all these definitions two main threads seem to emerge. One is associated with foolishness or miscalculation—'a popular name for any costly structure considered to have shown folly in the builder'.[9] It is not uncommon to find grandiose building schemes being abandoned during construction or shortly after completion, especially in Ireland, where many of the eighteenth-century landowners were frequently absent. The earliest recorded reference is, however, found in Britain, when in 1228 a castle under construction on the Welsh border for Hubert de Burgh had to be razed to the ground because of a treaty concluded with the Welsh. This created much amusement as Hubert had entitled the building 'Hubert's Folly' on its foundation, thus proving prophetic. Probably the word used was *folie* which in French also means delight or favourite abode (many French houses are still named 'La Folie').[10]

Ireland has its share of such projects. Frederick Hervey, the fourth Earl of Bristol and Bishop of Derry, built two great houses in Ireland in the eighteenth century and one in England. He seldom lived in his first house at Downhill, Co. Derry; the second at Ballyscullion, also Co. Derry, which was started in 1787, was not completed at the time of his death and was demolished a few years later, having gained the local title of the Bishop's Folly.[11] His third house, Ickworth, which is very similar to Ballyscullion and which he did not live to see, still stands in Suffolk. Ironically, most of his time was spent on the Continent on a perpetual Grand Tour, seeking art treasures to adorn his houses. A later but no less foolish building venture was undertaken at Glenbeigh, Co. Kerry. This large castellated house, built in the 1870s, now survives only as a ruined shell known as Winn's Folly. It was designed by the English architect W. E. Godwin for the fourth Baron Headley-Winn, who proceeded to sue his architect for excessive costs and leaking roofs and walls. After the experience Godwin was to advise aspiring young architects to refuse all offers of commissions in Ireland.[12]

Near Lismore, Co. Waterford, are two fine castellated follies built around the mid-nineteenth century, one an impressive bridge and the other an expansive pair of gate lodges. These were to have been the forerunners of an ambitious castellated house which, legend claims, was never built, as the follies proved to be too much of a drain on financial resources. An important consideration is also the position of the observer and his own particular interpretation of a building. What may appear as folly to a starving tenant, employed in the construction of a vast obelisk on top of a mountain to provide famine relief during a severe winter, may seem quite another thing to a patron who was building well within his means.

Further ambiguity about the term and its meaning is caused by the not infrequent appearance of the word 'folly' on modern Ordnance Survey maps of Ireland. This may represent a structure practical or ornamental, still standing or, as is more often the case, long disappeared. Failure to find such buildings, or the sad recognition that they may now have gone, is sometimes compensated by the fact that much of the pleasure involved in their discovery grows from the challenge of the hunt. In some instances stories survive in explanation, such as those associated with the Bishop's Folly or Winn's Folly; for others such as Burrel's Folly near Drumquin, Co. Tyrone, or Charleton's Folly near Glenavy, Co. Antrim, we can only speculate. Hamilton's Folly, marked on a hilltop under the shadow of Slieve Croob in Co. Down, is another example of a building or project surviving in name only. In this instance there is a possible association with the Hamilton family who owned Killyleagh Castle, which stands on the south-west coast of Strangford Lough.

The second root of the word is associated with the French term *feuillée* which literally translated means leafy arbour. This source implies a more rustic approach, such as that employed in the creation of root houses and hermitages, which generally cost little to build. It has nothing to do with spectacle and ostentation but embraces nature in a more modest way. It is this latter group which is most closely associated with eighteenth-century theorizing into the origins of architecture through speculation on the form of the archetypal building or primitive hut, raising a number of interesting associations which are unfortunately beyond the scope of this study.

In purely stylistic terms the word folly is more widely used to describe buildings and structures which are Gothick[13] or castellated in nature, often accompanied by adjectives such as crude, rustic, or primitive. By contrast the classical buildings—temples, monumental columns, obelisks and the like—were more refined in their construction. These achieve a much greater level of sophistication and are, more strictly speaking, garden buildings, principally to provide ornament and secondly for any of a great number of functions. For the people who erected them stylistic rigour was seldom of any great concern. Buildings of many contrasting styles grew up side by side and strange architectural hybrids were often produced, such as the Hindu Gothick gateway at Dromana, Co. Waterford.

One thing common to all follies and garden buildings is that they were a source of great pleasure and pride to their owners and were constructed with a zeal and passion rarely found in the well-mannered lifestyles of rich eighteenth-century landowners. Whatever their cost, it should not be ignored that these buildings were the privilege of wealth, security, and peace. One needed land to build on, and sufficient time and money to dispense on projects which, even if functional, were seldom essential. Malaise and boredom may have stimulated some of the more eccentric follies,[14] while the notion of fantasy and the need for

escapism may also have contributed. Underlying all of these various factors was the wish to create objects in a landscape to provide aesthetic pleasure, for which purely functional aspects were, if not totally absent, at least a secondary consideration.

In a vague and rather tantalizing way, the term 'folly' has entered into common usage in the widest sense, encompassing all manner of styles, forms, and scales of building. Because of this no apology will be offered if this study spreads its net very widely. Many totally functional buildings will be included which demonstrate an element of conceit or pretension, or merely an energetic pursuit of the absurd. As the building's relationship to the landscape in which it stands is often its *raison d'être*, many plain memorial structures are included, which, although they might seem dull in a city, attain a quite different expression when erected in an Irish field.

The ephemeral nature of many of the forms of garden architecture means that only a fraction has survived the passage of time, which makes estimating their numbers quite a difficult matter. Barbara Jones records some 800 examples[15] mostly in England, Scotland, and Wales, and John Harris has suggested that there may be as many as 10,000 in Britain.[16] In Ireland I have, at the time of writing, identified over 600 examples and I suspect that there may once have been as many as twice this number. The late Mariga Guinness made the extravagant claim in a magazine article that 'Ireland has more follies to the acre than anywhere else in the world.'[17] Though not an easy claim to prove, the concentration of follies and garden buildings which have survived in the provinces of Leinster and Ulster must surely approach the density of those built in England, where the practice originated.

Before looking at the actual buildings it is necessary to step back and examine the social and artistic climate which

2. A typical early eighteenth-century garden layout, from Plurche's *Spectacle de la Nature*: first English translation, 1733.

first stimulated the desire to create them. This came about as the result of a radical change in the way man perceived his relationship to nature. It first became apparent in the early part of the eighteenth century in England and created a new form of artistic expression manifested in garden design that was unique in Europe. In common with the notion of the folly it has numerous names: the natural style, the Picturesque, the landscape garden, the English garden, *le jardin anglo-chinois*, to name but a few. It has been called quintessentially English[18] and most historians tend to regard it as uniquely so.

Essential to the shift towards a more natural style of garden design was a strong reaction to its direct predecessor, the strictly geometrical arrangements of the French and Dutch schools, which found expression in tightly clipped and very formal arrangements which emphasized symmetry, neatness, and order (plate 2). The arrival of this style was reinforced by the succession of William III to the English throne in 1689. Generally these gardens were small in scale, and sited to fall within the protective shadow of the house, such as those recently restored at Portumna Castle, Co. Galway (plate 3) and Drimnagh Castle, Co. Dublin. This reflected the civil instability of the time, when great houses were still influenced by considerations of defence.

The major influences on the new gardens were connected with politics, psychology, poetry, and painting,[19] and its main protagonists were men with literary backgrounds, such as Jonathan Swift and his friend, Alexander Pope, both of whom used their poetry to project propaganda for the cause. These men believed that nature should not be suppressed into a controlled and man-made order, but allowed to grow and express herself in a natural way. The architect Sir John Vanbrugh was also a major influence and his previous profession before turning to architecture (without book or lecture)[20] was that of playwright.

Vanbrugh's main contribution to the development of the natural style was to interpret the garden in a new way by expressing it as an ideal city. At Castle Howard in Yorkshire he enclosed a part of the estate with a fifteen-foot high brick wall with monumental gateways and sham fortifications. In the park (or enclosed demesne) urban devices such as obelisks and temples became reference points, both to create specific set pieces and also to lead the viewer round the estate. The process of scene-painting would have been well known to Vanbrugh the playwright. It was also the underlying principle of Alexander Pope, who believed that gardens should be designed like paintings.

In this case the paintings were those of three seventeenth-century painters, the Italian Salvator Rosa and two Frenchmen who lived mostly in Rome, Nicolas Poussin and Claude Lorraine. The late paintings of Poussin and the work of Claude Lorraine in particular portray figures in ideal arcadian landscapes adorned with fantasy buildings from classical Antiquity. Their effect is both picturesque and nostalgic, evoking memories of a glorious and civilized past. The natural style sought not only to let nature take her true

course but also to adorn her with buildings, to embellish and thus underline her beauty. The belief was that a natural landscape, no matter how beautiful, could be further enhanced by the addition of a building or structure judiciously placed to represent the presence of civilization in a balanced and unimposing way. The building could either evoke association through memory or allegory, or simply demonstrate man in harmony with nature.

Pope's guiding principle for the laying out of a garden and the siting of buildings and structures within it was based on the importance of discovering the *genius loci*[21] or the presence of the place. Once identified, by means of surveying the land in question, the place that could then be improved by planting or, if appropriate, by the erection of a building. Pope advocated that these improvements should be developed almost as if one was painting a picture on a canvas, with the elements so arranged to create form, light, and shade to the best scenic effect. Not content with theorizing, Pope demonstrated his viewpoint by creating a garden, albeit on a relatively small scale, at his home in Twickenham on the banks of the Thames. This small garden, which contained a number of garden buildings, including the first garden grotto to appear in England,[22] was opened to the public in 1736. It was much visited and had an enormous influence on the subsequent development of the movement.

There is no doubt that the influence of this movement dramatically changed the topography of England and touched virtually all forms of art during the eighteenth century. Ireland's contribution to these developments was a crucial one. In this period Ireland was socially, politically, and economically influenced by England, and in matters of taste was quick to follow, and in some instances improve on, her popular aesthetic values. Significantly, the two greatest pioneers of the new style in England, Pope and Vanbrugh, are both associated through close personal relationships with influential characters in Ireland. These two associations, along with several others, will be discussed in more detail in the following pages, as they constitute the direct links along which the new ideas reached Ireland, with an equally dramatic influence on her own landscape.

IRISH LANDSCAPES AND THE NEW GARDENING

In the early eighteenth century the situation in Ireland was very different to that found in England. Throughout the preceding centuries Ireland had experienced continual turbulence and bloody campaigns, as the English planters established their foothold on the island. By the mid-seventeenth century Cromwell's victories in Ireland had caused some two and a half million acres of land to change hands, at which time the Irish landowners were pushed to the west, to the wet and infertile lands beyond the Shannon.[23] The short war of 1689–91 which resulted in the Protestant ascendancy brought about a further population shift of one million acres, by which time only 15 per cent of the land in Ireland was left in Irish ownership.[24]

3. A reconstructed seventeenth-century garden layout at Portumna Castle.

The total population at the opening of the eighteenth century is thought to have been around two million, compared to the five million population to-day and the eight million peak before the famines of the mid-nineteenth century. Ireland was therefore a much wilder and more sparsely populated country than England, with a much less stable political climate. Defensive considerations were still a major influence on house-building throughout this period, with tower houses being constructed as late as the mid-seventeenth century.[25] The eighteenth century was to see a marked change in these patterns. As stability returned the population started to grow, doubling by 1785; and after years of deforestation, for shipbuilding and charcoal smelting, Ireland's woodlands started slowly to regenerate. These changes were to stimulate a great phase in house-building which, for the first time, was free of constraints imposed by the need for defence. Coinciding with new ideas and approaches to the landscape, the surrounding countryside was included on a scale never before imagined. By 1700 confident estate-owners were beginning to build houses with large windows, through which they could admire the newly planted exotic trees in their demesnes.[26]

In Ireland many of the new gardens of the early part of the century were laid out on geometrical principles influenced by their seventeenth-century forerunners. What is important, however, is that the geometry which generally spreads from the house is not contained, but looks out to embrace the surrounding countryside in the manner of Vanbrugh. This reaching out and drawing in of the surrounding terrain is an essential feature of a more natural style of gardening, as it created ideal settings for set pieces which were provided by follies and garden buildings. Records of early eighteenth-century gardens preserved in drawings such as that of Dromoland Castle, Co. Clare,[27] generally illustrate this more expansive approach, with the regular geometry radiating outwards from the house before diffusing into the natural surroundings. One of the most striking examples of this principle still existing is Powerscourt in Co. Wicklow (plate 1). Although the formal terraced garden at Powerscourt as it survives today dates from a much later period, it helps to illustrate the principle by providing a most beautiful example of man-made and natural landscapes combining harmoniously within a single composition. Bantry House in Co. Cork is another fine example, with a sea lough in addition to its mountain background. It is combinations such as these that have led Irish garden historians to echo the claim often made of the English garden by suggesting that: 'The Irish union of man-made landscape with innumerable natural loughs, rivers, mountains and sheltered harbours is an achievement unique in European art.'[28]

Another notable feature in the developing practice of

using buildings as focal points in the landscape is concerned with what has been described as 'The Cult of the Ruin'.[29] This refers to the practice of using a ruin in a landscape for its picturesque effect. One of the earliest records of this concept being advocated is, once again, linked to Vanbrugh, who in 1709 suggested the retention of the ruin of Wood-stock Manor in the park of Blenheim Palace.[30] His intention was to stimulate a sense of history through conjecture and contemplation of the ruin's past.

One has only to look at any of the large number of illustrated guides to Ireland, mainly written in the nineteenth century, or simply to travel even a short distance in the country today, to see that Ireland enjoys a superabundance of ruined buildings. Centuries punctuated by wars, along with the dissolution of the monasteries by Henry VIII, left many romantic medieval ruins, most of which were ideally suited to picturesque adaptation. The eighteenth- and nineteenth-century topographical writers made good use of such ruins in their innumerable illustrations[31] and the interest continues today, with many of the best-known tourist posters in Ireland highlighting this legacy. Among the most commonly used are Dunluce Castle on the Antrim coast, the Rock of Cashel, Co. Tipperary, and Glendalough in Co. Wicklow.

Including ruins in a garden for scenic effect could take one of several forms: using an existing authentic ruin, demolishing and reconstructing part or all of an existing ruin in a more favoured position, or building a completely sham ruin, with or without the inclusion of remnants of genuine Antiquity. All of these approaches can be found in Ireland and will be considered in detail within the appropriate chapter. The period of stability in Ireland did not, however, last. Political reversals combined with further population shifts in the country have once again provided new generations of ruins to grace the landscape, with the sad legacy of many great houses, through neglect or civil unrest, surviving only as crumbling, picturesque ruins which evoke, with no little irony, echoes of those very ideals which originally inspired their design.

Ireland has a very rich and varied topography concentrated into a relatively small area. It is ideally suited to the natural or English style of gardening and in many cases the need to *improve* was slight. The land had never been tamed or enclosed to the same extent as in England, and the creation of false lakes and hills in the manner of Capability Brown was, for the most part, unnecessary, as there already existed plenty of these in their natural state. Ireland's most famous adopted architect, James Gandon, recognized the country's obvious topographical qualities. Although his fame is largely attributed to great urban commissions, he was certainly interested in the challenge of placing buildings in rural settings. In later life his letters show that he was also a keen gardener. Thomas Mulvany, Gandon's biographer, notes that during the years of his retirement Gandon amused himself by sketching designs for villa residences for the possible embellishment of some friends' favourite

retreats.[32] Mulvany goes on to tell us that it was one of Gandon's fixed and favourite opinions:

> that few countries contained more varied scenery than Ireland, or offered more appropriate sites for the erection of private edifices, where all the comforts of civilized life might happily combine and contrast with the wild poetry of nature.[33]

In his essay *On the Progress of Architecture in Ireland* Gandon himself wrote enthusiastically on the subject and posed the question:

> can any country be mentioned that abounds with more diversity of attractions, constituting all the attributes of landscape scenery, than Ireland, and every way adapted for architectural embellishments, either for the bold and aspiring residence of the lordly baron, the graceful villa abbey, or the sequestered cottage.[34]

The particular wording of this description is especially perceptive, as he strikes at the very essence of the quality which makes single buildings in rural settings so arresting. This lies in the contrast between the civilizing hand of man and the 'wild poetry of nature'. When these two contrasting forces harmonize successfully each will enhance the other.

A varied and interesting topography is not the only contributing factor to the success of Ireland's geography. The climatic conditions and the resultant flora have also played a major part. Ireland is as famous for its verdancy as for the rainfall which causes it. The soil structure is also ideal, as the country is generally low in lime and rich in peat. Added to these is the marked effect of the Gulf Stream, which warms the ocean off the western seaboard, resulting in what is colloquially referred to as 'softness'. This quality ensures for Ireland milder winters and moister summers than any other country of comparable latitude, making it ideal for growing flowering shrubs, fine trees, and herbaceous plants.[35] The combination of all these conditions helps not only the indigenous flora, but also the great influx of foreign species introduced during the eighteenth and nineteenth centuries, from such scattered corners of the globe as North America, the Himalayas, Australasia, and the Andes.

With its varied topography, potential for rich vegetation, and a ready-made supply of romantic, picturesque ruins, Ireland was therefore ideally suited to exploit the mania for the new style of gardening which was to sweep the country. By the early eighteenth century Ireland's natural forests had all but disappeared, and the re-establishment of her woodlands was about to occur. This was carried out on the initiative of eighteenth- and later nineteenth-century land-owners, whose good husbandry and judicious tree-planting should not be undervalued, as it is very much their legacy which we still see and enjoy in the Irish landscape today. The history of the spread of the new gardening is in many ways a story of the individuals who inspired it, and one that has been comprehensively and eloquently told by Edward Malins and the Knight of Glin.[36] It is therefore not necessary to

dwell too long on the matter in this study, except to touch briefly on the various groups of individuals involved.

The protagonists were found in four separate groups, each of which contributed equally to the cause in slightly different but complementary ways. These groupings could roughly be gathered under the titles of theorists and propagandists, practitioners, gifted amateurs, and finally patrons. The chief propagandist in Ireland, Jonathan Swift, was not only a famous literary figure but also a pamphleteer, humanist, and political theorist. In many ways his role echoed that of his friend Pope in England. Of the professional practitioners (in time there would be many) Edward Lovett Pearce and Thomas Wright stand out as the most influential, Pearce for his elegant classical designs for garden architecture, which were in complete contrast to the delightful rustic constructions and mystical grotesques of Wright. Fundamental to any great artistic movement are its patrons, who in the early days were led by Swift's friends, Lord and Lady Orrery. Later in the century patrons included such discerning and informed noblemen as the ideologically and characteristically opposed Earls of Charlemont and Bristol. These two great characters, despite their political and personal differences, indulged in many similar interests, which they demonstrated through an impressive record of patronage.

It is, however, the gifted amateurs who were probably the most enthusiastic advocates of the new gardening, and at the forefront of this group were the Dean of Down and Mrs Delany. Their influence was profound as they successfully incorporated a little of everything, one moment as propagandists, the next as patrons of their own small demesne, in which they expressed their ideas. They also acted directly as practitioners, designing the garden structures and decorating them with their own hands. The Earls of Clanbrassil were also notable both as patrons and gifted amateurs, with estates at Dundalk (now altered) and at Tollymore, which still survives as a tribute to patronage of and pupillage under Thomas Wright. The importance and influence of these disparate groupings is underlined, not only by an impressive legacy of buildings, but also by an extensive written record of their interests and achievements. Many of the buildings are preserved in their completeness, while others survive only as ruins or drawings, or even more faintly, as written descriptions. The written material which has survived is of great importance, ranging from the private papers and biographies of the noblemen and the vast output of Swift, to the writings and drawings of Wright, the drawings of Pearce, or the extensive and richly informative *Autobiography and Correspondence* of the formidable and perceptive Mrs Delany.[37]

Of fundamental importance to the spreading of the new gardening in Ireland are the relationships of many of these characters with leading figures across the Irish Sea. Swift's close friendship with Pope is recorded in their wonderful correspondence, and Swift's friend Patrick Delany was also known to the influential poet who headed the English propagandists. Through Edward Lovett Pearce there is a direct link through his father's cousin, Sir John Vanbrugh, who was not only the pioneer but also the greatest of the early practitioners. Mary Glanville was a mature woman who had lived almost all of her life in England before she settled in Ireland in 1743 to become Patrick Delany's second wife, and she would certainly have brought many fresh and original ideas with her. Although his stay in Ireland was a brief one, Thomas Wright's influence was enormous, and it remains a mystery why so few seem to have recognized his importance in England.[38]

The eccentric Earl of Bristol and Bishop of Derry was also English and spent his early years there, before his attentions were turned first to Ireland and eventually to continental Europe. One final connection existed between Ireland and the very mainstream of the natural style in England. This is found in the exceptional relationship between Lord Charlemont and his architect and friend, Sir William Chambers. Apart from his many accomplishments as the leading British architect of his day, Chambers was also an enthusiastic theorist of the new style of gardening,[39] whose garden buildings, notably at Kew, are among his earliest and most important work. Dublin and Trinity College were to benefit from this friendship, and Chambers also designed many schemes for Lord Charlemont, including the Casino, which undoubtedly represents the high point of Charlemont's architectural patronage. As Chambers did not visit Ireland it is fortunate that the record of their friendship and the flow of ideas between them is preserved in their extensive correspondence.[40]

Having briefly outlined the favourable conditions the country enjoyed, and introduced some of the characters who were to exploit them so splendidly, it is an appropriate point at which to focus attention on the actual buildings which are the subject of this study. These will be presented in a number of different categories, arranged as building types rather than styles, periods, or geographical groupings. Such an approach will invariably result in a certain amount of back-tracking, as we return time and again to a familiar demesne to consider yet another different building type. To those lovers of neat chronological sequence this convoluted journey might prove to be frustrating. The intention is to avoid the production of a dull historical gazetteer by considering the buildings as individual types and attempting to understand why they were built, or quite simply to prove of my subject 'Though this be madness, yet there is method in't.'

CHAPTER 1

Obelisks and Columns

Obelisks and columns are not generally considered to be follies, sitting as they often do in the squares of English towns, respectfully announcing the beginning or end of some grand urban axis. In Ireland, however, although some obelisks and columns do (or, in the past, did) occupy urban sites, they are more commonly found in very natural locations, often perched on some precarious or eccentric base. Despite being somewhat peripheral to the more widely held idea of a folly, obelisks and monumental columns are important, as they were among the earliest forms of built objects to be placed in garden settings, albeit on the ornamental and reduced scale of formal seventeenth-century layouts. The history of the earliest recorded monumental obelisk to have been erected in England is related in a 1981 article entitled 'Ripon's Forum Populi'.[1] This dates the first obelisk as the one constructed in the market-place at Ripon in Yorkshire in the year 1702.

Obelisks originated several millennia earlier as common features in the architecture of ancient Egypt. This enduring architectural element which, unlike the column or arch, has no structural function, has enjoyed a very chequered history in terms of its popularity. Several hundreds are thought to

4. Conolly's Folly, Castletown, rising above the flat plains of Kildare. (Photograph by Roberto D'Ussy.)

have stood in ancient Egypt, where their mysterious role is understood to have been symbolic, as representations of 'the pillar of life'. An obelisk consists of a tapering, square-section column which is topped with a pyramidon or small pyramid. A true obelisk is monolithic, being carved from one block of stone, and required great engineering and masonic skill to construct and erect. In origin they are unique to Egypt, where they often appeared in pairs to dignify temple entrances,[2] and little is understood about their symbolic function, although they are sometimes associated with sexual rites, hermetic wisdom, and secret societies.[3]

In much later times they came to represent liberty, like the Washington Monument in the United States. This obelisk at 555 feet high is the tallest in the world. Being constructed of masonry it is, however, not a true obelisk. True obelisks were erected in New York, London, Paris, Rome, and Constantinople (now Istanbul), all having been transported at great expense and with considerable engineering skill from Egypt. The outside world's fascination with the obelisk started many centuries earlier, during the Roman occupation of Egypt. This fascination has often reached extremes, as evidenced by determined attempts to transport them around the world. Ferrying a 300–400-ton piece of stone across the Mediterranean Sea would pose a daunting challenge with the use of modern technology, yet the Romans managed the feat in wooden galley ships. In total they transported up to fifteen true obelisks and erected them, along with numerous copies,[4] in their capital. The sites were generally important civic locations, such as the Circus Maximus, where one was erected by the Emperor Augustus. The Roman obsession with obelisks is unclear; certainly they symbolized the successful conquest of another nation, the achievement of a difficult challenge to stimulate the Roman ego, or perhaps they were simply regarded as beautiful objects.

The plundered Roman obelisks first came under attack after the decline of the Empire, when barbarian invaders vandalized them or Christians condemned them as pagan symbols. By the sixteenth century only one remained, standing in obscurity to one side of the new St Peter's basilica. A succession of popes expressed an interest in moving it into a more prominent position before Pope Sixtus V succeeded in doing so, with the aid of the architect Domenico Fontana. The idea was to transport the obelisk onto the axis of St Peter's and convert it to Christianity by surmounting it with a cross to purge its pagan past. A great spectacle built up around this very public feat of engineering, which required nearly a thousand men and a hundred horses and took several months to complete during the year 1556.[5] The success of the operation made Fontana's reputation and led to the excavation and resurrection of several other obelisks in Rome. This helped to reinstate the obelisk in the architectural vocabulary of the western world and created an interest in the form, which not only subsequent popes, but also other nations, were to emulate as Rome became the dominant force behind Western architecture.

5. Bernini's obelisk in the Piazza Navona, Rome.

The following century was to see the re-erection of further obelisks in the city of Rome. Several now stand in piazzas designed by the great master of Italian baroque, Gianlorenzo Bernini, who also designed the colonnade which encloses the obelisk of Sixtus V in St Peter's Square. Bernini's obelisk in the Piazza Navona is of particular interest as its arrangement was to become common to many Irish obelisks. The Navona obelisk was erected around 1650, on a rock-like cross-vaulted base of travertine and marble (plate 5). Known as the Four Rivers Fountain, it is adorned with figures and animals to represent the four great rivers of the world.

Vanbrugh was interested in the obelisk form and designed the second oldest known obelisk in England in 1714 for the Duke of Marlborough. Nicholas Hawksmoor, who often collaborated on work with Vanbrugh, was particularly interested in the obelisk form, and their work at Castle Howard probably marks its earliest appearance in a natural setting. Hawksmoor knew of Bernini's obelisk at Piazza Navona, wrote a treatise on the subject entitled *Explana-*

6. Stillorgan obelisk: elevation and plan.

tion of Ye Obelisk,[6] and designed an obelisk spire for St Luke's church, in London's Old Street. Prior to this the obelisk had been known in England in Elizabethan and Jacobean times only as a decorative feature with funerary associations. By the eighteenth century, mainly as a result of its promotion by Vanbrugh and Hawksmoor, obelisks lost their iconological validity and their funerary symbolism, as they became monuments to victorious generals and noble ladies.[7]

With such interest shown by his mentors Vanbrugh and Hawksmoor, it is not surprising that Edward Lovett Pearce introduced the form into Ireland. At Stillorgan, Co. Dublin, he designed an impressive example as a monument to Lady Allen, on a vast cross-vaulted rocky base. This monument, which may have been designed as early as 1727, bears certain similarities to Bernini's obelisk in the Piazza Navona, although the scale is completely different and the base of the Stillorgan obelisk is rustic and not at all figurative, like its Roman predecessor (plate 6). The structure is eloquently described by G. N. Wright, the Professor of Antiquities to the Royal Hibernian Academy, who wrote in 1831:

> The pedestal is formed of rock-work, now clothed with lichens, having a dark grotto or cave within it. Four flights of steps wind through the rude masonry and conduct to the foot of a beautiful delicate pyramidal column fifty feet in height tapering gracefully to its summit. A small apartment in the base of the pyramid is entered by four doorways opening to the resting place above the rock work.[8]

Some confusion may arise from the reference to pyramids, but apart from that, this very clear description can be verified today, as the obelisk still stands in a fine state of repair. The original garden setting has disappeared, but the monument stands as nobly as before. The fine cut stone of the obelisk contrasts strongly with the very rugged base, especially the door cases and their triple keystones (plate 7) which echo details of Hawksmoor's St Alfege, Greenwich, and St George, Bloomsbury. Inside the chamber at the base of the obelisk there is further good stonework which takes the form of a domed circular space, with niches or seats placed between each pair of the four entrances. The joints in the stone floor pattern follow the circle and, when viewed in plan, give an impression of ascending geometrical order rising from the disorder of the rusticated base below. Some of Pearce's drawings for the obelisk still exist, and on one he has written 'Lady Allen's burying-place, to be a monument to patience'.[9]

There remains some doubt as to the actual date of construction, as Professor Wright claims it to have been a product of famine relief of the 1740s[10] while several other sources date the construction much closer to that of its design.[11] Another source maintaining a date of 1727 is F. E. Ball who in 1902 described the monument in great detail[12] and claimed it as the great work of Pearce's life. If not his greatest work, it certainly ranks among Pearce's finest achieve-

7. Stillorgan obelisk: detail of the rusticated base.

ments and is a fitting example to open the descriptive side of this study. As with many of the buildings to follow, the Stillorgan obelisk demonstrates that a structure principally designed for memorial purposes can also satisfy a number of secondary functions. In this case it is a monumental piece of garden ornament, a garden shelter within the great rocky base, and a place of rest and contemplation within the small chamber at the base of the obelisk shaft. From this chamber there would once have been fine prospects of its setting and distant views of Dublin.

The Stillorgan obelisk proved to be the forerunner of an entire generation of cross-vaulted obelisks in Ireland, many of which are attributed to the German-born architect Richard Castle (sometimes spelt Castles or Cassels). Castle came to Ireland in 1729 to work as an assistant to Pearce and was fortunate to inherit many of his clients and commissions after Pearce's tragic early death at the age of 33. Two modest examples of brick cross-vaulted obelisks exist at Dangan, Co. Meath, an estate which, according to one contemporary account, once boasted twenty-five obelisks.[13]

Of these the remaining two survive in a rapidly decaying state.

The more complete of the two[14] is on a hill on an axis with the house which is now also a ruin, and is built entirely of brick set on a stepped stone base (plate 9). It is a well-proportioned composition and its appearance is enhanced by the crumbling disintegration and deeply weathered joints of the brickwork. Before long it will surely resemble the second remaining example, which was once of almost identical design but is now merely an eroded stump on a small hillock in the middle of a cornfield (plate 8). The modest nature and simple brick construction of these two obelisks suggest that many more may at one time have graced the estate. If so, it is likely that they would have been similarly placed on areas of raised ground, to create linking vistas between them and the house.[15]

A more decorative and refined obelisk on the cross-vaulted theme is to be found at Belan, Co. Kildare. This was also designed by Castle, and comprises a fine cut-stone structure in granite topped with a carved eagle, allegedly constructed in memory of a horse (plate 9). (Of all the many obelisks in Ireland, there are almost as many commemorating animals as monarchs.) Also constructed in the Belan demesne was a second obelisk precariously balanced on four pillars standing on a high square plinth (plate 9). Of all Castle's obelisks the grandest, and certainly the largest, is the towering edifice at Castletown which is known as Conolly's Folly. This was erected by Mrs Conolly, widow of William Conolly,

8. Dangan: detail of the ruined obelisk.

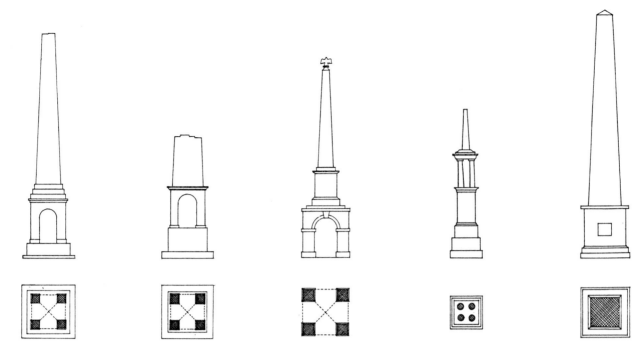

9. Obelisks at Dangan, (two) Belan, (two) and Killua: elevations and plans.

who was the speaker in the Irish House of Commons in the early eighteenth century.

Speaker Conolly amassed a great fortune, some of which went to build what is generally considered to be the first great Palladian mansion in Ireland designed to correct classical proportions. The architect of this design was unknown until quite recently, but it is now thought to have been largely the work of an Italian architect called Alessandro Galilei, with assistance from Edward Lovett Pearce.[16] The vast thirteen-bay central block (which Sir John Summerson once described as being of stupendous monotony)[17] is similar to an Italian palazzo. It is relieved by projecting wings linked back to the house by curving colonnades. Castletown demesne also contained a number of interesting follies and garden buildings apart from the obelisk, all of which will be discussed in due course. Through Pearce the link to Richard Castle is established, and his authorship has been argued convincingly in an *Irish Georgian Society Bulletin* article entitled 'A Case For Richard Castle'.[18] By coincidence Galilei's best known work, the façade of the basilica of St John in Lateran in Rome, stands in a piazza facing one of Sextus V's resurrected obelisks.

The obelisk or 'folly' as it has become known, consists of a shaft 70 feet high constructed on top of a series of diminishing stone arches which also measures 70 feet in height. The impression is monumental in the extreme, like a bizarre collection of architectural elements performing a human pyramid-style balancing act (plate 4). It has been called both the ugliest building in Ireland and the one real piece of architecture in Ireland; it has also become one of

Ireland's best-known follies. Standing on an axis two miles to the rear of Castletown House, from where it can be clearly seen despite its distance, the obelisk was built to provide famine relief after the severe frosts of 1739. The relief amounted to the sum of a halfpenny a day, which was considered to be a great act of philanthropy. In what must be the most quoted letter in Irish architectural history Mrs Conolly's sister, Mary Jones, refers to the building of the obelisk at a cost of more than £400.[19]

The design of the structure with its heap of arches, eight in all with five different sizes, is Palladian in detail and baroque in its overall composition (plate 10). Generally it is quite plain except for the stone pineapples resting on the curved tops of the lower side arches and the carved eagles perching on urns adorned with faces, which stand on tall plinths to either side of the obelisk shaft (plate 11). From the chamber behind the highest (and smallest) arch, under the pediment below the obelisk shaft, there are fine views back towards the house and the distant Dublin mountains. This chamber is reached by a narrow staircase within the massive piers (plate 12). In the early 1960s the Irish Georgian Society restored the folly with the help of a firm of Belfast steeplejacks, as it had deteriorated badly. During this work a number of original and ingenious construction techniques were discovered which were designed to shed rainwater off the masonry, thus protecting the joints, generally the weakest points.[20]

The architectural merits of the structure are probably best left to the eye of the beholder. Structurally it deserves great respect and it is very likely that the celebrated English

10. Conolly's Folly: elevation.

11. Conolly's Folly: detail of the eagle urns. (Photograph by Roberto D'Ussy.)

architect, Sir Edwin Lutyens, visited it on one of his trips to Ireland. It may even have provided the inspiration for his own design for the vast multi-arched memorial at Thiepval which commemorates those missing on the Somme during the First World War. In keeping with many original works of architecture it is no stranger to controversy, and one can only speculate on the reasons behind its impressive monumentality. Undoubtedly it provides a symbol of the great wealth and influence of Speaker Conolly, and in its day would have been a major landmark and vantage point on the flat plains of Kildare. Either way it is unlikely that its patron, Mrs Conolly, would have been pleased with the folly suffix the building has subsequently inherited.

More recently the folly has become the emblem of the Irish Georgian Society, and their logo is based on a delightful early drawing of it. In this sense the building has inherited a new meaning and significance, as the symbol of that small but resilient group of enthusiasts who are determined to protect Ireland's eighteenth-century architectural heritage.[21] While all obelisks include the pure and exciting form of their shaft, they are generally of little interest spatially. With the Stillorgan and Castletown obelisks there exists a rarely found complexity and dynamism, with the possibility of walking under, clambering over, and entering into the structures.

When compared to these two obelisks most of the others may seem rather dull and tame, and certainly none of the others displays the same degree of architectural flair. It would, however, be a mistake to discount them, because even if they do lack a flamboyant design, the very nature of their setting can often combine to produce a startling scenic effect. Stillorgan and Castletown, though spectacular in themselves, receive little help from their flat surroundings, but with the right setting even the dullest of obelisks can come to life and add a new dimension to the landscape in which it features.

12. Conolly's Folly: plan showing the staircase to the viewing level.

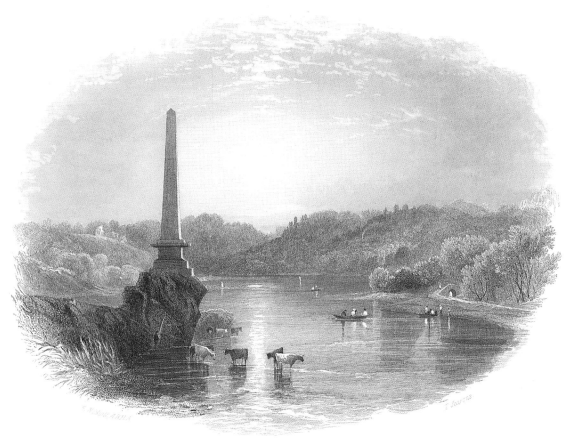

13. Boyne obelisk, engraved from a painting by Andrew Nicholl in
Bartlett's *Ireland Illustrated*.

One of the finest examples of this was the Boyne obelisk,
erected in 1736 supposedly at the point where William of
Orange led his army across the river to rout the Jacobite
army. This relatively plain obelisk was constructed upon an
impressive rocky outcrop beside the river on a site that
almost resembles Bernini's and Pearce's artificial versions.
We are told that the vertex of the shaft, which perched on a
picturesque rock twenty feet high, was 150 feet above the
river.[22] The lovely nineteenth-century engraving of a painting
by Nicholls (plate 13) clearly supports Samuel Hall's account,
and the monument is unique in being the only contemporary
structure to appear in Wright's *Louthiana*. It was blown up
by patriots in the 1920s, leaving only a small portion of a
stump, which even today remains stubbornly picturesque.

Other plainer obelisks in interesting settings include the
Ross Monument, erected in 1826 in Rostrevor, Co. Down, on
the shoreline of a sweeping bay with the Mourne mountains
as a splendid backdrop. This monumental granite structure
(plate 14) was designed by William Morrison to commemorate
Major-General Ross, who died during the American War of
1812–14. Fellow officers and the nobility and gentry of Co.
Down subscribed more than £2,300 towards its cost.[23]
Similarly engaging, more by virtue of its location than its
design, is the obelisk at Castle Dillon, Co. Armagh, which
stands with great prominence on a small hill and serves as a
useful landmark for much of the surrounding countryside.
This obelisk was erected by Sir Capel Molyneux, third
baronet and MP, to commemorate the winning of indepen-
dence by the Irish Parliament in 1782[24].

The largest of all Irish obelisks is the Wellington
Testimonial which stands in Phoenix Park, Dublin. This
enormous construction is perhaps appropriate for the man
whose family seat at Dangan was alleged to have contained
some twenty-five obelisks, although in Trim, Co. Meath, he
perches on an altogether more modest pillar. The obelisk,
which was erected in 1817, is the largest in Europe and
must surely be one of the ugliest. Hall describes 'as ungainly
and ungraceful an example of bad taste as the kingdom
could supply'; he goes on to claim that the cost of 'this
absurdity' exceeded £20,000.[25] Further distaste was echoed
by G. N. Wright in 1831:

£26,000 was placed at the disposal of a committee,
composed of persons of acknowledged taste and much
experience in the fine arts, and a competition was an-
nounced. The majority appeared to favour Mr Hamilton's
very elegant obeliskal design, while the men of pure
classical taste at once claimed the appropriate model

14. Rostrevor obelisk. (Courtesy of the Irish Architectural Archive.)

presented by Bowen copied from Trajan's Pillar. The most colossal, but least attractive, the design of Mr. Smirke, was however selected by the committee, to whom the public had delegated full power for that purpose.[26]

Colossal is a fair description, with its battered sloping steps with a periphery of 480 feet (plate 15), rising to a height of 20 feet, supporting a sub-plinth from which a pedestal 25 feet high rises to support the shaft of the obelisk, the top of which stands 205 feet above the ground below. At the time of its construction it was the largest obelisk in the world, and today it remains the largest in Europe. The plinth is adorned with bronze reliefs by the sculptors Kirk and Farrell, cast from cannon captured during the glorious campaigns they depict. An equestrian statue of Wellington, which appears on a much more elegantly proportioned version of the monument in a nineteenth-century engraving, was never added.[27] Despite the crudeness of its design the obelisk has long provided an important landmark for Dublin, as its clever siting exploits the long clear vista through the city provided by the River Liffey.

The Wellington monument is surprisingly popular today and the base is frequently seen swarming with visitors. It has not met with any of the hostility shown to monuments to other royal and political dignitaries, perhaps as a result of the heavy and lumbering design, which makes it rather intimidating, or else because the 'Iron Duke' was at least born in Ireland. In common with many other follies, the Wellington Memorial is not without its fanciful legends; in this case, most befitting the Egyptian funerary associations of the obelisk and its pyramidal base, they concern the accidental entombment of a drunken footman, last seen at the inaugural luncheon party held in a hollow chamber within the structure, which, in true Pharaonic tradition, has remained securely sealed ever since.

Elements of the ancient Egyptian masonic tradition, including the obelisk, have entered the symbolic language of Freemasonry and, not surprisingly, masonic associations can be traced to a number of Irish commemorative obelisks. These include Stillorgan, Rostrevor, the Wellington Testimonial, and the Gillespie monument in Comber, Co. Down.[28] The latter example, raised to the memory of Major-General Sir Robert Rollo Gillespie, is the most overtly masonic, with recognizable symbols adorning decorative panels on the shaft. This is topped not by a pyramidon but by an abacus supporting a statue of Sir Robert, a soldier adventurer who was killed in action at Kalunga, India, in 1814. According to the long inscription on the pedestal Sir Robert's dying words were 'One shot more for the honour of Down.'

Of the remaining obelisks, and there are a great many, the majority are of the 'victorious generals and noble ladies' variety, with quantities recording royal visits and not a few the demise of a beloved beast. The town of Dunlaoghaire contains an interesting small obelisk erected in 1823 to mark the point of George IV's departure from Ireland in 1821 (plate 16). This stands on four large carved stone balls, one of which has since disappeared only to be replaced by a block of wood. In a land and time famous for its field sports, obelisks associated with horses, hounds, and hunting are well represented. Examples include the delicately carved Brindley obelisk of 1880 near Ashbourne, Co. Meath, erected in memory of Mr Brindley, master of the Meath Hounds.

15. Wellington Testimonial: detail of the monumental stepped base.

16. George IV obelisk, Dunlaoghaire: a nineteenth-century vignette from Hall's *Ireland*.

Another is the Master McGrath memorial, a modest affair, more of a stone plaque with a carved relief of the greyhound of that name, topped with a small obelisk. It was erected in 1873 and later moved to its present setting near Dungarvan, Co. Waterford.

Other obelisks record all manner of significant events, not least the planting of the first potato in Ireland. This momentous event is alleged to have been carried out by Sir Walter Raleigh and the obelisk commemorating it is on a small hill not far from the ruined shell of Killua Castle, Co. Westmeath. The obelisk is quite crudely proportioned (plate 9) although built of well-cut stone, the joints of which are now weathering badly with several of the blocks becoming visibly loose. No reference is made to the potato in the brief inscription which simply reads 'To the memory of Sir Walter G Raleigh' on one side, and on another 'Erected by Sir Thomas Chapman Bart. A.D. 1810'. Once again this rather plain example does much to enhance the picturesque effect of rolling hilly pasture-land, to which the distant ruin of the house adds another layer of historical association.

One final obelisk of note is to be found in the grounds of Garbally Court, Ballinasloe, Co. Galway. This is a most unusual structure which marks the end of a long cross-axis to the garden front of the house. The obelisk stands on a high stepped plinth of square plan with the shaft rising from an octagonal base (plate 17). Eight projecting stone ribs spring from upturned scrolls, the shaft is hollow and pierced

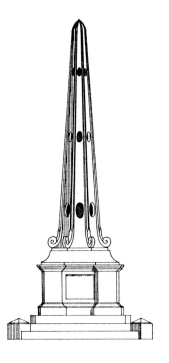

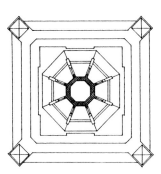

17. Garbally obelisk: elevation and plan.

to startling effect by three rings of eight elliptical openings which diminish in size as the obelisk tapers. This unique essay in obelisk design is the absolute antithesis of a true obelisk, as it so clearly demonstrates that, far from being monolithic, it is in fact hollow. The Garbally obelisk is in no way diminished by its flamboyant baroque-style madness, which makes it one of the most interesting to be found in the country.

A carved inscription running around the base reads as follows: 'This spire finished in December 1811 was erected from a design presented gratuitously by J. T. Grove Esq. Architect of the British Post Office and Board of Works to Richard Earl of Clancarty.' Such a full and concise inscription on a garden building is very rare, and must further endear this building to all architectural historians, who are generally more accustomed to scratching around in the brambles for date-stones and inscriptions, which rarely if ever exist.

Having considered a number of Ireland's more eccentric

obelisks, it is perhaps fitting to leave the final words to Gandon, who offered some rather quirky observations on the subject. He begins by stating that no monument could be more simple in design, construction, or durability than a single pillar, and goes on to suggest that:

A large block of stone being erected vertically, it might easily occur to a reflecting mind, that, by reducing the top to a pointed shape, it would not only preserve it from the weather, but also contribute to the beauty of its appearance, might have given rise to the obelisk.[29]

It would appear that Gandon based his supposition more on the climate of his adopted country than that of the obelisk's country of origin.

Monumental columns are generally less interesting than some of the more elaborate obelisks, although many are notable because of their siting or the fact that they sometimes make extremely good vantage points. When topped with a statue and placed in a rural setting they can provide the most romantic of landmarks. The precedent for this form dates back to ancient Rome, where a number of impressive examples still stand. These were mostly built in the second century AD

18. Nelson's Column: in a nineteenth-century view of Sackville Street from Bartlett's *Scenery and Antiquities*.

to commemorate famous military and naval victories and to exalt the emperor who presided over them. The most famous Roman column is that of Trajan, built AD 114 adjacent to his basilica. It is a Roman Doric column with a total height of 115 feet and is adorned with a continuous spiralling relief depicting his glorious victories. At the base is an entrance to the tomb chamber of Trajan, from where a spiral staircase rises through the shaft to a statue on top of the capital. In keeping with the Christian propriety now dominating this city, Trajan's statue has long since been replaced by one of St Paul.

Ireland was once well endowed with columns on the Roman model, with Nelson, Wellington, and a variety of other noble and military men represented. The most famous of all was Nelson's Column (known as 'the pillar') in Sackville Street, now O'Connell Street, Dublin (plate 18). Work on the structure started in 1808 after a lavish ceremony to mark the laying of the foundation stone in February of that year. Although it was designed by the English architect William Wilkins, its construction was supervised by Francis Johnston, in whose hand a drawing exists, annotated with an estimate of cost of £4,803.[30] It was certainly not a beautiful object, but one has only to look at early engravings or even more recent photographs to appreciate its great importance as a piece of cityscape, creating a focus for the wide and impressive

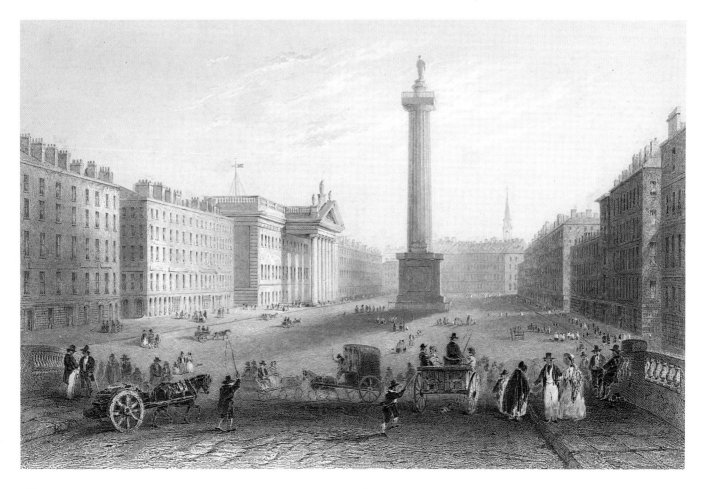

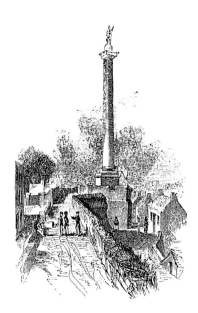

19. Walker's Column, Derry: a nineteenth-century view from Hall's *Ireland*.

sweep of Sackville Street. An ascent of Wren's beautiful column to commemorate the Great Fire of London shows us just how special these open-air panoramic views can be. A mid-nineteenth-century account of the Dublin column relates that Nelson's prospect was equally good:

> The Nelson pillar consists of a pedestal, fluted column, and capital of the Tuscan order, surmounted by a statue of the naval hero. The entire height of the pillar and statue is one hundred and thirty-four feet four inches. From the top an extensive view of the city, the bay and the surrounding country will well repay the trouble of the ascent.[31]

From its earliest days the column has stimulated controversy on grounds as varied as the lack of taste in its design or Nelson's lack of morals.[32] In more recent times, following the birth of the Irish republic, it continued to rankle, even though W. B. Yeats and Padraig Colum both argued for its retention. On 8 March 1966 the argument ended as the top of the structure, along with Thomas Kirk's fine statue, was blown up by 'person or persons unknown'. The army was later called in to finish off the job by blowing up the stump; and with that ironic twist Dublin lost one of its best-known if not best-loved monuments.[33] It is a shame that none of the several candidates nominated at various times to replace Nelson, ranging from the Virgin Mary and St Patrick to J. F. Kennedy and Eamon De Valera, was ever substituted so that one might still have climbed up to enjoy that unique view of Dublin.

An annotated measured drawing of the plan and elevation of Nelson's Column survives in the RIBA Drawings Collection in London, signed by one William Deane Butler and dated 21 June 1841. The drawing seems to have been

intended as a comparison between Nelson's Column and the Spring-Rice Column, which still stands in Pery Square in the centre of Limerick and is similarly depicted. The Spring-Rice Column was built in 1828 to support a statue of Lord Mounteagle, and at a height of only 79 feet is substantially smaller than its Dublin predecessor. Mr Butler was obviously unimpressed with the Limerick column and added the following caustic note about its author: 'There is nothing in the way of architecture to be admired, the design is from the pencil of a young aspirant Henry Baker Esq. (not very architecturally reared).'

Another strictly urban column which once stood in the city of Derry was the Walker Column, a Roman Doric structure which, although smaller in scale (at 81 feet) than Nelson's pillar, stood with such dramatic effect on the walls of the city (plate 19). This monument was erected in 1828 to commemorate the siege of Derry in 1688–9. It supported the heroic patriot, the Revd George Walker, complete with arm outstretched, who inspired defenders with the famous cry of 'No Surrender' during the siege of 1689. The statue of Walker by John Smyth of Dublin held a Bible in one hand and a sword in the other, which in true follyesque tradition is reputed to have fallen from his grasp on the day Catholic emancipation was granted. Like the Dublin column, Walker's Column was also accessible until it suffered a similar fate.

A third column to have fallen foul of political bombing was built at Caledon, Co. Tyrone. This was designed by

20. Caledon monumental column prior to its demolition. (Courtesy of the Irish Architectural Archive.)

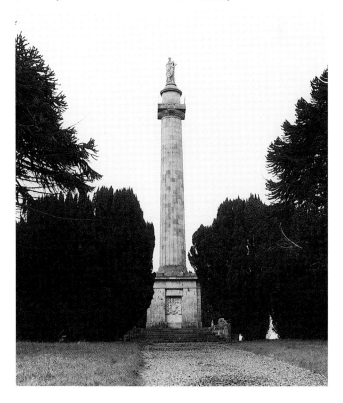

21. Monumental columns at Hillsborough, Rostellan, Dartry, Birr and Enniskillen: elevations.

William Murray in 1840, in a Greek Doric style with a tall plinth surrounded by four couchant lions. It was surmounted by a statue of the second Earl of Caledon, also by Thomas Kirk, and stood flanked by Irish yews in an avenue of monkey-puzzle trees (plate 20). Now only part of the base survives. Attacks on politically sensitive monuments have sadly become an all too common occurrence in Ireland, in a practice which has been eloquently described by one commentator as 'the senseless vandalism of the defenceless symbols of a bygone age'.[34]

The columns of some of the other 'noble generals' have fared somewhat better, such as that of Sir Galbraith Lowry-Cole, one of Wellington's generals during the Peninsular War. He stands on a fluted Doric column on a hill in a small park on the edge of Enniskillen, wrapped in a great cloak and leaning on a curved cavalry sword (plate 21). Around the base of the column is the trace of a fort, with arrow-shaped bastions in the ramped turf. The column, which was erected in 1845, also contains a staircase which gives access

to the abacus-block gallery, and is sometimes open for the public to enjoy wonderful views of Upper and Lower Lough Erne and the delightful island setting of Enniskillen. A number of smaller-scale columns crowned with statues still survive, with Wellington on one at Trim, Co. Meath, and, in a worthy break from the military tradition, Daniel O'Connell gracing another in Ennis, Co. Clare, which was built in 1865. In the town of Birr, Co. Offaly, an early column was erected in 1747 to commemorate the victory by the Duke of Cumberland over the Scots at Culloden the previous year (plate 21). The statue that once adorned it is no more, but at least the townsfolk of Birr had the good sense to retain the fine column, which still marks their central square.

Monumental columns are really at their best when in a completely rural and natural setting. Whether topped by decorative urns or statues, the contrast between such sophisticated symbols of urbanity and nature is often very striking. The celebrated novelist E. M. Forster, in his description of a monumental column built by the Romans in Egypt, contended

that: 'Architecture has evolved nothing more absurd than the monumental column; there is no reason that is should ever stop nor much that it should begin.'[35] There is also something wonderfully absurd about the image of a person standing on top of a high column, restrained precariously and in full public view. The notion does, however, retain some historical validity in the tale of the fifth-century Christian saint and ascetic Simon Stylites, who supposedly lived for thirty years on top of a column 72 feet high by 4 feet square, from where he preached to the crowds of pilgrims who congregated around him. One Irish example which evokes similar suggestions of the absurd is that of Arthur Willis Blundell Sandys Thrumbull Hill, third Marquess of Down-shire, who stands amid farmland outside the town of Hills-borough, Co. Down (plate 21). This column, whose architect is unknown, was built in 1848 and consists of a plain fluted Doric structure complete with a statue of the Marquess. It appears to be rather ridiculous when viewed in the incongruous setting of a ploughed hill, or in a gap between two of the bungalows which have been built at one end of

22. Hill's Column viewed from Lady Alice's seat within the demesne. (Photograph by Roberto D'Ussy.)

23. Hill's Column from a less impressive angle. (Photograph by Roberto D'Ussy.)

21

24. O'Brien column at Birchfield: an early postcard view. (Courtesy of Daniel Gillman.)

25. Rostellan obelisk: detail of base.

the field in which it stands (plate 23). Only from inside the demesne of Hillsborough Castle,[36] the Downshire estate, is the column's siting properly explained. From here it provides a wonderful distant eye-catcher, framed by carefully positioned mature trees and now complemented by the small circular temple built within the demesne (plate 22).

Decorative columns topped with urns are found at Dartry, Co. Monaghan, and Birchfield, Co. Clare. At Dartry (near Rockcorry) the column was erected to the memory of Richard Dawson, five times elected to Parliament, who died in 1807 aged 44. The column has a smooth shaft with a Doric capital topped with an urn and measures approximately 60 feet in height (plate 21). Oval medallions rise up from two sides of the plinth and the stonework throughout is extremely fine, although after years of neglect some of the joints are beginning to open up. It stands just outside the once famous demesne

known as Dawsons Grove, about which we will hear more later. Unfortunately this beautiful object, which up to now has provided a valuable landmark to the area, will soon disappear behind the thick ring of fir trees recently planted around it. These will eventually screen the pillar from view and invite the vandals to conclude the process already started by neglect, and Monaghan will lose this rare landmark of a type of which only a handful remain in the country.

At Birchfield, Co. Clare, the column was also erected to commemorate a local Member of Parliament, in this case Cornelius O'Brien, a Liberal anti-unionist member who was also a popular, improving landlord, of whom it was reputed that he built everything around here except the Cliffs of Moher.[37] The column is again in a fluted Doric style (plate 24), built in 1853, the plinth of which bears a long glowing inscription to the man it remembers. The O'Brien pillar dom-

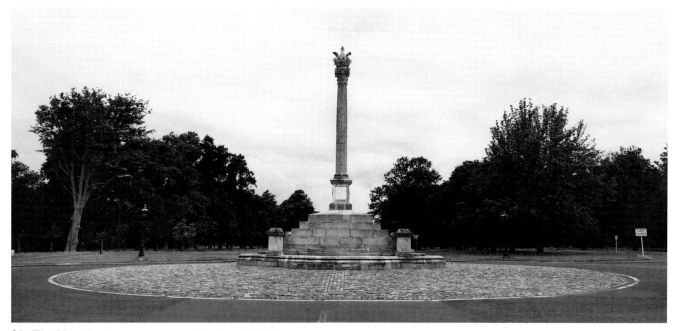

26. The Phoenix column now returned to its original site.

A small ornamental column in a splendid setting stands at Rostellan, Co. Cork, above a raised bank on the shoreline of a peninsula projecting into Cork harbour. The column has a plain, squat, Doric shaft on an elaborate vermiculated base (plate 21). Nearby there is some well-cut stonework dated 1797, in the shape of the prow of a ship. This projects out over the shore from a stone wall of random rubble, and evokes associations with the rostral columns of ancient Rome, on which effigies of the prows of captured ships were carved on monumental columns celebrating naval victories (plate 25). Further along this beautiful shoreline the first Marquess of Thomond built a castellated terrace which terminates in a battlemented round tower, the ruins of which still exist.

Other small-scale and purely ornamental columns survive in the grounds of Lyons House and Lucan House and in Phoenix Park in Dublin. The phoenix-topped column in the park of that name is a fine eighteenth-century structure, which misrepresents the origin of the park's name. This is derived not from the mythical bird but from the Irish *fionn-uisge* meaning clear or tepid water, after the spring well near the Viceregal Lodge.[38] After many years of relative obscurity, set off to one side of the road, the column has recently been resited in the middle of the carriageway (plate 26). This bold move onto one of the park's principle vistas has greatly enhanced the impact of the structure, which now enjoys an impressive monumentality out of all proportion to its modest scale.[39] Although not strictly speaking a column, the Sarsfield Monument at Lucan is worthy of inclusion. This was erected to the memory of Patrick Sarsfield and the design of James Wyatt, and consists of a fine decorative urn on a tapering triangular pedestal supported on three stone tortoises.[40]

Of all the monumental columns in Ireland the most impressive is surely the Brown-Clayton monument near Carrickbyrne, Co. Wexford. This stands some 94 feet high on top of a rocky outcrop beside the road to New Ross. It was erected in 1839 by General Robert Brown-Clayton, who as Colonel Brown-Clayton had distinguished himself in Egypt against the French almost forty years earlier. The column

27. Brown-Clayton monument: elevation and plan.

inates an impressive natural setting overlooking Liscannor Bay, and as a result is altogether more arresting than the finer carved Dawson monument. It is, however, unfair to compare the two, as the original setting for the Monaghan column was a much more appropriate landscape of rolling hills, scattered with small lakes and clusters of trees, which existed until the estate fell under forestry.

28. Brown-Clayton monument: view from the capital.

29. Brown-Clayton monument: a nineteenth-century view. (Courtesy of the Irish Architectural Archive.)

completed column (plate 29), from which rises a tall dressed flag-pole, the fixings for which are still intact inside the top of the shaft. Although in many ways a straightforward giant-order Corinthian column, its romantic setting and accessibility means that it can happily justify the title of folly.

Probably the saddest of all memorial columns to have been conceived in Ireland is Edward Lovett Pearce's design for a column in his own memory, a drawing of which survives in the library of Elton Hall.[43] As Pearce was buried in Old Donnybrook graveyard, where his grave is unmarked,[44] it seems unlikely that his column was ever constructed. The design is of modest scale and comprises a plain Doric column wrapped in a large spiralling ribbon (plate 30). It is not known whether or not Pearce foresaw just how soon the column would be required to commemorate his tragic premature death, by which time his short and brilliant career had already created a sufficient number of fine buildings to preserve his memory.

30. Column to his own memory by Sir Edward Lovett Pearce. (Courtesy of William Proby, Esq.)

commemorates his then commander, General Abercromby, and the British victory over the French of 1801. While serving in the campaign Brown-Clayton visited the so-called Pompey's Pillar at Alexandria, of which the Wexford column is almost an exact replica. The Alexandrian column has, in fact, no connection with Pompey and was erected around AD 297 to commemorate the Emperor Diocletian.[41] Built of red granite, the original is some 10 feet shorter than the Irish copy, which further differs by containing an internal staircase leading up to the capital.[42]

The Brown-Clayton monument, or 'the pinnacle' as it is locally known, is a robust and well designed structure of rough grey granite in neat regular courses rising from an almost cubic plinth up to a Corinthian capital (plate 27). An entrance in the plinth gives access to a tight spiral staircase of 119 steps, which are nicely detailed with a curving convex underside. The staircase is lit by a series of narrow splayed openings and eventually leads to a small landing and the open top with a frustratingly high lip (plate 28). Views of the surrounding countryside are spectacular, but should only be attempted with extreme caution, as there is no proper viewing platform nor any safety rail. A rare engraving, also of 1839, shows the architect, Thomas Cobden, in frock-coat and top hat, sitting with his drawing-board before the

CHAPTER 2

Grottoes and Shell Houses

Many architectural theoreticians throughout the centuries have speculated on the role of the primitive timber-built hut as an archetype of Western classical architecture. Similar links can also be drawn between the grotto and that other archetypal building type, the cave. The term 'grotto' covers a range of formations, natural, semi-natural, or man-made, which may or may not be adorned with shells or other ornaments. Once again the precedent can be traced back to the classical world of Greek and Roman Antiquity and is rooted in the Latin word *crypta*. In ancient times grottoes were held to contain the secrets of nature, providing abodes for muses and nymphs. This led to the Roman custom of creating *nymphaea*. These were fountains or temples consecrated to the nymphs, a class of semi-divine beings in the form of beautiful maidens, who inhabited seas, rivers, fountains, woods, or trees and attended the higher deities. It is also very likely that caves were consecrated to the gods long before the earliest temples were first constructed.

Cryptoporticus is the Latin word for a subterranean portico or passage which provided shade and connected buildings or parts of buildings. A distinction should be drawn between a crypt which is man-made and a cave (or cavern) which

31. Tullynally grotto in its present setting with the original roof covering now gone.

occurs naturally. One of the main attractions of the grotto type is that it often contains elements of both the natural and man-made worlds, thus creating a much sought-after sense of ambiguity. Such an ambiguity helps underline the very factors which attract us to grottoes: fear, curiosity, and the desire to enter despite the sense of unease. This is closely linked to our aesthetic perception and desire for sublime experience as outlined by the Irish philosopher Edmund Burke.[1] The grotto creates an atmosphere of gloom, solitude, and shade for the purposes of repose and contemplation, which may in turn provide enlightenment and poetic inspiration.

It has also been interpreted as a metaphor of the cosmos, especially in the highly decorated versions adorned with fossils, spars, and shells, the patterns of which served to create a layer of order growing out of disorder. Such collections were like showcases or museums through which man expressed his own artistic understanding of himself and the cosmos:

> Withdrawal into this illusory realm, into this world of fantasy, implies a communion, not with the outside world of nature still dominant in the garden, but here within the enclosed orbit of the grotto with the inner world of man.[2]

Water is a recurring theme derived from Roman nymphean origins and provides further symbolic associations with the life force. Many grottoes in the Campania region of Italy around the Bay of Naples were dedicated to Venus, the goddess of beauty and love, during the time of the late Republic.[3] In some respects the more recent practice of creating Marian shrines as grottoes in Roman Catholic countries is a continuation of this ancient tradition.[4]

In the mid-fifteenth century the Florentine humanist and architect, Leone Battista Alberti, wrote his famous treatise on architecture,[5] which included a lengthy description of the subject of grotto decoration:

> The Ancients used to dress the Walls of their Grottoes and Caverns with all Manner of rough Work, with little Chips of Pumice, or soft Tybertine Stone, which Ovid calls the living Pumice; and some I have known dawb them over with green Wax, in Imitation of the mossy Slime which we always see in moist Grottoes. I was extremely pleased with an artificial Grotto which I have seen of this Sort, with a clear Spring of Water falling from it; the Walls were composed of various Sorts of Sea-shells, lying roughly together, some reversed, some with their Mouths outwards, their Colours being so artfully blended as to form a very beautiful Variety.[6]

He goes on to explain that the 'Apartment' should be the domain of the master and his wife, and also to explain how valuable the cool and tranquil effects of such a room can be to those suffering from fever and that 'burning Drowth of the Mind, which kept you waking'.

The earliest grotto to appear in a British garden was that of Alexander Pope in the garden he created at his villa in

32. Stillorgan grotto: plan drawn by Edward Lovett Pearce. (Courtesy of William Proby, Esq.)

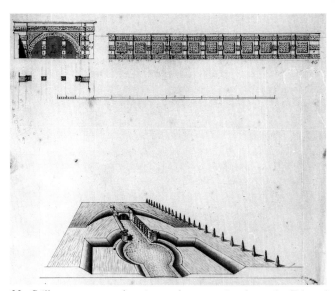

33. Stillorgan grotto: elevation and perspective drawn by Edward Lovett Pearce (Courtesy of William Proby, Esq.)

Twickenham.[7] This still survives largely intact and can be found under the convent school now occupying the large house that replaced his own. The grotto has an irregular central passage flanked with two blind side passages. It is completely encrusted with spars, minerals, and flints. No shells are evident and all of the more exotic fossils, which included stalactites from Wookey Hole in Somerset and

fragments from the Giants' Causeway in Co. Antrim, have since disappeared. Apart from its innovation and decoration as a virtuoso mineral and fossil collection, Pope's friend Jonathan Swift described it as a piece of poetic art which 'turned blunder into beauty'. The main stroke of genius was in its layout.

This was designed to run under the London to Hampton Court road, which separated the main part of Pope's garden from the house and the river. The grotto therefore provided a safe and private access but also served as a link between the contrasting atmospheres within the two separate parts of the garden. On the southern side the view of the river could be enjoyed from the mouth of the grotto. When passing through the passage from the house towards the main part of the garden one would have experienced an exciting and intriguing contrast between the relative darkness of the narrow, mirror-lined passage and the open, natural-style garden beyond. Mrs Delany notes having visited Pope's garden in an undated letter of about 1737[8] (at which time she was still Mrs Pendarves.) In the same letter she also mentions that she was currently working on a grotto of her own. Some six years later she would settle in Ireland and help to encourage there an interest in grottoes, which she had started during her first trip of 1731–3.

In Ireland the first grotto is not of the irregular *nymphaeum* sort, but an altogether more regular design by Edward Lovett Pearce at Stillorgan, close to his magnificent obelisk.[9] Two drawings in the Elton Hall collection show the design closely as executed. The first is of a formal garden layout with a seven-chambered grotto terminating a central axis (plate 32). Arranged in a straight line the seven square-planned and domed chambers, of which the central chamber is the largest, are entered through a rectangular ante-chamber. All the chambers contain niches, probably intended to be used as seats or for statuary. The second drawing (plate 33) is of a perspective and elevations showing the approach down a formal sunken avenue revetted with pilastered and panelled masonry leading up to the arched entrance, designed in the form of a Diocletian window. Although the original setting has long since disappeared under advancing suburban development, the grotto still exists in a garden in Stillorgan Park Avenue.

Considering its age, the structure is in a remarkably good state of repair, with only a section of the largest dome missing. Remains of a pebble floor can be seen, and it is unclear whether the walls were ever finished, although the remains of plaster reliefs can be seen in the high-level circular niches. There is a decidedly Roman feel about the interiors, with the niches, string-courses, brick arches and vaults. The largest central dome, which rises to a height of over 18 feet, appears to have had a circular opening at the apex, like the Pantheon in Rome (plate 34). Pearce's work for the Allens at Stillorgan had an added significance for the architect, as he also lived in the grounds of the estate in a house called the Grove,[10] and would doubtless have been able to enjoy the pleasures of his own garden design. In the

History of County Dublin of 1902 there are photographs of the grotto showing it very much as it appears today. The description is disappointingly brief: 'The walls of the passage and tunnel were built of brick and were decorated with niches, tablets and sculptural figures apparently designed on some classical model.'[11]

The oldest natural-style grotto for which references survive in Ireland is the one created by Mary Delany at the seat of the Bishop of Killala in Co. Mayo. This was something of a rarity, not only for its type but also its location, as there were relatively few follies and garden buildings constructed in Connaught, where the land was less fertile than most other parts of the country. The Killala grotto is well documented in the extensive correspondence of Mary Delany,[12] who in 1732, as the widowed Mrs Pendarves, spent several months at Killala during her first trip to Ireland. Mary Delany (I will use the name by which she is most commonly known, even though at this time her marriage to Patrick Delany was still eleven years away) stayed in Dublin before and after her time in Mayo, enjoying the social life and visiting houses and gardens.

34. Stillorgan grotto: interior detail of central chamber.

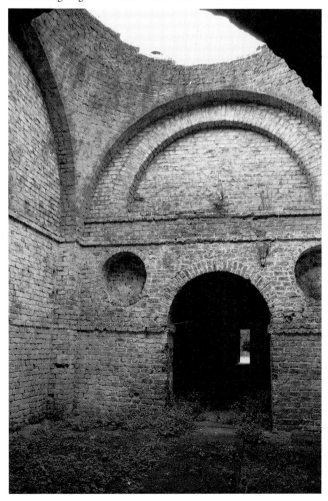

35. Tullynally grotto: elevation and plan.

She knew Edward Lovett Pearce, who is referred to as 'Capt. Pierce', and mentions him several times in her letters, including one interesting reference in a letter to her sister Anne. In this letter of 11 March 1732, which contains a rather critical description of Castletown House, she writes, 'our sleepy lover was yesterday dubbed a knight, and today I have promised to give him a meeting at the Graham's, where I shall dine, but I am afraid Sir Edward Pierce will hardly think it worth his while to make up for the neglects of Captain Pierce.'[13]

The two, who would have been around the same age, appear to have been on friendly terms, and may well have been acquainted before Mary came to Ireland, as we have an earlier reference to her recommending Pearce as an architect for her sister's consideration, even before her visit.[14] Another letter during her first stay in Dublin records her approval of Pearce's obelisk and the fine and extensive view from it. These letters therefore provide an interesting connection between the creative forces behind two of Ireland's earliest grottoes, and the changes in gardening trends which had only recently started to occur.

Only faint traces of the Killala grotto remain today, but we are fortunate to have a most detailed description, not only of its form but also the method of its construction:

> About half a mile from hence there is a very pretty green hill one side of it covered with nut wood; on the summit of the hill there is a natural grotto, with seats in it that will hold four people. We go there every morning at seven o'clock to that place to adorn it with shells—the Bishop has a large collection of very fine ones; Phill and I are the engineers, the men fetch and carry for us what we want, and think themselves highly honoured.[15]

The description continues to relate that the grotto enjoyed an extensive view of the sea and several islands, and that the Killala demesne also boasted a fine pillar like a Roman obelisk, of great height. Further descriptions of the work, and the collecting of shells for it, continue throughout the

summer and in one there is a reference to adding a pyramid to the grotto, which Mary promises secretly to dedicate to her sister.[16]

At Tullynally Castle in Co. Westmeath there exists a small grotto not dissimilar in scale to the one described by Mary Delany. This stands on a steep hill overlooking a natural garden, mostly of woodland interspersed with specimen trees. The grotto resembles a rustic belvedere and is cut into the side of the hill, with an octagonal plan and domed roof (plate 35). A continuous bench runs around the solid back wall, creating a very pleasant seat from which to enjoy the fine views out through the arched entrance doorway and flanking windows, across the surrounding plains to a distant lake. The door and window openings are formed by irregular river-eroded stones and tufa,[17] which continue into flanking walls of similar construction. A floor patterned in red and black pebbles suggests that the now bare brick of the back wall may once have been decorated. Some of the stones look like petrified vegetation and the exterior of the a domed roof, apparently having lost its original covering and subsequently rendered, now pokes up like a bald pate (plate 31). Before the present naturalistic landscape the gardens were arranged in a formal manner with basins, canals, and cascades.[18] The grotto probably dates from the late eighteenth or early nineteenth century.

One very good example of a largely man-made grotto with the appearance of being quite natural is at Charleville Forest, near Tullamore, Co. Offaly. Built into a small hill which runs alongside a diverted stream deep in an oak wood, it is approached by a narrow path running along the edge of the stream. The path passes through a rocky tunnel before opening up to reveal three large crude window openings almost hidden in the vegetation. Passing around these one comes to the entrance which is marked by a crude stone portal to one side (plate 36). As with all good grottoes, one experiences a sense of trepidation before being drawn into the darkness of the interior.

Inside, behind the three window openings runs an irregular passage 30 feet long which contains a recessed stone

36. Charleville grotto: entrance detail.

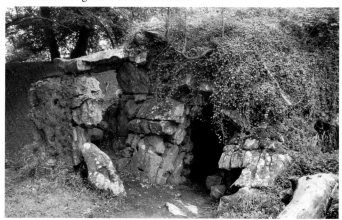

37. Charleville grotto: plan.

38. Powerscourt House: view from the boat-house grotto.

bench and three grotesque stone pillars which branch up towards the rocky roof of the passage, from which similar long narrow stones project back down into the space like teeth from a giant dragon. The passage eventually leads into a high round chamber about 15 feet in diameter (plate 37), the domed roof of which is pierced by three more openings at high level, which run out to the exterior providing light and air. Several more of the large 'dragons' fangs, complete the dramatic effect. All the stones used in the construction are large, natural, and uncut with the only obviously man-made elements being the Gothick ironwork grilles in some of the windows. As intended, the eerie atmosphere inside the grotto contrasts dramatically with the gentle flowing stream and the broad-leaved woodland which surrounds it.

The association between grottoes and water has already been noted and in England there exist many examples where the Roman precedent has been literally interpreted. These tend to be built beside water or contain water courses along with the customary white marble statue of a nymph or river god, like the famous example at Stourhead in Wiltshire. In Ireland there are surprisingly few grottoes facing or con-taining water. One exception is at Powerscourt, where a fairly plain vaulted grotto stands on the edge of an ornamental lake. It is entered by a simple arched opening with jagged stony rocks which project like rotten teeth. As the water flows into the grotto, it was probably intended to be a boat-house, as well as a quiet place to sit and enjoy the reflections of the water dancing on the ceiling on a sunny day (plate 38).

Another example is found in the garden of the now demolished Turvey House in Donabate, Co. Dublin. What is unique about this grotto is not that it is subterranean but that it has no natural light of any description. It is possible that, following the demolition of the house which stood nearby, some previous light source or means of entry was blocked up. At present access is extremely difficult and should be attempted only with caution, the right equipment, some company, and the permission of the landowner. The grotto is entered through a narrow opening in the ground, about the size of a small manhole, which gives access to a deep shaft opening onto the single chamber of the grotto. Inside the chamber, which measures only 9 by 24 feet (plate 39), is a shallow vaulted roof covered with rich clusters of shells in intricate patterns suggesting ribs on the vault. Along the centre line at the crown of the vault brightly decorated china plates and bowls are set in among the shells, along with pieces of glass and mirror. The shells are not exotic, being mostly razors, scallops, oysters, cockles, and mussels, many in flower-like clusters surrounded by hun-dreds of periwinkles.

To increase the drama further, the floor is completely submerged by water, which appears to enter from the end opposite the entrance shaft through a niche. Part of the niche is formed in brickwork and part cut into the earth with roots of trees projecting through. The water, which is fresh and clear, is a few inches deep at the shaft end but drops away suddenly at the mid point to form a plunge pool four to five feet deep. This suggests that the grotto was also used for taking cold baths, a practice not uncommon in eighteenth-

39. Turvey House grotto: plan.

century Ireland. The magical effect is, however, somewhat diminished by the lack of any daylight; even if the ends had originally been more open to permit light, it would still have been fairly gloomy. Certainly the space would have required plenty of candles to bring it to life. Barbara Jones makes a reference to a shell house and shell tunnel at Turvey House[19] but she did not visit it.

It has also been suggested that the Turvey House grotto may have been constructed as an ice-house in the eighteenth century and subsequently converted to a shell grotto in the nineteenth century.[20] Although ice-houses were seldom constructed so close to the main house and the structure is not typical, this theory would certainly explain the absence of any natural light source. Abandoned ice-houses, such as those at Luttrellstown and Castle Oliver, are often mistaken for grottoes, which is not altogether surprising because of their common subterranean or semi-subterranean character. In the grounds of Hillsborough Castle there is a fine surviving ice-house which very deliberately imitates a grotto.

This stands on a hill above an artificial cascade, and consists of a large rustic arched entrance of rounded sandstone boulders covered in moss and flanked by tall ferns (plate 40). The rockwork continues to form a rough dome which bursts through the crown of the hill, resembling a large rockery. Inside the structure is a conventional brick-lined ice-house with its double-coned storage space, reached by a short vaulted tunnel. The overall effect is very striking and demonstrates how, with little effort, a highly practical building can be given a pleasing ornamental quality to embellish a garden.

Another grotto design worthy of note is James Gandon's unexecuted proposal for remodelling the elevations of Slane Castle, Co. Meath, of which two ink and wash drawings by Gandon survive.[21] These show a wildly flamboyant design more typical of the Italian Renaissance than the composed neoclassical style normally associated with the architect. The elevation of the basement in particular includes a rich composition of curved staircases interweaving between an

40. Hillsborough: grotto-fronted ice-house. (Photograph by Roberto D'Ussy.)

41. Slane Castle: an unbuilt grotto proposal drawn by James Gandon. (Courtesy of the Irish Architectural Archive.)

array of grottoes, statues, and cascades (plate 41). It is a great pity that the scheme was not constructed, as it would have added yet another dimension to the impressive output of the man acclaimed by many as Ireland's most accomplished architect.

From the relatively few examples already cited, it is very clear that the notion of a grotto in the eighteenth century was a vague one. Crude subterranean holes, free-standing pavilions, and elaborate classical compositions all fell under the general title. A number of unexecuted designs survive in the collection of drawings of garden buildings by the little-known Irish architect Samuel Chearnley. This folio of drawings of 1745–6 entitled *Miscelanea Structura Curiosa*[22] includes several highly contrasting interpretations of grottoes. One refined classical design shows a small stone rotunda with an urn-topped domed roof. Internally the inner skin of the dome has a richly ornate pattern with decorative swags above a number of niches (plate 42). The only grotesque references to be found are in the large brooding faces on the

42. An ornamental grotto design by Samuel Chearnley. (Courtesy of the Irish Architectural Archive.)

keystones above the door and windows, and the scallop shell pattern above the niches, which are occupied by a group of nymph-like statues. Underneath one of the drawings a practical note advises that: 'In this section the niches may serve as seats by omitting the statues.'

In contrast to the elegant refinement of this grotto Mr Chearnley also left a more typically grotesque design. This

31

43. A rustic grotto with labyrinthal entrance: design by Samuel Chearnley. (Courtesy of the Irish Architectural Archive.)

consists of great rustic walls of evenly coursed vermiculated stone blocks astride a central arched entrance, which opens between high piers topped with great distorted heads. The plan shows that the entrance leads into a small maze of organically shaped tunnels before entering a more regularly planned room with windows, a projecting curved bay, and a fireplace (plate 43). A long footnote explains the conceptual basis of the design 'through to a frightful wildness proper for this horrible place which entering with terror through many windings is at length surprised in a Delightful Banqueting room—from whence an extensive prospect sho'd be answerable.'

In subsequent chapters we will encounter some further examples of Samuel Chearnley's wit and creativity which, as his note shows, greatly enjoyed the element of surprise. His two grottoes described above demonstrate a dilemma common to many designers of them. These are the conflicting desires to create on one hand a brooding, ominous atmosphere to instil terror, and on the other a delightful garden structure in which a picnic might be enjoyed. It is unlikely that any of Chearnley's designs were ever built, but many other grottoes survive, normally of a rather modest size. One such example is found at Belvedere, Co. Westmeath, an early photograph of which appears in *Lost Demesnes*,[23] showing the classic face-like arrangement of two windows flanking a central doorway. A similar example is found at Dromoland, between the rotunda and an ornamental lake. This has a pointed arched doorway and a single window to the vaulted interior, which measures 10 by 15 feet and contains a fireplace.

Probably the finest of all Irish grottoes is the one found at Ballyfin, Co. Leix. This is situated near the lake, in a stand of beech trees several hundred yards from the entrance to the house. This grotto is unquestionably the most architectural of all to be found in the country (plate 44), as it mimics in a totally rustic manner the principal features of the Morrisons'[24] fine design for the house, completed in 1822. These include the rustic tetrastyle portico (plate 45), and the saloon complete with lantern, chimney-piece, and free-standing columns (plate 46). A smaller second chamber echoes the rotunda room of the house, again with top lighting, and one half expects to stumble on some grotesque

44. Ballyfin grotto: a plan which cleverly mimics some of the major architectural elements of the main house.

version of the great Ballyfin conservatory, so close are the similarities. The grotto can be entered either through the portico or alternatively by the more discreet route of a long curving passage tunnelled into the hill on the opposite side. It is not known if either of the Morrisons was responsible for the grotto design but, as they are credited with the excellent folly tower on the hill above the house, it must be considered likely.

There are no shells to be found in the Ballyfin grotto, but the small circular chamber is lined with some remarkable fossils, which can best be described as resembling petrified intestines. A more scientific appraisal identifies them as the fossilized burrows of giant worms. These have been preserved by differential weathering, as the chemistry of the mud from which the rock was formed was altered in the burrows by its passage through the worms' systems.[25] All of the fragments have been carefully collected and set into the linings of the chamber, creating a most unusual effect,

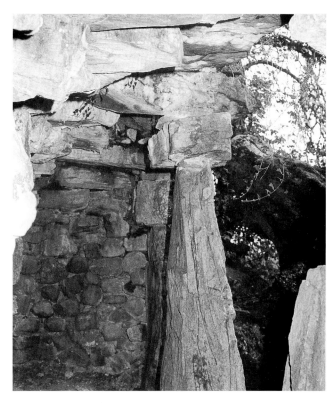

45. Ballyfin grotto: exterior view showing the rustic portico.

46. Ballyfin grotto: detail of a rustic column. (Photograph by Roberto D'Ussy.)

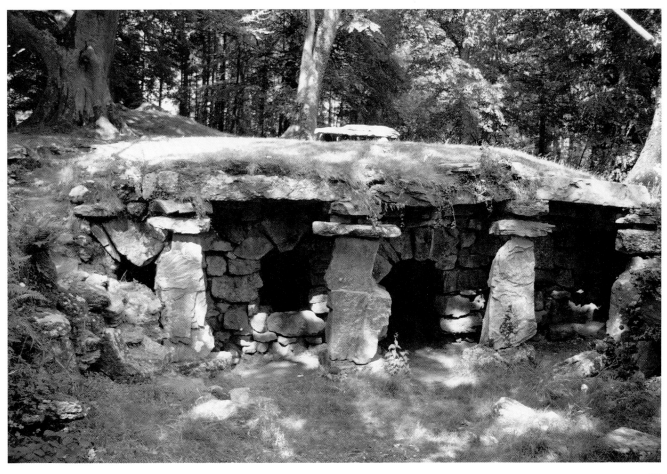

which is more interesting than ominous. Overall, a wonderful sense of modesty prevails throughout the sophisticated architecture of this particular structure. Its close similarity to the house also implies (with tongue very firmly in cheek and no little humour) that man only strives to copy what nature produces accidentally. In such a case the cave rivals the primitive hut as the archetypal building and source of classical architecture.

The importance of shells has already been mentioned as a commonly recurring motif in grotto design. Venus's association with shells, which featured strongly in her mythology long before Botticelli visualized the myth in his famous painting, offers one significant connection through her grottoes on the Bay of Naples. On a more prosaic level, it may simply be that shells have many similarities with caves and grottoes, and are therefore an appropriate decorative material. In some ways a shell is a microcosm of a cave, with its own dark interior which fills us with mystery and wonder.

Barbara Jones refers to 'the complicated and slightly inaccurate geometry of shells which never ceases to amaze',[26] and Mrs Delany writes of herself 'I have got a new madness, I am running wild after shells,' and goes on to describe her own fascination by noting that 'the beauties of shells are as infinite as of flowers, and to consider how they are inhabited enlarges a field of wonder that leads one insensibly to the great Director and Author of these wonders.'[27]

The twentieth-century French philosopher, Gaston Bachelard, has also written at length on the meaning and symbolism of the shell.[28] Bachelard suggests that an empty shell invites day-dreams of refuge through which one can psychologically gain a protected peace. The expression 'to

48. Curraghmore shell house: plan showing the pebbled floor decoration.

withdraw into one's shell' relates to this possibility and is aptly demonstrated by a snail, who at will can retreat immediately into the house he conveniently carries around on his back. The shell has long been held as a symbol of resurrection and hope, as represented by the snail emerging in spring after the winter's hibernation. There is also a sublime element inherent in shells, especially in the larger conch-like varieties, which are rough and often spiked on the outside, smooth and inviting on the inside, but like a cave, dark and forbidding with no knowledge of what may lurk within.

From Roman times to Alberti and into the eighteenth century, shells and grottoes have been inextricably linked, and in many ways the shell-lined grotto illustrates a fundamental characteristic found in all good follies and garden buildings. This is the provision of a private place where one can escape to dream and inhabit the secret world of one's own imagination. In the eighteenth century shells were collected with passion and sometimes at great expense. The extravagant Lord Donegall was said to have invested some £10,000 in shells, and contemporary references complained of Irish beaches being denuded of shells.[29] As with rare and exotic trees, a supply of exotic tropical shells was constantly requested of every well-travelled naval officer. Shell decoration is sadly an ephemeral art, especially when found in damp exposed or subterranean locations, and the surviving examples in Ireland are relatively few. To appreciate fully the great beauty of fine shell-work one must look at the shell houses, which are mainly independent pavilions above ground in which shells have a much better chance of staying in place.

Of these the two finest examples are to be found at Curraghmore, Co. Waterford, and Carton, Co. Kildare. The former consists of a solid, rustic building, with the cruciform plan of a miniature baroque church. The walls are built of large, irregular but slightly rounded stones, which are terminated by the overhanging eaves of a series of stone-

47. Curraghmore shell house: standing in a charming fernery not far from the main house.

flagged roofs. It stands discreetly amid a profusion of shrubs and ferns (plate 47) in the lovely demesne of Curraghmore House, seat of the Marquess of Waterford, near the town of Portlaw. The interior is in complete contrast to the plain rustic appearance of the exterior, and contains an Aladdin's cave of rich, shell-encrusted detail on a series of interlocking domed spaces. These are arranged axially around the largest central space, with three circular apses, each containing a window and a small rectangular entrance lobby. Niches are placed between the entrances to the apses and the entire plan is knitted together by an elaborate floor pattern of great intricacy worked in pebbles (plate 48). The shell-work is equally impressive and worthy of this delightful little structure. Virtually all the walls and domed ceilings are covered with tightly clustered shells of every description, creating imaginative and varied patterns. We are told that the glue used to fix the shells was made from ox blood and hooves; it has certainly worked well as the condition is remarkably good (plate 49).

Great rocks project down from the dome in the manner of the dragons' teeth at Charleville, but here they are also totally covered with shells and resemble the pointed heads of large fish. An echo of the sea is also found in the walls at low level where the decoration stops, exposing the large stones of the exterior, which resemble a rocky shoreline at low tide. In the centre of the building stands a white marble statue dressed appropriately as a nymph (plate 50), holding a conch in one hand and an unfurled scroll in the other. The statue is by the sculptor John Van Nost and its subject is the creator of the grotto, Lady Tyrone. Carved on the scroll is the following inscription: 'In two hundred & sixty one days

50. Curraghmore shell house: statue of its creator, Lady Tyrone, by John Van Nost.

49. Curraghmore shell house: detail of the shell-work which includes both indigenous and the more exotic imported varieties.

these shells were put up by the proper hands of the Rt. Hon. Cathne Countess of Tyrone 1754.'

The second exceptional example of shell-work in Ireland is found in the grounds of Carton House, laid out very much in the more contrived style of Capability Brown and containing a number of interesting garden buildings. Carton's shell house was the work of Lady Emilia, first Duchess of Leinster, and was start in the late 1740s. The shell room was constructed in an altered thatched cottage and combines the use of shells, glass and mirrors, along with bark, branches, and fir cones in random clusters or highly elaborate panels (plates 51–3) under a high domed skylight which creates a very pleasant quality of light. In some places lines of structure are picked out and in others great flowers burst open with mother-of-pearl blooms. The overall effect is still very impressive, even though the passage of centuries has dimmed the lustre of the shells and tarnished the mirrors. While the shell room with its deeply recessed Gothick windows remains unspoilt, the remainder of the cottage was extended in Victorian times to make a *cottage orné* to honour a royal visit. By contrast, this is rather a disappointment after the shell-covered interior, with the exception of the interesting, cast-iron, tree-trunk columns which support the overhanging roof.

51. Carton shell house: detail of the rich and varied shell-work.

52. Carton shell house: detail of the shell- and twig-work.

53. Carton shell house: interior view.

At Rubane House (formerly Echlinville) Co. Down, there is an unusual structure known as the Pebble House, very much in the shell-house tradition. It stands at the bottom of a gentle hill to the rear of the now much altered house, and is approached by a low single-arched bridge spanning a dried-up ornamental canal (plate 286). The building, which measures roughly 10 feet square in plan, has a richly modelled tufa front, with plain rubble walls to sides and back. It is entered by a central doorway flanked by niches, above which runs a series of five smaller niches, all neatly constructed from small round pieces of tufa. At high level the walls terminate in a battlemented parapet, behind which springs a square-planned ogival dome topped by a lantern (plate 54). Inside there are four niches at high level and traces of fine rococo plasterwork, now much deteriorated like the lantern. Earlier references mention pinnacles which

54. Rubane pebble house: elevation and plan.

55. Dungarvan shell cottage: decorated garden walls.

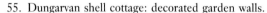

have now disappeared,[30] the remains of coloured glass in the lantern, and a suggested date for construction of 1740.[31] There is no evidence of shell or pebble decoration, but the name most likely derives from the vesicular appearance of the tufa, the surface of which resembles a cross-section through a mass of frozen bubbles.

Decorative shell-work occasionally appears on other types of follies, and two towers which will be discussed later, at Larch Hill and Ardglass, both retain traces of fine shell-work. The practice of decorating buildings with shells, so popular in the eighteenth century, has never really died out in Ireland and can often be seen in relatively small panels on cottages and bungalows near the coast. One interesting late nineteenth-century example is to be found just outside the town of Kildare, depicting a village scene, and there is another in Dungarvan, Co. Waterford. The latter, more recent example covers nearly every inch of the walls of house and garden (plate 55) and, although not in the class of the work of Mrs Delany or the Countess of Tyrone, is nonetheless a product of the same school. This fascination with the art of shell-work at times became almost fanatical:

> Many women have found no time to work, even in the eighteenth century when there was plenty of leisure for the rich, until they were old or ill, when they suddenly produced a lifetime's work in a few years. Indeed all the landscape and building, shell work and county histories produced at the time suggest many men and women must have used a weak heart, a delicate constitution, or even gout, to avoid the perpetual claims of sport or family life.[32]

The implication is that the act of doing, and not the end result, was the important thing, by providing some relief from the stifling boredom which must have plagued some women's existence in the eighteenth century.

CHAPTER 3

Hermitages and Rustic Arches

The hermitage is one of the more ambiguous categories of folly, which has much in common with the rustic arbour or root house and the rusticated free-standing 'grot-work' structures designed by Thomas Wright. In appearance many resemble grottoes and they are often mistaken as such on the first Ordnance Survey maps of the 1830s. What distinguishes the hermitage from other similar forms is the impression, implied or otherwise, that the building is inhabited by some mysterious, eremitic occupant. Virtually all of Thomas Wright's designs in his *Six Original Designs of Arbours and Six Original Designs of Grottos*[1] are annotated with colourful descriptions suggesting that his designs are suitable habitations for a series of Druids, Brahmins, or Anchorites, for the purpose of philosophic and no doubt ascetic retirement. Ireland is not without its own eremitic tradition, which is found in the mysticism associated with early monastic settlements. The retreat of St Kevin to the valley of Glendalough was responsible for the establishment of the monastery there. This grew up to accommodate the great numbers of pilgrims who visited the hermit, eventually forcing him from his retreat. St Kevin is reputed to have come from a princely family before living the life of a solitary

56. Tollymore hermitage from the bed of the Shimna river. (Photograph by Roberto D'Ussy.)

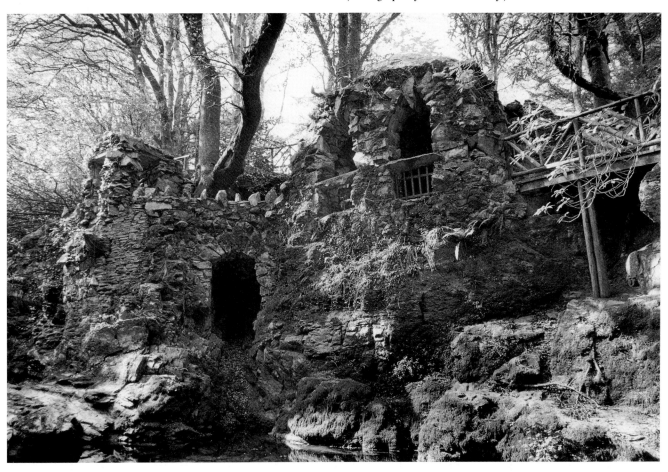

38

for seven years, first in a hollow tree on the north shore of the lake and later in a narrow cave (St Kevin's cell) on the south shore.[2]

To enhance the illusion of habitation in eighteenth-century garden hermitages, crude rustic furniture would be added, with appropriately chosen stage props to increase the dramatic effect. Life-like wax effigies of the hermit[3] were included in some instances, and in others, where illusion was not considered adequate, men were sometimes employed to play out the role. This practice was not uncommon in England throughout most of the second half of the eighteenth century and records exist of landowners advertising for suitable candidates in newspapers.[4] The lucky hermit in residence would generally be required to wear rough robes and leave his nails and hair uncut, and no doubt sit wild-eyed, muttering to a skull every time he heard visitors approaching. For these services, which sometimes involved the hermit taking up residence for several years, daily food was provided and a pension or lump-sum payment on completing his term.

All this theatricality was intended to stimulate feelings of unease in a search for the sublime, in the belief that fear was an important source of aesthetic perception. No such records exist of live-in hermits in Ireland, although it is certainly quite possible, given the cheap labour available from the indigenous population. It is, however, more agreeable to adopt the hope that this bizarre and degrading custom did not catch on in Ireland, perhaps influenced by the humanistic

57. Delville, the Beggar's Hut: an eighteenth-century watercolour sketch by Mrs Delany. (Courtesy of the National Gallery of Ireland.)

values of Dean Swift, the Delanys, and others responsible for the spread of the new ideas in gardening. In many ways the implied presence of a hermit is an even stronger stimulus than his actual presence, as this permits the visitor to enter the mysterious abode and risk an encounter with the occupant, who might return suddenly at any time.

Mary Delany gives us a fine description of a well-furnished hermitage at Caledon, Co. Tyrone, seat of Lord and Lady Orrery, who were friends of Swift and fellow pioneers in the shift towards more natural gardening:

> in the midst is placed an hermit's cell, made of the roots of trees, the floor is paved with pebbles, there is a couch made of matting, and little wooden stools, a table with a manuscript on it, a pair of spectacles, a leathern bottle; and hung up in different parts, an hourglass, a weather-glass and several mathematical instruments, a shelf of books, another of wooden platters and bowls, another of earthen ones, in short everything that you might imagine necessary for a recluse.[5]

We have no visual record of the Caledon hermitage, but it may well have been similar to those built by Lord Charlemont at Marino or the Delanys at Delville, sketches of which survive[6] (plate 57). These buildings, which are

58. St Enda's hermitage: elevation.

often called root houses, have a fairy-tale appearance with the door and window openings formed with the grotesque shapes of bows or roots of trees. The most famous of all the root-house hermitages was designed by Thomas Wright and, remarkably for such an ephemeral type of construction, is still standing at Badminton in Gloucestershire.

Unfortunately the root houses at Caledon, Marino, and Delville are no more. With most other rustic timber buildings of this nature, they have not survived the effects of Ireland's moist climate. The stone hermitages have survived better and a very good example exists in the grounds of a house which also goes by the name of Hermitage in Rathfarnham, Co. Dublin. This house, which was previously called Fields of Odin, is better known today as St Enda's, where Padraig Pearse moved his school in 1910. The grounds of the house are dotted with a great many follies, mostly in a rustic or Gothick style. There are two assemblies of huge standing stones with pretensions to prehistoric or druidic associations, one in the form of a shelter or seat and the other a strange primitive obelisk on a spreading base. Elsewhere there are towers, an elaborate star-planned fort, and a variety of simple rustic arches, all of which belong in subsequent chapters.

Of all these structures the hermitage is one of the most evocative. It is built of large crude stones which seem to grow from an outcrop of rocks set in a woodland clearing (plate 58). The distinction between the natural and the man-made is deliberately ambiguous and, with the passage of years and the resultant mantle of ivy and sprouting sycamores, one could almost believe it occurred naturally.

59. St Enda's hermitage: setting with the Druid's stone.

60. Tollymore hermitage: interior view of window, doorway, and stone bench. (Photograph by Roberto D'Ussy.)

The hermitage comprises a single large chamber with a door and window opening. Externally and at right angles to the main cell is a crude arched recess constructed of large rough stones, complete with keystone and stone bench, and nearby another smaller niche. In front stands a huge flat piece of stone supported by a series of smaller stones, in imitation of a small dolmen. This would no doubt have been the druid's altar, the philosopher's stone, or possibly a convenient table for picnics (plate 59).

A similar example, which appears to grow naturally from an existing rock formation, is found at Tollymore, Co. Down. This wonderful demesne on the lower slopes of the Mourne mountains is also well endowed with follies and has strong associations with Thomas Wright. The hermitage was constructed by Lord Clanbrassil in the 1770s as a monument to his friend Lord Monthermer, who died at the early age of 35. It is situated fifteen feet above a deep pool in the river Shimna, which has sculpted one of the most beautiful river valleys to be found anywhere in Ireland (plate 56). This example clearly demonstrates Alexander Pope's guiding principle on designing landscapes and siting buildings, that one had to discover the *genius loci*, or genius of the place, which nature has already provided and man need only embellish with thoughtful planting or the erection of a suitable building to underline such genius.

The hermitage is some 12 feet long, built into the rocks with a domed ceiling. A stone bench runs along the natural rock-face of the back wall, and the door and window openings are vaguely Gothic (plate 60). Approaching the building along the path beside the river, which is lined with a thick beech wood, the hermitage is well hidden until one is almost upon it. The final section of pathway is like a timber bridge with rustic balustrading, which spans between outcrops of rock before passing through the building itself. The scene is one of undisturbed calmness, except for the gentle sound of moving water. Its effect is both contemplative

and unworldly, and has been eloquently described by one nineteenth-century visitor who wrote:

> In this homely hermitage (the meditations of whose inhabitant are rendered solemn by the murmurings of the river), a stone bench, the full length of the enclosure, has been arranged for his couch or resting place. The planted hill, which forms the opposite bank of the river, confines the hermit's attention to the romantic scenery of his cell, and shuts out every foreign object.[7]

From the planted hill across the river the entire composition can be seen at its best in relation to the river. No artificial cascades or contortions are needed here, just the genius of nature pure and simple, and the judicious placing of an appropriate building which, in supporting Pope's theories, only adds to nature while creating even greater appreciation.

It has already been noted that hermitages and grottoes share much in common, both in appearance and the atmospheres they create, and certainly the last two examples display many common visual characteristics. It should also be stressed that while both forms can provide menacing and frightening stimuli, more pastoral and welcoming versions of each can exist. These may take the form of a simple rustic pavilion with its three arched openings, found in the garden at Glin Castle, Co. Limerick (plate 61), or the equally gentle demeanour of the hermitage at Waterston near Athlone, Co. Westmeath. In contrast to the hermitage at Glin, which is more of a shelter or seat than a building, the one at Waterston is a substantial if rather plain structure, designed as a place of retreat or for taking refreshment (plate 61).

It stands high on a hill facing south, above a large lake which seems to be artificial and is now drying up. The building is very simple with a crudely pedimented front, which contains a pointed arched door and flanking windows. The stonework is grotesque, with large knobbly rocks sur-

rounding the openings and the remains of a rustic finial on top of the pediment, which is totally overgrown with ivy. The interior, now quite ruined and roofless, provokes a very different atmosphere altogether. This was at one time rendered or plastered and contains a series of three niches on the back wall and the remains of a fireplace. From inside the views are excellent and the whole setting and atmosphere are those of tranquillity and calm. The building is slightly cut into the slope of the hill and is surprisingly devoid of any mature flanking trees, except for a solitary yew. This absence is perhaps explained by the inscription on a stone tablet set in the ground not far from the entrance to the hermitage, which reads:

> On
> Sunday the 6th of January
> 1839
> Ireland was visited with
> A tremendous hurricane
> which destroyed
> Much of the fine old timber
> Of this demesne.

A totally free-standing hermitage in a similar pastoral, lakeside situation is at Oriel Temple near Collon, Co. Louth. The house grew through a series of major extensions, from being an ornamental garden temple into a family residence.[8] This transformation has in turn been much altered and the building is now the Cistercian Mellifont Abbey. In the eighteenth century the grounds were considered to be of great beauty, much of which remains to be enjoyed today. A number of follies existed at one time, including the hermitage, a grotto, and a rustic cottage. Of these, the grotto has now gone and the cottage, which also acted as a hunting lodge, has been modernized. The hermitage remains, albeit in a fairly derelict state.

61. Hermitages at Waterstone, Glin, and Oriel Temple: elevations and plans.

It stands at the foot of a gently sloping hill, overlooking a lake encircled by trees, which conveniently break on the opposite side of the lake to frame a view towards the faint silhouettes of the distant Mourne mountains (plate 62). This exquisitely composed scene is a further example, on a much larger scale, of how the natural beauty of the terrain was appreciated and improved by the sensitive hand of someone who had carefully understood the genius of the place before starting.

The building is constructed of irregular rubble stone with lumps of tufa and gnarled, roughly shaped marble mixed through it, all of which gives a crude and heavy appearance. It is rectangular in plan, consisting of two linked chambers, the rear of which ends in a curved bay. Each of the chambers is crowned with thick rubble-stone domes which are expressed externally and make the building look like a giant headless camel. Large pointed-arched window openings with jagged rustic arches occur front and back, giving adequate light to the interior, which is entered through a doorway to one side flanked by two shallow niches. Inside,

the building is surprisingly sophisticated, with the front chamber circular in plan and the wall punctuated by a series of three niches or seats, and a fireplace (plate 61). From inside the view through the large opening over the lake is impressive and the atmosphere is almost homely, with the niches, fireplace, and patterned pebble floors.

There is no evidence of there ever having been shell-work or plaster on the internal walls, although the fireplace would suggest that there may once have been windows and a door, of which there are also remains at Waterston. It is likely that these buildings were used as summer-houses for picnics or other refreshments by a society which placed great value on the medicinal properties of fresh air. Whether or not it was ever furnished to imply that a hermit had taken up residence we can only speculate, and conclude that in this instance he would not have suffered too much discomfort.

One interesting Irish hermitage which was certainly inhabited by a gate-keeper, but not a hermit, is at Kilronan Castle near Ballyfarnan, Co. Roscommon. The hermitage and the house are now both in ruins, although enough of the

62. Oriel Temple hermitage: setting with view across the lake towards the Mourne mountains.

hermitage survives to give a good impression of how it looked. It is set into a steep tree-lined bank and stands inside a triple-arched rustic gateway overlooking a small lake. The building, which probably served as a secondary entrance lodge to the estate, is extremely grotesque in appearance. This is mainly due to the contorted plan and the fabulous shapes of the river-worn rock from which it is built. Internally there are two rooms (plate 63), the first of which is a narrow oval shape, entered by a pointed-arch doorway. It also contains a fireplace with a pointed-arch opening and three crudely elliptical windows to the front and one smaller round window to the side.

This room leads into a second chamber which has a more regularly shaped plan, tapering away from the entrance, with another fireplace and two large pointed-arched niches. Here the windows consist of small circular openings above ovals which look out through a wonderful open loggia of wildly shaped stone piers supporting high pointed arches (plate 64). The loggia and the pointed-arched reveals which surround the windows add a touch of architectural pretension, which contrasts nicely with the madness of the grotesque stones and the absurd plan shapes. Local recollections claim that it was inhabited by a gate-keeper and that leaded windows and a flat lead roof completed the building. It may well have been built for this purpose, as the internal finishes of lime plaster and stone-flagged floor imply. Its close proximity to the lake would suggest that it may equally have been designed for pleasure. Either way, it is a very charming building which seems much older than the main nineteenth-century house.

RUSTIC ARCHES

Rustic arches are fairly rare and not an easy category to pin down. They are generally large in scale and Gothick in flavour, but they should not be confused with sham ruins as they were not built to be deliberately ruinous. In many ways they resemble hermitages on a grand scale, which is the reason for their inclusion in this chapter, and the two examples to be considered here are sufficiently important to be given their own section.

The first of these is known as the 'Gothic arch' and is found at Belvedere, Co. Westmeath. This building is unique not only because it is carefully and purposefully designed, unusual for its type, but also because we know the name of the architect. In contrast to many of the other hermitages, which are generally both primitive and naturalistic in their design, this structure exhibits all the compositional and stylistic considerations of a serious work of architecture. This is not surprising, as it is unquestionably the work of Thomas Wright, the versatile English mystic, philosopher, and architectural Jack-of-all-trades, who visited Ireland and certainly left his mark during the middle part of the eighteenth century. The design appears in his *Universal Architecture*, of which the first two books, on arbours and grottoes, appeared in 1755 and 1758.

The so-called Gothic arch at Belvedere consists of the

63. Kilronan hermitage gate lodge: plan.

64. Kilronan hermitage gate lodge: setting showing the rustic loggia of river-worn boulders.

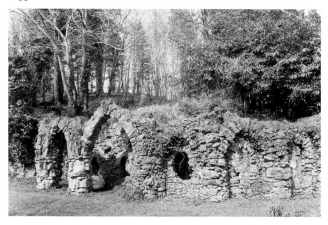

central part of Plate M from the *Six Original Designs for Grottos*, which is a large and complicated design not only in elevation but also in its planning. The plan shows a cruciform layout within the central bay, leading into a square-shaped room with four square columns (plate 65). Curved wings springing from the central bay are terminated by round towers with access to curved staircases. The structure is deeply embedded into an imaginary hillside, which partly explains the grotto label.

Externally the design has too much physical presence, and, although wildly grotesque, is too ordered to be considered a bona fide grotto. Like many of Wright's designs, the outward appearance hints at both classical and Gothic references. In this case the curved wings and symmetrical composition and the vaguely Venetian windows at the base of the side towers suggest Palladianism; while the pointed arches, quatrefoils, arrow slits, and corbelled tops of the turrets are medieval in influence. Along the top of the entire structure the walls appear to dissolve in the most bizarre fashion, which adds an unreal element to the whole composition. Wright includes the following detailed description of the design:

65. Thomas Wright's eighteenth-century grotto plan (plate M) from *Six Original Designs for Grottos*.

66. Belvedere rustic arch by Thomas Wright as built: elevation and plan.

Plate M Grottos—Elevation and Plan of an Artificial Grotto of the Antique Ruin Kind, supposed to be the Abode of an Anchorite.

Method of Executing Design M—The manner of Executing the Design is with Jointed Rockwork, so as to look all of a piece, but in the Gothic Stile of Building; and within it may be finished in the Grotesque Manner, the inward Apartment is intended to be lighted from above through the Roof or Rock-work, and may be either fitted up plain, or with tesselated Marbles with a Mosaic Pavement. This sort of building can't be too conspicuous, and will look well terminating the view of a lawn, provided it is well bordered with woods, and back with rock and hilly ground.

He also adds an interesting footnote, displaying a rare flash of eighteenth-century flexibility when he writes, 'N.B. If water can be brought to it, it will easily be form'd into a magnificent Cold Bath.'[9]

With such seductively drawn and written impressions of what might have been, it is very disappointing that only the front of the central bay was ever finished. This provides only a flat two-dimensional eye-catcher, but is none the less an impressive folly (plate 66). It is most beautifully sited on high ground and backed with trees (as Wright had suggested) across open undulating pasture-land ringed with woodland and dotted with picturesque clumps of trees. These have been carefully positioned to frame and direct the view towards the structure, which has a face-like appearance, common to many of Wright's designs. The composition consists of a central round-headed archway, above which projects an elaborate oriel window, like a great stone basket, flanked by a series of loopholes, pointed-arched windows, and square and circular openings. Great voussoirs in the arch and a raised string-course provide further decoration, and the parapet is topped by a grotesque line of river-worn rocks which resemble the roots of teeth (plate 67).

The building is dated around 1760 and we do not know if it was ever the intention to construct the entire design. Projecting stones from the sides suggest that they may have been built in to provide a key for future extension and certainly the first Earl of Belvedere lacked neither the will nor the money to embark on such an extravagant enterprise, as we shall see when considering some of his other folly-building ventures. It is also intriguing to speculate on which came first, the design for Belvedere or the design for the book? It is possible that the design was simply copied from the second volume of *Universal Architecture* after it was published in 1757. On the other hand, Wright records passing through the area around Lough Ennell in his published account *Itinerary for Ye South* of May 1747 and he may well have received a formal commission for some work at Belvedere. His influence is certainly evident throughout the demesne, particularly in the design of the other follies, even if he was not directly responsible for them. The very close and exact relationship between the building and the drawing suggest more than a mere passing involvement by its author. Wright was not unused to providing a prolific stream of designs as he travelled around the country, and the designs for rustic arbours at Belle Isle and Florence Court, Co. Fermanagh, Tollymore, Co. Down, and Dundalk House, Co. Louth, all of which have now disappeared,[10] have been attributed to him. Though it is interesting to speculate, such lesser details of how and when are unimportant. The building is there, and though incomplete, it is the largest and most important of any of the *Universal Architecture* designs to have been built.

The second example of a rustic arch is at Luttrellstown, Co. Dublin, and, while it is much simpler and less well detailed a design than that at Belvedere, it has an impressive scale and spatial complexity. It spreads across a deep wooded ravine containing a picturesque stream, of which large sections have been improved to create an impressive series of cascades. The stream drains an artificial lake on the edge of which stands a Doric temple-fronted cold bath. The rustic arch serves a dual function, forming a bridge linking the two higher edges of the ravine and also providing a suite of three rooms within the structure itself. A large round-headed archway bridges the wide path, and the rooms, all of which occur to one side, partly bridge over the stream and are partly cut into the side of the slope. These factors all combine to create a most dynamic and romantic composition (plate 68), which has been described as 'perhaps the finest of its kind in Ireland'.[11]

On the upstream side of the arch a small square turret springs up at high level, and is balanced on the other side by a more prominent round turret which runs the full height of the structure, with external steps to the top from the upper level. Entrance to the two main chambers is through the three pointed-arched openings in the base of the round turret. The chambers, which are linked and have vaulted ceilings, contain fireplaces and the larger of the two is positioned directly over the stream, with a large Gothic window facing upstream towards the cascades. Two smaller windows in this room, overshadowed by a giant yew tree, face downstream, and a third in the circular alcove looks

67. Belvedere rustic arch: detail of grotesque stonework.

68. Luttrellstown rustic arch: elevation and plan.

into the archway and the pathway down below. The third chamber is separated from the other two by a tall vaulted passage and is largely subterranean. This room appears to have been a service room with a fireplace and an abundance of storage reveals. There is also evidence that the building was constructed in two phases and it was clearly intended for some specific purpose, probably as a venue for well-provided picnics or even small banquets.

It is doubtful that this building was intended to appear as a ruin for, with the exception of the parapets of the bridge, it remains fairly intact and there is evidence that it once had windows. The arch adds a formidable presence to the valley as it springs up from a massive rocky outcrop to one side and goes on to link the path and stream of the valley floor with the high pathways along its top (plate 69). For all its rough and ready crudeness, this building is much more than a mere scenic backdrop, as it both addresses and combines all the existing forces of nature in a way that shows great architectural understanding and subtlety (plate 70).

69. Luttrellstown rustic arch: roof plan which bridges the valley. 70. Luttrellstown rustic arch: setting viewed from the valley floor.

CHAPTER 4

Towers

Of all the different types of folly in Ireland, towers are the most common and easiest to identify. They do, however, vary enormously in both style and size, serving an infinite number of functions from the frivolous to the very serious. With Ireland's turbulent past, it is not surprising that the country boasted a great legacy of towers even before the folly-builders set to work. Reading some of the early chapters of Maurice Craig's *Architecture of Ireland*,[1] one gets the impression that there were periods in Ireland's history when every building in the country was in the form of a tower. We also learn that the best-known of all Ireland's many types of tower, the round tower, is uniquely Irish in conception. Roughly a hundred exist in the country, of which thirty are relatively intact, and of the few which exist outside the country, all have Irish associations.[2] The Irish round towers vary little in design from one to the next, with an average base diameter of between 17 and 18 feet and a tapering shaft, which in some cases displays entasis,[3] and rises to average heights of between 80 and 95 feet, normally terminating in a conical cap.

They are thought to have been built between the tenth and twelfth centuries, and have long been the subject of

71. Ballyfin Tower in its impressive hilltop setting above the house. (Photograph by Roberto D'Ussy.)

Mouth of the Boyn

72. The Boyne mouth showing the Lady's Finger and the Maiden's Tower: an eighteenth-century view by Thomas Wright from *Louthiana*.

speculation and not a little fantasy. Thomas Wright surveyed and drew two examples in *Louthiana*[4] (plate 73) and also speculated fairly sensibly as to their possible use and origin. He is a little out in thinking they were built by the Danes, and his delightful drawings, which display all the entasis of a Tuscan column to which he compares them, is slightly exaggerated in being . . . not less than 130 feet. He goes on to suggest that they may have served as 'Bellfries or Curfue-Steeples, watch towers, warning towers, purgatorial pillars and Home-Directors',[5] by which he means landmarks for a quick return home in times of danger. If not totally accurate, Wright is at least closer to the truth than a later commentator, one Mr O'Brien, who almost a century later was to claim:

> The round towers of Ireland were all phalli, raised in adherence to the ancient fire worship of Persia, for the purposes of worshipping the sun, or male principles in the universe and for studying the revolutions and properties of the planetary orbs.[6]

In the third volume of Hall's *Ireland*[7] of 1843 there is a lengthy description of the mysteries which still surrounded the round towers. A great number of theories circulated around this time, from fire-towers to stylite or anchorite towers, with influences ranging from Greek and Roman to Gothic. It may not have been a very scholarly debate, but it certainly seems to have been an enjoyable one, and although the towers are today considered to have been used as belfries and safety deposits by religious orders, they still retain many of their old mysteries. In later medieval times towers were sometimes built as navigation aids or landmarks, such as the tall narrow tower at the mouth of the River Boyne at Mornington, Co. Louth. This is called the Maiden's Tower, as it was built during the reign of Elizabeth I. A charming vignette of the tower and the adjoining masonry pillar called the Lady's Finger appears in *Louthiana* (plate 72), dutifully guiding ships into Drogheda harbour at the mouth of the river.

These towers would no doubt have served the dual function of observation towers, perhaps with signalling beacons to spread warning of impending danger through attack from the sea.[8] Throughout Ireland's history, from the Danes onward, there has been a steady threat of invasion, as the

strings of ruined watch-towers along coastlines bear witness. Closely related to these towers are the magnificent Martello towers, built mainly along the eastern seaboard to repel the later threat of Napoleon. Around fifty of these towers exist, and they are not only very well built of crisply cut stone, but also exhibit a remarkable consistency in design. Built in the early years of the nineteenth century, they are round squat structures with massive thick walls and deeply sloping parapets. A large gun was mounted on the roof on metal rails which allowed it to rotate, with the living quarters and magazine below. Having been so well constructed, these

73. Irish round tower: an eighteenth-century survey drawing by Thomas Wright from *Louthiana*.

74. Lloyd's Tower: elevation as built.

towers are almost perfectly preserved and some have been converted into homes.[9]

The folly towers of the eighteenth and nineteenth centuries range widely in scale and design, from small pleasure pavilions to great compositions of romantic fancy. In the atmosphere created by these buildings there can also be found vast differences from the tranquil serenity of an example such as that found at Rostellan, on the shore of Cork harbour, to the brooding sublime monster at the Devil's Bit in Tipperary. An appropriately sublime description suggests that towers 'do a certain violence to the scene in which they are set, or even to the buildings from which they ascend, and . . . this is

why they were erected.'[10] Such a description may not apply to all towers, but it is certainly true for many.

One problem which the folly towers share with the historical towers of Ireland is the difficulty in dating them. The early tower-builders were so eclectic that they were quite capable of resurrecting a 100- or 200-year-old feature because it took their fancy.[11] In folly towers similar ancient features may occur. One notable example is the corbelled stone floor structure in the small watch-tower known as the Eye of Ardglass. Further ambiguity may be introduced by the popular habit of building in reclaimed fragments of true Antiquity. We have already noted some of the reasons why Ireland has so few intact medieval buildings standing today, and how these often became quarries used for later building projects. Along with all the ashlar and rubble stone, a great many carved stone features, window and door surrounds also found their way into later buildings to evoke historical associations and confuse future historians.

Much has been written about the complex psychology and megalomania of tower buildings, through Freudian phallic interpretations and stretching back to biblical accounts of the Tower of Babel. As a building form it occurs in virtually every developed architectural language, regardless of cultural differences. Towers convey a sense of security and power, while often displaying great elegance in their shape, through height and vertical proportion. Gaston Bachelard explains our fascination with towers in his essay on the phenomenology of the miniature.[12] In this he suggests that the act of contemplating a tower makes the rest of the world minute, provoking dreams of high solitude, detachment, and domination:

> From the top of his tower, a philosopher of domination sees the universe in miniature. Everything is small because he is so high. And since he is high, he is great, the height of his station is proof of his greatness.[13]

The attraction of towers to landowners is therefore an obvious one, as there is no better way to survey one's estate or display it to others than from a high vantage point of one's own creation. In most instances towers tend to be objects of pure aesthetic delight, never more so than when they occur in a natural landscape setting, as they are not only objects from which to see but also objects to be seen. Bachelard's countryman, Gustave Eiffel, would have been keenly aware of such exciting possibilities when he built his 1000-foot tower in Paris, which, in many ways, represents the world's greatest example of folly architecture.

The better to organize this varied category a number of subsections will be used, although these will surely overlap and certain themes will carry through nearly all the examples. Traditional Irish details such as projecting corner turrets, battlemented parapets, and battered base walls all appear frequently, unconstrained by any practical or defensive requirement, with only the limits of their designer's creative imagination to restrict them.

The importance of prospect has already been mentioned,

and it is also a recurring theme, along with those of monuments or memorials. To see and be seen are all-important considerations and for this reason towers are very often sited on top of hills. The earliest folly tower in Ireland is probably the one found at Carton, Co. Kildare, which appears on a painting of the estate by van der Hagen painted in 1730.[14] It is a square-planned, four-storey structure with battlements and seems early for a folly tower, most of which belong to the later eighteenth and nineteenth centuries. One of the finest and most impressive prospect towers in the country is Lloyd's Tower near Kells, Co. Meath. This tower is a most elegant circular structure, with finely dressed stone string-courses and window dressings (plate 74). Near the summit is a projecting viewing gallery, above which rises a hexagonal belvedere, which was once topped with a beacon. The tower has been described as an inland lighthouse and it is thought it was used as a co-ordination point for returning huntsmen.

The tower is beautifully sited on a gradual incline which in itself dominates the fairly flat surroundings, and the absence of any nearby trees makes it a very dominant landmark. It is alleged that from the base five counties can be seen. Certainly there are clear views of both the Mourne and Dublin mountains on a good day. Unfortunately the tower is no longer accessible as some of the internal stairs have been damaged, so it is no longer possible to ascertain whether the sea, which is about twenty-five miles away, can be seen. Not surprisingly, local claims suggest that it is clearly visible. The tower (which is described as a pillar in its inscription, and rises to a height of approximately 100 feet) was erected in 1791 by the first Lord Headford, later first Earl of Bective, to commemorate his father.

It was designed by a pupil of James Gandon called Henry Aaron Baker and the reference to the word 'pillar' is significant, as an earlier design for the structure was a monumental column. A drawing survives of this strange proposal[15] which shows a plain Doric column supporting a portion of Doric entablature on which stands an urn-topped belvedere (plate 75). The column and entablature combination seems both precarious and absurd. It is a close copy of William Chambers's drawing entitled 'The Doric Order in its Improved State', which is part of his plate entitled 'The Primitive Hut etc.' from *A Treatise on the Decorative Part of Civil Architecture*. This composition was intended only as a graphic illustration and not a literal interpretation as proposed at Headford. The open belvedere suggests that the summit of this early scheme was intended to be accessible. Its abandonment may have been a small loss to architecture, but as a folly it would have been splendid.

Another drawing of the tower also exists[16] but does not do justice to the elegance of its final appearance. It is interesting as it shows a well-dressed couple, one of whom is pointing to two small figures on the viewing gallery at the top of the structure. A ring of trees surrounds the tower and a small dog crouches beside the pointing man. The tower as executed is an excellent composition which survives in a remarkably good state of repair. Several lengthy inscriptions

75. Lloyd's Tower: drawing of an earlier unexecuted proposal. (Courtesy of the Irish Architectural Archive.)

76. Sampson's, Coolmore, Druid's Lodge, and Ardlui towers, at Ballykelly, Carrigaline, Killiney, and Blackrock: elevations and plans.

above the door give details of the memorial, and go on to list the stone-cutter, head mason, and overseer. Such an extensive tribute to the creative forces behind the building is well merited, and it would be nice to think that another plaque may one day tell of its repair and reopening.[17]

At Coolmore near Carrigaline, Co. Cork, on top of a hill above the house, stands a rather plain but interesting square-planned and battlemented tower (plate 76). It stands above a vaulted basement and rises in brick and rubble-stone construction to a height of some 30 feet. All of the door and window openings have pointed arches and the door case is particularly intriguing, having been constructed of cut-stone linings from a much older and probably medieval building. Internally the raised ground-floor chamber has a fireplace and a brick cross-vaulted ceiling. There is no evidence of an internal staircase and one of the openings at first-floor level suggests that an external stair may at one time have served this level. The views over Cork harbour are most impressive and would no doubt be even better if observed from the roof top, through the battlements, which rise up like bats' ears at the corners.

Two fine examples of towers embracing the important principles of the sublime aesthetic, although very different in their settings, are those found on the Devil's Bit, Co. Tipperary, and the Cliffs of Moher, Co. Clare. We have already noted the impact which Edmund Burke's famous essay had on the artistic sensibilities of the day, and the substantial influence it exerted in drawing attention to the beauty to be found in vastness and the awesome powers of

77. Carden's Tower in its sublime setting under the Devil's Bit.

nature. The great saddle in the ridge which gives its name to the mountain was caused by glaciation, even though colourful local legend would have it otherwise.[18] It is a dramatic and slightly frightening place. The tower known as Carden's Folly stands below the entrance to the gap, with its ugly and forbidding appearance adding an additional layer of gloom to the overall scene, even on a fairly bright day (plate 77). It is circular in plan and four storeys in height with dressed stone openings, a battered base, and corbelled crenellations, many of which have been toppled down to leave a jagged, uneven profile (plate 89). Access seems to have been through a trapdoor in the vaulted ceiling of the ground-floor chamber, and looking up through the now ruined floors one can see evidence of openings for fireplaces. The tower was probably used by the Carden family of Templemore Abbey, which once stood nearby, for outings and picnics, and to enjoy the dramatic setting with its remarkable views.

The second truly sublime example enjoys equally impressive views of a very different nature, as it perches on top of the 600-foot Cliffs of Moher looking out over the Atlantic Ocean. This squat little structure, which is more of a turret than a tower, is rendered magnificent by its dramatic setting. Today it consists of a round two-storeyed, battlemented structure (plate 78), with a second slightly lower tower butting into it on the seaward side and a single-storey castellated entrance porch on the landward face. It was built in 1835 by Cornelius O'Brien, who lived nearby, as a pleasure pavilion and to publicize the beauties of the cliffs. A contemporary description by a visitor suggests that the original building was more extensive than what remains today:

> a small castle on the most elevated part, to consist of two towers with furnished apartments, connected by large buildings for culinary purposes, and stables and coach houses adjoining—all for the accommodation of visitors to this stupendous scenery, who, on taking up provisions can have servants to attend, and the only return allowed by the kind-hearted owner is that they should make a remark in a book kept for the purpose.[19]

This interesting account gives us not only a picture of the

78. O'Brien's Tower in its spectacular setting on the Cliffs of Moher. (Courtesy of the National Library of Ireland.)

79. Father Mathew's Tower at Glanmire with a recent addition.

tower itself, but also some indication how such small and remote pleasure buildings were used for the taking of refreshments at an ideal vantage point after a walk or a carriage ride. Visiting this particular building on an overcast afternoon in early January, with strong winds driving sheets of rain and spray up off the tops of the cliffs, it is hard to imagine this impressive setting being any less sublime even on the calmest, hot summer's day.

Memorial towers are numerous throughout the country and one of the most famous is Father Mathew's Tower at Glanmire near Cork. It was built in the 1840s to the design of George Richard Pain, and presents a crisp Tudor Gothic appearance, with three storeys rising from a circular plan and a projecting circular stair tower. The window dressings and corbelled battlements are very fine and the whole composition provided an impressive memorial to the famous temperance campaigner whose statue stands before it. A rather surprising extension to the tower in recent years has changed the effect of it quite alarmingly (plate 79).

By the mid-nineteenth century memorial towers were becoming very common and two examples of similar scale can be found at Hollybrook near Bray, Co. Wicklow, and Sampson's Tower near Ballykelly, Co. Derry. Built in 1849 and 1859 respectively, the former is a four-storey round tower with slightly projecting battlements (plate 80), an imitation garderobe, and is thought to have been erected to honour a royal visit to Ireland. The latter is a slightly more complicated if less elaborate structure, comprising a square plan with a round stair tower intersecting one corner (plate 76). Both main and stair towers have arrow-slit openings and dog-tooth dressings, in imitation of machicolations, below slightly projecting parapets. A narrow red sandstone spiral staircase leads up past two square rooms with brick vaulted floors to the remains of a battlemented viewing gallery. The stonework is not as fine as the Hollybrook tower, but is none the less a fine example of its type, with square stone quoins and a battered base. An inscribed plaque above the doorway relates that the tower was erected to the memory of one Arthur Sampson, Justice of the Peace and Agent of the Worshipful Company of Fishmongers. It

stands at the edge of a fern-strewn, wooded approach which seems oddly discreet for a commemorative building, and although not far inland, it affords only distant views of the sea from its summit.

Two of the finest examples of nineteenth-century folly towers are found standing within a few miles of each other, at Scrabo and Clandeboye in north Co. Down. Both are well-designed essays in the Scottish baronial style, constructed within the same decade.[20] The earlier and smaller of the two is Helen's Tower, built by the fifth Lord Dufferin[21] in honour of his mother, Lady Helen Dufferin, and bears a date stone of 1850 above the entrance. The tower stands on high ground to the southern end of the estate and is approached by a wonderful curving path which rises up the rocky hill with occasional glimpses of the turrets above a sea of Scots pines (plate 81). A wide clearing in the trees allows an uninterrupted view of the entrance façade, which consists of a square-planned, four-storey tower with battered base, adorned with conical bartizans (plate 82). There is also a smaller and slightly higher square stair tower set back at high level, and an entrance porch at the base. The composition is particularly good, as is the quality of the stone dressings and corbelling, and the inward-curving conical roofs of the bartizans add a delightful touch (plate 83).

It was designed by the Scottish architect William Burn, who was known mainly for his country-house designs. A large collection of Burn's drawings for cottages, lodges, and towers is to be found in the RIBA Drawings Collection. These include the drawing dated 1848 for the Clandeboye Tower which is entitled 'Gamekeepers Tower'.[22] It is unlikely

80. Hollybrook Tower: detail.

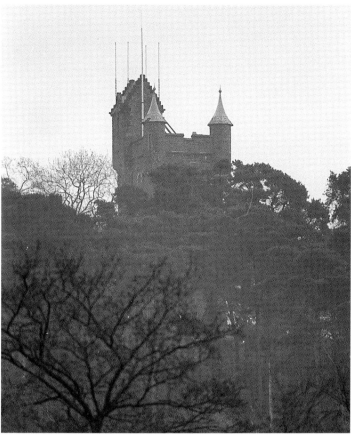

81. Helen's Tower, Clandeboye, rising above the surrounding treetops. (Photograph by Roberto D'Ussy.)

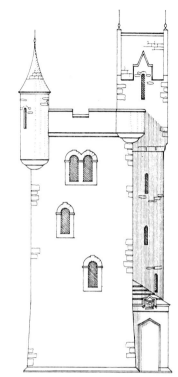

82. Helen's Tower, Clandeboye: elevation.

83. Helen's Tower, Clandeboye: detail of turrets.

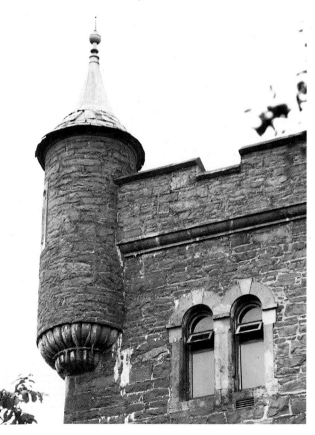

that the tower was ever used as such, as the interior is lavishly finished, with the octagonal upper storey lined with timber panelling and Gothic vaulting.[23] On the walls there are a number of bronze tablets containing poems by Kipling, Browning, and Tennyson, specially commissioned to celebrate the love between Lady Dufferin and her son. The best known of these reads:

> Helen's Tower here I stand,
> Dominant over sea and land.
> Son's love built me, and I hold
> Mother's love in lettered gold.
> Would my granite girth were strong
> As either love, to last as long.
> I should wear my crown entire
> To and thro' the Doomsday fire,
> And be found of angel eyes
> In earth's recurring Paradise.[24]

Some years after the inauguration of the tower a small privately printed edition of the Helen's Tower poems was produced under the title *The Book of Helen's Tower*. This gives details of the various formalities and the guests present at the inauguration ceremony and includes not only the Helen's Tower poems but also Lady Dufferin's poem 'To

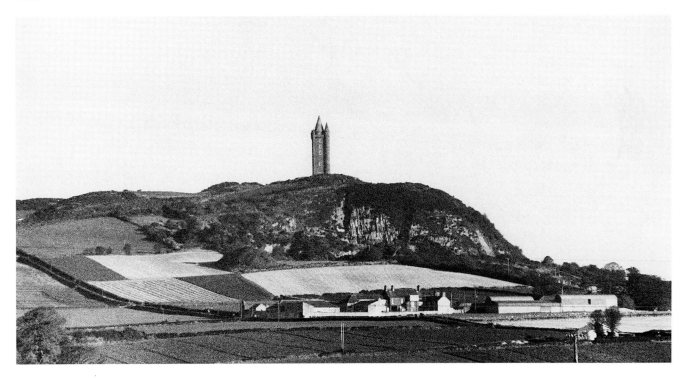

84. Scrabo Tower (Londonderry memorial) on its prominant headland.

Her Son',[25] along with a number of others to the Marquess and Marchioness of Dufferin and Ava. Concluding the collection are three poems by Byron, Coleridge, and Thomas Moore to R. B. Sheridan, the dramatist and statesman, who was Lady Dufferin's grandfather.

In his history of the Dufferin family entitled *Helen's Tower*, Harold Nicolson, nephew of the fifth Lord Dufferin, includes a lengthy description of the building:

> There are but three rooms one above the other and at the top a roof-bastion. A stone turret stairway leads from the ground floor where the caretaker has his kitchen and from which the smell of rabbit-stew and potato-cakes creeps into the upper chambers, mingling the living savour of an Irish bothy with the dead scent of closed rooms, of Victorian woodwork, of camphor and of decaying brocades. On the first floor there is a bedroom with a small four-poster hung with embroidered curtains. Above it is the sitting-room with a carved and diapered ceiling, each square of which contains a coronet or a crest. Upon the walls of this room are hung golden tablets, much stained with damp, upon which are recorded the poems associated with the name of Helen, Lady Dufferin.[26]

Nicolson appears to have been less than impressed by the brooding memorial atmosphere which had encroached upon the tower after the death of Lady Dufferin. He was more enthusiastic when describing the view from the roof-bastion:

> There is a sweep of sky around the battlements and the rush of the winds from Scotland. Below tumble the green fields and white cottages of Ulster and at one's feet the woods and lakes of the Clandeboye demesne. To the north, across Belfast Lough, rises the hills of Antrim; to the south, shine the wide waters of Strangford and the line of the Mourne Mountains. While to the east, across the North Channel, opens the whole panorama of Scotland, from the Mull of Kintyre to the hills of Carrick and Ayr. And then one closes the door upon that rush of wind and sky and sea, and is alone again upon the damp staircase, conscious of the brooding secrecy of those two silent rooms.[27]

This act of filial devotion and remembrance was not to be the only sad association with the building. An almost exact replica of the tower was later erected at Thiepval in northern France. This commemorates the appalling casualties suffered by the 36th Ulster Division on the Somme during the Great War. It was chosen for the memorial as the Ulster Division had camped and trained at Clandeboye beside the original, which was for many the last memory of home before their fateful embarkation. The French tower was dedicated in 1921 and bears a slightly altered version of Tennyson's poem which reads:

> Helen's Tower here I stand
> Dominant over sea and land;
> Son's love built me, and I hold
> Ulster's love in letter'd gold.

When gazing southwards from the roof-bastion, Harold Nicolson would have seen Scrabo Tower, which, while

similar in style (and equally dominant over sea and land) is altogether different in scale and setting. It stands high on a rocky, treeless outcrop above the town of Newtownards, near the end of Strangford Lough. From a distance the scale is deceptive, largely due to the massive rock on which it stands (plate 84). It is only when arriving at the base that one fully appreciates its great height (plate 86), rising to over 130 feet, almost twice as high as Helen's Tower. It was built to the memory of the third Marquess of Londonderry, a distinguished soldier and diplomat, who is noted for having tried to alleviate suffering during the potato famine. An inscription over the door tells us that it was:

Erected
In memory of
Charles William Vane
3rd Marquis of Londonderry
KG & etc.
By his tenants and friends.
Fame belongs to history, memory to us.
1857

The design by Charles Lanyon was the result of an architectural competition, but was chosen only after the first three designs had been rejected on the grounds of expense. As built, the tower is a much simplified version of Lanyon's competition entry, but is none the less an impressive edifice. It rises from a high knobbly base with the familiar arrangement of square plan with circular stair turret to one corner (plate 85) to impressive corbelled battlements with pepper-pot bartizans to the other three corners and a hugh conical roof. From the wide walkways behind the battlements (plate 87) it is possible to survey most of North Down, with its rolling drumlin landscape and the wide stretch of Strangford Lough.

Stone from the site was quarried and used in the construction, with basalt rock for the walls and Scrabo sandstone for the roofs, stairs, quoins, and window dressings. The use of this local stone and the large, rough projecting stones on the base give the building an additional and important link with the outcrop from which it grows. Internally there is a

85. Scrabo Tower: plan.

86. Scrabo Tower: elevation.

87. Scrabo Tower: view from the battlements.

A more modest example is found in the centre of the town of Bushmills, also in Co. Antrim. This tower is smaller in scale and much looser in its interpretation, with a series of blind reveals and decorative string-courses, which step in as it rises up to a lapped stone conical cap, more in the manner of the turrets at Scrabo Tower than of an authentic round tower. Erected as a clock tower, it provides the main focal point for the town (plate 95).

On a hill at Curraghmore, near Portlaw, Co. Waterford, stands an interesting eighteenth-century edifice on the round-tower theme (plate 89). It is known as the Le Poer Tower, and according to its inscription was erected in the year 1785 by George, Earl of Tyrone, to his beloved son, his niece, and his friend. It is a massive rugged structure, circular in plan with walls in excess of seven feet thick at the base. These

88. Chaine Memorial sham round tower, Larne harbour: elevation.

series of vertically stacked rooms, each with windows on all faces, brick cross-vaulted floors at the lower levels, and timber floors higher up the building. For 109 years, up to 1966, the tower was inhabited by a caretaker and used as a tea-house; more recently it has undergone an extensive restoration and now accommodates a visitors' centre.

Not surprisingly, there are a number of round tower replicas in existence. One of the grandest of these stands at the end of a causeway which projects out into the sea near Larne harbour, Co. Antrim (plate 88). It was erected in the late nineteenth century to commemorate James Chaine MP, who died in 1885. From its inscription we learn that it was 'erected by contribution of every class in this mixed community, irrespective of creed or party, all cordially united in esteem and affection for the memory' and it goes on to relate that Chaine had helped to establish Larne's harbour and links with the United States. The tower is a fairly accurate replica which rises to a height of some 95 feet, and is all the more striking for its unusual maritime situation. It provides a notable landmark for the ferries arriving at Larne harbour and is particularly impressive at high tide, when its battered base is partly submerged.

58

89. Carden's, Campden, and La Poer towers, at Devil's Bit, Charleville and Curraghmore: elevations and plans.

90. Le Poer Tower Curraghmore: detail of the entrance, which resembles a medieval round tower.

contain a central spiral staircase, lit by narrow windows with huge splays, which rises to a stone platform behind a low crumbling parapet. From the top there are fine views down over the Suir valley and surprisingly, despite the surrounding forest, the tower is clearly visible from the valley floor, on the road from Waterford to Clonmel. The most impressive feature of this tower, apart from the sheer mass of its walls, is the size and pattern of the masonry. Around the doorway in particular (plate 90) there are great roughly squared blocks of stone with a crudely wrought arched lintel and door jambs, suggesting building techniques from the primitive early Christian period.

In the more built-up setting of what has become suburban Dublin, another interesting subgroup of towers is to be found. These are fancifully known as 'spite towers' and are thought to be a product of tit-for-tat invasions on neigh-

bouring privacy. If the colourful stories are to be believed, these garden structures came into being when one party built a house too close to their neighbour's boundary and the indignant neighbour responded in the extreme by building a tower to reciprocate. One example is found at Ardlui in Blackrock (plate 76), built in the 1840s and comprising a modest round building some 40 feet in height, constructed of rendered rubble stone. One open and three blind rectangular openings rise above the Gothic entrance door to a slightly projecting battlemented crown. Internally a narrow stone stair winds around a central spine up to a platform with views of Dublin Bay, Howth, and the Dublin mountains. It stands on what was once the grounds of Ardlui House; the house is now gone and the tower has clearly seen better days. Remnants of Gothic window-frames can still be seen in some of the window reveals, which suggest that at one time it had a much finer appearance than what survives today.

A more refined example of a spite tower is found in the garden of Druid Lodge, Killiney. This lovely structure was built around 1832 of fine ashlar. It is square in plan with three storeys rising to a height of just under 40 feet (plate 76). Three steps lead up to a ground-floor room with glazed double doors, while an external stone staircase wraps around the side of the building to a door at the rear. The door opens into a room which takes up the full plan of the tower, with a narrow winding staircase to one end leading to a similar chamber above, then up to the battlemented flat roof. While the presence of windows on all four walls of the uppermost room, and the tower's close proximity to the neighbouring garden, might well support the spite theory, it is just as likely that the building was erected purely for the great pleasure it clearly affords. Views from Killiney Hill tend to be good even from ground level; from the battlements of a crisp stone tower they are even better. The greatest charm of this building is, however, the facility to use it for more than just a viewing platform. Its two small upper rooms are perfect for entertaining, reading, or contemplation, and, at the time of my last visit to the tower, a contented young guest was using one of the rooms as a temporary bedroom.

In nearby Dalkey a similar but simpler version of the Killiney Tower stood until a few years ago, when it was unfortunately demolished. Hayes Tower, as it was called (plate 91), was a rather plain, square-planned building, with battlements and a cement rendered finish. It was built by the Hayes family of Hayes, Cunningham and Robinson, the well-known Dublin pharmacists of Grafton Street. No one could claim that it was a beautiful building, but it was nicely sited, inoffensive, and the views alone would surely have more than justified its retention. One final garden tower worth noting in this section is found in the Stranmillis area of Belfast, in the grounds of the now demolished Beaumont House. This consists of a neat little three-storey brick octagon, with stone corbelling and sash windows, which was built into the corner of a garden wall around 1862.[28]

The tradition of building towers into walls goes back to the earliest times and was common practice in defensive constructions. It was also the form chosen for what can arguably be claimed to be the first true folly, Vanbrugh's great wall, which he designed for Castle Howard. This included gateways and quasi-military towers or turrets, and since those early days the formula has been repeated many times. A great many towers find their way into the designs for entrance gates, even on a relatively modest scale such as the entrance to Shelton Abbey near Avoca, Co. Wicklow, designed by Richard Morrison (plate 132). Many larger examples exist and we shall be encountering some of the more extravagant versions in the following chapter. There is also an established tradition of including towers in compositions for the great irregular ranges of castle-style houses so beloved by admirers of the picturesque. These cannot correctly be considered as follies, even though there are many similarities in the underlying principles of their design. In some cases relatively independent towers exist close to the house, linked only by a screen wall, as with the fine example to be found at Luttrellstown Castle, Co. Dublin.

91. Hayes Tower, Dalkey, photographed shortly before its demolition.

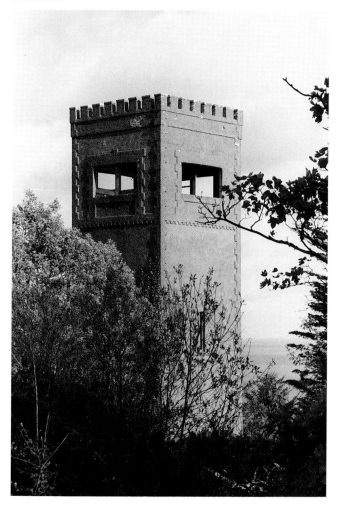

92. Cockle Tower, Larch Hill: elevation and plan.

A good example of the tower in a wall combination is found at Larch Hill in Co. Meath, an extremely interesting estate of modest scale dotted with an abundance of follies. The Cockle Tower, as it is known, a neat, battlemented, circular structure of three storeys, sits at the corner of a high garden wall, which is also adorned with double-stepped battlements capped with stone hemispheres (plate 92). A ground-floor chamber is entered on the diagonal, and consists of a simple domed room with deep, splayed, Gothic windows, which have a delicate glazing pattern containing some coloured glass. The interior of the room was once completely covered in beautifully patterned shell-work which gave the tower its name, and through the rubble and fallen shells evidence of a fine patterned floor survives. Most of the shells are common in Ireland but the patterns are very carefully composed with large cockles, mussels, limpets, and razors creating patterns infilled with hundreds of tiny periwinkles. About half the shell covering has now gone, but the care and beauty of its arrangement is still evident and would have graced any grotto or shell house. This room was clearly used as a summer-house, with a fireplace to provide heating on colder days.

To one side of the tower a single flight of cantilevered stone stairs rises up to a door at first-floor level. This leads to a second round chamber which also boasts fine shell-work, crowned by one large conch placed centrally in the apex of the domed ceiling. A staircase rises on the rear wall and gives access to a flat roof area behind the battlements. The implied third storey is created by a series of Gothic niches, which, along with the string-courses, doors and windows, and the high battlements, create a composition of considerable charm. Its corner position, where the two walls converge at right angles, make it an important focal point for the garden and the surrounding countryside outside the wall, and provides an ideal vantage point from which to admire both. Further along the wall is a simple dairy, consisting of three arched openings supported on two side walls and two stout columns. Similar deep pointed-arch stained-glass windows adorn the rear wall, which is also decorated with naval and military scenes in blue glazed tiles, which suggest a date of around 1800–20 (plate 93).

At Carrowdore Castle, Donaghadee, Co. Down, there is another fine example of a tower built into a wall, in this case the wall of a stable-yard. The tower is a quaint Georgian Gothick structure of three storeys with two chambers above a pointed-arch entrance archway. Built of rubble stone, the corners terminate in square piers with castellated tops, which flank a roughly pedimented gable, supporting a strange

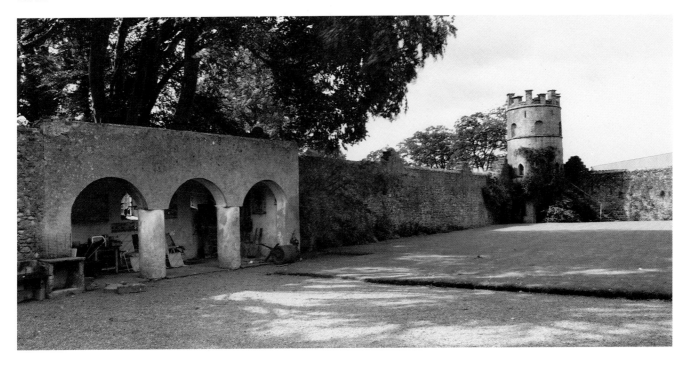

93. Larch Hill: Cockle Tower and ornamental dairy in their walled garden setting.

94. Carrowdore gate-tower entrance to stable-yard. (Photograph by Neil Kenmuir.)

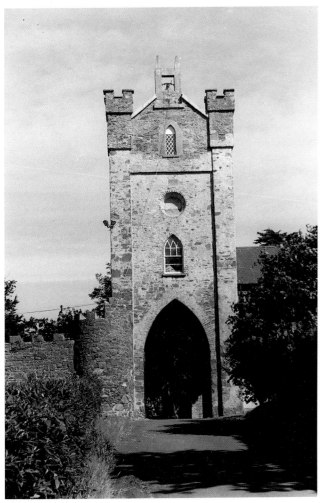

open stone structure which looks as if it once contained a bell (plate 94). A very similar but smaller-scaled version of a tower entrance to a walled stable-yard exists at Mount Rivers, Co. Cork. Here the entrance is simply for pedestrian access, comprising a splayed stone base with a simple flight of stairs set into it, leading up to a round-arched opening, above which a simple stepped tower rises with only a single diamond-shaped opening to relieve it (plate 95). Both of these structures provide just the right degree of architectural flourish to announce the entrance point and create an interesting eye-catcher to be viewed from the house.

Another modestly scaled tower is found in the much-follied grounds of the Hermitage, Co. Dublin. Here the tower is used as a clever architectural device to change levels in the garden, from a low artificial lake up to a path at a higher level (plate 96). A rectangular stone tower of two storeys sits adjacent to a wide stone stairway, the lower flight of which abuts a wall projecting at right angles from the tower. A second flight springs from the wide half-landing from which access is gained to the top room of the tower, while another much narrower stair rises back along a second flanking wall to reach the roof-top viewing platform. At the ground-floor level a short flight of steps leads down into a vaulted chamber with reveals to each side, and eventually to an even smaller chamber with narrow prison-like windows. It is hard to know what these lower chambers were used for,

95. Mount Rivers tower gateway and Bushmills clock-tower: elevations.

as the semi-subterranean atmosphere is not particularly inviting. The higher room and the rooftop belvedere do, however, provide perfect places from which to enjoy the lake and its waterfall.

One final and very picturesque example of a tower in a wall is found in the lovely setting of the shores of Cork harbour. This is at Rostellan and consists of a now ruined, low, round tower built on the end of a sham fortified battery (plate 97). The tower, which has lost its roof and part of its wall, rises from a high battered base from the shingly beach just below the high-tide level and in its heyday had a battlemented top and large window openings looking out to

96. Staircase tower at St Enda's and Sadleir's Tower, Mullaghill: elevations and plans.

97. Rostellan Tower viewed from the seashore.

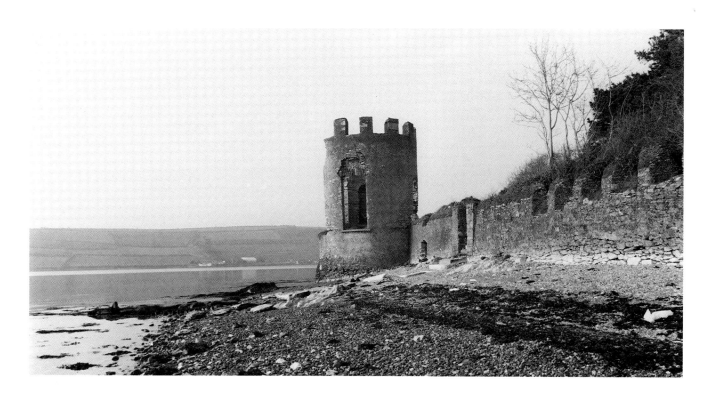

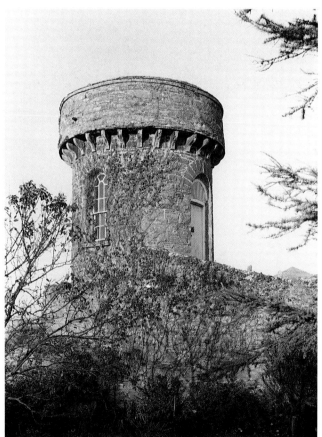

98. Rostellan Tower: elevation and plan.

99. The Eye of Ardglass with its adjoining garden wall.

sea. It is entered from a flight of grand stone steps on the landward side and internally there is evidence of a fireplace and storage reveals in the walls (plate 98). The tower was built by the fifth Earl of Inchiquin to entertain and honour the celebrated actress Mrs Sarah Siddons.[29]

In a similar spirit to the Rostellan tower, there are a number of other small towers which can best be described as pleasure pavilions. Two very fine examples of these are found on the edge of the ancient fishing town of Ardglass, on the coast of Co. Down. These two small towers are known as Isabella's Tower and the Eye of Ardglass (plate 100). Neither appears too incongruous in a town that contains one of the richest concentrations of medieval castles and tower houses found anywhere in Ireland. The folly towers date from the late eighteenth to the early nineteenth century, and both consist of circular turrets with projecting crowns springing from bases of differing geometries. Isabella's Tower is situated on a steep hill (which looks artificial) overlooking the town, and both its hexagonal ground floor and the projecting crown have dressed stone battlements. Windows and doors have pointed arches and diamond-paned glazing patterns, and a low stone wall surrounds the structure. The nicely detailed sandstone sills and drip mouldings, and the crisp slate dressings, which sharpen up the profile of the

brick corbelling, all show that no little thought went into its design and construction. Like the Rostellan tower, this one would have been used simply as a summer-house from which to enjoy pleasant views, in this case of the Mourne mountains and the Irish Sea.

The Eye of Ardglass is, probably, the older of the two, and is a very interesting building.[30] A cylindrical upper storey springs from a cubic ground floor in a most impressive manner, by vaulting inwards from the corners with large, flat, uneven stone slabs. This is a medieval building technique common to some of the surrounding castles, which in the middle of the ceiling creates an image not unlike the inside of a rose bloom, but the tower probably dates from a much later period. The ground- and first-floor chambers are lit by round-headed sash-windows, with early Victorian glazing bars, although it is likely that the building dates from the eighteenth century. At one time shells adorned the lower ground-floor room, until a zealous Victorian gardener decided to clean it up and hacked them all off.

The first floor is reached by a delicate stone staircase, cantilevered off a high garden wall into which the tower merges. Another interesting detail is the construction of the corbels, which consists of rubble stone set into curved slate templates. The coursed random stonework is very good, especially where the wall joins the tower, and the structure has a shallow conical roof which only just projects above the line of the parapet. The Eye of Ardglass is in many ways very similar to the Cockle Tower, with its garden-wall setting and shell decoration. In earlier days it probably enjoyed fine views of the nearby harbour; it looks particularly fine from the lovely garden which now abuts the outside of the wall (plate 99), from where one can get the impression of how these often modest little towers emphasized boundary walls, with fort-like conceit and implications of protection and privacy.

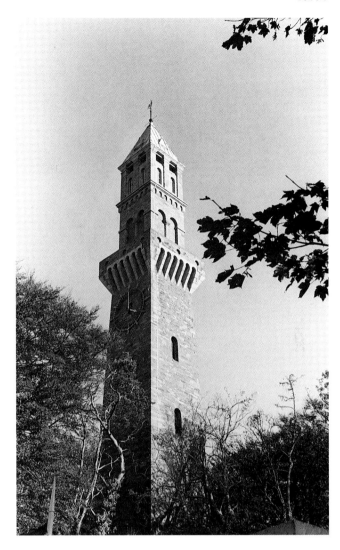

101. Farmleigh: Lord Iveagh's clock-tower is in fact a water-tower.

100. The Eye of Ardglass, Turnley's Tower, and Isabella's Tower at Ardglass, Cushendall, and Ardglass: elevations.

102. Ponsonby Tower, Piltown: elevation and plan.

One final example of the small pleasure tower is found on a desolate hill above a large bog near Mullaghill, Co. Offaly. This takes the shape of a small round tower with a smaller round turret rising from its central point (plate 103). Internally a staircase spirals around the hollow central core up to first-floor level, but access to the top is now impossible, owing to vandalism. It is difficult to picture exactly how the building was used. There is no decently sized internal space, which suggests that the tower was intended as a memorial or a modest prospect tower. An inscribed plaque on the wall reads 'Built Rev Sadler Provost TCD', along with a date which is not fully legible. This no doubt refers to the Reverend Franc Sadleir, born in 1774, who was Provost of Trinity College Dublin from 1837 until his death in 1851.[31]

One of the main reasons why so many folly towers exist is that many have been built for very practical and functional reasons, in addition to all of those factors already mentioned,

such as prospect, landmark, or pleasure. Clock-towers are common enough in towns where they can perhaps be considered as near relations, if not strictly speaking follies. In more rural settings they are much rarer. Lord Iveagh's tall Italianate clock-tower in a farmland setting at Farmleigh in Phoenix Park (plate 101), is a fine late nineteenth-century structure with an elegant tapering form adorned with machicolations and a pyramidal copper roof. This is somewhat deceptive, as it is in fact a highly functional water-tower.

Another water-tower which was originally constructed as a memorial is found at Piltown, Co. Kilkenny. This odd structure, known as the Ponsonby Tower, stands on an island in the middle of a road junction on the edge of town. A large, squat, stone octagon, with circular piers projecting from each of the angles, rises from a base of two deep steps (plate 102). The tower reduces in three diminishing bands, the lowest of which contains a series of pointed-arch reveals between the piers. Narrower reveals, also with pointed heads, decorate the second tier, while the third is a plain cement-rendered octagon of later construction. The tower was allegedly built as a memorial for a member of the Ponsonby family from the nearby Belline House, who was lost and assumed killed during the Peninsular War in the early nineteenth century. When the subject of the memorial arrived home safe and well the tower was left uncompleted. In later times the crude upper level was added when it became a water-tower.

One very practical and unusual tower is the triangular Campden Tower in the demesne of Charleville Forest in Co. Offaly. Charleville Forest is perhaps the finest nineteenth-century castle in Ireland and consists of a great range of battlemented towers and turrets, which in isolation would all make highly successful follies. The four-storey tower was built in 1840, with large stepped battlements and rubble-stone walls, terminating in crisp triangular quoins (plate 89). In reality, the acute 60-degree angle of each corner makes the building seem much higher than a straight side elevation, and in its heavily wooded setting it presents quite a shock when first encountered. Built into a single-storey wall which encloses a range of lower out-buildings, probably to house hounds and horses, the tower served as a hunting lodge. A carved crest above the entrance bears two small figures clutching arrows. Internally, the building contained a series of stacked triangular rooms with a small spiral staircase tucked discreetly into one corner, to lessen as far as possible the impact of the triangle. The interior is now a hollow roofless shell, in which one can see the remains of fireplaces and corner cupboards.

A tower very similar in scale and character to the Campden Tower is the one that marks the crossroads at the town centre of Cushendall, on the Antrim coast. This is known as Turnley's Tower (plate 100) and presents us with the argument that bona fide follies can be found in urban as well as rural settings. The tower is very much a focus for the small seaside town in which it stands, and is as famous for its eccentric creator as for the relatively modest building itself.

103. Sadleir's Tower in its desolate hilltop setting.

104. Turnley's Tower: rear view from the hill. (Photograph by Roberto D'Ussy.)

It was built in 1809 by Francis Turnley, an East India Company nabob, as 'a place for idlers and rioters'. Whether or not the tower ever served this public-spirited purpose is not known, but Mr Turnley's instructions concerning its functioning are well documented:

> The tower was the great object of Mr Turnley's thoughts; among his papers were instructions given to Dan McBride, an army pensioner, whom he appointed its guard. It was always to be provisioned for a year, and it was to have a permanent garrison of one man, who was not to leave it night or day; it was to be armed with one musket, a bayonet, a case of pistols, and a pike thirteen feet long, having a cross of iron or wood on its handle, so that it could not be pulled through the hole guarding the doorways.[32]

The structure is 20 feet square, and rises through four storeys with a slight batter to a battlemented parapet. A series of small-paned sash-windows project from the three upper levels (plate 104). Mr Turnley left nothing to chance and the first-floor bay window above the entrance contains a machicolated base for boiling oil or other suitable missiles. The tower is built of red rubble sandstone with squared quoins, and the narrow, deeply recessed arched entrance with its studded iron door is reached by three stone steps.

To conclude the chapter it is appropriate to consider one of the finest of all the folly towers to have been built in Ireland. The tower at Ballyfin, near Mountrath, Co. Leix,

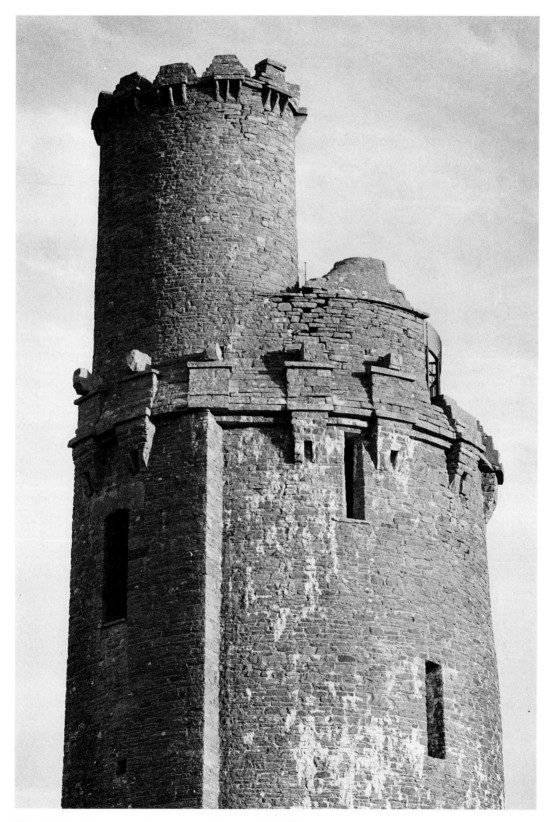

105. Ballyfin Tower: detail of turret. (Photograph by Roberto D'Ussy.)

106. Ballyfin Tower: plan of the rooftop observatory.

probably dates from the early 1820s when the Morrisons' excellent house was built for Sir Charles Coote. Today it survives as a Patrician college. Standing on a hill high above the back of the house, the tower is a majestic and romantic structure. It is surrounded by a deep, circular rampart crossed by a medieval-style drawbridge.[33] Inside the ramparts are a number of circular structures, now heavily overgrown, which suggest sham fortifications. In the middle of these stands a vast stone tower, rising six storeys in height (plate 71). While the fortified setting of ramparts and turrets is medieval in spirit,[34] the design of the tower was for its day extremely modern. The plan is a circle from which an elliptically shaped bulge projects slightly, containing a series of curving staircases. At high level a narrow circular turret rises from finely detailed crenellations (plate 105), behind which sit the remains of a quite remarkable, two-tiered, cast-iron, conservatory-like structure (plates 106–7).

Ballyfin House itself includes an important early curved-iron conservatory which dates from around 1850, but to build one in such an exposed setting is an astonishing show of optimism. It was designed as an observatory for Sir Charles Coote, who was a keen amateur astronomer, and such a bold endeavour was well rewarded by the wonderful views out over the surrounding countryside, which could still be enjoyed in sheltered comfort even during the harshest weather. It would be interesting to know just how long this delicate structure survived the ravages of its exposed situation before it was abandoned. Internally the tower is in an equally sorry state with windows broken, plaster falling off the walls, and the timber floors badly damaged. Like the Campden Tower, however, Ballyfin was solidly built and with luck may yet see better days, for if ever a folly tower in Ireland deserved restoration and repair, it must surely be this one.

On the evidence of the preceding pages, it is clear that towers were a popular and much-used building form for the folly-builders. They are widespread and appear in many different scales and settings. A great many more exist than have been described here, such as the fine example at Barmeath Castle, Co. Louth, or the octagonal towers at Quintin Castle, Co. Down. Almost all of the towers I have seen display some quality of delight and often add a slight touch of the absurd to lift the surroundings in which they are placed.

107. Ballyfin Tower: detail of the glazed roof of the observatory. (Photograph by Roberto D'Ussy.)

It is surprising just how many of the smaller garden towers stand forgotten in undergrowth in the grounds of abandoned or even occupied houses, such as the semi-ruined two-storey round tower which hides away in the corner of the garden at Daniel O'Connell's house at Derrynane, near Waterville, Co. Kerry. Often the plainer varieties of medium to small towers present an interesting exercise in pure geometry, with simple plain openings and an overall appearance that would not look out of place in the designs of the present-day European rationalist school of architecture. In this context one group immediately springs to mind. This is the line of three small towers, one circular, one square, and the third octagonal, which stand near the more recent lighthouse at the tip of Roches Point, Co. Cork. These towers are not strictly follies and would probably have served as earlier landmarks or beacons. Although they are now ruined, they still present a charming and useful landmark. Another early lighthouse constructed on the pier at Dunmore East, Co. Waterford, in 1814–32 was designed by the engineer, Alexander Nimmo, as a giant Greek Doric column,[35] which certainly brought an element of folly to this most serious and useful of building types.

CHAPTER 5

Gates and Lodges

Entrance gates and lodges may, on first reflection, seem a rather strange category to include in a study of this kind. In many cases they provide only a dull prelude to the richer treasures of the main house within the demesne. There are, however, a great many examples of gates and lodges where pure fantasy has taken control to create entrances of great extravagance or architectural flair, which makes their inclusion essential. One need only consider the vast extravagance at Ballysaggartmore, Co. Waterford, where overspending on the splendid twin gate lodges and the castellated bridge led to the abandonment of the construction of the new house. Another interesting aspect of this category is that it embraces so many of all the other types under consideration. In both style and form, large and small, from Gothic and castellated to Palladian and Greek Revival, they occur as towers, temples, triumphal arches. There is even a rustic hermitage.

Throughout all this indulgent fantasy it is important to remember that gates and lodges were often extremely functional buildings which housed a gate-keeper and his family. They also provided a public face to the more private house at a time when image and appearances were of great importance. As a result the entrances enjoyed an important

108. Bishop's Gate, Downhill: general view with the Hervey cenotaph in the background. (Photograph by Roberto D'Ussy.)

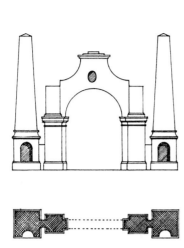

109. Classical gateways at Gloster and Arch Hall: elevations and plans.

symbolic role, and provided an opportunity to project the image and values of its creator. Often they play a clever supporting act, creating important first impressions and a sense of anticipation of the main event to follow. This can often cleverly interpret and enhance the complex psychology, excitement, and apprehension of arrival. An elegant classical archway or a prominently sited classical lodge will stimulate a very different atmosphere from a rugged barbican or a rustic arch.

Common to all follies, the siting of gates and entrances was of prime importance, not only for picturesque and scenic effect, but also to display at its best the wealth and style of its owner. It is because of the often successful siting of these buildings in the landscape that many gates and lodges find their way into this study. In a recent interesting book on gate lodges[1] their function is simply defined: 'Lodges were not merely garden structures, they were designed as entrances, garden buildings on the perimeter to lure respectable visitors to view similar pleasures within.'[2] The authors also note that, as a building type of generally consistent quality, it has surprisingly been ignored. If this is so in England, it is an even more neglected area of architectural history in Ireland. The great richness of this as yet untapped vein of architecture is obvious:

> A gate lodge offers a sequence of some 250 years of experimental design, during which professional architects backed by rich patrons essayed the problems of housing a working class family in a small structure of style and distinction.[3]

This reminds us again of the fact that lodges combined the dual function of garden ornament and servant's domicile, and in this bizarre duality, conflicts of interest could often arise. In *Trumpet at a Distant Gate* it is argued that utility often fought a losing battle with symbolism and display.

Many of the Irish examples will also demonstrate how families could sometimes be discreetly closeted in the most appalling, badly lit voids of some grand and extravagant edifice. In fairness, it should also be pointed out that there are many cases where the lodge-keeper and his family occupied an impressive and well built structure, in which they could enjoy the internal comforts of a building that others could only admire from the outside.

Within the scope of this category three basic models exist: the uninhabited archway or gate, the independent but inhabited lodge, and finally the inhabited entrance gateway. Often the first two models were employed together, with the archway or gates to create the impression and the independent lodge to house the gate-keeper. This arrangement would normally provide more comfortable accommodation than was sometimes found in the inhabited gateway extravaganza, wherein the impression of occupation was more important than any real consideration of the occupants. It is also possible that gate lodges were sometimes used as banqueting suites or pleasure pavilions. The most famous English example of this is at Badminton House, Gloucestershire, where William Kent designed a magnificent structure for the Duke of Beaufort, to serve as both a gate lodge and a dining pavilion. The classic error here is that the lodge greatly surpasses the house in interest and quality, which can only disappoint after the build-up of such anticipation.

The high standard of construction of some lodges suggests that they may have housed occupants of higher social standing than the lowly gate-keeper, who was quite an isolated figure with little or no contact with his masters. Often lodges situated at secondary entrances to the estate would have housed more valued servants or stewards. A multiplicity of gate lodges, like a boundary wall, not only defines the extent and grandeur of an estate, but also

110. Arch Hall gateway in its setting, looking towards the ruined house.

announces it very publicly to the world outside. As most of the lodges in Ireland are now abandoned and many are in a ruinous or semi-ruined state, it is often difficult to interpret just how they may have been occupied or otherwise used. By virtue of their peripheral location on the estate they are especially vulnerable to road widening, which often signals their demise, either by demolition or close proximity to noise and fumes. Of special importance in a country where so many of the eighteenth-century houses have now vanished, gate lodges, despite their vulnerability, may provide the only surviving remnants of what has been.[4]

111. Arch Hall gateway: detail of grotesque river-worn stone.

Early precedents of gate lodges, like towers, go back a long way; as long as there have been fortified walls there have also been strong and defensible gateways to enter them. The triumphal gateway is also a long-established form, often marking entry to the city as a manifestation of imperial ceremony and civic pride. From Roman to Napoleonic times this has been a much repeated urban device; and with the great influence of Roman architecture on eighteenth-century Ireland, it is not surprising to find numerous examples there. Barbicans and other medieval interpretations originating from castles or the fortified entrances to towns are also common.

The simple arched gateway ranges from wide castellated conceits to plain classical gateways and modest field gates. Two of the earliest arches, probably designed by Sir Edward Lovett Pearce, are found at Gloster, near Brosna, Co. Offaly, and at Arch Hall, Wilkinstown, Co. Meath. The former is a fine rubble-stone arch with a baroque sweep to its crown, which is pierced by an elliptical opening. The arch is flanked by a pair of obelisks with arched niches in their plinths (plate 109). It stands at the edge of a field some way from the house and was probably intended as an eye-catcher at the end of a vista through the woods, which has now become completely overgrown. Although the rubble stonework is quite crude, the structure is beautifully proportioned and the subtle projecting courses on the plinths and at the spring of the arch add a touch of elegance.

The second Pearce arch is now a dissolved ruin on axis with the equally ruined house, separated only by a flat

112. Russborough obelisk field gates: elevation.

treeless field (plate 110). In scale and type of construction the Arch Hall structure is very similar to that at Gloster. It comprises a central round-headed arch with piers carried up each side and topped with steep pinnacles which are somewhere between a pyramid and an obelisk in form. Above the main arch is an unusual pointed-arch opening which is approximately 9 feet high, of a proportion which suggests that it may at one time have contained a statue. Over this opening the stonework sweeps up to another pyramid-cum-obelisk pinnacle similar to the other two. Much of the outline has become blurred by neglect and decay, but in its original form it may have looked very like the reconstructed drawing (plate 109). Certainly this arch creates a most dynamic impression with its two central openings, the larger of which frames the house perfectly. The stonework of the voussoirs and inside the arch has been carefully selected to produce a grotesque rustication (plate 111), and there is evidence of tufa and shells set into the stonework.

Both of these arches display faintly baroque characteristics, and both are similar to the famous gates by Pearce's mentor, Vanbrugh, and his collaborator, Hawksmoor, at Castle Howard in Yorkshire. It is sad to see two such important early eighteenth-century structures, by one of Ireland's most accomplished architects,[5] crumbling away in such neglect.

No trace remains of roadways which may have passed under these two arches and it is likely that they were secondary entrances through fields situated on walks or rides. It is also possible that they were intended only as eye-catchers to be viewed from the house. On a smaller scale but in a similar spirit are the small field gates found at Russborough, Co. Wicklow, and Tollymore, Co. Down. At Russborough, in front of the house, is a long, iron, six-bar railing which is broken to each side by a delicate pair of gates with semicircular iron bracing, flanked by stone obelisks on high stone bases (plate 112). The miniature scale of the obelisks, which measure only 16 feet in height, is

very attractive and appropriate to the toy-like scale of the house, the façade of which is reputed to be the longest of any house in the country. Both sets of identical gates are clearly visible from the house and lead into a field which runs down to an artificial lake, past which are views of the Wicklow mountains. The house was designed by Richard Castle, Pearce's assistant and successor, and was built around 1740; the obelisks and the fine Gibbsian triumphal arch entrance gates probably date from the same time.

At Tollymore the gate piers are found just outside the boundary of the estate, on which there is a small cluster of similar constructions known as Lord Limerick's Follies. It

114. Barbican gate, Tollymore, possibly to the design of Thomas Wright: elevation and plan.

marks the entrance to a field by a pair of tall round gate piers with blind arrow-slit reveals. The piers are topped by tall sharply pointed cones, about the base of which is a crown of split river-worn stones, which have the appearance of great claws or teeth (plate 311). These are simply built in rubble stone, and bear all the hallmarks of Thomas Wright. Another set of simple gates in the grotesque Gothic style are found at the back entrance to Grey Abbey, Co. Down (plate 113). These consist of a series of four stone piers surmounted by tall pointed pinnacles, the inner two of which carry decorative entrance gates. The outer piers are connected to the inner piers by stone walls with castellated tops, which contain pointed-arch entrance-ways, also with iron gates. Nearby, and just outside the gates, stands an octagonal Georgian Gothic lodge. The entrance links the house to the local church, and, like the spire of the church, has more than a passing resemblance to the work of Thomas Wright.

More directly attributed to Thomas Wright is the Barbican Gate at Tollymore (plate 114), which spans the main approach to the site of the house, which has now gone.

113. Gothick gateway, Grey Abbey: elevation.

St Laurence's Gate at Droghedah.

115. St Laurence's gate, Drogheda: an eighteenth-century view drawn by Thomas Wright from *Louthiana*.

of modern living internally. There are a number of reasons why this trend was so popular in Ireland. One was simply the fashion of the day, which had turned towards a romantic fascination with an Antiquity much closer to home than Athens or Rome. Castles in all their many guises, authentic, sham, and nineteenth-century (modern), played an important part in the shift towards the picturesque, which followed the earlier gardening revolution with its Augustan influences of Poussin and Claude Lorraine. The political state in Ireland at the time may have stimulated another and more ominous reason for the popularity of this style. The period of uncertainty which followed the abortive rebellions and the Act of Union led to a certain defensiveness within the landowning classes, who in many cases had only been established within the preceding hundred years:

> By castellating their houses, or adding castellated wings to them, or in extreme cases replacing them by sham castles, they sought, at the subconscious level no doubt, to convince themselves and others that they had been there a long time and that their houses, like so many in England, reflected the vicissitudes of centuries.[7]

116. Barbican gate, Tollymore: detail. (Photograph by Roberto D'Ussy.)

Although the structure was constructed many years after Wright left Ireland, around 1777, his influence is very clear, and the gates resemble a similar unexecuted design for an estate at Wallington in his native Northumberland.[6] In style if not composition, the Barbican Gates are very similar to Wright's drawing in *Louthiana* of St Laurence's Gate at Drogheda (plate 115). The Tollymore gate consists of two circular crenellated towers of lightly rendered, random rubble, one on each side of a central pointed archway. The structure is adorned by quatrefoil loopholes, blind trefoil reveals, and a battlemented walkway between the towers (plate 116). In one tower is a low pointed-arch opening and in the other a staircase which leads to the battlements.

Nearby, and marking another entrance to the demesne, is the Bryansford Gate (plate 117), a neat Georgian Gothick structure built of finely cut granite blocks in 1786. The crocketed pinnacles and battlemented parapet, which were probably designed high enough to have been seen from the house, are supported by a pair of flying buttresses which spring from the flanking pedestrian gateways. A central Gothic arch provides the main thoroughfare, the spandrels above which contain some interesting cusp-like decoration (plate 118). This is created by three split cones radiating from a hemisphere carved in relief on the stone blocks of the arch, in imitation of the smoothed and rounded river-stones used to decorate many of the other follies which mark this interesting estate.

The castle style became very popular in Ireland in the nineteenth century as huge castellated houses sprang up all over the country, with greater or lesser degrees of historical accuracy in their outward appearance, and all the comforts

117. Bryansford gate, Tollymore: elevation and plan.

118. Bryansford gate, Tollymore: detail of bap-stone decoration in the spandrels.

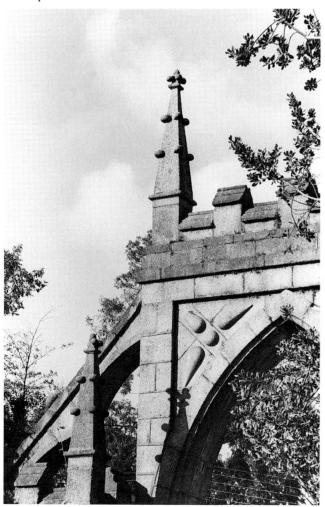

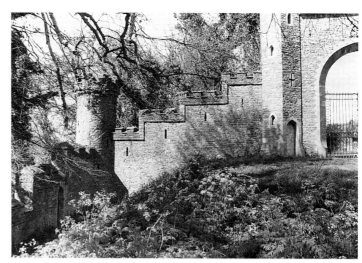

119. Castellated gateway screen at Slane Castle.

A very fine and expansive example of this style is Slane Castle, Co. Meath, which was started in 1785, to the designs of James Wyatt and later Francis Johnston, in a very beautiful riverside setting on the River Boyne. Approaching from the south, the main gate, designed by Johnston, is viewed from a hilltop across the river. It is partially obscured by trees and is carefully composed to link visually with the early multi-arched bridge which leads towards it. The gates consist of a long battlemented wall with a tall central arch flanked by hexagonal turrets. On the road side the wall steps up a gradual slope, ending in a small square tower. On the river side the wall steps down a much steeper slope to end in a small battlemented round tower (plate 119), from which another low wall projects at right angles along the river, ending in a small round tower. It is largely the effect of the latter wall that makes the composition so successful, as it reaches out and all but connects the entrance range to the impressive bridge. The stonework of this structure is very neat, with sharp dressings to doors, windows, and other embellishments and an interesting saw-tooth pattern around the doorways and central arch. Although these gates were designed purely for visual effect as an entrance screen, there is evidence of chimneys peeping above one of the flanking walls from a gate-keeper's lodge, tucked away discreetly on the other side.

Another notable castellated range is at Birr Castle, Co. Offaly. This was built during the early years of the nineteenth century, when the earlier castle was extensively remodelled and extended. The gates spread as a long and fairly low battlemented range, with a central pointed archway flanked by round towers, each linked by single-storey walls to small outer square towers (plate 120). Each tower has a rectangular window-opening with drip mouldings above, and the spandrels of the central archway are decorated by cross arrow-slits. Pedestrian doorways are set in the flanking walls adjacent to the round towers. At Castle Upton, Co. Antrim, there is a similar symmetrical, castle-style, entrance-gate screen. This is not quite as extensive as the Birr gateway, and with its heavy corbelling, battlements, and

120. Castellated gateways at Birr, Glin, Castle Upton, and Glin:
elevations.

blind arrow-slits, it creates a more resilient image to the outside world (plate 120). Castle Upton was remodelled in the late eighteenth century by Robert Adam and his fine castle-style stables are still largely intact. The entrance gateway and the boundary wall most likely date from a much later remodelling in the 1840s. Once again there is a small gate lodge carefully hidden away to one side of the entrance, and not intended to be seen. Across the main road, which now runs past the gateway, is an arrangement of low curved walls with stone cappings and cut-stone balls marking the end of the axial approach from the village, which was probably the main approach to the house in earlier times.

Entrance gateways inspired by the triumphal arches of the Roman Empire are very common in Ireland and were generally interpreted in the Palladian style. The examples which most closely resemble a triumphal arch are the lion-topped Doric arch at Mote Park, Ballymurray, Co. Roscommon,[8] and the magnificent Dodder Lodge at Rathfarnham, Co. Dublin, about which more will be said later. An early Palladian example is at Russborough, near the obelisk field gates previously described. The principal entrance passes through a heavily rusticated and pedimented archway, with flanking pedimented doorways (plate 121). The overall impression is one of sober plainness, relieved only by the deep chamfered joints, reminiscent of the detailing of James Gibbs, and the raised lion statuettes which adorn the pediment. In plan the central gates fold back neatly into reveals in which there are tall niches.

At Ball's Grove outside Drogheda, Co. Louth, there is a fine pedimented triumphal-arch gateway, with a round central arch and side doorways, above which are oval niches. An armorial crest adorns the centre of the pediment and further embellishment is added by a Greek key-patterned string-course, carried through into the decorative metal gates which are still intact (plate 124). The archway is no longer used as an entrance, as urban growth has overtaken the estate and the road now swings around it to one side. It is beautifully sited on the axis of the bridge which crosses over the River Boyne on the main Drogheda to Dublin road, even though somewhat diminished by the modern brick wall which now surrounds its base (plate 122).

Other classical gateways of similar design are found at Lyons House, Hazelhatch, Co. Kildare (plate 124). Here the gates were actually moved from Browns Hill, Co. Carlow, and re-erected by the recent owners, University College Dublin.[9] They consist of a pedimented central archway, flanked by doorways with projecting block surrounds. The side wings are neatly tied back to the central arch by carved stone volutes, and the wings are surmounted by the familiar presence of stone lions. A great sweep of metal railings on low brick walls curves out on each side, ending in square stone piers.

Another example of a gateway being moved is associated with the amusing story of Mr Smyth, who built himself a grand triumphal-arch entrance gateway at his home, Glananea, Co. Westmeath, in the late eighteenth century

121. Triumphal-arch gateway at Russborough: elevation and plan.

122. Ball's Grove gateway spoiled by recent inappropriate additions.

(plate 124). The story relates that Mr Smyth became known as 'Smyth with the gates', which resulted in his making a gift of the gates to a neighbour, who duly erected them at nearby Rosmead, only for the unfortunate Mr Smyth to be renamed 'Smyth without the gates'.[10] Today the gates stand at the roadside on the edge of a field as a romantic ruin. Rosmead House is also a ruin and the drive has almost disappeared. The arch is an elegant structure with Corinthian pilasters to the central archway, with low flanking walls ending in piers topped by urns. In its original form it was a much grander arrangement which included a unicorn couchant, colonnades, and statues, a drawing of which survives.[11] It was probably designed by the architect Samuel Woolley, and some of the decorative work is in Coade stone.[12]

Many other fine examples exist, among them the entrances to Lota Beg, Co. Cork, Carton, Co. Kildare, and the much later Seaforde, Co. Down. The gates at Seaforde were constructed around 1820 and present a rather bizarre Greek interpretation of a Roman triumphal arch (plate 124). A tall central arch, crowned by a pediment with acroteria, is flanked by wide secondary openings to each side, with the whole composition centred in a great curved railing, all of which step back a short distance from the road, providing an impressive spectacle when driving north from Downpatrick to Belfast. Northern Ireland has an interesting tradition in the erection of temporary triumphal arches to celebrate the annual Orange Order processions. These spring up and disappear with alarming speed before and after the Protestant 'marching season'. Royal visits stimulated similar temporary structures with fewer sectarian undertones.

One very impressive example was the 'Trades Arch' erected in Belfast to welcome the Prince and Princess of Wales (later King Edward VII and Queen Alexandra) during their visit in 1885. This enormous construction, which bridged the city's main thoroughfare, was adorned with symbols of Belfast's industrial strength, along with slogans commending temperance and hard work. The young Robert Welch captured the temporary arch in one of his early photographs (plate 123). Celebrating an earlier royal visit of George IV to Dublin in 1821, a grand temporary arch of a

123. Royal visit archway, Belfast 1885. (Photograph by Robert Welsh, courtesy of the Ulster Museum, Belfast.)

TRADES ARCH, ROYAL VISIT, BELFAST, 1897. R.W. 2705.

124. Triumphal-arch gateways at Seaforde, Ball's Grove, Rosmead, and Lyons House: elevations.

more architectural character was erected on Sackville Street under the supervision of Richard Morrison.[13]

On an altogether more modest but permanent note, some of the simple gate-pier entrances are worth mentioning. These include such examples as the sphinx couchant topping the piers at Castletown[14] and the lion-surmounted piers of the Lion Gate, erected by the Bishop of Derry at Downhill (plate 125).

Often in association with a triumphal arch or Gothick screen gateways, there will be a neat classical box, or an octagonal-fronted Georgian Gothick lodge. These would have housed the gate-keeper and are generally set back to one side, just inside the gates. The quality of the accommodation provided by these small but often significant buildings would have far exceeded the single-aspect, tree-shrouded dwellings we have noted earlier, with the lodge hidden behind a high windowless screen wall. A great variety of building styles can be found in the design of these detached gate lodges, consistent with the multitude of styles to be found in the houses they served. We have already encoun-

126. Gothick back lodge, Mount Stewart: elevation.

tered the grotesque hermitage lodge at Kilronan, which stands just inside an equally grotesque tripartite arched entrance. Simple rustic and Gothic-style buildings are also common and present a marked contrast to the refinement of the more sophisticated templar lodges.

Most large country houses had more than one entrance, and with the very large houses four or five entrances could occur. This provided great scope for experiment, and often a variety of styles may exist within one demesne. Greater sums of money would normally have been expended on the main entrance, through which all the important guests would arrive, but often a good deal of thought, if not money, went into the minor entrances. One delightful example is the charming Gothick cottage built into the boundary wall at Mount Stewart, Co. Down (plate 126). This is a tiny three-bay single-storey building with crude pointed-arch windows to each side of a central entrance door. The pattern of the glazing bars is delightfully naïve, and the slightly projecting side bays, with their four stone pinnacles projecting from the parapet, add just enough subtlety to transform what would otherwise have been a dull little box.

On a slightly larger scale, a similar back lodge survives at Luttrellstown Castle. This lodge, which is one of at least four entrances to the demesne, is similar in spirit to the famous rustic arch discussed before (see page 45). It stands on a crossroads and consists of a simple two-storey building with a pitched roof to one side of a wide entrance gate. On the other side is a wide stone gate-pier linked to a wall with an entrance doorway, which terminates in a single-storey castellated tower (plate 127). Each of the two side buildings has Gothic-style window openings and the whole is constructed of a rough knobbly stone which gives it its rustic appearance. The building is deceptive, seeming to be larger than it really is, and it is not clear whether or not it was ever inhabited.

125. Lion Gate Downhill: detail of gate pier. (Photograph by Roberto D'Ussy.)

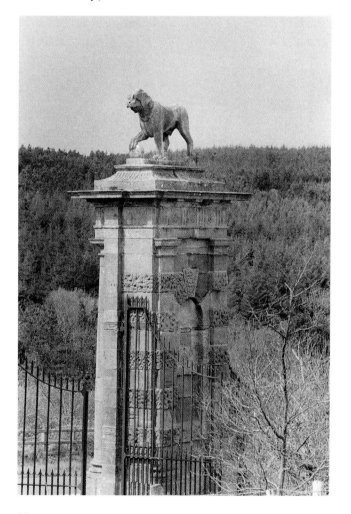

127. Back lodge, Luttrellstown: elevation.

128. Cottage *orné* gate lodge at Castle Coole: elevation.

129. Cottage *orné* at Farnham (now Killykeen Forest Park): elevation.

Rustic cottages were sometimes built to provide secondary lodges, and a very fine example of this type is found at Castle Coole in Co. Fermanagh (plate 128). This is a picturesque thatched cottage with deeply projecting eaves supported on rustic tree-trunk columns which create a simple loggia. A hipped bay projects on the front and all the windows have diamond-leaded panes. Rustic cottages or *cottages ornés*, such as this one, do not make very successful gate lodges. This is primarily because they are more suited to wooded or lakeside settings, where they can enjoy a relationship with their surroundings more harmonious than that afforded by the junction of two roadways. There is also the inherent problem of the primitive simplicity of a rustic cottage. This would have made it incapable of standing out sufficiently among the surrounding authentic cottages of the peasantry, thus lacking the necessary grandeur required of a demesne entrance.

In contrast to the Castle Coole lodge, the one on the Farnham estate, Co. Cavan, designed by one of the past Lady Farnhams, is not as fine. It is a much longer building but with similar rustic tree-trunk columns supporting set-back corners to one side and a recessed entrance loggia to the other. Now heavily restored, with painted windows and a tiled roof, the Farnham cottage has lost much of its earlier splendour, although traces of its pebbled decoration remain (plate 129). Its setting, on the verge of a beautiful tree-lined lake, far surpasses that of the Castle Coole lodge, and survives relatively unchanged since the time of the early nineteenth-century watercolour view found at Farnham House (plate 130).

130. Cottage *orné* at Farnham: an early watercolour view. (Courtesy of Lord Farnham.)

A number of notable *cottages ornés* were built at Glengarriff, Co. Cork, by Lord Bantry, and Glena Bay, near Killarney, Co. Kerry, by Lady Kenmare. The most splendid example is, however, the Swiss Cottage at Cahir, Co. Tipperary (plate 131). This large two-storey cottage is adorned with a huge curving thatched crown and a wealth of rustic columns and verandas. It was probably the work of John Nash, who designed several distinguished buildings of this kind in England, notably at Blaise Hamlet near Bristol. The practice of rural make-believe stretches back to Marie Antoinette of France, who dressed up to play at being a milkmaid in her rustic cottage at Versailles. This practice was also known to have taken place in Ireland at the rustic cottage in the demesne of Oriel Temple,[15] although it is unlikely that the custom was widespread: 'Most Irish gentry lived too close to the land and saw too much of the miseries of rural life to want to play at it . . . Life in a cabin, which was the life of the bulk of the population, was far from rustic bliss.'[16]

At Cahir the cottage was not designed as a crude rustic dwelling but a well-finished and lavishly furnished cottage, deliberately flawed and distorted to appear natural and unsophisticated. Windows, ceilings, and walls are in some cases deliberately constructed askew to create the right picturesque effect. Such rustic qualities did not, however, preclude the use of the finest hand-painted French wall-paper,[17] and the building was considered sufficiently comfortable to have been one of the principal homes of its creator, the second Earl of Glengall. The Swiss Cottage (the title Swiss is a misnomer as there is nothing remotely Swiss about the building) has recently been lavishly refurbished,[18] and furnished in keeping with its original state. Internally the spaces are well-lit, with the principal rooms multi-aspected, often with French windows to enjoy the maximum amount of sunlight and the magnificent views. The cottage stands on a steep hill overlooking the densely wooded River Suir, in a setting that has changed little since the time of its creation. Flowering borders have now been replanted beside the building, invading the columns of the rustic loggia, and the original cast-iron rustic fencing survives around the immediate garden. As a *cottage orné* the Cahir Cottage is one of the finest examples to be found anywhere, not only because is it so well designed, with both building and setting intact, but also because it captures and maintains to this day an overwhelming sense of escapism and relaxation.

One of the main attractions of a rustic cottage as a gate lodge was that it allowed for a freeing-up of form, so loved

131. Swiss cottage, Cahir. (Courtesy of the National Library of Ireland.)

SWISS COTTAGE. CAHIR. CO. TIPPERARY. 8463. W.L.

132. Shelton Abbey castellated gateway: elevation and plan.

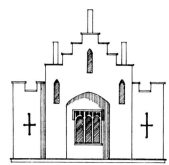

133. Shelton Abbey, Gothick gate lodge: elevation.

by admirers of the picturesque, which could not be achieved within the more rigid discipline of a classical box. In a similar way, Gothick-style lodges sometimes achieve an equal freedom of expression. A modest though interesting example of this is found at Shelton Abbey, near Avoca, Co. Wicklow, which combines an interesting Gothic lodge situated just inside a small castellated archway. An octagonal tower decorated with arrow-slits and corbelled battlements attaches to one side of the arch (plate 132) and the lodge is a symmetrical two-storey building with a central projecting bay, flanked by battlemented side walls with cross arrow-slits (plate 133). The central bay contains a mullioned window in a deep pointed-arch reveal, above which are three narrow Gothic windows. The building has a romantic, jagged profile, owing to its crow-stepped gable adorned with three cylindrical stone pinnacles, and is very likely the work of the Morrisons, who designed the main house.

Of all the independent gate lodges in Ireland the temple form must be the one that occurs most commonly. These often beautifully detailed buildings offered the opportunity to essay in miniature the style and image of the main house at the end of the drive. A great many of these lodges are found just inside a classical gate screen, such as those at Seaforde and Doneraile Court, Co Cork. Others are found at Castleboro, Co. Wexford, Caledon, Co. Tyrone, and Townley Hall, Co. Louth. Of this latter trio, Castleboro, like the main house, is now a ruin, and the one at Townley Lodge is an intact roofed shell, now used as a rather spartan shelter. Townley, which was built in 1819 to the design of Francis Johnston, who designed the main house,[19] is a very restrained and slightly severe building with a primitive Tuscan portico supporting a shallow pediment (plate 137). The lodge at Caledon, which stands beside a now disused

secondary entrance, is a very fine little building, with a similarly chaste and equally primitive appearance to that of Townley. It dates from 1815 and is possibly to a design by John Nash, who carried out works to the house and visited Caledon in 1808 and 1810.[20]

An interesting rustic temple lodge exists at Belline, Co. Kilkenny, in the manner of the primitive hut projected by William Chambers. Chambers's best-known illustration of the primitive hut appears in his *Treatise*, but he also produced a working design for such a structure, the drawing of which survives in the Royal Library at Windsor Castle.[21] Speculation on the likely origin and detail of the archetypal building or primitive hut constituted a major element of mid-eighteenth-century architectural theory. Since Vitruvius writings on architecture have consistently pondered the nature of the first building in an attempt to discover how the various architectural forms evolved. With the arrival of *Essai sur l'architecture* by the French Jesuit philosopher, Marc-Antoine Laugier, in 1753, the quest of discovering the nature of the primitive hut had reached an almost obsessive level, as many advocates came to believe that this archetypal model represented absolute architectural truth.[22]

The argument was based on the belief that the classical

134. Belline gate lodge: general view.

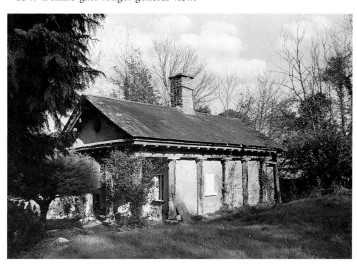

canon was derived from primitive timber architecture, with columns evolving from tree-trunks, pediments from triangulated roof members, and many other classical details from the simple methods of fixing the timbers together. It is for these reasons and associations that surviving built representations of the primitive hut are so valuable. Chambers's primitive hut of the Windsor design was probably never built, but the Belline gate lodge which survives is an almost exact replica (plate 134).

It was built to serve the late eighteenth-century Belline House, which around 1800 came into the possession of the third Earl of Bessborough, whose family seat stood nearby. It is likely that the lodge also dates from the late eighteenth century and there is a somewhat tenuous link with William Chambers, who undertook several commissions for the second Earl of Bessborough in England.[23] Whether designed by Chambers or not, the Belline lodge is remarkably close in

136. Belline gate lodge: elevation and plan.

135. Belline gate lodge: detail of primitive Doric entablature.

detail to the Windsor Library drawing. Only the stylobate is missing in the Belline lodge, which also differs in proportion slightly[24] and includes windows and a chimney to accommodate its function as a lodge. The primitive Doric detailing of the tetrastyle portico in both is identical. Rustic tree-trunk columns, capped with a square-stone abacus and rope-twist echinus, support an entablature consisting of rustic architrave, timber modillions, and a stepped rustic cornice (plate 135). Semi-engaged rustic columns return along both sides of the Belline lodge, in which further windows occur to illuminate the interior.

Internally there are three rooms compressed into an overall space measuring approximately 12 by 18 feet, of which the principal room, entered off the portico, has a fireplace on line with the central entrance door (plate 136). All rooms have square stone-flagged floors and there is an attic space under the roof, which is lit by a small circular window in the pediment. Despite its size and lack of sanitation, the lodge was lived in until relatively recent times. It stands surrounded by trees, near a small stream, a short distance inside the entrance to the demesne, with an abundance of climbing roses to complete the natural woodland setting. There is some quality which is strangely affecting in the Belline lodge, which has to do with the use of such a highly articulated architectural language expressed in so basic and primitive a way. In many ways it consolidates the abstraction of the theories of Laugier and Chambers, and evokes similarities with Rykwert's 'other' house.[25] It may be that garden buildings have not played any significant role in

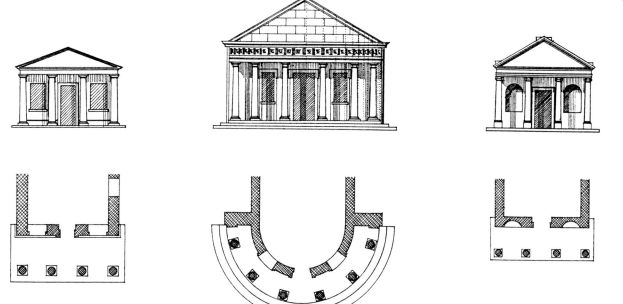

137. Templar gate lodges at Townley Hall, Rockingham, and Killua: elevations and part-plans.

the theoretical pondering on the archetypal building, but the surviving buildings and drawings of two of the eighteenth century's most interesting garden architects, Wright and Chambers, would suggest otherwise. Belline was inhabited until the 1980s, which, in view of its size and privations, would suggest that in this case man was certainly 'quite at home in his house, and his house as right as nature itself'.

Two interesting templar lodges which break the tradition of hiding behind entrance gates are those at Killua Castle and Loughcrew, near Oldcastle, Co. Meath. These both stand facing entrances to the demesnes which appear on the opposite side of the road. Killua is quite a small building set on a raised bank opposite what would once have been a secondary entrance. (Further along the road is a larger and less successful castellated gate lodge.) It consists of an Ionic portico, behind which is an entrance door flanked by two niches (plate 137). In recent years it has been tastefully converted into a pleasant if compact modern dwelling. The Killua lodge may have been built as a rival to the nearby Loughcrew, which stands directly opposite and on axis with the main entrance, which fans out in a wide curve of railings. Loughcrew was designed by the English architect, C. R. Cockerell, and after a succession of disastrous fires it is now a ruin.

The lodge is an impressive Greek Doric structure which stands on a stepped plinth. It is beautifully crafted with a fine ashlar portico, behind which is a nicely glazed central door in a blank wall with a rusticated base (plate 138). As in the design of the Killua lodge, there are no windows on the front of the building, probably to minimize the presence of the gate-keeper, but cleverly set well back from the front are two small fenestrated wings with hipped roofs running into

the side of the main building. If the Killua lodge was built to rival the Loughcrew lodge it certainly failed, as the latter is one of the finest temple lodges in the country. The common practice of siting lodges on the opposite side of the public road to the demesne entrance is believed to be a uniquely Irish custom: 'One suggested reason for this is that owners

138. Greek Revival gate lodge at Loughcrew.

139. Tiara gate lodge at Rockingham: view from the ruined gateway.

wanted to demonstrate to the world at large that they owned land on both sides of the road. But the practice is too widespread to support such a frivolous explanation.'[26] Practical and aesthetic considerations or the simple desire for symmetry may be more likely causes. Loughcrew clearly supports these latter theories; and its very prominent open aspect allows it to be fully enjoyed from quite a distance on the long sweep of the drive which leads towards it from the house. This building has an extremely strong presence. It is well situated with a backdrop of rolling velvety hills, and it is proof that a building does not have to be vast in scale to have a monumental presence.

One final example of a temple lodge which, like Loughcrew, was designed by one of the leading English architects of the day, is at Rockingham, near Boyle, Co. Roscommon. John Nash, who is much better known for the great sweeping curves of his large urban schemes, such as Park Crescent in London, designed this most unusual lodge, which has an interesting curved and colonnaded front (plate 137). Circular temples date back to Roman times and are common as follies in Ireland, but the circular column arrangement carried up into a curved pediment, as at Rockingham, must surely be unique. The portico is an impressive hexastyle composition, and the curving pediment gives the impression of a giant tiara (plate 139). Three stone steps follow the line of the curve and lead up to a glazed entrance door, flanked by windows in the curved bay which lies behind the portico. The entire portico is in a Roman Doric order of fine ashlar, from the rear of which stretches a long low single-storey lodge built in much rougher random stone. Nearby are the remains of some very fine carved stone gates which would once have completed the entrance. Rockingham in its prime was a vast landscaped demesne, with extensive lakeside and woodland walks and rides and a large collection of follies, many of which will appear later. The demesne has a number

of secondary entrances, also with interesting lodges, mostly on a Gothic theme but none as interesting as Nash's extraordinary 'tiara' lodge.

Of all the various design interpretations for entrance gates the inhabited archway is, without doubt, the most interesting and generally the most suitable for inclusion in a study of follies and other garden buildings. By 'inhabited archway' I mean an entrance through which a carriage may pass, which includes the gate-keeper's accommodation as an integral part of the intended architectural composition, rather than being hidden away as in some of the examples noted above. This group comes in many styles, but with a predominance of castellated Gothic and triumphal-arch classic. Although they are for the most part fairly large in scale, the accommodation they provide ranges from the generous to the paltry.

One of the most impressive triumphal-arch lodges is the Dodder lodge, which once marked the entrance to Rathfarnham Castle (plate 141). It is now surrounded by Dublin suburbs. The designer of this magnificent structure, which has not been without its critics,[27] is not known. It has certainly not been helped by the spread of suburbia and the addition of modern walls and railings, which, while not as destructive as those at Ball's Grove in Drogheda, are none the less annoying. The arch is built of rough granite, with plain Doric pilasters to each side of a central arched

140. Dodder lodge Rathfarnham: keystone detail. (Photograph by Roberto D'Ussy.)

opening. Above the entablature is a stone balustrade on which stands a series of carved urns. The panels between the pilasters are each decorated by a circular niche with a projecting architrave above an arched niche, recessed slightly into the wall. Completing the composition, a hirsute visage of a Roman God in Coade stone embellishes the keystone of the central arch (plate 140).

The internal face of the arch differs slightly by having quarter-engaged columns instead of pilasters flanking the arch, shallow square panels, and a plain entablature instead of the circular niches and Doric entablature of the opposite side. This seems a little odd, as the finer engaged columns should really belong to the more embellished face. It is further confused by the wide curved wall which appears on the plainer, columned side, suggesting that this was the direction of entry. The design appears to have been based on the triumphal-arch gateway at the Porta Portese in Rome, as the Roman predecessor combines engaged Doric columns, square recessed panels above niches, and a balustraded top on a simple archway (plate 142). Inside

141. Dodder triumphal-arch gate lodge, Rathfarnham: elevation and plan.

142. Porto Portese gateway, Rome.

the barrel-vaulted archway of the Rathfarnham lodge are doorways leading to the lodge-keeper's somewhat cramped accommodation, which is lit only by a single window positioned on each of the outer sides of the structure. No great consideration would have been given to the comfort of the occupant, who would not only have to suffer a home that was cramped and badly lit, but also one that was effectively chopped in two, a problem that the designers of symmetrical lodges never quite resolved.

The more modestly scaled lodge to Bantry House, Co. Cork, is one exception where the two sides connect on the first-floor level (plate 143). It is much smaller than Rathfarnham, but still manages to present a notable presence through the clever use of giant order pilasters. The walls are constructed of coursed stone which terminates with a balustrade adorned by large stone balls over each of the pilasters. Another modest version of a triumphal-arch gateway is found at Beardiville, Cloyfin, Co. Antrim. The house dates from the mid-eighteenth century and the gate-lodge is probably from the same period. It comprises a finely proportioned and pedimented central arch flanked by single-storey pavilions, each with a large Diocletian window composition, the central section of which was once glazed and is now blocked up (plate 144). The building is of roughly squared and coursed basalt, with the only decoration provided by the plain dressed stone of the quoins, window and archway surrounds. A small blind circular window and three stone-ball finials add further refinement to the pediment. This is a very simple building with just enough Palladian refinement to make it stand out and provide a dignified and notable point of entrance, even with the slightly clumsy way in which the hipped roofs of the wings are designed. It provides a divided living area similar to the Rathfarnham lodge, but somehow its lack of pomp and grandeur makes this more acceptable.

143. Bantry House, triumphal-arch gate lodge. (Courtesy of the Irish Architectural Archive.)

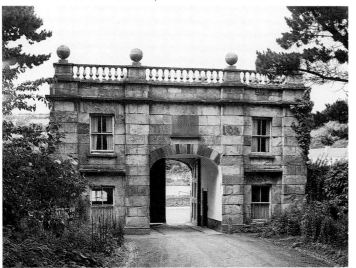

144. Beardiville gate lodge: elevation.

The impressive gateway known as the Volunteer's Arch was built as an entrance to the demesne of Lisreaghan at Lawrencetown, Co. Galway, to commemorate the Irish Volunteers of 1782. Today the house has gone and the driveway is now a public road which passes under the arch in a most delightful manner. The structure consists of a wide screen wall flanked by two pedimented pavilions, which provided the accommodation. A finely detailed triumphal arch rises between two doorways, in the centre of the screen. The design is extremely sophisticated, with semicircular niches, raised keystones, and two sphinxes couchant, in addition to the ball finial and the oval crested medallion on the pediment (plate 145). It stretches a full 85 feet in width, with the two lodges and their arched window openings set into deep reveals, very much a part of the composition. Behind the wall the two lodges extend into fairly sizeable dwellings, now sadly abandoned. These are plain but well-constructed and meant to be seen, in striking contrast to some of the examples previously discussed.

One of the finest of all of the inhabited classical gateways is the Bishop's Gate at Downhill, Co. Derry. Downhill was built by the infamous Earl Bishop, Frederick Hervey, whose earldom was Bristol and his bishopric Derry. This refined, well-travelled, and enthusiastic patron of the arts enjoyed great wealth but little common sense. His building exploits, and the rapidity with which he abandoned his recently finished or unfinished projects, are legendary. The Bishop's Gate at Downhill is one of two highly refined and extremely beautiful structures that he built to adorn his estate, which was largely situated on a bleak inhospitable cliff-top. This gate, which is often overlooked because of its illustrious and more spectacular neighbour, the Mussenden Temple, is a lovely object. It remains lived-in to this day and is maintained in an excellent state of preservation by the National Trust, which owns it (plate 108).

The gateway is really a screen wall, with a small lodge at one end set at right angles and projecting to each side of it (plate 146). A fine pedimented archway with Roman Doric columns provides the centrepiece of the screen. This has a carved frieze decorated with bucrania[28] and mitres, with the Bishop's mitre appearing again on a larger scale in the centre of the pediment. The flanking wall is rusticated with Doric pilasters, above which runs a frieze enriched with roundels and swags. To one side of the archway is a

145. Volunteer's Arch, Lawrencetown: elevation and plan.

niche in which stands a Roman figure; to the other side, an identically sized doorway preserves the symmetry. On approaching, the lodge stands to the right-hand side on a slightly raised bank, with a short flight of six steps up to the door. It is also very finely detailed, with a charming mixture of classical and Gothick detail.

The entrance door has a pointed arch, while the large windows have raised vermiculated surrounds and round heads. Projecting from the corners of the building are clusters of three slender engaged stone columns, above which runs a continuous cornice and a low stone parapet with crisp stone pinnacles rising over the groups of columns (plate 147). The arch and gateway were built around 1784, the arch probably to the design of the Bishop's architect, Michael Shanahan, and the lodge is credited to the stone-mason, James McBlain, who carved the stonework on the arch.[29] Passing through the gate leads into a sheltered glen, which was the only part of his estate in which the Bishop successfully managed to establish trees. On a bright summer's day with the full sun enlivening the south-facing stonework of the gate, it all seems a very long way from the notions of sublimity which are thought to have inspired the siting of the Bishop's demesne.

146. Bishop's Gate, Downhill: elevation.

147. Bishop's Gate, Downhill: corner detail of the gate lodge. (Photograph by Roberto D'Ussy.)

148. Hindu Gothick gate lodge at Dromana: elevation and plan.

One of the strangest gate lodges in the country is the Hindu Gothick gateway at Dromana, Cappoquin, Co. Waterford. This unusual structure was built around 1825, and stands at the end of a bridge spanning the Finnisk River just before it runs into the Blackwater. The design is a bizarre combination of styles, from flamboyant Gothic with ogival arched windows, to Brighton Pavilion Oriental, complete with onion dome and minarets. It spans the roadway in a typical symmetrical arrangement, with the dome positioned over the central pointed archway through which the road passes (plate 148). The two side chambers are well lit, each with a total of four windows and a small fireplace. Symmetry triumphs everywhere and is maintained inside the vaulted archway by false doors matching the entrances to the chambers (plate 149). Local history relates that John Nash's famous Pavilion for the Prince Regent was the inspiration, and that a temporary version of the present arch was erected to welcome home a pair of newly-weds who had spent their honeymoon in Brighton. After the success of the surprise timber and canvas gateway, the more permanent stone version, which now survives, was built.[30]

At Bracklyn Castle, Killucan, Co. Westmeath, there is an equally unusual rustic gateway, which combines Palladian planning (plate 150) and Gothick detailing, much in the manner of Thomas Wright's rustic arch at Belvedere. Situated on the side of a quiet secondary road, one comes upon the gateway suddenly and with quite a shock. A steeply sloping pediment pierced by a pointed-arch opening rises

above a central archway, to either side of which are square chambers, with stout piers topped by great irregular masonry pinnacles. The two side chambers are covered by slated pyramidal roofs with delightful curved ridges. Smaller imitation pavilions with pyramidal roofs and recesses, all built of rubble stone, are linked to the main structure by a metal railing, and wide curving walls reach out as if in welcome.

The rustic stonework is arranged with the stones carefully selected to maximize the most irregular and grotesque effect. There are a number of cut stones set into the structure, which may have been salvaged from another building, and also some large stone hemispheres, which look as if they have been split in two and installed in the fashion of the Tollymore 'bap-stones'. A plaque on the gable is dated 1821, although the structure could certainly date from an earlier time. The house it serves dates from the eighteenth century, with early nineteenth-century additions, and inside the demesne is a rustic mausoleum in much the same style as the gates, dating from 1836.

Of the numerous Gothic and castle-style gates one of the finest and most worthy of inclusion is found at Ballysaggartmore, near Lismore, Co. Waterford. Here it is reputed that the impressive and expensive twin-lodged gateway and castellated folly bridge cost their owner so much to create that the new castle-style house, which had also been planned, was never built. The identical twin lodges make an impressive pair, like small two-storey Tudor Gothic castles (plate 151). They are both set at a 45-degree angle to the central ogival arch which links them. This gives the composition a pleasing irregularity and makes it seem even

149. Hindu Gothick gate lodge: detail of the carriageway.

150. Grotesque gateway, Bracklyn Castle: elevation and plan.

151. Twin Gothic gate lodges, Ballysaggartmore: elevations and plans.

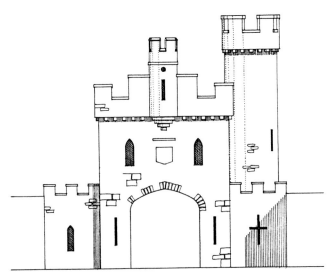

152. Slane Castle gate lodge: elevation.

larger than it actually is. Internally there are two ground-floor rooms and a third on the first floor which, in true folly fashion, can only be reached by going outside and up the round tower. It is possible that the upper rooms were designed not for the gate-keeper but for the owner's use as a summer-house, as the lodges are set in delightful wooded surroundings. The stonework construction is very finely detailed, with a riot of buttresses, drip mouldings, corbelled battlements, cross loopholes, and quatrefoils. These combine to make an extremely picturesque grouping. The lodges were probably built during the 1840s to the design of a gardener called J. Smith.[31] One can only admire his amateur talent, and regret that the money ran out before the house they were intended to serve was built.

Glin Castle demesne on the south bank of the Shannon estuary, Co. Limerick, has a very healthy supply of interesting follies and garden buildings, not least of which are two Georgian Gothick gate lodges. These can best be described in the words of their present owner as 'cardboard embattled', a description he has given to the style of the house. The lodges were built by the twenty-fifth Knight of Glin during the 1820s and 1830s, along with some other follies and improvements to the house and grounds. Of the two lodges, the larger one has now been converted into a pleasant teashop. It is a long low building with two-storey square towers to either side of an archway, extended by lower walls ending in small round towers (plate 120). The entire composition is battlemented and adorned with loopholes and Gothic arched openings, the most interesting of which can best be described as large pointed-arch quatrefoils, and which appear to be a recent addition.

A second lodge marks another entrance and is plainer than the former one (plate 120). This structure has a much higher central arch, with a mock tower to one side and an inhabited tower to the other. Decoration follows the familiar

theme and, like the main house, this lodge is rendered and painted white, which rather emphasizes the cardboard effect which gives these buildings much of their charm. Other follies on the Glin estate will be described in due course, and it is satisfying to note that the present and twenty-ninth Knight of Glin is continuing the tradition by adding new follies to his already rich stock.

The fine entrance gate to Slane Castle on the River Boyne, with its high screen walls and battlements by Francis Johnston, has already been described. Johnston also designed an equally fine inhabited lodge for the rear entrance. This is in the style of a romantic barbican, with a tall circular stair tower rising to one side of an otherwise symmetrical composition. The entrance is like one of the abstract faces so loved by Thomas Wright, with the arch as the mouth and two Gothic windows above for the eyes (plate 152). All of the tops of the lower flanking walls and the stair tower are battlemented, and the central barbican section has a huge stepped battlement with a circular corbelled turret directly above the archway. The generous first-floor room would have provided comfortable accommodation, or may possibly have served as a banqueting room.

Equally romantic, but of much later date, is the gate lodge at Castle Oliver, Kilfinane, Co. Limerick. This is a mid-nineteenth-century structure in fairy-tale Gothic, which would not look out of place in a Hans Christian Andersen story. Built of a soft reddish-brown sandstone, which is now covered with a fine patina of lichen, it consists of a lavish pinnacled archway, to one side of which stands a small irregular castle-style lodge of three storeys (plate 153). Every wall seems either battered or corbelled, and, in the corner of the lodge building nearest the arch, a square tower rises up to a steep pyramidal slated roof.[32]

153. Castle Oliver, the large romantic gate lodge and archway: elevation.

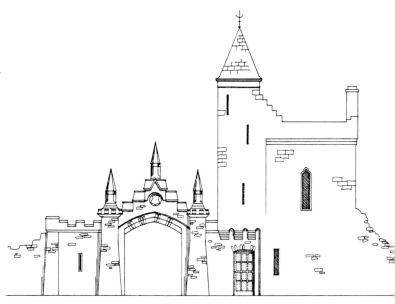

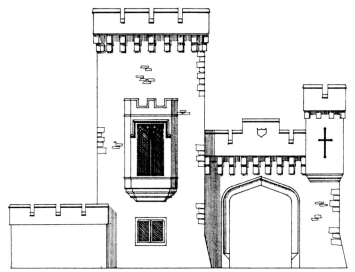

154. Johnstown Castle gate lodge: elevation.

Two very fine gate lodges in the castle style are found at Johnstown Castle, Co. Wexford, and Glenarm Castle, Co. Antrim. These lodges seem rather too elaborate to have been the abodes of gate-keepers, and may have served the dual purpose of entrance gate and pleasure pavilion, in the manner of Badminton. The Johnstown Castle lodge is quite a grand archway complete with battlement and turret, which extends from one side of a three-storey square tower (plate 154). At ground-floor level is a plain mullioned window, behind which a gate-keeper may have lived, and at first-floor level is a large oriel window with Gothic tracery, drip moulding, and castellated top. It is mainly the presence of this window which suggests that the room behind was intended for rather grander and more pleasurable purposes. Within the demesne are a number of other follies, including the picturesque castellated fishing lodge which rises out of the water at the edge of a lake. Samuel Hall provides a contemporary nineteenth-century account which tells us that the lake was not only artificial but also expensive:

> A noble sheet of artificial water immediately adjoins the castle, procured at immense cost, but having supplied for a considerable period, a means of employment to the neighbouring people. On its borders there are several turrets of carved stone, and the hand of taste is everywhere apparent.[33]

The hand of taste also played a part in the excellent siting and design of the Glenarm lodge. This stands on a secondary entrance to the estate, which is approached directly by a short street of modest houses leading from the main street in the village of Glenarm. In most appropriate castle-style manner, the barbican tower appears at the end of an old stone bridge which leads up to a Gothic arch, complete with heavy elaborately hinged doors and portcullis (plate 155). The bridge crosses a wide river, from the stony shore of which rises a vast stone battlemented wall with a

battered base, abutting either side of the gate lodge. Giant lime trees hang out over the wall, and a few hundred yards distant the river enters the open sea. Glenarm is the seat of the McDonnell family, the Earls of Antrim, whose previous seat, Dunluce Castle, was in an equally romantic cliff-top setting. The original house was built in the early seventeenth century, remodelled in the mid-eighteenth century, and reworked again in 1825 by William Vitruvius Morrison, who also designed the gateway.[34]

Since then it has attracted a great deal of praise from the tour writers and historians: 'one of the most romantic pieces of nineteenth-century medievalism in Ireland'[35] or the 'quintessence of Sir Walter Scott Antiquarianism... nothing could be more dramatic and romantic.'[36] The structure is beautifully detailed in random squared basalt with red sandstone dressings, and richly adorned with an array of battlements, arrow-slits, machicolations, and a round stair tower (plate 156). Its setting is as perfect today, and has changed little from the days of many contemporary engraving which were made (plate 157).[37] Written accounts were equally flattering:

155. Barbican gate, Glenarm: elevation, with a section through the bridge approach.

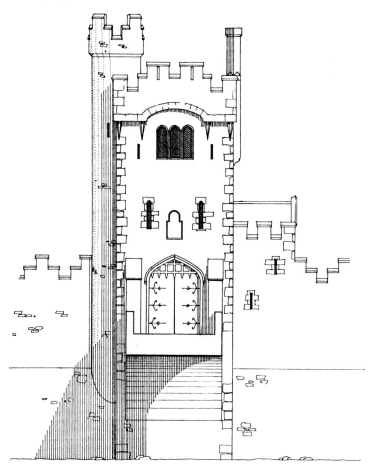

A small mountain-river brawls between the town and the lofty structure which in feudal days, lodged its master the McDonnell, and from the deep water rises the stern old wall, with its embrasures and towers, in as high a preservation as on the day it was completed. A great part of the walls and ornamental architecture of Glenarm are modern, but all the additions are executed in the finest spirit of antiquity. A more beautiful gem than the castellated structure, nestled between the overhanging sides of this ravine, I have never seen.[38]

This praise is much deserved, as the illustrations or a visit will readily support. The valley of the Glenarm River is one of the famous Green Glens of Antrim, and has that very Irish combination of mountains rising from the edges of a wide sweeping bay which makes Glenarm a setting of great natural beauty. And once again we have an example of how the judicious siting of buildings in a landscape can not merely harmonize with the natural beauty of the place but substantially add to it.

The Glenarm lodge is such a fine building in its design

156. Barbican gate, Glenarm, from across the bridge.

157. Barbican gate, Glenarm: a nineteenth-century view from Bartlett's *Scenery and Antiquities*.

158. Gothick lodge (after Batty Langley) at Castletown.

and construction that I suspect it may also have combined pleasure with practicality. A gate-keeper could easily have been accommodated comfortably in the lower adjoining section, with the higher floors for entertaining or solitary reflection, amid a range of beautiful views and with privacy assured by virtue of its height. The architect of the gateway, William Morrison, is also thought to have been the architect of the excellent folly tower at Ballyfin, mentioned in chapter 4 (see page 69).

There is a surprising lack of documentary evidence to confirm the architects of even the grandest of follies and garden buildings, and assumptions often have to be based on comparisons with the construction and date of the main house. In some rare instances, like the rustic arch at Belvedere, the architect is known because the design occurs in a published pattern-book. Gate lodges often appeared among the designs for follies and garden buildings in such eighteenth-century publications. One of the most famous of these was Batty Langley's *Gothic Architecture Improved* which was published in 1742, and from which the design of the Leixlip Lodge at Castletown House was taken.[39] Only the front of Batty Langley's octagonal planned design (which is described as a Gothic Temple) has been used (plate 158) and this attaches to a more practical rectilinear

159. Glin bathing lodge in its present setting.

building. It is none the less a very fine little building, with projecting stepped buttresses topped with pinnacles above a deeply projecting cornice. Between the buttresses are pointed-arch and circular windows with elaborate glazing patterns, over which rise ogival pinnacles, pierced by trefoil openings.[40]

One final example of a pavilion lodge, built purely for pleasure, is also to be found at Glin. This tiny stuccoed and battlemented building stands across a wide field in front of the house on the edge of the estate (plate 159). It is separated only by a narrow road from the shore of the Shannon estuary, and is equally charming when viewed from either side. Although small, the lodge is cleverly designed (plate 160), with a series of changing levels, a false turret, and accessible battlements. These lead to the upper floor of the round two-storey tower which provides the accommodation. A doorway through the wall under the battlemented screen, which links tower to turret, leads to the shore and suggests that the lodge may have been used for bathing or boating activities. Internally there are fireplaces, which would have provided added comfort to the users, whether drying out after some water-associated activity or simply enjoying the view.

Of all the lodges at Glin, this final and smallest example is the finest, not only for its siting but also for its amusing composition, which gives it the impression of being more extensive than it actually is. As it most closely resembles the spirit of the parent house it therefore best serves it, although only intended as a private gateway for pleasure-seekers. The Glin lodge also provides us with a final reminder that buildings erected to mark entry come in varying styles and forms, which were very often seized on and used in the

160. Glin bathing lodge: elevation and roof plan.

laying-out or improving of an estate. They are the most accessible of all the different categories of follies and garden buildings, generally sited on the more public fringes of the demesne. As follies they are also often unique in having been specifically designed for habitation, even if this consideration proved to be secondary to the pursuit of an Arcadian or picturesque effect.

CHAPTER 6

Forts and Sham Castles

Along with all the other examples of ruins to be found in Ireland, there are a great many small castles and ring forts of ancient origin. The entire Book I of Thomas Wright's *Louthiana* consists of 'Views and Plans of the Most Remarkable Bodes, Forts and Mounts . . . with an account of their ORIGIN as attributed to Natives or Foreign Colonies'. These delightful drawings are mostly of ring forts or raths dating from the early Christian period. Wright attributes their construction mostly to the Danes, apart from one, of which he claims, ''Tis said to have been the Station of a Colony of Scotchmen, or Albanians, from whence it has its Name.'[1] Book II is on the subject of the 'Principal Castles, Keeps, and Towers', most of which are quite small and have an almost toy-like quality about them, very much in the manner of a folly.

It has already been noted that the castle style of house-building influenced the folly-builders, through a desire for things picturesque and the romantic notions of false antiquity. This influence is most obvious in castellated gate lodges and folly towers. The tower at Ballyfin is so large that it could almost be considered a mock castle, and the extensive gates and crenellated walls at Slane and Glenarm are equally sham in their castle-style conceit. In a later chapter we will

161. Sham castle, Donaghadee, from the base of the moat. (Photograph by Roberto D'Ussy.)

162. Markree Castle entrance gates: a drawing by Francis Goodwin from his book *Rural Architecture*. (Courtesy of the Irish Architectural Archive.)

also encounter a large folly bridge adorned with small castles at either end. Of all the castellated entrance gateways in Ireland, the most extensive and castle-like must surely be the one at Markree Castle, Collooney, Co. Sligo. Built in the early l830s to the design of the English architect, Francis Goodwin, it extends some 300 feet in length and is illustrated in Goodwin's *Rural Architecture*,[2] which was published in 1835 (plate 162). It has rightly been described as 'one of the most spectacular Gothic entrances in Ireland'.[3] Markree is associated with the hymn-writer, Mrs Cecil Frances Alexander, who is known to have stayed there; and it is thought that the castle and its impressive gateway were the inspiration for her best-known hymn, 'All Things Bright and Beautiful'. The fourth verse refers to a purple-headed mountain and a river running by, which is an accurate description of Markree's setting; while the third verse reads:

> The rich man in his castle,
> The poor man at his gate,
> God made them, high or lowly,
> And order'd their estate.

Written in 1848, this smug apologia now seems rather archaic. It is possible to wonder whether line two refers to the famished peasantry outside, or a wretched gate-keeper living in some cramped void within the entrance archway.

Another impressive example is the large gate-tower to Brittas Castle, Co. Tipperary, by William Morrison. This was designed around 1834 for the unfortunate Major Henry Langley, who was killed by falling masonry during its construction. Following Major Langley's death, work on the main house was abandoned, leaving only the fourteenth- to fifteenth-century-style gateway, which is considered to be Morrison's most austerely antiquarian work.[4]

Quite apart from the large stage-set scenery of entrance arches and screen walls, a number of folly castles were built with some functional (and normally pleasurable) purpose in mind. Hunting and banqueting are activities which often go hand in hand, and they provided a purpose for some of the towers described earlier. At Rockingham there are two sham castles, one of which stands on a wooded island on Lough Key and the other in thick woodland near the edge of the lough. MacDermot's Castle on the appropriately named Castle Island was originally an authentic castle of the MacDermot family. (References to its fortifications date back to the twelfth century.) This was remodelled in the early nineteenth century into its present folly form. The island setting is ideal, with the tightly clustered profile of battlemented

towers reflected on the water (plate 163). One narrow square turret rises above all the others and the building, now neglected, is overgrown with a picturesque if destructive layer of ivy.

The castle was used for dances and parties, and local legend claims there was once a tunnel linking the island to the shore. Such a feat of engineering would have presented an almost impossible challenge in rural Ireland during the nineteenth century. It is more likely that the rumours were stimulated by the surviving extensive network of tunnels and storage chambers built near to the house. These accommodated the delivery and storage of fuel and provisions, all discreetly hidden to avoid despoiling the fine views from the house. Local stories also claim that MacDermot's Castle was at one time used as a home for the parson and that it was in fact occupied until the late 1940s.

Cloontykilla Castle is a pure folly, set in a clearing amid tall spindly trees and a thick sea of moss. It takes a substantial trek to find it and, as it is outside the complex of official forestry walks, it is rarely visited. This all helps to create an impressive gloom-laden atmosphere, which can be improved upon only by a steady, windless shower of Irish rain. It is remarkably similar in both plan and size to an early seventeenth-century castle known as Tully Castle, built on

164. Cloontykilla Castle courtyard: detail from the prospect tower.

163. McDermot's Castle, Rockingham, viewed from across Lough Key.

165. Cloontykilla Castle, Rockingham: elevation and plan.

166. Sham castle at Fota Island.

the west shore of Lower Lough Erne.[5] The structure consists of a large square battlemented wall, with lightly battered square towers or flankers, all of differing heights, on the four corners (plate 165). It is entered through a flat pointed central archway, complete with portcullis-style gate, which leads into a large open courtyard. At the back of the courtyard is a two-storey range of buildings of which only the walls survive. These have a rather Palladian appearance, with a large round window above the centrally placed doorway. Internally, the ground floor seems to have contained a series of relatively small chambers, with larger rooms on the upper floor.

In one of the rear corners adjacent to the range of buildings, a stone spiral staircase rises up inside the tallest of the towers to a fine vantage point 50 feet high, with views out to MacDermot's Castle and back down into the courtyard (plate 164). The stonework of the castle is very fine, and there is a date stone with the inscription 1839. Externally the curtain wall is relieved by a series of small Gothic shaped-slit openings and much larger blind Gothic reveals. Cloontykilla Castle was used as a hunting lodge and, with its large banqueting room, no doubt it also accommodated the post-hunt junketing. A description from the 1970s claims that the castle was lived in until the 1960s,[6] which, if true, makes its present state of dereliction an even sadder testimony to neglect.

At one end of Fota Island in Cork stands a small early nineteenth-century folly castle, designed by John Hargrave of Cork for the demesne which covers the island. This is a crisp two-storey stone-built structure with two round towers rising above the main rather square mass of the building. An equally box-like projection to the entrance front contains a porte-cochère. The decorative castellations are quite fine and the building becomes more interesting when viewed from the river towards the two towers (plate 166). In a very similar style, but much more interesting, is Blackrock Castle, situated further along the estuary of the Lee towards Cork city. This was an early nineteenth-century conversion of an older castle and stands on a rocky promontory which projects into the river. It is a fine baronial-style composition with a large round tower, complete with multi-stepped corbels and a taller stair tower.

One final interesting example of a sham castle is found at Heywood House, Co. Leix. This stands adjacent to the excellent and equally sham ruins which stand halfway along the drive, overlooking a deep valley which once contained a series of artificial lakes. The castle is a fairly plain structure, decorated only with simple battlements, arrow-slits, and Gothic windows. Internally there is a more elaborate plan arrangement, consisting of four round towers on the corners of a square central space. The tower or castle was designed to be read in conjunction with the more decorative ruined screen which stands in front of it and would have provided a sheltered vantage point from which to survey the landscaped valley, either through the Gothic tracery of the screen or over the top of it from the roof (plate 167).

In Donaghadee, north Co. Down, there is an early nineteenth-century sham castle which was built for a functional and very practical reason. Before Belfast grew to prominence Donaghadee had been the major port of the north of Ireland, linking with Port Patrick in Scotland; and it was still important enough to build an impressive new harbour in the early nineteenth century. Around 1821 the small sham castle was constructed on the edge of the town to store gunpowder used in the blasting operations required by the works. It stands on a Norman mote built by William de Copeland in the late twelfth to early thirteenth century.

167. Sham castle, Heywood: view across the rooftop.

168. Gunpowder magazine in the form of a miniature sham castle on the moat at Donaghadee: elevation and plan.

Locally referred to as 'the moat', it is thought to have been designed by the local landowner and amateur architect, Nicholas De Lacherois, to whom the town's market hall and the nearby Carrowdore tower are also attributed.

The building is a small compact affair, with a toy-like appearance from close up (plate 168). It has two square chambers, the plainer of which contains the only aperture, a metal entrance door, and small square piers projecting from two of its corners in the form of slim turrets. The second chamber, which is linked to the first by a narrow antechamber, is higher and more elaborate in its design, with octagonal pier turrets to all corners and a circular round tower rising an additional storey above it. It is constructed of rubble-stone walls, some of which are now rendered, with a decorative band of corbelled battlements to both walls and turrets. The walls are also relieved by a series of blocked windows and blind arrow-slits. From the town, with the scale confused by distance, the full picturesque effect of its irregular composition becomes apparent, and it creates an important and much-loved landmark (plate 161). The moat is also the principal vantage point, with commanding views over the fine harbour and lighthouse designed by Sir John Rennie. It would certainly be worth investing a little money to open up the building and install a staircase, so that the public might

enjoy an even more impressive view of this charming seaside town, which, like its 150-year-old description in Bartlett's *Scenery and Antiquities*, remains 'picturesque and flourishing'.[7]

Distinct from sham castles, there are a number of folly forts in Ireland, not altogether surprising for a country with such a war-torn past. Of particular interest in these buildings is the evidence that they were sometimes used for role-playing, for either pleasurable or symbolic reasons, through the staging of mock battles or other military displays. The most majestic example was at Dangan Castle, Co. Meath, seat of the Wellesley family and supposed birthplace of the Duke of Wellington. In the mid-eighteenth century a vast landscaped demesne was created by the Duke's father, Lord Mornington. This included a host of garden buildings and obelisks, two of which have previously been described (see pages 11 and 12). The most notable feature of all, however, was the great expanse of water he created, which so impressed Arthur Young in June 1776:

> he has formed a large water, having five or six islands much varied, and promontories of high land shoot so far into it as to form almost distinct lakes; the effect pleasing. There are above 100 acres under water, and his Lordship has planned a considerable addition to it.[8]

Mrs Delany has also left a full account of her visit in 1733, in which she describes among other things a number of boats used on the artificial lakes.[9] The Ordnance Survey map of 1836 shows a number of dried-up artificial lakes, one of which contained two islands entitled 'Gibraltar' and 'Battery'. The two obelisks, a grotto, and two other forts are also shown, but it is not clear whether the latter two were authentic or follies in origin. In his *Journey to Lough Derg*[10] Isaac Butler describes mock naval battles on the lake, with exchanges of cannon fire between the vessels, including a man-of-war, and the fortified islands. Today there exists scant evidence of any of this past splendour. The rot set in surprisingly early, and in Hall's *Ireland* of 1842 we are given a sad reminder that the neglect and decay of fine houses and beautiful gardens is not restricted to our own destructive century. Hall describes how the property changed hands after the death of Lord Mornington and was later leased to a Mr Roger O'Connor, who seems to have been a notorious asset-stripper:

> While in his possession the house and demesne were dismantled of every article that could be converted into money—the trees (of which there was an immense variety, of prodigious height and girth) rapidly fell beneath the axe; the gardens were permitted to run waste . . . at length, the premises being largely insured, the house was found to be on fire, and was, of course, consumed before any assistance could be obtained to extinguish it.[11]

W. H. Bartlett's engraving, published in 1845, shows the devastated estate with a sole obelisk outlined on a hill behind the shell of the house. Hall goes on to add with a great romantic flourish:

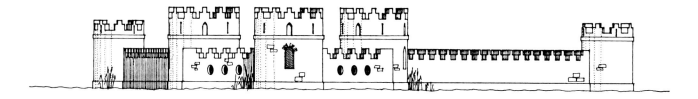

169. Children's miniature fort, Larch Hill: elevation and plan.

Most unhappily, therefore, one of the most interesting mansions in the kingdom is now but a collection of bared and broken walls; a mere shell, indeed; and fancy seeks in vain to connect the early thoughts and habits of the great men who issued from it, to amaze the world, with some nook fitted for silent study, or some chamber sacred to nursings of the greatness that was to be theirs thereafter.[12]

Mark Bence-Jones notes that Roger O'Connor, who was a United Irishman, may have leased Dangan with the ambition of entertaining Napoleon, who had conferred on him the title of honorary general. He also notes that Napoleon's great rival, Wellington, at one time contemplated buying back his family seat.[13] Although Dangan has sadly been lost to us, it is fortunate that a near neighbour of more modest means than the Wellesleys enjoyed an equal enthusiasm for follies and artificial lakes. At Larch Hill, home of the delightful Cockle Tower and ornamental dairy, there exists today a dried-up lake with a heavily overgrown island. On the island is an extensive battlemented fort with three small round towers and two slightly smaller turrets (plate 169). None of these is visible today without first crossing the marshy remnants of the lake and struggling through the thickest tangle of undergrowth and trees. In such a wilderness surveying is not the easiest of tasks! The effort is none the less rewarded, for the structure is still largely intact. On the Ordnance Survey map of the estate of 1836 the fort is clearly marked and named Gibraltar, in imitation of the fort at Dangan.

In plan the structure is roughly triangular with the three larger towers grouped at one of the points. The towers are one and a half storeys high, with rusty iron girders supporting a stone-flagged floor. This creates a rooftop battery with double-stepped battlements and slitted openings. There are a series of circular gun-hole openings in the walls that link the three towers, all of which have pointed-arch entrance doors and windows. A giant yew tree rises from the centre of the island, creating an even stronger atmosphere of abandonment. On the edge of the lake a barrel-vaulted boat-house survives, as do the remnants of a primitive temple on a second island. The map also shows a third small island linked to the shore by a causeway, and there appears to have been a second lake attached to the first by a thin canal. Mock naval battles were also played out at the Larch Hill Gibralter, just as they were at Dangan, and although the extravagance of flooding acres of perfectly good pasture-land would never be contemplated today, it would be very nice to see the Larch Hill fort cleared up a little. What was merely a source of titillation to amuse adults must have brought great excitement to the children of the household. Perhaps the young children of the friendly family who now own Larch Hill will some day enjoy similar pleasures.

A purely land-based fort is found at Tyrella House between Ardglass and Newcastle in south Co. Down. This is a plain square structure, with curved battered walls and large square stone battlements on top of a brick string-course (plate 170). On the side facing the house is a double

170. Children's miniature fort at Tyrella House: elevation and plan.

171. Tyrella fort: detail of ramparts with cannon.

brick archway leading up a short flight of brick steps into the open interior. To the eastern side, facing the sea, is an elevated rampart, on either end of which are small cannon (plate 171). Its careful siting and the elegant upward sweep of the walls add a sense of sophistication to this otherwise simple structure. From the ramparts there are fine views over a rolling landscape dotted with clumps of trees, and with an excellent background provided by Dundrum Bay and the Mourne mountains.

In the town of Hillsborough the artillery fort of 1650 was

converted into a charming Georgian Gothick garden house (plate 172), which Mrs Delany observed under construction in 1758.[14] Both the gatehouse, which includes a large first-floor reception room, and the vast enclosed and ramparted court were used solely for pleasure. The courtyard, which contained a bowling green, measured by Mrs Delany's estimate an English acre. Nothing could have been better suited for parties and receptions, judging by the interesting drawing which survives of one such gathering. This depicts a family wedding of 1837, with several thousand guests seated at tables in the open air of the courtyard. Hundreds of spectators look on from the tops of the ramparts and a group, which probably represents the wedding party, observes the proceedings from the first-floor gallery of the gatehouse.[15]

One final example of a folly fort is Emmet's Fort, which is hidden away in a corner of the St Enda's estate. Situated quite close to the excellent hermitage described before, the fort seems at first glance to be a rather uninteresting structure. From outside the garden it stands on the fork of a Y junction, partly hidden by the crude battlemented wall into which it is built (plate 173). It is only from the roof that the full complexity of the plan becomes apparent in the shape of a five-pointed star (plate 174). The points, which resemble arrowheads, are spaced by shallow recesses. In the inner courtyard created by the fort and the apex of the battlemented garden wall, there are two Gothic windows and an entrance door. At high level a series of circular gun-holes opens from the parapet, which has a rough stone coping. The structure is built of rubble stone and may once have been rendered.

Inside there are four oddly shaped rooms separated by spine walls which converge into a central chimney stack. On

172. Gothick fort, Hillsborough, from the entrance gate. (Photograph by Roberto D'Ussy.)

173. Emmet's Fort gate lodge, St Enda's: view from outside the boundary wall.

174. Emmet's Fort elevation and plan, showing children's narrow access staircase to roof.

the garden side, directly opposite the entrance door, there is the tiniest spiral staircase built into the thickness of the wall, which can only have been intended for small children. The fort is named after the patriot Robert Emmet, who is thought to have courted Sarah Curren there, possibly past the hermitage and along the folly-strewn path which is now known as Emmet's Walk. Sham castles and folly forts do not constitute one of the major categories in this study, but the nature of their conception, along with the conceits of the associated role-playing, provides us not only with an interesting group of garden ornaments, but also an insight into some of the more colourful pastimes of the society which created them.

CHAPTER 7

Ruins and Eye-catchers

The earliest recorded proposal to use a ruined building as a garden ornament has already been noted in Vanbrugh's letter to the Duchess of Marlborough of 1709. In this he urges her to retain the ruined shell of Woodstock Manor as an eye-catcher to close a vista in the new park at Blenheim. Vanbrugh argued that buildings from the past can convey a stronger sense of history through association with their past occupants and reflection on the remarkable things which have been transacted in them. He continued to expound on the aesthetic and picturesque qualities of the ruin and, in anticipation of Alexander Pope, suggests that the building would make 'one of the most agreeable objects that the best of landskip painters can invent'.[1] Vanbrugh's scheme at Blenheim was frustrated by the Duchess of Marlborough, who ordered the building to be demolished, but it does provide an early illustration of one of the guiding principles for the revolution in garden design which was about to occur.

An early example of the integration of a ruin into a garden design is found at Castle Ward, Co. Down, in a formal layout of 1724.[2] This included a long ornamental lake or canal positioned on the axis of the fifteenth-century Audley's Castle, which stands on a rocky height about a

175. The sham ruin in its present setting at Heywood.

176. Nineteenth-century views of medieval ruins from Hall's *Ireland*.

quarter of a mile away. The castle, with remains in a state of fairly good repair, provides a most impressive vista-closer, emphasized and framed by the open stretch of water bordered by trees. Frederick Hervey, the prolific Earl-Bishop of Derry, was also keenly aware of the ornamental potential of existing ruins. At Downhill he planned to add a folly spire to the thirteenth-century ruins of Dunboe church to provide an eye-catcher to the main south front of his house. Surprisingly for the Earl-Bishop, this project was not realized.

He did, however, construct a folly tower to enhance the pre-seventeenth-century ruins on Church Island, near his second Irish house at Ballyscullion. It was built in 1788 and still survives along with the church ruins, although the house has long since disappeared.[3]

We have already noted that, by the start of eighteenth century, the Irish landscape was richly endowed with authentic medieval ruins both secular and non-secular (plate 176). In a great many examples the picturesque qualities of such

ruins as Audley's Castle can still be seen today and provide some of the best-loved and most visited landmarks in the country. Many contrasting images exist, from the sublime cliff-top setting of Dunluce Castle, Co. Antrim (which, most appropriately, was abandoned when part of it fell into the sea after a rock slide) to the tranquil serenity of the Abbey of Glendalough, in the beautiful valley of 'the Two Lakes' or 'the Seven Churches', to use two of its more ancient names. In many Irish towns surviving medieval ruins provide a focus of both visual and historical interest, spectacular examples of which are found at Cashel and Trim. With the destruction of so many large eighteenth-century houses, a new generation of ruins has grown up with its own romantic imagery and historical associations,[4] and photographers have not been slow to realize the potential of such picturesque subjects.[5]

So what then lies behind our intense fascination and attraction to the cult of the ruin? Vanbrugh has identified two of the major reasons as visual appeal and historical association, both of which stimulate our own romantic vision of an idealized past. In addition to these aspects, there are yet further symbolic and subconscious stimuli which also captivate our imagination today. These become even more strongly ingrained in our minds as we try to grasp hold of the past in order to make sense of the present, or the even more confusing future. In the late seventeenth and early eighteenth centuries the best-known and most frequently visited ruins in the world were those of ancient Rome (plate 177). These represented not only the power and majesty of the Roman Empire, but also the frailty of human fortune, brought about by its fall. In contrasting the symbolic content of the classical and the Gothic ruin, Joseph Rykwert believes that: 'The Classical ruin shows the triumph of barbarism over taste, and at once evokes a "historical" recollection . . . while the Gothic ruin is clearly connected with epic, with timeless myth.'[6]

Such richly evocative associations would not have been lost on the designers and patrons of many follies and garden buildings, wherein the creation of mood was of prime importance. Another strange phenomenon associated with the cult of the ruin was the habit indulged in by some eighteenth-century architects of depicting their newly designed or completed buildings as ruins. In the mid-eighteenth century William Chambers produced a drawing of a ruined version of a mausoleum for Frederick, Prince of Wales, and several years later his contemporary and rival, Robert Adam, designed a highly elaborate domed folly ruin for Kedleston in Derbyshire. Unfortunately, neither of these was ever built.[7]

The best-known example of this genre was the representation of Sir John Soane's work at the Bank of England, depicted as a ruin by the brilliant architectural draughtsman and watercolourist, J. M. Gandy. This drawing was exhibited at the Royal Academy in 1830 and displays the vast complex through a crumbling, cutaway perspective, with all the appearance of a small ruined city of Antiquity. Chambers, Adam, and Soane would all have been influenced by the work of the Venetian architect and draughtsman, Giambattista Piranesi,

who, after settling in Rome, produced a series of etchings of the ruins in the Roman Forum, in addition to the more fantastic and original creations of his prison drawings known as *Carceri d'invenzione*.

In his interesting essay entitled 'The Theatre of Memory'[8] the French architect and teacher Antoine Grumbach suggests that ruins, along with drawings, provide vital clues to help us understand the *essence* of architecture. Grumbach argues that, before construction, the building is represented in the unique form of a drawing, through which medium the spectator has the God-like power of being able to wander at will from room to room, linking internal spaces, interior and exterior, without any of the constraints of staircases and walls. These imaginary observations are then lost once construction of the building has been completed, until later:

> When the building decays into ruins and is no longer concerned with the codes and rules of usage, it suddenly appears with a new dimension and presence. These ruins invite us to gain a new knowledge of the building by examining the above and below, in breaking down the separations of interior and exterior, and tracing the deep structures by which the building stood—all these qualities relate to qualities a building loses between its design and realisation. This loss and gain are probably the characteristics of *architecture*.[9]

177. Classical ruins at the Forum in Rome.

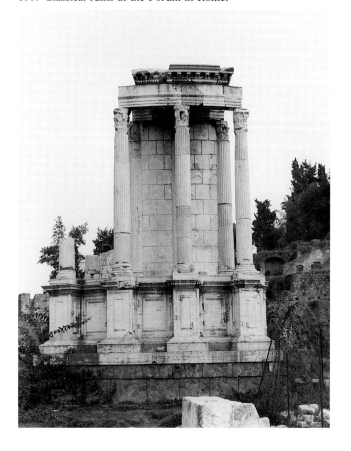

This rather poetic definition of the very essence of architecture is a mysterious and abstract one. It is not an easy notion to explain fully, but is surely an important part of the great thrill an architect may experience when his drawn lines spring out of the ground as walls, during the construction process. The process of ruination holds an equal fascination, as the building opens up its secrets in the gradual process of returning to its pre-construction state, that of a simple ground plan.

In the way in which great age can marry a building to its site, the ruin offers an even greater opportunity, as its crumbling walls invite nature to enter, with the result that the building quickly comes to resemble more a work of nature than a work of art. The roofless shell of Dunboden House, Co. Westmeath, is a perfect example of this. Now totally invaded by ivy, the roots of sycamores growing from the remnants of the upper floors step regularly down the profile of a ruined staircase.

It is therefore clear that the basis of our interest in and attraction to ruins is more complex than was first suggested. Certainly aesthetic considerations, in pursuit of the irregular charms of the picturesque, are important. So too are those qualities which can evoke historical and romantic associations. There may even be some validity in the more prosaic notion that the retention of an older building or ruin in the vicinity of a contrasting new building helps to project a sense of progress. It is most likely, however, that our fascination is more deeply ingrained in the subconscious world of our past memory, in a way that can be experienced more easily than it can be described.

In the case of the artificial ruin, built as a folly for purely ornamental purposes, the Gothic style clearly dominates. There are very few sham ruins in the classical style in either England or Ireland and, where they do exist, they are normally the result of reconstructing fragments of ruined houses in a picturesque manner. It seems somewhat strange that landowners, who were building small classical temples in great numbers, almost totally eschewed the creation of the classical ruin, which had proved such an inspiration to the architecture and garden design of the period. The reason may lie in the symbolic undertones referred to above, and that, for many advocates of the classical taste, the rival Gothic style was only acceptable in a ruined and defeated state—a triumph of taste and civilization over the buildings of the 'vulgar Goths'. There is also the more practical consideration, that a greater supply of raw material existed for the erection of Gothic fragments. As these buildings were generally two-dimensional ornamental screens designed to be viewed from a distance, it is unlikely that landowners were willing to dispense much money on their construction. Classical garden temples, which belong to another chapter, were frequently, in contrast, highly elaborate structures on which great sums of money were often spent. They were also in many cases very functional and much used.

The earliest mock ruin in England is thought to be the one at Cirencester Park, Gloucestershire, designed by Lord

178. Castle Oliver eye-catcher: elevation and plan.

Bathurst and Alexander Pope. Mrs Delany visited it and described it, 'with thicket overgrown, grotesque and wild,' in one of her letters to Swift.[10] Better known and more influential examples were to follow towards the middle of the eighteenth century, to the designs of the country gentleman and amateur architect, Sanderson Miller. Miller built sham castles as well as ruined castles and his delightful drawing for the ruined castle at Wimpole Hall, Cambridgeshire, contains all the ideal characteristics for a building of this nature. Circular towers in various states of decay are linked by screen walls; the composition is irregular and a line of trees combines purposefully to conceal the deception.

A very good, if less ambitious, example of this model is found at Castle Oliver, Co. Limerick, home of the fairy-tale gate lodge of a previous chapter. The structure, which is known as Oliver's Folly, stands on a high hill some distance behind the house and, although it lacks a mantle of trees, it is very much in the Sanderson Miller spirit. Two circular towers, one of two storeys and the other of three, are linked by a screen wall with a tall pointed-arch opening (plate 178). Both towers have battered bases and a series of narrow arrow-slit openings, and are entered by pointed-arched doorways. There is no evidence of any staircases to utilize their height as prospect towers; probably this was considered unnecessary, as the views from the base of the structure are wide and impressive. The construction is entirely of flat rough stones, with deeply recessed joints, giving the impression of dry-wall construction or deep weathering. Numerous sockets in the walls, which no doubt held the scaffolding during the construction, have been left unfilled and these, along with the crumbled battlements and eroded doorway

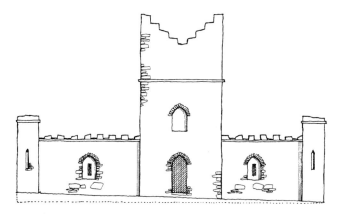

180. Hamilton's Tower eye-catcher beside the River Shannon at Glin: elevation and plan.

181. Hamilton's Tower: detail of the stone-work.

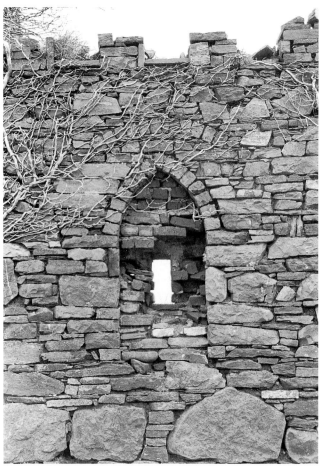

179. Castle Oliver eye-catcher: view from the doorway in the screen.

(plate 179), help to give this simple building an air of irregular, medieval charm. The scale of its structure is deceptive and can be seen from quite a considerable distance, owing to its prominent and elevated position, which is even more dramatic for the want of trees.

A less picturesque example is found in the flatter setting of Glin. Here the rather squat Hamilton's Tower has been built on a low hill above the Shannon to provide an eye-catcher from Glin Castle. This was probably one of the products of the twenty-fifth Knight's enthusiasm for garden buildings, and consists of a two-storey square tower with high multi-stepped battlements. Battlemented single-storey wings project from each side, ending in solid square piers in imitation of turrets (plate 180). Pointed-arch windows and blind arrow-slits add a modicum of decoration to what is a very simple building, although the irregular stonework, again

with deeply recessed joints, is very attractive at close range (plate 181). The side walls, which create the illusion of wings, appear to have been built at some later time, and one of them returns to form a semi-enclosure, which may possibly have been intended as a shelter for livestock. As with Oliver's Folly, it seems unlikely that the tower served any serious function other than a visual one.

Fleming's Folly, near the town of Ballinagh, Co. Cavan, is an interesting if somewhat ambiguous example of a sham ruin. Although its present state is certainly ruinous, it is not at all clear if it was originally conceived as such. It stands on an imposing gorse- and fern-covered hill with several rough outcrops of rock, in contrast to the more gentle drumlin hills which surround it (plate 182). On a level below the summit is a small reed-filled lake, which helps to give the setting a desolate and slightly gloomy atmosphere. The building is a square-planned structure which seems almost cubic in form, although its height is substantially less than the length of its side (plate 183). Two main openings, now much eroded, appear in the jagged rubble-stone walls. One seems to have been a window and the other a doorway. On two sides of the square the walls are massive, in excess of six feet thick, and one contains a staircase leading from the doorway up to a rough platform comprising the second of the two thick walls. There is no evidence of any roof, although the interior contains what appears to be a rough fireplace and two deep storage recesses in one of the walls. A further unusual detail is the construction of the four small piers, which project from each of the internal corners.

Local accounts relate that Fleming's Folly was once a much higher, tower-like structure, from the top of which

183. Fleming's Folly (elevation and plan) re-creates a typical Irish tower-house in miniature.

182. Fleming's Folly viewed from a distance across the drumlins of county Cavan.

111

184. A nineteenth-century view of Heywood, showing the sham ruin, Gothick orangery, and castellated gate lodge. (Courtesy of the Irish Architectural Archive.)

ships could be seen at sea. No evidence survives to support this, and it is highly probable that its present state may be a lot closer to the original than the more fanciful legend would have us believe. There is, however, an interesting similarity in the plan of Fleming's Folly to those of the tower houses at Ballyhowley, Co. Mayo, and Rathmacknee, Co. Wexford, plans of which are illustrated in *A Lost Tradition*.[11] These defensive houses from the fifteenth or sixteenth century both have similar staircases, wall recesses, and roughly similar-shaped plans. It is therefore possible that Mr Fleming built his folly in imitation of this earlier Irish tower house and the puzzle of whether or not it was purposely conceived as a ruin is unlikely to be solved.

Such vagueness as relates to Fleming's Folly is not uncommon when researching the history of follies and garden buildings. They are the least well-documented buildings of the eighteenth and nineteenth centuries. The often ruined state into which so many have now fallen further complicates the matter, as does the eighteenth-century habit of constructing those very deliberate ruins we are now considering. One example previously discussed, which illustrates this confusion, is the rustic arch at Luttrellstown. In its present state this contains many of the hallmarks of an intentional ruin. Only by a careful search of internal finishings or the remnants of door and window frames can it be proved to have been something more.

One of the most interesting sham ruins in Ireland is found at Heywood near Ballinakill, Co. Leix. The house has now gone, but the demesne, which far surpassed it, is still largely intact. It was laid out by Frederick Trench in the 1770s, very much in the romantic poetic tradition as advocated by Alexander Pope. The road rising up to the house passes three notable follies, a castellated entrance lodge and archway, the sham ruin, and a strange Gothic building, now ruinous, which may have been a summer-house or an orangery. These three structures are all shown in the full glory of their original setting in a fine lithograph of 1818 (plate 184), depicting the view from the house at that time. From the house and approach road there were views out over a valley containing artificial lakes with a bridge, now ruinous, to an Ionic Temple of the Winds, now demolished, which once stood on a distant hill.

The mock ruin is cleverly constructed to present a most convincing ruin, which could easily deceive from a distance (plate 175). It forms an irregular screen along the edge of the hill on the outer side of the road, and contains two impressive Gothic windows, each with fine tracery salvaged from the ruined Dominican friary at Aghaboe, some twelve miles away. The whole composition is given more substance by the Sanderson Miller-style sham castle described earlier,

which stands just behind it. Behind the larger of the two windows there is a stone seat from which the fifteenth-century tracery frames lake views in which a distant temple once featured (plate 185). Heywood is a perfect example of the best principles of the new gardening, and clearly demonstrates the careful manner in which follies and garden buildings were sited within a landscape, creating not only a good visual rapport with it but also with each other, despite the often quite considerable distances which separate them.

One further garland was to be added to this already beautiful demesne. The considerable talents of Gertrude Jekyll and Edwin Lutyens combined to create some very fine formal layouts in front of the house in the early part of this century. The house has now been replaced by a school run by a religious order and Lutyens's fine garden has recently been restored, although it is most unlikely that Gertrude Jekyll's original planting will ever be recreated.[12] Much has already been written on Lutyens's work at Heywood,[13] all of which really belongs to an era beyond the scope of this study. One item, however, may be relevant and appropriate to this chapter on the subject of ruins.

The Ionic temple referred to above is thought to have contained capitals salvaged from the Parliament House in Dublin during its conversion to a bank, which were subsequently used by Lutyens for the columns in his pergola[14] (plate 186). There are four even finer Ionic capitals built into the back of the small pavilion which stands beside the pond in the Lutyens scheme. It seems odd that such finely

186. An early twentieth-century pergola with salvaged Ionic columns by Edwin Lutyens at Heywood.

185. View through the salvaged tracery from Aghaboe Abbey in the sham ruin at Heywood.

carved objects would be placed on the outside of the garden, hidden from view, unless they too represent further evidence of salvage. The site of the Temple of the Winds at Heywood can still be found, but all that remains today is a circular rubble-stone base. This is now overgrown with turf, with a single romantic fragment of stonework, carved with roundels and swags, and bearing the inscription AEOLO VENTISQ SACRUM.[15] These fragments are extremely haunting and evocative of the vanished temple, and the spirit of Pope is everywhere. It recurs in the formal gardens of Lutyens on a shell-shaped fountain that came from the Coade factory of London in 1790, with the inscription GENIO LOCI QUIETI SACRUM.[16] In the Lutyens pavilion there is also a carved plaque bearing Pope's famous Lines:

> To smooth the lawn, to decorate the dale,
> To swell the summit, or to scoop the vale,
> To mark each distance through each opening glade.
> Mass kindred tints or vary shade from shade,
> To bend the arch, to ornament the grot,
> In all—let nature never be forgot.
> Her varied gifts with sparing hand combine,
> Paint as you plant and as you work design.[17]

This plaque, along with the Coade stone fountain, are certainly relics of the eighteenth-century garden, and Pope's lines may even once have graced the walls of the Temple of the Winds. Pope would probably not have felt very comfortable sitting in the formal geometry of Lutyens's work, but he

187. The Jealous Wall at Belvedere, the largest sham ruin in Ireland: elevation and plan.

would most certainly have enjoyed the eighteenth-century layout and in particular the excellent sham ruin.

Of all the sham ruins in Ireland the most spectacular, and the largest, is the Jealous Wall in the demesne at Belvedere, the setting for Thomas Wright's rustic arch (see page 43). This folly is remarkable not only for its size and design, but also for the tragic story which accompanies it. Many sketchy versions of this tale of love, infidelity, and jealousy have been printed over the years, the most balanced and best researched of which appears in the book *Titles* by Leo Daley.[18] The degrees of intrigue and controversy involved, and their link with the construction of the wall,

make it worth summarizing here.

Robert Rochfort, Lord Bellfield, was born in 1708 into a long-established family which had settled in Ireland in the thirteenth century. His father, George Rochfort, was a friend of Swift's and the family seat was at Gaulston, an ancient house dating from the fourteenth century, in a fine demesne. He had two younger brothers, Arthur and George, and was married twice, his first wife dying childless within a year of their marriage. In 1736 he took his second wife, Mary Molesworth of Dublin, who at 16 was some twelve years his junior. Although they had several children, Robert Rochfort seems to have shown little devotion to his family,

wrath, on a path that would eventually lead to his own ruination and imprisonment. The youngest brother, George, is thought to have acted as an *agent provocateur* throughout the accusation and lawsuit which Robert brought against his brother Arthur. Not content with the judgement of the courts, which ruled entirely in Robert's favour, he incarcerated his wife in Gaulston House, where she was to spend thirty years in lonely confinement, isolated from all normal human contacts, except for occasional visits from her three children. During this period it is thought that Mary Rochfort encountered her husband only once, accidentally. After that encounter, to save her husband from similar embarrassment, she was preceded on her walks in the grounds by a servant ringing a bell.

The case was widely reported at the time and several conflicting opinions exist concerning Mary Rochfort's guilt. Robert Rochfort was held in high esteem at court, and no less reliable a commentator than Mary Delany, whose husband the Dean had married the couple, clearly accepted Robert Rochfort's account.[19] Dean Delany would later give evidence at the trial of Arthur Rochfort when he was successfully sued for adultery after his return to Ireland. Damages of £20,000 were awarded, which resulted in Arthur's eventual death in a debtor's prison.[20] Meanwhile Robert Rochfort set about building Belvedere House near the shores of Lough Ennell. This was surrounded by a beautiful park adorned with many follies, some of which have been noted previously. Around the same time, in the early 1740s, Robert's youngest brother George built a larger house designed by the same architect, Richard Castle. It is thought that a subsequent quarrel between Robert and George, and not the unlucky Arthur, led to the construction of the Jealous Wall.

As with the rustic arch, the wall was built around 1760, by which time Robert Rochfort had been created first Earl of Belvedere. It is claimed to have been designed by a Florentine architect called Barradotte, although no record of this mysterious character exists in books on eighteenth-century Italian architecture. Another theory suggests Thomas Wright, who had certainly designed the rustic arch, but this should be discounted on stylistic grounds. Wright's follies and garden buildings are all highly original designs which combine quirky Gothic details with classical symmetry. While he would have enjoyed the irregular profile of the Jealous Wall, the random form and the detail of the openings seem all too straightforward to have been a product of Wright's inventive mind.

This should not detract from the wall itself, which is still one of the most imposing follies to be found in Ireland. It is a highly articulated structure which steps back and forwards, changes direction, curves, and in one instance doubles up with a single-storey pointed-arch loggia, along its 180-foot length. These articulations create a clever illusion of depth and complexity, as well as providing structural bracing for what is, in fact, a simple three-storey wall (plate 187). A great many round, square, and pointed openings relieve the wall, and carry the illusion even further. The top is totally

spending most of his time away from the family seat, where they resided. The unhappy Mary Rochfort, who had been reluctant to enter into the marriage, had become increasingly dependent on the friendship and support of Arthur Rochfort and his large family, who lived at the nearby Bellfield House. In 1743 Rochfort accused his wife of having an affair with his brother Arthur, producing one of the great scandals of the eighteenth century.

Mary Rochfort initially admitted the charge, but the nature of her confession and the degree of force needed to obtain it are not known. The hitherto highly respected Arthur Rochfort fled the country to escape his brother's

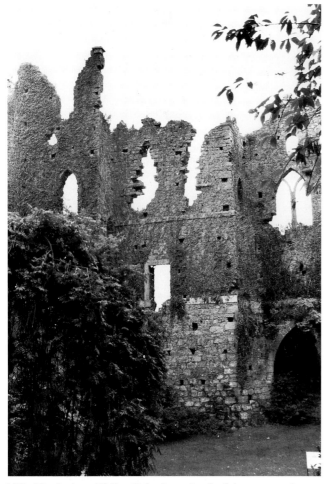

188. The Jealous Wall at Belvedere: detail of the stonework.

deranged. Up until her death she repeatedly claimed her innocence, as did her alleged accomplice, Arthur Rochfort. It is without doubt a story of great sadness and controversy, which is unlikely ever to become clear. For all his alleged cruelty, Robert Rochfort was well connected and highly regarded, and the evidence of the beautiful garden he created proves that he did not lack sensitivity. The house he left is certainly one of the best sited in Ireland, with its magnificent terrace sloping down towards the lough, ringed by trees and dotted with small tree-covered islands. From the steps at the top of the terrace one can perhaps make more sense of the intriguing and ambiguous Jealous Wall, which not only adds a romantic and picturesque focus, but successfully shuts out any hint of the outside world, and especially the views of brother George's house. In this way the splendid isolation of the setting and the full glory of nature is protected, while the attention is attracted towards the main focus of both house and garden, which is of course the beauty of the lake.

Although there are no deliberate classical ruins in Ireland, there are now a great many accidental examples resulting from the destruction of so many great houses during this present century. In some cases fragments have been reused as garden ornaments, as in the temple at Heywood with its columns from the old Parliament House. Another example is found in the grounds of Gandon's Custom House in Dublin. This consists of a cluster of three columns, with some fragments of entablature and a series of eroded Corinthian capitals. There are also various salvaged stone fragments, one of which is dated MDCCXLI (plate 190). On a grander scale is the now dismantled Greek Revival portico from the thrice-burnt Loughcrew. Here the vast drums and Ionic

irregular, giving the impression of gradual decay which is carried through to some of the window openings. Some of these have been fully eroded, while others retain only fragments of stone tracery.

Over the years the wall has generally survived remarkably well, which is a tribute to its construction.[21] Being a sham ruin, however, of which no earlier drawings survive, it is impossible to tell just how much of the original still exists. Fortunately the picturesque but damaging ivy, which completely covered the wall a few years ago, has now been cut, revealing all the pock-mark sockets of the original scaffolding, which greatly adds to the crumbling effect (plate 188). Walking around the circular half-tower which terminates one end of the wall, a stable-yard dating from a later period is revealed. This is built tight up against the structure. The scale of the wall is quite hard to take in from close by, and really only comes into its own when viewed from a distance. It is best seen from the house, and, bounded by specimen trees, it gives a most romantic impression (plate 189).

Mary Rochfort was released from her prison only on the death of her husband in 1774, by which time her spirit had been broken and it is thought she had become mentally

189. The Jealous Wall viewed from the terrace in front of the Belvedere house.

190. A sham ruin of classical fragments erected in the Custom House, Dublin. (Photograph by Roberto D'Ussy.)

191. Fragments from the portico of Loughcrew scattered after the fire of 1960.

capitals of the columns are scattered about in a manner more associated with Campania than Westmeath (plate 191). This totally accidental composition would no doubt have pleased Loughcrew's architect, C. R. Cockerell, whose knowledge of Greek architecture came from surveying and drawing such ruins, and it would have afforded him at least some compensation for the loss of the house.

In a land well endowed with passage graves and standing stones it is not surprising that imitations of these structures found their way into the folly-builders' repertoire. Many surveys of antiquities were published in the eighteenth century, of which Thomas Wright's *Louthiana* is probably the best illustrated, and, if the interpretations were not always accurate, the interest was, without doubt, genuine. As a result there are a number of fake druidic seats, circles, and standing stones, among the most interesting of which are the Druid's Seat at Killiney and the crude obelisk-like construction found at the Hermitage, St. Enda's, on the edge of Dublin (plate 192).

In the grounds of Hillsborough Castle, set in a delightful woodland glade in a corner of the garden, is another interesting and unusual sham ruin. This resembles a Druidic arrangement of standing stones, with one lintel still intact in the manner of Stonehenge. The stones, which are all of red sandstone, are intended to represent an early Christian church and are known locally as Cromlyn's Chapel (plate 192–3). Cromlyn, which in Irish means 'crooked glen', is thought to have been a site of Christian worship since the early seventh century, and seventeenth-century records refer

192. Druidic obelisk and Cromlyn's Chapel, sham ruins at St Enda's and Hillsborough: elevations.

117

to the ruined chapel and burial ground of St Malachy of Cromlyn.[22] There is little doubt that the surviving stones are merely a late eighteenth- or early nineteenth-century sham intended to evoke interesting historical associations with the now vanished early Christian building. A surviving photograph of the stones from 1890 shows a crude pediment resting on the lintel; unfortunately this has since been removed.[23]

It is sometimes difficult to distinguish between a deliberately artificial ruin and a folly ruined by neglect. In some cases the ruined state and the union with nature represent the zenith of a folly's artistic expression, as it comes closest to the very ambiguity it so often seeks to project. This ideal state, however, must, by its very delicate and ephemeral nature, be short-lived, for once toppled the stones are very rarely, if ever, replaced.

The term 'eye-catcher' is a rather vague one, unfamiliar to most people's architectural vocabulary. In eighteenth-century correspondence and literature it was used widely to describe any number of ornamental buildings, from sham ruins and obelisks to elaborate dovecotes and barns. These were quite literally built in the landscape to attract attention by catching the eye. This very simple definition could equally apply to many of the more complex buildings which serve a variety of functions in addition to this more basic requirement. Within the context of this chapter we shall limit our scope to the most literal and simple interpretation: a flat two-dimensional structure, intended only as scenery.

In this form eye-catchers often echo the flat scenic qualities of the sham ruin and, although they are generally limited to the Gothic style in Ireland, it is unlikely that they were seriously intended to deceive the viewer into believing that the buildings belonged to an earlier age. Sometimes a dwelling is found tacked onto the back of the structure, screened from view, such as the cottage-backed eye-catcher at Lawrencetown, Co. Galway (plate 194). Two flying buttresses spring from a rather plain central panel, which is relieved by slightly projecting side piers, a pointed-arch reveal, and a stepped gable. Further decoration is in the shape of pinnacles and small circular reveals. It is likely that the eye-catcher predates the cottage, as the structural necessity for the buttresses would have been obviated by the bracing provided by the building. The buttresses are in fact the most interesting part of what is a rather plain building, both being topped with pinnacles, one of which contains a pointed-arch reveal.

At Grey Abbey, Co. Down, near the picturesque ruins of

193. Cromlyn's Chapel, a sham ruin at Hillsborough. (Photograph by Roberto D'Ussy.)

194. Eye-catchers at Lawrencetown (two) and Grey Abbey: elevations and part-plans.

the thirteenth-century Cistercian abbey, is Grey Abbey House. On a slight nearby hill, which overlooks the ruins, the house, and the parish church, stands a delightful early nineteenth-century eye-catcher, which in more recent years has had a cottage attached (plate 194), as at Lawrencetown. This was built in 1807 as a sketching room, with an octagonal chamber behind its flat façade. Although the Grey Abbey eye-catcher is a simple rendered structure, it is a relatively refined composition and well enough proportioned to suggest that an architect or at least a good amateur conceived it. A central crow-stepped gable, adorned with a quatrefoil and cross arrow-slits, is flanked by slim piers with pinnacled tops which rise from a battered base. Several steps led up to delicate glazed doors set into a Gothic-shaped reveal, which provided an ideal picture window for those sketching inside. The building is surrounded by trees, which would at one time have disguised its lack of depth, and the overall impression is very fine, as are the excellent views from the building itself.[24]

Another fine rendered eye-catcher can still be seen at Ardfert, Co. Kerry. This survives as a free-standing arch with simple rendered embellishments. The gable pattern on the rear face of the structure suggests that it may also at one time have fronted a cottage. Numerous rustic-arch structures have been built which fall comfortably into the category of eye-catchers, such as those found at Tallagh, Danesmote, and Kilronan.

One final example of the two-dimensional eyecatcher is also found at Lawrencetown, not far from the cottage eye-

catcher described above. It stands, strangely devoid of any trees, at a sharp bend in the road, which provides a perfect face on approach from one direction and makes it virtually invisible from the opposite approach. This may have been intended as a deliberate illusion, or it may simply be the result of road changes following the demolition of the house and the dividing up of the estate. Either way the structure is an excellent example, with the right balance of pretension and modesty. Built in neat rubble stonework, the composition comprises a central recessed bay with a pointed-arched doorway flanked by narrow piers, each with ogee window openings (plate 194). At high level there is a series of slit reveals, above which runs a string-course. The tops of the piers end with a blind circular reveal and a stone pinnacle rising from a flat capping stone. The same pattern is repeated above the central doorway. To restrain the structure, delicate buttresses spring from each side, which, along with the door and window openings, create an effect of lightness.

There is something about this particular structure which represents that essential quality present in all the very best follies. This pertains to the use of architectural elements not in the literal but the abstract sense, combined with simplicity and a judicious eye for proportion. It is both a conceit and also a humble, but often subtle statement about the more meaningful architecture which may have inspired it. In this way such buildings provide important connections with those hard-to-define *essentials* referred to before; and for this reason alone, they cannot fail to ornament the landscape in which they stand.

CHAPTER 8

Gazebos and Summer-houses

'Summer-house' is another of those generic words which covers a vast range of garden buildings in a less than specific manner. Just as the cartographers of the first Ordnance Surveys were often confused by the subtle differences between rustic buildings, hermitages, and grottoes, which all became grottoes, so too was there confusion with many of the free-standing garden structures which appeared on the maps as summer-houses. This should not be seen as a criticism of the surveyors, for it is quite remarkable that such minor and relatively insignificant buildings appear at all on maps to a scale of six inches to one mile, and it is mentioned only to illustrate the general confusion with regard to the nomenclature. In the English language 'summer-house' dates back to the mid-fifteenth century and quite simply means 'a structure in a garden or park, usually of simple and often rustic construction, designed to provide a cool shady place in the heat of the summer'.[1] By this definition, the rustic cottages described in chapter 5 could well be included. As they tend to be larger in size and often provide temporary or even permanent habitation, we shall exclude them in favour of the more intimate pleasure pavilions, erected only for short-term, daytime use.

The terms 'gazebo' and 'belvedere' are also often applied

195. Hillsborough gazebo viewed from within the ramparts of the fort. (Photograph by Roberto D'Ussy.)

196. Rathkenny tea-house, Heywood orangery, and Hately Manor summer-house: elevations.

to buildings in a loose and rather vague manner. In fact they mean the same thing. 'Belvedere' is more commonly used in France and Italy, while 'gazebo' is of English origin in spite of its mock Latin ending. A brief look at the etymology of these two words provides the simplest explanation of their origins and a clearer definition of their function. 'Belvedere' is the older of the two words, originating in the late sixteenth century from French and Italian roots meaning 'fair sight'— *bello*, beautiful and *vedere*, to see. Its architectural definition is 'a raised turret or lantern on the top of a house, or a summer-house erected on an eminence, commanding a fine view'.[2] 'Gazebo' is a much later word of mid-eighteenth-century origin and its dictionary definition is identical to that of belvedere. It derives from a Middle English word of unknown origin, 'gaze', meaning to look fixedly, intently, or deliberately at something.

The importance of prospect is immediately evident, as is the reason for constructing such buildings: the enjoyment of viewing from them beautiful scenery or some other interesting spectacle. While the attached variety of a raised turret or lantern connected to a house would no doubt function in a similar way, it is on the isolated version that we shall concentrate. The reference to a summer-house in the definition is also relevant, as this is another word which often suffers from vague and ill-defined usage. Summer-houses, as their name suggests, are largely used during the finer weather of the summer months, when gardens and demesnes are at their peak of growth. Links with sport and leisure are common, such as looking on at field sports like hunting, riding, and racing, or the more gentle pursuits of fishing or boating. The building's siting on an eminence was also an important factor which underlines the dual function of pleasure building and prominent garden ornament.

As with most folly types, there exists a great variety in the degree of elaboration and sophistication, ranging from simple rubble-stone structures to fine ashlar-faced buildings with richly carved mouldings. Greater or lesser degrees of comfort were afforded. While adorning the landscape, all without exception provided some sort of shelter combined with excellent views.

An early example is found at Rathkenny, near Cootehill, Co. Cavan. This building is more correctly a summer- or tea-house than a gazebo and stands, not on an eminence, but in the quiet seclusion of an early eighteenth-century garden. This was laid out facing an earlier house, now gone, having been replaced by the present house of the 1820s, which stands some way off. The situation and views are excellent, owing to the wide river which separates house from garden. Particularly fine is the oblique view of the garden from the present house, across the water. This may have influenced its siting.

Today the garden is approached by a fragile metal bridge, on the axis of the tea-house. Accounts exist which suggest that it was originally accessible only by boat, to accommodate male revelling in the garden, outside the influence of female company restricted to the opposite bank.[3] On entering the walled garden the ground rises up in a series of terraces with flights of steps flanked by urn-topped brick piers and mature Irish yews. Clipped beech and box hedges add to the overall formality. The path finally arrives at the tea-house situated on the back wall, at the top of the garden.

The building is a fairly simple composition consisting of a central Gothic-shaped doorway containing double doors reached by a short flight of steps (plate 196). Lancet windows occur on either side, and the brick construction with stone quoins carries up to terminate in a battlemented parapet. Although modest and understated, the building does much for the garden and links nicely to the garden wall through the curved flanking sections which provide it with simple wings. The style of the pavilion suggests something earlier than Georgian Gothick and it may well be a rare survivor of the late seventeenth century.

A similar but more modest version of the Rathkenny building is found in another riverside situation at Hately Manor, Carrick-on-Shannon, Co. Leitrim. This odd little structure stands at the bottom of a fine garden which slopes from the house down to the banks of the River Shannon. It has a flat front with two Gothic-shaped doorways, between which at high level is a circular window opening (plate 196). The construction is of squared random stone with brick dressings to the openings, expressed quoins, and battlements. There is an unusual curved rear wall which faces the river, while the front of the structure looks back towards the house. The absence of any windows suggests that the building

197. Man-of-war Cove and Ardglass bathing-houses: elevations and plans.

was used more as a storeroom than a pleasure pavilion and that its ornamental qualities were enjoyed from the house and not the river. It may also have been used to store boating equipment, as the remains of a man-made jetty exist, leading out from the bottom of the garden in line with the house.

At the romantically named Man-of-War Cove, near the mouth of a quiet tree-lined valley on the deserted coastline south of Cork, stands a small summer-house which has much in common with the form of the previous two examples. Perched on a rocky outcrop above the sea, the building was probably used for picnics and bathing expeditions. It has two round-arched doorways separated by a tall slim niche in the dividing pier. Arched reveals are built into the wall on either side of the doorways, which are approached by an interesting flight of steps, with higher steps providing rough seats to either side (plate 197). The effect of the steps and reveals gives the building an air of pretension that is not quite justified by its modest rubble-stone construction. In the now roofless interior there are two niches, the ruins of a fireplace, and a large window opening in the outer side wall which affords excellent views of the dramatic headlands and the sea. It is a most beautiful and isolated place and ideal for its purpose, with the spirit of the place everywhere in evidence.

At Heywood there is an intriguing ruined building not far from the fine sham ruins mentioned before (see page 112). This appears quite prominently on the right-hand side of the lithograph of 1818, along with the sham ruins and the gate lodge, with fine Gothic tracery and an unusual raised basement (plate 196). It seems to have been quite elaborate and would doubtless have been used as a pleasure building. The structure, which has a distinctly Gothic style, is predominantly brick-built with stone dressings and pinnacles to slim piers which enclose the five pointed-arch openings (plate 198). The composition was quite carefully considered, with all but the central opening being contained in larger

pointed-arch reveals. The top is battlemented between the pinnacles of the three central bays and the side bays slope down slightly, with the outside piers at a lower level. Some of the cut stonework looks as if it may have originated from an earlier building, as in the construction of the nearby sham ruin.

Inside the shell of the building there are few clues to its purpose, as the interior is completely gutted. There are strange horizontal ducts built into the back wall, supported on cantilevered stone flags. Built out from the rear of the building to one side is a square stone chamber, and on the opposite side a flight of steps leading downwards has been largely infilled. Further mystification is created by the remains of a large cut-stone Gothic window opening to the rear of the main chamber. It is difficult to decipher for what use the building was originally intended—possibly an orangery or an early conservatory, with the rear extension housing some form of heating which was ducted into the main space. Certainly, on the evidence of the lithograph, it was at one time regarded as an important garden ornament, regardless of its intriguing function.

Chinoiserie, the fashion for free interpretations of Chinese art and architecture, became an important inspiration to the aesthetics of garden design in the early to mid-eighteenth century. Descriptions and illustrations of Chinese gardens had first been introduced to Europe by French Jesuit missionaries, and were later to be popularized by a number of books on the subject, the most notable and influential of which was *Designs for Chinese Buildings* by William Chambers, published in 1757. Advocates of the new gardening were attracted to the Chinese garden because of the irregularity which made them more natural. Chambers also pointed out in his books that Chinese gardens were intended to excite the senses and emotions, an idea which was concurrently being reinforced by Edmund Burke's *Philosophical Enquiry into the Origin of our Ideas of the Sublime and Beautiful*. Chinese-style garden buildings became popular, normally in the form of summer-houses or tea-houses, although the well-

198. Heywood Gothic orangery: detail of the battlemented and pinnacled parapet.

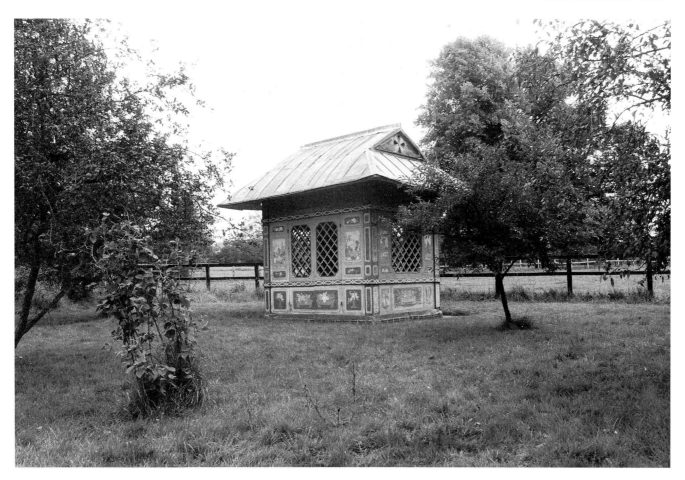

199. The Chinese tea-house at Harristown prior to its move back to Stowe.

known pagoda at Kew Gardens is a large-scale exception. Often associated with water, the Chinese bridge was also a common feature. The ephemeral nature of the timber construction of most Chinese garden buildings has resulted in very few survivors of the style, and in Ireland there has in recent years been only one intact example.

This was until recently at Harristown, Co. Kildare, and is considered to be the earliest example of this style of building in the British Isles.[4] It was originally designed for the grounds of Stowe in Buckinghamshire, possibly by William Kent. There it stood in a lake and was reliably recorded in correspondence of 1738.[5] Some years later it was moved twenty miles to Wotton House, where it again enjoyed a lake setting before its more recent relocation in the 1950s to Ireland.[6] Having remained at Harristown until 1992, the building has now been returned to Stowe.[7] By virtue of its uniqueness and long residence in Ireland, the building deserves inclusion in this study. It consists of a simple rectangle in plan, with wide projecting eaves and delicate fretted windows and doors (plate 199). Inside and out, the walls are painted with Chinese figures, flowers, trees, and mythical beasts.[8] This rare and delicate building has a quite

remarkable appearance, and its very survival for almost two and a half centuries, despite frequent moves and a return journey across the Irish Sea, is a measure of its beauty and importance.

Prototypes of the summer-house can be found in earlier Elizabethan or seventeenth-century gardens, and in the pleasure pavilions of what we would consider to be the classical Chinese garden. While differing in form, they none the less share many of the principal characteristics of the gazebo, even if they are in some cases situated with a greater emphasis on intimacy than prominence. Gazebos almost always take the shape of circles, hexagons, or octagons. It is not exactly clear from which precedents these particular buildings have arrived, especially the latter two geometries. Circular structures were known through Roman temples and standing stones, but octagons and hexagons belong more to the language of Gothic architecture than to the classical canon. The principal exception of the octagonal Tower of the Winds in Athens was not widely known before Stuart and Revett's *Antiquities of Athens* appeared in 1762.

The fine gazebo at Belvedere offers a tenuous link with the possibility of a Gothic precedent. This stands on raised

200. Belvedere gazebo: elevation and plan showing the outline of the turf bastions.

ground on which the traces of earthwork bastions can still be seen, and provides a prominent feature on the direct approach to the Rustic Arch from Belvedere House. It would originally have commanded views out over the lake through gaps in the ring of trees which are now overgrown. The structure is a brick octagon, with regular courses of stone facings, and openings in all of its sides, one of which is a door and the other seven, windows. These are formed by flat ogival arches with crude voussoirs, above which are quatrefoil patterns recessed into the stonework (plate 200). Sadly this building is now in a state of advanced decay, with the roof gone and many of the wall panels beneath the windows eroded away, which makes it difficult to imagine how it originally appeared. Thomas Wright, whose name has been linked to the Jealous Wall and who certainly designed the Rustic Arch in the same demesne, may have been responsible for the gazebo, the spirit of which can be seen in his fine drawing of the octagonal baptistry at Mellifont Abbey in *Louthiana*[9] (plate 201).

At Downhill there is a large circular gazebo which stands

201. Mellifont Abbey baptistry: an eighteenth-century drawing by Thomas Wright from *Louthiana*.

above the Black Glen (plate 202). This is an impressive rubble-stone structure with shallow brick arches and brick dressings to a bold embattled top. There are six full-height openings in all and a strange square projection to the rear which, in its present state, is difficult to explain. It is known as Lady Erne's Seat after the bishop's daughter, Mary, who married Lord Erne, and commands fine views over the glen, the fish ponds, which still exist,[10] and out to sea (plate 203). The full-height openings imply that the building was intended as an open structure, and there is the suggestion that it may have been used for the more utilitarian purpose of threshing and winnowing corn.[11]

202. Lady Erne's Seat, the gazebo at Downhill: elevation and plan.

203. Lady Erne's Seat at Downhill: present setting.

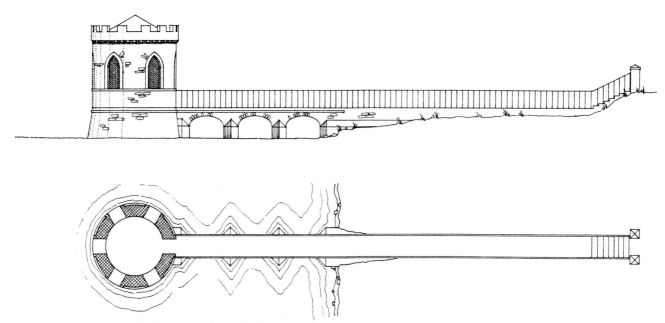

204. Fishing pavilion, Rockingham: elevation and plan.

A practical, but no less interesting, octagonal gazebo stands on the shoreline at Ardglass. This tiny structure, which was probably intended for use as a bathing hut, is built of roughly squared and coursed stone (plate 197). It consists of a castellated octagon with a square doorway entrance from the rear and a vaulted porch projecting from the front, with a small Gothic window opening on one side. When the tide is in the slightly battered base becomes partly submerged and the building appears at its very best, while still being accessible from the outcrop of rock which runs close to the rear doorway. The Ardglass gazebo was most likely instigated by the creator of the nearby Isabella's Tower, which it closely resembles.

Another charming example of a gazebo with a specific function is the circular fishing house, sometimes referred to

205. Fishing pavilion, Rockingham, viewed from the bridge.

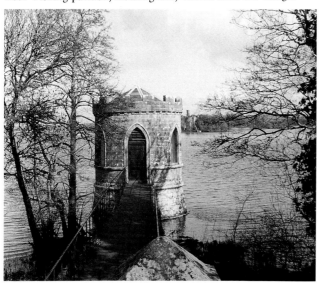

as the temple, which rises from the waters of Lough Key at Rockingham. This is a small circular building with a hexagonal slate roof, rising behind a castellated parapet, a battered base, and a series of six pointed-arch openings (plate 204). One of these is a doorway and the others windows and, as at Downhill, their regular spacing overlays a hexagonal pattern on the circle. The doorway is reached by a three-arched stone bridge, which links the gazebo to the shoreline. It is a neat, well-built structure (plate 205) and provides an ideal spot from which to admire the lake and the folly castle on the island opposite.

There is a most unusual gazebo on a complex hexagonal theme at Brayhead House, near Bray, Co. Wicklow. This consists of a brick-built structure with three small hexagons attached to alternate sides of a larger central hexagon (plate 207). The entrance is a deeply chamfered pointed archway, with a steep pointed relief carried up in brickwork above it (plate 206). This sets into one of the non-projecting faces of the central hexagon and there are paired Gothic windows in the other two. Internally, only one of the hexagonal projections is open, revealing a circular interior with two rectilinear reveals; the others are blocked up, maintaining the hexagonal geometry. The building has for some years been used as a mausoleum for nuns of the religious order which now occupies the house. Surrounded by mature trees in the now much-neglected garden, the roofless building has lost much of its former presence, even though the interesting geometry of its plan is still apparent. Modern development has also encroached quite close to the building, which in former times, from its relatively elevated position, would probably have enjoyed fine views of the sea.

On a smaller scale are the two small rustic gazebos found at Larch Hill, Co. Meath. These are extremely modest structures, more in the form of open shelters than enclosed spaces. The first is situated on high ground at the corner of

208. Larch Hill gazebo seat: elevation and plan.

At the bottom of the sloping plain at Larch Hill, and on the opposite side of the lake to the house, stands a second gazebo-type building. This is also of very primitive construction, with a hexagonal base, on which stand six rough columns, the back three of which are engaged by varying degrees into a long screen wall. This runs across the back of the hexagon and projects slightly forward, terminating in circular piers (plate 208). All of the construction is of crude random rubble and both the central section and the piers are capped with shallow rubble domes. Behind the three free-

209. Bellevue gazebo and banqueting room: section and plans.

206. Brayhead House gazebo: detail of entrance.

207. Brayhead House gazebo: plan.

the vast field which slopes down to the dried-up artificial lakes. It consists of four crude masonry columns built adjacent to a boundary wall, all of which combine to support a rough masonry roof. Robert Watson, who is thought to have built most of the follies at Larch Hill, was a master of the local hunt. This primitive gazebo, along with the Cockle Tower mentioned in chapter 4, may well have provided vantage points and shelter for interested spectators.

standing columns on the lakeside there is a stone seat, with two similar seats (or possibly mounting-blocks) centred on each of the side walls. It is an ideal vantage point from which to look back towards the house, and at one time would have included the lake and fortified islands described before.

An impressive octagonal gazebo was built high up on the edge of the Glen of the Downs in Co. Wicklow. This was part of the Bellevue estate created by the wealthy Dublin banker, David La Touche, in the mid-eighteenth century. Once again the careful choice of site is obvious, with the ample store of natural beauties, in the shape of deep valleys and the conical peaks of the two Sugar Loaf mountains, being fully exploited. Nowhere is this more apparent than from the now ruined gazebo, which seems to hang off the steep side of this extremely picturesque valley. It is illustrated in Bartlett's print of about 1845,[12] which shows the full majesty of the dramatic setting. Although much of the structure has now disappeared, there is just enough to give an impression of how it once looked.

The building is entered through a rectangular ante-chamber (plate 209). This is attached to the back of the main octagonal room, the front of which projects out over the valley side, supported on made-up ground. Four large round-arched windows frame magnificent views and a second doorway leads off to one side. It was constructed entirely of brick and nothing remains of the internal finishes, except for some terracotta floor tiles in the antechamber (plate 210). Both rooms contained fireplaces, and the walls are almost three feet thick, all of which suggests that it was a well-built and, most likely, well-used building. Certainly it was still

being enjoyed some sixty years after its construction, as G. N. Wright's account of 1827 relates:

> The octagon house is a small building, raised upon a rock in an extremely exposed and elevated situation; the interior is hung with drapery, and assumes the appearance of a bell tent; from the windows, which are glazed with plate glass, there are varied and extensive views; that to the south over the Downs, to the north of the Sugar Loaf, Scalp etc., there is here a judicious collection of books and some few shells and minerals. In the hall of the octagon building is a stuffed panther, so placed that it scarcely ever fails of startling the stranger who enters unwarned of its presence. Below the octagon house is a very curious building of rustic masonry, or rock-work, called the Banqueting Room; it is built of the Gothic Style, and in imitation, probably, of an apartment excavated from solid rock; it is now much gone to ruin. The octagon building which was erected in 1766 is the design of Mr Enoch Johnson; the Gothic Banqueting Room was built in 1788 after the design of Francis Sandys Esq., an eminent architect and native of Ireland who died at Belleview.[13]

This colourful description is worth quoting at length, as it provides us with a very clear and full account of the building's interior furnishings, all of which sheds light on how it was used. More than a passing interest in the sublime is obvious from the building's setting alone, but it is interesting to note the internal props, such as shells, minerals, and the stuffed panther, which may have added to the mood. The building also seems to have been quite lavishly furnished, with its drapery linings, and must have provided a very pleasant and

210. Bellevue gazebo: the ruined shell.

comfortable place in which to sit and enjoy the 'judicious collection of books'.

The Gothic Banqueting Room which Wright refers to is still largely intact, and by virtue of its cave-like construction is probably no less derelict than when he described it. Standing a little way off to one side and on a lower level, it contains many similar features to the gazebo. At the rear is a small closet, entered down a short flight of steps, which leads into a long vaulted room with an octagonal bay to the front. This projects out over the hillside in a similar manner to the octagon room, and contains three Gothic-shaped windows. The atmosphere in this lower building is bleak and rather gloomy, and the absence of a fireplace must have contributed to the gloom.

It is, however, a most impressive structure from outside, and not unlike some of the hermitages described in chapter 3. Partly excavated out of the hillside and partly built of random rubble, with large irregular stones at the corners and around doorways, it creates all the charming ambiguity, found somewhere between man-made and nature, which was so important for buildings of this kind. There is some uncertainty as to whether the architect was Francis Sandys, the father, or Francis Sandys, the son, and it is possible that they may have collaborated in the design of the Banqueting Room. The son was the more eminent architect and was partly responsible for the Earl-Bishop of Derry's houses at Ballyscullion and Ickworth, the latter of which still stands. Either way it is an indication of how fairly modest garden structures of this kind were taken seriously enough to be designed by established architects; and it remains a tribute to their skill and judicious siting that, even in their ruined state, the buildings remain powerfully evocative.

On a more sophisticated level of design, we know that Lovett Pearce designed ornamental garden buildings with polygonal plans, which could justifiably be called gazebos. These were designed for specific clients but today remain only as drawings and it is not clear if they were in fact ever built.[14] The first is a simple hexagonal structure placed on a battered square base, partly submerged by the waters of the lake on which it stands (plate 211). Pearce's note on the drawing reads: 'A room for Mr Creighton to be built on a sunk island on Lough Hern'. It is approached by a short flight of steps in the base, which branch to each side, off a half-landing, on line with the Palladian-style entrance door. Internally, directly opposite the door, is a fireplace, and the other four faces of the octagon all contain windows. The proposed height was quite substantial, with a second series of square windows on all faces at higher level, and a hexagonal roof with a central chimney, which would have called for an ingenious flue arrangement from the fireplace on the outside wall. There is a second note regarding the setting out of the building, warning that the top of the base should be 'above or equal to the water in the Lough Herne floods', and this, along with the dimensions, suggests that the drawing was intended for construction. Mr Creighton may well have been Crichton of the early seventeenth-

211. Creighton gazebo: drawings by Edward Lovett Pearce. (Courtesy of William Proby, Esq.)

century Crom Castle on Lough Erne.[15]

The second Pearce gazebo consists of an impressive dodecagonal loggia with arched openings surrounding a circular two-storey drum with square windows and a conical roof terminated by a chimney-stack. Internally the drum becomes an octagon with a doorway and three windows in the cross axis and a fireplace and three niches on the diagonals (plate 212). As with the previous design, there are dimensions and notes on the drawing, one of which reads: 'Summerhouse for Dawson's of Dawson Castle'. This may well have been Dawson's Court, the house which preceded Emo in Co. Leix, or possibly Dawson's Grove in Co. Monaghan. Both of these designs, and in particular the latter, are delightful exercises in pure geometry, and it is a great pity that they were never built.

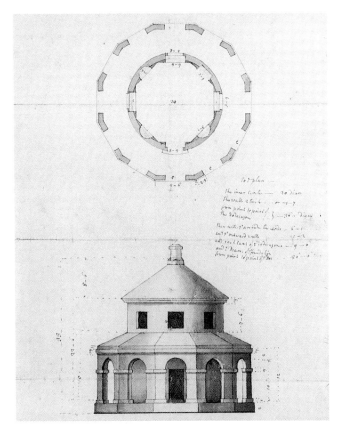

There are some similarities between the Creighton gazebo and the fine gazebo which still stands in the grounds of Leixlip Castle, at the meeting of the Rye Water and the River Liffey. The castle dates back to the twelfth century with many subsequent changes and additions, and its name, Leixlip, is derived from the Danish *lax-haulp*. This refers to the nearby salmon leap, which was famous for its great beauty before being submerged through damming for a hydro-electrical scheme. It is therefore not surprising that the gazebo stands right on the water's edge, above a vaulted boat-house. The entrance to the boat-house is by a rough flight of curving steps leading down by one side of the main steps to the gazebo, under which is found a small chamber, which may have been designed to store boating equipment. In former times the higher water-levels would have flowed into the main chamber, directly underneath the gazebo, providing a most impressive sight (plate 213).

212. Dawson gazebo: drawings by Edward Lovett Pearce. (Courtesy of William Proby, Esq.)

213. Leixlip gazebo: a late eighteenth-century view by Jonathan Fisher from across the River Liffey. (Courtesy of the Irish Architectural Archive.)

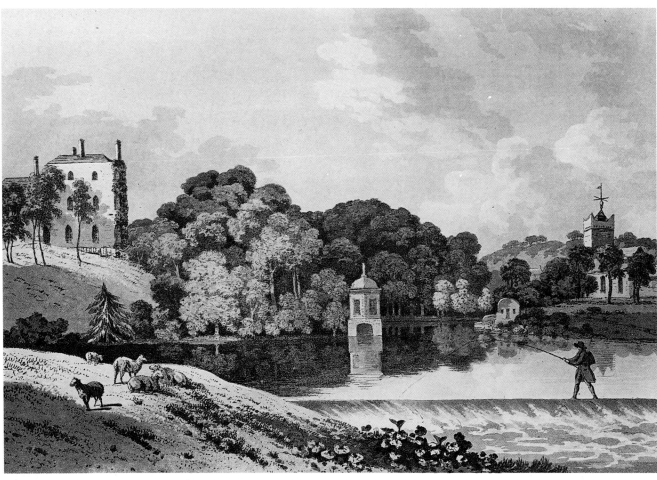

214. Emo gazebo: elevation and plan.

Co. Leix (plate 214). This consists of a fine octagonal gazebo perched on top of a triumphal arch-style base, which contains a service room on one side and a staircase on the other. This arrangement is similar to William Kent's lodge at Badminton, with a banqueting room above the estate entrance. The central section projects slightly and its tall arched opening springs from a plinth several feet above ground level. Circular and round-headed niches occur in the recessed side sections, all trimmed with deeply rusticated dressed stonework, in contrast to the rubble-stone construction. Similar pairs of niches are interspersed with a door and three windows on the gazebo, which has fine ashlar facings and trims (plate 215). At one time it appears to have contained two floors, both of which, like the roof, have now gone. The overall composition is most impressive, and the more refined upper section contrasts nicely with the robust base, which has two great arches at low level on the outer sides of the plinth (plate 216). A recent account[16] suggests that the building dates from the third quarter of the eighteenth century; it certainly predates Gandon's neighbouring masterpiece of

215. Emo gazebo: detail of the stonework. (Photograph by Roberto D'Ussy.)

The gazebo itself is a neat hexagonal composition in random stone and brick dressings (plate 217), with door, fireplace, and windows all arranged as Pearce's design for Lough Erne. A hexagonal roof and central chimney stack are further similarities, although at Leixlip the roof is domed and not pitched. Internally the dome is expressed in hexagonal brick vaulting and none of the wall linings has survived. The construction date and architect of the building are unknown, but there is a stylistic connection with some of Pearce's other garden structures. Another, if rather tenuous, connection is the purchase of Leixlip Castle in 1731 by William Conolly, nephew and heir of Speaker Conolly, for whom Pearce worked on the neighbouring Castletown. The grand, stepped approach and pedimented doorway make the Leixlip gazebo a noble little building, and the interior certainly echoes Pearce, with the fine fireplace and the diagonally laid floor-tiling which imitates, in a modest way, the flooring to the entrance hall of Castletown.

Another excellent gazebo, about which little is known, is the unusual structure known as the Temple at Emo Court,

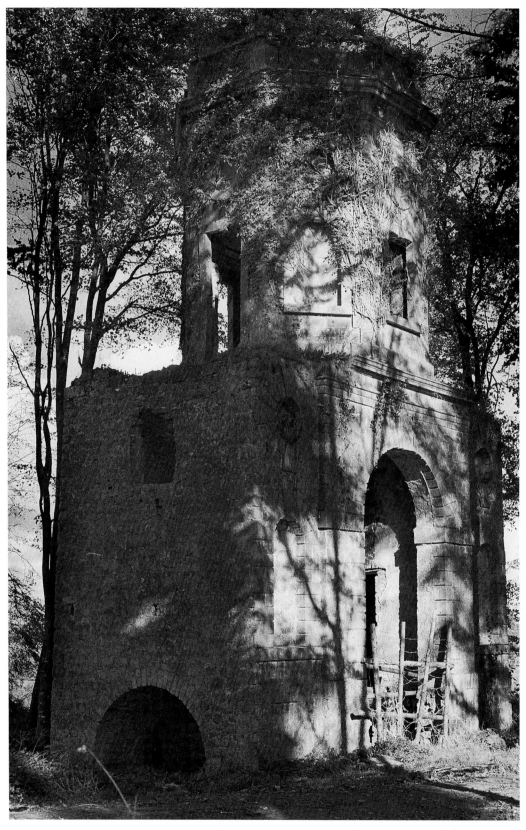

216. Emo gazebo: the side view in its present state. (Photograph by Roberto D'Ussy.)

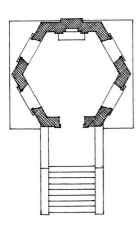

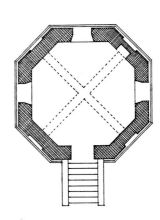

217. Gazebos at Leixlip, Harbourstown, and Dromoland: elevations and plans.

Emo Court. The style could, however, belong to an earlier period, and has marked similarities with the towers of Edward Lovett Pearce's now demolished house at Summerhill, Co. Meath.[17]

In a much more controlled setting than most of the examples previously described is the small square gazebo on the north-east wall of Hillsborough Fort. It stands above an arched gateway, cut into the earthworks on the inner side, and, like the walls, is constructed of random rubble stone. This is relieved by dressed stone quoins, corbels, and the tracery of the fine ogival Gothick windows[18] (plate 195). The rooftop viewing gallery, along with the arched loggia, which both appeared on the famous wedding party print, are now gone, but despite this, much of its charm remains. At Castlewellan, Co. Down, stands the ruin of an octagonal gazebo of brick and stone construction, with interesting Moorish keyhole window openings. This modest little structure, which dates from around 1860, was delightfully sited to enjoy magnificent views of Dundrum Bay and the Mourne mountains, most of which have now been lost through afforestation.

Near Fourknocks, Co. Meath, there is a fine hexagonal gazebo which stands on an artificial mound (plate 218). This once belonged to the demesne of a house called Harbourstown, which has now gone. The mound is on the summit of a flat hill, with fine views of the surrounding countryside. Pike's *Dublin* reports it as 'an eminence on which stands a turret 550 feet above sea level' and continues to relate that it was 'erected by Richard Caddell, otherwise Farrell, about 1754'.[19] It is an elegant and well-built structure in blue limestone with plain Palladian details. There are five arched windows and a simple doorcase with a slightly raised architrave and a strange cornice-style moulding, which projects from a string-course running around the building just below the spring of the window arches. At higher level, on line with the windows and door, is a series of raised plaques; above this is the cornice which finishes in a stone balustrade (plate 217). The balustrade was once topped with urns on the piers at each of the corners. These have now gone, along with the roof and a section of the balustrade itself.

Much thought had gone into the building's setting; the artificial mound ends with a low wall and ditch, which runs in a circle around its base. Further out, a line of beech trees has been planted to encircle the mound, although many of these are now dead or dying. There are also two small

133

vaulted chambers built into the wall, on the opposite side of the gazebo to the entrance door, the function of which is unclear, and it appears that the building once contained a staircase, which may have led to a rooftop viewing platform.

Probably the finest of all the Irish gazebos is the one at Dromoland Castle, Newmarket-on-Fergus, Co. Clare. It survives from a formal baroque garden of the early eighteenth century, which was subsequently overlaid by a more natural landscape later in the same century. The early garden and its ornamental buildings were commissioned by Sir Edward O'Brien. The drawings for it, including a fine plan of the layout, mentioned earlier, have survived. The gazebo stands some distance from the house, which is now a hotel, on top of an artificial mound on a flat hill commanding extensive views, and would have been well suited for its intended purpose of watching horse-racing.[20]

It consists of a two-storey octagon, built of rubble stonework walls with brick dressings, which appear at one time to have been rendered. The cornice, string-course, and arches over the windows and door are all of well-cut stone, and the shallow octagonal roof rises to a stout, tapering finial, also in stone (plate 217). An entrance door and three windows are centred on alternate faces of the octagon, with the intervening faces containing blind window-shaped reveals with square reveals above. The principal room is reached by a flight of stone steps leading up to the doorway, and stands over a semi-basement level entered through a cutting in the ground

on the opposite side (plate 219). This room has a high vaulted roof with four brick ribs and the remains of a fireplace, but no clue as to where the chimney may have emerged.

In the lower room, which was probably a service room, there is also a vaulted ceiling, with lunettes admitting light from the four half-round window openings which occur on alternate walls. The door and windows on the main level are much smaller than the larger arched reveals in which they stand, and it is possible that they are the result of later infilling. If so, the gazebo would once have presented an even more impressive sight than it does at present. Unfortunately it is unlikely that we will enjoy the sight of this delightful and important early building for very much longer, as it has now developed major structural cracks and needs urgent attention, which, sadly, it is unlikely to receive.

The surviving design drawings of the Dromoland gazebo show two earlier versions of the scheme. One is a neatly drawn plan and elevation showing an octagonal structure with a highly elaborate door surround and an octagonal dome supporting a top-heavy chimney (plate 220). The second version differs from the final one only by having an ogival segmented dome rather than the flatter sloping roof as built. There is also an interesting site plan showing a dimensioned layout of the artificial turf-mound bastions, with a walk, foss, and slope. Many drawings survive of unbuilt garden buildings, but it is very rare to find drawings

218. Harbourstown gazebo in its present setting.

219. Dromoland gazebo: view from the rear elevation.

220. Dromoland gazebo: original drawings of an earlier unexecuted design. (Courtesy of the Irish Architectural Archive.)

of an executed design. Gazebos and summer-houses are an unusual category of garden building. Having no strong architectural precedent like temples or towers, they often prove to be structures of great interest and originality. Despite this, they have suffered more neglect than most of the other types. The Harbourstown and Dromoland gazebos are typical of a great many Irish follies and garden buildings, which exist on eighteenth-century demesnes, now divided into farmsteads, with the original houses either ruined, demolished, or converted to other uses. It presents a problem which is difficult to address. In most cases the farmers who now own them are willing to tolerate their presence, and leave the buildings to erode away slowly. Clearly they cannot be held responsible for their repair and upkeep, and they are generally very tolerant of the few enthusiasts who wish to cross their fields to visit them. It is, however, depressing to have to relate that, of all of the examples cited in this chapter, only a few remain in anything resembling an intact state.

135

CHAPTER 9

Temples

Of all the different categories of follies and garden buildings, garden temples surely represent the greatest artistic triumph. At the time of their construction, they were the only form of garden building to be accepted as serious works of art, and in some instances they are to be found among the highest ranks of architectural achievement. Temples are undoubtedly the queens of garden ornament and, as such, were often the most extravagantly constructed and lavishly finished. Contrary to the trend in other types of garden structures, they normally seem to be in better states of preservation; in some cases, in more recent times, they have been restored at great expense.

In the eighteenth century many architects took their commissions for these buildings very seriously, and for some, despite the confines of the smaller scales involved, garden architecture arguably constitutes their best work. The landscapes of Poussin and Claude feature many romantic ruins, but it is those landscapes with temples that remain the most evocative (plate 222). Ruins speak of past glory and achievements, while an intact temple suggests continuity with all the triumph of taste and civilization of the Augustan Age, which so inspired the eighteenth-century landscapes of Britain and Ireland.

221. Marino Casino in its current, much changed setting. (Photograph by Roberto D'Ussy.)

222. Landscape with the ashes of Phocion by Nicolas Poussin.
(Courtesy of the Walker Art Gallery, Liverpool.)

The temple is to be found in some form or other in the architecture of almost every civilization. It represents a symbolic dwelling-place for the gods, an interface between heaven and earth, a sacred place where ceremony and ritual are practised.

> The most cherished possession of every race was its sacred canon of cosmology, embodied in the native laws, customs, legends, symbols and architecture as well as the ritual of everyday life. The inner secrets of this life-giving tradition were preserved in the principal temple, which both sheltered and displayed the sacred canon; for the temple was itself a canonical work, a model of the national cosmology and thus the social and psychic structure of the people.[1]

The architecture of the temple provides a stage for the acting out of ritual, which underlines the authority of the gods and, in so doing, provides order to a society. With such a weight of responsibility resting on these buildings, it is not surprising that the greatest architectural ambition and endeavour was lavished upon them. Many of the world's greatest architectural landmarks fall within this building type, spanning continents, civilizations, and millennia. Some

still exist, while others are known only through the written word or mystical inheritance. They vary greatly from Hellenic temples to Gothic cathedrals, and Aztec ziggurats to the temples of Egypt, India, or China.

One of the greatest sources of mystery and speculation in the Old Testament is the description by the prophet Ezekiel of the Temple of Solomon in Jerusalem.[2] This has been reconstructed countless times in drawing or model form, despite the fact that no single fragment has survived.[3] The standing stone circle of Stonehenge has stimulated as much mystery and conjecture. Inigo Jones, the father of English Classicism, was convinced that it was a Roman temple, because of its technical resource and geometrical perfection.[4]

It becomes apparent very quickly that temples are both complicated and mysterious buildings. In their simplest form they were established in such natural settings as caves, mountains, springs, or woods, where the only *architecture* apparent was that of nature. These primitive temples or holy places would be decorated and embellished by the societies that revered them, with ever-increasing sophistication, until they developed into buildings and eventually into what we would define today as architecture. The link between temple and siting is of great significance. Very often it is found that

137

existing Christian churches in Britain stand on several layers of the remains of previous religious buildings. These may include earlier Christian churches, Roman temples, and sites of druidic importance, and the exponents of ley-line and dowsing theory press further claims that under sites of religious importance are found related patterns of underground water-courses and lines of magnetic force.[5]

In the Western world the model for the most immediately recognizable form of the temple is that of classical Antiquity: a simple one-storey, normally prostyle structure, with a portico and pediment. On this simple model a great many variants exist, even within the architecture of the ancient Greek civilization which is thought to have refined it first. The origins of this most influential of all architectural languages are also thought by many to have developed from natural elements and have been touched upon briefly in an earlier chapter (see page 84). Throughout the Greek and Roman Empires the model of the classical temple was developed to a highly sophisticated level, often stretching the structural possibilities of its simple constructional method to the limits. Scale varied enormously, and the model was largely restricted to religious buildings.

It was almost a millennium after the fall of the Roman Empire, during the Renaissance, that other buildings began to make use of templar façades in their external appearance. Important civic and public buildings were the first secular ones to boast pediments and porticoes and, by the sixteenth century, houses were also beginning to adopt similar features. This was largely thanks to the influence of the architect born in Paduan, Andrea Palladio, who has been described as 'the most imitated architect in history':

> All over the western world, hundreds of thousands of houses, churches and public buildings with symmetrical fronts and applied half columns topped by a pediment descend from the designs of Andrea Palladio.[6]

Palladio, who died in 1580, was probably the greatest single influence on the architecture of Britain and Ireland during the eighteenth century, and copies of his *Quattro Libri* (1570)[7] would have been known and referred to by every major architect of the age. An architectural movement, headed by Lord Burlington and William Kent in England, grew up under the title of 'Palladianism'. Because of the great boom in country-house building at the time, this movement enjoyed widespread popularity in Britain and Ireland throughout most of the eighteenth century. Palladian houses sought to capture the independence and completeness of Palladio's villas in the Veneto, and were in most cases the central focus of the landscaped demesnes which surrounded them.

The Palladian-inspired temple form, however, was not restricted to churches and houses, and soon spread to embrace civic, educational, institutional, and even commercial buildings. In Dublin, which was second only in importance to London during Britain's eighteenth-century empire, one finds evidence of such buildings at Trinity College, the Parliament House, the Four Courts, and the Royal Exchange. By the nineteenth century the form had spread still further to the fronts of museums, gaols, and railway stations, and in this present century to office blocks, supermarkets, and carpet warehouses.[8]

As a garden ornament the temple belongs to a purer architectural age, when the form still evoked associations with dignity, nobility, and antiquity. The old gods may have gone, but the new gods of culture, taste, and civilization had taken their place; and the garden temple was just one way in which the new deity could be revered through the humble obeisance of nature. In the context of an eighteenth-century demesne garden temples return to the natural settings they would have addressed in their earlier and more primitive manifestations. The importance of buildings and other garden ornaments cannot be stressed too strongly in evaluating the success of the natural style of gardening. Nature was to reign at all costs, aided by the judicious hand of taste. Most judicious hands, however, did seek some credit for their deferential efforts. The erection of a garden building was one way of adding a discreet signature, and, in so doing, adding a new layer of beauty to the scene, providing further evidence of the harmonious interaction between man and nature.

In the sixteenth century Andrea Palladio was responsible for placing temple fronts on houses in rural settings. Two centuries later Sir John Vanbrugh was the first architect in Britain to use temples as decorative ornaments in a landscape, thus returning them to the sylvan settings of their ancient past. Palladio believed that the house was 'nothing other than a small city',[9] and Vanbrugh used the same metaphor for the garden at Castle Howard, through his 15-foot high 'city wall' boundary pierced with monumental gateways. Inside the garden he carved open spaces or 'squares' in the planting, into which he introduced obelisks and temples as a reference to the city, in what John Harris has described as 'urban scenography'.[10]

In this very theatrical context, which was probably in-

223. Temples of Vesta and Fortuna Virilis, Rome.

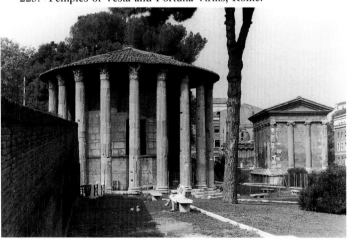

fluenced by Vanbrugh's earlier career as a playwright, the garden building provides a focus for scenographic effect to attract and direct anyone enjoying a walk in the garden. Vanbrugh's temple garden at Castle Howard was probably unique in Europe at the time.[11] It was soon being copied enthusiastically throughout Britain and Ireland.

It is important to note that not all the temples of Antiquity were of the massive scale associated with such well-known examples as the Parthenon in Athens. In ancient times many small temples were also built, which exhibit an almost ornamental quality. The Tower of the Winds in Athens measures only 22 feet 4 inches across its octagonal ground plan, while the temples of Fortuna Virilis and Vesta in Rome (plate 223) are also of a size matched by many garden temples. The peristyle temples of Vesta in Rome and Tivoli were of particular interest to the designers of garden buildings. Measuring just 18 feet 6 inches and 24 feet across (excluding colonnades), they have provided the inspiration for many of the finest circular garden temples. With his family connection to Vanbrugh, it is not surprising to find the name of Edward Lovett Pearce associated with some of the earliest garden temples in Ireland. His design for a large garden temple in the Roman Doric style, found in the Elton Hall collection, is similar in scale and form to the Fortuna Virilis in the Roman Forum.

Pearce's design (plate 224) differs from the Roman precedent in a number of ways; his portico is Doric instead of Ionic, the entrance is enriched by niches and a Diocletian window over the doorway, and by the addition of small projecting wings from either side, at the rear of the cella. It is unlikely that this impressive structure was ever built, although the copious notes on the drawing suggest that its construction must have been seriously considered. They read almost like a letter from the architect to his client, in which he describes details of his design. The small projecting rooms were intended to provide 'conveniences' and a bath, and would be hidden from view by planting, which is

224. A large garden temple: design, elevation, plan, and section by Edward Lovett Pearce. (Courtesy of William Proby Esq.)

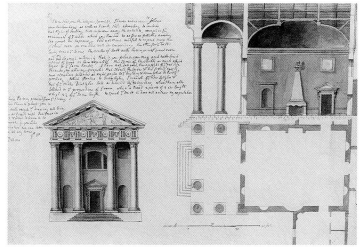

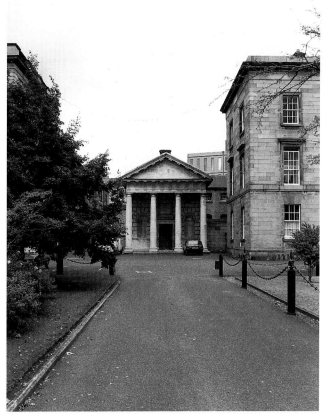

225. The Printing House at Trinity College, Dublin, by Richard Castle.

probably why they appear on plan but not elevation. Of greater interest is Pearce's explanation of his design for the portico, 'which portico is tetrastyle timber cols of the sides systylos and that of the middle diastylos both as directed by Vitruvius, whom I have also followed in the proportions of the room'.[12] A scale bar on the drawing shows that it was intended to be built at an impressive scale, almost 40 feet wide with columns 30 feet in height. The frieze incorporated a good deal of carved decoration, with extensive reliefs indicated on the pediment and bucrania on the frieze.

The interior of the design was also well detailed, with a vaulted ceiling, dado and cornice, elaborate door surrounds, and a strange chimney-piece surmounted by a tapering pedestal like a squat obelisk, supporting a bust. A large niche is placed directly opposite the fireplace and six smaller niches, some of which have square windows placed above them, are arranged symmetrically around the walls. The building was most likely intended as a showcase for a small display of sculpture. It was the work of Ireland's finest architect of the time and great care was taken in its design. Doubtless it would have cost a considerable sum of money to construct and, with its fine interiors and ancillary rooms, was clearly intended for entertaining and regular use. These functions are typical of many of the temples that will be discussed later in this chapter.[13]

226. Drumcondra garden temple: elevation and plan.

Although there is no evidence to suggest that Pearce's design was ever built, there is more than a passing resemblance between it and the Printing House at Trinity College Dublin, which was constructed around 1734 by Richard Castle, Pearce's assistant and the fortunate heir to his architectural practice. This little building (plate 225), which both housed the printing-press and in later years served as the press's logo, is uncharacteristically fine for Castle and may well be a development of his more skilful master's work. The Printing House still stands beside the dining hall. It is somewhat plainer and squatter than the Pearce temple, but is fronted by a tetrastyle Doric portico, behind which is an entrance flanked with niches, as in Pearce's design.

An early temple is found in the garden of the important early eighteenth-century Drumcondra House, Dublin. Edward Lovett Pearce carried out some work on the house in 1727, and may have designed the temple, although it is generally attributed to Alessandro Galilei,[14] the Italian architect with whom Pearce is thought to have collaborated on the design of Castletown House mentioned before (see page 12). The temple consists of a finely worked front, which has been likened to 'the top half of an Italian church façade'.[15] There is certainly something quite baroque about the way in which the two window bays step in, breaking the plane of the pediment, also in the overall richness of the pilasters, modillions, and the door and window surrounds, all of which combine to create great variety and movement within a quite flat façade (plate 226).

The triangular and segmental pediments over the openings are certainly Italianate in design (plate 227) and very similar to the window openings at Castletown, all of which argues for Galilei's authorship. Had this temple been built in the grounds of Castletown, one would almost have believed it to have been a mock-up or sample panel, constructed in advance of the main house to demonstrate detail and convince a doubting client. It is possible that in some cases temples were used in this way, as *essais* or maquettes to explore architectural ideas on a more modest and inexpensive scale, before starting a large country house. The inexpensive nature of small garden buildings favoured novelty, and architects relished the opportunity to develop a new manner or to explore formal problems on a small scale.[16]

There also exist a great many garden temples of a very modest nature, in stark contrast to the vast extravagance we shall encounter towards the end of this chapter. Many are in the form of open or semi-enclosed structures, generally unadorned but no less impressive for their simplicity. The most basic of this type consists of a simple ring of open columns supporting a hemispherical dome. In classical nomenclature

227. Drumcondra garden temple: door-case detail.

228. Circular garden temples at Castletown, Dromoland, and Belan: elevations and plans.

these are known as monopteral temples, distinct from peripteral temples in which the circular colonnade encloses a cell or cella. There are two fine examples of monopteral temples to be found at Dromoland, Co. Clare, and Belan, Co. Kildare.

The Dromoland temple dates from before 1740 and appears on an estate map of that date. It is a delicate rotunda of eight Doric columns bearing a lead-covered, timber dome on a plain frieze (plate 228). Surmounting the dome is a small bronze statue of Mercury, and the structure stands on a stepped circular base, which has an interesting paving pattern of concentric octagons and circles. The temple is placed on a hill at the crossing point of two straight paths, which are probably remnants of the formal garden layout predating the present more natural arrangement. A circle of yew trees surrounds the building and there are fine views from it over two artificial lakes. At Belan the rotunda is thought to have been the work of Richard Castle, who is credited with the design of the two nearby obelisks which have also survived, and was partly responsible for Belan House, which was built around 1743. It stands near the top of a hill in a wide open field with commanding views out over the flat plain of Kildare (plate 229). In detail it has a primitive Tuscan appearance, with eight columns perched on tall pedestals, all in rough granite, supporting a plain granite frieze and dome (plate 228).

Of the two structures, the Belan temple retains a stronger feeling of antiquity. This is helped by its exposed hillside siting and the appearance of its rugged granite construction. The tall pedestals on which it stands also add a more serious air than the ornamental stepped base of Dromoland. It was initially through the books of Vitruvius and Palladio that descriptions of antique temples and the correct relationship of their constituent parts became known to architects working in Britain and Ireland. As the interest in the rules of the classical canon grew throughout the eighteenth century, numerous publications emerged to support them. In many

cases these merely reiterated the words of Vitruvius and Palladio, while presenting them in a more accessible form for both architects and the interested reader alike. One such publication, *The Rudiments of Ancient Architecture*, by an anonymous writer of the late eighteenth century,[17] was 'Calculated for the Use of those who wish to attain a summary Knowledge of the Science of Architecture'. A typical extract defines the monopteral temple:

> There are also round temples, of which some are Monopteral, without cells, and built on columns: the other is called Peripteral. Those without cells have a tribunal or throne, and are ascended by steps of one third of the diameter of the temple: the columns, placed on pedestals, are as high as the diameter of the temple, taken at the outer side of the pedestals; their thickness is one tenth part of the height of the shaft and capital: the height of the architrave is half the diameter of the column: the frieze, and other ornaments above, may be according to the general rule.[18]

229. Belan temple in its present setting.

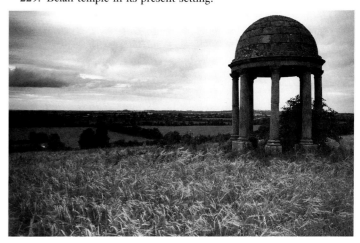

230. Hexagonal temple at the Neale: elevation and plans.

central hexagonal arrangement of piers, which support the columns of the structure above. The outer walls are relieved by niches in four of the six faces, and by two large arched openings in the principal face opposite the entrance (plate 231). Little is known about the date or designer of the building, but it may have been a part of the new park laid out by the first Lord Kilmaine in the 1770s.[19]

In the Castletown demesne at Celbridge, Co. Kildare, stand the remains of another interesting variation on the theme. This small circular temple, known as Mrs Siddons' Temple, is columnar for five-eighths of its circumference and solid for the remainder (plate 228). It has four free-standing Doric columns with a further two half-engaged into the solid section, built of roughly coursed random rubble (plate 232). An elaborately profiled cornice and entablature provide evidence that some thought was exercised in its design, and, as at the Neale, it seems likely that at one time a roof (very probably domed) would have existed.[20] The temple stands on slightly raised ground overlooking the Liffey, about half a mile from the house in the direction of the Leixlip entrance and the Batty Langley lodge described before (see page 95).

231. The Neale temple: interior of the undercroft.

An interesting variation on the monopteral theme is found at the Neale, near Ballinrobe, Co. Mayo. This temple is hexagonal and consists of six plain Doric columns supporting a correct entablature with a finely carved cornice and frieze. It stands on a high hexagonal stone base and at one time probably included a timber roof structure (plate 230). The stone base is in itself an interesting construction. Entering from the rear one is confronted by a riot of complicated cross-vaulting. The vaults spring from the outer walls to a

232. Mrs Siddons's Temple before restoration, with Castletown House in the background.

structures at Larch Hill, the temple has an engaging primitive quality which makes it seem timeless. The simple post and lintel construction and the total absence of detail suggest a primitive Greek model; yet it could equally have been inspired by Stonehenge.

These very simple columnar temples remained popular throughout the eighteenth century and continued to appear in the gardens and parks of the nineteenth and early twentieth centuries. One early example, known as the Doric Rotunda, was built at Templeogue, Co. Dublin, in the early eighteenth century and has since been moved twice, first to Santry and then later to its present situation at Luggala, Co. Wicklow.[21] The beautiful Edwardian garden at Ilnacullin, Co. Cork, also includes a hexagonal version not unlike the one at the Neale. Victorian bandstands, fountains, and similar memorials adorning so many municipal parks are further derivations of the same basic architectural form. It is the very simplicity and perfection of this model which have contributed to its success, no doubt assisted by the relatively modest cost and ease of construction.

Of the more sheltered variety of garden temple, many were specifically designed as garden seats to provide shade or shelter. These were sited either within the more formal parts of the garden or in the parkland, and would in all cases have been erected in carefully selected vantage points from which to enjoy the delights of the scenery. At Fota there is a small circular temple containing a seat, with two free-standing columns and a domed roof. It is built into a high garden wall and terminates a cross axis in the garden

233. A primitive circular temple, Larch Hill: elevation and plan.

It is thought that this riverside route marked an earlier approach to the house than the present entrance and avenue from Celbridge village. If so, the temple may have been designed as an important scenic feature along the way. Alternatively, it may simply have been built to provide a sheltered seat in a particularly tranquil corner of the demesne.

Returning once more to the multi-follied demesne of Robert Watson at Larch Hill, we can find the remains of a large circular temple on an artificial island. This stands on the dried-up lake which also contains the island fort and battery of chapter 6 (see page 104). The temple is a strange primitive structure (plate 233) consisting of eleven stout circular rubble-stone piers, which, through a system of flat stone lintels, support a shallow rubble-stone entablature. In the centre of the arrangement is a stepped circular tribune or altar, which at one time housed a large stone statue of Nimrod the hunter. Around the side of the island are a series of circular reveals set into the masonry, with the appearance of blind gun-holes. Like many of the other

to the rear of the house (plate 234). In the grounds of Hillsborough Castle, Co. Down, there is another small garden temple, which also contains a curved seat behind its screen of Ionic columns. This novel structure, known as Lady Alice's Temple, was constructed of cast iron and erected in 1880. It overlooks a small ornamental lake and is best viewed down the impressive yew avenue on the opposite side of the lake (plate 235).

Also in the Hillsborough demesne is a fine Greek Revival temple, consisting of a rather chaste stone-built structure in a correct Doric order (plate 239). It stands at the end of a terrace on the southern front of the house, to which it is joined at right angles. The structure is little more than a covered seat with an open portico front, built into the boundary wall. To one side the stonework extends to form a blind doorway, over which runs a band of triglyphs, at a lower level than the main entablature. This small extension exaggerates the scale of the structure in a clever way, and, although little is known of its provenance, it is without doubt skilfully designed.

234. Garden wall temple seat at Fota Island.

235. Lady Alice's Temple: the cast-iron Ionic temple at Hillsborough viewed from the yew walk. (Photograph by Roberto D'Ussy.)

In a more natural setting, befitting their strongly held views on the subject, the Delanys had a fine temple seat. This has now gone[22] but numerous descriptions and some photographs have survived. It was a neat pedimented structure with Ionic columns, and was raised on a flight of three steps. The interior was decorated with a fresco by Mrs Delany and a medallion bust of Swift's friend Stella. Swift is also thought to have penned the inscription on the entablature, which read FASTIGA DESPICIT URBIS[23] in a reference to the distant views of Dublin city. The temple may well have provided the vantage point for some of Mrs Delany's delightful sketches of the estate,[24] as it never appears in any of them. It is also possible that many of her famous letters and memoirs, in time collected into her *Autobiography and Correspondence*, were penned there.

Francis Johnston designed a seat in the rustic temple style at the Spa Well in Phoenix Park. An ink and wash drawing of the plan and elevation survives (plate 236) and is signed and dated 1810, but it is not known if the structure was ever built. The design has an open tetrastyle front with a shallow pediment similar to his gate lodge at Townley Hall. A bench seat runs around the chamber behind the portico, with a window in each of the side walls to increase the aspect. It is a very simple structure with all the primitive charm of the rustic temple lodge at Belline. The columns are unadorned tree trunks with plain square tiles providing each one with a simple abacus. Above these are four strange roundels set into the frieze which, along with the diamond pattern on the floor, add the merest hint of sophistication necessary to reveal the hand of an accomplished architect.

By the year the design was made Johnston had already established his name and had completed two of his most important house commissions, Charleville Forest and Townley Hall. This drawing is therefore a valuable survival, as it provides us with proof that a busy and highly regarded architect could still find the time to design such a modest garden building. It was also the practice for architects with a less demanding work-load to prepare designs for garden buildings, with a view to their publication and the advancement of the architect's reputation. Both William Chambers and John Soane produced such publications early in their careers, and we have already noted that one of the designs from Thomas Wright's book was built at Belvedere. England was in time to be flooded with similar folios and publications, but they are rarely found in Ireland.

An exception is the collection of designs by one Sam Chearnley Esq., now at Birr Castle, which will be discussed in a further chapter (see page 218). An impressive number of temple designs are featured in the collection, including several with pyramidal roofs and one of a peripteral hexastyle composition. They range in scale from small one-room designs, to more extravagant multi-roomed plans which are also called 'Casina'. One of the designs, entitled 'Pavilion, Temple or Casina', consists of a domed space superimposed on a Greek cross plan. The style is distinctly baroque and the design closely resembles Vanbrugh's Temple of the Four Winds at Castle Howard.

236. Francis Johnston's drawing for a rustic temple seat at the Spa Well, Phoenix Park, Dublin. (Courtesy of Mrs W. S. Brownlow.)

It consists of a flight of steps leading up to an engaged tetrastyle portico, with an entrance door flanked by niches. Pilasters adorn the flanks of the wings on the principal front only, and all three pediments visible carry statuary (plate 237). The dome has elaborately detailed ribs with receding circular lights, and is topped by a small belvedere. Internally there are four rectangular rooms linked by a circular corridor, three of which connect to the central domed space. Despite the practical omission of the pilasters to the rear of the building, this particular design was most likely the product of pure architectural fantasy, unrestricted by the need to comply with any serious function or cost constraint. Had this design been built, it would surely have been among the finest in Ireland.

The celebrated James Gandon is much better known for his large public buildings, which provide several of the best architectural landmarks in Dublin; but he too, was not averse to reducing to the smaller scale on occasion. Drawings exist for several garden buildings, including a dairy, mausoleum, and temple, although it is unlikely that any of these was ever executed. The temple design is for a rather large structure in a primitive Tuscan style.[25] It features an entrance portico with paired columns to each side of a central doorway in an arched reveal raised on three steps. The side bays also have doorways surmounted by pediments and approached by

steps. Rising from the central space is a large octagon or hexagon, with a shallow pyramidal roof and large arched windows to each face. The design is not as successful as we would expect for an architect of Gandon's high standing, and the proportions of the portico and side doors are unusually squat. It is not known whether or not the building was intended for pleasure or funereal purposes, but it does provide us with useful evidence that Gandon designed for the garden as well as the city.

The functions most commonly associated with temples appear to have been commemorative or simply those of pleasure. As with most of the categories of follies and garden buildings there are some exceptions, which combine the aesthetic considerations of a building in a landscape with more practical uses. We have already encountered a great many templar gate lodges, of which Rockingham, Loughcrew, and Belline are the most notable. In some instances other less prosaic uses were also combined.

At Luttrellstown, in the demesne of the large rustic arch, is found one such example. The building stands in an impressive setting on the side of an artificial lake (plate 238), which lies to one side of the main driveway leading up to the house. It consists of a cut stone Doric portico fronting a long rubble-stone chamber, which once contained a cold bath. Entering through a central doorway behind the portico, one arrived in a simple rectangular space which was well lit

237. A large domed garden temple design, elevation, and plan by Samuel Chearnley. (Courtesy of the Irish Architectural Archive.)

238. Luttrellstown cold-bath temple viewed from across the lake.

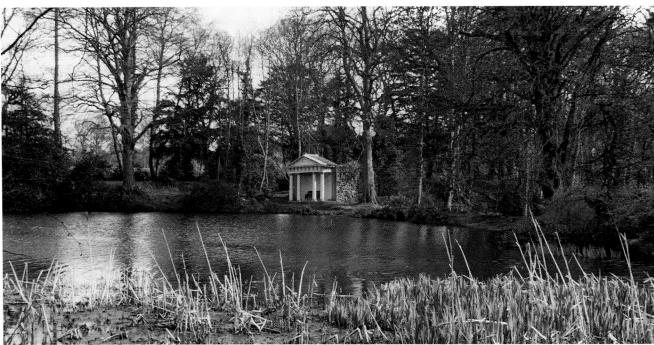

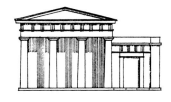
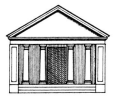

239. Tetrastyle garden temples at Luttrellstown, Hillsborough, and Blackrock.

by a series of pointed-arch windows, stepped dramatically halfway along its length. On the higher of the two levels, which was, most likely, a changing area, there was a fireplace, and on the wall facing it a niche (plate 239). Water was channelled through the building from the lake and then out into the wide cascade, which had been created to retain the edge of the lake and provide a causeway for access to the building.

The entire combination of lake, cascade, temple, and bath makes an impressive composition, and its achievement required no mean feat of engineering. Unfortunately the cold bath remains only as a shell, the plunge pool filled with weeds and dead leaves. It would most certainly have presented an impressive sight in its intact and functioning state, and may even have proved quite usable for other purposes because of its conveniently positioned fireplace. When not in use for ablutionary purposes the entrance area was probably used for sitting in and taking refreshments. Mrs Delany may have been describing the Luttrellstown building in a letter of June 1750 to her sister, when she wrote:

> At 2, the supernumeraries went away; we dined in the cold bath—I mean in its antechamber; it was as pleasant as a rainy day could be when we wanted to roam about. The cold bath is as far from their house as Mrs Whyte's is from you; the coach carried us, and brought us back to the house for tea and coffee.[26]

As Mrs Delany is not more specific, the cold bath in question could have been the one at nearby Lucan House, the home of her hosts of that day, although, in a subsequent letter to her sister, she mentions having driven in the Luttrellstown demesne. Despite the uncertainty of the exact location the excerpt is worth quoting, as it clearly indicates that garden buildings were used and enjoyed, not only on sunny days but also during less clement weather.

In Blackrock, on the outskirts of Dublin, there is another temple building with a site just as impressive as that of the Luttrellstown cold bath. Like Luttrellstown, the Blackrock building also appears to have had a dual function. It stands right on the edge of the sea, with the entrance front almost perpendicular to the sea wall (plate 240). Nearby is a small private harbour, which suggests that the building had some connection with boating or bathing, and may have been used to store equipment. The building is rather plain and is constructed of rendered rubble stone and brickwork, except for the portico, where the columns and mouldings around the pediment are all in granite. It is raised on a flight of three steps, the top one of which is aligned with the sea wall. Strange granite piers occur to each side of the frontage, tending to compete visually with the columns (plate 239).

240. Blackrock seaside temple, probably associated with boating or bathing.

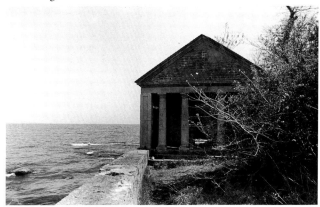

ELEVATION AND PLAN OF A DOG HOVSE DESIGNED FOR A NOBLEMAN ROMAE

241. A templar dog-kennel design for the Bishop of Derry: elevation and plan by John Soane. (Courtesy of the Sir John Soane Museum London.)

Despite their eccentric spacing, the impression of a hexastyle portico is created. This eccentricity of the design does not take away from the splendour of the setting. At high tide it is most impressive.

Inside the building there is a single chamber with a fireplace on the gable end and two windows looking out to sea, with the excellent prospect of Dublin Bay and Howth in the distance. The interior does not appear to have been lavishly finished, which suggests that the building was designed to serve as a store. It was probably constructed, along with a bridge spanning the railway tracks, with a compensation award from the Dublin and Kingstown Railway Company. This company built Ireland's first railway along the coastline, thus severing existing gardens from the sea. The railway was conceived in 1831 and opened in 1834, which suggests that the temple boat-house may date from around the mid to late 1830s. Design drawings of the building survive in a family

sketchbook belonging to Anne Dawson and Florence Balfour, wife and sister of Blayney Townley Balfour of Townley Hall, Co. Meath. The drawing is described as a 'bathhouse' for the Reverend Sir Harcourt Lees.[27]

A quite bizarre example of a distinctly functional temple design was the young John Soane's Canine Residence for the Bishop of Derry. The two men met in Rome in the late 1770s and the record of the Bishop's rather shoddy treatment of the inexperienced Soane has been well documented in the architect's own notebooks.[28] The Canine Residence was just one of a number of unexecuted designs that Soane carried out for Downhill and its demesne. It consisted of a circular exercise enclosure around an unusual temple-like structure, with three wings projecting from a central domed rotunda. Quarter-engaged columns flank the three entrances placed between the wings, which were intended to house the kennel attendant, a sick bay, and the bitches, with the dogs in the central rotunda. A charming illustration survives in the Soane Museum (plate 241) of a later Royal Academy exhibition drawing of the scheme,[29] the original drawings of which had by then been lost. This includes an annotated plan and a rendered elevation showing a fairly plain Doric order with a dome, and canine figures keeping guard above the entablature. Soane was also partly responsible for another small temple at Downhill. This was part of his design for the cenotaph, based on the Roman Tomb of the Julii at St Rémy, to commemorate the Bishop's brother. A sketch of this survives in the Soane Museum.[30]

From the examples discussed above, it can be seen that garden temples were built in a wide range of sizes, and that their construction varied from the simple open columnar type to the large sophisticated designs seen in the drawings of Pearce and Gandon. A wide range of usage is also evident, as in the very practical gate lodge, which not only controlled the entrance but frequently served as a precursor to a similarly styled main house. Garden temples enjoyed many diverse functions—from sculpture gallery to cold bath and boat-house to kennel, as well as their more common uses for pleasure and as memorials.

In the final selection of garden temples to be considered the genre developed an even higher level of architectural achievement and completeness. Here the buildings start to display lavish interior and exterior detail, not only equalling but in some cases surpassing the grandeur of the houses they served. These temples were often on quite a large scale, with a complex arrangement of rooms cleverly arranged within a unified temple form. They also seem to have been much used by their owners, both to receive guests by day and to entertain by night. It is almost as if their creators wished to build an alternative to their main house, in miniature. The full extent of the interest which was sometimes shown in such buildings is well illustrated by the history of Oriel Temple at Collon, Co. Louth. This was built as a garden temple in the 1780s by John Foster[31] and enjoyed to such an extent that, by 1812, he had extended the building rather dramatically and taken up permanent residence there.

242. Castle Ward: the classical west elevation.

Modern additions and alterations have rather overpowered the original building, which is now difficult to identify. The temple has almost disappeared and the building now serves as the Cistercian abbey of Mellifont.

The final four temples to be considered are of the highest artistic quality; two are unquestionably numbered alongside Ireland's finest eighteenth-century buildings and therefore deserve particular attention in this study. All four were constructed close to the sea, although the relationship to the sea is more marked in some than in others. Rather surprisingly, three are to be found in the north of Ireland, at Castle Ward, Downhill, and Mount Stewart, and the fourth at Marino on the outskirts of Dublin. The temple at Castle Ward is the simplest of the four, but no less interesting as a result; it stands in a most beautiful wooded demesne, which lies on the western shore at the southern end of Strangford Lough, Co. Down.

Because of its unusual and eccentric design, Castle Ward House could almost be considered a folly. It was constructed around the year 1763 by Bernard Ward, later first Viscount of Bangor, and his wife Lady Anne, daughter of the first Earl of Darnley. Both husband and wife took an active and conflicting interest in the design of the house, resulting in a most peculiar architectural concoction. The western front was built in the classical style favoured by Bernard Ward, with a fine engaged Ionic portico above a rusticated ground-floor level, while the eastern, seaward front is in Lady Anne's preferred style of Strawberry Hill Gothick (plates 242–3).

Internally the stylistic battle continued, with two ranges of rooms separated by a central corridor. Rooms to the east,

such as the saloon and the dining-room, fell within Lady Anne's control, while the fine entrance hall to the west front fell within that of Mr Ward. The compromise reached in the architectural conflict was not achieved in the equally contentious marital battle, and the couple parted not long after the house was completed.[32] Once again we are fortunate to have the reliable Mrs Delany's account, an enlightened opinion of the couple and their strange house, from the time when she lived nearby, in a house called Mount Panther:

> I was much disappointed when I was at Castleward at the weather's being so bad, for it is so fine a situation that I wished to take some views. Mr Ward is building a fine house, but the scene about it is so uncommonly fine it is a pity it should not be judiciously laid out. He wants taste, and Lady Anne Ward is so whimsical that I doubt her judgment. If they do not do too much they can't spoil the place, for it hath every advantage from Nature that can be desired.[33]

Mrs Delany proved to be an astute judge in her opinion of the demesne, which continues to this day to provide a setting of great beauty. It was largely laid out in the first half of the eighteenth century, with much of the planting carried out under the direction of an earlier Ann Ward, wife of Judge Ward and mother of Bernard. This landscape has been very little altered. The passing centuries and mild damp climate have left an impressive arboretum with many fine indigenous and exotic species. All this helps to justify the National Trust's confident claim that 'few houses in the British Isles stand in a more beautiful setting than Castle Ward with its wide views over Strangford Lough.'[34]

Although thwarted by rain on the visit to Castle Ward

243. Castle Ward: the Gothick east elevation.

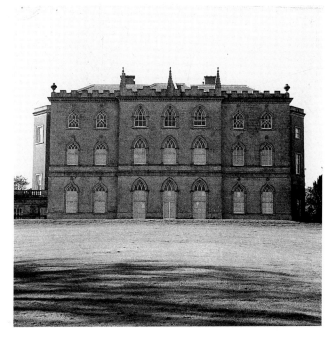

mentioned in her letter of August 1763, Mrs Delany did manage to take at least one view of the demesne during an earlier visit in 1762. This exists as a pleasant watercolour of the temple and the temple water, now in the National Gallery of Ireland (plate 244). The temple water consists of a long stretch laid out as a formal canal in 1724 on the axis of the surviving fifteenth-century tower-house called Audley's Castle, and near to the site of the early eighteenth-century house of Judge Ward. In Mrs Delany's sketch the canal appears to have silted up badly, possibly by design, as tastes had by then shifted away from formality. It also shows the rusticated entrance to a grotto, halfway down the hill below the temple, which has now vanished.[35]

The temple is very neatly composed, possibly to the design of Robert Morris,[36] with an impressive one and a half-storey Doric portico with flanking demi-pedimented wings (plate 245). This is beautifully detailed in Bath stone, with a finely carved frieze containing floral roundels; while the rest of the building is in brick, with stone string-courses and pediment surrounds. Because of its tetrastyle format and demi-pedimented wings, it is often likened to the façade of Palladio's Il Redentore on the Giudecca in Venice.[37] It is,

244. Castle Ward: the Palladian garden temple and grotto in an eighteenth-century watercolour by Mrs Delany. (Courtesy of the National Gallery of Ireland.)

245. Castle Ward garden temple: elevation and plan.

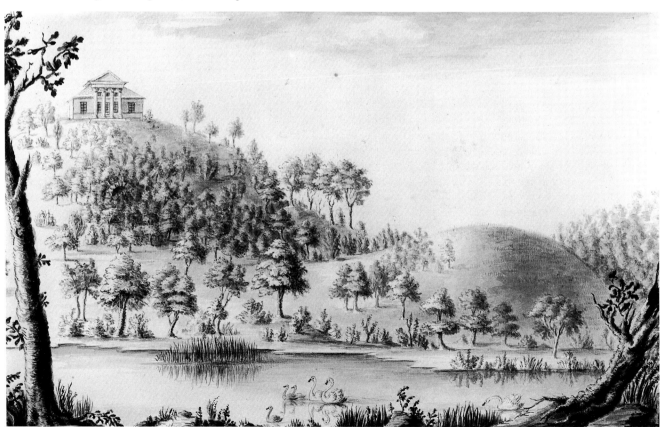

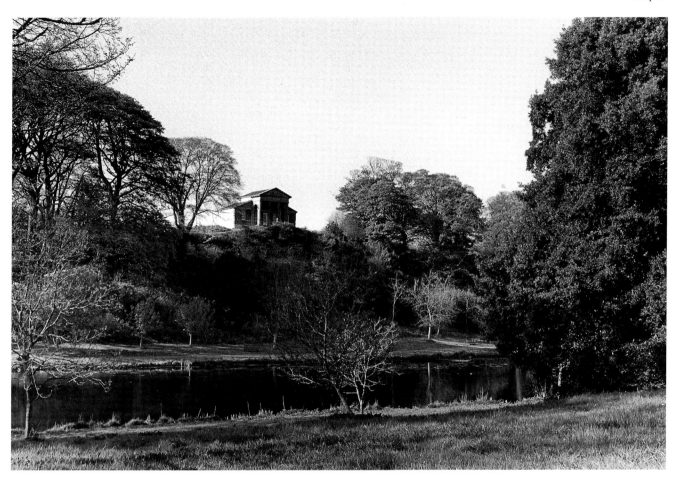

246. Castle Ward garden temple: the present setting viewed from across the lake; the grotto has now disappeared. (Photograph by Roberto D'Ussy.)

however, much closer to the façade of Palladio's other great Venetian church, St Giorgio Maggiore, and also bears a close resemblance to Lord Burlington's design for an orangery at Chiswick.[38] The entrance is approached by a generous flight of stone steps cut into a turf bank, which sweeps up to the base of the portico and is flanked by two windows, which are repeated in each of the wings. Above the door and windows, in the entrance bay, are square blind reveals, which in Mrs Delany's sketch appear as windows. The overall simplicity of the design is enriched by the excellent colouring and the contrast between the rich ochre of the Bath stone and the deep red of the brickwork. Internally there are three linking rooms, corresponding to the three bays of the building, with the remains of fireplaces. Little else survives of its original interior finishing.

Its hilltop situation overlooking the canal is quite splendid, and the views to and from the building are equally impressive (plate 246). The view from the temple depicted in William Ashford's painting of the 1770s,[39] into which the corner of the building projects, is an excellent one, which has changed

little over the years. In true Arcadian fashion, there is virtually no other building to be seen, just a large irregular lough stretching out to sea, beyond a beautiful rolling landscape of densely wooded hills. Architecturally, Castle Ward may be the least accomplished of these final four temples, but there is no doubt that its setting is exceptional. For this reason alone, it is worthy of inclusion among such distinguished architectural company.

Of this final group of folly temples, the one at Downhill, Co. Derry, is the most dramatic. It stands on the top of a 200-foot cliff, overlooking the Atlantic Ocean in a truly sublime situation. The Earl-Bishop's interest in circular forms of architecture has already been noted, from the designs for his kennels and the cenotaph he erected to his brother's memory. He also built two great houses based on circles or ellipses, but his circular temple on a cliff is certainly his finest architectural achievement. The temple was built on the central axis to the back of the house (plate 247), the main front of which faces away from the sea. Constructed between the years 1783 and 1785, it is attributed

to the Cork architect Michael Shanahan, whom the Earl-Bishop adopted while he was still Bishop of Cloyne. Shanahan accompanied his patron on one of the Bishop's many trips to Italy and seems to have been almost exclusively employed by him. Both of the Bishop's Irish houses are partly credited to Shanahan, along with most of the garden buildings at Downhill.[40]

Some doubts remain, however, as the Bishop had the habit of employing any number of the more established architects he happened to meet during his series of Grand Tours. Robert Adam, James Wyatt, and John Soane are all associated with at least some of the designs for Downhill, while the names of Francis Sandys and the Italian Mario Asprucci are both linked with the Bishop's English seat at Ickworth in Suffolk.[41] It is almost as if the Bishop were more interested in the theory and design of architecture than in its realization. His best-known portraits have distinctly architectural backgrounds,[42] but his reputation for completing projects was very poor. We are fortunate that the Downhill demesne was one project that he did complete, if only for the excellent temple.

The temple was dedicated to Mrs Mussenden, who was born Frideswide Bruce, the daughter of one of the Bishop's

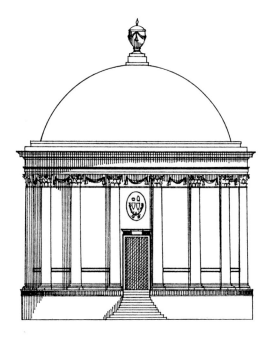

247. Mussenden Temple viewed from the service buildings behind the main house.

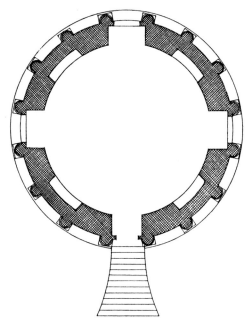

248. Mussenden Temple, Downhill: elevation and plan.

cousins and considered to be one of the great beauties of her time. Their openly affectionate friendship was to cause some degree of scandal, no doubt encouraged by the 52-year-old Bishop's separation from his own wife, who had long since been dispatched to Suffolk. A recent biographer has concluded that the relationship was an innocent one;[43] the scandal did, however, come to an abrupt end with the untimely death of Mrs Mussenden at the age of 22, shortly before the building was completed. As a result it became her

249. Mussenden Temple frieze: detail. (Photograph by Roberto D'Ussy.)

memorial and is still known as the Mussenden Temple. In a lengthy written reference to the temple, the Bishop outlines his ideas for the building and identifies its intended use as a library, and also his controversial thoughts on the possible use of its basement:

> I intend to build a Grecian temple in Frideswide's honour. It shall be called the Mussenden Temple. I intend to build it on the edge of a cliff. It will give employment to the poor of the district, and employment, as you know, is one of my cures for Ireland's ills . . . It is to be circular in shape, domed—not unlike Bramante's temple on Mount Gianicolo. Elegant, exquisite, looking towards the sea. Below there will be a drop of hundreds of feet on to the strand of Magilligan . . . It is to have a library and a crypt underneath. A luminous idea has just struck me. I might provide a stipend of £10 per year for a priest, and my Roman Catholic workmen could worship in the crypt.[44]

The latter idea was an extremely liberal one for a Protestant bishop to adopt in late eighteenth-century Ireland, but is wholly consistent with the Bishop's widely recorded opposition to the penal laws, and his efforts to encourage Catholic emancipation.[45] Sadly the library interior no longer exists, having fallen victim to the Bishop's neglect. A depressing account of its decay exists in the diary of Mr Justice Day, who in the year 1801, just sixteen years after the building's completion and two years before the Bishop's death, was to write:

> in the rear is the Ocean over which upon an elevated abrupt and prominent Cliff the Bishop had built a handsome Grecian temple full of valuable but mouldering books, some on shelves and some piled in disorder upon the floor.

Mussenden Temple (plate 248) is thought to have been inspired by the temples of Vesta at Tivoli and Rome, which also inspired Bramante in his design for the Tempietto at Mount Gianicolo, mentioned by the Bishop in his letter.

During his trips abroad the Bishop seems regularly to have engaged architects to survey any of the buildings of Antiquity that took his fancy, and John Soane has recorded one such visit to survey the ruins of the temple at Tivoli. The result of this architectural synthesis at Downhill has provided a worthy interpretation and a most acceptable successor to its more famous Roman precedents.

The building stands on a rugged basalt plinth, from which sixteen three-quarter engaged Corinthian columns rise to support a fine Corinthian entablature (plate 249), from which springs the dome, capped with a stone finial in the shape of an urn. Finely carved mouldings encircle the building at base and dado levels and a series of festooned panels are carved between the capitals. The pale-coloured sandstone came from quarries at the nearby coastal town of Ballycastle and was carved by a local mason, David Mc Blain, whose father had carried out much of the stone-carving for the main house. On the frieze of the entablature, interspersed with reliefs of coronets, leopards, and bishops'

250. Mussenden Temple interior: westward view of the strand.

mitres, which align with the columns, is an inscription in Latin from Lucretius:

SUAVE MARI MAGNON TURBANTIBUS AEQUORA VENTIS,
E TERRA MAGNUM ALTERIUS SPECTARE LABOREM.

Tis pleasant, safely to behold from shore
The rolling ship, and hear the tempest roar.[46]

Three tall windows and an entrance door divide the building along the compass points. The door lines through with the

251. Mussenden Temple: section and basement plan.

252. Mussenden Temple basement: interior. (Photograph by Roberto D'Ussy.)

axial approach and faces south. It is reached by an elegant tapering staircase and surmounted by an oval plaque in Portland stone, bearing the Bishop's coat of arms. Once inside, the views framed by the vast windows are quite remarkable. The northerly view is out to sea towards the Scottish island of Islay, to the east are the headlands of the Giant's Causeway, and to the west the beautiful expanse of Magilligan Strand with the Donegal hills in the distance (plate 250).

All the internal linings have now gone, revealing an inner brick skin with an interesting octagonal construction. Four blind reveals (which probably held the bookcases) repeat the door and window openings in the blank panels of the octagon; and at high level there is a series of eight circular niches (plate 251). The six diminishing rows of plaster coffers which once lined the inside of the dome have now gone; but some fragments of them remained in 1970, when the building was described and surveyed for a magazine article.[47] This survey of the pattern of the dome is reproduced

on the sectional drawing of the building, which also shows the crypt with its interesting central column (plate 252), in which the Bishop accommodated the spiritual needs of his Roman Catholic employees.

Like Castle Ward, the demesne at Downhill has changed little over the years, apart from the condition of the house, which is now an impressive ruin. This is largely because the Bishop was never able to establish trees on top of the exposed cliff. Downhill remained the favourite of his three grand residences, even though he was to spend by far the greatest part of his latter years in continental hotels.[48] For all its vast scale, the house is less interesting architecturally than the temple, despite its fine stone detailing. It seems strange that the house turns its back on the sea so decidedly, while the temple embraces it so very enthusiastically. No doubt the hostility of the elements affected the decision, and contemporary accounts relate that the winds were sometimes so strong that the servants were obliged to make their way from the temple to the house on their hands and knees.[49] The wind and rain would also have been responsible for the decay of the fine library, which was unheated, either through oversight or concern that the inclusion of a fireplace and chimney might have disturbed the harmony and perfection of the design. This rather impractical omission emphasizes the way in which pure architectural ideas were often pursued uncompromisingly in the erection of follies and garden buildings.

Of all the follies and garden buildings in Ireland, the Mussenden Temple is without question one of the most successful. The dramatic cliff-top setting (plate 253) is well matched by the excellence of the different prospects from within. Furthermore, it stimulates all the sublime emotions of vastness, terror, and awe in the best possible way, by contrasting them with an expression of refinement, civilization, and taste. This is not, however, a case of man struggling to compete with nature, like some lighthouse or castellated tower. It is a delicate Augustan temple growing from the cliff and embracing fully all the power of the elements that threaten its very survival. Through this rather absurd contrast, the two extremes take on an added importance. Each extreme is reinforced in its own particular qualities, while simultaneously providing a worthy complement to its opposite: man and nature in harmony.

The penultimate temple to be described is the Temple of the Winds at Mount Stewart, Co. Down, which stands at the opposite end of Strangford Lough, about fifteen miles as the

253. Mussenden Temple: cliff-top setting. (Photograph by Roberto D'Ussy.)

254. Tower of the Winds, Athens: an eighteenth-century survey drawing from Stuart and Revett's *Antiquities of Athens* published in 1762.

must be added the distinction of his having been James 'Athenian' Stuart's only Irish patron. It is therefore appropriate that Stuart's only Irish building, the Temple of the Winds at Mount Stewart, provides such a fitting testimony to his patron's cultural interests and vision.

James 'Athenian' Stuart was a colourful figure, whose reputation and importance in the history of eighteenth-century architectural history seem out of proportion to the small number of buildings he designed. He was, however, responsible for the design of the first Greek Revival building in Europe and is widely accepted as the father of the revival, through his publications on the major buildings of Greek Antiquity. Stuart was born in London in 1713, the son of a Scottish father who died young, leaving him to support his mother and siblings by working as a fan painter. During this period he studied mathematics, geometry, and anatomy, and is reputed to have taught himself Latin and Greek with the sole purpose of understanding the captions on prints published after pictures of the ancient masters.[53] Several years later he travelled to Rome, largely on foot, to pursue his interest in and study of art.

In Rome Stuart met Nicholas Revett, with whom he planned an expedition to Greece, to survey and publish accurate descriptions of the antiquities of Athens. This proposal was warmly supported by the Society of Dilettanti, some of whose members, including the Earl of Charlemont, agreed to finance the expedition. They arrived in Greece in 1751 and, after a number of adventures including brushes with both Greek and Turkish officialdom, they left in 1753. The surveying went well and we are told that one obliging Athenian permitted the demolition of his house, which was blocking free access to the Tower of the Winds.[54] Having returned to England in 1755, they prepared their surveys for publication. The first volume of *The Antiquities of Athens* 'measured and delineated by James Stuart, and Nicholas Revett, Painters and Architects', appeared in 1762.

These drawings were the first accurate survey of Greek classical remains and were therefore of immense architectural importance. They were to establish Stuart's name during his lifetime, even though the revival was not to gain momentum until the following century. Stuart seems to have been a rather easygoing character, who was not well-disposed to excesses of work. As a result he built comparatively little, and from this modest output it is his garden architecture which attracts the greatest interest. Much of this was directly inspired by the temples and monuments he surveyed in Greece, but he was more than a mere copyist, as his lavish interiors testify. Of all the Greek models he imitated, the tower of Andronicus Cyrrhestes, better known as the Tower of the Winds (plate 254), which required such extreme actions to record it, seems to have been the most favoured. This most unusual little building is the one A. E. Lawrence describes as 'the only surviving horologium or clock tower of Greek antiquity'. In view of its uniqueness and the great interest it excited in Revett and Stuart, it is worth describing in full:

crow flies from the temple at Castle Ward discussed above. It was built by Robert Stewart, the product of a wealthy and cultivated family, whose father Alexander had acquired the demesne in 1744. He had been educated in Geneva, completed the Grand Tour, been painted by Mengs in Rome, and returned from Italy in about 1762,[50] at the age of 33. He is also thought to have been highly regarded by Lord Charlemont,[51] creator of Marino, the final temple building to be discussed in this chapter.

Robert Stewart was created Baron Londonderry in 1789, and during the following years continued to advance up the peerage, becoming Viscount, Earl, and eventually the first Marquess of Londonderry. Accomplished though his own life may have been, his final advancement is a direct result of the political and diplomatic achievements of his eldest son, Viscount Castlereagh, who in time became the second Marquess of Londonderry.[52] The first Marquess was a popular, improving landlord, who, like Lord Charlemont, was much more interested in Ireland than England. He was also a man of impeccable and discerning taste, and to this

It was built in Julius Caesar's new market-place, at or soon after the middle of the first century, by Andronicus of Cyrrus. The building is octagonal (25 feet 6 inches in diameter), and bears at the top of each side a relief of the personified Wind which blew from that direction. Sundials were attached to the sides, and a projecting turret held the tank that supplied a water-clock. There were also two porches, each with two Corinthian columns prostyle carrying a pedimented entablature, the back of which was engaged in a face of the tower . . . From the summit of the tower rises an octagonal Corinthian capital, upon which, 47 feet above the ground, was pivoted a bronze statue of a Triton holding a rod that acted as a wind-vane.[55]

Revett designed a temple at West Wycombe, Buckinghamshire, loosely based on the Tower of the Winds, and Wyatt's design for the Radcliffe Observatory in Oxford also bears certain similarities to it. Stuart produced two other designs for garden temples more closely related to the Athenian model; the earlier of these was built in 1764, at Shugborough in Staffordshire. This was later to gain much

acclaim as the first Greek Revival building in Europe. It is, however, the later building, dating from the early 1780s, which is the more accurate and interesting interpretation of the two; and it still graces the north shore of Strangford Lough as a part of the first Marquess's improvements (plate 256).

The Mount Stewart temple stands on top of a densely wooded hill, close to the shore line, approximately a mile to the east of the house. Some doubts exist about the exact date of construction, which was sometime in the early 1780s.[56] Good records exist of accounts paid to the various craftsmen and from these we learn that David McBlain, the master mason at Downhill, carried out a similar role at Mount Stewart, along with a second mason, Michael Campbell. John Ferguson carried out the excellent marquetry work on the floors and William Fitzgerald was the plasterer. Most of the work was carried out *in situ*, although some of the ornamental work and chimney-pieces came from England.[57]

Externally the building resembles a belvedere more than a temple, and in some instances it has been described as such. Its precedent was certainly not a temple; neither was it

255. Temple of the Winds: porch detail. (Photograph by Roberto D'Ussy.)

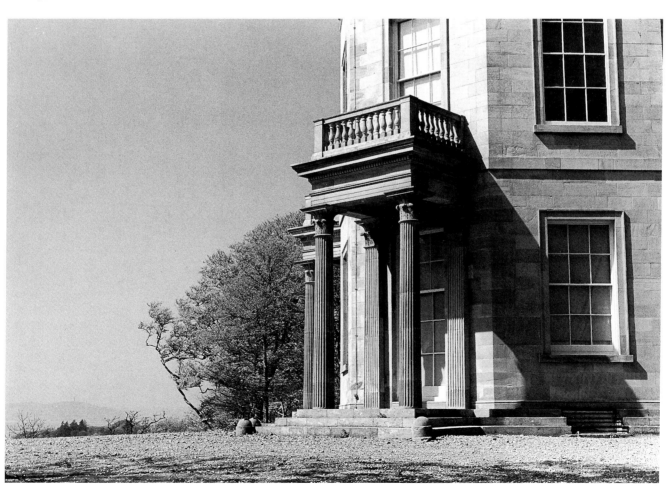

a belvedere. In such circumstances it is probably best left to the nomenclature of the person who conceived and paid for its erection, which in this case seems to have been 'temple'. The building is faced in a fine grey stone, which takes on a delightful yellow hue on a sunny day, and was quarried at the nearby Scrabo Hill. For the most part the detailing is fairly restrained, with perfect ashlar walls and plain string

mouldings and window surrounds. Only in the two projecting porches does the carving become noticeably richer, with fluted columns, balustrade, and the famous stylized Corinthian columns (plate 255), which are exact replicas of those in the Athenian building. This is a late variant, decorated only with a single row of acanthus leaves beneath a row of tall narrow palm leaves.[58]

The Mount Stewart building is remarkably close in size and height to its ancient precedent, and also stands on an identical three-stepped base (plate 257). There are, however, a number of marked differences, which are consistent with

256. Temple of the Winds, Mount Stewart, viewed from the southern approach. (Photograph by Roberto D'Ussy.)

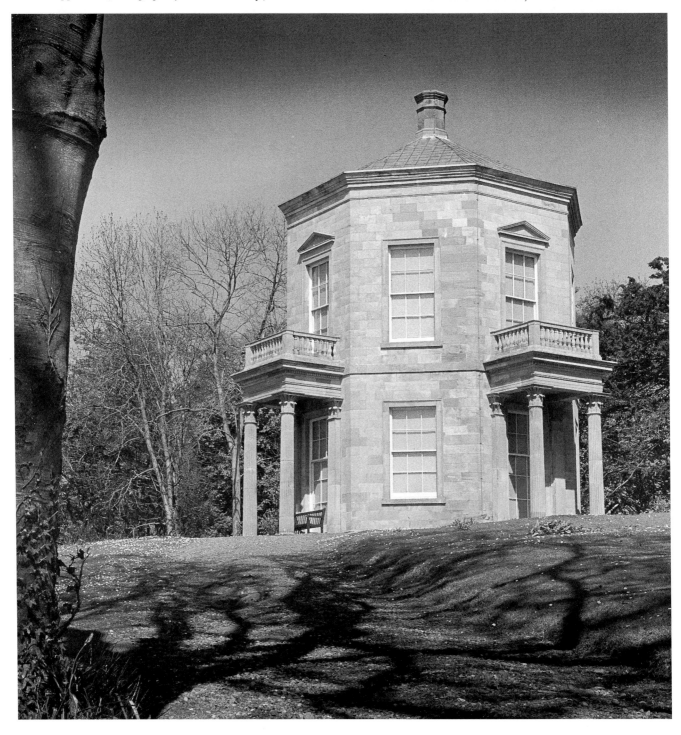

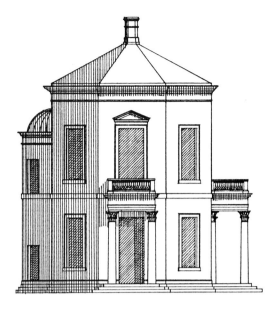

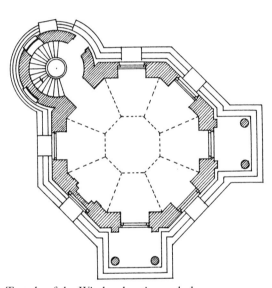

257. Temple of the Winds: elevation and plan.

apparent from inside the building and is only barely noticeable from the outside. The rooms are dominated by the magnificent floor and ceiling patterns. These reflect each other by radiating outwards in elegant octagons from a central point, following the geometry of the space (plate 258). The plasterwork is similar in design to that in Stuart's refurbishment of Wren's chapel at the Naval College in Greenwich, and is much better suited to the delicacy and scale of Mount Stewart than the more robust grandeur of the Wren building. The floor in the main salon is an equally impressive marquetry design, of which Lewis takes special note in his *Topographical Dictionary* of 1837: 'the floors, which are of bog fir, found in peat moss on the estate, are for beauty of material and elegance of design, unequalled by anything in the country.'

At basement level there is a passage leading to a range of service rooms cleverly concealed from view, which indicate that the building was clearly conceived as a banqueting house. There also exists ample documentary evidence to support its use for the most social of functions: 'by day, members of the family and their guests would repair to it for rest and contemplation, and by night for dessert and post-prandial conversation.'[59] Also recorded is the response of the third Marquess who replied in a letter to the suggestion that the temple be converted to a mausoleum after the suicide of Lord Castlereagh: 'I have no Taste for Turning a Temple built for Mirth and Jollity into a Sepulchre—The place is solely appropriate for a Junketting Retreat in the Grounds.'[60] As we have already discovered, the third Marquess was in time to receive his own impressive memorial—the imposing Scrabo Tower discussed earlier

258. Temple of the Winds: interior. (Courtesy of the Irish Architectural Archive.)

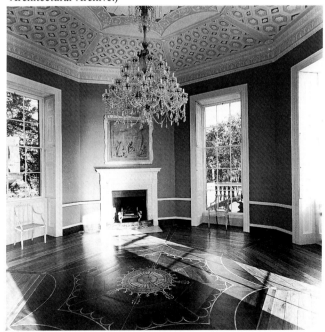

the different functions of the two buildings. The most obvious is the introduction of large windows to some of the faces of the octagon and the omission of the decorated panels depicting the winds. To the rear of the building the apsidal domed projection is slightly larger in plan and carried up to a much higher level, enclosing a staircase to the first floor, from where the views are at their most striking. One final alteration is the change of detail above the porticoes, where the entablature is topped, not by a pediment as in Athens, but with a balustraded flat roof. This is reached through a deeper than normal sash-window which extends right down to floor level, so that the excellent views can be further enjoyed from external balconies.

Internally the spaces are very striking because of the generous fenestration, although some of the windows seen from the exterior are actually false. This deceit is not

259. Temple of the Winds: view looking over Strangford Lough. (Photograph by Roberto D'Ussy.)

(see page 57). This tower, most appropriately, also served as a pleasure building. Several generations later a mausoleum was finally built in the demesne, referred to by the Gaelic name, *Tir na n'Og*, which will appear in a later chapter (see page 176).

We should be thankful that the outrageous proposal to convert the Temple of the Winds to a mausoleum was so emphatically dismissed by the third Marquess. The rich atmosphere of gaiety and social intercourse would certainly have been lost by the introduction of sombre funerary associations. These would not only have destroyed our perception of the interior of the building, but would also have cast an air of gloom over its beautiful situation, which is surpassed in variety only by Castle Ward and in drama by Downhill. Strangford Lough is a long sea lough with a narrow mouth, pinched by a peninsula which runs along its eastern side. At the head of the lough, near Mount Stewart, the tidal influence is less noticeable but no less attractive. The Stewart family used the lough for boating and one story relates that the famous statesman, Lord Castlereagh, when

still a young man was saved from drowning after his boat capsized, having been spotted from the excellent vantage point at the Tower of the Winds.[61]

Standing at the same point today, sensing the ghosts of past revelries and enjoying the great beauty of the setting (plate 259), one can readily appreciate the sense of harmony sometimes existing between the natural and man-made worlds, a true example of *genius loci*, where the place seems so right for the building and the building so right for the place.

The final temple to be considered, known simply as the Casino, will provide a fitting conclusion to a chapter already richly endowed with architectural delight. It stands at Marino, a short distance north of the city of Dublin. This remarkably accomplished work is generally considered to be among the very finest garden buildings in Europe, and 'an extremely advanced and refined example of Franco-Roman neo-classic taste'.[62] Neoclassicism emerged in the middle of the eighteenth century, when a more studied and historic view of Antiquity developed and the influence of Palladio diminished in favour of authentic Greek and Roman architecture. Its effect was profound and, according to John Summerson, neoclassicism was 'that new spirit which, about the middle of the eighteenth century, altered the balance of the European's attitude to the past and therefore to the present and the future'.[63]

The arrival of these ideas coincided with the popular custom of the Grand Tour, during which architects, wealthy noblemen, and gentlemen developed their love for Antiquity and refined their perception of good taste. Grand Tours also provided many opportunities for wealthy patrons to meet talented and compatible architects, who could assist them in the creation of their own private version of Arcadia after returning home. One such meeting took place in Rome during the early 1750s when James Caulfield, later first Earl of Charlemont, met William Chambers. This marked the beginning of a long personal friendship between the patron of the Casino and its architect.

There is no surviving evidence to prove that the two men did actually meet in Italy, although Chambers's authoritative biographer, John Harris, has established a convincing argument, which suggests that they did.[64] Lord Charlemont's biographer, Francis Hardy, also supports this view: 'Lord Charlemont was a kind benefactor to several young artists then at Rome. Sir William Chambers, whose fortune, at that time, was very limited, and his friends, or acquaintances, not many, he particularly distinguished, and was of signal service to him.'[65] The friendship that existed between the two men was a lasting one, strengthened no doubt by their common interest in art and architecture and unaffected by their difference in rank. Chambers was to carry out several commissions for the Irish peer over a long period, until the time late in his career when the demands of the extensive Somerset House on the Thames in London reduced his capacity to take on smaller domestic commissions.[66]

Charlemont (1728–99) was a major figure in Irish

260. Marino Casino: urn detail. (Photograph by Roberto D'Ussy.)

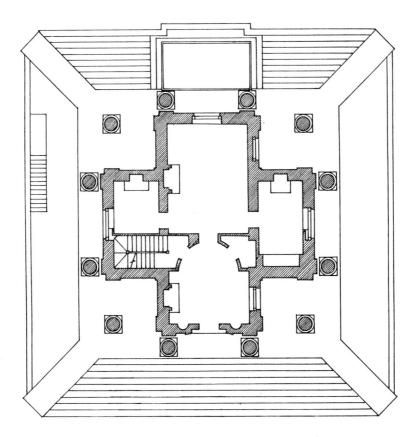

261. Marino Casino: elevation and plan.

eighteenth-century history[67] who, after an extended Grand Tour which lasted for nine years, returned to Ireland because of his sense of duty and patriotism. This patriotism stimulated a very active political life, and also, according to Hardy, found expression in his love of architecture, in which we are told he indulged, not solely from 'the elegant gratification which it affords, but from the nobler sense of his duty, as a citizen, who was bound to cultivate the interests of his native land'.[68] Many of the leading intellectual and artistic figures of the day, including Burke, Reynolds, Hogarth, and Johnson, were numbered among his friends; and the doors of his beautiful and well-stocked library were always open 'to all those who had any claim on his attention, either from similarity of constitutional principles, or their cultivation of those pleasing and liberal studies which, in general, employed his mind'.[69]

Chambers was born in Gothenburg, Sweden, in 1723, of middle-class Scottish parents. In the first stage of his career he spent almost ten years with the Swedish East India Company, during which time he visited China and the East and amassed sufficient fortune to enable him to go to Paris and then Rome to study architecture. In Paris he enrolled in the academy of the influential teacher, Jean-François Blondel, where he came into contact with several of the leading figures of French neoclassicism. Some of the architectural influences of this period were later to appear in the plan of Lord Charlemont's Casino. Chambers then moved to Rome, and for several years acquainted himself with the resident circle of wealthy Englishmen and Irishmen who would later provide him with useful contacts and commissions.

In 1755 he settled in London and began to establish his reputation as a practitioner. To speed up the inevitably slow start to his practice, Chambers embarked on the well-established practice of self-publicity through print. His first publication was a series of designs for Chinese garden buildings, which was to play a leading role in popularizing the style. He also proposed a publication of designs for 'Villas, Temples, Gates, Doors and Chimney Pieces', which he was later to abandon for the more serious *Treatise on Civil Architecture*.[70] Significantly, it was in the realm of ornamental garden buildings that Chambers first enjoyed a measure of public success. This was owing to royal patronage, and resulted in his designs for an impressive collection of temples in various shapes and styles at Kew. Some of these still survive, among them the Pagoda. It is also worth noting that Chambers's most radical neoclassical design, the unbuilt mausoleum to Frederick, Prince of Wales, of 1751–2, was also intended for the garden at Kew.

The mausoleum (a romantic drawing of the building depicted as a ruin) shows all the influence of Chambers's period of study and his architectural contacts in Paris and Rome. This design is considered to be of major importance, 'in some respects representing the beginnings of English neoclassical architecture'.[71] Middleton and Watkin go on to describe how the design was 'too heady to be acceptable in England in the 1750's, and that after one further exercise in the style, Chambers was to lose his nerve and retreat into a safe second generation Palladianism'.[72] This final purely neoclassical design of 1756 was for the unbuilt Harewood House in Yorkshire, which has been described as a glorious opportunity, and 'ended in a momentous failure'.[73] The plan, conceived in the true Grand Prix manner of the French Academy, was as elaborate and complicated as it was impractical. In its principal elevation, however, the design showed greater promise and in particular the small end pavilions. Some of the ideas for these were to surface a few years later in Lord Charlemont's Casino.

Tracing the provenance of a building is a much-loved practice of architectural historians, but in some cases it can be taken a little too far. John Summerson's association of Harewood and the Casino almost suggests that the Casino, as we see it today, appeared in its entirety in the Harewood design.[74] In reality there are slight similarities only in the elevational treatment, and no clues in the plan of the Harewood pavilions to the great richness and ingenuity which were to follow at Marino. The association is, however, significant as it further underlines the building's neoclassical origins, which, along with its circle of columns, suggest that Chambers did not totally abandon the influence of his distinguished French professor.

The Casino is a building that offers delights on many levels, all of which combine to display a great wealth of ingenuity and detail. Such intense skill and thought have gone into its creation that it presents an impression almost approaching perfection. This is most obvious in the neat and very compact plan, which is a Greek cross encircled by a series of twelve free-standing columns. Of these, eight are aligned with the outside corners of the projecting wings of the cross, while the other four are diagonally aligned with the re-entrants (plate 261). They are not placed in a perfect circle, as the four 'corner' columns are shifted outwards approximately half a column diameter from the others. The dynamic interplay between these two major elements is none the less richly spatial and illusory, nowhere more so than in the charming corner spaces defined by re-entrant and column, and the slightly confusing effect of the columns, which retreat on three planes from each elevation.

Internally the planning is surprisingly complex, with a series of four different-sized rooms and a dog-leg staircase, dovetailing precisely into the unobliging Greek cross plan to create an impressive suite of axially linked rooms. The principal entrance is on the east front of the building and leads into a vestibule with niches to either side of the doorway, and a fireplace and window facing each other from the side walls. Directly opposite the entrance, a semicircular planned lobby containing three doors leads off the main rectangular space. Its two flanking doors give access on one side to a small closet and to the staircase on the other, while the central door enters the saloon, which is the principal room in the building. To complete the arrangement, the boudoir and study appear on opposite sides of the saloon, with facing doorways tight against the entrance wall, cleverly

reducing the impact of circulation on the furnishing and function of so compact a group of spaces.

All the rooms are arranged in a strict axial manner, with doorways lining through with windows, and fireplaces on their central cross axis, all of which immediately suggests a highly refined and carefully worked-out rapport with the exterior of the building. A closer examination of this plan shows that this is not quite the case, as all sorts of interesting idiosyncrasies begin to surface. The most obvious of these is the existence of the staircase in a building which, from the outside, appears to be single-storey. This could most innocently have been interpreted as an access stair to serve a rooftop belvedere. In fact it proves to be the vertical circulation in a building of three storeys.

An inspection of the great north and south windows uncovers further evidence of a clever deception, as the external sashes, which measure five panes wide by six high, are boxed out on the inside to produce much smaller windows on a three-by-four-pane module. This skilful illusion is necessary, owing to the conflict in scales between the small

262. Marino Casino: corner detail with leopard couchant. (Photograph by Roberto D'Ussy.)

side rooms and the total elevations in which they occur. Diminishing scales to accommodate conflicting requirements of proportion between the inside and the outside of a building was not a new idea at that time. It had long been the practice when designing large domes, such as Wren's masterpiece, St Paul's Cathedral in London. Chambers's own pupil, James Gandon,[75] would also, in time, demonstrate the idea admirably in the Four Courts in Dublin.

The use of blind windows was another illusionist device, which was commonly employed to maintain symmetry on the exterior, while permitting awkward internal planning. Chambers also uses this particular trick on the west wall of the saloon, which is ironically the only room large enough to accommodate a full-size external window. In this instance the blind window is arranged to maintain the symmetry with the window to the vestibule, and would have totally thrown the saloon out of balance and scale had it been a real one. The remarkable shrinking windows at Marino are, to my knowledge, unique and no less impressive in the way they trick our perceptions.

Continuing our journey around the building in plan, the staircase leads up to a further suite of rooms, most of which are small closets. The exception is a grand state bedroom above the saloon, which was the main reception room, and contained a large day-bed on a raised dais behind an Ionic columnar screen. This level is very well served by natural light, despite the fact that none of its windows is visible from ground-floor level. These are set well back behind the balustrading and in the small valet's room are cleverly chamfered to permit maximum light from a modestly sized opening. From this floor it is possible to gain access to the roof, which was clearly intended for use as a gazebo.[76]

The basement level (plate 263) is a collection of vaulted service rooms, including a generous kitchen. Once again the introduction of natural light is ingeniously handled, without any evidence of external glazing to the basement. This is achieved through a void which runs around the building, carefully hidden by balustrading to the east and west elevations and bridged by the wide flights of steps to the north and south. Further light is introduced through an additional void cut into the steps on the south elevation, which is screened by a large and beautifully carved stone urn (plate 260). The basement is reputed to have been linked by a subterranean passage to the main house, which stood about 500 yards away. This arrangement was to have protected the harmonious setting of the building from the intrusion of servants at work. Rumours also survive, suggesting that a second tunnel led from the Casino to the beach at Clontarf, where Charlemont bathed to ease his arthritis and gout. No firm evidence survives to support these rather extravagant claims, which are more likely to result from later romantic imaginings than eighteenth-century extravagance, especially by a man whose resources were already well stretched.

Externally the building appears as a single-storey unified whole, with no hint of its complex three-storey interior (plate 221). The principal north and south elevations are

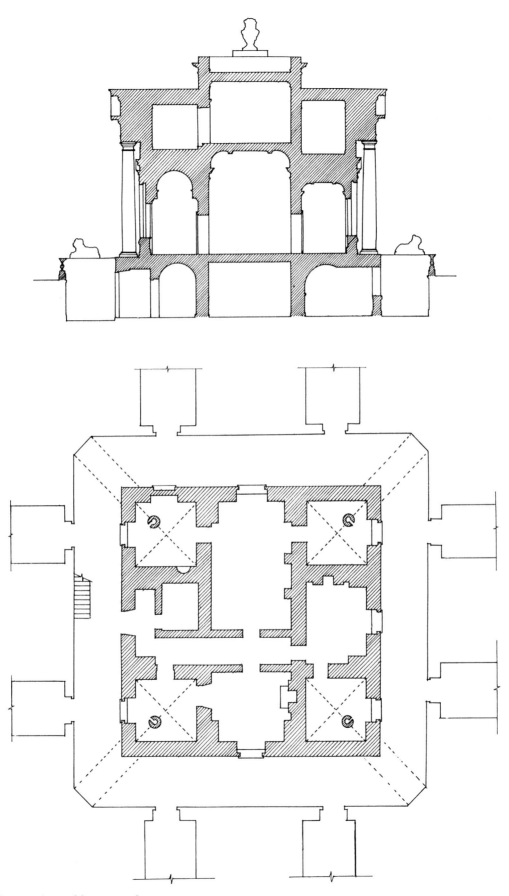

263. Marino Casino: section and basement plan.

264. Marino Casino frieze: detail. (Photograph by Roberto D'Ussy.)

The east and west elevations are less successful, mainly because of the rather arbitrary pediment placed over the central bay, and the continuous balustrade, which lacks the elegance of the rising steps. On the west elevation the splendid monumentality created by the great central windows is slightly spoiled by the two smaller windows, one real and the other false. These quibbles are very minor, relative to the overall excellence in composition and detail of the building as a whole. It should also be noted that the dynamic effect of the ring of columns, the interplay between them and the richly modelled and articulated form of the building, cannot effectively be captured in two-dimensional representations.

The whole of the exterior of the building is in white Portland stone, which helps to accentuate the richness of the detail and the great skill of the stone-carving. This was executed under the supervision of Simon Vierpyle, a sculptor whom Charlemont also met in Rome. The only significant element not in stone (apart from the windows of course) is the magnificent front door in bleached Irish oak, which blends beautifully with the pale hue of the stone. Chambers's clever trickery, which contributed so much to the success of the interior of the building, is also much in evidence as we move to the outside.

Of particular interest are the decorative urns, with their delicate mermaid figurines, which wrap themselves around the upper parts. These stand centrally above the attic, on the principal north and south elevations, and are in fact chimney pots. The technical feat of ducting the various flues from so many different points around the building (four alone on the ground floor) was no mean achievement. Equally impressive is the way in which rainwater was drained from the roof through the four corner columns, which are hollow. The final stroke of ingenuity was the design of the front door, which included a large secret window. This consists of a large balanced sash contained in a reveal above the door, which could be pulled down when the double entrance doors were fully open. By transforming the door in this way, light and aspect were gained for the interior, and the subtle message issued that his lordship was not receiving visitors.

It is unfortunate that none of the original furniture or chimney-pieces remain to demonstrate in greater detail how the building was used. The excellent plasterwork and the inlaid floor finishes are proof that the quality of the internal furnishings was very high (plate 266). Various themes occur in the plasterwork, including gardening tools and musical instruments. The study is adorned with the stellar constellations and the signs of the zodiac, while the ceiling in the saloon is dominated by the head of Apollo in a great sunburst. All the principal rooms have richly patterned marquetry floors containing eight different woods, none of which is from Ireland. During the recent extensive restoration of the building[77] every effort has been made to match the original colours and finishes of walls and ceilings as closely as possible to the original. The silk wall-linings of the saloon and extensive gilding of the plasterwork and columns in the state bedroom are an indication of this.

the more successful views, as the building rises from its low podium, which is approached by an elegant flight of shallow steps. These run between long narrow pedestals on each of the four corners, set at an angle of 45 degrees and each carrying a magnificent stone leopard couchant (plate 262). The walls of the building are neatly rusticated, in contrast to the smooth shafts of the columns and corresponding pilasters on all the outside corners. A correct Roman Doric order is used for the capitals and the entablature, which is adorned with a frieze containing exquisitely carved bucrania (plate 264). The underside of the cornice and the soffit of the entablature are also enriched by a lavish demonstration of intricate carving and pattern-making. This carries up above the entablature with swags carved in relief on the projecting central block in imitation of an attic storey, flanked by balustrades at a lower level and topped by a decorative urn. On each of the four corners of the attic block, on plinths rising from cornice level, stand carved statues of Venus and Apollo to the north, and Bacchus and Ceres to the south.

Both the Earl and his architect took a very active interest in every detail of both the exterior and the interior of the building, and a great deal of the correspondence between the two men still exists.[78] In this we find Chambers making all manner of suggestions, from the cutting-out of mock-up templates for the chimney urns to check the proportions on site, to instructions in the most minute detail for the paint colours.[79] It is the closeness of the relationship between the two men, and their common interest and sense of purpose, which made this small building such an outstanding success. Charlemont was the perfect client, not because he gave his architect a free hand to indulge his fancy, but because he himself was an interested and discerning partner in the relationship, who had his own valuable contribution to make to the proceedings.

The dates of the Casino's construction are not very precise, but it is known that it took a long time to build and cost a great deal of money. John Harris believes the often quoted figure of £60,000 is exaggerated, but even if half this amount was spent it would represent a vast sum. The first design sketch appears on a paper with other notes dated 1757, and it is thought to have been started by 1759. Work would continue for well over ten years, with instructions on painting from Chambers arriving as late as 1773. The first sketch design for the Casino (plate 265) makes an interesting comparison with the finished version. This shows a similar plan with a Greek cross encircled by columns, of similar proportion and geometry. A second ring of columns is repeated on a smaller scale inside the building, which consists of a single undivided space. The building is single-storey and without any windows, although some clever top-lighting would no doubt have been a feature. One leg of the cross provides the entrance, while the other three contain what appear to be altars, on which dedications are inscribed to Architecture, Painting, and Sculpture.

These altars display a clear indication of Charlemont's artistic priorities, with architecture significantly placed on the central axis in line with the door. The sketch has the appearance of a much simpler garden temple dedicated to the arts and used as a sculpture gallery. How soon the brief changed into what eventually became an extravagantly finished small villa is not known. This provides us with an intriguing mystery of which came first, the client's conception or the architect's proposal. Either way the end result is much more than simply a garden building, an ideal miniature palace, or Charlemont's and Chambers's model of perfection in the art form they most admired. It is also possible that the Casino was a surrogate country house, as the main Marino House was not of great architectural merit, and Charlemont may have decided he could build on a small scale what he could not afford to rebuild on a grand one.

The very process of building and communication with an accomplished architect who was also a good friend may have influenced the prolonged construction period as much as the paucity of the Charlemont purse. It should not be forgotten that the Casino was only one of a great many

265. Marino Casino: plan of the original design by William Chambers (redrawn).

building projects considered by Lord Charlemont throughout this period. Others included the completion of a fine town house on the north side of Rutland Square (now Parnell Square) in Dublin, and the probably unexecuted neoclassical design for a hunting lodge at Roxborough, Co. Tyrone.[80] In addition to the Casino and a good many other garden buildings, there was also the laying out of the Marino demesne.

266. Marino Casino: interior of the saloon. (Courtesy of the Irish Architectural Archive.)

Lord Charlemont's demesne at Marino, which contained a number of other important garden structures, including a rustic hermitage and a Gothic Revival temple known as Rosamund's Bower, deserves brief description. The hermitage was constructed of knarled and twisted roots and branches in the manner of Thomas Wright's hermitage, which survives at Badmindon in Wiltshire. Johann Heinrich Muntz, a German architect whom Charlemont befriended in Rome, may have been the designer of the temple, which stylistically resembles one he produced for Kew. Muntz also designed an interesting Gothic-style Egyptian Room for Charlemont, which was never built.[81] The demesne has changed out of all recognition since Charlemont's time, largely as a result of urban spread, which started to encroach on the estate as early as the late eighteenth century.[82]

Contemporary views from the estate show a fairly open grassy meadow, ringed with trees, which sweeps gently down towards the city of Dublin and the mouth of Dublin Bay. In the centre of the meadow stands the Casino, quite magnificent in its uncluttered and simple setting. A series of three views was taken from the roof of the Casino in 1816 for Francis William Caulfield, who succeeded his father to become the second Earl of Charlemont. They were drawn by Thomas Leeson Rowbotham[83] and later combined into a panoramic watercolour which was also published as an engraving, entitled *A View of Part of the Bay and City of Dublin, taken from Marino*.[84] This shows the full splendour of the aspect from the Casino's rooftop gazebo, the bay dotted with ships in sail and the skyline of the city rooftops, with a magnificent backdrop formed by the Dublin mountains and the Wicklow hills.

Both Marino House and most of its demesne have long since vanished, along with all the other garden buildings and the artificial lake. Fortunately a moderate parcel of clear land remains around the building, which, from carefully chosen angles, allows the worst effects of suburbia to be blanked out. Garden buildings are generally much less vulnerable when they fall within the protective curtilage of a large house. With the house and estate long gone, the Casino has survived only because of its excellence. After many years of neglect, its recent restoration is reputed to have cost 'another small fortune'.[85] No doubt this restoration budget, like the construction budget, will multiply further in the public imagination. A visit to the building will, however, quickly convince sceptics of the merits of such expenditure.

The resurrection of the Casino, in most of its former glory, is a fitting tribute to the relationship and friendship between Lord Charlemont and Sir William Chambers. Quite apart from the architectural quality of the building, it is important historically because of the extensive contemporary documentation, which records the careful process of its construction and the obvious pleasure given to both architect and patron. We have already noted that Lord Charlemont was an interested and enlightened patron and as much a perfectionist as Chambers. He may even have been responsible for the excellent siting of the building, and the great irony of the story is that Chambers did not see his masterpiece, as he never visited Ireland.

There is a sensible dictum which reads that 'one can only produce a good building by having a good architect *and* a good client.' The Casino at Marino certainly benefited from both, and the care and attention lavished on its creation is a testimony to their shared interests and friendship. Lord Charlemont was much given to writing epitaphs and tributes to his friends,[86] but he was seldom to express his sentiments more profoundly than in his long epitaph for Chambers:

> Sir William Chambers, Knight &c,
> Fellow of the Royal Academy,
> And Professor of Architecture.
> The best of men, and the first of
> English Architects.
> Whose buildings, modelled
> From his own mind,
> Elegant, pure, and solid,
> Will long remain the lasting monuments
> Of that taste,
> Whose chastity could only be equalled
> By the immaculate purity of their author's heart
> James Earl of Charlemont, his friend,
> From long experience of his worth and talents,
> Dedicates this Inscription
> To him and friendship.

The abundance, variety, and levels of sophistication of this building type provide convincing evidence that garden temples are the most common and treasured category of the buildings within this study. An association with Antiquity, which is both romantic and symbolic, may be one reason for their popularity. In *The Poetics of Space*, Bachelard points out that dreaming of the minute is another form of escapism. As garden temples are on one level merely scaled-down versions of much larger temple buildings, perhaps they also provided the chance to escape for relaxation, contemplation, and reverie.

There is also the important link between the temple form and the archetypal building as represented by the primitive hut, which interested William Chambers so much and was described earlier (see page 84). One final reason for the enduring success of small garden temples may simply be the outstanding effect achieved by placing a beautiful object in a natural setting, whether it be tetrastyle and pedimented or monopteral and domed. In their most simple and rustic state, they are still both interesting and evocative, and at their refined best they can achieve the very highest levels of artistic and architectural expression.

CHAPTER 10

Mausoleums

Throughout the previous chapters we have encountered many follies and garden buildings, from several different categories, which have memorial associations. Obelisks with their funerary connotations are obvious candidates, such as those at Stillorgan and Castletown. Monumental columns were also popular, especially when there were military connections with the subject. Many towers were also built as memorials, such as Helen's Tower and the nearby Scrabo Tower in north Co. Down, and, although it was conceived to honour a young living subject, the Mussenden Temple ended up as a memorial after Mrs Mussenden's premature death. The common link between commemorative follies and mausoleums is that they were deliberately conspicuous, designed to make the greatest possible impact on posterity. This aspect was clearly grasped almost 6000 years ago by the Pharaohs, who built the most lasting of all man-made tombs, the Pyramids.

Most of the commemorative follies described so far did, however, incorporate some other and often practical function, which subsequently detached them from the dry funerary ambience we normally experience when visiting mausoleums. These functional aspects may have included something as straightforward as an easily accessible vantage point, similar

267. Knockbreda Churchyard: general view with the Greg Mausoleum. (Photograph by Roberto D'Ussy.)

169

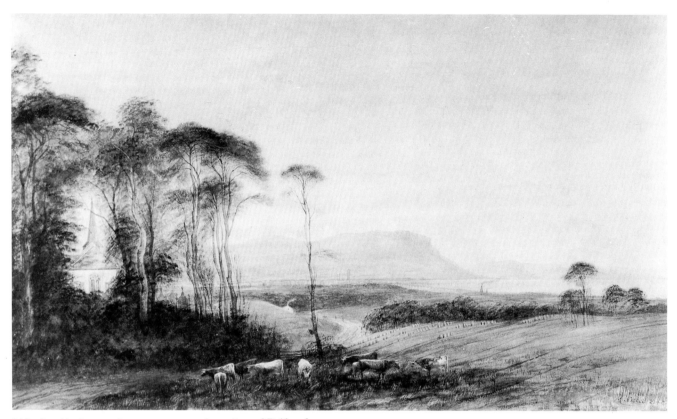

268. A mid-nineteenth-century watercolour view of Belfast from Knockbreda Churchyard by Andrew Nicholl. (Courtesy of the Ulster Museum Belfast.)

to Stillorgan and Castletown, from which to enjoy the beauty of the demesne. It was better still if the vantage point were enclosed and heated and could provide the facilities to prepare refreshments, as at Clandeboye and Scrabo. We have already noted the third Marquess of Londonderry's indignant reply to the suggestion that the Temple of the Winds should be converted to serve as a mausoleum. It is therefore appropriate that his own memorial tower at Scrabo was built with both pleasure and memory in mind.

The reason for including this chapter is not just to reiterate all the previous examples (of which there are many) with memorial associations, but to explore those buildings which were built primarily as mausoleums and placed in the landscape to achieve a similar artistic effect to all the other categories considered so far. In many cases we will find that romantic, poetic, and even picturesque qualities could be produced by a building more usually identified with death and the sublime. At this point it is worth defining what we actually mean by a mausoleum and considering how the term originated. In an article entitled 'Mausoleums of Ireland'[1] they are defined as 'funerary structures having the character of a roofed building, and large enough to stand up in, or at least having that appearance'.[2] Although the ritual of constructing tombs stretches back to the earliest times, not only to Egypt's impressive legacy of 4000 BC but also to

Newgrange in Ireland, around 2500 BC, the origin of the term 'mausoleum' dates from much later. It is derived from the tomb erected to King Mausolos at Halicarnassos by his widow, in 353 BC at the height of the Hellenic period of ancient Greece.

This most famous of all tombs, one of the seven wonders of the world according to Sir Banister Fletcher,[3] was a massive structure comprising a vast podium approximately 90 feet by 120 feet, supporting a tomb chamber surrounded by Ionic columns, surmounted by a stepped pyramidal roof. Great Roman dignitaries, such as Augustus and Hadrian, were honoured on an equally massive scale, by which time King Mausolos's name had entered the language as a building type.[4] The term 'cenotaph' also originates from the Greek language, meaning an empty tomb or 'a sepulchral monument to one whose remains are elsewhere'.[5] For our present purposes the terms will not be imposed too rigidly, as there are some instances where mausoleums do not provide final burying places, and at least one cenotaph structure which does.[6]

While some very fine examples of remote mausoleums are to be found in the Irish countryside, most are located within graveyards surrounding churches, or in the great metropolitan cemeteries created in the nineteenth century. These settings, however, provide more than a passing interest

to this study, as several factors which have influenced their appearance are linked to the principles underlying the natural style of landscaping. This is most obvious in the example of the rural church and churchyard, which were very often sited within the demesne of a large house, with the spire providing an important scenic landmark. At Coolbanagher, near Emo Court, Kilbixy, and Rockingham there are good examples of small country churches attached to estates and deliberately sited to exploit their picturesque effect. Often these modest and generally very plain little churches were designed by successful and established architects, most notably James Gandon at Coolbanagher and Richard Castle at Newtownbreda, near Belfast.

The church at Newtownbreda, known as Knockbreda Parish, was consecrated in 1737[7] and is the oldest in the Belfast area. It is well named from the gaelic *cnoc-breadai*, meaning a hill and broken land, and despite Victorian additions and urban spread, it remains one of the most perfectly sited small churches in the country. The mid-nineteenth-century painting by Andrew Nicholl, entitled *Belfast from Newtownbreda Churchyard*,[8] shows off the church at its most picturesque (plate 268). This delightful hilltop setting is crowned by a high canopy of spindly beech trees surrounding the church, to the north of which is found one of the most interesting graveyards in Ulster. The main feature of this wonderfully atmospheric place[9] is the excellent collection of impressive mausoleums. These were positioned to maximize their scenic effect, the success of which is portrayed in Nicholl's painting.

The graveyard is filled with a rich assembly of memorials of varying scales, of which the four mausoleums are the most interesting. These all appear in the Nicholl painting, with the impressive Greg memorial being dominant. The other two surviving mausoleums[10] are the Rainey and Cunningham memorials, and all three date from the last decade of the eighteenth century. In style these structures are an interesting blend of the oriental and classical, with square-plan forms and corner columns (plate 267). The roofs are flamboyant dome-like structures, which sweep up amid an abundance of urns and pinnacles, with sealed entrances and inscribed panels in the arched recesses on each of the walls. It is not known who designed these rather unusual structures, and architects of note were certainly few on the ground in Belfast at the time. Their style combines elements of Chambers and Gibbs, and (significantly for this study) are possibly based on some of their published designs for pavilions and small temples.[11]

There are many other charming and often abandoned Church of Ireland graveyards in the Republic of Ireland, most of which can boast at least one fine mausoleum in the adjoining graveyard. At Castlerickard, Co. Meath, in true Egyptian manner and with interesting stone jointing, is a large pyramid to the Swift family, in imitation of the Roman tomb of 12 BC known as the Pyramid of Caestus. On the corner of his church at Coolbanagher, Gandon also designed a fine pedimented and urn-topped mausoleum for his friend and patron, Lord Portarlington. There is also a very good example by an unknown hand in the churchyard of Ballylyons in Co. Cork, erected for James Barry, Earl of Barrymore, who died in 1747. This generously sized structure has a fine plain pedimented front with an entrance in the manner of a Venetian window, and contains an interesting monument.[12]

Not so well composed but none the less interesting is the large pyramid-topped neoclassical structure which almost overpowers the ruins of the dainty Gothic Revival church at Kilbixy, Co. Westmeath (plate 269). The mausoleum contains the remains of various members of the Malone family, including the first and only Lord Sunderlin, who lived at the nearby Baronstown House. It comprises a square-planned stone box with fluted Doric columns in antis, crowned by a massive steep-sided pyramid resting on a stepped base (plate 270). Internally there is an impressive cross-vaulted roof which supports the great mass of masonry above, and a series of arched reveals in the back and side walls, in which are placed three black sarcophagi. In common with many mausoleums of this nature, a second vault exists below floor level.

The earliest death inscribed is that of the Rt. Hon. Anthony Malone who died in 1776, but the structure must

269. Malone mausoleum, Kilbixy, overpowering its less monumental neighbours.

270. Mausoleums at Hately Manor, Kilbixy, and Bracklyn Castle: elevations and plans.

surely date from a later period, as James Wyatt's well-known mausoleum at Cobham Hall in Kent, which the Kilbixy monument surely imitates, was not designed until 1783. A more likely date for its construction would coincide with the death of Lord Sunderlin in 1816. The rather heavy detailing, especially around the base of the pyramid, and the unfortunate and ostentatious siting so close to the church, tends to diminish both buildings. It is none the less an interesting example of its type, and despite its lack of beauty, exerts a notable presence on the surrounding landscape. Many other large mausoleums, including the fine Burges mausoleum in St Michael's churchyard, Castlecaulfield, Co. Tyrone, are illustrated in James Curl's *Mausolea in Ulster*.[13]

The two metropolitan cemeteries in Dublin deserve a brief mention, as these were both thought to have been modelled on the famous Père Lachaise cemetery in Paris, which, before it became so densely filled, must have created the impression of a landscape by Poussin or Claude. Even today, some areas of Père Lachaise are more like a romantic, densely follied park than a great brooding necropolis for the city's rich and famous. The Prospect cemetery at Glasnevin and Mount Jerome cemetery near Harold's Cross were both founded in the early 1830s and, in their own modest way, combine the joint attractions of interesting mausoleums and the graves of the famous. Glasnevin is traditionally the Roman Catholic burial ground and as such abounds with Celtic crosses, imitation round towers, and *pietàs*; while the Protestant Mount Jerome follows a more classical tradition, with urns and draped female figures. The most famous grave from either cemetery is probably that of Daniel O'Connell, whose memorial at Glasnevin, based on an Irish round tower, was designed by the antiquary George Petrie.[14]

It is, however, in a truly rural setting that mausoleums fall more easily into the realm of follies and garden buildings. Often they were erected to satisfy ornamental as well as commemorative requirements. One of the finest examples of this combination is to be found in the demesne of the prolific Bishop of Derry at Downhill. The memorial, which is strictly speaking a cenotaph, was erected to the memory of the Bishop's brother, the second Earl, George Hervey, who was Lord-Lieutenant of Ireland from 1766–7. Frederick Hervey had good reason to be grateful to his eldest brother, who secured for him his first fortune through the bishopric of Derry. He also contributed indirectly to his second

fortune by dying at a relatively early age, without issue, thus allowing the earldom to pass one step closer to the Bishop.

The monument was an impressive structure based on the tomb of the Julii, built by the Romans at St Rémy, near Arles in Provence, around 40 BC. John Soane produced a sketch design based on the Roman model for the Bishop (plate 271), although the work was finally carried out by Michael Shanahan. Shanahan's version was, not surprisingly, very similar to Soane's, but less elegant in its proportions. It consisted of a square-planned cross-vaulted structure with arched openings and corner columns, standing on a high plinth. The monument was crowned with a domed monopteral tempietto containing a fine statue of the Bishop's brother in Roman dress by Van Nost. Neither the tempietto nor the statue could withstand the great winds of 1839, since when the fragments have lain around the base of the now stunted structure, awaiting repair.[15] The Bishop certainly had ornamental motives, as 'he destined the mausoleum to act as part

271. Hervey cenotaph, Downhill: a sketch design drawing by John Soane. (Courtesy of the Sir John Soane Museum, London.)

272. Hervey cenotaph in its wild moorland setting, viewed from the ruined Downhill Castle. (Photograph by Roberto D'Ussy.)

of an open air museum of reconstructed antiquities within the grounds of Downhill'[16] (plate 272).

In the grounds of Hately Manor, Co. Leitrim, is a fine classical mausoleum of the St George family, dating from 1865. Hately Manor is a very charming, small-scale version of Castle Ward, with the front elevation in the classical style and the rear in Gothick. There is, however, nothing whimsical about the mausoleum, which stands, surrounded by yews and railings, off to one side at the rear of the house. It consists of a neat, square structure with a projecting Doric porch, over which rises a large armorial plaque (plate 270). Despite the plaque, which is certainly oversized, the composition is refined. So too is the detailing with its deep rustic joints, between blocks of heavily vermiculated stone, which combine effectively with the gloomy setting to create the desired effect of dignity and quiet solemnity.

An equally solemn atmosphere is found at the rustic mausoleum in the grounds of Bracklyn Castle. This unusual construction, which closely resembles the entrance gates of the demesne, is more like a grotto or a hermitage than a mausoleum. It stands on a wide circle of slightly raised ground, retained by a rustic stone wall and thickly planted with yew trees, in the middle of a large open area of grassland. The mausoleum is a simple rectilinear structure with pinnacles at high level, and rough piles of rubble at low level, on each of the four corners. Like the gateway, the crude rustication of the stonework is carefully and quite skilfully composed to suggest that nature and not man was the major force behind its creation (plate 270).

The illusion is dispelled by an inscribed pentagonal tablet to one side of the entrance door, dated 1860, and an oval date-stone above the door which reads: 'This tomb was erected by J. F. T. Esq. in the year of our Lord 1836. N. Kiernan Builder.' A low doorway with an iron gate leads down into the chamber, around three sides of which runs a rough stone ledge. The style and setting are very like the work of Thomas Wright, and the atmosphere created by the building, with the thick canopy of yews and the nearby sarcophagal tomb, is splendidly gloomy and not a little threatening. Not far from Bracklyn Castle is found another interesting mausoleum on the same theme of a chamber within a circle. This is in the grounds of the now ruined house known as Dunboden Park, near Mullingar. The Dunboden mausoleum is a much more complex and elaborate construction in the form of an impressive circular labyrinth, now largely overgrown by trees.

The strong iconographical associations between the labyrinthine form, Hades, and death heighten further an atmosphere of tranquillity and solemn reflection. If one of the principal aims of a folly is to shake the reality of its surroundings, then the Dunboden mausoleum may rightfully be included. In plan, the complex consists of two concentric circular mounds, the inner one of which contains a rectangular chamber. Both the outer face of the outer mound and the inner face of the inner mound are constructed from large roughly squared blocks, while the sides of the access

passage between consist of two steep banks of earth (plate 274). Entrance through the outer ring is gained through a pointed-arched doorway and vault, on the eastern side, and through the inner ring by a similar doorway and vault on the western side.

This latter vault is linked to the main chamber by a passage, off which a side doorway leads to the innermost circle, from where the outside of the chamber can be viewed (plate 273). The entrance vault, passage, and main chamber are all aligned along the east-west axis and each increases slightly in width, most effectively heightening the drama of the approach sequence. In the middle of the rectilinear chamber is a tall plinth on which stands the fragmented remains of a large veiled plaster urn. Light enters from a large Gothic window on the east of the chamber and from two deeply chamfered slit windows at low level on the north- and south-facing walls. A fourth small opening occurs at high level in the west-facing gable above the passage; this permits a narrow beam of setting sunlight to highlight the urn, to dramatic effect. The sense of melancholy is further

273. Cooper mausoleum, Dunboden: external detail of the central chamber.

274. Cooper mausoleum, Dunboden: section and plan.

enhanced by the inscription on the plinth which relates the details of the memorial's subject:

Joshua Harry
Second son of Edward Synge Cooper
of Markree Castle in the County of Sligo
by Anne his wife
Eldest daughter of the late Harry Verelst
Formerly Governer of Bengal

Nat. June 25th 1799
Obt. February 5th 1819

In deo fidens obiit
In deo solo spes nostra.[17]

Joshua Cooper's early death and his parents' obvious grief are also described in the sentimental but moving lines of verse which also appear:

He sleeps who once had beauty once had grace.
Grace that with tenderness and sense combined
To form that harmony of soul and face
Where beauty shines the mirror of the mind.
Such was our son that in the morn of youth
In purest innocence in natures pride
Blest with each art that owes its charm to truth
Sunk in his mothers fond embrace he died.

The overall design of the Dunboden mausoleum is not unlike some of the drawings of Danish forts by Thomas

175

Wright in *Louthiana*,[18] without of course the great mounds that often appear (plate 275). Of particular note is plate XVIII, the Castle Guard at Atherdee, about which Wright speculates:

> This is manifestly a Work of great Labour, and undoubtably designed at first for a Memorial of something worthy of being long remembered, and nothing is more natural (since we don't want parallel Instances) than to conclude it a sepulchral Monument, a Burying place of some of the Irish Kings.[19]

Wright continues with a discussion of burial mounds in general and describes types 'incompassed with a deep Trench . . . and further on . . . commonly attended with a square Fort, or Redoubt, adjoining to the main Trench'.[20] He also draws a parallel with the burial mound at Newgrange and quotes two passages from Pope's translation of the *Iliad*, after which he leaves it to the reader to judge whether or not the burials of Patroclus and Hector accord with the practice of the Danes. Because of Pope's recurring appearance in this study, and the similarity between Wright's surveys and the Dunboden mausoleum, the lines are worth quoting here:

> The sacred Relicks to the Tent they bore;
> The Urn a Veil of Linnen cover'd o'er.
> That done, they bid the Sepulchre aspire,
> And cast the deep Foundations round the Pyre;
> High in the Midst they heaped the swelling Bed,
> Of rising Earth, Memorial of the Dead.
>
> The snowy Bones his Friends and Brothers place,
> (With Tears collected,) in a Golden Vase;
> The Golden Vase in purple Palls they roll'd,
> Of softest Texture, and inwrought with Gold.
> Last, o'er the Urn the sacred Earth they spread,
> And rais'd the Tomb, Memorial of the Dead.[21]

Such associations may be a touch fanciful, but they none the less help to build up an impression of the forces which may have influenced this strange memorial to such a tragic early death. Greek heroes, prehistoric Irish earthworks, and the poetry of Alexander Pope all have some claim over Dunboden, which should not in any way detract from the ingenuity and success of this very clever design. From its excellent planning and impressive earthworks to the fine solid detailing of the stonework, the mausoleum was carefully considered, and no expense spared on its construction. It remains today as powerful and emotive as the day it was created, despite attack from both alders and vandals; and, as with many of the great mausoleums and monuments erected before it, it is surely destined to crumble slowly into oblivion.

On an equally impressive scale, but from a much later period, is the private burial ground in the demesne of Mount Stewart, where the Temple of the Winds, described in the previous chapter (page 157), is also found. This is called *Tir na n'Og*, which is Gaelic for the mythical Land of the Ever-Young, and was created by Lord and Lady Londonderry

275. The Castle Guard at Atherdee: an eighteenth-century survey drawing by Thomas Wright from *Louthiana*.

in 1926–7. The layout consists of a rectangular walled garden with conical-roofed circular towers, and quaint convex walls on the outside corner. On the central axis stands a square-planned two-storey pavilion with a pyramidal roof, and on the cross axis is an entrance gateway, which has flanking niches containing statues of the Irish saints Patrick and Brigid. The style is a charming fusion of Arts and Crafts and Art Deco, which would not look amiss in an illustration for the stories of the Brothers Grimm. There is some fine metalwork and stained glass and the atmosphere is not at all gloomy.

Both the walls and pavilions were built from local Newtownards sandstone by an elderly stonemason called Joe Girvan, from the neighbouring town of Greyabbey.[22] The atmosphere of *Tir na n'Og* is tranquil and contemplative with few funerary references, apart from the circular plaques depicting scenes from the afterlife. As its name suggests, the outlook is optimistic, with the afterlife presenting a prospect of both hope and interest. Within the walls the layout appears a little tame, with a fairly formal layout of paths, lawns, and shrubs. This is not, however, the case from the outside, which works perfectly within the overall design of the garden, as the buildings rise up among the thickly planted hillside on which they stand. An artificial lake stretches out from the foot of the hill, across which the composition is viewed to its greatest effect (plate 276).

Far removed from the sombre funereal associations found in most of the examples we have considered so far is a small group of three structures which could only be described as eccentric mausoleums. These are very likely the result of colourful invention as much as declining mental capability,

but still present us with an amusing and whimsical attitude to death and the afterlife. The monuments are all extremely modest and our interest in them stems partly from the unusual theories and bizarre parting requests associated with them. One of these is Grubb's Grave, which stands on a bare hillside with panoramic views over the Suir Valley, two miles to the east of Clogheen in Co. Tipperary. This is an odd beehive-shaped structure of rubble stone, like a solid version of one of the clochans[23] found on Great Skellig. It contains the mortal remains of one Samuel Grubb of Castle Grace, whose request to be buried standing upright was carried out after his death in 1891.

Mr Brackenridge of Clogher, Co. Tyrone, must have held similar theories to those of Mr Grubb. His grave is marked by a crisp cut-stone tower, which rises in three diminishing steps off a square base (plate 277). At ground-floor level there are arched window and door openings, and the top is finished with a plain metal railing. Access to the first-floor level is by a very narrow stair just 18 inches wide

276. Tir n n'Og, the Arts and Crafts mausoleum, viewed across the artificial lake at Mount Stewart.

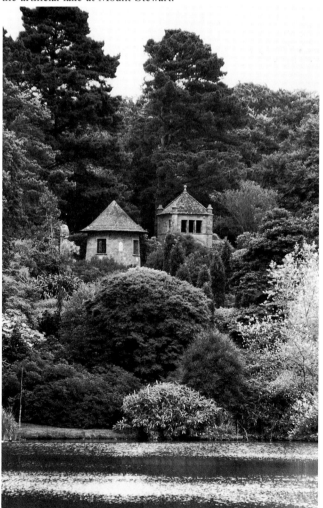

277. Brackenridge Tower: elevation and plan.

contained in the wall thickness. From here the top floor is reached by ladder through a trapdoor. There is no date or inscription on the structure, which is known locally as Brackenridge's Folly; the fine Italianate villa he built nearby, known as Ashfield, dates from 1841. Mr Brackenridge is said to have been buried upside-down under the tower, having maintained that the poles would be reversed when the world ended, and that at the Resurrection he would therefore be the right way up.[24] Local tales relate that the the hilltop tower was Mr Brackenridge's revenge on members of the local community who had ostracized him; as a result those who had looked down on him in life would be obliged to look up to him in death. Unfortunately the legend of the upside-down burial will never be proven as the mausoleum in the base of the tower was broken into and vandalized by troops stationed nearby during the 1940s.[25]

The final mausoleum of this group of eccentrics is that of the great hunting and folly-building enthusiast Robert Watson, whose simple charming structures have featured in most of the previous chapters in this study. Robert Watson's parting joke was to unite his two great passions and express them in a delightful illusion of pure fantasy. In the latter stages of his life, no doubt troubled by guilt and the ghosts of the many foxes his hounds had dispatched from the world,

278. The Fox's Earth, Larch Hill: elevation and plan.

small square openings at ground level in each of the side walls, just high enough to accommodate a fox, quickly restore the illusion. If curiosity directs the visitors to kneel down in the mud and look into the tiny opening (with a torch) they will not be disappointed. One of the narrow side chambers is scattered with the bones of rabbit-sized mammals, suggesting that Mr Fox-Watson did return to enjoy his reincarnation! It is not impossible that the bones did end up in the Fox's Earth by some natural means, but it is much nicer to imagine that, like the hermitage-builders and their props, the bones were another part of Robert Watson's illusion.

Returning to the more serious subject of designs for houses of the dead, it is not surprising to find that the temple form again dominates. Several of the examples we have already considered, such as Coolbanagher, Castle Lyons, and Knockbreda, are all clearly inspired by templar forms. In Roman times burial was allowed only outside cities. Temple-shaped tombs were often erected along roads, like the Via Appia in Rome and the Street of Tombs in Pompeii. The buildings in the Street of Tombs are like a series of small elaborate houses, which reminds us that house-shaped tombs are also a common feature of many cultures. In Ireland they exist from early Christian times, with surviving examples at Banagher, Bovevagh, Corran, Clones, and Slane.

As with follies and garden buildings in general, the templar mausoleums are sometimes very accomplished pieces of architecture, often designed by architects of note. Gandon left designs for an unnamed mausoleum of which four cross-section drawings survive in his own hand.[27] These show only the outline of an interesting domed structure with

279. The Fox's Earth: detail of the rustic tempietta.

he is said to have convinced himself that in his next life he would be reincarnated as a fox. To accommodate his second coming he built himself a fine rustic mausoleum which could conveniently double as a fox's earth (plate 278).

In the tradition of the ancients, which would no doubt have pleased Thomas Wright,[26] the building consists of a rectilinear chamber built into an artificial circular burial mound. The mound is cut back to reveal an arched entrance, with a central door and flanking windows, all with crude pointed arches. An embattled wall continues the circular line of the mound around the cutting, with stout stone piers marking the entrance opposite the doorway. On top of the mound is a crude circular temple (plate 279) built along the same simple principle as the gazebo described earlier, to give the illusion of columns and a dome without the complexity such structural forms normally require.

The interior of the burial chamber is a simple vaulted space of almost square plan, which is rather a disappointment after the build-up of expectation and mystery. However, two

Section of the Mausoleum

281. Castle Upton mausoleum designed by Robert Adam: elevation and plan.

projecting porticoes, the interior of which is richly adorned with a series of niches and reveals to accommodate a variety of urns and a large sarcophagus. Even in this barest sketch impression, Gandon's familiar authority is evident. It is a great pity that the building never materialized as evidence of the skill in small-scale projects which he so amply displayed in his larger works.[28]

Another drawing of a mausoleum exists, by a contemporary of Gandon, which, like the Gandon design, was probably never executed. This was by Thomas Cooley, the architect of the Royal Exchange, now the City Hall, in Dublin, which was built during the 1770s after an architectural competition of 1769, in which he defeated some impressive opposition, including Gandon and Thomas Sanby. Cooley's mausoleum design[29] (plate 280) is like a miniature version of his Royal Exchange building, with the Pantheon-style juxtaposition of portico to dome. It was probably designed for Richard Robinson, Primate of Armagh (1709–94), whom Cooley served after settling in Ireland on the success of his competition entry.

Unlike Gandon and Cooley, who both moved to Ireland following important commissions there, the great majority of English architects were content to undertake work *in absentia*. Of these William Chambers and James Wyatt were probably the most prolific. Chambers never set foot in the country, and Wyatt made only one visit in 1785.[30] Equally remarkable is the fact that Chambers's great rival and contemporary, Robert Adam, built almost nothing there. His only Irish commission for new work was carried out at Castle Upton, Co. Antrim. This includes a fine stable block and an exquisite mausoleum, probably the finest in Ireland.

This mausoleum, built in 1789 to the memory of the Hon. Arthur Upton, is a calm and restrained building of great beauty and delicacy, appropriately more subdued in detail than much of Adam's work (plate 281). It stands on

Plan of the Vault

280. Circular mausoleum: section and plan by Thomas Cooley. (Courtesy of the Armagh Public Library.)

179

the edge of open countryside, some way from the house, surrounded by a quiet walled graveyard, and it has been crowded out a little by the addition of later headstones (plate 282). The projecting central bay is a rusticated triumphal arch with an attic cornice, supporting two small sarcophagi and an urn, behind which rises an impressive stone pyramidal roof. To either side are plain recessed bays, with niches containing beautifully detailed urns, over which there are small circular reliefs of Grecian women.

Heavy iron doors lead into the wonderfully chaste interior, which is square in plan with a stone cross-vaulted roof and shallow recesses, within deeper arched reveals, to each of the four walls. The emptiness of the interior, every surface of which is in neatly jointed stone relieved only by wall plaques, is both solemn and moving. It is hard to imagine that the building was designed to be seen from afar, as all of the non-entrance walls, which face the open landscape, are extremely plain. One can only be disappointed that such a lovely building does not benefit from an open setting more suited to its excellent design. Drawings by Robert Adam survive in the Sir John Soane Museum, showing an earlier variant of the design. This scheme consists of a more open structure with a much greater degree of modelling to the exterior, through the addition of engaged columns and niches to the front and side walls. Despite these differences, the drawings closely resemble the mausoleum as it was built.

A vast, unfinished, Greek Revival mausoleum exists in the grounds of Oak Park, Co. Carlow. Only the walls were built, in fine ashlar granite facings on a brick core, which survive as a great ruined shell. The plan of the building consists of a rectangle measuring 71 feet by 35 feet, with an apse at one end. Facing this is a large entrance doorway, which provides the only relief to the otherwise blank walls (plate 283). The size and quality of this building, despite its austerity, could have provided a substantial parish church. This extravagance seems excessive for a family mausoleum and may have contributed to its abandonment before com-

282. Castle Upton mausoleum in its present sadly overcrowded setting. (Photograph by Roberto D'Ussy.)

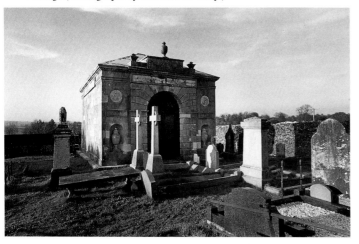

283. Entrance detail of the vast Greek Revival mausoleum at Oak Park.

pletion. It is thought to have been from a design by John B. Keane, which was exhibited at the Royal Hibernian Academy in 1841.[31]

The final building in this chapter is found at Dartrey, Co. Monaghan. This was erected *circa* 1770 to the memory of Lady Anne Dawson, wife of Lord Dartrey, whose son's memorial column we have already encountered. James Wyatt, who, like Robert Adam, was the leading figure in a distinguished family of architects, was responsible for the design, which is not dissimilar to the Thomas Cooley design mentioned earlier. It consists of a domed structure with a tetrastyle portico in a shallow pilastered relief, unlike the more vibrant free-standing portico of Cooley. A flight of steps leads up to the arched entrance door and there are blind window reveals and circular openings in each of the side panels. The impressive dome shown on Wyatt's drawing was originally constructed and replaced in later years by a less successful slate-covered hipped roof.[32]

As built, the design is rather disappointing, being very flat and meanly constructed, mainly of brick with only the portico and one or two trimmings in stone (plate 285). It is, however, of great interest for two main reasons. The first of these is the interior, which housed a fine sculptural group by Joseph Wilton, who carved much of the best work at the Marino Casino. Lady Anne Dawson (1733–69) died young, and the sadness of her premature death was depicted in the sculpture by a life-sized angel, floating on a cloud, beside a large urn on a tall plinth-like altar, while the grieving husband and infant son look up in anguish from its base.[33]

The second feature of interest is the very deliberate siting of the building, which exploits its full scenic potential. This has been lost to us today, as the views have all disappeared

284. Lady Dawson's Mausoleum under construction: an engraving from a late eighteenth-century painting by Gabriele Ricciardelli.

285. Lady Dawson's Mausoleum at Dartry by James Wyatt: elevation.

beneath a blanket of conifers. Fortunately it has been preserved in the excellent painting by Gabriele Ricciardelli of 1772,[34] which appeared as an engraving in 1780 (plate 284). The view is taken from behind the partly constructed mausoleum and looks out over twisting lakes and rolling drumlins, dotted with judiciously planted clusters of trees. Such landscapes, which are so common in Ireland, enjoy all the most cherished attributes of natural beauty and variety so beloved of the natural style.

The idyllic scene in the painting could almost be one of Poussin's, with stonemasons busy at work on the building, while cattle graze in the distance and a young couple rest in the foreground, beneath a cloud-filled Irish sky. In reality, the noble stonework of the painting was replaced by a more economical brick structure, perhaps to allow for the extravagant sculptural group. But this is of little importance, as it is the building's position in the landscape rather than its inherent quality which is important. Despite its present state, the success of this relationship survives in Ricciardelli's painting, which, like Nicholl's view of Newtownbreda, demonstrates the great rapport that could be achieved between man and nature, apparent even in the houses of the dead.

181

CHAPTER 11

Bridges

Highly functional structures, such as bridges, do not generally incorporate those characteristics associated with follies and garden buildings. Water is, however, a primary element in garden design and has contributed to the attraction of many of the buildings discussed before. Where water exists bridges are likely to be found, and in a land where serious function provides no great obstacle to fantasy and whimsy, enough interesting examples survive to warrant a short chapter on the subject. The bridges worthy of inclusion fall roughly into three main groups, which can rather loosely be entitled: folly or grotesque styles, classical ornamental, and Gothic fantasy. There are also one or two interesting and eccentric railway bridges of later date. Running through all of these examples is a common theme. Their design addresses not only the functional problem of overcoming some obstacle, but also provides an arresting visual object, which often creates a noticeable impact on the landscape in which it has been placed. Any well-designed bridge will attract such visual interest, and there is no doubt that the structures of Eiffel and Brunel are both beautiful and arresting. It is, however, those bridges which deceive through superfluous addition or detail that are of most interest to this study. In such cases the structures present an ornamental

286. Rubane pebble house: a general view with the ornamental bridge. (Photograph by Roberto D'Ussy.)

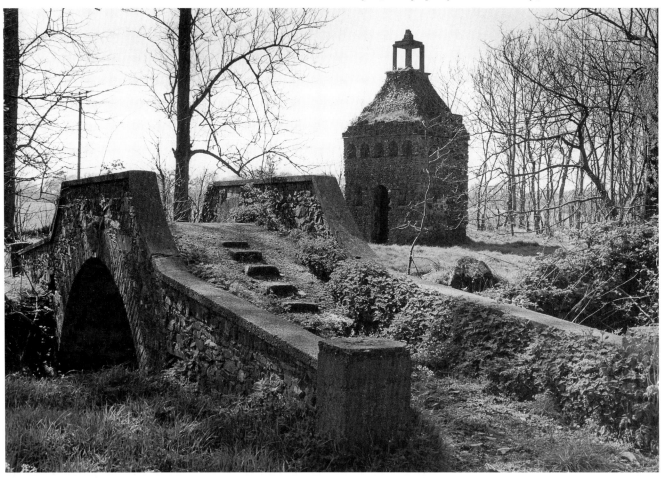

quality, which can be either dramatic, amusing, or simply intriguing.

One of the most appealing aspects of viewing bridges is that one can normally enjoy them from afar, because of the unrestricted course of the river or ravine they span. This is particularly noticeable in dense urban situations, where river views may offer the only long vistas in the town or city. Most of the capital cities of western Europe can be seen at their best from vantage points on their bridges. Dublin is no exception, with its elegant bridges linking the two sides of the quite unique but rapidly disappearing quays.[1] From the distant view of the Wellington obelisk, it is clear that Europe's largest obelisk was carefully positioned on the impressive and protected vista created by the river, which brings an awareness of the monument right into the centre of the city.[2]

Of the folly or grotesque type, a modest but suitably representative example is found in the grounds of Danesmote House near Rathfarnham, Co. Dublin. Danesmote, or Glynsouthwell as it was originally known, contains a rich scattering of small folly structures, many similar to the nearby Hermitage. These are arranged around a small glen through which runs a cascaded stream, which nature commenced and man completed. The most interesting structure here is probably the rustic bridge. It consists of a delicate elliptical arch, in rustic construction, spanning the stream above a deep rocky gorge (plate 291).

Large irregular rocks in the arch of the bridge are deliberately arranged in a seemingly random configuration to imply an accident of nature, which only heightens the elegant geometry of the ellipse. At the high point of the bridge, which is narrow and without any form of balustrade, is a second rustic arch, springing over the pathway perpendicular to the main arch of the bridge. The second arch is a purely superfluous device to add visual interest and a touch of humour. It enables one to be over and (in a sense) under the bridge simultaneously. Thus amusement and pleasure are added to the overall charm of the composition.

287. Horn Bridge, Tollymore, in its present altered setting. (Photograph by Roberto D'Ussy.)

288. Ivy Bridge: parapet termination piers: elevation.

The demesne at Tollymore, through which runs the beautiful River Shimna, is also rich in follies. With the hand of Thomas Wright very much in evidence, it is not surprising to find a number of interesting bridges. Horn Bridge carries a path which runs over a small tributary on the north side of the Shimna. This is a small rendered rubble structure dating from the mid-eighteenth century (plate 287) with a central pointed arch, flanked by blind quatrefoils and semicircular piers, which rise to a deep and slightly projecting crenellated parapet. The design has many similarities to the Barbican gate mentioned before (see page 74), and is almost certainly by Thomas Wright. It is probable that the tributary was formed into an artificial cascade, once carefully planted with ferns and other luxuriant species.[3] This would have been intended as a deliberate set piece, to be viewed and enjoyed from the bridge, as was the nearby cascade on the Spinkwee River, also attributed to Wright.[4]

In the previous description of the hermitage in memory of the Marquess of Monthermer the intrinsic natural beauty of the Shimna has been touched upon. This lovely river needed no 'improvement' or artificially constructed cascades; instead it has been repeatedly crossed by a series of bridges (six in number) to link up the network of serpentine walks which thread through the woodlands and along the riverside. It is not necessary to describe all of these in detail, even though great thought and care have been taken with their generally modest construction. Most of the bridges are named and several have carved date-stones, as the creators of Tollymore were enthusiastic inscribers. Inscriptions survive not only on date-stones, and the memorial plaques on the hermitage and obelisk, but also on the natural rock, close to the river. Here there are quotations of poetry and scripture. These draw the reader's attention to the surrounding beauty, urging him in the words of John 1:3 to 'Stop, look around, and praise the name of Him who made it all.'

The earliest bridge is called the Old Bridge, inscribed 'JH 1726' and 'Repaired 1822'. Others include the late eighteenth-century Altavady Bridge, Hore's Bridge of 1824, and Parnell's Bridge, named after Sir John Parnell (1744–1801). All of these bridges are single-span, rubble-built structures, as are the two most interesting examples, Ivy Bridge and Foley's Bridge. Ivy Bridge has a date-stone of 1780 and a letter 'C' surmounted by a coronet. The arch of the bridge is pointed and there are elaborate curved parapets terminating in detached, pinnacle-topped turrets,

289. Foley Bridge: view from the bed of the River Shimna.
(Photograph by Roberto D'Ussy.)

(plate 288) containing pointed-head niches. Although the date on the bridge is many years after Wright's visit to Tollymore,[5] Eileen Harris has noted similarities between Ivy Bridge and Codger's Fort at Wallington, Northumberland, which survives today as a ruin.[6]

By comparison, Foley's Bridge is a much simpler structure in the form of a semicircular arch, with low, gently sloping parapets, which seems to grow out of rocky outcrops on either side of the river (plate 289). It has two stones with finely carved inscriptions, bearing the date '1787' and 'Ht. Foley' which was the maiden name of Lord Clanbrassil's wife, Grace. Foley's Bridge is certainly the most beautiful of all the bridges over the Shimna, and its success is due to a number of reasons. The almost miniature scale of the structure (its crossing is barely more than a footpath in width) and the delicate circular geometry of its arch are delightful. These are further enhanced by the overall lightness of the construction, which measures little more than three feet from top of arch to top of parapet. Added to this simple and elegant structure is a string of 'bap-stone' decoration, which follows the curve of the arch, set just above the voussoirs. 'Bap-stones' (so called for their resemblance to the small round loaves of bread called baps) are the river-worn boulders about the size of small footballs, which are split and then applied as decoration. They decorate other follies on the estate, often attributed to Wright. This final gesture adds a distinctly ornamental quality through these clever light-catching reliefs, all adding to the wonderful harmony between the natural and the man-made, which so enriches the place.

In beautiful settings like the Shimna Valley rustic bridges were also a common feature. These were constructed of unbarked wood taken from surrounding woodland, with which they blended perfectly. Unfortunately few of these bridges exist in their original state. Their construction was of an ephemeral nature and, like that of the rustic summerhouses, could not withstand Ireland's damp climate. Many, however, are preserved in the albums of turn-of-the-century photographers. Some of these were published as superior tourist brochures, with brief descriptive captions. The popular waterfalls of Glenariff in Co. Antrim contained a number of fine examples, such as the Rustic Bridge, with a caption proclaiming, 'The Glens of Antrim abound with waterfalls embowered in exquisite sylvan scenery.'[7]

On a much larger scale, but of similar (if somewhat eccentrically applied) geometry to Foley's Bridge, is the Spectacle Bridge over the river Aille, near Lisdoonvarna, Co. Clare. This remarkable structure, which was built around 1875–80, spans a deep gorge in the form of a conventional semicircular arched opening, over which is a full circular opening of similar diameter. The bridge is faced in large neatly squared stone blocks, with the outer edges of the voussoirs, between arch and circle, touching. Square turrets rise full height from a point about halfway along the sloped sides of the gorge, on the wide flank-walls of the bridge, which have a distinct batter. The central section, with the

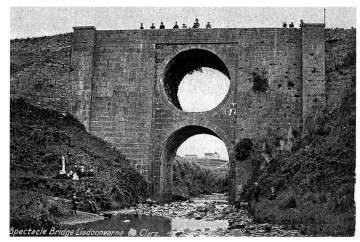

290. Spectacle Bridge, Lisdoonvarna: an early postcard view. (Courtesy of Daniel Gillman.)

openings, is framed by a vertical wall panel, cut into the batter. This helps to emphasize the verticality, giving it a decidedly modern impression, unusual for a bridge of this age. Were it not for this feature, the structure would appear very heavy when viewed from afar. It provides a striking landmark, and judging by the old postcards and cigarette cards on which it has featured, has always been an enduring tourist attraction (plate 290).

Concluding this first group of unusual bridges is the excellent Fairy Bridge on the Rockingham demesne, situated on the edge of Lough Key, Co. Roscommon. This impressive structure stretches a considerable length, rising steadily from each of its curving sides to span a narrow canal, roughly one-fifth of the overall length. The most remarkable aspect of the structure is its wildly grotesque appearance, created by the heavily weathered limestone blocks from which it is constructed. As with the nearby gate lodge of Kilronan Castle, these curiously shaped stones were gathered locally.

> The fluting on the stones has been naturally produced by the effect on the limestone blocks of weakly acidic rainwater. Some blocks at the base of the parapets show natural pits or fretting and these had been brought from the lake whose acidic waters slowly etched away the lime. Similarly the curiously shaped topmost stones at the parapet ends were moulded by lake-water action, the purer bands of limestone having been eaten away leaving the impurities.[8]

Despite the extreme deformity of the blocks, the design and detailing of the bridge are surprisingly elaborate (plate 291). It was built in 1836, which is too late to link it with Thomas Wright, who would most certainly have admired it. All of the stones are carefully selected and positioned, and the irregular rotten-teeth appearance of the central arch recalls Wright's rustic arch at Belvedere. To either side of the arch are two shallow niches, above which runs an irregular projecting

291. The rustic bridge at Danesmote, the ornamental bridge at Arch Hall, and the Fairy Bridge at Rockingham: elevations.

string-course. The balustrade is a series of blind triangular reveals interspersed with long, slightly projecting blocks arranged vertically, and at the centre point rises an irregular pinnacle. Similar, but much larger pinnacles terminate the parapets like grotesque, petrified figures.

Short flights of contrastingly neat stone steps lead down to a narrow walkway or towpath, from where the grossly irregular underside of the arch can be appreciated (plate 292). Unlike many bridges, which are often barely noticeable from the road or path that crosses them, the form and detail of the top and sides of the Fairy Bridge are equally impressive. Artificial cascades often incorporate interesting rustic bridges and causeways, of which Luttrellstown has a number of good examples. It is, however, for its scale and audacity, not to mention its excellent detailing, that the Fairy Bridge stands out as the exceptional example of its kind in Ireland.

Classical bridges of a more ornamental nature have

292. Fairy Bridge, Rockingham: detail of the grotesque stonework of the arch.

featured in landscaped gardens from the earliest times, and it is not surprising to find that Vanburgh was responsible for the earliest example in England. This is the Grand Bridge at Blenheim, which lies on the *cour d'honneur* of the palace and contains over thirty rooms. The extravagance of the bridge provided a further point of contention between Vanbrugh and his client, the Duchess of Marlborough, and is thought to have contributed to his eventual dismissal. It is now partially submerged by an artificial lake created by Capability Brown, which, although concealing the lower sections, does add to the romantic image of the structure. Several fine variations on this theme of bridges containing pleasure accommodation appear in England, most notably at Stowe, Kedleston, and Wilton, none of which is matched by any of the bridges to be found in Ireland.

There are, however, a number of fine straightforward classical bridges with a distinctly ornamental quality to be found in both the cities and the demesnes of Ireland. The finest is probably the one constructed under the supervision

of Thomas Ivory at Carton, Co. Kildare (plate 293), to a design by Isaac Ware, which appears in his *Complete Body of Architecture* of 1755. This bridge is a graceful multi-arched structure, with a bracket cornice beneath a plain balustrade. It is supported on sharp water-spreading piers, which seem rather unnecessary, as it spans a rather sluggish ornamental lake. At Arch Hall, now a romantic ruin which has been attributed to Edward Lovett Pearce, one or two fragments of an early formal layout can still be traced within the surrounding farmland. Of these the Vanbrugh-style archway, which stands on the axis of the house, has already been discussed. Off to one side of the house is found a long narrow canal spanned by a delicate single-span bridge. This sweeps up gradually to a high central arch, which is topped by a tall, square pier (plate 291).

The bridge, which is narrow and without balustrades, is of similar rustic construction to the arch, and the pier at one time probably supported an ornamental finial or urn. Scattered around the base of the bridge are a number of cut-stone blocks, which appear to have been taken from the ruined house. This would suggest that the upper courses of the pier, which are also of cut stone, are later additions. As the house and gateway are attributed to Pearce, it is likely that the bridge is also one of his designs. His garden drawings for the Allens at Stillorgan indicate very clearly that he was not averse to formal and axial garden layouts. Both the archway and the bridge would have been prominent features in the flat landscape which surrounds the house, and, like the arch at Gloster, are much more important than their humble construction suggests. This is not only because they are among the earliest ornamental garden buildings in Ireland, but also because they demonstrate that the beauty and elegance of such structures is not necessarily dependent on extravagant materials and highly skilled craftsmen. When directed by the judicious hand of a skilled designer, even modest materials like crudely shaped brick and rubble stone can be transformed into structures of the highest order.

At Rubane, Co. Down, near the Pebble House, there is a

293. Classical Bridge, Carton, based on a design by Issac Ware. (Courtesy of the Irish Architectural Archive.)

294. An ornamental bridge at Rubane and a small dry bridge at Ballysaggartmore: elevations.

295. Art Gallery Bridge over the Liffy: an unbuilt design by Sir Edwin Lutyens; perspective sketch. (Courtesy of the RIBA Drawings Collection, London.)

small ornamental garden bridge (plate 286), spanning a now dried-up water-course with a shallow brick arch. The flanking walls sweep up to a horizontal balustrade in rubble stone, which may at one time have been rendered. A large key-stone bearing a woman's face in relief seems out of place with the rubble stone, and also suggests that the original finish of the bridge was stucco, possibly painted or jointed to resemble stone. This bridge, which probably dates from the mid-eighteenth century, is one further (if modest) example of the important role bridges often played in the ornamentation of gardens throughout numerous periods.

While the Irish landscape is sadly lacking in the extravagant and extensive bridges of Vanbrugh, Gibbs, and Adam, two plans at least were drawn up for urban settings, which are certainly worthy of mention. These were both intended for Dublin and neither was completed. James Gandon, whose excellent classical design for Carlisle Bridge (1791–5) included Palladian colonnades over the footways, made the earlier of these. Gandon was certainly a strong believer in the grand architectural statement, and in his essay *Hints for*

296. Egyptian railway arch near Newry: an early postcard view with the cornice still intact.

Erecting Testimonials, he advocates not only the erection of testimonials in our squares and public places, but also making the bridges triumphal, 'dedicated to our gallant army and navy, whose achievements have astonished the world'.[9] Carlisle Bridge was built without the colonnades, which were abandoned as too expensive.[10] The present O'Connell Bridge is a late nineteenth-century version of Gandon's original, the drawings of which have now been lost.[11]

Over a century later Sir Edward Lutyens designed another extravagant 'gallery bridge'. This featured heavy flanking pavilions above small side arches, and a large central arch topped by a colonnade running between the pavilions (plate 295). On plan the side pavilions were paired on either side of a footbridge which would have replaced the present Halfpenny Bridge. The structure was designed to house the Sir Hugh Lane collection of modern paintings.[12] Lutyens's creative talent, of which Ireland has ample evidence, is not in question, but it is perhaps fortunate that this scheme remained unexecuted, as it would undoubtedly have blocked the fine Liffey vistas which are such a notable feature of the city.

Railway engineers, like architects, were not opposed to occasional flights of stylistic fancy when designing bridges. One of the most interesting is the 'Egyptian' arch near Newry, Co. Down, on the Belfast to Dublin line (plate 296). This is an impressive masonry structure, which carries the railway at some considerable height above the road below. The underside of the arch transforms cleverly from a circular form at the centre of the vault, by curling up on the outside corners of the opening to provide a more fitting squared-off appearance. Raking sides rise up to a deep curving cornice in the Egyptian manner;[13] and apart from its thinly disguised arch (which would have been unknown to the ancient Egyptians) the Newry arch would not look out of place alongside the great pylons of the Temple of Isis at Philae.

It was built by William Dargan for the Dublin and Belfast Railway Company in 1851, and was very likely inspired by Broadstone Station in Dublin, completed in 1850. This equally impressive Egyptian-style essay was by John Skipton Mulvany, and has been described as 'the last building in Dublin to partake of the sublime'.[14] Another example of Egyptian-style railway engineering survives at Blackrock, Co. Dublin. This is the entrance to the tunnel created at Maretimo, on the Dublin to Kingstown railway, to avoid cutting off Lord Cloncurry's access to the sea. The Loop Line Bridge over the Liffey is another interesting example of monumental railway engineering, with a strong reference to the ancients. It is supported on pale stone piers, which ironically imitate the Roman Doric order of the nearby Custom House that it so grossly disfigures. The piers are, however, finely detailed with deeply projecting cornices and some interesting 'Hibernian Doric' embellishments around the necks of the columns. This massive, elevated structure recalls the great aqueducts of the Romans, and, had it been more judiciously sited, it would have been accepted more easily as a memorable civic landmark. Other railway bridges in castellated or Gothic style occur at Blackrock, Co. Cork, and Drogheda, Co. Louth, both of which, along with the Loop Line Bridge, are illustrated in *Across Deep Waters: Bridges of Ireland*.[15]

At Clandeboye, Co. Down, Lord Dufferin created an impressive landscaped park with two interesting folly bridges, in addition to the excellent Helen's Tower discussed before (see page 54). The bridges, like the tower, are in a Scottish baronial style and provide a private entrance under the railway line to Helen's Bay station. This terminates a private driveway, known as Clandeboye Avenue, which leads to the house approximately two and a half miles away. Both bridges have shallow Gothic arches, each with moulded voussoirs and flanking bartizan-like projections. On the more elaborately detailed of the two the mock bartizans are circular with tall conical roofs, like the pepper-pot projections on the tower. Above the point of this arch is a large finely carved coat of arms, supported by a pair of rather undernourished lions (plate 397), while the plainer of the two bridges bears a

297. Helen's Bay railway station: detail of the armorial crest on the Scottish baronial bridge. (Photograph by Roberto D'Ussy.)

298. Helen's Bay railway station, baronial bridge: view from the carriageway. (Photograph by Roberto D'Ussy.)

much weathered date-stone inscribed 1853. The effort and expense involved in the construction of the Clandeboye bridges suggests that, in some instances, the relatively new railway network was enthusiastically patronized by the landowning classes. Although the estate continues to be well maintained, this private access has for many years been abandoned to the advance of ivy, ferns, and elders, which provide a most attractive air of romantic desolation[16] (plate 398).

A lengthy account of the station and Lord Dufferin's private waiting-room; when it was still in use, was written by his nephew, Harold Nicolson: 'The station at Helen's Bay was in those days (and indeed until the advent of the motor-car eliminated the train journey from Belfast) one of the most fantastic in the United Kingdom.'[17] He goes on to describe the train passing over the bridge spanning the two-and-a-half-mile avenue which links Clandeboye to Helen's Bay and the sea. The private waiting-room and its contents are described and dismissed as 'the least successful room that I have ever known'.[18] Of the bridges he wrote:

Yet there were stranger things to come. Having rested in the waiting-room the visitor was then conducted back into that corridor and down a flight of steep stone steps which led to the level of the avenue. On reaching the bottom he was startled to find himself in a large pentagonal forecourt. The wall of this Propylaea were constructed of black granite irregularly morticed together with thick cement. There were a large number of turrets, pinnacles, barbicans, embrasures, machicoulis, ramparts, merlons, battlements, and arrow slits. The avenue through this outer ward was at right angles to the railway line. To the right there was a high portcullised gate-way which led to the sea. To the left an even more imposing feudal arch disguised the railway bridge. Each of these two arches was decorated with a large coat of arms—dexter, a lion with a tressure flory conterflory or, sinister a heraldic tiger ermine.[19]

The final group of bridges to be considered is distantly related to the baronial style of the Clandeboye ones, and can best be described as Gothic fantasies. These effectively range from the sublime to the ridiculous and most certainly deserve their inclusion as follies. Wicklow has many examples of sublime landscape, from the waterfalls at Powerscourt and the Devil's Glen to the steep-sided valleys of Luggala and Glendalough. In some cases the natural and man-made have combined in an impressive manner, such as the gazebo and banqueting hall at Belleview on the Glen of the Downs, mentioned before (see page 128). The most impressive combination is however the romantically named bridge at *Poul-A-Phouca*, which is Irish for the Phouca's Hole. According to Irish fairy mythology, the *phouca* or *pooka* is a misshapen, goat-like imp, haunting lonely glens and dark recesses. A possible forerunner of Shakespeare's Puck, 'he can also adopt the shapes of many different animals.'[20]

The nineteenth-century topographical writers wrote enthusiastically about the bridge and falls, considered to be 'sublime to a degree, or . . . the most picturesque in Wicklow'.[21] Bartlett's engraving in *The Scenery and Antiquities of Ireland* of 1845 displays all of the author's romantic enthusiasm, touched with more than a hint of exaggeration. The description in the text is equally effusive and worth quoting:

The cataract is formed by the descent of the river Liffey through a narrow opening in a craggy precipice, falling from a height of upwards of one hundred and eighty feet, over several progressive ledges of rocks, till it is precipitated into a dark abyss, where it forms a whirlpool of frightful appearance and depth.[22]

The bridge was built in the 1820s to the design of Alexander Nimmo and includes an elegant pointed arch with flanking crenellated turrets adorned with blind window openings and loopholes. In Bartlett's *Scenery and Antiquities* Coyne goes on to describe it thus:

> A handsome bridge of a single Gothic arch has been thrown across the chasm through which the water rushes. The span of this arch is sixty-five feet, and its key-stone is one hundred and eighty feet above the level of the river.[23]

Poul-A-Phouca is no mere fancy of an over-imaginative engineer, but a carefully considered fantasy designed to exploit and enhance the sublime and romantic qualities inherent in the natural setting. This intent is borne out by its close proximity to the pleasure grounds in which it was clearly designed to feature. These were created by the Earl of Miltown, whose seat was the nearby mansion of Russborough.

> On one side, the Glen for some distance, both above and below the fall, is overhung by abrupt and naked rocks; on the other, the banks being less precipitous are cut into walks, and otherwise tastefully embellished.[24]

Mrs Hall also mentions Lord Miltown's grounds, which are laid out in good taste and from which the falls can be seen to great advantage.[25] She also notes that the grounds included 'covered seats, cool walks, grottoes, and a ballroom, which in "the season" is much frequented by "sod-parties," at which we are informed that—a dance is no infrequent termination to a pic-nic.'[26] The great bridge at Poul-A-Phouca was therefore not intended to be only a practical means of crossing a ravine, but also an important romantic landmark. It also served as a most impressive backdrop for gay alfresco gatherings, a fact which provides an interesting insight into how such landscaped demesnes could be designed to satisfy the social requirements of a large partying crowd. The pleasure grounds and the ravine have long since become overgrown, but the drama of the bridge and its setting remains to delight us today (plate 299).

Not far from Poul-A-Phouca is a smaller Gothic bridge in a fortress style, with some sham castellated details and a vaulted room in one of the abutments. It is possible that Nimmo was also responsible for this bridge, which lacks the impressive setting of Poul-A-Phouca and merely provides a land bridge to allow access under the road. A similar land bridge exists on the Farnham estate in Co. Cavan, which was built as one of the secondary entrances to the demesne under a road which runs at a higher level. The width of the

299. Poul-A-Phouca bridge: view from the river-bed.

'bridge' is in excess of 170 feet, although the central opening spans a mere 13 feet. It is hardly noticeable from the road, and is best seen by approaching the opening across the wide open field which slopes slightly from both sides down to the entrance (plate 300).

This approach was once marked by a grand avenue of trees, which today survives only as a sequence of dead stumps. The construction is in roughly coursed rubble stone, with a series of blind arrow-slit reveals terminating in stub-like turrets. An interesting watercolour of the structure

300. Farnham dry bridge: elevation.

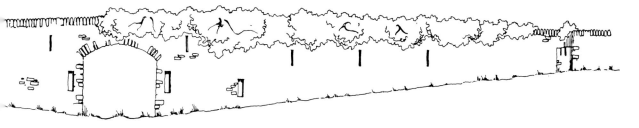

301. Farnham dry bridge: an early watercolour view showing the unbuilt castellations around the entrance arch. (Courtesy of Lord Farnham.)

exists at Farnham House (plate 301), which shows a much larger arched entrance with tall flanking towers and a castellated parapet, viewed through the avenue of trees, and with three horsemen in the distance disappearing into the estate. It is not clear whether the watercolour version was ever built, or whether it was a figment of the artist's imagination, or even the sketch for an architectural proposal.

The watercolour bears the inscription 'View of Farnham,' and 'Farnham Gate from the Park,' and is signed 'C. B. Wynne sketch'd June 20.' The Farnham estate is set in a beautiful landscape of rolling hills interspersed with many natural lakes and water-courses. It is likely that the land-bridge gateway was the work of an enthusiastic amateur, like the nearby rustic cottage thought to have been designed by one of the Ladies Farnham.

One final example of a dry-bridge archway is found at Ballysaggartmore, Co. Waterford. This is a small but well-detailed composition, with a central pointed opening flanked by tall narrow turrets, and stepped sides terminating in smaller turrets. The turrets have simple castellations and the structure is enriched by a number of blind Gothic reveals and trefoils (plate 294). It carries a path at high level which crosses over a lower one passing under the arch, and is a fitting offspring of its more illustrious neighbour, which will be discussed shortly.

A number of interesting gateways with bridge approaches, such as those at Glenarm and Dromana, have already been described. In these examples, the presence of the bridge adds greatly to the sense of arrival and entrance. At Ashford Castle near the village of Cong, Co. Mayo, there is an impressive entrance structure, designed by J. F. Fuller, which successfully combines both bridge and gate lodge. This late Victorian exercise in pomp and grandeur consists

of a fine castellated six-arched bridge. On its outer side are two octagonal turrets, with a castellated lodge and entrance arch, complete with arrow-slits and machicolations, on the castle side (plate 302).

Such wild extravagance as that found at Ashford is only surpassed in the folly bridge at Ballysaggartmore. This wonderful indulgence of massive proportions was not even intended to serve as the gate lodge, as a separate lodge was built (in duplicate) further along the approach. The Ballysaggartmore bridge is the stuff of pure fantasy. It spans the merest trickle of a mountain stream in a charming wooded glen, and consists of a castellated and buttressed structure with curved ends, each adorned with miniature castles, which would not shame a Camelot film set (plate 303). Each castle combines a series of round or square towers of differing heights, dissected by central archways to allow access to carriages crossing the bridge. The plans of the two small castles are roughly triangular in shape, one of which is marked by circular turrets and the other square.

302. Ashford Castle, the castellated bridge: approach.

303. Castellated folly bridge at Ballysaggartmore: elevation and plan.

304. Ballysaggartmore, the impressive folly bridge viewed from the approach drive.

It is hard to see how these tiny irregular spaces could have served any practical use whatsoever, except to afford pleasure to those driving over the bridge on the way to the house.

The bridge was built by Arthur Keily around 1837, and has been credited to the design of his gardener, Mr J. Smith,[27] who is also thought to have been responsible for the fine double gate lodge. It is hard to imagine that this sophisticated design is the work of an amateur, as it is both cleverly planned and well detailed. The curved walls of the approaches work perfectly, sweeping round sharply to enter the bridge, no doubt carefully planned to emphasize the second castle. This also presents the more interesting diagonal view, which, with clever massing and proportioning, creates the impression of a much larger and more complicated scale of building than what is there (plate 304). There is also the clever play on duality, implied symmetry, and good attention to detail, all of which would suggest the direction of a discerning and talented practitioner.

Ballysaggartmore is, however, something more than just a romantic architectural embellishment. In many ways it is the perfect embodiment of an architectural folly, primarily for the absurdity of such a vast heap of a structure bridging such a modest stream. There was at one time a rather half-hearted attempt to widen it and so justify the two outer arches. It is also reputed to have been that classic example of the folly-builders' affliction—over-ambition. The story relates that the bridge and gate lodge were intended as a grand entrance to what was to be an even grander castle. Plans for the castle, which was to have rivalled that of Mr Keily's brother,[28] were abandoned when it was found that the budget had been fully expended on completion of the splendid embellishments to the driveway.

CHAPTER 12

The Eccentrics

Even with the wide range of categories in this study, a notable collection of stubborn exceptions remains; they are best described as the eccentrics. In most cases these tend more towards the folly than the ornamental garden building in style, but it is wrong to assume that all are the product of pure whimsy. While many are clearly the work of a free imagination seeking only to delight and give pleasure, there are a significant number which have been constructed for the most practical of motives. This unexpected bow towards functionalism has not curbed the creative spirits behind their designs, and must surely dispel forever the general misconception that follies are useless buildings constructed for no particular purpose. A general characteristic running through this group is that many are tall and very often conical or pointed. They are also often found in clusters and are usually thought to have been the work of interested amateurs, although some are known to be the work of architects of reputation.

One very distinctive group includes cones, pyramids, and rustic pillars, collectively entitled 'Cones Bones and Druids' by Barbara Jones.[1] The druidic reference is apt, as they

305. Killiney Head: one of the great views of South Dublin from the obelisk, with the step pyramid and small cone in the foreground. (Photograph by Roberto D'Ussy.)

often appear like crude latter-day interpretations of the neolithic and later prehistoric constructions which dot the Irish countryside.[2] Most of these examples date from the early to mid-eighteenth century and the structure known as the Killiney 'Obelisk' is perhaps the most famous and best-known example. It stands on a site of great prominence and natural beauty, on a hill to the southern end of Dublin Bay. Bartlett's two views of Killiney Hill from *Scenery and Antiquities*[3] capture not only the building but also the excellent setting, which remains equally impressive to this day, and must surely be one of the best views of the south of County Dublin.

His drawing to the south shows the elegant sweep of Killiney Bay (regarded by some as Ireland's Bay of Naples) with the obelisk in imitation of the delightful pointed cones of the Wicklow mountains. The northern view towards Dalkey Island and Dublin Bay (plate 306) contains more detail, with the obelisk and its approach path. The structure is an elegant, tapering cone, like an upturned ice-cream cornet, on top of two square-planned blocks. Of these, the upper block contains an open chamber and the lower a series of large arched reveals which once housed bench

seats (plate 307). The rubble-stone construction has been rendered with roughcast in modern times, probably in imitation of its originally intended finish (plate 308). There is little embellishment, apart from a simple string-course with corbels on the lower block and a small pediment above the south-facing opening on the upper block. Two inscribed stone plaques relate some of the building's history. The higher of these is positioned below the pediment, bearing a simple crest and an inscription that reads:

> LAST year being hard with the POOR the walls about these HILLS and THIS erected by JOHN MAPAS Esq. June 1742.

The Killiney structure was therefore yet another product of famine relief, like Conolly's Folly, which was built some three years earlier. Directly underneath, on the lower block, a second lozenge-shaped plaque reads: 'Repaired by Robert Warren Esq. MDCCCXL.' By the time of this restoration (almost a hundred years after its construction) the hill seems to have been open to the public. Bartlett's view of the scene, which dates from the early 1840s, shows crowds of visitors, most of whom are dressed in the garments of the common folk rather than the costumes of the gentry. Also of interest

306. Killiney Hill: a nineteenth-century view of the obelisk from Bartlett's *Scenery and Antiquities*.

307. Killiney obelisk: elevation and plan.

at one time and a carved stone plaque above the door reads simply MOUNT MAPAS. On slightly higher ground to the north of the small cone, a step-pyramid makes the final member of this notable trio. Built on a slightly sloping rocky base, this neat little structure consists of seven crisply constructed steps, with a line of smaller intermediate steps, in classical amphitheatre style, running up the centre on one side (plate 309).

There is a date-stone on the pyramid inscribed 1852, which is considerably later than both the construction and the repair of the obelisk. The stonework of the small cone, which is undated, seems to be of earlier construction, and the 'Mapas' inscription suggests it may be closer to the older building in date. It is likely that Robert Warren from the nearby Killiney Castle, who restored the obelisk, also built the pyramid and possibly the small cone. He also built the small tea-house tower in 1853, lower down the hill on the landward side, beside the present entrance gate. The hill became an official park known as Victoria Hill in June 1887, to mark the jubilee, and later, in July 1891, it was trans-

308. Killiney obelisk viewed from the approach up Killiney Hill. (Photograph by Roberto D'Ussy.)

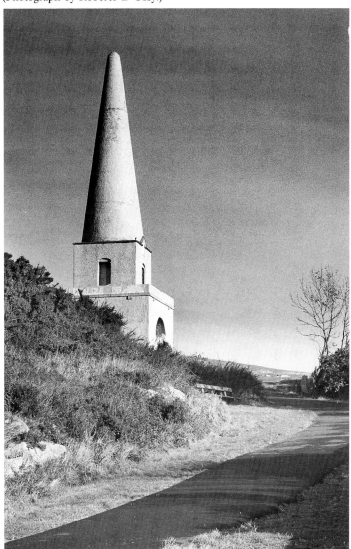

in his drawing is the evidence of an external flight of stairs. This suggests that the upper chamber was intended to be accessible, to provide framed views in all directions from the absolute summit of the hill. The structure is essentially a very plain object, but no less impressive for that. It was deliberately designed to mark a very special location. From this setting, nature's extra special bounty or *genius loci* could be admired and enjoyed to the full. With a height in excess of 50 feet, it was also built to provide a clear landmark to make the spot recognizable from great distances. The size and shape of the structure, together with the prominence of the headland on which it sits, jutting out between the two great bays, make it one of the most seen and best loved of all Irish follies. It is also one of the first sights to greet the visitor arriving in Dublin or Dunlaoghaire by sea, the sole method of arrival at the time of its construction.

Close to the Killiney obelisk, positioned a little way down the hill, there are two other follies. The first is a small conical structure in rubble stone, with a miniature cone, in imitation of its neighbour, placed on two stepped hexagonal blocks (plate 315). A brick pointed-arched door-way leads into a chamber in the lower hexagon, with a small pointed-arch window. This tiny structure was also rendered

ferred to the township of Killiney and Ballybrack under the Open Spaces Act. Both the folly-builders and the park commissioners chose their site well, as a visit today will readily confirm (plate 305).

The step-pyramid has a famous precedent from an earlier time, which still survives near Ballinrobe, Co. Mayo. This is a much taller and altogether more impressive structure of ·nine steps rising to a height of 30 feet, from a base of over 40 feet in width (plate 309). It stands in a field beside the road to Cong, a great massive crumbling pile of dry-stone construction like the surrounding field boundaries (plate 310). On the rise of the fourth step is a cut-stone plaque with a long Latin inscription which reads:

TEMPLUM FORTITVDINIS
MEMORIAE DILECTISSIMIERATIS
GEORGII BROWNE ARMIHVIVSCE
PATRIAE QVONDAM DECUS & TVTAMEN
VIXIT * AD 1750[4]

The structure, which was at one time crowned by a lead figure of Apollo, is reputed to have been designed by the Earl of Charlemont for his brother-in-law, Sir John Browne of the Neale—a house now vanished.[5]

A second cluster of small conical follies survives at Tollymore; although relatively modest in scale they are of more than passing interest. They are known as Lord Limerick's Follies (plate 311), but, as with almost everything else at Tollymore, the guiding hand of Thomas Wright is clearly evident. The tall pointed forms and grotesque embellishments so beloved by Wright predominate, along with an obvious interest in geometry, which contrasts with the simple rubble construction. Three separate structures make up this group, which is strung along the Bryansford Road on the northern boundary of the estate. Of these one is built into the boundary wall on the estate side, while the others are linked to the more primitive boundary walls of fields on the opposite side of the road.

The folly built into the boundary wall is a neat square-planned structure in rubble stone, topped with a tall pyramid,

309. Step pyramids at Killiney and the Neal: elevations and plans.

310. Step pyramid at the Neale, with a lone figure demonstrating its deceptively monumental scale.

311. Lord Limerick's Follies, Tollymore: elevations and plans.

312. The middle pyramidal folly built into the estate boundary wall at Tollymore. (Photograph by Roberto D'Ussy.)

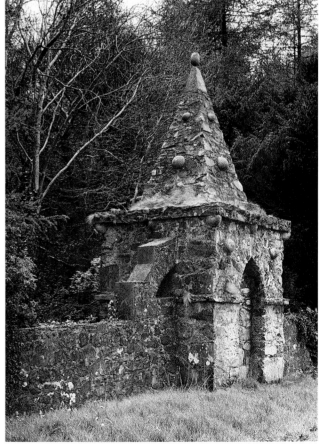

flanked by small flying buttresses springing from the top of the boundary wall on either side. Pointed-arch vaulting opens up on the inner side of the structure facing the demesne, with a blind reveal of similar shape on the road-side. It may at one time have been a small pedestrian gateway leading from the estate, a notion that is supported by the presence of the other two follies outside. Alternatively, it may have been constructed as a seat, even though there is no obvious view apparent from the inner side of the structure, which today is surrounded by dense woodland. The form of the building and its simple geometry are most appealing, as are the tiny buttresses, which could well be structural, given the mass of the pyramid supported by the vault. A symmetrical pattern of 'bap-stones' adorns the pyramid and the spandrels of the arched reveal, giving a delightful knobbly appearance. This is repeated in the river-worn corbels supporting the crude cornice to the lower block, and the egg-shaped finial which tops the pyramid (plate 312).

These 'bap-stones' (so called for their similarity to small round loaves of bread) are just one of the many charming features that recur throughout many of the Tollymore follies, and they probably came from the Shimna River. They also

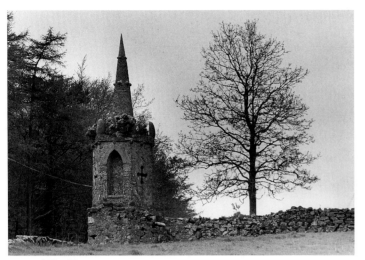

313. The large folly at Tollymore, with bap-stone encrusted spire and elevated seat. (Photograph by Roberto D'Ussy.)

occur on the largest of the group, which stands a short way up the hill, on the same side of the road as the tall conical gate piers described earlier. This final example is the largest and finest of the group. It is built at the intersection of two dry-stone field walls, on a raised bank above the road, which helps to exaggerate its height. The structure is again an interesting play of geometry, with a solid hexagonal block rising from a roughly circular base, topped by a tall tapering cone reminiscent of a small church spire.

Three courses of 'bap-stones' ring the spire, diminishing in size as it sharpens to a point, and the corbelled overhang and split-stone pinnacle details of the other two follies are repeated to great effect (plate 313). On the faces of the hexagonal block there are alternating blind quatrefoil loopholes and pointed-arch reveals, one of which is slightly deeper and forms a niche-like seat. This is reached by a flight of crude stone steps which wind up around the drum to a small landing at the base of the seat, from which fine views of the surrounding countryside fall away towards the sea. All three of the structures appear at one time to have been rendered or lime-washed, which would have emphasized their interesting geometry.

There is little doubt that Wright was the author of these designs and some of his surviving sketches, if not identical, are certainly of a similar scale and style.[6] Some doubt does, however, exist as to the date of their construction. One account dates them pre-1744[7] and therefore before Wright's visit to Ireland in 1746–7, without naming a source. Other Irish sources date them after 1777, as they do not appear on Bernard Scale's detailed maps of the estate of 1760 and 1777. It is possible that the structures existed before 1777, but were too small to be worth featuring on the estate maps; alternatively they may have been executed to Wright's designs many years after his Irish visit.

The title given to the follies suggests one final possibility. Wright's connection with the family was through Viscount

Limerick, later first Earl of Clanbrassil, to whom he dedicated *Louthiana*, and with whom he is known to have stayed on his Irish tour. During this period Wright is known to have taught drawing and mathematics to the Earl's son, who became the second Earl of Clanbrassil on his father's death in 1758. The first Earl was responsible for laying out the demesnes at Tollymore, and also the family's principal seat in Dundalk, in the mid-eighteenth century. Both of these are among the earliest examples of estates in Ireland to be landscaped, following the fashion started in England by Pope and William Kent.[8] Most of the buildings at Tollymore are thought to have been erected by the second Earl, who was a suitably gifted amateur architect (as his father had been before him), capable of interpreting the ideas and designs of Thomas Wright.

The question of dates and authorship does not in any way diminish these charming structures, which seem to have been designed simply for the delight of their appearance. Although they are spread out over a reasonable distance, all three can be seen simultaneously (plate 314), and the two lower structures feature strongly in the view enjoyed from the seat in the third. Their appearance on the outer edge of the demesne may have something to do with delineation, or the suggestion that the estate controlled lands beyond the boundary wall of its park. They may also have been created in a manner similar to that of some entrance gates, to provide the outsider or visitor with some hint of what he could expect to find within this beautiful demesne.

In a similar spirit to Lord Limerick's Follies, but of more rustic appearance and construction, is the small beehive structure which stands in the grounds of Coolmore, Carrigaline, Co. Cork. This intriguing little building is built from a mixture of irregular lozenge-shaped stones, which jut out like scales as they corbel up to the bullet-shaped crown (plate 315). Rough stone jambs and crude lintels form pointed-arched entrances on either side, flanked by irregular stone pinnacles similar to the finial which crowns the structure. The interior is roughcast and, despite the double entrance, it was most likely constructed as a rustic seat. It is

314. The large folly at Tollymore viewed from beside the folly-field gates.

315. The obelisk, Coronation Plantation, the beehive cone at Coolmore, the Pinnacle Glassan, the small cone, Killiney, and the Bushe Fountain, Kilfane: elevations and plans.

aligned with the house and the hilltop tower described before, and stands in an idyllic setting among trees, on slightly rising ground above the estuary of the Owenboy River south of Cork (plate 316).

An interesting obelisk-like monument is found in the Coronation Plantation in the Wicklow mountains not far from Blessington. The obelisk bears a lengthy but worn inscription commemorating the planting of over 1500 Irish acres of woodland by the Marquess of Downshire. It also notes that the fencing was completed in August 1851, but the date of the completion of the planting has now been worn away. The structure is a rather ungainly heap (plate 315), consisting of a steep pyramidal pinnacle on a crude stepped base, in the midst of the now thinning woodland near the source of the River Liffey. Surviving trees are a mixture of Scots pines and some broad-leaved trees, which in this case add to the beauty of the mountains and suggest that, in its former glory, the plantation deserved its commemoration.

Many examples in this final collection appear as crude interpretations of some of the categories previously discussed. We have already seen, at Killiney and Tollymore, several imitations of spire-like obelisks, and the monumental column also has a number of imitators. The term 'pillar' is a word in common use which has no specific meaning in the context of classical architecture.[9] It is, however, perfectly adequate for the mongrel-like imitations. One example is the rustic pillar which marks the 'geographical centre of Ireland'[10] at Glassan, Co. Westmeath (plate 315). Known locally as the Pinnacle, it is a simple circular structure very similar to the Lady's Finger at Mornington, built of solid rubble stone with a slightly projecting cut-stone band at high level, from which springs a shallow domed cap.

Both of these pillars originate from the eighteenth century. The Pinnacle bears a date-stone of 1769, and the

Lady's Finger at Mornington appears in Thomas Wright's drawing of the 1740s in *Louthiana* (plate 72). The Glassan pillar stands on a hill two miles north-east of the town, and from it there are wonderful panoramic views of the much flatter surrounding countryside. It is likely that both structures were erected as landmarks to aid travel, and in the case of the Mornington pillar, which sits at the mouth of the River Boyne, to aid navigation.

316. Coolmore: a rustic beehive cone in its riverside setting.

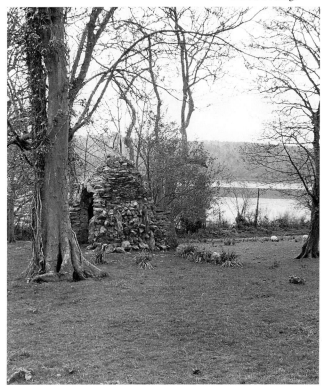

317. The Metal Man: elevation.

On a much larger scale, and also built to aid navigation, are the Metal Man pillars near Tramore, Co. Waterford (plate 318). There are five pillars in total, three on the Doneraile Cliffs at Great Newtown Head, and another two on the cliffs across Tramore Bay on Brownstown Head. They are attributed to the engineer Alexander Nimmo (the designer of the Poul-A-Phouca bridge), and may have been built in response to a famous shipwreck of 1816, which resulted in the loss of 363 lives from a homeward-bound troopship from the Peninsular War. Tramore Bay is exposed to southerly gales, and the pillars would doubtless have provided a useful landmark or 'daymark' to help sailors avoid the cliffs.

They are all of similar size and shape, with wide circular bases 20 feet in diameter and rising with a slight taper to a height of almost 75 feet. Constructed of roughly hewn coursed stone blocks, with cut-stone to the shallow bases and projecting bull-nosed caps, they appear to have been limewashed at one time. On one of the pillars stands a greater than life-size figure of a Metal Man, after whom the

pillars are called. He is dressed in the costume of the early eighteenth-century British sailor, in a patriotic combination of white trousers, red shirt, and short blue jacket. His hair, face, and eyes are also painted in a realistic manner, and he adopts a dramatic stance, with one outstretched arm and extended finger pointing towards the dangerous cliffs, while his other hand is slipped nonchalantly into the pocket of his jacket (plate 317).

Lifelike figures of this kind are not uncommon in Ireland, and other examples exist, such as the Metal Man in Sligo Harbour and the Cement Sailor at Dalkey. It is not clear if the Metal Man was intended as a memorial to the lost passengers and crew of the stricken troopship. Figures may have been intended for all of the columns, as the low chamfered pedestal on which the Metal Man is placed has been repeated on two of the other structures. The existence of the figure has no doubt been responsible for the super-stition which has arisen in connection with the pillar. This suggests that any unmarried ladies who succeed in hopping round this pillar three times will be married within the year! A delightful early postcard depicts the spectacle of three hopeful women with their skirts hitched up, hopping round the base (plate 319). Another three women, off to one side, are either waiting their turn or providing a cynical audience. This charming gathering is presided over by the unflinching metal male, who continues his seaward gesticulation unaffected by the efforts in progress below him. Highly imaginative and often fanciful associations occur frequently throughout Ireland, often attaching colourful myths to a particular building or structure, irrespective of the serious-ness of its original function.

At Castle Caldwell, Co. Fermanagh, there is another lifelike effigy, in this instance a giant stone fiddle, five feet in height, leaning against the gate lodge. The stone commemorates the fiddler, Denis McCabe, who fell out of Sir James Caldwell's barge and drowned in Lough Erne on 13 August 1770. An amusing, if somewhat insensitive verse reflects on the tragedy:

318. The Metal Man, Tramore, with one of its neighbouring unoccupied columns.

319. An early postcard view of hopeful spinsters hopping round the Metal Man. (Courtesy of Daniel Gillman.)

> Beware ye fiddlers of the fiddlers fate,
> Nor tempt the deep lest ye repent too late,
> Ye ever have been deemed to water foes,
> Then shun the lake till it with whiskey floes,
> On firm land only exercise your skill,
> There you may play, and drink your fill.

A more abstract stone sculpture is found at Curraghmore, Co. Waterford. This is called Mother Brown and consists of a small head-shaped appendage projecting from a much larger mass of rock. The stone is a natural occurrence and appears to have been deliberately positioned at some point to resemble a seated female figure, very much in a manner which would have delighted the late Henry Moore. Larger-scale natural phenomena of a figurative nature often find their way onto maps and into the local vocabulary, such as the Mad Man's Window and Napoleon's Nose in Co.

Antrim, or the Devil's Bit and the Devil's Punch Bowl in Tipperary and Wicklow. In Co. Donegal, near the village of Falcarragh, is the Cloghaneely, which has similarly given its name to the district. The name is a corruption of the Irish—*Cloch* (stone) *ceann* (head) of *Faoladh*. A full account of this interesting structure with its colourful legend appears in *North West Ulster*, and is certainly worth repeating:

> A huge lump of white limestone with crystalline red veinings turned into a folly monument by Wybrants Olpert who, with Sarah, his wife, set it on top of a pillar of rubble stone in 1774. The Cloghaneely . . . is said to be stained with the petrified blood of Faoladh, whose head was cut off on the stone by a one-eyed giant, Balor, who lived on Tory Island and had stolen one of Faoladh's cows. Faoladh's grandson, like Ulysses, got his own back by piercing the giant's eye with a red-hot iron.[11]

Another unusual and very architectural feature worthy of inclusion in this section is the external monumental stairway. Two fine examples exist at either end of the country, one at Bantry House, Co. Cork, and the other at Glenveagh, Co. Donegal. Truly monumental staircases, rising dramatically out of a garden, evoke a wealth of romantic associations; they can also provide a very practical vantage point from which to admire the beauties of the demesne. At Bantry the stairs rise steeply to the rear of the house, through semi-formal terraces, up to an impressive height (plate 320). From this point an almost aerial view of the house and garden can be had, with the bay and distant mountains lending a magnificent backdrop, on a par with the famous view of Powerscourt.

320. Bantry House: monumental staircase rising behind the house. (Courtesy of the Irish Architectural Archive.)

321. The Bone House, Caledon, with one of the eroded piers revealing the secret of its unique construction.

It is in the contrast between orderly man-made gardens and the unadorned power of natural beauty that the uniqueness of the Irish garden is best represented. Such a contrast can also be claimed for the appearance of a strictly architectural element in an otherwise natural setting. The staircase at Glenveagh, which is found in a suitably wild landscape, is a perfect example of this. It rises in one single dramatic flight of 67 steps up a steep hillside, flanked by rhododendrons, and leads to a high terrace which overlooks the estate and the lough on which it is sited. The Glenveagh steps are a relatively recent addition, being part of the extensive works carried out by the present owner, Mr Henry McIlhenny, who bought the Victorian castle and estate in 1938. Their presence in the landscape is a powerful one, and they certainly deserve the title of *scala regia*, as one appreciative visitor has described them.[12]

One of the most singular buildings, not only of this chapter, but of the entire study, is the Bone House at Caledon, Co. Tyrone. This bizarre structure, which appears to have been erected to serve as a summer-house, has a front entirely constructed of bones. The front consists of a

series of five large piers formed by setting thousands of femur-type ox or deer bones directly into lime mortar (plate 321). The bones are laid with the length pointing inwards and the knuckle outwards, in horizontal courses, with a vertical arrangement on the corners to provide sharp arrises to the corners of the piers. Because of the curve of the knuckle of the bone on the outer face, the mortar is completely hidden, giving the startling effect of a continuous pattern of bone.[13]

Behind the loggia there are the remains of a simple rectangular room, with an apse located in the centre of the rear wall (plate 322). It was created by John Boyle, fifth Earl of Orrery, a friend of Jonathan Swift, Alexander Pope, and the Delanys, and a fellow enthusiast for the new style in gardening. Lord Orrery's gardening exploits are well documented in the *Orrery Papers* and Mrs Delany's *Correspondence*, and are described in some detail by Malins and Glin in *Lost Demesnes*. The 'Ivory Palace', as it was known, stands beside a bend in the Upper River Bann, and despite its current dilapidated and overgrown state, it continues to amaze almost 250 years after it was constructed.

In contrast to the pinnacles, step-pyramids, monumental staircases, and the Bone House, all of which were erected purely for ornament or coordination, the remainder of this chapter will concentrate on a variety of buildings which effectively combine eccentricity and sound practical function. Most are a product of mundane everyday needs, although one or two are linked with pleasure. They are included because they exhibit those essential characteristics found in all good follies and garden buildings—the addition of quality and interest to the landscape in which they feature.

A number of interesting wells exist, which are very much in the folly idiom, successfully combining the provision of a fundamental human necessity with the creation of an interesting landscape feature. In Ireland there are a great many 'Holy Wells' dotted around the countryside. These may have set the precedent for the custom of erecting small ornamental structures to enclose them. Thomas Wright provides a delightful illustration (complete with circular arbour) of one such well in his drawing of the Lady Well near Dundalk (plate 323), and notes, 'round which the Roman Catholics do Penance on the 9th of September,

322. The Bone House, Caledon: plan of the surviving wall and 'ivory' pillars.

called the Patron Day'.[14] A similar plain stone structure, with a fine, carved-head keystone, marks another Holy Well at Grey Abbey.

The Burren area in Co. Clare is dotted with wells both sacred and secular. One sacred example is St Brigid's Well near Birchfield, which has been a continuous focus for pilgrimage and devotion since the early nineteenth century. Its well-house was built by Cornelius O'Brien, who also built the tower on the Cliffs of Moher, and whose monumental memorial column and burial vault are both found beside the well. It is, however, secular wells which are of greater interest to this study, and a fine example is to be found further along the Clare coastline near Ballyvaughan. This is known as Tobercornan or the Pinnacle Well, *tober* being the Irish word for well. The well is a solid Gothic-style structure of probably early nineteenth-century date, consisting of a square-planned chamber with a pitched roof and a central pointed-arched entrance doorway. On each of the four corners are diagonally projecting buttresses topped with faceted stone pinnacles. There is a noticeable antique quality to the irregular squared and coursed stonework, which, along with the structure's interesting form, make it a prominent feature in the barren landscape for which the area is famous.

At Toome Bridge, Co. Antrim, there is a conically shaped fountain known as the 'Fountain of Liberty' with a plaque inscribed 'THIS FOUNTAIN FREE TO ALL THE DESIGN AND GIFT OF JOHN CARY 1860.' John Cary also built a 'Temple of Liberty, Learning and Select Amusements',[15] which has now sadly disappeared. Another interesting fountain is found at Kilfane, Co. Kilkenny. This is called the Bushe Fountain, and was probably built by, or commemorates, the Bushe family, branches of which lived at the nearby houses of Kilfane and Kilmurry. The fountain consists of a cylindrical base surmounted by a hemispherical dome topped with a small obelisk-like finial. There are three curved steps butting up to the side of the base, but the inscription has unfortunately become illegible, apart from the name 'Bushe' (plate 315). The structure has a modest scale, but this is more than compensated for by its delightful shape and detail.

Ice-houses are another type of functional building, which often received special treatment to create a picturesque or ornamental effect. They were constructed in the grounds of most large country houses throughout Ireland, in the days before refrigeration. Unlike wells and fountains, which are generally found in the public domain, ice-houses were mostly sited inside the walls of the demesne, within relatively easy access of the house. Although strictly functional in their use, some ice-houses were clearly constructed to serve as visual features in the landscape. They were built mainly in the eighteenth and early nineteenth centuries, and although few remain intact, many ruins survive. Until the last quarter of the nineteenth century, when artificial ice production became established commercially, the ice-house was the only reliable means of refrigeration.

323. Lady Well: an eighteenth-century drawing by Thomas Wright from *Louthiana*.

The chronological development of the ice-house is an interesting subject which has been covered at some length in *Ice and Cold Storage: A Dublin History*.[16] Most of the examples to be found in Ireland are brick, domed or vaulted structures, either totally or partly submerged into the ground or the side of a hill. As a result it is generally only the design of the entrances which held any scope for the folly-builders and landscapers of the eighteenth and nineteenth centuries. Entrances usually opened into a short vaulted passage, which led to a much larger chamber with a shallow domed roof and an inverted cone base, at the bottom of which the ice was stored. The structures were stocked by layers of ice from the ponds or rivers beside which they were often sited, like those which survive at Luttrellstown and Castletown.

Two interesting examples of ice-houses with simple classical entrances were built in eighteenth-century demesnes within Phoenix Park. One was in the grounds of the Chief Secretary's Lodge, for which drawings exist[17] although the structure has since been cleared away. The other survives in what was formerly the garden of the Viceregal Lodge, now a part of the Dublin Zoological Gardens. This entrance is a pedimented brick structure, with a central doorway flanked by rusticated brick piers, and was almost certainly intended to be seen as an ornamental feature in the garden. The fine grotto-fronted ice-house which survives in the grounds of Hillsborough Castle has already been mentioned (plate 40). It is built into a slight hill, with its crown becoming a rockery, and has a rustic entrance flanked by great clusters of ferns and constructed of large rounded sandstone blocks.

324. Gothick ice-house, Castle Blunden: elevation and plan.

either side by slightly recessed wings with shallow pointed-arched reveals. Behind this façade is the more traditional arrangement of a vaulted passage, in this case with reveals halfway along on either side, which leads to the circular ice chamber (plate 324).

Externally the structure is all in rendered rubble stone, with a covering of slate to the vault and the conical roof of the ice chamber. The interior of the passage is finished with a stone-flagged floor and neat brick vaulting; and the ice chamber, which extends to a depth of about twelve feet below the level of the passage, is a splendid circular structure with a brick dome. It stands on the edge of an open field above a small stream, clearly visible from the main driveway when coming from the house (plate 325).

In some instances strictly functional buildings are worth mentioning, if only for the eccentricity of their design. One such flight of fancy was built at Enniscrone, Co. Sligo. This was the bizarre castle-style bath-house with its odd corner turrets, photographed by the pioneering Irish photographer Robert French in 1905 (plate 326). Seaweed baths were taken at Enniscrone in the mid-nineteenth century as a cure for excessive eating and drinking and a therapy against rheumatism. The habits of the bathers appear to have been as eccentric as the appearance of the building: 'The bather immersed himself in the hot seaweed and rubbed it over his body, covering himself with its oil. A steam bath came next, followed by a cold shower.'[18]

Another very functional building deserving to be included in this chapter is the Hell-Fire Club, situated at Mount Pelier in the Dublin mountains, above Tallaght. Once again we have a building which has acquired a mantle of notoriety as a result of numerous myths and legends which have grown up over the years, quite detached from its original function. It was built as a hunting lodge in the early eighteenth century by Squire Conolly and today survives as a most impressive ruined shell.

It is not very clear how the building became known as the Hell-Fire Club, as the notorious society founded around 1735 in imitation of the earlier English version usually met at the Eagle Tavern in Dublin.[19] The lack of any hard and fast evidence, if anything, encourages the speculation and rumour. Some of Dublin's most respected chroniclers have enjoyed perpetuating the myth. From Constantia Maxwell we learn that:

Internally there is a brick inner structure with the typical double-cone volume. The entrance, which resembles the mouth of a mysterious cave, looks over an open stretch of garden containing a man-made rivulet.

Gothic-style doorways also feature regularly, befitting the more grotesque and cave-like nature of ice-houses and their windowless interiors. The finest surviving ice-house in Ireland is probably the one at Castle Blunden near Kilkenny. This quaint little building is a most successful garden ornament, but, as most of its structure is above ground, it was probably not quite so successful at preventing ice from melting. The entrance is a pointed-arched doorway, above which there is a simple pediment adorned with three crude pinnacles and a blind circular reveal. It is flanked on

> When rakish gentlemen wished for congenial society they rode up to Mr Conolly's hunting-lodge, perched like Noah's Ark on the top of Mount Pellier, among the Dublin Mountains. Here they were reported to drink heavily, indulging in blasphemous oaths, and amusing themselves with preposterous orgies.[20]

Maurice Craig has also mentioned the possible association between Conolly's hunting lodge and the club, and indulges in a touch of 'colouring' by noting the popular legend of Squire Conolly's son having conversed with the Devil in the dining-room at Castletown. He goes on to suggest that

325. Gothick ice-house, Castle Blunden, viewed from the driveway.

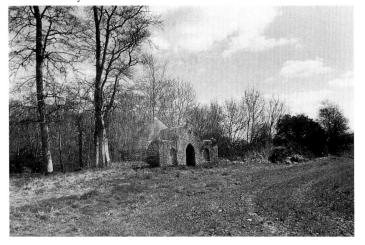

the hunting lodge was possibly the location where 'they per-formed the notable experiment which rumour has handed down, of setting fire to the building in which they were carousing, in order to anticipate with greater realism the sensations of Hell itself.'[21] Fire is thought to have destroyed the building shortly after its completion, resulting in the rebuilding of the roof in a massive masonry structure. This remains remarkably intact today, despite many years of neglect and the use of the roof as a platform for an enormous bonfire in honour of Queen Victoria's visit of 1849.[22]

There are also stories of black cats being seated at the dinner table, the plundering of stones for construction from a nearby megalithic burial site, and all the usual tall tales associated with the occult. Perhaps there is an element of truth in the rumours, as the building seems to have been abandoned and then used as a quarry as early as 1763 by Lord Ely of Rathfarnham, who built a shooting lodge further down the hill.[23] The abandonment has not diminished the romantic attraction of the building which continues to be a focus of interest and intrigue. This is no doubt helped by

326. Castellated bathing pavilion, Enniscrone: an early photo-graph by Robert French. (Courtesy of the National Library of Ireland.)

327. Hell-Fire Club, Mount Pelier, appropriately sited on a bleak bare hill.

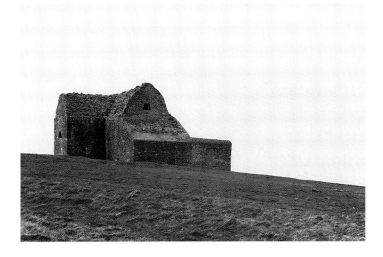

328. Hell-Fire Club: ground and first-floor plans.

the excellent situation and beautiful views, which the site still enjoys despite the creeping advance of a coniferous plantation.

The building stands like a great crouching monster (plate 327) on the crown of a bare, grassy hill, which is both desolate and bleak. From the back and sides the vaulted building, with its abutments and projections, has an interesting irregular appearance, while the front is a more sober Palladian arrangement. It consists of a long rectangular block with single-storey mono-pitched chambers flanking a central two-storey section, from which a small porch extends to the front and a larger projection to the rear. Two high walls project from the outer sides to the front of the building, probably to provide shelter, one of which has a mounting block built up against it.

The ground floor contains a suite of two rooms, a closet,

and an entrance lobby planned around a central staircase, with two single-storey flanks accessible only from the exterior, probably serving as stables (plate 328). In one of the two larger rooms there is a great fireplace. This was probably used as a kitchen, with the other room providing servants' accommodation. The first floor provided the main reception rooms, with the central arrangement around the staircase repeated. Here the two main rooms are each lit by a pair of tall windows on the front side of the building and by a third half-round window high up in the vaulted gable wall. Niches flank the central fireplace opening, and also occur in the gable wall under the half-round window. At one time the staircase (which is a modern replacement) probably continued up to serve the small chamber in the roof void, at the centre of the building.

The planning and detail of the building are remarkably sophisticated for its very rugged appearance, and it is probable that an architect, or at least a gifted amateur, was responsible for the design. As some doubt still lingers as to the author of Conolly's main house, the palatial and well documented Castletown, there is small chance that the designer of his hunting lodge will ever be known. The rugged stone shell has survived well and is a popular attraction for ramblers and sightseers by day, and, judging from the number of empty cider bottles and lager cans, it is still visited by some latter-day club members by night. The spirits of Lord Ross and his companions would no doubt approve!

To conclude this final chapter on the different categories of follies and garden buildings, it is very appropriate to feature a small selection of buildings which successfully combine all of the most important qualities one could hope to find in such structures. In all of these final cases the buildings are ornamental, eccentric, and also highly functional. They fall into two different but closely related types, both of which, like many of the functional buildings in this chapter, are associated with food.[24] Barns and pigeon-houses, or dovecotes as they are more commonly known in Britain, have been built for many hundreds of years, but nowhere with the degree of fantasy touched upon in the design of the barns and pigeon-houses found at Tollymore, Waterston, Rathfarnham, and Castletown.

At Tollymore the barn is effectively disguised as a rustic Gothic church complete with spire and pinnacles, and enriched with the familiar river-worn stones also seen on many of the other buildings on the estate. Once again the design is attributed to the prolific Thomas Wright, even though the barn was probably not built until the late 1750s, with the spire being added in 1789. It is called the Clanbrassil Barn after Lord Limerick's earldom, to which he was raised in 1756, and stands just inside the Bryansford gate described earlier. The building is really a large decorated rectilinear box with a shallow pitched roof so arranged to make the most of its dramatic effect. It is built of rubble stone with small flints and pebbles set into the mortar joints (in imitation of a medieval process known as galletting) with

329. Clanbrassil Barn, Tollymore: elevation.

granite dressings. The spire rises from an octagonal drum or belfry, with blind and louvred lancet openings. This is supported on a square base, with a series of granite string-courses and bap-stone decoration. A series of slender pinnacles mark the angles of the octagon and are repeated on the gable at eaves level. Both front and rear gables have large quatrefoil windows set in diagonally arranged, square granite dressings, and a small crocketed bell-cot to the rear.

The main gable is extended to one side by a castellated wall and a fine pointed-arched gateway. This provides an important addition to the overall composition, and repeats much of the construction and detail of the barn. Bap-stone decoration occurs as a central flower-pattern on the spandrel, and as rough crockets on the outer face of the central arch, which springs between tall narrow piers containing lancet niches (plate 329). The piers, which are square in plan, become octagonal at higher level with lancet reveals in imitation of the spire. These terminate in bell-shaped bases supporting stone acorn finials, which match the one on the central arch. Entry to the barn is through the archway, where a forecourt opens up from the long side elevation, featuring a series of Georgian-style windows, pointed-arched doorways and ventilators (plate 330). The barn is a highly accomplished building despite its rustic construction, and easily surpasses the design of many a small Irish church.

A skilful hand was certainly behind its creation and measurements of the spire survive in one of Lord Clanbrassil's notebooks, tending to support his reputation as a gifted amateur architect. One has only to admire the splendid composition of the spire of the barn framed by the Bryansford

gate, set against the magnificent background of the Mourne mountains (plate 331) to realize that its creator not only appreciated the finer points of architectural composition, but also demonstrated a keen awareness of how to introduce buildings into the landscape very successfully.

Continuing the pointed theme of spired and conical forms that has so dominated this chapter is another interesting structure thought to have been designed by an architect of some standing. This is the Pigeon House at Waterston, Co. Westmeath, which is attributed to Richard Castle. He is often rather harshly treated by Irish architectural historians, almost as if they resent the fact that many of his buildings would probably have been designed by his more gifted master, Edward Lovett Pearce, had Pearce not met with such an untimely death. While many of Castle's larger buildings are noticeably dull and uninspired, a number of garden buildings of great variety and originality are attributed to him. We have already seen evidence of his work at Belan, Castletown, and Russborough, and his Pigeon

330. Clanbrassil Barn: detail of one of the side entrances with galletted stonework.

331. Clanbrassil Barn viewed through the Bryansford gate with the Mourne mountains rising in the distance. (Photograph by Roberto D'Ussy.)

House at Waterston is a worthy member of this impressive selection.[25]

This was built as a large eye-catcher and stands on top of a shallow hill in the park (plate 333), about half a mile from the house, which is now a ruined shell. It consists of a tall, octagonal, tower-like structure resting on a square-planned base in which there are fine keystoned arches springing from a projecting string-course (plate 332). In the drum of the tower is a series of blind window reveals, and towards the top of the spire, which terminates in a delicate weathervane, there is a ring of tiny square openings with landing ledges, which give the only external hint of the building's function.

Internally, a cross-vaulted roof springs from the head of the arches, through which a trapdoor leads up to the pigeon-loft in the tower. The inner skin of the tower is in brickwork

with built-in nesting boxes, while the rest of the structure is in rubble stone with cut-stone dressings. On the entrance level, the open arches have at a later date been partially infilled with a large circular window above either a door or window opening in each side. This work was probably carried out to convert the ground-floor chamber into a summer-house or gazebo, at which time the chimney was probably built. Unfortunately the infill panels were built flush with the outer face of the stonework, greatly reducing the effect of the arches, which are such an important part of the composition. None the less it remains an impressive structure, over 55 feet in height, making it a notable landmark. Like Lord Limerick's follies, it is a delightful geometrical exercise, built to amuse and delight, and in this case produce pigeons and eggs for the table, even if they were somewhat difficult to collect.

Pigeon-houses were often built beside buildings used to store grain, the principle being, presumably, that one's spilled grain was consumed by the pigeons and then recovered (indirectly) as pigeon meat. There are two famous examples of this, where conical-shaped pigeon-houses stand adjacent to eccentrically shaped barns which were used as grain stores. These are the Bottle Tower in Rathfarnham and the Wonderful Barn near Leixlip, in what was once part

332. Waterston pigeon-house: elevation and plan.

333. Waterston pigeon-house, initially built as an eye-catcher for the now ruined Waterston House.

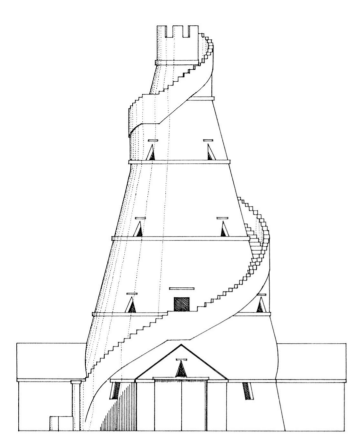

335. The Bottle Tower, Rathfarnham, in its present suburban setting with the adjoining pigeon-house.

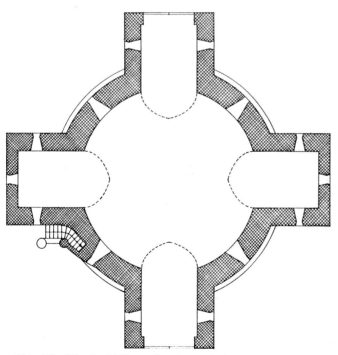

334. The Wonderful Barn: elevation and plan.

of the Castletown demesne. The Bottle Tower and its pigeon-house (plate 335) are the later buildings and are clearly an imitation of the Wonderful Barn. A description of 1903 tells us that:

> The extraordinary cone-shaped tower encircled by a winding staircase adjacent to it, which stands at the back of Rathfarnham demesne, near the road to Dundrum, was erected by Maj. Hall, who probably modelled the tower long known as 'Hall's Barn' on a similar structure called 'the Wonderful Barn' erected by the Conolly's about the same time at Castletown.[26]

As the Wonderful Barn dates from the early 1740s this suggests that Major Hall's barn also belongs to the first half of the eighteenth century. Stories relate that it was furnished with fireplaces and once occupied, and while this may have occurred in later years, it was almost certainly constructed as a barn like the Castletown model it imitates. The term 'bottle towers' probably refers to the building's shape, which resembles that of early bottles. Large conical shapes such as these have very few precedents in Ireland, although one interesting example was built in Ballycastle, Co. Antrim, in 1755, and preserved by an early Robert Welch photograph in 1875. This was the cone of the old glassworks of which bottles were the main product.[27]

The forms of the Bottle Tower and the Wonderful Barn are much more complicated than mere cones, because of the unusual geometry created by the cantilevered staircases snaking around them. As the Wonderful Barn is the larger and more complicated structure, and arguably one of the finest follies to be found in Ireland, it deserves a thorough description. The barn was built in 1743 by Mrs Conolly to close a vista to the east of Castletown, and, like the great obelisk which stands on the north-facing axis, is some considerable distance from the house. It rises to a height of 70 feet in a delicate tapering cone, encircled by the snake-like staircase (plate 336), which terminates in a viewing gallery surrounded by a delicate battlemented crown (plate 334).

At ground-floor level there are four projecting, pedimented bays in a Greek cross arrangement, the pointed-arched vaults of which intersect the great dome of the barn. Above the dome of the ground-floor room is a series of four more domed chambers, diminishing in size towards the point of the cone (plate 337). These are all entered from the staircase and lit by four windows, which are rectilinear on the ground floor, triangular on the first, second, and third floors, and elliptical on the fourth floor. The projecting bays are lit by chamfered rectilinear windows in the side walls and triangular openings in the gable ends. In the centre of each of the upper floors is a circular trapdoor through which the grain was poured, to spread it out onto the floor below to dry.

Internally the structure is a remarkable display of fine brick vaulting, with an outer skin of rubble stone, which for the most part is rendered, but in places vertically hung with slates. The external detail is equally good and carefully considered, with projecting stone gargoyles to drain the open platform at the top of the stairs, and dripstone weather

336. The Wonderful Barn, Castletown: external stair detail. (Photograph by Roberto D'Ussy.)

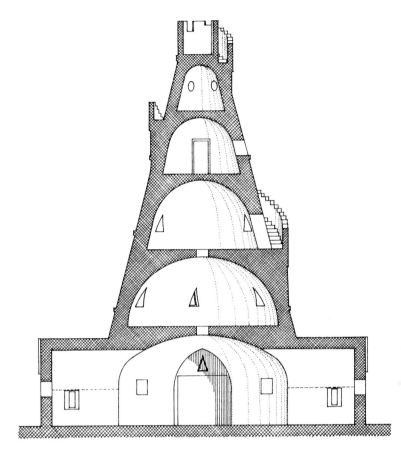

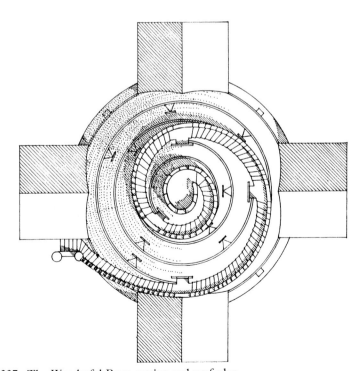

337. The Wonderful Barn: section and roof-plan.

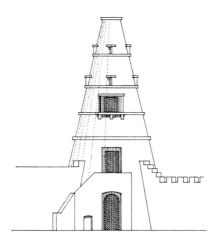

338. Pigeon-house beside the Wonderful Barn: elevation and section.

339. One of the adjoining pigeon-houses viewed from inside the Wonderful Barn. (Photograph by Roberto D'Ussy.)

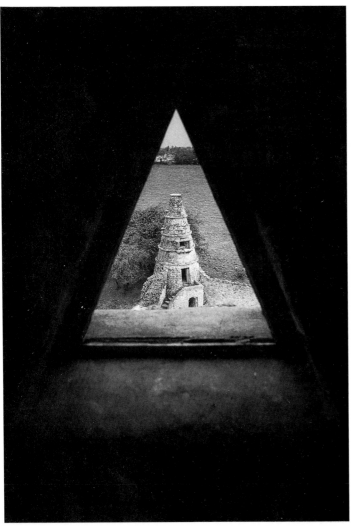

mouldings above all the doors and window openings. A projecting string-course runs around under the window-sills on each storey and the top of the solid balustrade of the staircase is stepped, adding an extra dynamic to the upward spiral movement. The form of the building is strikingly original and seemingly without precedent in any architectural language. A slight similarity exists between it and the minaret of the Great Mosque of Samarra, built in Persia in 847, but there is little possibility that this would have been known in Ireland in the 1740s. There is a date-stone inscribed 1743 and EXECUT'D BY IOHN GLIN; sadly little is known about this imaginative and ingenious man.

The barn stands at one corner of a rectangular, walled courtyard, on two of the other three corners of which are found conical pigeon-houses (plate 339). These are built in a similar manner to the barn, in rendered rubble-stone with roughly hewn stone dressings (plate 338). They stand three storeys high, with domed ground-floor chambers entered through doorways in the side of external stone staircases, which in turn lead up to the domed first-floor rooms. The top storey of each one is a tall cone-shaped volume lined with a honeycomb of nesting boxes, accessible only by a small square opening at high level, which is framed by deeply projecting stone dressings. A series of four stone bands, of shallower projection, encircle the upper half of each cone, terminating in a flat circular cap. Triangular stone ledges for the pigeons to land on are supported on triangular stone brackets, adding a final touch of delight to the upper two string-courses. In their own way, the pigeon-houses are almost as impressive as the barn itself, although the sheer scale of the barn is a major aspect of its uniqueness. Despite their great age, all the buildings survive in a remarkably intact state, as a further tribute to their creator's ingenuity (plate 340).

The barn was built by the Squire's widow Katherine, and, like the obelisk, was a famine relief scheme. Mrs Conolly's generosity was widely acclaimed, and at the time

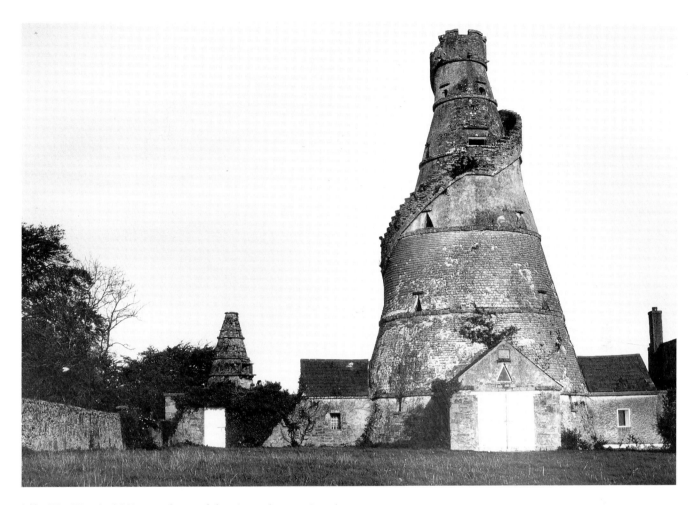

340. The Wonderful Barn and one of the pigeon-houses viewed from outside the courtyard. (Photograph by Roberto D'Ussy.)

of her death was acknowledged by Mrs Delany in a letter of September 1752, in which she wrote, 'her table was open to her friends of all ranks, and her purse to the poor.'[28] The great wealth of the late Squire Conolly's estate obviously demanded large barns to store its produce; the large house he built also required great long vistas, with objects of an appropriate scale to terminate them. Both the obelisk and the barn closed such vistas, and it is reputed that the hunting lodge, which became known as the Hell-Fire Club, can be seen from the house on the south-facing vista.

This deliberate planning becomes particularly clear when viewing the obelisk from the top of the barn; it is easily visible despite the two miles' distance which separates them. The barn was therefore clearly intended to be seen from the park around the house, and was no mere product of function alone. It would also have provided a much-needed vertical element in a county renowned for its flatness. The crow's nest of a gallery at the top of the staircase is almost 65 feet above ground level. This is almost 25 feet higher than the highest accessible point of Conolly's Folly, which must surely have made it one of the highest vantage points in Kildare in the eighteenth century. It is an intriguing thought to speculate on, how this remarkable structure was either conceived or constructed. What drawings were produced for its construction? How did the masons managed to set it out on site? The bird's-eye view is probably the drawing which best demonstrates the marvellous snail-shell complexity of this most singular of buildings (plate 337). It is very unlikely that such a drawing was ever produced at the time of its erection, but one thing is certain—the building is well named!

CONCLUSION

The Unbuilt and the Recent

This book opened with a question of definition, in an attempt to understand what was meant by the term 'folly'. The intention of doing so was to establish early on the difficulty involved in trying to pigeon-hole this most elusive of building types. Follies and garden buildings were built for so many different reasons, both decorative and functional, that neat precise definitions are not easy to establish. In some respects these definitions are so variable that they become meaningless. Such an absence of order and discipline, which could almost be described as anarchic, should not detract from the intrinsic value of the buildings in question. Their freedom from the normal constraints of other more purposeful construction brings an equal freedom of design and expression, much of which has to do with an attempt to please the eye and bring pleasure, unencumbered by the more generally accepted conventions of the day. Innovation is an obvious product of such freedom—the early use of Renaissance motifs, the first accurate Greek order, the first Gothic Revival, the first sham castle—all these appeared in garden buildings.[1] There is also the possibility that a more serious impulse lay behind the creation of some of these buildings—architecture stripped

341. One of the group of recently constructed stone cones at Sneem by the sculptar and glass artist, James Scanlon. (Photograph by James Scanlon.)

back to its essence, as a cave or primitive hut, in a theoretical search for the archetypal building.

Follies and garden buildings represent in many examples 'the architecture of memory', for so many examples celebrate the architecture of ancient civilizations and past achievements. Throughout history, powerful men have striven to control the mortality which will eventually end their power and their heroic deeds. They have done this through the medium of stone, through a variety of creations ranging from great cities and palaces to individual monuments in the form of pyramids, arches, or columns. This practice of emperors and pharaohs has continued in the Western world throughout past centuries up until the present day. The scale and ambition behind their designs often reflects the wealth, power, and degree of self-esteem of the state in question.

During the eighteenth and nineteenth centuries Britain was a major world power, with an economy based on exploiting much of the rest of the globe. Ireland was in one sense neither a colony nor a part of the homeland. Although economically repressed by England, the minority land-owning class lived very well on the backs of the poor, who made up the indigenous majority. Not all landowners were cruel exploiters; indeed, many dedicated the greater part of their lives to the service and improvement of the state of Ireland. Such noble patrons could well afford to be generous when one considers the manner in which they acquired their great wealth. This differed little from other colonial powers of that era, none of which was beyond reproach. It is not, however, the responsibility of this study to pass judgement on their actions, but rather to assess the quality of their achievements in stone.

It has already been noted on several occasions throughout this book that the rich and varied topography of Ireland was ideally suited to the natural style of gardening. This is underlined by the great number of natural-style demesnes which survive in the country, despite the absence of any major figures in the practice of landscape architecture. During this period a great number of Irish-born or Ireland-based architects flourished, among them Lovett Pearce, Gandon, Johnston, and the Morrisons, to name a few, but not one major landscape designer in the manner of Capability Brown or Humphry Repton is recorded. There are also very few examples of the English masters having practised in Ireland, although Brown is reputed to have dismissed an invitation to landscape the Carton demesne by declaring that he had not finished England yet! One can only conclude that the existing terrain was, in most cases, easily transformed into a natural-style demesne by the careful siting of the house and some judicious planting. To this would be added a network of paths to link up with the garden buildings, which were built to provide important points of focus.

The depth of involvement often found between Irish patrons and their architects may also help to explain why so few landscape specialists are known in Ireland before the late nineteenth century. Lord Charlemont and the Bishop of

Derry may have created demesnes with strikingly different characteristics, but they were motivated by a similar desire. They wished to create an artistic showpiece to represent the civilization and values of the classical age, so much admired by both men. It is also significant that these two noblemen appear to have been more interested in the process of creating than in the finished product. Such interested and well-informed landowners would have encountered little difficulty in conceiving designs for their own estates and those of their friends. Many of the lesser buildings previously described are also likely to have been the product of land-owners acting as amateur architects. It is intriguing to consider the degree to which patrons may have influenced the designs of garden buildings attributed to some of the leading practitioners of their day.

A good many original drawings of designs by Irish architects of the first rank survive. What is surprising is that,

342. *Termination*: an eye-catcher design, elevation drawing by Samuel Chearnley. (Courtesy of the Irish Architectural Archive.)

217

one notable unpublished collection does survive and is of sufficient interest to permit a brief digression to consider it. This was the work of one Samuel Chearnley Esq. entitled *Miscelanea Structura Curiosa*, designs from which have already been described. The collection of over fifty designs for garden buildings, along with various larger-scale projects, dates from the mid-1740s and survives at Birr Castle, Co. Offaly. Little is known about Chearnley, other than that he came from Springfield, Co. Waterford, was patronized by Sir Lawrence Parsons, third Baronet of Birr Castle, and died young in 1746 at the age of 29.

The title-page of *Miscelanea Structura Curiosa*, which translates as 'Strange Buildings of All Sorts', sets out its contents like a manifesto:

<div align="center">

Miscelanea

Structura Curiosa

A

Collection of Different Designs, Inventions & Edifices

as

</div>

Ruins	Terminations for Vistows . . .
Grottoes	Temples
Surprises	Triumphal Arches
Cascades	Chimneys
Fountains	Monuments
Bridges	Sections of Halls & Gallerys
Obelisks	Together with Plans & Elevations.
Columns	

<div align="center">

By Samuel Chearnley

Octob. 24th 1745.

</div>

343. *Obelisque*: an eye-catcher design, elevation drawing by Samuel Chearnley. (Courtesy of the Irish Architectural Archive.)

despite the abundance of garden buildings to be found in Ireland, and the suitability of the natural landscape, no collections of designs or pattern-books were ever published there. Such collections were fairly common in England, either as books solely on garden architecture, such as those by Thomas Wright and John Soane, or else as subsections of larger works demonstrating a wider range of the architect's *oeuvre*, as produced by Batty Langley, James Gibbs, and William Chambers. Of the many lesser-known architects' published collections of designs for garden buildings, the one by Thomas Collins Overton is among the most charming. This appeared in 1766 under the title *The Temple Builder's Most Useful Companion*, 'Being 50 Entire New Original Designs for Pleasure and Recreation consisting of Plans, Elevations and Sections in the Greek, Roman and Gothic Taste.'[2]

Although no published collection of Irish designs exists,

This unusual catalogue is of particular interest, as it describes the way in which one eighteenth-century architect decided to entitle and categorize a disparate group of designs for follies and garden buildings. The designs range from refined classical studies to grotesque rustic work, mostly with a greater consideration for the ornamental than the functional. It is likely that the drawings were intended for publication and that Chearnley's patron, Sir Lawrence, played a part in the conception of some of the designs. A substantial article has been written on the collection, identifying some of the sources which may have influenced the designs.[3] While many of the designs are clearly derivative, they are all certainly very competent, with no shortage of wit, humour, and invention. James Gibbs seems to have been a very definite inspiration, not only through his church towers, which greatly influenced some of the 'terminations' (plate 342), but also through several near

copies of garden pavilions from Gibbs's *A Book of Architecture*, published in 1728.[4] There are also influences from Colen Campbell and Inigo Jones, whose work would probably have been known to both Parsons and Chearnley through the other great architectural publication of the day, *Vitruvius Britannicus*.

One of the most unusual designs is for an obelisk (plate 343) consisting of a series of ten diminishing arches stacked on top of each other, greatly resembling a pagoda. Most of the classical designs are in an English Palladian style, into which slight touches of baroque are sometimes introduced, through a ribbed and decorated dome or a profusion of statuary. Typical of Chearnley's small temple buildings is the contents of plate 344. This shows two single-room structures, one plain and square, with a stepped pyramidal roof topped by a statue of Mercury, and the other a domed rotunda with four segmental, arch-topped entrances at the cardinal points.

344. *Temples*: two small temple designs, elevation and plan drawings by Samuel Chearnley. (Courtesy of the Irish Architectural Archive.)

The finest of the temple designs is an elegant two-storey composition, the design of which is attributed to Sir Lawrence, with the drawing by Chearnley.[5] It consists of what appears to be an octagonal gazebo, with an obelisk-topped segmented dome, astride a tall square-planned base on a stepped plinth. The base level is entered through a series of four pedimented entrance arches, flanked by semi-engaged columns. The four legs of the base contain small circular chambers, in one of which rises a spiral staircase, giving access to the upper chamber. As in many of the temple designs in the collection, there is an air of unreality about the plan, which appears unconvincing structurally. It is also highly unlikely that such an expensive design would have been considered without some form of accommodation within it to facilitate some functional or pleasurable activity. Samuel Chearnley does not seem to have been overly enthusiastic about the science of construction, as one of his notes reads: 'NB. The plans & scales of the fore going designs have been omitted as being to depend on the workmans fancy more than any rules.'[6] Such considerations (or the lack of them) tend to support the view that these

designs had no serious intentions beyond the amusement provided by 'paper architecture'.

In his grotesque and rustic designs, away from the more obviously recognizable sources, Chearnley becomes highly original and amusing. Sham ruins are a strange and perverse architectural creation when built, and they seem even more shocking when seen in the premeditated form of a drawing.

346. *Amphitheatre*, possibly a deliberate grotesque parody of the Temple of British Worthies at Stowe: elevation drawing by Samuel Chearnley. (Courtesy of the Irish Architectural Archive.)

345. *Ruin* and *Natural Ruin*: designs for sham ruins, elevation drawings by Samuel Chearnley. (Courtesy of the Irish Architectural Archive.)

Ruin & Natural Ruin are the titles of two such designs, both of which appear only as elevations. The first shows a fragmented portion of an imaginary cut-stone building with a vaguely Romanesque appearance and three large, grimacing masks on the keystones of the arches (plate 345). The second resembles a large pile of rocks, with the ghost of a corner turret and several window openings at high level. A large entrance archway opens up at ground-floor level with the casual appearance and implication of a natural phenomenon, which is the main conceit of the building. In a similar style is the design for an *Amphitheatre in Ruin*. This consists of a tall semicircular wall of rusticated stonework, which is punctuated by tall niches and topped with a circle of grotesque, smirking heads. The heads appear to be attracted by a small robed figure, kneeling on a plinth and making some kind of address (plate 346). Both the composition and detail of this design are highly amusing and may even have been intended as a parody of William Kent's well-known Temple of British Worthies at Stowe.

The final selection of rustic designs falls under the intriguing title of *Surprises* (plate 347). These are mostly small arched structures occupied by a series of either humorous or ominous occupants. Menace is provided by a large brooding bust or a great gnarled head, or in a third example a small, lurking, half-concealed figure waiting to pounce. In another an alligator appears to drink from a pool which is filled by a water-spouting snake. A small dog crouches in a further

arch, while the final surprise is created by the bearded, squatting figure of a man, who, with hat on and breeches down, enjoys a quiet smoke while answering a call of nature. That such a number of amusing rustic designs appear among the more sedate essays in neo-Palladianism is a mark of the range and charm of Chearnley's *Miscelanea*. It is unfortunate that it has never reached a wider audience.

It is perhaps a little harsh to dismiss Chearnley as being merely a provincial amateur architect. His collection, which is much greater in its range of designs and twenty years earlier, is not dissimilar in quality to that of Overton. There is no doubt that many of the designs of both men were plagiarized, but no more so than most of those of more celebrated architects of the eighteenth century. To criticize

the author of these borrowed designs is almost as unfair as criticizing Inigo Jones and William Kent for raiding Palladio, John Soane's 'quotations' from the Temple of Vesta at the 'Tivoli Corner' of the Bank of England, or 'Athenian' Stuart's literal reworking of the Temple of the Winds at Mount Stewart. Through his 'borrowings' Chearnley shows that he was at least in touch with the best of the contemporary architecture of his day.

From such a base, it is possible that with a longer life and the publication of his book he could have developed into an architect of repute. He certainly possessed a good eye for proportion and a fine graphic style, a keen wit, and an inventive playfulness which catches the very essence of many of the best garden buildings. This includes the confidence to try out things one would never contemplate outside a garden: the stacking of diminishing arches on top of each other to create a hybrid between an obelisk and a pagoda, or the isolating of steeples and domes as parts of other buildings

347. *Surprises*: a series of designs for small grotesque niches with a variety of startling occupants, elevation drawings by Samuel Chearnley. (Courtesy of the Irish Architectural Archive.)

to test how they look on their own. Most important of all the aspects of Chearnley's work is the demonstration of the many varied moods and atmospheres such garden buildings can create. From civilized refinement to gay amusement to sublime terror—all endeavour to provide an architecture of *escapism* and *fantasy*, in contrast to the more evocative architecture of *memory*.

Having thus identified the fundamental aspects of memory, fantasy, or escapism, at least one of which underlies the building of most garden structures, the importance of establishing a definition becomes less important, especially when overlaid by the quality of *delight* which seems to invest almost all garden buildings. 'Their only function is to be attractive. Their aim is to give delight, and for this reason the degree of their attractiveness is the only true measure of their success.'[7]

I hope that this study will have shown that delight is only one purpose, albeit an important one, behind the erection of follies and garden buildings, and that the myth of follies being merely frivolous buildings without function should be rejected forthwith. To relegate such buildings to the confines of uselessness and delight is to miss their central role in the creation of an art form of great importance—the natural-style garden. It is also a denigration of their often

348. The recently constructed rustic arbour seat built into a garden wall at Glin.

symbolic and sociologically complex content, the seriousness of intent found in their creators, and the rich talents in the men and women who designed and constructed them. The question of why gardens have become so very important during recent centuries in the Western world is probably best answered by the direct parallel in the steady increase of industrialization and urban growth. One possible answer is found in *Collage City*, where it is suggested that 'The Garden was a criticism of the city and hence a model city.'[8] Vanbrugh's revolutionary designs at Castle Howard were the first time the idea of a garden as a city was literally projected. Its central idea of placing buildings in a garden setting was to influence generations of gardeners to follow and help to create the greatest sustained period of gardening in western Europe, and possibly of all time. Its legacy is found in so many of the great urban parks, which provide pools of relief and calm amid spreading cities. It is almost as if man is forever striving to escape the reality of the crowded urban mess he has created, retreating into an idealized version of his first habitat, which Christian mythology tells us was a garden.

EPILOGUE

Why then did the practice of creating such gardens and their associated garden buildings die out? The answer lies in the socio-economic changes that occurred within the class of individuals who were largely responsible for their creation. By the end of the nineteenth century the upper landowning classes were beginning to experience a decline in their fortunes. Their power base, controlled and concentrated by the practice of primogeniture and generations of stability and continuity, was finally being undermined, first of all by a series of radical liberal reforms, which reduced rental values on their land, and secondly by the tragic consequences of the First World War, which decimated the youth of all classes and led to sweeping changes in the political and social order.[9] In Ireland the decline occurred at an even quicker pace, because of the traditional feuding between landed and landless, which eventually saw the creation of the Irish Republic. Large country houses were still being built in Ireland throughout the Victorian and Edwardian ages, during which time some fine gardens were laid out with interesting garden buildings, like those at Heywood and Ilnacullin.

A combination of the First World War and the Easter Rising in Dublin in 1916 prevented any further additions[10] and accelerated the decline of many of the great patrician demesnes. In the period of civil unrest between 1916 and the establishment of the Irish Free State in 1922, many great houses were burned down and their estates abandoned. Land was subsequently divided up into smaller holdings, resulting in many follies and garden buildings losing all sense of their original context. This has not in all cases led to a diminution of the number of buildings extant. They often appear just as romantic and striking in cultivated land as

349. The late twentieth-century Gothick gate lodge at Leixlip Castle.

they ever did in their original parkland setting. The main problem, however, is one of maintenance, as it is clearly unreasonable for the owners of small or medium-sized farms to accept the repair costs of great stone monuments which they did not wish to inherit in the first place. Many are, if not looked after, at least tolerated in a reasonable way.

Not all the large houses and estates in Southern Ireland disappeared during the turbulent first quarter of the early twentieth century. Apart from the number of great houses open to the public, owned by government, religious or educational establishments, there are a good many estates still in private ownership. A number of these have been described in earlier chapters, and two of them have been adding to their stock of garden buildings in recent years. At Glin the rustic arbour constructed in the mid-1980s (plate 348) is one such modest addition, and others are planned.[11] At Leixlip Castle there have also been several recent additions to the garden architecture. The gate lodge, designed by John Redmill and built in the early eighties, is a battlemented and buttressed two-storey building, in the manner of the nearby Batty Langley lodge to Castletown. It stands on a stepped base and is adorned with simple window mouldings, string-courses, and a series of Gothick windows (plate 349). The fanlights of the windows are blind and cleverly exaggerate the overall scale of the building, despite its low, modern, floor to ceiling heights.

In the garden of Leixlip, behind the castle, are two further and more recent additions. The first of these is a fine Gothick greenhouse by David Sheenan, of rectangular plan with chamfered outer corners, built against a high garden wall (plate 350). A fully glazed roof rises from the walls, which are of brick construction with cobble infill, cast ball finials, and Gothick windows. Almost opposite the greenhouse, across a lawn, stands the most recent arrival. This is a stone tetrastyle portico, which has been salvaged from a demolished house and reconstructed to provide a small temple seat (plate 351). The shallow pediment is supported on four Ionic columns, which stand on a raised plinth, reached by a short flight of steps. Underneath the portico is a marble statue of a winged cupid and a nymph, on either side of which seats are placed. This neat little composition is a successful addition to the garden, and was created to fill a gap caused by the recent loss of a mature tree, which had opened up an unsightly view to a nearby dam. When considered in context the recent building activities of the owners of Leixlip and Glin do not appear so eccentric. Both the owners are acknowledged authorities on eighteenth-century Irish architecture, and through their various efforts within the Irish Georgian Society they have done much to conserve Ireland's eighteenth-century architectural heritage.[12]

Apart from these additions in the gardens of Glin and Leixlip, there have been few other projects for garden buildings in recent times in Ireland. The neoclassical revival which is slowly emerging in England has had few advocates in Ireland. One exception is found at Mount Temple, near Russborough, Co. Wicklow.[13] This building started as a small classical villa, and has subsequently been extended by the addition of wings and a primitive hut-style stable building, complete with telegraph pole columns and horseshoe triglyphs. Another revivalist example is found in the delightful terraced garden of Kildrought House, on the banks of the River Liffey in Celbridge, Co. Kildare. At the top of the garden the Dutch gable of a new single-storey cottage can be seen, which successfully complements the fine early eighteenth-century house and provides a charming eye-catcher from the garden[14] (plate 352).

Surprisingly, for a country with such a rich heritage of

350. The late twentieth-century Gothick greenhouse in the garden of Leixlip Castle.

351. The recently erected temple seat in the garden at Leixlip Castle, incorporating a salvaged nineteenth-century Ionic portico.

fine garden architecture, there have been few instances of modern buildings following the genre. One notable exception is the unfortunate Moylurg Tower, a large, crude, reinforced concrete composition which was erected in Lough Key in the 1970s (plate 353). Built as a prospect tower on the site of Nash's now vanished Rockingham House, it embodies the function if not the spirit of its eighteenth- and nineteenth-century predecessors.[15] In more recent years there have been a few projects from Ireland's emerging generation of young architects. Shane O'Toole's unbuilt

352. A dutch-gabled eye-catcher cottage, recently constructed in the garden of Kildrought House. (Photograph by William Stewart.)

353. Moylurg tower, Rockingham: a rare example of twentieth-century brutalism in a natural-style demesne.

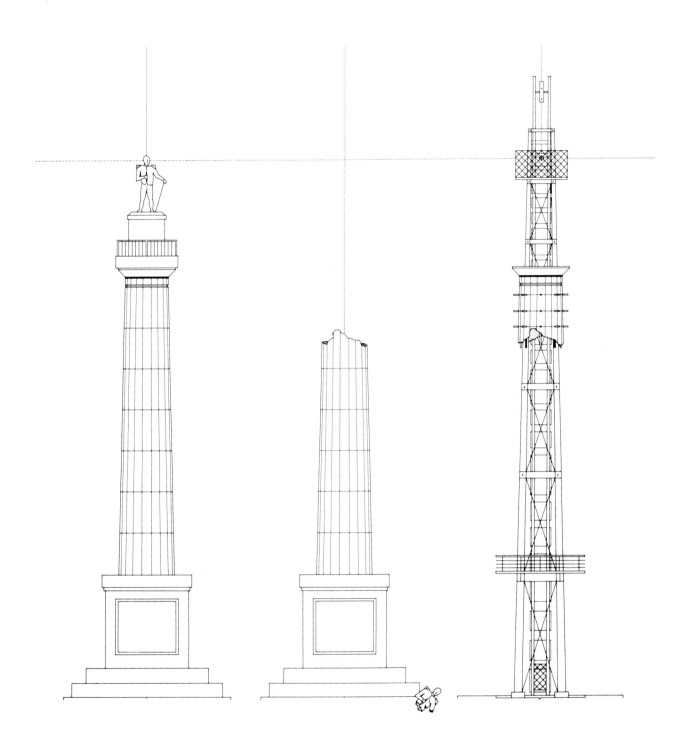

354. *The Pillar Project*, O'Donnell, Tuomey, and Egan's proposed replacement for the demolished Nelson's Column in Dublin. (Drawings of elevations, courtesy of O'Donnell Tuomey.)

Greek Revival mausoleum is one such example, and Paul Keogh's Avonmore Pavilion at Dublin Zoo is another.[16] The latter is a pleasant essay in a modern rationalist style, the tower of which is typical in scale and simplicity of many small garden structures. It was constructed in 1988 as a demonstration milking-parlour for children.

Also in 1988, to mark the Dublin millennium, an exhibition was arranged by Shane O'Toole for the design of a replacement for Nelson's Column on its original site in O'Connell Street, Dublin. Entitled *Collaboration: The Pillar Project*,[17] the rules demanded that the entries be jointly designed as a collaboration between an architect and a sculptor. The project was a purely hypothetical excercise, with little likelihood of any of the schemes being built; even so, the entries were few and the results generally disappointing. Of the schemes which did manage to capture the real essence of what was being sought, the joint entry of Felim Egan, Sheila O'Donnell, and John Tuomey was the most interesting (plate 354).

This amusing proposal was for a modern column consisting of a tall curving steel lattice, from which various elements were supported, corresponding to the original one. At the base level, in line with the top of the original plinth, there was to be a speaking gallery for addressing public meetings. Higher up the structure a stone capital and a fragment of shaft, modelled on the earlier column, were to be supported as an historic reminder of its predecessor. Crowning the structure, a viewing gallery was proposed, with a telescope corresponding to Nelson's eye level. Overall their design was an accomplished and witty solution, very much in the spirit of many follies and garden buildings.[18]

One quite remarkable group of recent structures created by the sculptor James Scanlon, with the help of local labourers and stonemasons, certainly deserves inclusion. The work, which is situated in the small Kerry village of Sneem, was sponsored by a modest Arts Council grant and consists of four stone structures, three pyramidal and one conical in form. Built of carefully selected rubble stone, with deeply recessed joints, they combine elements of early Christian construction from Gallarus and Skellig with the geometry and scale of Thomas Wright (plate 341). Despite these ancient associations the structures are unmistakably modern through the installation of beautiful coloured glass, the medium through which Scanlon's reputation was originally established during the 1980s.[19]

Apart from this small number of revivalist and modern projects, there have been few additions to the quota of follies and garden buildings in Ireland since the First World War. Added to this is the reality that many of the existing crop are fading quietly away, unnoticed and unprotected. For a number of complicated reasons (the explanation of which is not appropriate to this study) many consider the efforts of conservationists to be futile, given the general lack of

interest in the architecture of this period. The problem is more acute in the Republic of Ireland than in Northern Ireland, where state funding, Department of the Environment controls, and the activities of the National Trust have resulted in a relatively more optimistic situation.[20] Of all the eighteenth- and nineteenth-century building types found throughout Ireland, follies and garden buildings are without doubt the most neglected. This is not only the result of their smallness of scale, ambiguous purpose and ownership, but also because of the attitude of many historians, who have generally tended to disregard them as serious works of architecture. In Britain a happy band of enthusiasts came together under the title of the Folly Fellowship to focus attention on follies and garden buildings, fight for their preservation, and challenge the general public's indifference. The organization, which was founded in 1987, is now a regisered charity and since its instigation there has been a steady increase of interest in the subject.[21]

The excellent work and success of English Heritage and the National Trust, the latter of which includes many fine properties in Northern Ireland, clearly demonstrate a successful strategy. This not only safeguards houses and gardens of historical importance, but also provides valuable resources for local amenity use and tourism. The problem of finding uses for many of the potentially habitable follies and garden buildings has been cleverly addressed by the Landmark Trust, which operates in England, Scotland, and Wales.[22] Realizing that the original intention of many of these buildings was to provide pleasure, the Trust carefully restores its buildings for that very purpose and then lets them for short-term holiday use. In a country with such dependence on tourism as Ireland, the possibilities for similar usage seem obvious.[23] Without the benefit of occupants, permanent or transitory, remote follies or garden buildings will always be subject to vandalism. The Irish Georgian society has learned this to its cost at both the Dromana Gateway and the Dawson Mausoleum. In both cases the buildings suffered severe damage through vandalism after repair and restoration had taken place.

It is a cruel irony that buildings which, at the time of their inception, deliberately projected a romantic air of antiquity and ruination, have now inherited an authentic mantle of decay. In many instances, it can no doubt be argued that they have reached a climax, a short-lived but ideal state. If indeed we do believe that the classical ruin represents a triumph of barbarism over taste and the Gothic ruin a sense of epic and timeless myth,[24] how should we interpret the ruination of sham ruins and false antiquity? Perhaps as a triumph of apathy and neglect over appreciation? Certainly it represents the loss of something rather special and quite unique, which, in this more socially prosperous but architecturally impoverished age, we are unlikely to find either the patronage or the inspiration to repeat.

355. Lady Dawson's Mausoleum, designed by James Wyatt
Built circa 1770
Destroyed by vandals circa 1960
Repaired by the Irish Georgian Society circa 1961
Photographed 1988

High Towers, fair Temples, goodly Theatres,
Strong Walls, rich Porches, princely Palaces,
Large Streets, brave Houses, sacred Sepulchres,
Sure Gates, sweet Gardens, stately Galleries,
Wrought with fair Pillars, and fine Imageries:
All those (O pity!) now are turn'd to Dust,
And over-grown with black Oblivion's Rust.

From Edmund Spenser, *Ruins of Time*[25]

Notes

INTRODUCTION

1. Edited by John Musgrove, 1989; now greatly increased in size, with 1600 pages and 1700 illustrations.
2. Barbara Jones, *Follies and Grottoes*, p. 1.
3. Stuart Barton, *Monumental Follies*, p. 9.
4. Roger White, *Georgian Arcadia*, p. 9. This fine little booklet was the catalogue of an exhibition to mark the golden jubilee of the Georgian Group.
5. Ibid.
6. Ibid.
7. *Shorter Oxford English Dictionary*, 1980 ed. p. 781.
8. Kenneth Clark, *The Gothic Revival*, p. 65.
9. *Oxford English Dictionary*, 2nd ed., 1989, vol. VI, p. 4.
10. Ibid.
11. Mark Bence-Jones, *Burke's Guide to Country Houses*, vol. I, *Ireland*, p. 28.
12. Godwin's reputation also suffered as a result of his elopement with the actress Ellen Terry. His client's son, the fourth Lord Headley, travelled to Mecca and became a Muslim. The house was finally burnt in 1922. Mark Bence-Jones, *Burke's Country Houses: Ireland*, p. 136.
13. Gothick with a K refers to the eighteenth-century Georgian version, and should not be confused with true medieval Gothic or the nineteenth-century Gothic Revival.
14. David Watkin, *The English Vision*, p. 52.
15. Barbara Jones, *Follies and Grottoes*, p. 1.
16. John Harris in Julia Abel Smith, *Pavilions in Peril*, p. 3.
17. Mariga Guinness, 'The (Deliberate) Follies of Ireland', *Ireland of the Welcomes*, 20, no. 5. Jan.–Feb. 1972, pp. 19–25.
18. John Harris in a lecture at the Architectural Association, London, 16 February 1989.
19. David Jacques, *Georgian Gardens*, p. 12.
20. Swift's poem *The History of Vanbrugh's House* of 1708 includes the lines: 'Van's genius without thought or lecture / Is hugely turned to Architecture.'
21. *Genius loci* literally translated means the (tutelary) spirit of the place.
22. Earlier, seventeenth-century shell-rooms were created, such as those at Woburn Abbey and Skipton Castle. These were generally decorated rooms within the main house or lodge, rather than detached or newly created structures.
23. Frank Mitchell, *Reading the Irish Landscape*, p. 185.
24. Ibid., p. 186.
25. DOENI, *Historic Monuments of Northern Ireland*, p. 46.
26. Frank Mitchell, *Reading the Irish Landscape*, p. 186.
27. The geometrical pattern has now disappeared, but a drawing of it survives and is illustrated in *Lost Demesnes*, p. 22.
28. Edward Malins and the Knight of Glin, *Lost Demesnes*, p. 3.
29. Title of chapter 3 of *The English Vision: The Picturesque in Architecture, Landscape and Garden Design*, by David Watkin.

30. *The Complete Works of Sir John Vanbrugh*, vol. IV, *The Letters*, ed. G. Webb, p. 30. For an illustration of the romantic engraving of the manor prior to its demolition see Geoffrey Beard, *The Works of John Vanbrugh*, p. 106.
31. Hall and Bartlett are good nineteenth-century examples and Thomas Wright's *Louthiana* is an excellent eighteenth-century example.
32. Thomas Mulvany, *The Life of James Gandon*, 1846, reprinted 1969, ed. Maurice Craig, p. 234.
33. Ibid.
34. James Gandon, *On the Progress of Architecture in Ireland*, reprinted in the 1969 edition of Mulvany's *Life*, pp. 259–60.
35. Edwards Hyams, *Irish Gardens*, p. 22.
36. The full title is *Lost Demesnes: Irish Landscape Gardening 1660–1845*.
37. See Pearce's Drawings at Elton Hall, Wright's *Louthiana* and *Universal Architecture*, Charlemont's papers, Royal Irish Academy, etc. A selection of Mrs Delany's letters was published in 1991 as *Letters from Georgian Ireland*.
38. See Eileen Harris's three articles on Thomas Wright in *Country Life*, 26 August to 9 September 1971, and also *Thomas Wright: Arbours and Grottos*.
39. See John Harris, 'Sir William Chambers, Friend of Charlemont', *IGSB*, July 1965, pp. 67–100.
40. Preserved in the library of the Royal Irish Academy, Dublin.

CHAPTER 1 OBELISKS AND COLUMNS

1. Richard Hewlings, 'Ripon's Forum Populi', *Journal of the Society of Architectural Historians of Great Britain*, 24, 1981.
2. Sir Banister Fletcher, *History of Architecture*, p. 37.
3. See Peter Tomkins, *The Magic of Obelisks*.
4. *The Magic of Obelisks*, p. 13.
5. Ibid. A full account of this feat is contained in chapter 2.
6. Manuscript in Blenheim's Long Library.
7. Hewlings, 'Ripon's Forum Populi'.
8. G. N. Wright, *Ireland Illustrated*, p. 24.
9. Howard Colvin and Maurice Craig, *Drawings in the Library of Elton Hall by Sir John Vanbrugh and Sir Edward Lovett Pearce*, p. 4.
10. G. N. Wright *Ireland Illustrated*, p. 24.
11. M. Craig, Malins and Glin, R. White, among others.
12. F. E. Ball, *History of Dublin*, vol. I, p. 125.
13. Malins and Glin, *Lost Demesnes*, p. 41.
14. Some repointing of this obelisk has been carried out in recent times.
15. One of these appears in a view of Dangan by Bartlett on the title-page of volume II of his *Scenery and Antiquities*.
16. Desmond Guinness, *Castletown*, Irish Georgian Society guide book.
17. *Architecture of Britain 1530–1830*, p. 228.

18. *Irish Georgian Society Bulletin*, VI, no. 4, Dec. 1963, p. 61.
19. Ibid. p. 63.
20. Ibid. p. 61.
21. The society was founded in 1958 and one of its original founders, the late Mariga Guinness, is buried underneath the western arch.
22. Hall's *Ireland*, p. 337.
23. E. McParland and others, *The Architecture of Richard Morrison and William Vitruvius Morrison*, p. 155. William Morrison also designed the Skinner Monument accross the Irish Sea at Holyhead on a Roman rostral theme; see p. 106.
24. Mark Bence-Jones, *Burke's Country Houses: Ireland*, p. 66.
25. Hall's *Ireland*, p. 337.
26. G. N. Wright, *Ireland Illustrated*, p. 16. 'Mr. Smirke', later Sir Robert, went on to design the British Museum.
27. Smirke's design sketches for the obelisk survive in the RIBA Drawings Collection, London, one of which shows the importance of the omitted equestrian statue of Wellington.
28. James Stevens Curl, *The Art and Architecture of Freemasonry*, p. 190.
29. Mulvany's *Life of Gandon*, ed. Craig, p. 275.
30. National Library Dublin; published in *Irish Architectural Drawings*, ed. M. Craig and D. J. V. Fitzgerald.
31. Bartlett, *Scenery and Antiquities*, pp. 152–3.
32. Bolger and Share, *And Nelson on his Pillar*, p. 11.
33. David Griffin informs me that fragments of the inscription on the base of the column survive in Kilkenny.
34. Peter Pearson, *Dunlaoghaire Kingstown*, p. 135.
35. E. M. Forster, *Alexandria: A History and a Guide*, p. 161.
36. Later to become Government House and now official residence of the Secretary of State for Northern Ireland and visiting members of the Royal Family.
37. George Cunningham, *Burren Journey West*, p. 71.
38. P. W. Joyce, *Pocket Guide to Irish Place Names*.
39. The column was taken down in 1989 and re-erected in the middle of Chesterfield Road, its original position, during 1990. The work was carried out under the supervision of the Board of Works.
40. Tortoise support details of this nature were common in Renaissance times and several examples of the type exist in England. *Irish Architectural Drawings* catalogue, p. 13.
41. E. M. Forster's excellent guide to Alexandria (pp. 160–1) includes a rather disparaging description of 'Pompey's Pillar' and provides a translation of the inscription to Diocletian on the base which reads: 'To the most just Emperor, the tutelary God of Alexandria, Diocletian the invincible: Postumus, prefect of Egypt.'
42. See Con Costello, 'Pompey's Pillar in Wexford', *IGSB*, XIX, nos 1–2, Jan.–June 1976, pp. 1–9.
43. Colvin and Craig, *Elton Hall Drawings*, no. 244.
44. M. Craig, 'Sir Edward Lovett Pearce', *IGSB*, XVII, nos 1–2, Jan–June 1974, pp. 10–14.

CHAPTER 2 GROTTOES AND SHELL HOUSES

1. Edmund Burke, *A Philosophical Enquiry into the Origins of our Ideas of the Sublime and Beautiful*, London, 1757.
2. Naomi Miller, *Heavenly Caves*, p. 11.
3. Ibid. p. 20.
4. There are many of these shrines in Ireland, where one also finds several examples of artificial caves constructed on the side of Roman Catholic churches to represent the Resurrection of Christ, such as those at St Paul's, Arran Quay, Dublin, and St Mary's, Chapel Lane, Belfast.
5. In ten books; it is the second oldest surviving architectural treatise after Vitruvius.
6. Alberti, *Ten Books of Architecture*, Book IX, ch. IV, ed. Joseph Rykwert, p. 192.
7. See the excellent GLC catalogue *Alexander Pope's Villa*, London, 1980; it accompanied an exhibition at Marble Hill House, Twickenham.
8. Mrs Delany, *Autobiography and Correspondence*, vol. II, p. 2.
9. Probably Ireland's earliest obelisk.
10. M. Craig, 'Edward Lovett Pearce', *IGSB*, XVII, nos 1–2, Jan.–June 1974, pp. 10–14.
11. F. E. Ball, *History of County Dublin*, vol. I, p. 123.
12. Mrs Delany, *Autobiography and Correspondence*, 1861–2. Some of Mrs Delany's work at Delville is illustrated in plates 10 and 11 of C. P. Curran, *Dublin Decorative Plasterwork*, London, 1967.
13. Ibid. vol. I, pp. 342–3.
14. Ibid. p. 275.
15. Ibid. p. 361.
16. Ibid. p. 363. Her affectionate coded dedication reads 'I will secretly dedicate it to you know who. If not 'tis time you should and every looking glass can inform you.'
17. Tufa is a generic name for naturally occurring rock with a vesicular appearance, which resembles frozen bubbles. There are two main types, volcanic and calcareous, the richly textured surfaces of which were much prized by grotto builders.
18. M. Bence-Jones, *Burke's Country Houses: Ireland*, p. 277.
19. Barbara Jones, *Follies and Grottoes*, p. 430.
20. Mairead Johnston, *Ice and Cold Storage: A Dublin History*, published privately by Autozero Ltd, Dublin, 1988, p. 46.
21. In the National Library of Ireland.
22. These drawings of 'curious building of all sorts' are in the Birr Castle collection.
23. Malins and Glin, *Lost Demesnes*, p. 87.
24. Both father Richard and son William 'Vitruvius' are thought to have worked on the design; see the Irish Architectural Archive monograph, *Richard Morrison and William Vitruvius Morrison*, E. McParland and others.
25. Analysis by the Geological Survey of Ireland.
26. Barbara Jones, *Follies and Grottoes*, p. 95.
27. Mrs Delany, *Autobiography and Correspondence*, vol. I, p. 483.
28. Gaston Bachelard, *La poétique de l'espace*, Paris, 1957, translated into English by M. Jolas as *The Poetics of Space*, 1964; see chapter 5, Shells.
29. Malins and Glin, *Lost Demesnes*, p. 42.
30. A photograph of the structure with the pinnacles intact occurs in *The Archaeological Survey of County Down*, Belfast, 1966.
31. Barbara Jones, *Follies and Grottoes*, p. 95.
32. Ibid. p. 157.

CHAPTER 3 HERMITAGES AND RUSTIC ARCHES

1. Thomas Wright, *Universal Architecture*, London, 1755 and 1757; reprinted in *Thomas Wright: Arbours and Grottos*, ed. Eileen Harris, 1979.
2. *AA Illustrated Road Book of Ireland*, p. 176, and D'Alton, *History of Ireland*, p. 77.
3. A photograph of one such effigy, the Hawkstone Hermit, appears in Roger White, *Georgian Arcadia*, p. 14.
4. Barbara Jones, *Follies and Grottoes*, p. 184.
5. Mrs Delany, *Autobiography and Correspondence*, vol. II, p. 492.
6. Mrs Delany's sketch of the Beggar's Hut at Delville and Thomas Santelle Roberts's drawing of the Root House, Marino,

both illustrated in Malins and Glin, *Lost Demesnes.*

7. A. Atkinson, *Ireland Exhibited to England*, London, 1823.
8. Mark Bence-Jones, *Burke's Country Houses: Ireland* p. 229.
9. Thomas Wright, *Arbours and Grottos*, The Method of Executing Plate M.
10. See Eileen Harris in her edition of *Arbours and Grottos.*
11. Malins and Glin, *Lost Demesnes*, p. 74.

CHAPTER 4 TOWERS

1. M. Craig, *The Architecture of Ireland: From the Earliest Times to 1880.*
2. Ibid. p. 34.
3. Entasis is a deliberate swelling in the middle of a column shaft, designed to counteract the optical illusion which gives a shaft bounded by straight lines the appearance of curving inwards.
4. T. Wright, *Louthiana*, Book III, plates XIV, XV, and XVI.
5. Ibid. Book III, p. 18.
6. Henry O'Brien, *The Round Towers of Ireland*, London, 1834.
7. *Hall's Ireland*, vol. III, pp. 200–4.
8. These structures sometimes appear as 'Fire Towers' on Ordnance Survey maps.
9. A brief insight into life in a converted Martello tower during the early years of the twentieth century has been left by the tower's most celebrated occupant, James Joyce. The tower in which *Ulysses* opens, at Sandycove near Dunlaoghaire, is now a Joyce museum.
10. Archie Gordon Craig, *Towers*, p. 9.
11. Maurice Craig, *Architecture of Ireland*, p. 97.
12. Gaston Bachelard, *Poetics of Space*, chapter 7, Miniature.
13. Ibid. p. 173.
14. Illustrated in Malins and Glin, *Lost Demesnes* p. 9.
15. Collection of the Hon. Desmond Guinness.
16. Collection of the Hon. Desmond Guinness.
17. I have been told that the cupola survives in the town of Kells.
18. Folklore tells that this was caused by a ravenous devil who, on finding his snack unpalatable, spat it out onto the plain below to form the Rock of Cashel.
19. G. Cunningham, *Burren Journey West*, p. 78.
20. Encouragingly Scrabo Tower has been restored and reopened to the public in recent years.
21. Later first Marquess of Dufferin and Ava.
22. This is a perspective pen-and-wash drawing of the tower very much as built. As the upper stories of the tower were lavishly furnished and used by the Dufferin family, it seems unlikely that the building was ever used as a gamekeeper's lodge. Harold Nicolson describes cooking smells coming from the caretaker's kitchen, and an earlier and simpler design by Burn, entitled Ballyleidy Sketch for Gamekeeper's House and Tower, also survives in the RIBA Drawings Collection. This suggests that the earlier intention to use the structure for a gamekeeper's residence was changed in favour of the more important commemorative associations.
23. See Gavin Stamp in *Helen's Tower*, UAHS *Clandeboye* 1985.
24. Alfred, Lord Tennyson, 1861. Lady Dufferin died in 1867 after an unsuccessful fight against cancer.
25. 'June 21st 1847 To my Dear Son on his 21st Birthday with a Silver Lamp Fiat Lux.' Lady Dufferin also wrote the lyrics of the popular song *The Lament of the Irish Emigrant.*
26. Harold Nicolson, *Helen's Tower*, p. 138.
27. Ibid. p. 141.
28. A photograph of the tower can be seen in the UAHS publication, *The Architectural Heritage of Malone and Stranmillis*, by Paul Larmour, 1991, p. 175.

29. Mark Bence-Jones, *Burke's Country Houses: Ireland*, p. 248.
30. Charles Brett in *East Down*, UAHS (p. 10) believes the base may be fifteenth-century.
31. *Dictionary of National Biography*. The date inscribed appears to be 1820 but is more likely to be 1840 or 1850.
32. Charles Brett, *Glens of Antrim*, UAHS, pp. 34–6.
33. One of the brothers has informed me that the drawbridge survives in storage down at the main house.
34. It is possible that the tower was deliberately constructed to appear as a ruin. Several details would support this, but it is difficult to be sure as the building is at least 150 years old and has suffered from neglect in recent years.
35. Maurice Craig, *Architecture of Ireland*, p. 282.

CHAPTER 5 GATES AND LODGES

1. Tim Mowl and Brian Earnshaw, *Trumpet at a Distant Gate: The Lodge as Prelude to the Country House.*
2. Ibid. p. vi.
3. Ibid. p. xii.
4. Gate lodges were often spared the fate of many Irish country houses, which fell to arson attacks during the 1920s.
5. Maurice Craig, *Architecture of Ireland*, p. 168.
6. Thomas Wright, *Arbours and Grottos*; see the illustration of a drawing for Wallingford in the Catalogue of Works.
7. Maurice Craig, *Architecture of Ireland*, p. 248.
8. See illustration in Mark Bence-Jones, *Burke's Country Houses: Ireland*, p. 212.
9. The estate was sold by UCD in 1990.
10. Mariga Guinness, *Ireland of the Welcomes*, 20 no. 5, p. 20.
11. The drawing is in the Castletown Collection and is illustrated in Guinness and Ryan, *Irish Houses and Castles*, p. 20. There are similarities between this design and Robert Adam's entrance to Syon House on the Thames to the west of London.
12. Coade stone was an early type of artificial cast stone manufactured in London from 1769 onwards. A successful and quite convincing substitute for carved stone, its formula was kept secret and is now lost.
13. Edward McParland and others, *Richard Morrison and William Vitruvius Morrison*, p. 86. Plate 76 shows the arch in a painting by William Turner.
14. These are attributed to Sir William Chambers and are similar in detail to the lead sphinx at Lord Burlington's Chiswick House.
15. Mark Bence-Jones, *Burke's Country Houses: Ireland*, p. 229.
16. Brian de Breffney, *The Houses of Ireland*. p. 178.
17. From the Dufour company of Paris.
18. The cottage had been subjected to much vandalism and deterioration until its recent restoration in 1989. It is now open to the public as a National Monument under the care of the Office of Public Works.
19. Frank Mitchell, *IGSB*, XXX, 1987, p. 53.
20. Alistair Rowan, *North-West Ulster*, pp. 161–2. The building was apparently used as a school at one time.
21. John Harris, *Sir William Chambers*, plate 196.
22. For more on this interesting subject see Joseph Rykwert, *On Adam's House in Paradise.*
23. One of these was a Corinthian garden temple for his son-in-law, the fourth Earl of Fitzwilliam; see John Harris, *Sir William Chambers*, p. 239.
24. There is in fact a striking resemblance to the proportion and configuration of Inigo Jones's Tuscan portico for St Paul's church, Covent Garden.

25. J. Rykwert, *On Adam's House in Paradise*, p. 140. 'I am chiefly interested in the "other" house. This may be a house which had once existed, before heroic or divine intervention turned it to stone; it may involve a hut still standing, which had "in the first days" been inhabited by god or hero; most commonly it is a rite of building huts which in some way resembled or commemorated those which ancestors or heroes had built at some remote and important time in the life of the tribe. In every case they incarnate some shadow or memory of that perfect building which was before time began: when man was quite at home in his house, and his house as right as nature itself.'
26. Maurice Craig, *Architecture of Ireland*, p. 319.
27. Ibid.
28. Bucrania are carved representations of ox skulls, which sometimes appear as decorative motifs on Doric friezes.
29. Donald Girvan, *North Derry*, UAHS, pp. 57–8.
30. The building, which had fallen into disrepair in the 1960s, was extensively restored by the Irish Georgian Society. Since then it has suffered further attacks of vandalism.
31. M. Bence-Jones, *Burke's Country Houses: Ireland*, p. 28.
32. The roof has now gone and the lodge is derelict, but it recently enjoyed a brief revival and superficial restoration when it was used as a location for a comedy feature film about ghosts called *High Spirits*.
33. Hall's *Ireland*, vol. II, p. 170.
34. A drawing of the rear elevation of the barbican survives and can be seen in McParland's *Richard Morrison and William Vitruvius Morrison*, p. 100.
35. Mark Bence-Jones, *Burke's Country Houses: Ireland*, p. 136.
36. C. Brett, *Glens of Antrim*, p. 13.
37. Drawing by A. Nicholl from Hall's *Ireland*, vol. III, p. 131.
38. Bartlett, *Scenery and Antiquities*, vol. I, p. 32.
39. Batty Langley, *Gothic Architecture Improved*, plate LVII.
40. The building has undergone recent restoration. Gate lodges generally suffer a better fate than most other follies as they are potentially habitable.

CHAPTER 6 FORTS AND SHAM CASTLES

1. Thomas Wright, *Louthiana*, Book I plate II.
2. *Rural Architecture* 1835, originally published 1833–4 in two volumes under the title *Domestic Architecture: A Series of Designs in the Grecian, Italian and Old English Styles*.
3. Mark Bence-Jones, *Burke's Country Houses: Ireland*, p. 136.
4. E. McParland and others, *Richard Morrison and William Vitruvius Morrison*, p. 42.
5. Department of the Environment, Northern Ireland, *Historic Monuments of Northern Ireland*, pp. 121–2.
6. Barbara Jones, *Follies and Grottoes*, pp. 73–4.
7. The text of Bartlett's *Scenery and Antiquities* begins with embarkation at Donnaghadee, which is described as a picturesque and flourishing port, a sign that at that time it was still competing with Belfast as the main sea route to mainland Britain.
8. Arthur Young, *Tour of Ireland*, entry for 28 June 1776, p. 10.
9. Mrs Delany, *Autobiography and Correspondence*, vol. I, p. 406.
10. The exact date of this is unknown but is thought to be around 1744; the manuscript is in Armagh Public Library.
11. Hall's *Ireland*, vol. II, p. 377.
12. Ibid.
13. Mark Bence-Jones, *Burke's Country Houses: Ireland*, p. 100.
14. Mrs Delany, *Autobiography and Correspondence*, vol. III, p. 513.
15. Drawing in Hillsborough Castle.

CHAPTER 7 RUINS AND EYE-CATCHERS

1. *The Complete Works of Sir John Vanbrugh*, vol. IV, *Letters*, ed. G. Webb, pp. 29–30.
2. *Castle Ward*, National Trust Guide, 1982.
3. See Alistair Rowan, *North-West Ulster*, p. 248 and p. 138.
4. *The Vanishing Country Houses of Ireland*, by the Knight of Glin, David Griffin, and Nicholas Robinson, provides a sad record of the loss.
5. Ruined houses often feature in the many photo books on the Irish countryside, of which *In Ruins: The Once Great Houses of Ireland*, by Simon Marsden and Duncan McLaren, is the most atmospheric I have come across. It includes three follies—the Lawrencetown Eye-catcher, the Rosmead Gates, and Conolly's Folly.
6. Joseph Rykwert, *On Adam's House in Paradise*, p. 103.
7. See John Harris, *Sir William Chambers*, plate 7, and David Watkin, *The English Vision*, p. 52.
8. Antoine Grumbach, 'La théâtre de la mémoire', *Architectural Design*, 48, no. 8/9, 1978, pp. 2–5.
9. Ibid.
10. Mrs Delany, *Autobiography and Correspondence*, letter to Dean Swift of 24 October 1733, vol. I, p. 421.
11. McCullough and Mulvin, *A Lost Tradition: The Nature of Architecture in Ireland*, plate 231.
12. An ANCO scheme carried out the work in the mid-1980s with the help of the Irish Garden Plant Society, but the great labour required to maintain the Jekyll borders was considered unpractical.
13. Malins and Bowe, *Irish Gardens and Demesnes from 1830*.
14. Malins and Glin, *Lost Demesnes*, n. 54, p. 102.
15. 'Sacred to Aeolus and the winds.' (Aeolus was the demi-god who controlled the winds.)
16. 'Sacred to the spirit of a peaceful place.'
17. Alexander Pope, *Epistle to Lord Burlington*.
18. Leo Daley, *Titles*, London, 1981, pp. 42–67.
19. Mrs Delany, *Autobiography and Correspondence*, vol. II, pp. 278–9, contains a letter from Mrs Delany in which she describes dining with Lord Belfield and notes the story of his wife's intrigue and incarceration.
20. L. Daley, *Titles*, p. 59.
21. Unfortunately the high winds of more recent years have brought down some sections of the wall, which is now fenced off for safety reasons.
22. John Barry, *Hillsborough*, pp. 1–2.
23. Ibid. plate 1.
24. Having been vandalized, burnt, and on the market for some time, the cottage has recently been purchased and its restoration is planned.

CHAPTER 8 GAZEBOS AND SUMMER-HOUSES

1. *Oxford English Dictionary*, 2nd ed. 1989, vol. XVII, p. 176.
2. Ibid. vol. VI, p. 411.
3. Mark Bence-Jones, *Burke's Country Houses: Ireland*, p. 240.
4. Patrick Conner, 'Britain's First Chinese Pavilion', *Country Life*, 25 June 1975, pp. 236–7.
5. Ibid.
6. A rare example of architectural salvage moving westwards across the Irish sea.
7. At Stowe the National Trust is planning to restore the building and relocate it onto a platform in the upper lake of the Japanese garden, linked to the shore with an iron bridge. (National Trust Thames and Chilterns Region, *Newsletter*, Autumn 1992.)

8. Most of the painting appears to have been reworked or over-painted at some time. This recent work is of a very poor standard.

9. Thomas Wright, *Louthiana*, Book III plate XVIII.

10. This is known as Port Vantage and records exist to show that the Bishop tried to blast the rock on the valley floor to create a harbour.

11. *Downhill*, National Trust Guide.

12. W. H. Bartlett, *Scenery and Antiquities*, vol. II, p. 169.

13. G. N. Wright, *Guide to Co. Wicklow*, p. 45. He also mentions a rustic temple nearby: 'This little temple being composed of unbarked wood and not being attended to, is fast going to ruin.'

14. Colvin and Craig, *Architectural Drawings in the Library of Elton Hall*.

15. This structure may have been built in Pearce's day and later adapted to the mid-eighteenth-century building which survives today; see Alistair Rowan, *North-West Ulster*, p. 223.

16. *Irish Georgian Society, Newsletter*, Spring 1986, pp. 1–3. The society has commissioned a survey of the condition with the aim of instigating some emergency repairs, but these have not yet been carried out. One slight improvement however, is that the thick forest of fir trees which until recently surrounded the structure has now been cleared.

17. See illustration in Maurice Craig, *Architecture of Ireland*, pp. 183–4.

18. The architect of the gazebo, like the converted fort/garden-house, is not known, but its fine composition and detailing suggest that an accomplished hand designed both buildings. Sanderson Miller has been suggested (Alistair Rowan, 'Georgian Castles in Ireland,' *IGSB*, VII, no. 1, Jan.–Mar. 1964, pp. 2–30), but no clear evidence has emerged to confirm this.

19. Pike's *Dublin* of 1908 includes a photograph of the gazebo complete with urns on the piers of the balustrade.

20. David Griffin informs me that the Dromoland gazebo originally contained murals of racehorses.

CHAPTER 9 TEMPLES

1. John Michell, *City of Revelation*, London, 1972, p. 30.

2. The Old Testament Book of Ezekiel.

3. See Joseph Rykwert, *On Adam's House in Paradise*, chapter 5. Guides at St Sophia, Istanbul, claim that several of the columns used in the construction of the sixth-century basilica were salvaged from the Temple of Solomon. Although some of the columns have been salvaged, connections with the biblical building are fanciful.

4. Jones's drawing of Stonehenge restored, along with a geometrical analysis of the plan, were published by his pupil John Webb in 1655.

5. There are numerous books on the subject, of which Alfred Watkins, *The Old Straight Track*, is considered by devotees to be the seminal work.

6. James Ackermann, *Palladio*, London, 1966, p. 19.

7. Andrea Palladio, *Quattro libri dell' Architettura*, Venice, 1570. A translation was published in 1738.

8. The final bastardization has now taken place, with giant-order columns, pediments, and entablatures constructed in glass-reinforced plastic.

9. A. Palladio, *Quattro libri*, trans. J. Ware, Book II, chapter XII, p. 47: 'since the city is as it were but a great house, and on the contrary, a country house is a little city.'

10. John Harris, Architectural Association lecture, 16 February 1989.

11. Ibid.

12. Colvin and Craig, *Architectural Drawings in the Library of Elton Hall*. This note refers to the construction (timber) and spacing of the columns, systylus being two column diameters and diastylus three as prescribed by Vitruvius.

13. Alistair Rowan, *Garden Buildings*, p. 1.

14. Mark Bence-Jones, *Burke's Country Houses: Ireland*, p. 113.

15. Maurice Craig, *Architecture of Ireland*, p. 196.

16. A. Rowan, *Garden Buildings*, p. 11.

17. *Rudiments Of Ancient Architecture Containing an Historical Account of the Five Orders, with their Proportions, and Examples of Each from Antiques*, London, 1789; 3rd ed. printed for J. Taylor, 1804.

18. Ibid. p. 61.

19. M. Bence-Jones, *Burke's Country Houses: Ireland*, p. 222.

20. A glass-reinforced plastic dome was added by the Irish Georgian Society in 1991, effectively restoring the building when viewed from a distance, but not so effective when seen from close quarters.

21. A contemporary watercolour by Gabriel Beranger, illustrated in Malins and Glin, *Lost Demesnes*, p. 18, shows the temple in its original setting on a spiral ramped mount.

22. Mark Bence-Jones notes that the temple was demolished in the 1940s in *Burke's Country Houses: Ireland*, p. 101. A photograph survives in the Irish Architectural Archive and is illustrated in *Lost Demesnes*, plate 46.

23. 'It looks down on the roofs of the city.'

24. In the National Gallery of Ireland.

25. The drawing survives in the National Library of Ireland and is illustrated in Edward McParland's *James Gandon, Vitruvius Hibernicus*, plate 195.

26. Mrs Delany, *Autobiography and Correspondence*, vol. II, p. 563.

27. Frank Mitchell, 'The Evolution of Townley Hall'; *IGSB*, XXX, 1987, pp. 1–61. Plate 23b illustrated the unsigned sketch of the 'bathhouse'.

28. Pierre du Prey, 'Je n'oublierai jamais: Sir John Soane and Downhill', *IGSB*, XXX, nos 3–4, July–Dec. 1978, pp. 17–40.

29. The drawing is entitled 'Plan of a Dog House Designed For a Nobleman Romanae.' Exhibited at the Royal Academy in 1781. An interesting design drawing for a 'dogg-house' by Edward Lovett Pearce survives in the Elton Hall Collection.

30. The design of the structure as built is credited to Michael Shanahan of Cork.

31. Mark Bence-Jones, *Burke's Country Houses: Ireland*, p. 229.

32. *Castle Ward*, National Trust Guide, 1982, p. 4.

33. Mrs Delany, *Autobiography and Correspondence*, vol. IV, p. 21.

34. *Castle Ward*, National Trust Guide.

35. The undergrowth is now so thick that it is impossible to determine if any of the remains of the grotto survive.

36. Malins and Glin, *Lost Demesnes*, p. 111.

37. M. Bence-Jones, *Burke's Country Houses: Ireland* and *Lost Demesnes*.

38. In the Burlington-Devonshire Collection. Illustrated in *Garden Buildings*, by Alistair Rowan, p. 10.

39. This appears in Guinness and Ryan's *Irish Houses and Castles*, p. 94.

40. See Peter Rankin's *The Irish Building Ventures of the Earl Bishop of Derry*, 1972.

41. Now owned by the National Trust. The Bishop never saw this house even in an uncompleted state.

42. Batoni's portrait has a church spire and Madame Vigée-Lebrun's depicts the Bishop beside the base of a giant column with Mount Etna in the background. A miniature by an unknown artist has a similar background, with the Bishop holding a plan of Ballyscullion.

43. Brian Fothergill, *The Mitred Earl*, pp. 32–4.
44. Quoted in 'The Mussenden Temple Downhill' by Michael McCafferty in *Plan Magazine*, March 1970.
45. The Bishop's position opposed that of Lord Charlemont on this matter and is related in Hardy's *Life of Charlemont*, vol. II, p. 131.
46. Dryden's translation from Lucretius, De *Rerum Natura* (2.1–2). A literal translation reads: 'When the winds are throwing the seas into confusion in the great ocean, it is sweet to watch from land the great hardship of others.'
47. Michael McCafferty, *Plan Magazine*, no. 1, March 1970, pp. 16–18.
48. The many Bristol Hotels on the Continent were named in honour of his patronage.
49. Also from the diary of Mr Justice Day.
50. The Knight of Glin, *The Temple of the Winds*, National Trust Guide, 1966, p. 3.
51. Ibid.
52. As Foreign Secretary he played a major role in the Congress of Vienna 1814 and the Peace of Paris 1815.
53. Howard Colvin, *Biographical Dictionary*, pp. 793–7.
54. Ibid.
55. A. E. Lawrence, *Greek Architecture*, Harmondsworth, 1957, p. 237.
56. *Mount Stewart*, National Trust Guide, p. 25.
57. Ibid.
58. A. E. Lawrence, *Greek Architecture*, p. 237.
59. H. W. Hyde, *The Rise of Castlereagh*, London, 1933.
60. *Mount Stewart*, National Trust Guide, p. 29.
61. *The Temple of the Winds*, National Trust Guide, 1966.
62. Maurice Craig, *Architecture of Ireland*, p. 196.
63. John Summerson, *Architecture of Britain 1530–1830*, p. 247.
64. John Harris, 'Sir William Chambers: Friend of Charlemont', *IGSB*, VIII, no. 3, Jul.–Sept. 1965, p. 67.
65. Francis Hardy, *Life of Charlemont*, vol. I, p. 52.
66. A full account of all Chambers's commissions for Lord Charlemont is to be found in the excellent IGSB article by John Harris mentioned above in n. 64.
67. See Maurice Craig's *The Volunteer Earl*, 1948.
68. Hardy, *Life of Charlemont*, vol. II, p. 167.
69. Ibid.
70. *A Treatise on Civil Architecture, in which the Principles of that Art are laid down, and Illustrated by a great Number of Plates, Accurately Designed, and Elegantly Engraved by the best Hands*, 1759.
71. R. Middleton and D. Watkin, *Neoclassical and 19th-Century Architecture*, p. 167.
72. Ibid.
73. John Harris, *Sir William Chambers*, p. 40.
74. John Summerson, *Architecture of Britain 1530–1830*, p. 258.
75. James Gandon was a pupil of Chambers in London and Gandon's great Irish commissions were largely due to Chambers's recommendations and an introduction to a group of influential Irish peers which included Charlemont.
76. John Harris, *Sir William Chambers*, p. 44.
77. The Casino was the first eighteenth-century building to be adopted as a national monument by the Irish Government in the 1930s. It was reopened to the public in 1984 after a ten-year programme of restoration work.
78. *The Charlemont Correspondence*, Historic Manuscripts Commission, London, 1891–4.
79. John Harris, *Sir William Chambers*, pp. 42–5.
80. John Harris, 'Sir William Chambers: Friend of Charlemont', *IGSB*, VIII, no. 3, July 1965, p. 99.
81. Drawings of this survive and a plan and section appear in *The Origins of the Gothic Revival* by Michael McCarthy, plates 17 and 148.
82. A legal case was fought in the late eighteenth century opposing the construction of Marino Crescent, which spoiled the sea view from the Marino demesne: see M. Craig, *The Volunteer Earl*, pp. 201–2.
83. See Michael Wynne, 'The Charlemont Album', *IGSB*, XXI, nos 1–2 Jan.–June, 1978, pp. 1–6.
84. Ibid. These drawings are in the collection of Mr and Mrs Paul Mellon at the Yale Center for British Art.
85. The restoration costs are hard to estimate exactly as much of the work was carried out by the Board of Works. £750,000 is an approximate figure.
86. Several epitaphs by Charlemont appear in Hardy's *Life*, including one for Joshua Reynolds and a very long one to the Marquess of Rockingham. His epitaph for Chambers is the most eloquent.

CHAPTER 10 MAUSOLEUMS

1. Maurice Craig, 'Mausoleums in Ireland', *Irish Historical Studies*, LXIV, Winter 1975, pp. 410–23.
2. Ibid. p. 410.
3. Banister Fletcher, *A History of Architecture*, 12th ed. 1945, p. 123.
4. See chapter 3 of Howard Colvin's *Architecture and the Afterlife*, 1991.
5. *Oxford English Dictionary*, 2nd ed., 1989, vol. II. p. 1028.
6. Conolly's Folly, a memorial to Speaker Conolly, is now the last resting-place of Mariga Guinness, one of the co-founders of the revived Irish Georgian Society.
7. Paul Larmour, *Belfast: An Illustrated Architectural Guide*, p. 105.
8. Collection of the Ulster Museum, Belfast.
9. I have known this place well from my earliest years, since when it has always been a great delight and never remotely frightening.
10. The fourth mausoleum was unfortunately demolished during some rather thoughtless tidying up of the graveyard in the mid-1980s. The inscription had long since become illegible.
11. P. Larmour, *Belfast: An Illustrated Architectural Guide*, p. 105.
12. Maurice Craig, 'Mausoleums in Ireland', p. 413.
13. Another one of the excellent Ulster Architectural Heritage Society publications, Belfast, 1978.
14. Maurice Craig, *Dublin 1660–1860*, p. 331.
15. The headless statue now stands in the charming garden of the gate lodge just inside the Bishop's Gate.
16. Pierre du Prey, 'Je n'oublieray jamais: John Soane at Downhill', p. 19.
17. 'Trusting in God he died * Our hope is in God alone.'
18. Thomas Wright, *Louthiana*, Book I plate XVIII.
19. Ibid. p. 11.
20. Ibid.
21. Ibid. p. 12.
22. Edward Hyams, *Irish Gardens*, p. 129.
23. Clochans are corbelled dry-stone constructions resembling beehives in appearance, which were built during the Early Christian Period.
24. *AA Illustrated Road Book of Ireland*, p. 122.
25. Alistair Rowan, *North-West Ulster*, p. 194.
26. The composition is very like Thomas Wright's design for a mount on the lawns, with a temple and grotto, for Badminton. The Castle Barn is also very similar in detail to the garden walls at Larch Hill, but it is unlikely that there is any connection other than coincidence.
27. The drawings survive in the National Library of Ireland and are illustrated in Craig and Fitzgerald, *Irish Architectural*

Drawings, plate 69, and E. McParland's *James Gandon*, plates 25 and 94.

28. Edward McParland believes these drawings to be early design sketches for the Church of St John the Evangelist, Coolbanagher, with the possibility that the church was initially conceived as a mausoleum; see *James Gandon Vitruvius Hibernicus*, pp. 98–102.
29. Ibid. plate 52.
30. Howard Colvin, *Biographical Dictionary*, p. 941.
31. E. McParland and others, *Richard Morrison and William Vitruvius Morrison*, p. 136.
32. A photograph of this can be seen in Craig and Glin's *Ireland Observed*, p. 38.
33. A fine photograph of the almost complete sculptural group appears in *IGSB*, IV, no. 1, Jan–March 1961, p. 15. Alas this is now in pieces, having been severely vandalized.
34. Collection of the Hon. Desmond Guinness.

CHAPTER 11 BRIDGES

1. Sadly at the time of writing the rapid decline of the quays continues unabated, with the senseless destruction of eighteenth-century houses. This unique river front will soon be totally abandoned to memory and old photographs. The most recent decline is chronicled in Frank McDonald's excellent book *Saving the City*, Dublin, 1989; see pp. 24–5.
2. Contemporary views are well recorded by Malton, Bartlett, and others, and can still largely be enjoyed from the bridges today.
3. The cascade survives but the modern planting and paths are not appropriate and fail to understand the original 'natural' intentions.
4. *Thomas Wright: Arbours and Grottos*, ed. Eileen Harris, Tollymore section.
5. Ibid. Wright spent eight days at Tollymore in August 1746.
6. Ibid. Wallington section.
7. Numerous examples can be found in the books of early photographs, or in the excellent *Emerald Isle Albums* published by William Lawrence; see especially *The Glens of Antrim*, 1912.
8. Forest and Wildlife Service, *Lough Kee Forest Park*, guide.
9. Mulvany's *Life of James Gandon*, ed. Craig, p. 282.
10. Maurice Craig, *Dublin 1660–1860*, p. 247.
11. Ibid. The original did however include eight obelisks; see *James Gandon* by E. McParland, plate 71, p. 117.
12. The collection is now partly exhibited in the Municipal Art Gallery in Lord Charlemont's town house in Parnell Square. As Lane's bequest condition that the collection be housed in a purpose-built gallery was never met, it is shared and rotated between Dublin and London.
13. The impressive cornice evident in the Lawrence print has now been substantially reduced in size.
14. M. Craig, *Dublin 1660–1860*, p. 300.
15. Michael Barry, *Across Deep Waters*, pp. 26–7.
16. The private waiting-rooms are now occupied by a restaurant and there are plans to clear the undergrowth and create a walk.
17. Harold Nicolson, *Helen's Tower*, p. 222.
18. Ibid. p. 223.
19. Ibid. p. 224.
20. W. B. Yeats, *Irish Fairy and Folk Tales*, London, 1893, p. 140. The quotation goes on, 'On solitary mountains and among old ruins he lives, "grown monstrous with much solitude," and is of the race of the nightmare.'
21. J Stirling Coyne in Bartlett's *Scenery and Antiquities of Ireland*, vol. II, p. 178.

22. Ibid.
23. Ibid.
24. Ibid.
25. Hall's *Ireland*, vol. II, p. 200.
26. Ibid.
27. Mark Bence-Jones, *Burke's Country Houses: Ireland*, p. 28.
28. Probably John Keily's nearby Strancally Castle at Knockamore, designed by James and George Richard Pain around 1830.

CHAPTER 12 THE ECCENTRICS

1. Barbara Jones, *Follies and Grottoes*, pp. 227–47.
2. See Royal Irish Academy, *Atlas of Ireland*, p. 40.
3. Bartlett's *Scenery and Antiquities*, plates entitled Killiney Hill and Killiney Bay, facing pages 162 and 163 of vol. II.
4. This obituary is very much in the style of others by Lord Charlemont and as he is reputedly the designer of the pyramid it is likely that he also wrote the inscription. It reads: 'Temple of Courage. You were a monument of the best beloved George Browne. The arms of this man were formerly the great glory and protection of his country. He has lived his life. AD 1750.'
5. Malins and Glin, *Lost Demesnes*, p. 141.
6. *Thomas Wright: Arbours and Grottos*, ed. Eileen Harris.
7. Barbara Jones, *Follies and Grottoes*, p. 93.
8. Mark Bence-Jones, *Burke's Country Houses: Ireland*, p. 114.
9. John Summerson, *The Classical Language of Architecture*, p. 131.
10. There are apparently quite a number of different points claimed as the 'geographical centre' of Ireland.
11. Alistair Rowan, *North-West Ulster*, p. 291.
12. Graham Rose in a *Sunday Times Colour Magazine*.
13. The bones are reputed to have come from the midden of an encampment of Shane O'Neill; A. Rowan, *North-West Ulster*, p. 164.
14. Thomas Wright, *Louthiana*, Book III title-page.
15. *AA Illustrated Road Book of Ireland*, p. 259.
16. Mairead Johnston, *Ice and Cold Storage: A Dublin History*, published privately by Autozero Ltd Dublin 1988.
17. Office of Public Works.
18. Kiernan Hickey, *The Light of Other Days*, London, 1973, p. 145. The building has recently come onto the market with the estate agent's suggestion that it would make a good holiday residence.
19. Maurice Craig, *Dublin 1660–1860*, p. 154.
20. Constantia Maxwell, *Dublin under the Georges*, pp. 98–9.
21. M. Craig, *Dublin 1660–1860*, p. 154.
22. Ibid.
23. C. Maxwell, *Dublin under the Georges*, p. 291.
24. Tim Buxbaum's fine book *Scottish Garden Buildings* subtitled *From Food to Folly* is highly recommended.
25. It is possible that Castles also designed the octagonal pigeon-house at Castle Hume, Co. Fermanagh, described in A. Rowan's *North-West Ulster*, p. 185.
26. F. E. Ball, *History of County Dublin*, vol. II, p. 135.
27. Plate 104 of *Ireland's Eye: The Photographs of Robert John Welsh*, Belfast, 1977.
28. Mrs Delany, *Autobiography and Correspondence*, vol. III, p. 158.

CONCLUSION

1. Alistair Rowan, foreword to *Garden Buildings*.
2. Identical versions of the collection were also published under the title *Original Designs of Temples, and Other Ornamental Buildings for Parks and Gardens, in the Greek, Roman and Gothic*

Taste; see Howard Colvin, *Biographical Dictionary of British Architects*, p. 603.

3. Christine Casey in her article entitled 'Miscelanea Structura Curiosa' in the *Irish Arts Review*, 1991, pp. 85–91.

4. Gibbs's two designs on plate 77 of his *A Book of Architecture*, for Lord Cobham at Stowe, seem to have been particularly influential, with details from them appearing in several Chearnley designs for temples.

5. Entitled simply *Temple* it is inscribed with the note: 'This temple was first intended to the top of a high hill.' The drawing is also signed 'S^r Lawrence Parsons Ba^rt, In^t. Sam^l Chearnley Delin^t.'

6. Inscribed at the foot of the page entitled *Grottoe* which contains a plan, section and elevation of a small rotunda.

7. A. Rowan, *Garden Buildings*, p. 1.

8. Colin Rowe and Fred Koetter, *Collage City*, Cambridge, Mass., 1978, p. 175.

9. For a full account see David Cannadine's *The Decline And Fall of the British Aristocracy*, London, 1990.

10. In his autobiography *Architect Errant*, the Welsh architect Clough Williams-Ellis (the creator of Portmeirion) regrets the abandonment of his one and only Southern Ireland commission, 'A most romantic project... on the lovely shores of Bantry Bay... for Lady Kitty Somerset.' The project was abandoned after workmen had been shot at and the contractor jailed (p. 162). This period coincided with the civil unrest which occurred around the time of independence.

11. On a visit to Glin in 1989 I inspected a full-scale two-dimensional timber and canvas mock-up of a small battlemented tower; this was being moved around from place to place to help determine the most appropriate location.

12. Both Desmond Guinness and the Knight of Glin have published numerous books on Irish eighteenth-century architecture. The Hon. Desmond Guinness was a co-founder of the revived Irish Georgian Society and for many years its. President. He has recently stepped down and has been succeeded by the Knight of Glin.

13. Also to the design of John Redmill.

14. There is also a very recently constructed brick and glass orangery-style building with brick piers displaying entasis.

15. I have received unconfirmed reports that there are plans to demolish the tower, which, if carried out, will probably make it the shortest-lasting prospect tower in Ireland.

16. See *New Irish Architecture I*, 1986, pp. 30–1 and *New Irish Architecture III*, 1988, pp. 34–5, published by the Architectural Association of Ireland.

17. The entries to the competition were published in a booklet entitled *Collaboration: The Pillar Project*, Dublin, 1988.

18. See *Collaboration: The Pillar Project*, pp. 24–6 for more details.

19. See *Works 1*, '*James Scanlon Sneem*', Dublin, 1991.

20. Many Northern Irish conservationists would no doubt dispute this, pointing out numerous cases of insensitivity towards the preservation of old buildings. Many such buildings in the province have also suffered from the effects of the civil unrest of the last twenty years.

21. The organization was the brainchild of Gwyn Headley and Wim Meulenkamp (co-authors of *Follies: A National Trust Guide*, an extensive gazetteer of British follies), along with the architect Andrew Plumridge. The Folly Fellowship now has a membership in excess of 1000, a small number of whom are from Ireland, which falls within its scope of interest. Quarterly magazines are produced and garden parties periodically arranged at interesting folly venues. Their official manifesto is to preserve, protect, and promote follies, grottoes, and garden buildings.

22. This excellent body was set up by Sir John Smith in 1965 and is generally recognized as one of the leading conservationist bodies in the country. Approximately 200 'minor but handsome buildings' have been saved from demolition, vandals, or decay to be enjoyed by hundreds of short-term occupants every year.

23. Encouragingly an Irish Landmark Trust has recently been founded to pursue a similar conservation philosophy to the Landmark Trust. At the time of writing the organization remains very much in its infancy. It is to be hoped that it will achieve similar successes to its British forerunner.

24. Joseph Rykwert, *On Adam's House in Paradise*, p. 103.

25. This quotation appears on the title-page of Thomas Wright's *Louthiana*. Our neglectful attitude to old buildings in Ireland seems to have changed little since 1758.

Gazetteer

This gazetteer is a first attempt at trying to identify the full range of follies and garden buildings constructed in Ireland. It is arranged by province and county and includes only those structures which survive, or for which some record survives to confirm their existence. Buildings known to have vanished completely at the time of writing, or for which only a trace survives insufficient to convey the form of the building, will be shown in *italics*. An asterisk* denotes a building which has been mentioned in the text and a dagger † indicates a building I have heard about but not confirmed at the time of writing. Brief descriptions are provided only for buildings not mentioned in the text. This list does not pretend to be comprehensive. With the large numbers involved, it may include many inaccuracies. These will occur even among the buildings I have visited during the lengthy period of research which preceeded the writing of this study, such is the unfortunate speed of decay. I will therefore welcome any additions or corrections the reader may wish to submit, which should be sent to me at my practice address at 66 Southwark Bridge Road, London, SE1 OAS.

*	building described in text
Italics	building no longer existing
†	building not yet confirmed

The spelling of counties and towns in this gazetteer follows that used by the Irish Architectural Archive.

CONNAUGHT

Co. Galway

Ballinasloe	Mausoleum: a Doric, open, tempietta-style structure on a high plinth containing a sarcophagus.
Clarinbridge	Gazebo.†
Clonbrock House	Cottage *orné*: a heather-thatched single-storey cottage with rustic columns.
Garbally Court	Obelisk.*
Lawrencetown	Volunteer Arch: gateway.*
	Gothick eye-catcher.*
	Eye-catcher cottage.*
Portumna Castle	Gates: a fine Gothic Revival gateway with stout column-clustered piers topped with elaborate pinnacles.
	Dog's memorial: an inscribed stone plaque on castle.
Tyrone House	Mausoleum of the St George family.

Co. Leitrim

Hatley Manor	Mausoleum.*
	Summer-house.*

Co. Mayo

Ashford Castle	Castellated bridge.*
	Towers and castellated outworks in the garden, similar in design to bridge.
Ballymacgibbon	Tower allegedly built for Sir William Wilde, father of poet and playwright Oscar.†

Hollymount House	Memorial urn to a horse.†
Killala	Grotto: fragments of Mrs Delany's C18 creation.*
	Knox's folly: an impressive eye-catcher in roughly coursed stone, consisting of a series of pinnacled, cross-vaulted flying buttresses.
Neale	Doric temple.*
	Step pyramid.*

Co. Roscommon

Ballydangan	Eye-catcher cottage: a curved gable end with a round window above central door, flanked by harp-shaped windows; built as an ice-cream parlour in the mid-1930s.
French Park	Circular-planned pigeon-house.
Kilronan	Hermitage gate lodge.*
	Rustic arch: a tripartite archway entrance with grotesque stonework like the nearby hermitage gate lodge.
Mote Park	Gateway: a fine lion-topped triumphal arch with engaged Doric pilasters and entablature.
Mount Talbot	Gateway: a modest, classical, triumphal-arch entrance with a central carriageway flanked by side openings.
Rockingham	Sham castle (MacDermot's Castle).*
	Sham castle (Cloontykilla Castle).*
	Fairy bridge.*
	Tiara gate lodge.*
	Gazebo.*
	Moylurg tower.*
	Gothic gate house: an elaborate battlemented structure with Gothic windows spanning a driveway.
	Ornamental dairy.†

Co. Sligo

Enniscrone	Gothick bathing pavilion.*
Hazelwood House	Grotto.†
Markree Castle	Sham castle/castellated entrance gateway.*
	Gate lodge: a small battlemented symmetrical lodge with central carriageway.
Rosses Point	Tower: a small square structure with stepped battlements and first-floor windows.
Sligo	Metal Man, similar to the one at Tramore, at entrance to harbour.

LEINSTER

Co. Carlow

Borris House	Tower: a squat, square-planned, battlemented structure forming part of the office wing.
Duckett's Grove	Gateway: a most impressive and extensive double entrance range with numerous battlemented towers, machicolations, and a portcullis.

236

Erindale	Ornamental Gothick barn with miniature obelisks.
Oak Park	Mausoleum.*
	Gateway: a triumphal-arch entrance with pairs of engaged Ionic columns on high plinths.

Co. Dublin

Abbeville	Ornamental dairy: a fine classical design by James Gandon.
	Gate lodge: Gothic-style with half-octagon front.
Ballybrack	Pyramid: Duke of Dorset's monument *circa* 1830.
Ballymount	Sham ruin on a mound sketched by Barbara Jones; it also appears in Ball's *Dublin*, and is thought to be from the seventeenth century.
Belcamp	Washington Tower.
Blackrock	Ardlui: Spite Tower.*
	Bathing temple at Maretimo.*
	Bridge: Egyptian-style railway bridge at Maretimo.
	Gazebo: the shell of a hexagonal brick structure with pointed-arch openings in fine seaside setting originally Blackrock House.
	Shell house, C20.†
Brooklawn	*Grotto: a small unadorned grotto now in the grounds of King's Hospital School.*
Carrickmines	Barrington Tower square planned C19 Gothic tower.
Clontarf/Marino	Casino.*
	*Gothic temple.**
	*Gothic seat.**
	*Root house.**
Clontarf/St Anne's	Temple: a Pompeian-style water temple beside lake.
	Gothick bridge and hermitage beside cascaded stream.
	Grotto: a rustic grotto with a view towards Hill of Howth.
	Sham ruin over entrance drive.
	Herculanean dwelling with an authentic statue of a Roman soldier excavated from Herculaneum.
	Sham Druidic circle with stones taken from Giant's Causeway.
	Roman monument: a replica of the Tomb of the Julii at St Rémy.
Clonskeagh Castle	Thompson's Tower.†
Crumlin	*Summer-house: an interesting pepper-pot structure with an octagonal turret reached by an external stair, perched on a square base. Dated 1795 in Ball's Dublin.*
Dalkey	*Hayes Tower.**
	Cement sailor: a painted C19 figure with capstan and anchor.
	Telegraph tower.†
Delville	*Temple.**
	*Hermitage.**
Drumcondra	Temple.*
Dublin	Sham ruin, Custom House garden possibly fragments of Parnell Squart Sedan-chair men shelters mentioned below.*
	*Nelson's Column.**
	*Royal visit archway.**
	Temple: Trinity College Printing House.*
	Clock-tower, Trinity College: a French-style campanile of 1855 by Charles Lanyon.
	Rustic pavilion, St Luke's Hospital grounds: a large heather-clad garden house with cast-iron Gothic-style windows fine shell and pebble work, moss covered ceiling and split came decoration built in 1861, now semi ruined.
	Summer-house: St lukes Hospital, a Squat pebble dashed single storey structure built in 1908 with chimney and unusual thatched finial.

	Temple-style shelters for sedan-chair men in Parnell Square, appear in Malton's view of Charlemont House.
	Summer-house at Simmonscourt Castle: a fine nineteenth-century octagonal pavilion with Ionic columns, French windows, and a slated roof.
Dublin Zoo	Avonmore pavilion.*
	Ice-house entrance: a pedimented brick entrance with raised brick courses to imply rustication.
Dunlaoghaire	Obelisk to mark George IV's visit.*
	Lifeboat house on the East Pier, designed in a primitive Greek style.
	Anemometer: a small plain structure in a primitive Greek style, built into the wall of East Pier.
Farmleigh	Clock-tower.*
Glasnevin Cemetery	Tower: O'Connell memorial replica of an Irish round tower.
Howth	Tower: a three-storey embattled structure at Howth Lodge Hotel.
Islandbridge	War memorial: an extensive classical layout by Lutyens with stepped pyramidal tempiettas and columned screen.
Killiney	Obelisk.*
	Small cone.*
	Step pyramid.*
	Spite Tower.*
	Sham Druidic ruin: a crude circle of standing stones and Druid's seat.
	Tea-rooms/tower: a neat stone square-planned structure with deep projecting eaves.
Kilmainham	Gateway: a castellated archway by Francis Johnston.
Knockmaroon	Gazebo.†
Lucan	Cold bath: simple pedimented structure in tufa.
	Sarsfield memorial.*
Luttrellstown	Temple/cold bath.*
	Rustic arch.*
	Tower: an embattled round tower with deep stepped corbels, connected to the house by a screen wall.
	Obelisk commemorating Queen Victoria's picnic.
	Rustic gate lodge.*
	Ice-house entrance.*
	Rustic pavilion: a hexagonal timber structure with branch, pebble, and shell-work patterns.
	Grotto appears on early C19 Ordnance Survey map.
Marlay	*Cottage orné: a thatched Gothick cottage survives in an 1834 pencil drawing by Anne La Touche.*
Mount Jerome	Mausoleums: many fine examples in Dublin's principal cemetery, a very modest version of Père Lachaise in Paris.
Mount Merrion	*Gothick summer-house appears in William Ashford's 1805 watercolour.*
	Rustic temple appears in William Ashford's 1805 watercolour.
	Obelisk.†
Mount Pelier	Hell-Fire Club.*
Newlands	*Grotto.*
Phoenix Park	Wellington obelisk.*
	Phoenix column.*
Portrane Asylum	Sham round tower: C19 round tower 100 feet high, containing commemorative busts.
Rathfarnham	Bottle tower.*
	Pigeon-house.*
Rathfarnham Castle	Dodder lodge.*
	Hermitage.†
	Sham castle.†
	Temple: an impressive circular two-storey structure with a Doric loggia running round at ground-floor level.

Rathfarnham/ Danesmote	Rustic bridge.*
	Rustic arch: simple archway like the bridge.
	Rustic seat: semi-ruined like the bridge.
	Gateway: a small cut-stone pedestrian gateway.
Rathfarnham/ St Enda's	Gazebo: a plain single-storey building, with external steps leading up to the roof.
	Hermitage.*
	Rustic arches, large and small, crude Gothic arches.
	Tower.*
	Emmet's fort.*
	Rustic obelisk.*
	Druid's seat.*
Santry Court	*Temple: an open octagonal rotunda now at Luggala.*
	Pillar: a Gothic-style memorial to an Arab stallion.
	Bridge: a fine classical bridge with stone balusters and lions couchant on terminating piers; now much altered.
Shanaghanagh Castle	*Monumental column reconstructed from various fragments of classical Antiquity; erected by Sir George Cockburn in 1832, later moved to Sissinghurst, Kent.*
Skerries	Obelisk, Hamilton monument: a modest plain obelisk on a high stepped base.
Stillorgan	Obelisk.*
	Grotto.*
Tallagh	Rustic archway with large grotesque voussoirs.
Terenure House	Rustic boat-house.†
Turvey House	Grotto.*
Woodbrook	Sham temple: the re-erected portico from the Royal College of Physicians, Dublin.

Co. Kildare

Belan	Eagle obelisk.*
	Column obelisk.*
	Temple.*
	Gazebo: a semi-ruined two-storey hexagon with stone quoins.
	Chinese bridge: a highly elaborate two-arched foot-bridge.
	Grotto with shell and mineral decoration.
	Hermitage, dore-house, and Gothic temple, along with the Chinese bridge and grotto, appear on an estate map of 1774.
Carton	Tower.*
	Shell house.*
	Boat-house: a steep-gabled lakeside structure with ornate bargeboards.
	Bridge.*
	Umbrellas with rustic cast-iron columns like the shell house.
	Ornamental privy: a small timber structure in Chinese style.
	Ornamental dairy, also by Thomas Ivory.
Castletown	Conolly Folly.*
	Wonderful Barn.*
	Pigeon-houses.*
	Temple.*
	Batty Langley lodge.*
	Sphinx gates.*
Celbridge/ Kildrought	Eye-catcher/cottage gable*
	Orangery: a small C20 brick and glass structure; piers constructed with entasis.
Furness House	Column formerly at Dangan, now in a vista to the front of the house.
Harristown House	Chinese tea-house now returned to Stowe.*
Hill of Allen	Tower: a tall plain round tower with religious inscriptions, built in 1860.
Kilcurran	Donnelly's hollow obelisk: a small obelisk commemorating the early C19 boxer, Dan Donnelly.

Kildare	Shell cottage.*
Kilkea Castle	Gazebo.†
Leixlip Castle	Gazebo/boat-house.*
	Gothick gate lodge.*
	Gothick conservatory.*
	Temple seat.*
Leixlip/ St Catherines	Shell house/grotto: a small tufa chamber with shell-encrusted pinnacle.
	Gothic stable yard.†
Lyons House	Gateway.*
	Column: on garden front a small ornamental column topped with statue of Venus.
	Pavilion seats: Chinese, mid-C19, in cast iron.
Moone	Ornamental factory.†
Moore Abbey	Gateway: a fine symmetrical castellated Gothic-style entrance.
Oldtown	Tower and turret.†
Palmerstown	Sham castle.†
	Dog's memorial.†
Tully	Japanese tea-house in fine early C20 allegorical Japanese garden.

Co. Kilkenny

Ballyragget	Pigeon-house.†
Belline House	Rustic gate lodge.*
	Pepper-pot pavilions: a pair of large circular structures with conical roofs and three levels of stone-dressed window openings; function unclear.
Castle Blunden	Gothick ice-house.*
	Summer-house built of cane in woods behind house.
	Ornamental earth closet.†
Castlecomer House	Ardra tower.†
Kilfane	Bushe fountain.*
Kilkenny (near)	Gazebo: a large ruined two-storey octagon with arch-headed windows.
Piltown	Ponsonby tower.*
	Holy well: a fine cut-stone structure with large rusticated voussoirs; contains a bench seat.
Shankill Castle	Gateway: a large castellated entrance with an attached lodge similar to the one at Johnstown Castle.
	Gothick conservatory with ogival-headed windows above a stone-columned loggia.
Woodstock	*Rustic pavilion: Lady Louisa's summer-house with twig-pattern decoration, bones, and antlers.*

Co. Leix

Ballyfin	Grotto.*
	Tower.*
	Templar gate lodge with eagle topped gate-piers.
Bellegrove	*Italianate conservatory by Sir Thomas Dean.*
Castle Durrow	Gateway: an impressive castellated entrance.
Emo	Gazebo.*
	Portarlington mausoleum, Coolbanagher churchyard.*
Heywood	Gateway: an embattled entrance arch flanked by octagonal asymmetrical towers.
	Sham ruins.*
	Sham castle.*
	Summer-house (C19).*
	Summer-house (C20) by Lutyens.*
	Greek temple.
Shaen	Gateway: a modest castellated entrance flanked by an octagonal tower and turret.

Co. Longford

Carrigglass	Gateway: a plain single triumphal arch with niches in the piers, by James Gandon.
	Archways: two fine rusticated classical archways (one pedimented) to stable and farmyards, also by Gandon.

Mosstown	Orangery *circa* 1840, now ruined. Octagonal pigeon-house.
Castle Forbes	Gateway: a French-style stable entrance.

Co. Louth

Ball's Grove	Classical gateway.*
Barmeath Castle	Tower: tall, round, stone structure with cross arrow-slits, a corbelled embattled parapet, and a battered base.
Beaulieu	Summer-house: a Victorian pavilion with ornate bargeboards and branch-work decoration. Ornamental glasshouse.†
Castle Bellingham	Castellated gate house facing village green.
Drogheda	Castellated railway bridge.
Dundalk House	*Chinese bridge over artificial waterway.* *Rustic pavilion in the Thomas Wright manner, like the one that also existed at Tollymore.*
Louth Hall	*Grotto appears on early C19 Ordnance Survey map.*
Oriel Temple	Temple considerably extended and now contained within larger house. Hermitage.* Rustic cottage now much altered.
Townley Hall	Templar gate lodge.*

Co. Meath

Arch Hall	Classical gateway.* Bridge.*
Ashbourne	Brindley obelisk.*
Bellinter House	Ornamental orangery.†
Boyne	Obelisk.*
Castlerickard	Pyramidal mausoleum.*
Dangan	Obelisks (2).* *Folly fort.*
Dunsany Castle	Gateways: several Gothic gateways to the demesne, one in the form of a sham ruin.
Gibbstown	Campanile.†
Harbourstown	Gazebo.*
Kells	Lloyd's tower.*
Kilbixy	Mausoleum.*
Larch Hill	Fox's Earth.* Cockle Tower.* Gazebo/seat.* Primitive temple.* Folly fort.* Dairy.* Feuillée: a tight stand of mature beeches on a spiral mound. Boat-house: a small Gothic-shaped vaulted structure with a turfed roof. Gothick stables: a delightful range of Georgian Gothick stables with fine stone dressing to openings. Gazebo: crude rubble-stone piers and a simple solid dome, like Fox's Earth and gazebo seat.
Loughcrew	Greek templar lodge.* Rustic seat.† Sham souterrain.†
Mornington	Maiden's tower.* Lady's Finger.*
Slane	Gothic gateway/lodge.* Castellated gateway/screen.* Ornamental factory.†
Tobertynan House	Tower: a Gothic-style ruined structure sketched by Barbara Jones.
Trim	Wellington's column: a small-scale statue-topped column.
Summerhill	*Balloon house: a square-planned gate lodge with Gothic-style windows and a remarkable curved pyramidal roof.* Gateway: a fine triumphal-arch entrance with

rusticated stonework, circular and round-headed niches; presumably by Pearce.
Mausoleum: a large church-like building now in ruins.

Co. Offaly

Birr Castle	Castellated gateway.* Column.* Gothic observatory to house the Earl of Rosse's famous telescope. Boat-house: a small Victorian structure with ornate bargeboards. Cottage *orné*.†
Clara House	Gothic gates.† Tinnamuck spire.†
Charleville Forest	Grotto.* Camden tower.* *Gothic dairy: an elaborate battlemented and pinnacled structure appears in an 1801 painting by William Ashford.* Castellated gateway: an entrance in a similar language to the main house.
Gloster House	Classical archway.*
Mullaghill	Sadleir's tower.*
Tullamore	Acre's folly: tower.†

Co. Westmeath

Baronston	Tower: a tall square ruined water-tower.
Belvedere	Gazebo.* Eye-catcher/rustic arch.* Sham ruin.* Grotto: a small crude structure with windows to either side of a central entrance in stonework similar to the rustic arch.
Bracklyn Castle	Rustic gateway.* Rustic mausoleum.*
Dunboden	Mausoleum.*
Glassan	Rustic pillar.*
Jamestown Court	Square Gothic-style eyecatcher tower at Castle town Geoghan.†
Killua	Obelisk.* Templar gate lodge.* Gothic gate lodge: an embattled symmetrical structure in neatly cut stone. Sham ruin: a fine stone-built structure with quatrefoil and pointed-arched openings.
Knockdrin	Gateway: a castellated three-storey tower and a small two-storey square tower to either side of a battlemented entrance. Gothick summer-house: a simple stone structure with pinnacle-topped piers in a stepped terraced garden.
Rosmead	Classical gateway.*
Tullynally	Castellated gate lodge: a simple battlemented structure with a small round tower connected to one side. Grotto.*
Waterston	Pigeon-house/eye-catcher.* Hermitage.* Classical stables with a tall, semi-ruined, pedimented archway by Richard Castle.

Co. Wexford

Barnstown	Obelisk visible from road near Barnstown.
Berkley Forest	Summer-house: a crude stone Gothic-style pavilion with thatched roof.
Carrigbyrne	Brown-Clayton column.*
Castleborough	Templar lodge like the main Palladian-style house, now ruined.

Ferrycarrig	Clg round tower.†
Johnstown Castle	Castellated gate lodge.*
	Fishing pavilion.*
Kilmokea	Temple seat: a strange shallow-pedimented structure with pairs of Doric columns in antis.
Rossgarland	Tower.†
Saltee Island	King of Saltee's throne.†

Co. Wicklow

Ballyarthur	Rustic temple.†
Bellevue	Gazebo.*
	Gothic banqueting hall.*
	Rustic temple: described by G. N. Wright.
Brayhead House	Gazebo.*
Charleville	Doric temple conservatory.
Coronation Plantation	Obelisk.*
Dunran Castle	Tower: low battlemented folly tower.
Hollybrook House	Tower.*
Kilruddery	*Conservatory: a large ornate structure by William Burn.*
	Gates: classical-style entrance arrangement as at Fota and Ballyfin.
Luggala	Temple: a Doric rotunda moved first from Templeogue and then from Santry.
	Rustic bridge: a small two-arched foot-bridge in irregular grotesque stonework.
Old Kilbride	Pyramid and Egyptian temple.†
Poul-A-Phouca	Gothic bridge.*
	Gothic bridge, smaller and much plainer than Poul-A-Phouca.
Powerscourt	Grotto.*
	Tower: an imposing circular stone C19 structure with high battlements and flagstaff.
	Obelisks and classical gateways in screen to sides of house.
	Pagoda in C20 Japanese garden.
Ranelagh House	Gazebo.†
Russborough	Classical gateway.*
	Obelisk field gates.*
	Monumental column: a small Doric column topped with a trumpet-playing winged nymph.
	Grottoes mentioned in Hall's Ireland.
Shelton Abbey	Castellated gateway.*
	Gothick gate lodge.*

MUNSTER

Co. Clare

Birchfield	O'Brien's column.*
	Castellated stables: a large battlemented range now in ruins.
Cliffs of Moher	O'Brien's tower.*
Dromoland	Gazebo.*
	Temple.*
	Grotto: a small stone structure similar to the one at Belvedere.
	Gate lodge: a Tuscan templar lodge with fine tetrastyle portico.
Lisdoonvarna	Spectacle bridge.*
Mount Ievers	Pigeon-houses.†
Tobercornan	Pinnacle well.*

Co. Cork

Anne's Grove	Castellated gateway by Benjamin Woodward.
	Rustic bridge: an elegant single-span foot-bridge.
Bantry	Gate lodge.*
	Monumental staircase.*

	Gateway: a Venetian window-styled archway with steps leading up to pedimented stable entrance topped by a fine Corinthian tempietta.
Ballylyons	Mausoleum.*
Blackrock	Sham castle: an imposing C19 battlemented structure on a rocky outcrop on the Lee estuary.
	Tower: a squat round C19 castellated structure.
Blarney Castle	Sham Druidic ruins: a small rock circle.
	Tower: a tall campanile-style round tower linked to the castle.
Bridestown	Towers: a pair of vaguely French-style two-storey polygonal towers flanking the entrance.
Castle Hyde	Gateway: a sphinx-topped, trefoil-arched wickets with Doric entablature to either side of a metal gate.
Castle Martyr	Gateway: a castellated entrance screen.
Castletownbere	Temple: a primitive rubble-stone rotunda with painted sham windows on hill near old mine shafts; possibly a gunpowder magazine.
	Boat-houses: two simple battlemented structures in rubble stone with cross arrow-slits.
	Towers: numerous square-planned, battlemented, three-storey structures along the coastline, probably signal towers.
Coolmore	Tower.*
	Rustic seat.*
Creagh Cas	Gateway: an impressive pinnacled and battlemented Gothic entrance screen with a large central archway flanked by two smaller ones.
Doneraile Court	Gates: a classical gateway with a plain templar lodge.
Dunboy Castle	Gate lodge: a two-storey Gothic lodge; the main house is now a spectacular ruin.
Fota Island	Gates: a classical design of piers with a templar lodge by the Morrisons; similar to Ballyfin.
	Temple.*
	Sham castle.*
Glanmire	Father Mathew's tower.*
Glengarriff	*Cottage orné with undulating thatched roof, rustic columns, and verandas.*
Ilnacullin	Hexagonal temple: a simple open-topped structure.
	Italian pavilion: a delightful open pavilion with Venetian window-style openings beside a rectangular pool.
	Casita: a larger-scaled version of the pavilion with a slender-columned loggia; all early C20.
	Tower: a three-storey square-planned bell-tower with viewing gallery under pyramidal roof.
Kilcrohane	Tower: Mr Bandon's Folly, a square-planned three-storey structure in coursed stone with a battlemented crown and small central turret.
Lotabeg	Gateway: an impressive Ionic archway with hound couchant and detached flanking side entrances.
Luskin's Bridge	Leader's folly: an unsuccessful mid-C19 aqueduct.
Man-of-War Cove	Bathing pavilion.*
	Castellated lime kiln: a simple structure similar in construction to the nearby bathing pavilion.
Mount Rivers	Tower.*
Miltown Castle	Gates: tall eagle-topped gate piers with interesting gable end to lodge, with bust-filled niches.
Rostellan	Column.*
	Tower.*
Stannards Grove/ Near Rockmills	Rustic obelisk: stepped pier as at Billy, Co. Derry, but with tall pyramidal top erected over the grave of a greyhound. Photograph in *Journal of the Cork Historical and Archaeological Society*, 1920, pp. 226–7.

Tivoli — Gothick temple: an elaborate two-storey structure appears in a late C18 painting by Nathaniel Grogan; now much altered.

Co. Kerry

Ardfert — Eye-catcher: a late C18 Gothick arch with ornate stucco decoration.
Gates: C19 battlemented lodge gates.

Ballybeggan Castle — Grotto: reputedly by Dr Delany.†

Derrynane — Tower: a modest two-storey circular tower perched on a rocky outcrop, with pointed-arch windows and an external stair to first-floor room.

Dingle — Hussey's tower: Castellated two storey tower of 1840.
Eask tower: a rubble-stone daymark approximately 20ft high, with a wooden hand pointing towards the harbour.

Dromore Castle — Tower: a plain square-planned rubble-stone tower with small corner turrets; now much ruined.
Gate lodge: a small castellated structure by Deane and Woodward.

Glenbeigh — Whinn's folly.*

Muckross — Cottage *orné*: a smaller version of Cahir.

Sneem — Stone cones C20.*

Waterville — Ship House: a large C20 beach house in the form of a ship.

Co. Limerick

Castlegarde — Castellated gateway with squat round tower.

Castle Oliver — Eye-catcher: Oliver's folly.*
Gate lodge/archway.*
Ice-house: an impressive domed structure constructed of large irregular boulders with a rustic arched entrance.

Glin — Eye-catcher: Hamilton's tower.*
West lodge.*
Village lodge.*
Bathing lodge.*
Rustic seat.*
Hermitage.*

Limerick City — Monumental column.*

Shannon Grove — Ornamental stone pigeon-house.

Co. Tipperary

Brittas Castle — Gate tower.*

Cahir — Cottage orné (Swiss Cottage).*
Gazebo.†

Clogheen — Grubb's grave.*

Devil's Bit — Tower.*

Killoran House — Tower: a plain two-storey round tower with battlemented parapet and raised entrance.

Knocklofty House — Tower known as the Googy: a domed Gothic octagonal structure.

Marlfield — Gates: classical entrance gates with twin Doric lodges.

Nenagh — Tower: elaborate stepped battlements above narrow arched openings added to original medieval round castle in 1860 for picturesque effect.

Newtown Anner — Shell grotto.
Temple: standing on an island in a lake.

Shanbally House — Gothick gazebo: an interesting two-storey octagon in rubble stone with dressed stone round-headed windows. Projecting brick battlemented parapet contains elliptical arches and circular niches.

Templemore — Woodcock Carden's Tower: a plain circular stone three-storey structure with corbelled top.

Co. Waterford

Ardo (Ardogena) — Towers: numerous folly-style tower additions to two-storey house, now an impressive ruin.

Ballysaggartmore — Castellated bridge.*
Gothic gate lodges.*
Small bridge.*

Dromana — Hindu Gothick gateway.*

Curraghmore — Shell house.*
Stable archway: fine Vanbrugh-style entrance to courtyard.
Le Poer tower.*
Mother Brown: a natural figure-shaped stone.*

Dungarvan — Greyhound obelisk.*
Shell cottage.*

Tramore — Metal Man pillars.*

ULSTER

Co. Antrim

Antrim Castle — Gates: entrance gateway with octagonal turrets.

Ballycastle — *Bottle tower/glassworks.**

Ballylough House — Gate lodge: an interesting circular-planned battlemented lodge similar to the bathing lodge at Glin.

Beardiville House — Classical gate lodges.*

Billy — Pillar: a crude stone structure 25 feet high, of coursed basalt with three diminishing, rotated, square-planned piers, commemorates the Trail family.

Bushmills — Clock-tower.*

Castle Upon — Mausoleum.*
Castellated gateway.*
Stable yard: a fine castellated range by Robert Adam.

Crumlin — Tower: a tall stone clock-tower memorial with pyramidal roof, to the Pakenham family.

Cushendall — Turnley's tower.*

Glenariff — *Rustic pavilion: a branch-decorated thatched pavilion known as Fog House.*
Rustic bridges to give access to the picturesque waterfall.

Glenarm Castle — Barbican gateway.*
Sham ruin.†

Kilbride — Mausoleum: an interesting Mughal-style structure like a small plain Taj Mahal; commemorates the Stephenson family.

Kilroot — *Egg cottage: an unusual small elliptical-planned thatched cottage, photographed by Robert Welch.*

Larne — Chaine memorial: a replica Irish round tower.*

Shane's Castle — Tower: a small telescope-shaped turret and battery in an impressive lough-side setting, attributed to John Nash. Orangery: an embattled camellia house, also by Nash.

Toome Bridge — Fountain of Liberty.*

Co. Armagh

Bishop's Palace — Obelisk 114 feet in height designed by Francis Johnston to commemorate the Duke of Northumberland.
Temple: a small Ionic tetrastyle structure built as the primate's private chapel, also by Johnston.

Castledillon — Obelisk.*
Gateway: a pair of small classical lodges linked by a low entrance screen.

Lurgan — *Mechanical Man: C18 description by John Wesley quoted at length by Barbara Jones.*

Co. Cavan

Butler's Bridge	Gateway: a simple classical arch.
Cabra Castle	Gothic stable-yard.
Crossdoney	Fleming's folly.*
Farnham House	Rustic cottage.*
	Dry bridge.*
Kilnahard	Rustic entrance arch.†
Rathkenny House	Summer-house.*

Co. Derry

Ballykelly	Sampson's Tower.*
	Mausoleum: a large Greek revival structure for the Cather family in Walworth Old Churchyard.
	Mausoleum in Gothic revival style for the Gage family in Tamlaghtfinlagan churchyard.
Ballyscullion	Sham ruin.*
Bellarena	Tower: C18 structure 25 feet high, consisting of a stone staircase winding around a brick belvedere 5 feet wide, with Gothic-style arches.
Castle Dawson	*Obelisk erected by the Bishop of Derry to the virtues of the Dawson family.*
	Gate lodge: a picturesque L-shaped cottage.
Derry	*Walker's column.**
	Bishop's gate: an impressive late C18 triumphal arch designed by Henry Aaron Baker, with sculpted panels and carved keystone faces.
Downhill	Bishop's gate and lodge.*
	Lion's gate.*
	Mussenden Temple.*
	Bristol cenotaph.*
	Gazebo.*
	Eye-catcher/ruin.*
	Domed pigeon-house built into walled garden with ice-house below.
Drenagh House	Templar gate lodge with Ionic tetrastyle portico.
Garvagh	Clock-tower: battlemented war memorial.
Limavady	Beresford obelisk: 40 feet high sandstone obelisk of 1840 to commemorate the Marquess of Waterford.
Pellipar House	Gate lodges: a pair of pedimented classical lodges.

Co. Donegal

Bunbeg	Tower: a folly-style signal tower.
Bundoran	Cassidy's Folly.*
Camlin	Castellated gateway with tall round flag-tower.
Convoy House	Impressive castellated gateway/entrance lodge of 1806, with a quaint square tower and projecting bartizans.
Falcarragh	Cloghaneely.*
Glenveagh	Monumental stairway.*
	Gothick conservatory: a battlemented C20 design.
	Umbrellas: C20 open pavilions with conical shingle-clad roofs.

Co. Down

Ardglass	Isabella's Tower.*
	Eye of Ardglass (tower).*
	Bathing gazebo.*
	Castellated barn: a large late C18 structure with pinnacle-topped square tower and pointed-arched windows, similar in spirit to that at Tollymore.
Banbridge	Crozier monument: a statue-topped tempietto on bare adorned with polar bears to Capt. Crozier who along with Sir John Franklin, perished in search of a north-west passage.

Belfast	Albert Clock (tower): an imposing Italianate structure 145 feet high, now the leaning tower of Belfast; designed by William Barre.
	Pilot Office, one described as a collapsed telescope in the Tudor manner; a small two-storey octagon with a projecting circular turret.
	Beaufort House (garden tower).*
	Mausoleums: several interesting neoclassical sturctures in Cliften Old Graveyard.
	Gate lodge: a symmetrical Gothick-style lodge to Friar's Bush graveyard.*
	*Royal visit archway.**
Belvoir Park	*Gate lodges: a pair of octagonal pepper-pot lodges linked by entrance screen wall.*
Castle Ward	Temple.*
	Eye-catcher/ruined tower house.*
	Grotto appears in Mary Delany's C18 watercolour.
Castlewellan	Gazebo.*
	Temple: a Georgian Gothick temple with tall octagonal-based spire, demolished in 1850s.
	Pigeon-house: a large plain brick structure, square-planned with pyramidal roof.
Carrowdore Castle	Gateway tower.*
	Eye-catcher: a plain Gothick-style sham gate lodge.
Clandeboye	Helen's Tower.*
	Gothic railway bridges.*
	Romanesque chapel: a large stone private chapel with Gothic tracery and a fine Norman-style doorway.
	Thatched beehive: a small, quaint, timber structure raised on piers with an overhanging thatched roof.
Comber	Gillespie Obelisk.*
Donaghadee	Sham castle.*
Dondonald	Cleland mausoleum: a most impressive greek doric structure of 1842, with Ionic domed tempietta all in neat ashlar graint.
Dromore/Bishop's Palace	*Timber obelisk: a drawing of this survives and is illustrated in* Lost Demesnes *by Malins and Glin.*
Grey Abbey	Gothick eye-catcher.*
	Gothick gates and octagonal lodge.*
	Holy well: a small stone vaulted structure with a carved face above entrance.
Hillsborough Castle	Greek temple.*
	Iron temple.*
	Hill's column.*
	Gothick fort.*
	Gazebo.*
	Grotto/ice-house.*
	Cromlyn's chapel/sham ruin.*
Killyleagh	Gate house: an impressive battlemented gate lodge linked by a screen wall to existing conical-roofed round towers.
Knockbreda	Mausoleums group.*
Mount Stewart	Gothick gate lodge.*
	Temple of the Winds.*
	Tir na n'Og/mausoleum.*
	Dodo terrace: an interesting C20 collection of stone-carved animals including gryphons, a mermaid, baboons, crocodiles, dodos, and many more.
Newry	Egyptian-style rail bridge.*
Newtownards	Scrabo Tower/Londonderry memorial.*
Portaferry	*Whalebone arch: a slender Gothic-shaped arch, the surviving remains of a whale beached in the 1920s.*
	Folly castle: a small ruined watch-tower (possibly Foley's castle).
Portaferry House	Gazebo: a semi-ruined Gothic-style structure.
Quinton Castle	Castellated towers, turrets, gateways and battlements: an extensive collection of mainly

octagonal structures of various scales from one to three storeys in an impressive seaside setting.

Rademon House — Obelisk to W. S. Crawford MP 1864, perched on a hill with interesting souterrain under base.

Rostrevor — Ross obelisk.*

Folly fort known as Greenhan Park Castle overlooking Carlingford Lough, consisting of a square, rubble-built, battlemented tower with Gothick windows, on battlemented bastions.

Rowallane House — Obelisk: a squat pyramidal structure constructed of oval bap-stones similar to those used at Tollymore. Turrets/bellcote: ornamental features built into garden wall.

Rubane House — Pebble house.*

Bridge.*

Seaford House — Gateway and gate lodge.*

Tollymore — Lord Limerick's Follies (3).*

Barbican gate.*

Bryansford gate (Gothick).*

Hermitage.*

Horn bridge.*

Foly bridge.*

Ivy bridge.*

Clanbrassil Barn/sham church.*

Obelisk granite shaft on battered base with pedimented plinth adorned by acroteria. Commemorating James Bligh Jocelyn R. N. who died aged 23 in 1812.

Cascades on the Spinkwee, now difficult to identify.

Rustic arbour: photographs survive of an open Thomas Wright-style pavilion with tree-trunk columns and a thatched roof.

Tyrella House — Folly fort.*

Co. Fermanagh

Bellisle — *Grotto and temple, both described by Arthur Young.*

Rustic hut in the Thomas Wright manner.

Tower.†

Octagonal tower.†

Castle Caldwell — Octagonal gazebo of 1770, built by Sir James Caldwell.

Fiddlers stone.*

Castle Coole — Rustic cottage.*

Castle Hume — Pigeon-house: an octagonal C18 brick-lined tower with octagonal timber cupola.

Crom Castle — Tower: a circular-planned, battlemented structure of 1847 built as an observatory.

Boat-house: a battlemented structure of 1850.

Gazebo: a mid-C18 hexagonal stone building, perhaps linked to earlier Lovett Pearce design.

Ely Castle — Gate lodge: a primitive templar lodge with statued niches and Tuscan columns.

Enniskillen — Bridge Lodge: Gothic-style lodge with lattice windows and quatrefoil-shafted columns.

Lowry-Cole column.*

Florence Court — *Cottage orné: a thatched lodge with Gothick windows and whalebone entrance.*

Rustic arbour: a thatched open pavilion with tree-trunk columns and branch-work patterns.

Grotto.†

Chinese summer-house.†

Marble Arch — Grotto.†

Co. Monaghan

Castleblayney — Temple: a large C19 temple with fluted Ionic columns in antis, and an impressive lakeside setting on Lough Muckno.

Dartry — Dawson mausoleum.*

Dawson column.*

Monaghan — Dawson obelisk: a plain mid-C19 structure on an elaborate plinth and stepped base.

Rossmore Castle — *Towers and turrets: impressive tall additions to house now gone.*

Co. Tyrone

Caledon — Bone house.*

*Hermitage.**

*Monumental column.**

Templar gate lodge.*

Ornamental factory.†

Ornamental dairy.†

Castlecaulfield — Mausoleum: a fine large Doric temple structure for the Burges family.

Clogher — Brackenridge's tower.*

Dungannon — Gateway: a miniature folly castle in cement rendering, of 1931 former entrance to a reservoir.

Lindsayville — Mausoleum: an impressive Egyptian-style mausoleum with a stepped pyramidal roof topped with a squat obelisk.

Roxborough Castle — Gate lodge: an overly ornate Italianate structure with a crude modern extension.

Fort: a two-storey pedimented archway with gate keepers appartment in neat ashlar stone leads to low battlemented stone walks with corner bastions.

Tower: an impressive tall rubble stone round tower with fine cut stone dressings to plinth, parapet and cross-arrow slit openings.

Stewart Hall — Castellated screen in rubble stone with brick corbelling a neat stone bartizan and squat round towers at each end, *circa* 1830.

Tynan Abbey — Castellated gateway: with large octagonal and small square towers to either side of a portcullis-style entrance archway.

Bibliography

Alberti, L. B., *Ten Books on Architecture*, trans. J. Leoni, ed. Joseph Rykwert. London, 1955.

Automobile Association, *Illustrated Road Book of Ireland*. Dublin, 1970.

Bachelard, Gaston, *The Poetics of Space*, trans. Maria Jolas. London, 1964.

Ball, F. E., *History of County Dublin*, vols I, II, VI. Dublin, 1902–20.

Barry, John, *Hillsborough: A Parish in the Ulster Plantation*. Belfast, 1962.

Barry, Michael, *Across Deep Waters: Bridges of Ireland*. Dublin, 1985.

Bartlett, W. H., *Ireland Illustrated*. 3 vols. London, 1831.

—— *The Scenery and Antiquities of Ireland* [with text by] N. P. Willis and J. Stirling Coyne. 2 vols. London, 1845.

Barton, Stuart, *Monumental Follies*. Worthing, 1972.

Beard, Geoffrey, *The Works of John Vanbrugh*. London, 1986.

Bell, G. P., Brett, C. E. B., and Maxwell, Sir Robert, *Portaferry and Strangford*. UAHS, Belfast, 1969.

Bence-Jones, Mark, 'A Plea for the Gates', *IGSB*, **II** no. 2, 1959, pp. 21–6.

—— *Burke's Guide to Country Houses*, vol. 1, *Ireland*. London, 1978.

Bolger, William, and Share, Bernard, *And Nelson on his Pillar*. Dublin, 1976.

Brett, C. E. B., *Glens of Antrim*. UAHS, Belfast, 1971.

—— *East Down*. UAHS, Belfast, 1973.

—— *Mid Down*. UAHS, Belfast, 1974.

Brewer, J. N., *Beauties of Ireland*. 2 vols. London, 1825.

Buxbaum, Tim, *Scottish Garden Buildings: From Food to Folly*. Edinburgh, 1989.

Casey, Christine, 'Miscelanea Structura Curiosa', *Irish Arts Review*, 1991, pp. 85–91.

Clandeboye. UAHS, Belfast, 1985.

Clarke, Kenneth, *The Gothic Revival: An Essay in the History of Taste*. London 1928.

Colvin, H. M., *A Biographical Dictionary of English Architects, 1600–1840*. London, 1978.

—— *Architecture and the Afterlife*. New Haven and London, 1991.

Colvin, H. M. and Craig, Maurice, *Architectural Drawings in the Library of Elton Hall by Sir John Vanbrugh and Sir Edward Lovett Pearce*. Oxford, 1964.

Conner, Patrick, 'Britain's First Chinese Pavilion?', *Country Life*, 25 January 1979, pp. 236–7.

Costello, Con, 'Pompey's Pillar in Wexford', *IGSB*, **XIX** nos 1/2, 1976, pp. 1–9.

Coyne, J. Stirling *see* Bartlett, W. H., *The Scenery and Antiquities of Ireland . . .*

Craig, Archie Gordon, *Towers*. Newton Abbot, 1979.

Craig, Maurice, *The Volunteer Earl*. London, 1948.

—— *Dublin 1660–1860*. Dublin, 1969.

—— 'Sir Edward Lovett Pearce', *IGSB*, **XVII** nos 1/2, 1974, pp. 10–14.

—— 'Mausoleums in Ireland', *Irish Historical Studies*, **LXIV**, 1975, pp. 410–23.

—— *The Architecture of Ireland: From the Earliest Times to 1880*. London, 1982.

Craig, Maurice, and Fitzgerald, D. J. V., eds., *Irish Architectural Drawings*. [Catalogue of an exhibition to mark the 25th anniversary of the Irish Architectural Records Association.] Dublin, 1965.

Craig, Maurice, and the Knight of Glin, *Ireland Observed*. Cork, 1970.

Cunningham, George, *Burren Journey West*. Limerick, 1980.

Curl, James Stevens, *Mausolea in Ulster*. UAHS, Belfast, 1978.

—— *The Art and Architecture of Freemasonry*. London, 1991.

De Breffny, Brian, and Folliott, Rosemary, *The Houses of Ireland*. London, 1975.

Delany, Mary, *Autobiography and Correspondence*, ed. Lady Llanover. 6 vols. London, 1861–2.

—— *Letters from Georgian Ireland*, ed. Angélique Day. Belfast, 1991.

Department of the Environment, Northern Ireland, *Historic Buildings of Northern Ireland*. Belfast, 1987.

Dixon, Hugh, *Donaghadee*. UAHS, Belfast, 1977.

Doyle, J. B., *Tours in Ulster*. Dublin, 1854; reprinted, n.d.

Du Prey, Pierre, 'Je n'oublieray jamais: Sir John Soane at Downhill', *IGSB*, **XXX** nos 3/4, 1978, pp. 17–40.

Ferguson, W. S., Rowan, A. J., and Tracey, J. J., *City of Derry*. UAHS, Belfast, 1970.

Fletcher, Sir Banister. *A History of Architecture on the Comparative Method*. London, 1896.

—— 12th ed. London, 1945.

—— 19th ed., ed. John Musgrove. London, 1989.

The Folly Fellowship, *Follies*: [A quarterly magazine published since 1988.]

Forster, E. M., *Alexandria: A History and a Guide*. 3rd ed. New York, 1961.

Fothergill, Brian, *The Mitred Earl: An Eighteenth-century Eccentric*. London, 1988.

Gallagher, Lyn, and Rodgers, Dick, *Castle, Coast and Cottage: The National Trust in Northern Ireland*. Belfast, 1986.

Georgian Group *see* White, Roger, *Georgian Arcadia*...

Georgian Society Records. 5 vols. Dublin, 1909–13; reprinted, 1969.

Girvan, Donald, *North Antrim*. UAHS, Belfast, 1972.

—— *North Derry*. UAHS, Belfast, 1975.

Girvan, Donald, and Rowan, Alistair, *West Antrim*. Belfast, 1970.

Glin, The Knight of, 'Richard Castle, Architect: a synopsis', *IGSB*, **VII** no. 1, 1964, pp. 31–8.

—— 'New Light on Castletown', *IGSB*, **VIII** no. 1, 1965, pp. 3–9.

Glin, The Knight of, Griffin, D., and Robinson, N., *Vanishing Country Houses of Ireland*. Dublin, 1989.

Grumbach, Antoine, 'Le théâtre de la mémoire', *Architectural Design*, **48** nos 8/9, 1978, pp. 2–5.

Guinness, Desmond, 'Visiting Georgian Ireland', *IGSB*, **VIII** no. 2, 1965, pp. 43–54.

—— 'Follies in Ireland', *IGSB*, **XIV** nos 1/2, 1971, pp. 21–8.

Guinness, Desmond, and the Knight of Glin, 'The Conolly Folly: a case for Richard Castle', *IGSB*, **VI** no. 4, 1963, pp. 59–73.

Guinness, Desmond, and Lines, Charles, *Castletown*. [Undated guidebook].

Guinness, Desmond, and Ryan, William, *Irish Houses and Castles*. London, 1971.

Guinness, Mariga, 'The (Deliberate) Follies of Ireland', *Ireland of the Welcomes*, **20** no. 5, 1980, pp. 19–25.

Gunnis, Rupert, 'Some Irish Memorials', *IGSB*, **IV** no. 1, 1961, pp. 1–15.

Hall, Samuel Carter, and Hall, Anna Maria, *Ireland: Its Scenery, Character, etc.* 3 vols. London, 1841–3.

Hardy, Francis, *Memoirs of the Political and Private Life of James Caulfield, Earl of Charlemont*. London, 1812.

Harris, Eileen, 'The Wizard of Durham: The Architecture of Thomas Wright I', *Country Life*, 26 August 1971, pp. 492–5.

—— 'A Flair for the Grandiose: The Architecture of Thomas Wright II', *Country Life*, 2 September 1971, pp. 546–50.

—— 'Architect of Rococo Landscapes: Thomas Wright III', *Country Life*, 9 September 1971, pp. 612–15.

Harris, Eileen, ed. *see* Wright, Thomas, *Thomas Wright: Arbours and Grottos*...

Harris, John, 'Sir William Chambers: Friend of Charlemont', *IGSB*, **VIII** no. 3, 1965, pp. 67–100.

—— *Sir William Chambers*. London, 1970.

Harris, Walter, *The Antient and Present State of the County of Down*. Dublin, 1744; reprinted, n.d.

Hayden, Ruth, *Mrs Delany: Her Life and her Flowers*. 2nd ed. London, 1992.

Headley, Gwyn, and Meulenkamp, Wim, *Follies: A National Trust Guide*. London, 1986.

Herrmann, Wolfgang, *Laugier and Eighteenth-century French Theory*. London, 1962.

Hewlings, Richard, 'Ripon's Forum Populi', *Journal of the Society of Architectural Historians of Great Britain*, **24**, 1981, pp. 39–52.

Horner, Arnold, 'Carton, Co. Kildare: A Case Study of the Making of an Irish Demesne', *IGSB*, **XVIII** nos. 2/3, 1975, pp. 45–104.

Hyams, Edward, and MacQuitty, William, *Irish Gardens*. London, 1967.

Irish Architectural Archive *see* Glin, The Knight of, and others, *Vanishing Country Houses of Ireland*...; McParland, E., and others, *The Architecture of Richard Morrison and William Vitruvius Morrison*...

Irish Architectural Records Association *see* Craig, M. and Fitzgerald, D. J. V. eds. *Irish Architectural Drawings*...

Jacques, David, *Georgian Gardens: The Reign of Nature*. London, 1983.

Johnston, Mairead, *Ice and Cold Storage: A Dublin History*. Dublin, 1988.

Jones, Barbara, *Follies and Grottoes*. London, 1953.

—— 2nd ed., enlarged. London, 1974.

Joyce, P. W., *Pocket Guide to Irish Place Names*. Belfast, 1984.

Larmour, Paul, *Belfast: An Illustrated Architectural Guide*. Belfast, 1987.

—— *The Architectural Heritage of Malone and Stranmillis*. UAHS, Belfast, 1991.

Latocnaye, H.-M. Bougrenet de, *A Frenchman's Walk through Ireland, 1796–7*. Dublin, 1797.

—— ed. Joan Stevenson. Dublin, 1917; reprinted Belfast, 1984.

Lewis, Samuel, *Topographical Dictionary of Ireland*. 2 vols. London, 1837.

McCarthy, Michael, *The Origins of the Gothic Revival*. New Haven and London, 1982.

McCullough, Niall, and Mulvin, Valerie, *A Lost Tradition: The Nature of Architecture in Ireland*. Dublin, 1987.

McParland, Edward, 'Francis Johnston, Architect, 1760–1829', *IGSB*, **XII** nos 3/4, 1969, pp. 61–139.

—— *James Gandon, Vitruvius Hibernicus*. London, 1985.

—— 'A Bibliography of Irish Architectural History', *Irish Historical Studies*, **XXVI**, 1988, pp. 161–212.

McParland, Edward, Rowan, Alistair, and Rowan, A. M., *The Architecture of Richard Morrison and William Vitruvius Morrison*. Dublin, 1989.

Malins, Edward, 'Mrs. Delany and Landscaping in Ireland', *IGSB*, **XI** nos 2/3, 1968, pp. 1–16.

Malins, Edward, and Bowe, Patrick, *Irish Gardens and Demesnes from 1830*. London, 1980.

Malins, Edward, and the Knight of Glin, *Lost Demesnes: Irish Landscape Gardening 1660–1845*. London, 1976.

Marsden, Simon, and McLaren, Duncan, *In Ruins*. London, 1980.

Maxwell, Constantia, *Dublin under the Georges 1714–1830*. London, 1936.

—— rev. ed. London, 1956.

Middleton, Robin, and Watkin, David, *Neoclassical and Nineteenth-century Architecture*. New York, 1980.

Miller, Naomi, *Heavenly Caves: Reflections of the Garden Grotto*. London, 1982.

Mitchell, Frank, *Reading the Irish Landscape*. London and Dublin, 1986.

—— 'The Evolution of Townley Hall', *IGSB*, **XXX**, 1987, pp. 1–61.

Mowl, Tim, and Earnshaw, Brian, *Trumpet at a Distant Gate: The Lodge as Prelude to the Country House*. London, 1985.

Mulvany, Thomas, and Gandon, James, *The Life of James Gandon*. Dublin, 1846.

—— Reprint, ed. Maurice Craig. Dublin, 1969.

Nicolson, Harold, *Helen's Tower*. London, 1937.

Northern Gardens. UAHS, Belfast, after 1980.

O'Reilly, Seán, *The Casino at Marino*. Dublin, 1991.

Palladio, Andrea, *The Four Books of Architecture*, trans. Isaac Ware. London, 1738; reprinted New York, 1965.

Paterson, T. G. F., 'The Edifying Bishop (The Earl Bishop of Derry and his building)', *IGSB*, **IX** nos. 3/4, 1966, pp. 67–83.

Pearson, Peter, *Dunlaoghaire Kingstown*. Dublin, 1981.

Quintana, Ricardo, *Swift: An Introduction*. London, 1955.

Rankin, Peter, 'Downhill, Co. Derry', *Country Life*, 8–15 July 1971, pp. 94–7, 154–7.

—— *Irish Building Ventures of the Earl Bishop of Derry*. UAHS, Belfast, 1972.

—— *Mourne*. UAHS, Belfast, 1975.

Rowan, Alistair, 'Georgian Castles in Ireland', *IGSB*, **VII** no. 1, 1964, pp. 2–30.

—— *Garden Buildings*. [Drawings in the RIBA Collection.] London, 1968.

—— *Buildings of Ireland: North-West Ulster*. London, 1979.

Royal Irish Academy, *Atlas of Ireland*. Dublin, 1979.

Rudiments of Ancient Architecture. 3rd ed. London, 1804.

Rykwert, Joseph, *On Adam's House in Paradise*. New York, 1972.

—— *The First Moderns*. Cambridge, Mass., 1983.

Shaffrey, Patrick, and Shaffrey, Maura, *Irish Countryside Buildings*. Dublin, 1985.

Smith, Julia Abel, *Pavilions in Peril*. London, 1987.

Summerson, Sir John, *The Architecture of Britain 1530–1830*. London, 1953.

—— *The Classical Language of Architecture*. London, 1964.

Swift, Jonathan, *Works*. Edinburgh, 1757.

Tomkins, Peter, *The Magic of Obelisks*. New York, 1981.

Vanbrugh, Sir John, *Complete Works*, vol. IV, *Letters*, ed. G. Webb. London, 1928.

Watkin, David, *The English Vision: The Picturesque in Architecture, Landscape and Garden Design*. London, 1982.

White, Roger, *Georgian Arcadia: Architecture for Park and Garden*. [Catalogue of an exhibition to mark the golden jubilee of the Georgian Group.] London, 1987.

Willis, N. P. *see* Bartlett, W. H., *The Scenery and Antiquities of Ireland*...

Wright, G. N., *Guide to County Wicklow*. London, 1822.

—— *Ireland Illustrated*. London, 1831.

Wright, Thomas, *Universal Architecture*. 2 vols. London, 1755–8.

—— *Louthiana, or an Introduction to the Antiquities of Ireland*. London, 1758.

—— *Thomas Wright: Arbours and Grottos*, ed. Eileen Harris. London, 1979.

Wynne, Michael, 'The Charlemont Album', *IGSB*, **XXI** nos 1/2, 1978, pp. 1–6.

Young, Arthur, *A Tour in Ireland 1776–8*, ed. Constantia Maxwell. Cambridge, 1925; reprinted Belfast, 1983.

Index